SICKERT

WENDY BARON

SICKERT

PHAIDON

PHAIDON PRESS LIMITED, 5 CROMWELL PLACE, LONDON SW7

PUBLISHED IN THE UNITED STATES OF AMERICA BY PHAIDON PUBLISHERS, INC.
AND DISTRIBUTED BY PRAEGER PUBLISHERS, INC.
III FOURTH AVENUE, NEW YORK, N.Y. 10003

FIRST PUBLISHED 1973
© 1973 BY PHAIDON PRESS LIMITED
ALL RIGHTS RESERVED

ISBN 0 7148 1543 8
LIBRARY OF CONGRESS CATALOG CARD NUMBER: 73-165859

PRINTED IN GREAT BRITAIN BY R. & R. CLARK LTD., EDINBURGH

Contents

Acknowledgements

MY research into Sickert's work over the past fifteen years has received help from many sources. I wish to thank the University of London for the award of a Postgraduate Studentship from 1959 to 1961 and for assisting me from their Central Research Fund with the loan of photographic equipment supplemented by a grant towards photographic and travelling expenses. I also wish to thank the Paul Mellon Foundation for British Art for grants towards travel expenses from 1967 to 1969, and the Paul Mellon Centre for Studies in British Art for a further research and travel grant from 1970 to 1971.

So many people have helped my work that I can name but a few individually. First of all I must state how warmly I appreciate the help given to me over the years by Miss Lillian Browse. An authority on a particular subject does not always treat a subsequent student so generously. Miss Browse has answered all my many questions. She has used her unrivalled archives to help me trace pictures and has allowed me free access to her photographic material. It is hardly necessary to state that her two books on Sickert have been of great use to me and that I am particularly indebted to her invaluable catalogue of Sickert's work in public collections throughout the world. The Sickert exhibitions which she and her colleagues at Roland, Browse and Delbanco have mounted have been a particular pleasure to me and it was, indeed, their Sickert exhibition of 1957 which first excited my especial interest in the artist. I must also make individual mention of Professor Lawrence Gowing for his stimulating supervision of the research for my Ph.D. thesis on Sickert.

I should like to thank the many art dealers' galleries whose directors and staff have been most helpful in answering questions arising from the compilation of my catalogue. The help given to me by particular dealers about particular problems is acknowledged in footnotes to the text but I must especially thank Messrs. Thomas Agnew and Sons Ltd., Messrs. Brown and Phillips of the Leicester Galleries, and Messrs. Arthur Tooth and Sons Ltd. for allowing me access to their archives and photographic collections. Messrs. Christie, Manson and Woods and Messrs. Sotheby and Co. have given me similar help for which I am most grateful.

My thanks are due to the many friends and colleagues of Sickert whose recollections of his life, his work, and his teaching have been of great interest and provided me with invaluable source material. The reminiscences of Miss Marjorie Lilly, Mrs. Madeline Clifton, the late Mrs. Swinton, and the late Miss Ethel Sands were of particular value. I am especially indebted to those who have allowed me access to letters by Sickert. I wish to thank the entire staff of the many public collections throughout the world which possess Sickert's work. They have given me every possible information about their pictures. I must single out Mr. E. Willett, whose responsibility it is to care for the unique collection of Sickertiana bequeathed by the Sickert Trust to the Islington Public Libraries. I am also glad of this opportunity to thank, most warmly, the many hundreds of private owners of Sickert's work who, almost without exception, have likewise put themselves to considerable trouble to arrange for me to view their collections and answer my numerous questions about their pictures.

I have appreciated the advice and encouragement given to me by friends and teachers at the Courtauld Institute of Art. I am particularly grateful to Dr. Bruce Laughton. Finally my gratitude is due to my husband—who has read, re-read and revised my Sickert manuscripts—and to my children Richard and Susannah for their forbearance with my preoccupation with Sickert over so many years.

W. B.

ACKNOWLEDGEMENTS

The author and publishers wish to express their gratitude to the owners of pictures in private and public collections who have kindly allowed their works to be reproduced. Names of owners are given in the picture captions.

They would also like to thank those who provided photographic material for this book, in particular Miss Lillian Browse, the Leicester Galleries, and the Arts Council of Great Britain.

Finally they wish to make particular acknowledgement to Mr. Henry Lessore.

Introduction

THIS is a study of Walter Richard Sickert's stylistic and technical development. It is not a biography. It is not even primarily concerned with estimating Sickert's place in English art. Sickert's stature as a leading figure in English art for the duration of his working life, and as perhaps the most important English painter since the death of Turner, is generally acknowledged. During a period of some sixty years, from Victorian times until the Second World War, Sickert had, by advice and example, something to offer each succeeding generation of painters. Without apparent effort, and certainly without explicit allegiance to any of the more radical French-inspired trends and movements which from time to time dominated the aims and efforts of his younger colleagues, Sickert maintained a modern image and retained the sincere respect of painters and public alike. In a host of short-lived private schools in his many studios, at the Westminster Technical Institute on and off from about 1908 until 1918, at the Royal Academy School and many provincial art schools from the 1920s onwards, Sickert taught generations of young English men and women to etch, draw, and paint[1]. His studios were the accepted place for his contemporaries and colleagues to forgather and as such they became vital centres for communication and co-operation between painters. The influence Sickert exerted upon and received from his fellow painters will, it is hoped, emerge from the discussion of his work which follows.

There is already a considerable literature on Sickert. His pupil, Dr. Robert Van Buren Emmons, wrote about the general outlines of his life, writing, and painting[2]. Lillian Browse has written two informative and well-illustrated monographs[3]. Osbert Sitwell edited a choice anthology of his writings[4]. There have been several short picture-books, and chapters in more general surveys[5]; there will undoubtedly be more books on Sickert. His personality, the times he lived through, the people he knew, are all of great interest. Sickert was a man of wide-ranging talents. His youthful career as an actor from 1877 to 1881[6] left him with a delight in all things theatrical, both as a participant (he liked to declaim Shakespeare and adopt eccentric disguises) and as a spectator. He was concerned with his social, political, and intellectual environment; in later life he besieged the press with letters on a startling variety of public issues[7]. He had some knowledge of Latin and Greek and was fluent in French, German, and Italian. He read avidly in many languages. He was a brilliant and witty talker. He swam and for a time in middle age began each day in the Euston baths. He was astoundingly handsome, although in later life he often disguised his good looks behind an unkempt beard and a scruffy assortment of old clothes. In his eighty-two years he had three wives, many mistresses, and innumerable friends. Sometimes he was a recluse, sometimes an extrovert. Few painters have been as articulate as Sickert. In his public writings he left a full record of his acutely perceptive, but often idiosyncratic, views on art and artists. His private correspondence was equally voluminous and illuminating. But whatever his current enthusiasms, whatever his current image, he worked at his painting, his drawing, and his etching.

Jacques-Émile Blanche, the French painter and friend of Sickert, wrote that Sickert's output was perhaps 'greater than Constable's and Corot's taken collectively' as would be realized 'if it were possible

to get together the thousands of pictures he painted' and the 'sketches that are hidden here, there, and everywhere'[8]. Blanche's estimate was probably correct. For much of Sickert's sixty painting years his studios were like assembly-lines, with a range of canvases in the course of preparation every day, each one receiving a coat of paint, then left to dry, as Sickert went on to the next. The chief motive of this book, as distinct from previous books on Sickert, is to establish the chronology of his work; to discuss the chronology in terms of his stylistic and technical development in the text, and to document and illustrate it as far as possible in the catalogue.

Aspects of Sickert's art: 1. Professionalism

The key to understanding Sickert's art is the recognition of his profound professionalism. In his writings and in the more public aspects of his private life Sickert often cultivated the extroverted flippancy, the eccentricity and casual manners of an English gentleman. As an artist he secretly nurtured a total, consuming dedication of purpose wholly at variance with his public image as a witty, talented, handsome, and rather naughty *habitué* of the English, French, and Italian *salons* as well as of the fishmarkets of Dieppe. The characteristic English-born painters of Sickert's generation were gentleman-amateurs. They were content to deploy their talents in the production of charming, taste-ful, beautifully executed but inherently slight paintings. Sickert was not so content. His history as a painter was one of constant experiment, analysis, and exploration. He struggled endlessly, devising new recipes for painting, restlessly experimenting with different styles and techniques, sometimes labouring at a picture in his search for the ideal handling until he had destroyed all its charm and delicacy beneath a dark and oily mass of superimposed coats of paint. He was a true professional, with a proper respect for, and an enduring curiosity about, his craft.

'Half the artist is his knowledge of what is properly the raw material of art.'[9] 'A great painting happens when a master of the craft is talking to you about something that interests him.'[10] Sickert praised Pissarro's *La Côte des Bœufs* for its very 'laboriousness'[11]. These statements of his conviction are among the most deeply serious Sickert made. Painting is a craft which needs to be learned through some sort of system akin to apprenticeship. He quoted the studio practice of the Old Masters and the example of Turner who 'was colouring views and drawing marines in the way of trade at the age of eleven. There is no greater mistake than to say he survived this because he was a genius. It is the other way about. He was a genius partly because he knew his trade when our gentlemanly young art-students are entering the antique.'[12] Sickert revered tradition because the craftsman makes use of the experience of his predecessors, handed down from generation to generation. He reiterated that there is no such thing as modern art, that history is one unbroken stream, that if we know Degas, Degas knew Ingres, and so on, *ad infinitum*[13]. He even enquired into the etymology of the word 'artist' and triumphantly announced, 'English critics have forgotten the derivation . . . which means in Greek "joiner" '[14].

2. Family background

The explanation of Sickert's professionalism can be found, at least in part, in the circumstances of his birth and family background[15]. Sickert was not English, he was European. His heritage was Danish, German, Irish, and French as well as English. He was born in Munich in 1860. His mother was half English, half Irish, but she had been brought up abroad and lived for many years in Dieppe. His father was a Dane from Schleswig-Holstein but the Prussian annexation of this protectorate in 1866 made the Sickert family technically German subjects. It was the prospect of the future conscription of

his sons in the German army that persuaded Oswald Sickert to emigrate to England in 1868.

Not only were Sickert's antecedents European but he was the third generation of a family of professional artists. His paternal grandfather, Johann Jurgen Sickert, worked in the service of King Christian VIII of Denmark and painted 'easel pictures'[16]; his father Oswald Adalbert Sickert was a painter and graphic artist of some repute in Germany and he had studied and worked in France. Sickert, in his retrospective accounts of his father, stressed this French connection. Modifying Horatio's words to Hamlet he characterized his father as 'more an antique Parisian than a Dane'[17]. It is also significant that he interpreted even the embryonic stages of his own training primarily through its relationship to the mainstream of French nineteenth-century painting:

> For the understanding of Whistler's painting, I had the good fortune to be prepared, in the 'seventies, by the fact that I had received my earliest artistic education from two painters, both also affiliated to the French school. The one was my father, who had studied at Couture's, and was influenced by Courbet, and the other was Otto Scholderer, who had been subjected to the same influence.[18]

3. Technique and style

Sickert's inheritance prepared him to get the best out of his training with Whistler and make it a real apprenticeship in the craft of painting. His observation of, and collaboration in, the ritual preparation of palette and canvas for Whistler conditioned his lifelong fastidious reaction to the matter and substance of paint. Sickert's emphasis on the importance of technique and the achievement of what he called 'quality' in painting can be traced back to his training at the hub of the aesthetic controversies of the period. It was Whistler who campaigned so fiercely with his pen in his writings, with his brush in his paintings, and with his voice at the dinner table and in his lectures, that subject was unimportant compared to treatment, that pictures were to be regarded as decorations which were beautiful or not as a result of their treatment alone. The whole question of art, its nature and intrinsic qualities, was being re-examined by writers and artists at this time. Sickert's insistence that the artist is primarily a craftsman may have owed something to William Morris's theories about the nature and function of the artist. Sickert and his first wife often visited Morris at Chiswick in the 1880s and there is an interesting similarity in their ideas about the value of imperfection in a work of art. To Morris imperfection revealed the hand-made quality he looked for which communicated the individual relationship between creator and creation. To Sickert 'Deformation or distortion in drawing is a necessary quality in hand-made art'; it was *'not a defect'* but *'one of the sources of pleasure and interest'* provided it *'result from the effort for accuracy of an accomplished hand, and the inevitable degree of human error in the result'*[19]. Sickert once defined art as 'the individual quality of failure, or the individual coefficient of error of each highly skilled craftsman in his effort to attain the expression of form.'[20] R. A. M. Stevenson, in *Velasquez*, first published in 1895, echoed and clearly articulated the new attitude to painting. In the chapter called 'The Dignity of Technique' he asserted that 'technique is art', that 'the man who has no interest in technical questions has no interest in art'[21]. To those who agreed with Stevenson the discovery of the ideal technique, involving the thorough exploration of the properties of oil paint, was of paramount importance.

Sickert's early choice of Degas as the painter whom he felt could best guide him is another aspect or demonstration of his professionalism. While the more advanced of Sickert's English contemporaries found their inspiration in the painting of the true Impressionists, whose approach to the creation of pictures was dictated by the eye rather than by the mind, Sickert, convinced of his own potential but unsure how to exploit it, found his inspiration in Degas, the most intellectual and traditional painter of his generation in France.

Influenced by Degas, Sickert rejected the current fashion of painting *alla prima* as practised by Whistler and the Impressionists. When painting *alla prima* the style and handling of a picture was to a large extent conditioned by the haste demanded of an artist in capturing a fragment of nature in its entirety upon the canvas in one session. The characteristic Impressionist *facture* and Whistler's smooth blending of wet upon wet paint were both evolved as answers to this problem[22]. Sickert, guided by Degas, learned to paint in the studio, from memory, from drawings, from photographs and like documents. This return to traditional studio practice enabled him to control and premeditate his execution, his technique, his composition, and his style. But Sickert was liberated from the technical and stylistic preconceptions which governed the work of most pre-Impressionist painters. When Sickert, working in the studio from drawings and other documents, planned his pictures he was free to pick and choose from the wide repertoire of styles, techniques, and handlings open to any artist of his post-Impressionist generation. Sickert used this freedom with experimental detachment.

To understand Sickert's work it is essential to realize that these experiments were not aimless. He had a definite objective, to discover the ideal technique and the ideal handling. His search for these ideals was the impetus behind his apparently erratic technical and stylistic development, and the logic of this development can itself only be understood within the framework of an accurate chronology.

The emphasis of the book

Sickert rarely dated his work and his experiments involved him in apparent inconsistencies which confuse a straightforward interpretation of his development. It is, therefore, necessary to gather together all the documentation possible for dating particular examples of his work. A chronology based only on stylistic analysis would lead first to a false grouping together of all pictures executed in one or other manner, and then to the arrangement of these groups into an equally false sequential order. This kind of simplification of his chronology would destroy the very basis of our understanding of Sickert as a profoundly serious artist.

A cursory glance at this book reveals that both text and catalogue deal with Sickert's work up until 1914 in much more detail than his later work. There are several causes for this uneven weighting but it is in no way a value judgement on the relative merits of his earlier and later works. The most important cause is that the span of over thirty years from Sickert's early training with Whistler within the tonal impressionist tradition until 1914 was his formative period. It embraces his most famous productions, the London and Paris music halls, the Dieppe and Venetian landscapes, and, to most people the essence of Sickert's mature art, the Camden Town interiors. Yet for Sickert all these pictures were stepping-stones. They were experiments in style, in technique, in handling, and in subject matter. At different stages of his development certain of the styles of painting evolved by Sickert, styles which were often at root methods of handling and sometimes expressions of particular types of subject matter, appeared momentarily to be the objective towards which he had been working. But they were discarded. It was not until 1914 that Sickert evolved a technique of painting and method of handling which he felt to be the successful climax to his years of experiment and which, therefore, remained the basis of all his later paintings.

The chronology of Sickert's painting after this formative period is naturally more straightforward and needs little realignment. Changes in subject matter rather than changes in style and handling distinguish the different periods from 1914 onwards. Supplementary evidence for dating his later pictures can be found in the many exhibitions of his recent pictures at the several galleries which came to deal in his work[23]. More works are dated. There is more readily accessible documentary evidence. Emmons, his biographer, had first-hand knowledge of Sickert's life and work after 1927 and his account

of the later period is basically reliable. Other friends, colleagues, and pupils of these years have either published their own accounts of Sickert or helped others to do so with their informal recollections[24]. When Sickert, in later life, gained more official recognition his doings, as the grand old man of English painting, were constantly proclaimed by the press[25].

The detailed documentation of pictures discussed in the text (e.g. early press reviews serving to date and/or identify works, other evidence for dating works, the relationship of pictures to studies and versions, etc.) is generally given in the catalogue section. It may, therefore, be helpful to read each chapter in conjunction with the relevant catalogue section/s. Both text and catalogue are arranged chronologically and a note indicating the chapter of the text in which each work is discussed is appended to the main catalogue entries.

NOTES

1. Possibly the very force of Sickert's personality was responsible for the relatively mediocre performance of the majority of his pupils whose individual talents were so easily submerged by Sickert's example. Enid Bagnold, *Autobiography*, London, Heinemann, 1969, p. 73, wrote that Sickert 'was such a teacher as would make a kitchen-maid exhibit once'. She attended Sickert's school at Rowlandson House and, p. 75, she recalled 'His lightning-teaching tore across clouds of muddle and broke them up. For a time. His danger was that he gave short cuts to success . . . two of my drawings were exhibited at the New English, and one was mentioned in *The Times*. That didn't make me an artist . . . I got a long way but I was only a Sickert-product.'

2. *The Life and Opinions of Walter Richard Sickert*, London, Faber, 1941 (henceforth referred to as Emmons). Sickert himself read the manuscript of this book but gave neither help nor hindrance. The book is a primary source of information about Sickert's life and his later working methods. It also presents a good all-round portrait of the man. Historically, however, it is frequently inaccurate as regards Sickert's life and work before 1915.

3. *Sickert*, London, Faber, 1943, edited by Lillian Browse with an essay on his life and notes on his paintings and incorporating an essay on his art by R. H. Wilenski (henceforth referred to as B.43); *Sickert*, London, Rupert Hart-Davis, 1960 (henceforth referred to as B.60), the major monograph to date on Sickert.

4. *A Free House! or The Artist as Craftsman, being the Writings of Walter Richard Sickert*, London, Macmillan, 1947 (henceforth referred to as Sitwell). The selection is good although one or two important articles are omitted. The editing is uneven, with some minor misquotations and some incorrect quotations of sources.

5. Quoted in the bibliography.

6. According to Emmons, pp. 27–8, it was Sickert's father who dissuaded his son, on the grounds of financial insecurity, from beginning to train as an artist when he left school in 1877. It is doubtful whether parental disapproval was really responsible for Sickert's delayed commitment to this course because his alternative choice of acting as a career was scarcely more secure. It is likely that Sickert, with his brilliant and volatile temperament, wanted to extend his talents and personality in other directions before he settled down to the single-minded dedication of purpose which was the only way

he could properly pursue his career as a painter. Sickert never graduated beyond minor parts on the stage, although he worked with illustrious companies, under Irving, Mrs. Kendal, Isobel Bateman and George Rignold.

7. His letters to *The Times*, for example, were so frequent that they became something of an institution from the later 1920s onwards. Sickert expressed opinions on various topics, e.g. Fish as Food (20 April 1929), and Pylons on the Downs (5 October 1929).

8. *More Portraits of a Lifetime, 1918–1938*, London, Dent, 1939, pp. 108–9.

9. The *English Review*, June 1912, pp. 486–93, 'The Royal Academy', p. 490.

10. The *Burlington Magazine*, 40, June 1922, pp. 260–71, 'French Art of the Nineteenth Century—London', p. 266.

11. The *Burlington Magazine*, 43, July 1923, pp. 39–40, 'French Art at Messrs. Knoedler's Gallery'.

12. The *English Review*, July 1912, pp. 645–54, 'Mural Decoration', p. 650.

13. The *Burlington Magazine*, 29, April 1916, pp. 34–5, 'O Matre Pulchra'.

14. The *Burlington Magazine*, 31, November 1917, pp. 183–91, 'Degas', p. 191.

15. Swanwick, H. M. (Sickert's sister), *I have been Young, An Autobiography*, London, Gollancz, 1935, gives a history of the Sickert family. B.60 summarizes Sickert's immediate ancestry.

16. W. R. Sickert, Preface to an exhibition of the work of his father and grandfather held at the Goupil Galleries in 1922.

17. The *Burlington Magazine*, 31, November 1917, pp. 183–91, 'Degas', p. 184.

18. The *Fortnightly Review*, 84, December 1908, pp. 1017–28, 'The New Life of Whistler', p. 1023.

19. The *Fortnightly Review*, 89, January 1911, pp. 79–89, 'Post Impressionists', p. 83. Sickert did not acknowledge Morris's influence; indeed with regard to what he called 'the law' as to deformation and distortion he wrote that he had 'never found this done by any writer on art. . . . Not only have I not found it done well, I cannot find that it has been done at all.'

20. The *New Age*, 26 March 1914, 'On Swiftness'.

21. A large paper edition, *The Art of Velasquez*, was published London, George Bell, 1895. A revised edition, *Velasquez*, appeared in 1899. The quotation is from p. 75 of the 1962 edition (London, George Bell) revised and annotated by Theodore Crombie, with a study by Denys Sutton.

22. Whistler, unlike the French Impressionists who painted *alla prima* from nature, also painted in the studio, often from memory. But even in the studio Whistler painted spontaneously and *alla prima*, covering the whole canvas in full colour and frequently applying more than one coat of paint, indeed finishing his picture, in one session.

23. Notably the Savile, Beaux Arts, and Leicester Galleries.

24. These accounts are noted in the following text and/or the bibliography.

25. A large and very useful collection of press-cuttings, containing much information relevant to Sickert's later life, his recent work, his exhibitions, his opinions, and movements, is in the Islington Public Libraries, London.

I

Early Career until 1885. The Pupil of Whistler

ICKERT's first career as an actor was not a great success. In 1880 he was still touring the provinces (six-night stands in different towns) playing minor parts in the repertoire of scenes from famous plays presented each night. He acted under the name of Mr. Nemo and the high-light of his career occurred in Liverpool in April 1880 when his acting of the French soldier captured by Pistol in *Henry V* received favourable notice in the press. He loved the costumes and relished their constant changes but seems to have had less interest in the finer points of acting. During this time he read a great deal, especially Goethe and Jean Paul François Richter; he was 'inspired to write some plays: but that is as far as it has got, nothing being brought to paper'; and above all he worshipped Ellen Terry. He seldom painted. On a holiday in Dieppe in August 1879, for example, he sat and read but 'As to painting I have done nothing'[1].

Why he suddenly decided that painting, not acting, was his *métier* is unknown. Possibly his enthus-iasm for painting was encouraged by Whistler because, contrary to common belief, Sickert had met Whistler long before he entered the Slade. In a letter to Alfred Pollard dated 19 May 1879 he wrote, 'I went to see Whistler the other day. He showed me some glorious work of his and it was of course a great pleasure to me to talk with him about painting. Such a man! The only painter alive who has first immense genius, then conscientious persistent work striving after his ideal he knowing exactly what he is about and turned aside by no indifference or ridicule'[2]. The true story of how Sickert and Whistler first met may never be known[3], but it is significant that the meeting took place when Sickert was still an actor and prompted him to write so seriously and feelingly about his future profession. While it was certainly Whistler who persuaded Sickert to abandon the Slade so soon after his arrival, it may also have been Whistler who advised Sickert, when disillusioned with his acting career, to enter the Slade under the direction of his old friend Legros.

Sickert's formal art school training at the Slade lasted only a few months. At twenty-one he was older than many of his fellow students and possibly he found the tuition boring. Like all Legros's new students he must have been confined to the Antique rooms and encouraged to copy in the National Gallery and Print Room. Although Sickert probably found Legros's instruction that students should train their memories and sketch things seen in the streets[4] more relevant to his own artistic inclinations, he perhaps realized he could do this privately. He had family contacts, and later acknowledged that his father and his father's friend Otto Scholderer were responsible for his pre-Whistlerian artistic education[5]. There was easy access to the private studios providing models and informal tuition which abounded in London, and Sickert apparently frequented Heatherly's[6] as well as Scholderer's studio. As soon as he was past the apprentice stage Sickert himself began to hold classes for students of painting, drawing, and etching, and maintained this habit throughout his life, although many of his schools were short-lived[7]. Sickert's father, who had worked in Germany mainly as a graphic artist regularly

providing illustrations for such popular weeklies as the Munich *Fliegende Blätter*, introduced his son to the work of his German colleagues, for example, Diez, Busch, and Oberländer, and to their English equivalents, for example, Keene and Gilbert. Sickert's early knowledge and permanent enthusiasm for the economy and skill with which the black-and-white illustrators of his father's generation expressed the essential humour, character, and vitality of a scene or figure encouraged the development of his own facility in the rapid sketching of random human subjects.

By the winter of 1881–2 Sickert, temperamentally and artistically, was ready to abandon the Slade ('You've wasted your money, Walter: there's no use wasting your time too!'[8]) and attach himself to Whistler's band-waggon. His own background had prepared him for Whistler's familiarity with French painting and painters. His personality was equal to the challenge of Whistler's and the two men must each have been attracted to the other's qualities of wit, charm, and grace. The outcome of the ludicrous Ruskin trial, at first so damaging to Whistler's pride and pocket, was that he became the acknowledged leader of advanced art in England and the magnet to which were attracted all the younger painters who were dissatisfied with the established Academic example.

Some account of the character of Whistler's studio arrangements in relation to his pupils (or followers as they were more aptly called) is given by Mortimer Menpes[9]. Whistler taught only by example; he neither examined his pupils' finished work nor suggested their choice of subject. Menpes remembered only one occasion when Whistler gave verbal advice to Sickert and himself. This was the 'secret of drawing', every word of which Sickert jotted down on his cuff. The gist of this secret was that the artist should seize on the chief point of interest and draw it in elaborately, then expand from it outwards; in this way the picture would be a perfect thing from start to finish and be complete even 'if one were to be arrested in the middle of it'. Whether or not Menpes's memory is accurate about Sickert's dramatic reception of this advice it is true that Sickert frequently approached his drawings in this way, constructing them radially, working from the main focus of interest outwards towards the peripheries which, like Whistler's, were implied rather than stated. This is even found in the earliest dated work definitely by Sickert[10], a *Self-Portrait* (C.10) pen and ink drawing of December 1882, in which, however, the closely worked and laborious cross-hatching is more reminiscent of his father's black-and-white illustrations than of Whistler's drawings.

As the favourite of Whistler's pupils Sickert was in constant attendance upon the 'Master', mixing his colours, preparing his palette, and running errands. Sickert also accompanied Whistler on his memorizing expeditions, especially at night. Whistler would gaze at a subject, turn his back and enumerate its main features for Sickert to check against a list. When Whistler's memory and Sickert's list tallied it was home to bed and a nocturne from Whistler next morning[11]. Sickert's early collaboration in this visual memory training must have helped his own later practice of painting in the studio away from nature, although, like Degas, Sickert then used memory largely to supplement the information stored in his preliminary drawings done direct from the subject.

Although Whistler did not directly advise his pupils on their choice of subject his interests were, not surprisingly, strongly echoed in Sickert's early production. When, for example, Whistler's sitters came to the studio Sickert took the opportunity to try his hand at portraiture alongside his Master. He later recalled painting *Miss Waller, Miss Barr*[12], 'a small panel of Duret while Whistler painted his large portrait' and 'a sketch of the blue girl, actually taking the mixture off Whistler's palette'[13]. He also watched Whistler work on the portraits of (amongst others) *Sarasate, Lady Meux, Lady Archibald Campbell, Mrs. Cassatt*, several of *Maud*, as well as his own and his wife's portraits[14]. This close contact between master and pupil accounts for the wholly explicit and dominant influence of Whistler on Sickert's own portrait painting of the 1880s. Sickert's earliest dated portrait, *The Grey Dress* (Fig. 2) of 1884, reflects Whistler's more informal portraits, such as those of Maud of about the same date[15].

The presentation of the figure, the radical restriction of tone and colour (the figure is painted in greys relieved by a few touches of black and white against a grey background), even the flourish of Sickert's signature, are all Whistlerian. Only the solidity of the paint with its impasted ridges is less typical of Whistler[16]. In undated portrait studies of this period, such as *Le Corsage Rayé* (Fig. 7) and *The Little Street Singer* (Fig. 1)[17], the quality of the paint and its application are closer to Whistler. In *The Little Street Singer* thin slippery coats of white and palest blue blend wetly together; the hands are notes of pale pink, the feet are darker blue stains, and the hair a thin shadow of brown. Possibly one of Whistler's *White Girls* was the inspiration for this portrait. The extreme simplification of figure and background, the blurring of features and form, betray a degree of indulgence in Whistlerian effects for their own sake which recalls Sickert's later criticism of Whistler plagiarists that 'If a figure has no feet to speak of, we are asked to accept the fact as "atmosphere" '[18].

Although these are all vertical full-length portraits they are relatively small in scale. Sickert did, however, attempt the grand Whistlerian manner of life-size, full-length portraits during the 1880s. No example is traced today but some idea of Sickert's achievement in this vein can be gained from the representation of a lost picture, *Miss Fancourt* (C.15), in the background of Sickert's portrait of *Wilson Steer* (Fig. 39)[19]. It is, however, the relatively small-scale self-portrait, *L'Homme à la Palette* (Fig. 4), which most successfully emulates Whistler's grand full-length style of portraiture. *L'Homme à la Palette* may well have been directly inspired by Whistler's portrait of *Pablo de Sarasate*. Sickert's pose is identical to that of Sarasate, but in reverse, the only difference being that Sickert has substituted the tools of a painter for those of a violinist. The *panache*, the defiantly elegant grace of Whistler's representation of the creative artist has been transferred by Sickert to his own portrait.

L'Homme à la Palette is painted entirely in different tones of brown relieved by a few white accents at collar and cuffs[20]. The paint is thin and liquid, the definition simplified and wholly dependent upon the subtle relation and truth of the tones. It is so much more accomplished in its Whistlerianism than *The Grey Dress* and *The Little Street Singer* that it must have been painted at a later date. It has been suggested that it was painted as late as 1894, the year of its exhibition at the New English Art Club[21], although in my opinion this is improbable. *L'Homme à la Palette* is unlike Sickert's much harder and more tightly defined portraits of the early 1890s but it must be remembered that Sickert could, and did, pick and choose from his repertoire of styles, so that consistency in his work in any one *genre* at any one time is not always to be found or even to be expected. In *L'Homme à la Palette* Sickert may have been deliberately, and rather naughtily, demonstrating how he could rival Whistler at his own game.

An equally accomplished example of Sickert's emulation of Whistler's portrait style, but this time of Whistler's more informal bust-length studies of girl models, is *Tête de Femme* (Fig. 8). It is a thinly painted dark brown portrait, in which the streaky brushwork, the gentle modelling, the low softly graded tones, and the presentation of the head are so close to Whistler that it has even been mistaken for a genuine Whistler[22]. Like *L'Homme à la Palette*, *Tête de Femme* is impossible to date accurately. Sickert's mastery of Whistler's idiom is once again so assured that some time in the mid to late 1880s is perhaps as close as can be suggested, although a later date still, involving a conscious and artificial revival of a Whistlerian handling and style, cannot be ruled out.

Sickert must also have painted some *genre*-type figure studies during the early and middle 1880s. A rare surviving example may be *Girl Sewing* (Fig. 5) of about 1885–6, which almost certainly once possessed a more anecdotal title[23]. The beautifully balanced composition, the delicate truth of the tonal relations, and the precision of the accents, reveal how well Sickert had learned his craft from Whistler although he chose, in this picture, to give the definition a non-Whistlerian clarity.

Portraiture and figure studies represented only a small part of Sickert's activity during the 1880s.

Moreover, by the next decade, the majority of Sickert's portraits were independent, in handling and composition, of Whistler's example. Of more permanent relevance to his future development was the training he received from Whistler in sketching directly from nature, both in various graphic media and in oil on small panels.

Not many drawings by Sickert of the early 1880s survive, probably because his method of painting directly from nature precluded the necessity for making drawn studies. A few sheets exist mounted with a miscellany of figure sketches drawn in hard pencil. These casually observed glimpses of every-day life, showing figures in restaurants, trains, and so forth, may well have been used as preparatory studies for his etchings[24]. Indeed, the style of Sickert's draughtsmanship at this period is best reflected in his etchings. Except for a few plates in full tone (e.g. *The Acting Manager, The Kitchen*), these were slight both in content and style. The nervous, flickering quality of the sharp drawing is derived from Whistler, as is the type of subject, glimpses of metropolitan and country life. Sickert later called Whistler's etching 'a feast of facile and dainty sketching on copper. And let those who despise sketching remember that there are certain truths, certain beauties, certain swift relations between the thrilled observer and the fleeting beam of light, of which sketching, and sketching alone, is the human and intellectual expression.' However, he then qualified this statement: 'it is only the artist whose sketching is informed by the necessity of making it a means to something further, who touches the highwater mark of excellence in the sketches themselves'[25].

Sickert's sketches on copper of the early 1880s were generally not informed by this necessity. Only a few of his more deliberately worked and ambitious etchings, such as *The Acting Manager*, were studied further and expanded in the context of new compositions.

Little panel landscapes, townscapes, and seascapes represent a large part of Sickert's *œuvre* through-out his career; in content, and to a certain extent handling, there is less development away from the early Whistlerian examples in this field of his work than in any other. However, later in his career, such oil sketches were often used as studies for larger canvas versions painted in the studio, whereas in the 1880s they were considered as ends in themselves.

Even when Sickert critically re-evaluated Whistler's talents he retained an unqualified admiration for his former master's little panel paintings:

> Whistler expressed the essence of his talent in his little panels, *pochades*, it is true, in measurement, but masterpieces of classic painting in importance. . . . The relation and keeping of the tones is marvellous in its severe restriction. . . . The extraordinary beauty and truth of the relative colours, the exquisite precision of the spaces, have compelled infinity and movement into an architectural formula of eternal beauty. Never was instrument better understood and more fully exploited than Whistler has understood and exploited oil-paint in these panels. He has solved in them a problem that has hitherto seemed insoluble: to give a result of deliberateness to a work done in a few hours from nature[26].

It is these qualities which Sickert ever sought to emulate, not only in his own panels but also in his paintings on canvas. They are the permanent basis of his Whistlerian inheritance.

Sickert's earliest extant landscape panels were painted when he and Menpes were with Whistler in St. Ives during the winter of 1883–4. Menpes[27] records that on this visit Sickert 'almost invariably went off by himself painting pictures, sometimes five and six a day' but only two panels are as yet traced. The composition of the tiny seapiece *On the Sands* (Fig. 9), with its horizontal bands of shore, sea, and sky, the sketchy description of the figures breaking the line of the seashore, and the streaky application of the liquid paint, reflect Whistler's style. However, the naïve charm of this panel results from qualities which are independent of Whistler's example, from the freshness of observation in the quaint little figures, from the vivacity of the light-toned colours, and the movement of the foreground brushwork.

Sickert's panels of the early 1880s did not usually possess the individual personality and vitality of *On the Sands*. The other St. Ives example, *Clodgy Point, Cornwall* (Fig. 11), is almost totally derivative except that the brushwork is more free and clumsy than an authentic Whistler. *Battersea Park* of 1884 (C.31) and *Martin Église* (Fig. 6) are also less independent than *On the Sands* in their interpretation of the Whistlerian idiom. The planar divisions of their compositions, their low silvery tonalities, the liquid quality of their thin paint (streakily applied in *Battersea Park*, more wetly blended in the French scene) are all faithfully derived from Whistler. However, even at this early date Sickert experimented with daring methods designed to combat the remote vagueness of his refined tonal painting. *The Water Cart, Pourville* (C.34) was almost certainly painted at about the same time as *Martin Église* (c.1885)[28]; the panels are the same size; their compositions are similar, both showing a relatively empty stretch of steeply rising ground; their muted tonal registers are similar. However, in the Pourville landscape Sickert disturbed the softly blended effect by scoring all over the panel—possibly with the end of his brush.

Sickert especially admired Whistler's seascape panels, and himself painted many such subjects in the 1880s. Sickert's mother, for instance, wrote to a friend in March 1884[29] that Walter was at Ramsgate visiting the Cobdens (his future wife's family) where 'he thinks he can paint some seas and other things'. A little painting on panel of a *Beach Scene* (C.32), showing a group of figures on the sands with a line of beach huts and buildings on the diagonally sloping horizon, is dated 1884 and may be such a Ramsgate subject. The soft pinky grey colour harmony and the notation of the figures are close to Whistler, although Sickert also seems to have been aware of French prototypes such as Degas's and Boudin's beach scenes. A seascape (Fig. 18) of an unidentified locale (it may be Scheveningen and thus a work of 1885 or 1887) is much more reminiscent of Sickert's description of Whistler's achievement in giving you 'in a space nine inches by four an angry sea, piled up, and running in, as no painter ever did before'[30]. The handling of the clouds and breakers is very close to such Whistlers as *La Grande Mer, Pourville*. Another seascape, *La Plage, Dieppe* (Fig. 13), probably painted in the summer of 1885, is particularly close to Whistler's panels of the same summer when he too was in Dieppe. The composition, the choice of colours painted over a dark ground (the sea is pale turquoise with a deep blue strip along the horizon, the foreground shingle is grey, the sky blends from grey to purple), the application of the oily paint in streaky parallel strokes, the notation of the figures as irregular little patches of paint with no drawing, are all Whistlerian. *The Harbour, Dieppe* (C.36), probably painted during the same summer, in its opalescent tonality, its high horizon, and deep empty foreground punctuated towards the middle ground by the few darker accents of the ships, is closer to Whistler's river scenes.

Until 1885 Sickert's subject matter, the compositional arrangements of his pictures, and his handling were almost totally dependent upon Whistler's example. Most important of all, Sickert, like Whistler, painted *alla prima*. After this initial period of almost complete acceptance of Whistler's methods the logic of Sickert's technical development was based largely on his reactions to and against this method of painting. Sickert later described how Whistler

> painted with coat upon coat of paint, considerably thinned with oil and turpentine. He considered it essential to cover the whole picture practically in one wet, and he thereby succeeded in getting the exquisite oneness that gives his work such a rare and beautiful distinction.
>
> But the thinness of the paint resulted in a fatal lowering of tone, . . . The obligation to cover entirely, or the effort to cover entirely, necessitated an excessive simplification of both subject and background. *Mastery, on the contrary, is avid of complications*, and shows itself in subordinating, in arranging, in digesting any and every complication.[31]

In the panels, tiny oil sketches painted from nature in one sitting, 'all the disadvantages of his methods became advantages'[32]. However, like Whistler, Sickert did not confine his practice of painting *alla*

prima to tiny panels. On the contrary, in a letter to Whistler of about March 1885[33] (the earliest known to me of the many communications of his technical experiments contained in his private letters) Sickert wrote, 'I have tried the Petroleum oil on a life-sized canvas: it is *perfect*: not sticky like turps: Keeps wet: doesn't sink in: works quicker somehow, and fresher: five of it to one of burnt oil: I wish you would try it—.' This recipe is a personal modification of the Whistlerian method, apparently developed better to implement the covering of the canvas in one wet, and probably the painting of wet on wet—all on a life-sized canvas.

The thin, flimsy quality, the slightness of form and content, inherent in this method of painting was the basis of Sickert's later criticism of Whistler.

> He accepted . . . the very limited and subaltern position of a *prima* painter. These paintings were not what Degas used to call '*amenées*', that is to say, brought about by conscious stages, each so planned as to form a steady progression to a foreseen end. They were not begun, continued and ended. They were a series of superimpositions of the same operation, based on a hope that the quality of each new operation might be an improvement on that of the last[34].

The introduction of Degas's name into this criticism of Whistler's work was not fortuitous. It was, almost certainly, Sickert's contact with Degas in Dieppe in the summer of 1885 that awakened, or triggered off, his realization of the limitations of Whistler's method of painting. Sickert, furnished with a letter of introduction from Whistler[35], first met Degas in Paris in 1883, but this was too early in his career to do more than arouse his enthusiasm in relatively trivial ways. Menpes records that the Whistler followers at one time took to painting through chinks of doors, and from the tops of hansom cabs, practices which sound like adaptations of Degas's famous habits. Menpes also wrote, 'It was Walter Sickert who first saw Digars' [*sic*] work. He brought enthusiastic descriptions of the ballet girls Digars was painting in Paris. We tried to combine the methods of Whistler with Digars, and the result was low-toned ballet girls.'[36] All this suggests a very immature reaction to Degas on the part of the Whistler followers, touching no more than the fringe of the meaning of his art.

When Sickert met Degas for a second time, in Dieppe in 1885, he was better able to assess what he had learned and was still learning from Whistler. This is not to say that Sickert's mature appreciation of the faults and virtues of Whistler's art as expressed in his writings of the twentieth century was consciously formulated by 1885[37]. However, he does seem to have begun to realize that a wholesale acceptance of Whistler's methods was not suited to his own temperament, talents, and ideals as a painter, that he himself needed to create pictures of greater firmness and actuality than the vague atmospheric flimsinesses so beautifully and tastefully created by Whistler. He was also ready to appreciate that what his paintings needed was not so much the introduction of ballet girls, as some guidance in how to avoid the sketcher's approach to the production of pictures, how, in other words, to make his pictures more *amenées*. Degas, and a greater knowledge of French art generally, fostered by his frequent visits to France from 1885 onwards, provided Sickert with the means and ideas with which to experiment.

NOTES

1. This information about Sickert's acting career and the quotations are all taken from Sickert's letters to his former friend (at King's College School) Alfred Pollard. Pollard became a bibliographer and later Keeper of Printed Books at the British Museum. The letters now belong to Pollard's grand-daughter, Mrs. L. Woudhuysen, who kindly showed them to me.

2. I have retained Sickert's somewhat idiosyncratic grammar and punctuation in the quotations from his letters, except that 'and' replaces his frequent '&', and I have italicized foreign words and phrases for the sake of clarity.

3. Emmons, p. 32, says they met at a party and the next day Sickert followed Whistler into a tobacconist's shop to renew their acquaintance. William Rothenstein, *Men and Memories*,

London, Faber, 1931, Vol. 1 1872–1900, p. 169, tells a more colourful story of how their association was prompted by Whistler's amusement at witnessing Sickert's tribute of a bouquet of roses to Miss Ellen Terry after a special theatrical performance. Sickert, anxious that his bouquet would travel safely from the gallery to the stage, had misguidedly weighted it with lead. Whistler's appreciation of everyone's discomfiture was loud, and thus they met.

4. Rothenstein, *Men and Memories*, Vol. 1, p. 24, in his description of the Slade under Legros, Chapter III, pp. 22–35. Admittedly Rothenstein was there some years after Sickert but the training programme had not changed. Sickert, in his writings, never mentioned his time at the Slade. It seems to have left little impression upon him.

5. The *Fortnightly Review*, 84, December 1908, pp. 1017–28, 'The New Life of Whistler', p. 1023. Scholderer was a friend of Fantin-Latour and his portrait was included in Fantin's *Hommage à Manet*. He concentrated mainly on still life painting and his influence is not apparent in Sickert's work. However, there are so few definitely authenticated works by Sickert done before 1884, by which time he was dominated by Whistler's example, that no adequate assessment of his earliest style is possible. Sickert evidently executed several still lifes in the 1880s (he showed *White Flowers* at the Society of British Artists in 1885—see under C.17—and a pastel *Nature Morte* at Les XX in 1887). *Violets* (Fig. 10) is one of the few extant examples. The handling of this little panel is Whistlerian; the pattern of the sharp elusively wavering lines of the stalks and their shadows against the unparticularized blot of paint representing the flowers is particularly suggestive of Whistler's capricious attraction towards Japanese effects. There is only one painting extant which, if it is indeed by Sickert, probably represents his work before he joined Whistler's studio. It is *The Artist's Mother* (C.9), a bust-length three-quarter view of a woman who appears much older than Sickert's mother (born in 1830) would have been *c.*1880. It in no way resembles other paintings by Sickert. Nevertheless, the very sombre tones, the limited range of colours, the smooth paint applied in block-like strokes, the lines of drawing visible in outlining the face, are compatible with an attribution to an inexperienced artist attempting to emulate a Courbet-type realistic and unsentimental portrayal. The portrait could be a very early work, painted when Sickert was still under the guidance of his father who, he claimed, had been influenced by Courbet.

6. Alfred Thornton, *Artwork*, VI, No. 21, Spring 1930, pp. 1–17, 'Walter Richard Sickert', p. 12.

7. The first was in 1893 in The Vale, Chelsea. Later in the 1890s he joined up with Miss Florence Pash to run a school in Victoria Street. In the next century he had numerous schools in different studios in Camden Town and later in Manchester and Islington. He also taught in art schools, his longest engagement being at the Westminster Technical Institute where he taught intermittently from about 1908 until 1918.

8. Emmons, p. 32.

9. *Whistler as I Knew Him*, London, Black, 1894, chapter called 'Master and Followers', pp. 15–30.

10. The word 'definitely' is used because of the existence in Sickert's studio at his death of a drawing (C.8) inscribed 'Husum Aug 1 1876' (Husum is south of Copenhagen in Schleswig-Holstein). The drawing, of a girl seated by a river, is neatly done in pencil, the body tightly constructed as a series of angular planes, and if by Walter Sickert (as opposed to any other member of his family) very competent for a boy of sixteen.

11. Thornton, *Artwork*, 1930, p. 12.

12. The *Art News*, 10 February 1910, 'Where Paul and I Differ'.

13. The *New Age*, 15 June 1911, 'L'Affaire Greaves'. Sickert noted that his panel of Duret was exhibited at Suffolk Street, so that although it must have been painted in 1882 (the date of Whistler's portrait), it can only be *A Portrait Sketch* shown at the Society of British Artists on the first occasion Sickert exhibited there in the winter of 1884–5 (201). A little watercolour called *Whistler's Studio* (C.12), showing a girl in blue on a dais in front of a blue curtain with a blue picture in the background, may reflect Sickert's experience watching Whistler paint *The Blue Girl*.

14. These portraits were listed in the *Art News*, 10 February 1910, 'Where Paul and I Differ'. There is a tiny elaborately cross-hatched pen and ink copy by Sickert of *Mrs. Cassatt* (C.13).

15. Maud may in fact have been Sickert's model for this portrait. A little street scene (C.33) about this date dedicated 'To Miss Maud' may be a record of Sickert's gratitude to her.

16. Nevertheless the use Sickert made of these ridges to define the folds of the dress illustrates a Whistlerian method later criticized by Sickert when he wrote of *Symphony in White No. 3* (the *Fortnightly Review*, 84, December 1908, pp. 1017–28, 'The New Life of Whistler', p. 1026): 'Folds of drapery are expressed by ribbons of paint in the direction of the folds themselves, with hard edges to them. Only painters can quite understand the depths of technical infamy confessed in this last description. It means the drapery is no longer painted but intended.'

17. Although its conception is more artificial and vapid than his later music hall subjects this portrait is Sickert's first picture of a public entertainer.

18. The *Art News*, 10 February 1910, 'Where Paul and I Differ'.

19. The portrait of *Wilson Steer* (Fig. 39) was exhibited at the N.E.A.C. in April 1890 and was probably painted earlier that year. *Miss Fancourt* (C.15) must, therefore, have been painted earlier still. Sickert showed a portrait of *Miss Fancourt* in the same exhibition called by the *Spectator*, 5 April 1890, an 'effective black and white sketch' but considered less lightly by the *Magazine of Art*, 1890, p. xxx, who compared it to a full-length Grieffenhagen and thought it ran the latter artist's work close as the best work in the show. It is therefore probable that the work shown in 1890 is the same as that seen in the background of Steer's portrait. An etching of *Queenie Fancourt*, similar in pose to the glimpse we obtain of her behind Steer, was dated *c.*1885 by the late Mr. Harold Wright in his manuscript on Sickert's etchings (British Museum).

20. *Sarasate* was an arrangement in black but other Whistler portraits were based on a harmony of browns.

21. Daniel Thomas, *Art Gallery of New South Wales Quarterly*, 10, No. 1, October 1968, pp. 431–2, 'Some Problems of Dating and Identification', quotes Ronald Pickvance's suggestion that the picture was painted *c.*1894, the main reason being that it is about the same size as Sickert's portrait of *Aubrey Beardsley* (Fig. 40). However, several of Sickert's portrait and figure studies of the 1880s, when he often favoured a vertical Whistlerian format to present his full-length representations, are also of approximately this size.

22. Ronald Pickvance, *Apollo*, 76, July 1962, pp. 404–5, 'Sickert at Brighton'.

23. It could, for example, be *Despair*, shown at Van Wisselingh's Dutch Gallery in 1895 (30) in the exhibition Sickert shared with his brother Bernhard.

24. For example, a sheet mounted with four studies of figures at restaurant tables (C.11) was probably used for the etching *At Moreau's*.

25. The *Fortnightly Review*, 84, December 1908, pp. 1017–28, 'The New Life of Whistler', p. 1021.

26. Ibid., pp. 1027–8.

27. *Whistler as I Knew Him*, p. 140.

28. Martin Église is a village a few miles inland from Dieppe, and Pourville is just along the coast. No visit by Sickert to Dieppe is recorded in 1884 (although he may have gone there) so that the panels must be dated *c*.1885.

29. The letter is among many written by Sickert's mother to her friend Penelope Muller whose grandson, Commander F. S. Stewart-Killick, R.N., kindly showed them to me.

30. The *Fortnightly Review*, 84, December 1908, pp. 1017–28, 'The New Life of Whistler', pp. 1027–8.

31. The *Art News*, 10 February 1910, 'Where Paul and I Differ'.

32. The *Daily Telegraph*, 1 April 1925, 'With Wisest Sorrow'.

33. In the collection of Whistleriana belonging to the Department of Fine Art, University of Glasgow. The letter can be dated from Sickert's reference to Whistler lecturing to the University of Cambridge. Whistler delivered his 'Ten O'Clock' to this university in March 1885.

34. The *Daily Telegraph*, 1 April 1925, 'With Wisest Sorrow'.

35. Sickert went to Paris to accompany Whistler's *Mother* to the Salon.

36. *Whistler as I Knew Him*, p. 19 and p. 21 (chinks of doors).

37. In his published writings of the 1890s, for instance in different issues of the *Whirlwind* in 1890, Sickert was still professing unqualified admiration for Whistler, comparing him to Velasquez (2 August) and calling him a living Old Master (28 June).

II

1885-7. Influences from France

IN 1885 Sickert, after an engagement of several years, married Ellen, a daughter of Richard Cobden. Ellen was attractive and intelligent but twelve years older than Sickert and more conservative in her social habits. Their marriage was not to survive Sickert's unpredictability and restlessness; his constant unfaithfulness eventually led to its breakdown in the mid-1890s[1], although when the bitterness of their divorce had subsided and Sickert had returned to England after his self-imposed exile to Dieppe from 1898 to 1905 they sometimes met as old friends[2]. In the 1880s Sickert's relationship with the Cobden family introduced him to a wide circle of Liberal politicians, many of whose portraits he was to draw and paint in the 1890s. Sickert in return introduced Ellen to his circle of acquaintances among the summer visitors to Dieppe. In the summer of 1885, following a honeymoon tour which ranged across Europe, the newly married couple came to stay in Dieppe. Sickert's parents and Whistler were also in Dieppe that summer—a virtual transportation *en bloc* of his London environment to this Norman port. Sickert was, of course, already familiar with Dieppe, having spent several childhood holidays there with his family, and he had passed through again in 1883 when taking Whistler's *Portrait of his Mother* to the Paris *Salon*. Sickert's mother had been to school in Dieppe and the town was full of tender associations for his entire family[3]. As Oswald, Sickert's brother, explained in a letter to Edward Marsh, 'The Sickerts can't expect other people to see in Dieppe all that it means to them. We have inherited the place from Mother who came to school here when she was eleven, and was happy and well for the first time. Father came here too, years before they were married, and afterwards he did his best work here.'[4]

Dieppe, however, for Walter Sickert was to become something more than a friendly and nostalgic haven. It became his second home and the friends he made there were to determine much of the pattern of his future life and career. The process by which Sickert, as an adult personality in his own right, really settled into the life of the town began in 1885. Possibly his marriage at first helped to introduce a certain stability into his social relationships, although as it turned out, Ellen was never at ease with Sickert's Dieppe friends, finding them too informal and bohemian.

Dieppe in the later nineteenth century was an exciting international social and artistic centre. Along with its Normandy neighbours it helped to inspire Proust's Baalbec. All kinds of people stayed in Dieppe during the summer, English and French society, respectable middle-class families, writers, painters, sculptors and politicians. These visitors tended to form their own colonies, but certain people were accepted by all these groups. Sickert was one such free agent. His fluency in both English and French, his wit, his charm and astonishing good looks, his dual position as a member of a respected middle-class family (the Cobdens) and as an artist, made him welcome wherever he went. Indeed, later Sickert was to transcend the one remaining social barrier and be accepted equally among the indigenous working population of the town—the fishermen and women of Le Pollet. Jacques-Émile

Blanche was another free agent. He was perhaps the most important hub of Dieppe's summer activity and his contacts in the town extended everywhere. Nearly all the summer visitors to Dieppe congregated in his mother's drawing-room and Jacques-Émile's studio at Le Bas Fort Blanc on the outskirts of the town. The brilliant members of the Halévy family, the John Lemoinne family (Blanche later married their daughter Rose), George Moore, Degas, Helleu, Monet, Pissarro, André Gide, Beardsley, Symons, and Conder are just a selection from among the friends who visited him in Dieppe at one time or another[5]. Sickert and Blanche had already met in London (probably earlier in 1885[6]) and during the summer, having rented a house nearby, he and his wife became *habitués* of Blanche's circle. Ellen Sickert got on particularly well with the older Halévys and with the political Lemoinnes as well as with Whistler, who also knew Blanche and with whom she was always in accord.

The significance of the role played by Jacques-Émile Blanche in Sickert's life can hardly be stressed too strongly. Sickert himself treated Blanche rather casually in later life. Their friendship cooled towards the end of the first decade of the twentieth century when Sickert gradually dismissed Blanche as a fussy, rather gloomy and lightweight personality[7]. This change of attitude was typical of the rather harsh and unpredictable intolerance of Sickert's maturity, and did not do justice to Blanche's extensive gifts nor to the help he had given Sickert in his early years.

Blanche was a painter of considerable if limited talent; later in his life he also wrote—novels, criticism, and his very informative memoirs[8]. He was the son of the eminent Dr. Émile Blanche who, at his clinic at Auteuil, had treated a great number of noted French intellectual and artistic personalities—according to Daniel Halévy '*tous les psychasténiques du siècle romantique, depuis Gérard de Nerval jusqu'à Guy de Maupassant*'[9]. Blanche's early familiarity with his father's circle was responsible for developing his own wide-ranging mental and artistic inclinations. He called Edmond Maître (the youngest of his father's friends and the friend in turn of Fantin-Latour, Baudelaire, Verlaine, Monet, and Renoir) his 'spiritual father'[10].

Blanche and Sickert had much in common. They were almost exact contemporaries (Blanche was a year younger and they both died in 1942). Both enjoyed what amounted to double nationalities. Just as Dieppe was Sickert's second home, London was Blanche's; he had been evacuated there as a child during the troubles in Paris in the 1870s and thereafter he continued to visit London frequently. Blanche was extraordinarily generous to Sickert. Sickert was, as he wrote later, his 'best friend during a period to which I wish to set no term'[11]. He constantly used his influence to encourage the Parisian dealers, Durand-Ruel and later Bernheim-Jeune, to show Sickert's work. Sickert had only to ask to become a member of some Parisian group for Blanche to arrange it. For instance, Sickert's invitation to show with the *Société Nouvelle de Peintres et de Sculpteurs* in 1903 at Durand-Ruel must have been at Blanche's instigation, for he was a member of that society. Sickert wrote to Blanche from London in 1906 that he wanted to become a *sociétaire* of the *Salon d'Automne*[12] and the next year he was duly elected[13]. Blanche introduced Sickert to private clients; it is impossible to state now, categorically, which introductions were due entirely to Blanche but André Gide and Paul Robert, who both bought extensively of Sickert's work, were probably among them. Louis Vauxcelles wrote in 1907 of Blanche's unremitting support for Sickert: Blanche, described as so hard on his colleagues, had for Sickert '*une parfaite et fraternelle équité*'[14]. Blanche obtained for Sickert a teaching post in Paris, supervising once a week at a school where he was a member of the staff[15]. Most remarkable of all is the vast number of paintings by Sickert which Blanche himself bought. He could not have wanted so many for his own pleasure and indeed their number was clearly an embarrassment to him for he gave some away to friends and pupils[16] and others to art galleries (almost all the Sickert pictures in French public collections were donated by Blanche). Many other Sickert works from his collection were disposed of after his death through Parisian dealers (and most have found their way back to England) but the collection

still in the possession of the Blanche family remains very large. It is true that some of these pictures were given to Blanche by Sickert (the earliest, given to Blanche in June 1885, must be the charming *Jardin en Angleterre*, C.35, an idyllic outdoor scene which owes something to early Monet, something to Steer, and nothing to Whistler) but no other single individual ever bought so many of Sickert's pictures—because no other was as generous with his help as Blanche.

It was at Blanche's house in 1885 that Sickert renewed his acquaintance with Degas. Panel paintings such as *La Plage* (Fig. 13) and *The Harbour* (C.36) illustrate the strong influence Whistler still exerted upon Sickert's work when they were together; but the people Sickert met among Blanche's circle began to temper the exclusiveness of Whistler's dominance over his artistic life and in other Dieppe paintings of 1885 he experimented, if timidly, with ways of modifying his Whistlerianism.

In *The Laundry Shop* (Fig. 19), for example, the motif and its compositional arrangement are still typically Whistlerian[17], but Sickert's relatively emphatic definition of the rectilinear framework of verticals and horizontals and his attention to the individual particularization of the components of his subject betray a new interest in the constructional aspect of painting and a real attempt to avoid the simplified definition, the atmospheric blurring, of similar Whistler scenes. Sickert painted the picture on canvas and on panel, the latter being somewhat larger than Whistler's, and Sickert's earlier, panels. He applied the paint in several superimposed coats in an attempt to expand the actual process of painting and build up the picture to a more planned conclusion. It is even possible that he used drawn documents for his preparation, if the squared drawing of a *Laundry Shop* is related to this particular composition[18].

Sickert's innovations in the treatment of *The Laundry Shop* attest the accuracy of Jacques-Émile Blanche's statement that after meeting Degas 'the figure drawing, the decorative and architectural pattern' became accentuated in Sickert's painting[19]. The extent of Sickert's departure from a strictly Whistlerian treatment is best appreciated by comparing *The Laundry Shop* with other shop scenes such as *The Butcher's Shop* (Fig. 12), probably painted c.1884. *The Butcher's Shop* entirely lacks the crisp definition of *The Laundry Shop*. It is an almost monochromatic study in tone (the general scheme of greys is relieved only by a few touches of pinkish brown). The softly smudged tonal transitions, a result of the wet blending of the smooth, thin paint, clearly indicate that it was painted in one sitting from nature.

The conscious effort Sickert made in *The Laundry Shop* to define the details and increase the weight of his paint gives the picture a somewhat hard and wooden quality. The drawing is more sophisticated but otherwise the type of painting has something in common with van Gogh's early Dutch pictures. In other little panels of shops and terraced house fronts painted later in the 1880s Sickert was to achieve a more fluent representation by adopting a stylistic compromise between the liquid atmospheric vagueness of his earlier scenes and the definitive particularization of *The Laundry Shop*. In *The Red Shop* (alternatively known as *The October Sun*, Fig. 20), painted c. 1888, the paint is smoother than in *The Laundry Shop* and has no impasted ridges, but it has greater body and opacity than in the earliest panels. The definition is not so laborious, the boundaries of objects not so sharp, as in *The Laundry Shop*, but Sickert achieved clear particularization of all the main details (for example, the lettering on the shop awning is quite legible). The tonal scale remains low, but Sickert broadened his colour range beyond the limits permitted in his early panels; the shop is painted in a brilliant scarlet (a colour much used in Sickert's music hall paintings of 1888 and 1889).

The Laundry Shop is only one of many panels painted in 1885 to demonstrate Degas's influence upon Sickert. The emphasis Sickert placed upon the figures in his beach scene, *Le Quatorze Juillet* (Fig. 14), as regards both their number and individual definition, suggests a Degas-inspired effort to increase the everyday realism of his representation. The clearly defined foreground group of two women under a

parasol is especially reminiscent of Degas. Nevertheless, the basic inspiration of this panel is Whistler-ian with its horizontally aligned composition, its low tonality and delicately related values, its restric-ted colour range, and the way the figures are noted as irregular little patches of paint with spindle legs trailing away to nothing. The paint surface is smooth and oily, like a contemporary Whistler, but this quality was approved by Degas, for in a letter of 1914[20] Sickert recalled, 'Degas commended . . . my panels in '85 because they were *"peint comme une porte"*. *"La Nature est lisse"* he used to say.'

Degas's example also inspired Sickert to broaden the range of his subject matter. In 1885 Sickert painted two race-course scenes (Fig. 15, C.25) and, more significantly in the light of his future develop-ment, he painted a circus subject complete with equestrienne and audience. In *The Circus* (Fig. 21) Whistlerian spaciousness is completely abandoned. Every inch of the small panel is filled with figures and architecture. The compositional construction is derived—on a reduced scale—from Degas's theatre and ballet subjects, and Degas's devices—effecting an abrupt entry into the scene by means of a *repoussoir* parapet and silhouetting the foreground audience against the floodlit stage—are adopted. This type of compositional construction was to be used by Sickert in his early music hall paintings.

In 1886 the New English Art Club (N.E.A.C.) was founded as a protest by a small group of younger English (and American) artists against the narrowness of the Royal Academy. Most of the New English founder members had studied for a time in France and their experience had enabled them to compare the exhibiting opportunities, the teaching methods, and the quality of the established art in the two countries. The early history of the Club was troubled and complicated[21] but the selection and hanging was democratically decided. Leighton, visiting the first show of 'these impressionists', pronounced that 'The second year will try these men, and the third year probably disband them.'[22] In fact, although many of the founder members were later absorbed by the Royal Academy and similar establishment societies, others such as Steer and Fred Brown were to become instrumental in changing the whole direction and emphasis of English art.

Sickert was not a founder member of the N.E.A.C. In 1886 he was still, in spite of his recent contact with Degas, too much a member of Whistler's coterie to associate himself with a radical breakaway movement which was independent of Whistler's patronage. When he exhibited it was still as 'pupil of Whistler', apparently even on the occasion of his first one-man exhibition at Dowdeswell's in January 1886. Unfortunately I have traced no catalogue of this exhibition and must rely on the press review in the *Illustrated London News*[23] for an indication of its content, 'a score of oil paintings'. The reviewer remarked:

> In what our neighbours call *facture* Mr. Sickert has certainly caught something of his master's trick; but in the inner perception of the 'things unseen', which Mr. Whistler led us often to feel were lurking behind his misty foregrounds, the pupil has still much to learn. If his aim has been to catch fleeting impressions and to transfer them at once to his canvases for subsequent use and study, there is no reason to find fault with the delicacy of his perception; but it is rather a misnomer to call such works pictures, or to attempt to pass them as the result of serious application. For the most part, the colouring is flat and opaque, and in nearly every case far too imitative of his master's 'symphonies' and 'arrangements'. The single figure 'Olive' (8), however, shows that Mr. Sickert, when left to think for himself, can produce satisfactory work, and contains the germ of better things.

This review suggests that Sickert's exhibits, apart from *Olive* (untraced), were slight Whistlerian landscape panels and the reviewer's assessment of them—fine as preliminary studies but they needed to be built on further—probably echoed Sickert's own growing realization of the limitations of his current methods of work. His frequent visits to France from 1885 onwards[24] encouraged his emancipa-tion from Whistler and enabled him to study and find inspiration in sources other than Degas. Menpes surprisingly records that at various times Whistler's followers tried painting in spots and dots, in

stripes and bands, and at one time took to stating the exact time of day on their pictures[25]. These experiments could all have been indirectly derived from French Impressionism and Post-Impressionism. No spotted or striped Sickert painting of this period is extant[26], but a Dieppe panel painting, *Le Marché aux Bestiaux* (Fig. 17) of *c.* 1886, suggests that Sickert used, somewhat timidly, the example of French Impressionism to help dilute his Whistlerianism. The subject, a tree-lined avenue, is close to Impressionist motifs. The basic handling is still Whistlerian, but a hint of Impressionist method may be recognized in Sickert's novel use of separated dabs of paint, a few of different colour and tone from the general green of the trees, to enliven the underlying uniform stains suggesting the foliage. The character of the definition, the half-statement seen for example in the disjointed articulation of the tree-trunks, is not simply an instance of Whistlerian vagueness of form but is instead ideally suited to translate the mirage quality of an avenue of trees in filtered sunlight. This treatment springs from an innocent perceptual approach to nature related to an Impressionist vision.

Late in 1886 Sickert's emancipation from Whistler and his self-confidence received further encouragement from an invitation to exhibit with *Les XX* in February 1887. The *invités* were 'chosen for their distinction and/or *avant-gardisme*' and Willie Finch, as talent scout, wrote of Sickert to Octave Maus, the organizer of *Les XX*, '*j'ai vu des choses charmantes de lui—très raffinées comme art*'[27]. Sickert immediately began work on a very large picture but this was not finished in time and its subject is unknown[28]. Instead his major contribution was *Répétition. La Fin de l'Acte* which, as *Rehearsal. The End of the Act* (Fig. 3), had just been shown in London at the Society of British Artists' winter exhibition of 1886–7[29]. He sent besides a group of etchings, a pastel *Nature Morte*, and a selection of earlier paintings (among them *Le Quatorze Juillet* and *Les Courses de Dieppe*, both of 1885). Sickert's submissions must have seemed very timid in comparison with the work of such co-exhibitors as Seurat, Ensor, and Pissarro. *Indépendance Belge*[30] remarked that Sickert '*a exposé plusieurs paysages et marines dont l'un est intitulé*: Trois Nuages, *et que nous n'avons pas pu distinguer des autres, tant ils sont tous nuageux*'.

It is significant that later in 1887 Sickert made a deliberate and, for him, radical attempt to brighten his palette and clarify his definition. This time he drew inspiration not from Degas nor from the Impressionists, but from Manet. In 1883 Whistler had given Sickert an introductory letter to Manet as well as to Degas. Manet had been too ill to see Sickert but allowed him to visit his studio[31]. Sickert's lukewarm assessment of Manet's talents, expressed in his writings of the next century, should not be taken as a reflection of his attitude in the 1880s. Indeed, in 1890 Sickert called Manet 'one of the most brilliant and powerful painters who have ever lived' and thought his work so valuable to the student in teaching him his business that he advised the nation to buy a Manet instead of making a foundation art scholarship[32]. A small group of pictures, painted in Scheveningen in 1887[33], indicates a very positive and enthusiastic reaction to Manet's work on Sickert's part. In a panel, *Windstoeln on the Beach* (Fig. 16), and in a larger painting on canvas of a similar subject (Fig. 22), Sickert uncompromisingly abandoned his soft tonal transitions, his limited and muted palette, and his habit of painting over a dark preparation. The paint in both pictures is applied in flat, abruptly juxtaposed patches of clean, high-toned, strongly contrasting colours—a *facture* strongly reminiscent of Manet. The red wood of the panel and the white of the canvas are allowed to show through in places and heighten the vivacity of both tone and colour. In the canvas the paint has an entirely new creamy opacity. Sickert also painted an interior scene in Scheveningen, *The Kurhuis* (Fig. 24), in which not only the handling (in particular the treatment of the beermug and cup in the foreground) but also the subject (a crowded drinking café) recall Manet. This type of subject was new to Sickert's painting, although not to his etching[34], and it is likely that a picture such as Manet's *La Servante de Bocks* provided the initial inspiration for *The Kurhuis*.

The hypothesis that Sickert saw his own work at *Les XX* in Brussels early in 1887, and then stopped

on the way home in Scheveningen to paint in this new manner, would conveniently have explained this sudden attempt to brighten his palette and make his handling of paint both franker and cleaner. However, Sickert's correspondence with Octave Maus proves that he did not go to Brussels[35]. He may, nevertheless, have reacted to such criticisms of his work in the Belgian press as that quoted above and felt challenged to experiment with ways to avoid the Whistlerian fogginess for which he has been castigated. The example of Manet's handling, remembered after a delay of four years, offered a potential solution—with which, however, Sickert was not long to persevere.

NOTES

1. Some idea of the quality of their marriage can be obtained from Ellen Sickert's novel, *Wistons: a Story in Three Parts*, London, Fisher Unwin, 1902 (published under the pseudonym Miles Amber). *Wistons* clearly reflects a certain amount of personal experience and emotions in the relationship of the husband and wife.

2. Proof of these meetings is obtained from several of Sickert's letters, e.g. a postcard to Mrs. Humphrey, postmarked 25.11.05, saying, 'I am grieved to say I forgot I was dining with my wife on Sunday when I accepted your invitation'; a letter to Miss Hudson of 1910 when he was unwell telling how his 'divinely good and generous' wife asked him to give up work and rest for a time at her expense. Ellen died in 1914.

3. The history of the Sickert family in Dieppe is fully described by Simona Pakenham, *60 Miles from England. The English at Dieppe 1814–1914*, London, Macmillan, 1967. This book is an invaluable source of information about life in Dieppe during the Sickert period.

4. Quoted by Edward Marsh, *A Number of People, A Book of Reminiscences*, London, Heinemann and Hamish Hamilton, 1939, p. 50.

5. Not all these visits coincided with those of Sickert.

6. Jacques-Émile Blanche, *Portraits of a Lifetime, The Late Victorian Era, The Edwardian Pageant, 1870–1914*, London, Dent, 1937, p. 45, implies that this first meeting was at his friend Mrs. Edward's house, where Whistler had sent Sickert to woo Fantin-Latour to visit Whistler's Tite Street studio, a previous copy of the 'Ten O'Clock' lecture having failed to do the trick. This book is, of course, a primary source of information about Sickert's relationship with Blanche and his circle.

7. For instance, in a letter to a friend and pupil, Miss Ethel Sands, written in 1916 (the letter can be dated from a reference to an exhibition of Gore's pictures at the Carfax Gallery which took place in February 1916) Sickert wrote that a visitor to one of his Saturdays 'brought a certain gloomy certainty that everything is wrong and that she wasn't at liberty to say why. She has transferred to the war the kind of Jacques Blanche view of life that she previously applied to smaller matters'.

8. In two volumes, *Portraits of a Lifetime* and *More Portraits of a Lifetime*.

9. Catalogue preface to the exhibition 'Walter Sickert, Jacques-Émile Blanche' held at the Musée de Dieppe in 1954, p. iv. In Auteuil there is now a road called Rue de Docteur Blanche in honour of Jacques-Émile's father.

10. *Portraits of a Lifetime*, p. 41.

11. Ibid., p. 49.

12. Sickert wrote in a postscript of a letter to Blanche, 'I wish I could become an English member of the *Salon d'Automne*'. The letter, addressed from Mornington Crescent, is datable to 1906 from the remark that Sickert had lent 'Neuville to a talented young painter called Gore', which he did in 1906.

13. Blanche's responsibility for obtaining these opportunities for Sickert cannot be definitely proved. It can, however, be assumed from the tenor of Sickert's letters to Blanche over the years which take for granted Blanche's intermediary powers; knowledge of Blanche's character, his generosity and evident delight in using his influence, support the assumption, as have my conversations with people who knew him. As early as 1887 Sickert suspected Blanche of having instigated his invitation to show with *Les XX* in Brussels. In a letter to Blanche Sickert asked, 'Have I to thank you for pointing me out to the Kingdom of Belgium, for I cannot imagine that my unassisted fame would have led any Society, however perspicacious, to single out the genius that is modestly hidden in the suburb of Hampstead?' (*Portraits of a Lifetime*, p. 299). In fact Willie Finch, not Blanche, was responsible for this invitation (see Bruce Laughton, *Apollo*, 86, November 1967, pp. 372–9, 'The British and American contribution to *Les XX*, 1884–93').

14. *Gil Blas*, 12 January 1907, 'La Vie Artistique. Exposition Walter Sickert'.

15. Mme Berthe Noufflard, a friend and former pupil of Blanche, told me that Sickert supervised weekly for a time at Mlle Settler's painting class where Blanche and Lucien Simon also taught. She cannot recall the year and did not herself meet Sickert. Sickert's letters to Mrs. William Hulton, a friend who lived in Venice, substantiate this information. On his return from Venice in the summer of 1901 Sickert told Mrs. Hulton, 'I am thinking of taking a *cours* that has been offered me in Paris to eke out a precarious living by teaching what I can hardly live by practising.' Whether he accepted this particular post is uncertain but, about February or March 1903, he wrote to Mrs. Hulton, 'I have been up and down to Paris every week for a studio in which I am teaching with Simon and Blanche . . . We are taking a big studio next autumn with Simon's name, which is a great draw, I expect I shall at last make a little money reg'lar which I badly want.' Sickert's letters to Mrs. Hulton were presented by her daughter, Lady Berwick, to the Ashmolean Museum, Oxford. Lady Berwick annotated and helped to date them. The second letter quoted is datable from Sickert's reference to his former wife's recent publication of *Wistons*, op. cit., of which he was about to send Mrs. Hulton a copy. Lady Berwick still has this copy, inscribed 'To Mrs. Hulton. W.S. March 1903'.

16. Mme Noufflard has two such pictures given to her by Blanche.

17. A. McLaren Young, catalogue of the Whistler Exhibition, Arts Council 1960, note to No. 53, *The General Dealer*, p. 67, wrote, 'From the later eighties onwards, Whistler painted, drew and made etchings and lithographs of a great many houses and shops viewed directly from in front'. However, Denys Sutton, *James McNeill Whistler*, London, Phaidon, 1966, p. 195, note to Plate 103, *Chelsea Shops*, says Whistler painted many such subjects in the early 1880s and exhibited a number at Dowdeswell's in 1884. He also quotes from Menpes, *Whistler as I Knew Him*, of Whistler's excursions in Chelsea to study shop scenes. E. R. and J. Pennell, *The Life of James McNeill Whistler*, London, Heinemann, 1908, Vol. 2, p. 26, discussing Whistler's work of 1883–4, wrote that the followers 'worked for Whistler in the street, hunting with him for his little shops . . .'. Finally Sickert, the *Fortnightly Review*, 84, December 1908, pp. 1017–28, 'The New Life of Whistler', p. 1025, stated that 'Whistler's talent . . . evolved in his Nocturnes, his little streets and seas, and shops, that something new which justifies an artist for his existence.' If Whistler had not tackled such subjects until the later eighties we would have to assume that Sickert influenced Whistler towards such subjects and their compositional expression, a totally unacceptable hypothesis which is contradicted by all the sources and evidence quoted above.

18. In 1885, perhaps inspired by Degas's attraction to *blanchisseuses*, Sickert both etched and painted Dieppe laundry shops. The squared drawing (C. 23) is certainly a preparation for a related laundry shop composition of 1885.

19. *Portraits of a Lifetime*, p. 46. Blanche, writing forty years later, mistakenly gave the date of Degas's arrival in Dieppe as 1886. He was also mistaken in his statement that Sickert's Whistlerian paintings before that date were music halls.

20. Written to Miss Ethel Sands (see Chapter XV, note 38 for dating).

21. The early history of the N.E.A.C. is fully told by W. J. Laidley, *The Origin and First Two Years of the New English Art Club*, London, privately printed, 1907.

22. Quoted by Laidley, p. 57.

23. 23 January 1886.

24. Sickert not only stayed for fairly long periods in Dieppe nearly every summer but he also made more casual and fleeting visits to France such as that recorded by his mother when she wrote to a friend in June 1886, 'Walter has been to Paris for a few days to see the *Salon* and is back again'. Letter in the collection of Commander F. S. Stewart-Killick, R.N. (see Chapter I, note 29).

25. *Whistler as I Knew Him*, pp. 20–1. The only work known to me on which Sickert stated the time of day is the sheet of restaurant drawings 'At Moreau's' (C.11).

26. A possible exception to this statement is the curious painting *Les Modistes* (C.14). This painting has always been accepted as by Sickert in the literature but it looks more like a work by Starr. It was bought by the City Art Gallery, Manchester, as early as 1928 and is signed 'Sickert' (although the signature is unusually thick and clumsy). The picture presents an odd assortment of different kinds of handling; the modelling of the heads is unsure and the hair of the girls is very tightly and prosaically defined in the manner of any number of late Victorian English artists; passages such as the further girl's skirt are painted in fine hatched coloured strokes, reminiscent of Renoir; the background is painted in squared blocks of colour over a dark ground, reminiscent of Courbet; finally, all the way down the centre of the picture there are horizontal ridges of paint as if the paint had been laid on in ruled strokes leaving a thicker ridge at the base of each stroke. Neither the picture as a whole nor any individual passage is at all like any known work by Sickert but if the traditional attribution is correct *Les Modistes* can only be an experimental work of the kind recorded by Menpes. It would also be a very early example of a *genre* subject by Sickert.

27. Quotations from Laughton, *Apollo*, Nov. 1967, 'Les XX'.

28. Laughton (op. cit.) tells how Sickert, on receipt of his invitation, began to paint '*Une toile carrée de six pieds*'. In his letter to Blanche (see note 13) Sickert remarked he was working on a picture for *Les XX* measuring 1·75 × 1 metre.

29. Discussed in Chapter III.

30. 25 February 1887.

31. These facts were recalled by Sickert, the *Daily Telegraph*, 3 June 1925, 'Self Conscious Paint'.

32. The *Whirlwind*, 28 June 1890.

33. Sickert is traditionally supposed to have visited Scheveningen on his honeymoon tour in 1885 but no visit is recorded in 1887. However, two Scheveningen paintings and a number of etchings are dated 1887 and although all of them might have been executed from preparatory studies made two years earlier this is improbable.

34. In 1886 Sickert completed several etchings of foreign café interiors, for example the Munich beerhouse subjects, using information presumably collected on his European honeymoon tour in 1885.

35. I am indebted to Dr. Bruce Laughton for showing me a transcript of this correspondence. That Sickert did not visit the exhibition is apparent from a postscript in one letter: '*Je suis enchanté d'entendre que vous avez tant de succès avec l'exposition que j'aurais tant aimé visiter.*'

III

1887–90. Mainly Music Halls

THE year 1887 was a landmark in Sickert's development. He exhibited with an *avant-garde* society abroad. His stylistic experiments were influenced, for the first time in any significant degree, by painters other than Degas and Whistler. And he began to paint true music hall pictures of which *The Circus* (Fig. 21) was only a foretaste. From 1887 until 1889 Sickert concentrated the main energy of his developing artistic personality on the creation of his music hall paintings.

Sickert's enthusiastic adoption of a subject matter for which there were no Whistler models was a symptom of his determination to emancipate himself from Whistler's paternalistic domination over his artistic life. His efforts towards independence also led him to submit his work for exhibition with groups other than the Royal Society of British Artists (R.B.A.) of which Whistler was president. Whistler evidently resented such freedom from his patronage; he advised Sickert against exhibiting *The Height of the Season, Dieppe* (untraced) at the Institute of Oil Painters in 1888 (279), compelling Sickert to justify his action thus: 'Now that you have taught me to walk I am not crying to be carried. I do not mean to throw myself on your good nature but take my chance and peddle my work where I can. In fact I have no other choice . . . Painting must be for me a profession and not a pastime.'[1]

In the same year, 1888, Sickert joined the New English Art Club, just forestalling Whistler's resignation from the R.B.A. when 'The Artists came out and the British remained'[2]. The N.E.A.C. thus became Sickert's main forum for exhibiting his work.

Sickert's enthusiasm for the N.E.A.C. was immediate. He wrote to Blanche soon after joining the Club that it 'will be the place I think for the young school of England'[3]. He was at once drawn into the dissensions which troubled the early history of the Club. The rift in the N.E.A.C. began in its foundation year, 1886, when Fred Brown was annoyed that Steer's entry, *Andante*, was hung badly. The only real bond between the founder members was their common wish for a popular vote. Steer's painting stood for what the English called 'Impressionism', and a supporting clique grew around him which by 1888 included Roussel, Starr, Maitland, Francis James, Bernhard and Walter Sickert, besides his original champion Brown. As the strength of this clique grew it gradually gained control of the jury, which led to the resignation of several of the original members who were not in sympathy with 'Impressionist' painting, and to the resignation *en masse* of the Scottish artists (excepting Mac-Gregor) when one of their works was rejected by the jury. Other members of the N.E.A.C., for example the followers of the *plein-air* painter Bastien-Lepage, also seceded in time as they were drafted off to the Royal Academy. This reduction in membership in fact helped the Club to acquire a more clearly defined personality. Moreover, its prestige and authority in the 1890s was greatly heightened when Brown succeeded Legros as director of the Slade (1892), and when such sympathizers as George Moore, D. S. MacColl, and R. A. M. Stevenson were appointed as art critics to the *Speaker*, the *Spectator*, and the *Pall Mall Gazette* respectively.

The virtual control of the N.E.A.C. by the 'Impressionist' clique took time to achieve. In the late 1880s the internal politics of the Club required delicate handling. Sickert wrote to Blanche early in 1889[4]:

> Our friends i.e. the Impressionist nucleus of the N.E.A.C. have all advised that *my name must not this year appear* much in proposing or seconding people as my work is said to be most unpopular with the dull but powerful section of the N.E.A.C. the people whose touch is square and who all paint alike and take their genealogy I believe from J. P. Laurens.

The directive that Sickert lie low perhaps explains why he showed only one work that year. In any event the 'Impressionist nucleus' organized their own exhibition at the Goupil Gallery in December 1889. They called themselves the 'London Impressionists'. In the organization of the group and as its chief spokesman Sickert played a prominent part. In the space of a year and a half he had advanced his status from being 'pupil of Whistler' to being one of the leaders of the 'young school of England'.

It was Sickert who wrote the catalogue preface of the exhibition[5]. In trying to define what were the aims of the group he had to explain what they meant by 'Impressionism':

> Essentially and firstly it is not realism. It has no wish to record anything merely because it exists. It is not occupied in a struggle to make intensely real and solid the sordid or superficial details of the subjects it selects. It accepts, as the aim of the picture, what Edgar Allan Poe asserts to be the sole legitimate province of the poem, beauty. In its search through visible nature for the elements of this same beauty, it does not admit the narrow interpretation of the word 'Nature' which would stop short outside the four-mile radius. It is, on the contrary, strong in the belief that for those who live in the most wonderful and complex city in the world, the most fruitful course of study lies in a persistent effort to render the magic and the poetry which they daily see around them. . . .

This statement of Sickert's beliefs owes little to French Impressionism except in so far as it accepts the liberation of subject matter pioneered by the Impressionist generation in France. It owes much to Whistler who, in his London landscapes, had been trying to convey 'the magic and the poetry' of the city, and in his writing, talking, and lectures (notably the 'Ten O'Clock' first delivered in 1885[6]) constantly stressed that beauty was the sole true aim of a picture. Indeed, Sickert's preface, like Whistler's 'Ten O'Clock', was a manifesto of the 'aesthetic' creed. The French inspiration behind it was limited to the cross-channel fertilization of ideas which had contributed to the growth of the movement from Baudelaire onwards[7]. In 1885 Robert Louis Stevenson had stated: 'It may be said with sufficient justice that the motive and end of any art whatever is to make a pattern; a pattern, it may be, of colours, of sounds, of changing attitudes, geometrical figures, or imitative lines; but still a pattern.'[8]

In 1890 Maurice Denis in France asserted: '*Se rappeler qu'un tableau—avant d'être un cheval de bataille, une femme nue, ou une quelconque anecdote—est essentiellement une surface plane recouverte de couleurs en un certain ordre assemblées.*'[9]

In his 1889 preface Sickert stated what he considered to be essential to a painting: 'Not new facts, certainly, about the subject of a picture', but 'nothing more than a subtle attribute which painters call "quality", . . . A certain beauty and fitness of expression in paint, apparently ragged perhaps, and capricious, but revealing to the connoisseur a thoughtful analysis of the essentials in the production of the emotion induced by the complex phenomena of vision . . . real quality, like style in literature, is the result of the complete knowledge of the subject treated, and of simplicity and directness in the treatment.'

In 1895 R. A. M. Stevenson was to write that technique in painting is 'the method of using any medium of expression so as to bring out the character of a decorative pattern, or to convey the sentiment with which you regard some appearance of the external world'.[10]

All these statements were part of the same polemic although differences in emphasis can be distinguished. Denis, Robert Louis and R. A. M. Stevenson all stressed the importance of pattern at the expense of subject. Sickert was rather less radical and intellectual, and closer to Whistler when he emphasized the primary importance of quality, that is, the treatment and handling of paint which should support the expression of the subject although it did not matter what subject was chosen. Robert Louis Stevenson was, it is true, writing of all the arts and R. A. M. Stevenson's alternative definition of technique was closer to Sickert, especially to Sickert's statement, written in 1891 (when he again compared painting to literature): 'A page of description is distinguished as literature from reporting when the resources of language are employed to convey, not a catalogue of facts, but the result of the observation of these facts on an individual temperament.'[11]

Sickert's aesthetic, and that of the London Impressionists for whom he was elected to speak, must be understood in this context, as part of the excited examination of the intrinsic meaning of art, literature as well as painting, which was prevalent at this time. Most of the 'London Impressionists' had, at one time or another, been pupils of Whistler or deeply influenced by him. It was only in the manner in which they tried to implement their ideals that they departed, at times, from Whistler's example. Sickert, for instance, felt that Whistler's handling was not, for himself, the best method of achieving quality in painting, and that Whistler's subject matter did not express what he, Sickert, found most magical and poetic in London life. Sickert found this magic and poetry primarily in the London music halls.

Music hall in England began only towards the middle of the century, and as a place of entertainment the halls were chiefly patronized by the lower classes[12]. However, by the later 1880s and the early 1890s they became something of a cult, invested with glamour and excitement for the more bohemian literary men who saw in them a refreshingly vulgar protest against the suburban respectability which blighted Victorian England[13]. Sickert was the first English artist to paint the music halls.

There were French prototypes, a fact commented upon by the critic of the *Scotsman*[14] when he remarked that the painter of *Collin's Music Hall* (shown by Sickert at the N.E.A.C. in 1889) probably had no clear motive in painting such a subject 'except that music halls were often painted by some of the French Impressionists'. Sickert replied to this charge[15]:

> It is surely unnecessary to go so far afield as Paris to find an explanation of the fact that a Londoner should seek to render on canvas a familiar and striking scene in the midst of the town in which he lives. . . . I found myself one night in the little hall off Islington Green. At a given moment I was intensely impressed by the pictorial beauty of the scene, created by the coincidence of a number of fortuitous elements of form and colour. . . . the fact that the painter sees in any scene the elements of pictorial beauty is the obvious and sufficient explanation of his motive for painting it.

This explanation for painting music halls anticipates, by some months, the similar statement of his aesthetic beliefs in the 'London Impressionists' catalogue preface. However, even if Sickert's motive for painting music halls was his desire to express 'the elements of pictorial beauty' and the 'magic and the poetry' of such London scenes, his memory of Degas's theatres and *cafés-concerts* must have prompted his initial inspiration. Degas's theatre and ballet pictures suggested the compositional framework of Sickert's earliest music halls, but it was surely his *cafés-concerts* with their vital atmosphere, harsh light effects, and robustly characterized *chanteuses*, that reminded Sickert of their nearest English equivalent, the Cockney music hall. The London halls were often attached to a pub and thus had a drink licence. Although they were larger than the Paris *cafés* the chairmen did much to foster the atmosphere of intimacy between *artiste* and audience.

Several French artists also followed Degas's lead and adopted the *cafés-concerts* and music halls as a subject for painting in the 1880s, among them Seurat and Raffaëlli. However, although many of the

French examples have a striking affinity to Sickert's early music halls, showing the stage behind a few rows of audience, they cannot be regarded as sources for Sickert's work, but rather as a parallel, contemporary manifestation of interest in the same subject.

The genesis of the music hall as a subject for painting was, in fact, merely an extension of the tradition of representing theatre interiors. There was a long tradition in England of painting portraits of actors dressed in the character of their major roles, or in scenes from famous plays: Whistler himself followed this tradition in his many portraits of actors, of the dancer *Loie Fuller* in action, and in one instance—*Connie Gilchrist*—of a music hall actress in stage dress doing her skipping act. There were, however, very few comprehensive representations of theatres before the mid-nineteenth century. Hogarth's theatrical paintings (*The Beggar's Opera* and his pictures of amateur country house performances) belong in conception and composition more to the category of conversation pieces than to that of theatre interiors. Richmond's severely neo-classical *An Audience at Athens during the Representation of the Agamemnon* can be classed as a history painting. In France Guys, for example, made charming sketches of ladies in the audience at the Opéra, and Daumier found theatre audiences ideal subjects for his acute powers of characterization. In Germany Menzel painted *A Performance at the Théâtre de Gymnase* (1856) as a souvenir of his visit to Paris; the composition and the detached presentation (with no hint of caricature as in Guys and Daumier) are similar to Degas's and Sickert's pictures of such scenes. It is not, however, suggested that the Menzel was known to and inspired Sickert, because it was not bought by the Berlin Art Gallery until 1906.

A more likely source of inspiration for Sickert's music halls may, on the other hand, be found in popular German graphic art of the 1860s. The *Fliegende Blätter* reproduced woodcuts of theatre scenes which in their compositions (planar arrangements with the stage in the background, the audience seen from the back in the foreground), in occasional details such as a 'cello top projecting from the orchestra or the use of a member of the audience as a *repoussoir* figure in the immediate foreground, and particularly in their down-to-earth plebeian characterization, anticipate Sickert's music halls[16].

The only English prototypes which in any way resemble Sickert's music halls are also found among the prints and drawings of graphic artists. Sickert was probably familiar with many of the prints popularly circulated in the nineteenth century. He may well have known some of Rowlandson's theatre drawings. *Rowlandson's Show*, for example, dated 1811, was engraved in 1816 and reproduced in 1880 in Grego's *Rowlandson the Caricaturist*[17]. The compositional arrangement of the audience, seen from the back, disposed parallel to the stage on which some sort of variety show is in progress, is close to that used by Sickert in his early music halls. *A Speech from the Stage* is closer to Sickert in its atmosphere but less so in its composition. This watercolour (formerly in the Henry Harris Collection) was not engraved or published as far as I know; it is quoted not as a specific influence but as an example of the kind of drawing Sickert might have known by Rowlandson or his contemporaries. One further example will suffice: Sandby's aquatint after Dance of the ballet *Jason et Médée* as presented in 1781. This aquatint, contained in an oval, is interesting because three members of the orchestra are shown in the lower segment with the stage above them, a usage later adopted by both Degas and Sickert (although in the Sandby the heads do not overlap the stage and thus do not form the *repoussoir* silhouettes beloved of Sickert and Degas).

Alfred Thornton[18] stated that, to all appearances, *Rehearsal. The End of the Act* (Fig. 3), exhibited at the Society of British Artists in the winter of 1886–7, was the first of Sickert's theatre pieces. Appearances, in this case, were misleading. *Rehearsal. The End of the Act* (or *Répétition. La Fin de l'Acte* as it was called upon its re-exhibition at *Les XX* in 1887), in spite of its title suggesting a Degas-type behind-the-curtains glimpse of the ballet girls mentioned by Menpes, is not a true theatre piece at all. Contemporary press reviews of both the London and Brussels exhibitions prove that this picture is, in fact, the

portrait of Miss Helen Couper-Black (later Mrs. D'Oyly Carte) now known as *The Acting Manager*—
the title of the compositionally variant etching of the same sitter. The etching is dated 1884; the paint-
ing was probably done a little later. The original title of the picture may have represented a gesture of
homage to Degas (at the same time it is an early example of Sickert's *penchant* for ambiguous titles), but
stylistically this portrait of Miss Couper-Black, who has collapsed onto a sofa at the end of an exhaust-
ing rehearsal, is more akin to the scenes of distressed gentlewomen so popular in Victorian England:
indeed the *Illustrated London News* critic interpreted the picture anecdotally as 'a young debutante
overcome by a sense of failure'[19]. It is also possible that Rembrandt's philosophers in their studies
inspired the conception of the portrait, although this source is more easily recognized in the etching
than in the painting. The translation of the Rembrandtesque convention into a romantically myster-
ious portrait is a distortion or sentimentalization of his prototype typical of a Victorian artist.

With *Rehearsal. The End of the Act* proved to be a portrait, *The Circus* may claim the distinction of
being Sickert's first painting of a theatrical subject. There is, however, evidence that Sickert was
drawing in the music halls before 1885. A study of a figure (listed C.40) standing before a shaded wall
or backcloth, originally mounted (almost certainly by Sickert) on a sheet together with fifteen other
slight drawings of miscellaneous subjects, is inscribed, partly illegibly, with words which can only be a
music hall lyric ('What a . . . honest/He never goes out on a spree/O such a . . . is he'). The style and
handling of all these drawings, as well as the subject matter of several of them, indicate that they
were drawn at approximately the same time as the 1884 sheet of restaurant studies at Moreau's (C.11).
When Sickert met Degas in 1883 he must have seen his theatre and *café-concert* as well as his ballet
pictures. The study of a singer may be recognized as a timid, but apt, translation of a Degas *chanteuse*.
Possibly this sketch was executed as preparatory information for Sickert's etching. Just as Sickert's
etchings of figure subjects, his restaurant interiors for example, forecast his later interest in painting
such scenes, so his interest in painting music hall subjects was anticipated in a few etchings. Sickert
etched *The Old Mogul Tavern* in 1884, and *The Queen's Palace of Varieties* in 1885[20], although in both
etchings he represented only the audience and omitted any reference to the stage and *artiste*.

The earliest known example of a true music hall painting by Sickert is *The Lion Comique* (Fig. 25),
exhibited (under the title *Le Mammoth Comique*) at the R.B.A. in April 1887. *Bonnet et Claque. Ada
Lundberg at the Marylebone Music Hall* (Fig. 23) was probably painted at about the same time. Both are
painted on canvas. The sharp delineation of the figures, the abrupt juxtapositions of dark and light
tones, with little attempt to soften the transitions, the smooth application of the paint in flat patches
of clean colour, and the consistency and chalky opacity of this paint, are the same in both pictures
(and are, incidentally, qualities of handling also found in the Scheveningen beach scene on canvas
of 1887). Both have pale-toned backgrounds against which the two-dimensional black-coated figures
are silhouetted. The function of the pink strip in the background of *Ada Lundberg*, to introduce warmth
into the otherwise cold harmony of buff, stone, blue, and black, is the same as that of the wine-red
band of colour in the foreground of *The Lion Comique*, painted as it is in an equally cold scheme of blues,
greys, greens, and black. The handling of the singers' faces, as light, flat, almost unmodelled patches
of paint, and the convention in which their wide-open mouths are depicted, are similar. The slight
element of caricature in the round, simple faces of the audience in *Ada Lundberg* is echoed in the singer's
face in *The Lion Comique*. There is a stylized, frankly decorative and unreal quality about these pictures.
This is partly a consequence of the nature of the tonal oppositions which by severely limiting the
gradations result in descriptive simplifications of a different kind from, but equally radical to, those
found in the early Whistlerian works in which the total register was limited.

Compositionally the two pictures are completely different. The limited view focused upon the stage
of *The Lion Comique* represents a somewhat formal compositional approach to music hall painting

derived directly, but in simplified form, from Degas's theatre pictures of the late 1860s and early 1870s. Sickert reduced the scale and content of his pictures in comparison with a Degas, but retained the well-defined parallel horizontal divisions of orchestra, stage, and backcloth. *Ada Lundberg* is a unique and daring experiment designed to incorporate *artiste* and audience into intimate union. It reverses Sickert's usual compositional formula for music hall pictures in that the stage figure here acts as a *repoussoir* for the audience—which foreshadows Arthur Symons's assertion in 1892 that 'in a music hall the audience is part of the performance'[21]. The inspiration for this experiment is unknown. *Ada Lundberg* curiously anticipates Ensor's *L'Intrigue* of 1890 in the way Sickert has placed the head of the woman in the right foreground corner with a frieze of mask-like grinning faces behind. Ensor did exhibit with *Les XX* in 1887 (although *L'Intrigue* was not painted until three years later) so that possibly Sickert was aware of his work and knew a similar composition in that year. In his music hall pictures of the next few years Sickert continued to paint subjects incorporating both *artiste* and audience, as he had in *Ada Lundberg*, but he abandoned the compositional innovations of that picture in favour of the simpler Degas formula used in *The Lion Comique*.

The several versions of *Gatti's Hungerford Palace of Varieties* illustrate this compositional type. The version of Gatti's showing the *Second Turn of Katie Lawrence*, which was one of Sickert's two submissions on the first occasion he exhibited with the N.E.A.C. in April 1888, and which was accorded the place of honour jointly with Steer's *Summer Evening*, is now untraced. The critics of the press, who much enjoyed ridiculing the 'new art' of the Club, devoted considerable space to its description, and their references to its large size and details of its content disprove the assumption that the N.E.A.C. picture and that now in Sydney, Australia, are one and the same. Emmons[22] refers to a number of life-size paintings, afterwards destroyed, which Sickert did of Katie Lawrence. Although not quite life-size, the N.E.A.C. picture was possibly one of these destroyed paintings; one reviewer estimated the canvas as measuring 60 × 36 inches (the Sydney painting measures $38\frac{3}{4} \times 33\frac{1}{4}$ inches), and another estimated that the 'impudent looking wooden doll' Miss Lawrence was 'about four feet high'[23]. Yet another advised Miss Lawrence to sue for libel[24]; she did not do this but, again according to Emmons, she did refuse Sickert's offer of one of her pictures: 'not even to keep the wind out at the scullery door'.

The approximate appearance of the N.E.A.C. picture may well be reflected in a pen drawing, published in 1895[25], entitled *Kate O'Grady, You're a Lady*. The narrow vertical format of the drawn composition, details of the definition of Katie Lawrence ('with hands down to her knees', 'her mouth . . . twisted under her left ear'[26]) and the proportion of the surface which she occupies, accord with the press description of the exhibited picture, although the 'enormous' 'splay feet'[27] are glossed over in the drawing and the 'jumble of hats and fiddle heads'[28] in the foreground are reduced in number.

Although the Sydney version of *Gatti's* (Fig. 28) is not the picture shown at the N.E.A.C. it was a major work for Sickert, which he evidently prepared and painted with considerable care and devotion, probably a short time after his exhibition picture. Another smaller version (listed C.42) in Yale University is closely based on the Sydney picture (with minor variations in the definition of the audience) but stylistically it appears to be a later work, and is probably *Ta-ra-ra-bom-de-ay* which Sickert began to paint in 1903 to send to the Venice *Biennale* but did not finish in time[29]. Yet another picture of Gatti's (Fig. 27) is dedicated to Jacques Blanche but the inscription identifies the *artiste* as Queenie, not Katie, Lawrence. Queenie and Katie Lawrence were different, unrelated *artistes*. Katie Lawrence appeared at Gatti's in May and July 1887, but from January 1888 until May 1889 she was out of England on a tour of Australia. Queenie Lawrence also played at Gatti's in July 1887 and returned again from March to April 1888 while Katie was in Australia. Sickert also etched Gatti's showing *Emily Lyndale as Sinbad the Sailor*.

Over 140 preparatory drawings related to the various versions of Gatti's survive. When painting music halls Sickert could not refer to his subject except through drawings and memory. Sickert's visual memory had been trained by Whistler; Whistler too had encouraged his facility to draw quickly and sharply. But, like Whistler, Sickert had hitherto tended to separate his graphic from his painted work; his drawn sketches were translated into etchings but seldom used as information for his paintings. Possibly the extraordinarily large number of studies Sickert made for Gatti's reflects the enthusiasm of his recent conversion to the method of working entirely from drawings[30]. Moreover, the extant Gatti's studies can represent only a proportion of those originally executed, because they include no study of the whole composition and relatively few of the *artistes*. They are all tiny notes on scraps of paper, their scale presumably conditioned by Sickert's desire to work unobserved in public places.

When painting his various pictures of Gatti's Sickert selected from this store of information. Some drawings he did not use at all, some he used for several compositions. For instance in 1887 he studied Nellie Brown and Florence Hayes as well as Katie Lawrence at Gatti's, and in 1888 he studied Kate Harvey as well as Emily Lyndale in tights (information used for his etching) and a demure slim girl whose pose and dress are very similar to those of Queenie Lawrence[31]. Similarly Sickert selected a figure here and a figure there from the numerous notes he made in 1887 of the members of the audience, the 'cellist, and the chairman, and combined them into new arrangements, presumably in his exhibition picture and certainly in the Sydney painting. The majority of the architecture studies—both of the stage and the auditorium—were made in June 1888, obviously too late to be considered as preparations for the picture exhibited in April. Only six architecture studies were done in 1887, whereas nineteen studies of the stage architecture and five of the empty seats in the auditorium were drawn in 1888. The main difference (besides size) between the N.E.A.C. picture and the two other versions showing Katie and Queenie Lawrence respectively was the lateral extension of the composition to include a detailed description of the stage in the smaller pictures. Having worked on his exhibition picture, which was almost filled with figures, Sickert probably found his interest in Gatti's revived by further studies of its architecture. The studies of the stage architecture were utilized in both the Katie and Queenie Lawrence pictures, but the studies of the empty auditorium were more specifically related to the latter painting[32].

The two paintings of Gatti's illustrate two different approaches to what was ostensibly the same subject. They are alike only in their basic compositional format and in the view of the interior which they comprehend. The change of *artiste* is the most trivial of their differences. In *Katie Lawrence* the representation of the audience is highly particularized. In *Queenie Lawrence* the audience is reduced to a few scattered, perfunctorily treated figures. *Katie Lawrence* provides a complete linear definition of the stage architecture. *Queenie Lawrence* suggests the architectural setting by implication rather than by statement; Sickert's interest was in translating the light and shade effects in the empty auditorium, and in conveying the decorative aspect of the stage architecture by the effective use of colour, a yellow tinted grey with a chequered application of vermilion and emerald rectangles, in the backcloth. Not only did Sickert explore and emphasize different aspects of the same interior in these two versions of Gatti's, he also experimented with different methods of handling. *Queenie Lawrence* is smaller than *Katie Lawrence*. The liquid paint and the softly smudged tonal transitions suggest that it was painted in thin wet coats superimposed on underlying wet coats of paint, that is, in Sickert's old Whistlerian manner in spite of the fact that it was painted from drawings. On the other hand, the sharp delineation of the figures, the abrupt, clean juxtapositions of flat patches of paint of different tonality with no hint of blended transitions found in *Katie Lawrence* would have been impossible if Sickert had painted wet on wet. Only by painting in planned stages, on underlying dry pigment, could Sickert have obtained such

effects as the thin, sharp strips of highlight marking the contours of toppers and bowlers, and the clear jig-saw of tones which models the foreground hat.

Sickert's reputation as a painter of music halls was consolidated in 1889[33]. His only work at the N.E.A.C. in April was *Collin's Music Hall. Islington Green* and three (perhaps four if the untraced *Trefolium* was a music hall) of his six pictures at the 'London Impressionists' in December were music halls—*The Oxford Music Hall, Little Dot Hetherington at the Bedford Music Hall*, and *The P.S. Wings in an O.P. Mirror*. The dichotomy in Sickert's handling of music hall subjects illustrated in the two versions of Gatti's is echoed in *Collin's* and *The Oxford. Collin's Music Hall* (C.50) is destroyed, but from its reproduction in 1909[34] it appears to have been painted much in the manner of *Katie Lawrence*. It was also close to Gatti's compositionally; as *Truth*[35] remarked Sickert chose to 'paint music hall scenes which mainly consist of a dozen or so hats and bonnets, and the vague form of a popular "artiste".' *The Oxford Music Hall* (C.51), on the other hand, is much closer, both in content and handling, to *Queenie Lawrence*. The understated definition and the softly smudged tonal transitions suggest it too was painted wet on wet. The scene is viewed from above and at more distance than in *Queenie Lawrence*, so that the emphasis on the setting (at the expense of the figures) is even more exclusive; the *artiste* is a remote puppet and the audience are small indistinct smudges scarcely interrupting the parallel highlight-tipped rows of the stalls.

Of all the London music halls Sickert's name is most closely associated with the Bedford in Camden Town. His paintings of the gallery of the Old Bedford in the 1890s, and of the towering auditorium of the rebuilt New Bedford in the first two decades of the twentieth century, are among the most remarkable visual records of theatre interiors ever painted. And it was in his earliest paintings of the Bedford that Sickert first experimented with ways of presenting his subject—a comprehensive view of *artiste* and audience, stage and auditorium—other than by following the simple, logical Degas-derived formula used in *Gatti's, Collin's* and *The Oxford.* In *Little Dot Hetherington* and in *The P.S. Wings in an O.P. Mirror* (both Bedford scenes) the compositions and spatial plans are of the greatest complexity, because a major part of each subject is represented through its reflection in a looking glass.

These pictures are the first examples of Sickert's use of a looking glass as an integral part of his compositions. In the Bedford gallery pictures of the 1890s the glass was to be an important compositional feature, and in the later Camden Town figure subjects the use of reflections often extends and elaborates the spatial, psychological, and formal constructional relationships. However, in none of these later paintings (with the possible exception of one picture of *La Gaieté Montparnasse*, Fig. 164, a Paris music hall of 1907) was the use of the device disguised—as it is in *Little Dot* and *The P.S. Wings*—so that it is not immediately obvious that we are looking at a reflected rather than a real image. In none of the later paintings is the consequent definition of the real spatial plan so obscure and ambiguous.

It is possible that objective observation of its physical characteristics prompted Sickert to depict the Bedford in this way. The great mirrors happened to be set in the right places and at the right angles to provide striking juxtapositions of stage and audience. However, it is also probable that his pictorial conception was conditioned by artistic precedents. Although the reflected image had a long history in painting there were not many precedents for Sickert's manner of disguising its use, nor for the way he showed almost the entire subject in terms of a reflection as he did in *Little Dot* (Fig. 26). Perhaps the nearest nineteenth-century ancestor of *Little Dot* is Manet's *Un Bar aux Folies-Bergère*[36], in which the interpretation of the extensive reflection as such is also, to a certain degree, disguised. Manet gave little circumstantial evidence of the presence of a mirror—brief glimpses of its frame are caught on either side of the barmaid's hips—but he betrayed the true character of his scene by representing each object both as real and as a reflected image (however much he obscured their single identity by the spatial separation of their complementary aspects). Sickert, on the other hand, defined the glass

frame in *Little Dot* explicitly but this is the only clue given to identify the scene as a reflection. No part of the reflected image is also seen as a real object. The frame is, therefore, liable to be read as just another decorative detail of the ornate Victorian interior, perhaps the top of a balustrade over which the main scene is viewed. Only more detailed study exposes the physical impossibility of grouping and disposing the figures, and relating them to the angled stage, in the space behind this horizontal 'ledge'. The spatial ambiguities are explained only when it is realized that the whole scene is viewed in a mirror and thus cut off at an arbitrary point and reflected at a chance angle.

When planning and constructing *Little Dot* Sickert probably recalled Manet's experiment with a similar problem. However, Sickert compromised with the idea of basing his picture on a reflected image much less than did Manet, and this suggests the possibility of another, concomitant source of inspiration for its conception—Velasquez's *Las Meninas*, in which the whole subject is translated on to canvas from a reflected image. Velasquez was a primary source of influence for the painting of both Manet and Whistler, and the more progressive art circles in England in the 1880s were keenly aware of his technical greatness although they knew his work mainly from reproductions. Sickert's remarks, published in an issue of the *Whirlwind* in 1890[37], expressing disgust with *The Times* critic's adverse comments on *Las Meninas*, prove that he knew and admired this particular picture.

Velasquez's subtlety and ingenuity in *Las Meninas* far surpassed Sickert's in *Little Dot*. Sickert's picture has none of *Las Meninas*'s devious interlocking of motives. However, the idea of painting a subject which is entirely contained within a reflection is in itself so unusual, even when divorced from the particular ingenuities of Velasquez's approach, that *Las Meninas* was probably partly responsible for the conception of *Little Dot*. Velasquez's example may also have suggested to Sickert the inclusion of a second mirror reflection, itself contained within the larger one. In *Las Meninas* the king and queen who are being painted are reflected in the small mirror on the background wall; in *Little Dot* a part of another mirror reflecting the stage-box on the right of the picture is re-reflected in the main glass.

The spatial construction, or ground-plan, of *The P.S. Wings in an O.P. Mirror* (Fig. 30) is easier to interpret than that of *Little Dot*. The title of the picture exactly describes its content[38]. However, Sickert's use of a reflected image in *The P.S. Wings* is again ambiguous. In *Little Dot* audience and stage are contained within one reflection. In *The P.S. Wings* the reflection is used perversely, to separate these two elements. In a music hall, *artiste* and audience enjoy an intimate psychological union; in Sickert's picture, although reflected stage and real audience are in close proximity on the surface, not only do they appear totally unaware of each other's existence but this separation is further emphasized by their great disparity in scale.

The handling of both these pictures developed from that of Sickert's earlier 1888 music halls. The paint is smooth, thin, and liquid, but Sickert has tried to avoid the indistinct definition of *The Oxford* and *Queenie Lawrence* by using brighter, more dashingly applied highlights to pick out the contours without at the same time resorting to the full schematic modelling of the tones found in *Katie Lawrence*. The colour is also more varied and lively. In *Little Dot* touches of vermilion, white, and emerald green tell against a more muted harmony of greys, yellows, maroon, and blue, while in *The P.S. Wings* the stage figure is a brilliant red flattened in a dazzle of light.

The music hall pictures which Sickert exhibited at the 'London Impressionists' won him critical acclaim and did much to confirm his reputation. The *Star* commented[39]:

> the man who has made the greatest improvement in his own line, and from whom I do not see that we want any other, is Walter Sickert. His studies out of doors only prove his cleverness, not his originality. But his Music Halls are the greatest possible advance over anything he has yet shown; from his reproduction of Gatti's to his portrait of a hat to this year's complete rendering of the halls, their performers and audiences is an immeasurable distance.

However, Sickert also painted some less ambitious music hall pictures in the late 1880s showing only the stage figures, such as *Minnie Cunningham at the Old Bedford* and *The Sisters Lloyd*. Sickert did not exhibit these pictures at the N.E.A.C. until autumn 1892 and spring 1894 respectively. During the first half of the 1890s Sickert was to concentrate on portrait and landscape painting but perhaps he thought it politic to exhibit these earlier, publicly unknown pictures in order to sustain his reputation as the painter of music halls. Possibly for the same reason (but also because their subject was suitably bohemian) Sickert's contributions to the *Yellow Book* in the 1890s included several reproductions of his earlier music hall paintings[40].

Minnie Cunningham (Fig. 37) was probably painted in 1889, after her first appearance at the Bedford in July. Her pure profile pose, the vivid red of her dress, and Sickert's interest in reflected light, all recall characteristics of *The P.S. Wings*. But in *Minnie Cunningham* Sickert presented the figure alone, with complete simplicity and directness, standing in the shallow space limited by the backcloth behind and the footrail in front. The shallow space, the vertical format, the planar composition, the delicate refinement of the figure, the smooth, thin paint which in places reveals the brown underpainting, are all Whistlerian qualities. However, the form is not over-simplified; the backcloth is defined in enough detail to support the figure compositionally and the figure itself is modelled carefully so that the tonal fields, although gently graded, do not dissolve into a general blur. *Minnie Cunningham* suggests that Sickert, having tried in his major music halls various methods of avoiding Whistlerian simplifications of form and composition, now felt competent to revive and re-use those qualities of the Whistlerian style which suited his purpose without, at the same time, losing hold of the definition of form and content.

In *The Sisters Lloyd* (Fig. 34) Sickert again represented only the two stage figures and enough of the stage and backcloth to suggest their ambience. The handling of the painting, although in some respects also reminiscent of Whistler, differs from *Minnie Cunningham* and illustrates Sickert's experiments with yet another technique. The simplification of form, the elliptical definition of the figures which precludes any attempt at particularization or even clarity of outline, the dependence upon the precise relations of the tones to create plastic reality from the abstract pattern of paint, are all Whistlerian. But the paint itself is far more solid and opaque than Whistler's; the brushwork, especially in the figures, more untidy, the tonal contrasts more sudden, and above all the colour both more brilliant and functionally important. The realization of the figures depends as much upon colour as upon the gradations and relations of the tones. (Today the painting is dark and dirty so that the full effect of the colour, dominated by the striking orange hats worn by the sisters[41], is hardly apparent.) Possibly the inspiration behind this technical experiment by Sickert was Steer, who together with Sickert was the most influential member of the London Impressionist group. Both subscribed to the general aims of the group but their manner of painting differed profoundly. Steer's painting at this date, in its untidy brushwork and use of bright colour, approximated much more closely to that of the French Impressionists. Sickert, in painting *The Sisters Lloyd*, was perhaps trying to emulate the direct freshness, the impressionistic vivacity of Steer's work by imitating, if not the details of his handling, at least the broad basis of his approach, the swift brushwork and the full brilliant colour.

Sickert also painted some music halls on panel during this period, which in spite of their small scale cannot be considered as sketches but as complete finished pictures. They too were studied from drawings and painted in the studio. The extant examples are all Bedford scenes, three showing *Vesta Victoria* (Fig. 36, C.48) and another of a different *artiste* called *Red, White and Blue* (Fig. 29). They have in common their vertical format (incorporating the stage *artiste* and a small section of the theatre with a few figures in front) and their method of handling; in all the coloured glass frieze below the footrail is an important feature.

The stylistic character of these panels may have been dictated by the special effort Sickert had to make to cast off his Whistlerian method of handling when working on a small scale. In these panels it is as if Sickert had listed the characteristics of Whistler's handling and then, in glorious defiance, had deliberately exaggerated their exact opposites. Whistler's vague definition is replaced, for the first time in Sickert's painting, by the most explicit sharp drawing in black, delineating not only the outlines but also the details of his subject. Whistler's muted, refined, and gradual tonal modulations are replaced by the most abrupt contrasts and juxtapositions of flat simplified blocks of uniform tones. Whistler's sombre and limited range of colour is replaced by a virtual tapestry of jewel colours, dominated by the vermilion, royal blue, emerald green, and white of the glass frieze, colours which are repeated throughout the panels with the addition (among other colours) of a bright yellow gold used in the highlights. The solid opacity of the paint, the precise definition, the clean juxtapositions of colours and tones, the sharp application of the highlights, and the meticulous finish of two of the four panels (the exceptions are the sketchier versions of *Vesta Victoria*) indicate that the panels were painted in successive planned stages and led gradually towards their conclusion just as if they were much larger paintings on canvas.

The characteristics of handling found in these panels were not individually new to Sickert's painting. The precise definition (but not the sharp drawing) and the schematic nature of the tonal construction were found in *Katie Lawrence*; the bright colours (in a less concentrated form) were used in *Little Dot*. However, never before was any one of these qualities so exaggerated, nor were they combined together in quite this way. In a sense these panels—which were probably painted from 1889 to 1890—represent the culmination of Sickert's work on music hall pictures in the 1880s. Not only do they combine and assimilate the essential qualities of his various technical experiments but compositionally they illustrate a sophisticated compromise between the severe simplicity of, for example, *The Lion Comique* and the more ambitious complexity of such paintings as *Little Dot*. The vertical format of the panels and their limited content give them a superficial resemblance to *The Lion Comique* but in *Red, White and Blue* the slight diagonal orientation introduces new spatial interest and in *Vesta Victoria* not only is the architectural detail more complicated but a mirror-image extends the composition by providing a glimpse of the gallery and a member of the audience. Sickert very rarely exhibited at the Royal Academy so his choice of the more finished version of *Vesta Victoria* called *The Stage Box* to show at Burlington House in 1898 is, perhaps, an indication that he recognized the extent of his achievement in these panels.

NOTES

1. Letter to Whistler in the collection of Whistleriana belonging to the Department of Fine Art, University of Glasgow.
2. This famous phrase is variously quoted by different sources but the words given here are the most common rendering.
3. The content of this letter proves it to have been written after the spring show of the N.E.A.C., but before August, because Sickert remarked that Whistler was to marry Mrs. Godwin, an event which took place in August.
4. Letter can be dated 1889 because Sickert asked Blanche to persuade Helleu to exhibit with the Club (which he did in 1889); moreover it was written before April because it refers to the administrative preparations for the exhibition which opened that month.
5. Preface quoted in full (with some misprints) by D. S. MacColl, *The Life Work and Setting of Philip Wilson Steer*, London, Faber, 1945, Appendix C, pp. 175–6.
6. 20 February 1885 at Prince's Hall; the text was privately printed in that year and subsequently reprinted in London (Chatto and Windus) 1888 as well as abroad, in America, France, and Germany. The lecture too was many times repeated.
7. The background and history of the aesthetic movement in France and England is related by William Gaunt, *The Aesthetic Adventure*, London, Jonathan Cape, 1945. Frank Rutter, *Art in my Time*, London, Rich and Cowan, 1933 gives some of the background of this movement with particular reference to its application to painting.
8. The *Contemporary Review*, 47, April 1885, pp. 548–61, 'On Style in Literature: its technical elements', p. 550.
9. *Art et critique*, 23 and 30 August 1890, '*Définition du Néo-Traditionnisme*', under the pseudonym Pierre Louis.
10. *Velasquez*, London, George Bell, p. 81 of 1962 edition (see Introduction, note 21).
11. 'Modern Realism in Painting', written in 1891 and published

in *Jules Bastien-Lepage and his Art*, edited by A. Theuriet, London, Fisher Unwin, 1892, pp. 133–43, ref. pp. 140–1.

12. W. MacQueen Pope, *The Melodies Linger On! The Story of Music Hall*, London, W. H. Allen, 1950, gives a fairly detailed account of the history and character of English music hall.

13. For example, George Moore, *Confessions of a Young Man*, written in 1886 but first published (Swan, Sonnenschein Lowrey) in 1888, wrote of music hall as 'a protest against the villa, the circulating library, the club' (p. 125, London, Heinemann, 1952 edition).

14. 15 April 1889.

15. *Scotsman*, 24 April 1889. Ronald Pickvance, *Apollo*, 76, April 1962, pp. 107–15, '*The Magic of the Halls and Sickert*', discussed this charge and Sickert's reply.

16. Examples include woodcuts in No. 1077, 1866 p. 79 (by Oberländer), No. 1161, 1867 p. 117 and No. 1163, 1867 p. 133 (both unsigned). Oberländer was among Sickert's favourite German graphic artists, and was one of the triumvirate whom he recalled with nostalgia in the *Burlington Magazine*, 41, October 1922, pp. 180–8, 'Diez, Busch and Oberländer'.

17. London, Chatto and Windus, 2 vols., Rep. Vol. 2, p. 313.

18. *Artwork*, 1930, p. 12.

19. 4 December 1886.

20. Harold Wright, MS., British Museum.

21. The *Fortnightly Review*, 51, 1892, pp. 716–22, 'A Spanish Music Hall', p. 716.

22. p. 49.

23. *Sunday Chronicle*, 6 May 1888; *John Bull*, 14 April 1888, respectively.

24. *Truth*, 3 May 1888.

25. The *Idler*, in a series called 'The Music Hall' by Sickert, p. 170.

26. *Sunday Chronicle*, op. cit., *Truth*, op. cit., thus described the N.E.A.C. picture.

27. *Truth*, op. cit.; *Sunday Chronicle*, op. cit., respectively.

28. *Magazine of Art*, 1888, p. xxx.

29. Dating, title etc., explained in Catalogue under Fig. 28, C.42.

30. Sickert must also have made drawings for *Ada Lundberg* and *The Lion Comique*, neither of which could have been painted on the spot, but no studies are traced. There is one study for *The Circus*, showing the audience in the foreground.

31. Queenie Lawrence was not advertised in the music hall gazettes as engaged at Gatti's early in June (the drawings are variously dated June 4, 6, 7 and 8, 1888) but it is possible she made an unscheduled appearance, perhaps as a late stand-in for a colleague.

32. Studies of the seats in the empty auditorium drawn in June 1888 (Fig. 27, C.43, Studies 4) are inscribed with numerous colour notes, one of which refers to the reflected lights on the rims of the seats which is so beautiful a feature of the Queenie Lawrence painting.

33. The *Star*, 15 April 1889, wrote that Sickert 'SEEMS TO LIVE IN MUSIC HALLS'.

34. Frederic Wedmore, *Some of the Moderns*, London, Virtue, 1909, unpaginated after 'Walter Sickert' chapter, pp. 43–50.

35. 25 April 1889.

36. The picture, painted 1881–2, was in Manet's studio at the time of Sickert's visit in 1883 (it was included in the *Vente Atelier Manet* in 1884).

37. 28 June 1890, p. 12.

38. The mirror is to the left of the audience, that is, the Off Prompt side of the stage; the *artiste* faces to her left, that is the Prompt side (remembering that what we see in Sickert's picture is a reversed reflected image).

39. 3 December 1889.

40. *The Old Oxford Music Hall*, I, April 1894, p. 85; *The Old Bedford Music Hall* (that is, Little Dot Hetherington) and *Ada Lundberg*, II, July 1894, p. 221 and p. 225 respectively; *Collin's Music Hall, Islington* and *The Lion Comique*, III, October 1894, p. 137 and p. 139 respectively.

41. Many of the contemporary press reviews commented on the colour effects of the picture; *Truth*, 12 April 1894, 'a couple of red-headed mops'; the *Spectator*, 21 April 1894, 'a delightful study of colour'; *The Times*, 9 April 1894, 'large orange hats', etc.

IV

1890-5. Portraits, Landscapes, Music Halls

SICKERT's position as a leading member of the new generation of young English painters was established by 1890 and the next ten years of his career was a period of consolidation. In 1895 he shared a major retrospective exhibition with his brother Bernhard at van Wisselingh's Dutch Gallery. However, in spite of having shown some of his work abroad in various European capitals during the previous decade[1], his reputation was still almost entirely national, and confined to a select circle even within his own country.

Sickert had now truly graduated from the apprentice stage and began to teach in private schools of painting and pass on to others the fastidious attitude to his raw materials and their preparation which he had learned from Whistler. If Alfred Thornton's recollection of his time as co-teacher at Sickert's class in The Vale, Chelsea, in 1893 is accurate he must have confused his students; Thornton related how Sickert would one day instruct that brown grounds were essential, another day that brilliant white ones were, another that fish glue in priming was the sole road to technical salvation, and yet another that *toile ordinaire* should be used as Jacques Blanche had said its surface resembled that used by Velasquez[2]. In the later 1890s Sickert collaborated with his friend, colleague and informal pupil Miss Florence Pash in running a school in Victoria Street. Sickert taught the evening classes for more advanced students (where it is interesting that he already preferred ugly models, one of whom was middle-aged, very fat, had a squint and deformed teeth) while Miss Pash taught society ladies in the morning[3]. Sickert also produced a certain amount of critical journalism during this decade. Besides contributing an important chapter, called 'Modern Realism in Painting', to a book on Bastien-Lepage[4], he wrote reviews for a wide variety of newspapers and periodicals. Sickert loved both teaching and writing but he also undertook these pursuits in the 1890s because he needed the money. During this period Sickert's financial security, which depended heavily upon his marriage to Ellen Cobden, was at first threatened and ultimately destroyed by the gradual disintegration of their relationship; he and his wife finally separated in 1896 and divorced in 1899, but even when they were still happily together Sickert must have wished to contribute his share to their joint income.

Sickert's private life and public prestige during this decade were also marred by the acrimony of his relationship with Whistler. Whistler's fondness for his former pupil decreased in proportion to Sickert's growing emancipation from his influence and patronage, cooled further because of Sickert's continuing friendship with Sir William Eden (the Baronet with whom the Butterfly quarrelled), and terminated in outright enmity with Whistler's slighting remarks upon Sickert's competence made from the witness box in April 1897 during the course of yet another legal wrangle concerning the technique of transfer lithography[5].

In spite of all these upheavals, which at last led him to desert London for Dieppe in the winter of 1898, Sickert during the 1890s worked seriously and solidly on, painting portraits, landscapes, and

music halls and experimenting with style and technique. He was no longer at the centre of the dissensions of the London art world. The N.E.A.C., now much reduced in membership and more autonomous in character, settled down during this decade. Many of its members and its supporters held respected posts and the Club was superseded as the main object of public hostility and derision by the more 'dangerous' exponents of 'decadence' in the literary and fine arts with whom Sickert was only peripherally connected.

Portraits

From 1888 until 1898 Sickert used the N.E.A.C. as the main forum for showing his more important recent works to the public. Although he also showed a small proportion of earlier paintings, an analysis of the pictures he exhibited biannually with the Club can be used as a fairly accurate index of the relative time he devoted to different types of subject matter at any one period. Between 1890 and 1895 Sickert showed twenty-seven pictures at the N.E.A.C.—sixteen portraits, seven landscapes, and four music halls (of which three were probably earlier works[6]). Painting was not only Sickert's vocation: it was his trade and portraiture was potentially more profitable than either music hall or landscape painting. A reputation as a portrait painter led not only to commissions to paint portraits but also to work as an illustrator for journals and periodicals. For example, the success of his portrait of *Charles Bradlaugh* (Fig. 35), one of three portraits Sickert showed at the N.E.A.C. in April 1890, undoubtedly influenced the *Whirlwind* to commission from Sickert a weekly 'full-page cartoon . . . of a person of distinction, taken from life'. Sickert's first cartoon was of *Bradlaugh* and the *Whirlwind* introduced Sickert to its readers as 'the painter of the famous portrait in oils of Mr. Bradlaugh that was exhibited in Knightsbridge a few months ago. The picture was universally pronounced to be the best likeness of Mr. Bradlaugh ever painted and was most highly appreciated both by himself and his family'[7]. Sickert contributed portrait drawings to the *Whirlwind* each week from 28 June 1890 (its first issue) until 30 September, whereupon he defected in spite of editorial threats of dismissal. Sidney Starr filled in for him, although in December, shortly before the *Whirlwind* closed down, Sickert published one more portrait (all listed C.52). Sickert also worked for other periodicals between 1890 and 1895. For example, he published another series of portrait drawings in the *Pall Mall Budget* in 1893 (listed C.52), and his contributions to the *Cambridge Observer* (edited by his brother Oswald) and the *Yellow Book* included portrait drawings as well as illustrations of his work in other *genres*. Sickert's contributions to the *Savoy* and the *Idler* did not include any portraits but later, in 1897, he resumed work as a portraitist with a series of caricatures for *Vanity Fair*. Thereupon Sickert's activity as a graphic illustrator ceased until 1911 when he began drawing for the *New Age*[8].

Stylistically the *Whirlwind* and the *Pall Mall Budget* portraits are unexciting. They are mostly half- or bust-length pen and ink drawings in which Sickert's main concern was to catch a good likeness. It is probable that most of the portraits published in the *Pall Mall Budget* in 1893 were drawn in 1890 and were perhaps originally intended for the *Whirlwind*. Indeed the portraits of *Labouchere* and *The Stuart Heiress* were reprinted from the earlier series[9]. Only two of the *Pall Mall Budget* portraits, *John Gilbert* and the *Maharajah of Bhavnagar*[10], were recent works, studied, as the paper acknowledged, at special sittings. In these two portraits Sickert expanded his technique as compared with the 1890 series by supplementing his pen and ink line drawing with the use of wash. The rich black wash used in the background and in the shadows of the figure is particularly effective in the drawing of the picturesquely attired Maharajah who sat to Sickert when he came to London for the opening of the Imperial Institute in 1893.

The use of wash in *Gilbert* and the *Maharajah* suggests that Sickert sought to enrich and soften the

uncompromising hardness and spareness of pen and ink portrait drawing. By 1894 he went further and rejected pen and ink altogether as his preferred medium for drawn portraits. In the portraits of *Richard le Gallienne*, dated 1894 (C.61), and *Mrs. Ernest Leverson*, dated 1895 (Fig. 33), both published in the *Yellow Book* in 1895[11], he used soft black chalk. In both these portraits interest is concentrated exclusively upon the faces which are handled with a new sympathy and tenderness only partly attributable to the medium.

Sickert's portrait paintings of this period echo the stylistic characteristics of his contemporary portrait drawings. There is in the paintings the same direct, somewhat unimaginative endeavour to convey a good working likeness without either flattering elisions or tasteful paraphernalia. The motive behind this approach to portrait painting must have been Sickert's desire to paint portraits in a non-Whistlerian manner. Of the three portraits he showed at the N.E.A.C. in 1890 only *Miss Fancourt* (C.15)—which was probably painted earlier, in the 1880s—emulated the grand Whistlerian style. The portrait of *Steer* (Fig. 39), although a full-length, was a much smaller informal work, showing Steer seated, legs crossed, against the ostensibly casual background of a corner of Sickert's studio. Its parallel among the *Whirlwind* drawings is the full-length portrait of *Jacques-Émile Blanche* which, perhaps because the sitter was a close personal friend, is treated more informally than the others in the series and shows Blanche seated with his dog Gyp on his knees (Fig. 32). The half-length of *Bradlaugh* (Fig. 35) introduced the type of format Sickert was to use in his other *Whirlwind* drawings as well as in more of his painted portraits of the early 1890s, such as *G. J. Holyoake* (C.59), shown at the N.E.A.C. in November 1892. These portraits are still dark in tone and restricted in colour but the tonal contrasts are sufficiently strong to avoid vague blurring of the definition. There is, nevertheless, a quality of slightness about these portraits similar to that found in the drawings. The thin coats of paint are not constructively applied to create the mass and weight of the body; large areas of the canvas are simply glossed over; the slick highlights are drawn rather than painted.

The fluid sketchiness and superficial *bravura* of these portraits is also seen in Sickert's grandest portrait of the 1890s, the full-length, life-size portrait of *Bradlaugh at the Bar of the House of Commons* (Fig. 38), shown at the N.E.A.C. in April 1893. Sickert perhaps conceived this portrait as a *riposte* to Whistler, an imposing large-scale portrait in which the subject is both highly particularized and represented as doing something significant. This portrait is generally assumed to have been painted in the later 1880s because it commemorates the famous episode in Bradlaugh's career when in 1886 he finally took the oath in the Commons. Bradlaugh died in January 1891 but there is no reason to suppose that the portrait was painted within his lifetime at all. Indeed, it was stated in the press to be a 'posthumous full-length commission'[12]. The N.E.A.C. catalogue acknowledged that the head was taken from a photograph (making it the first documented instance of Sickert's use of photographs for painting) and the body could have been studied from a model. The use of a photograph has given this area of the portrait a different character from that found in the smaller picture of the same sitter. Not only does Bradlaugh look much younger (presumably because the photograph reflected a younger Bradlaugh than Sickert studied from life in 1890) but the still-life quality of the photographic document is transmitted to the painting. The modelling is harder and cleaner and the delineation of the features is very precise. However, the general handling of the portrait, with its glossed-over areas of shadow relieved by slickly applied strips of highlight, is basically similar to that seen in Sickert's less formal portraits of this period. This dichotomy in its handling is harmful to its comprehension as a whole. In fact, when the two portraits of *Bradlaugh* are directly compared the success of the smaller picture, in capturing some living aspect of the sitter in spite of its confused modelling and drawing and its lack of substance, becomes apparent.

Sickert's tendency to draw with paint in his portraits of the early 1890s became an advantage when

he painted *George Moore* (Fig. 31). The light, sketchy, almost graphic manner in which he used his brush to model the naïve, oval face, the incredulous round eyes, and the drooping moustache, suited the element of caricature discernible in this portrait. Not only did Sickert catch a likeness but he conveyed the amusing ingenuousness of his sitter's personality. Moore himself recalled that he 'only sat twice for the astonishing and now celebrated portrait, and when, owing to a press of work, I was compelled to abandon sittings, the portrait was chaos. But Mr. Sickert had got from me all he wanted.'[13] Moore quoted this experience as illustrating Sickert's practice of observing, studying, but not copying nature, his method of making drawings, perfecting his memory, and painting from the studies. A comparison of the painting exhibited at the N.E.A.C. in November 1891 with two drawings of Moore, published in 1893[14] but probably originally executed as studies for the painting, reveals how heavily Sickert depended upon drawings when painting. There is even a close relationship between the techniques he employed. The lines of hatching in the drawings which follow the form of the face are directly translated to the painting with no modification of function. The lines of short parallel ink strokes defining the outlines of the nose and eyebrows become soft strips of shading outlining the same features in the painting. The painting is, in fact, conceived as a drawing in coloured paint. In this particular portrait the value of colour is great; nothing could better emphasize the full naïvety of Moore's expression than the china-blue eyes and sandy moustache.

Sickert's talents for the swiftly drawn likeness, his ability to capture and slightly caricature the most striking physical attributes of his subject, are displayed again in his small full-length study of *Beardsley* (Fig. 40), painted in 1894. When the portrait was exhibited at the Dutch Gallery in 1895 it was called a 'Sketch in Distemper'. The texture of its paint is certainly dry and chalky but the reference to 'distemper' is perhaps as much an allusion to the character of Sickert's subject as an accurate description of his medium[15]. The handling of this portrait is very effective and totally dissimilar from that of Sickert's more formal and finished portraits of the 1890s. The surface of the picture resembles a simple jigsaw of interlocking dry, flat, uniformly coloured and toned patches of paint, a conception which may well have been influenced by the current popular style of coloured caricature drawings such as Sickert himself was to execute for *Vanity Fair* in 1897[16]. *Miss Beerbohm* (C.62) is another informal sketch of a friend, this time studied with no hint of caricature, in which the painting is again economical and the drawing relaxed. As in Beardsley's portrait the face is hardly seen so that the whole figure is treated with equal emphasis. Indeed, the success and charm of both these pictures is partly due to the fact that they are less portraits than figure studies. It should also be remembered, as significant of Sickert's versatility and willingness to experiment with different methods of treatment contemporaneously, that his very Whistlerian self-portrait, *L'Homme à la Palette*, shown at the N.E.A.C. in April 1894, may have been painted at about this date, and possibly his van Dyckian sketch for a *Portrait of Lady Eden* (C.63), a flamboyant arrangement of a sitter with dog shown at the N.E.A.C. in 1898, was also a work of the first rather than the second half of the decade.

The idea we can obtain of Sickert's portrait style at this period is necessarily incomplete as so many of his pictures are untraced. Whereas his portraits of famous public men, such as *Bradlaugh* and *Holy-oake*, remained known, his portraits of less well-known persons, and particularly of his women sitters, were lost. *Miss Beerbohm* is a rare surviving example of a female portrait, but it is hardly typical of the more finished products we can presume he exhibited at the N.E.A.C. In fact, eight of the sixteen portraits Sickert showed at the N.E.A.C. between 1890 and 1895 were of women and all—with one possible exception—are as yet untraced[17]. The exception is the portrait of *Mrs. Ernest Leverson* exhibited in April 1895. This portrait may possibly be identified with the small half-length picture of a lady lying in a hammock (C.58) which according to an undocumented tradition is said to represent Sickert's wife, Ellen, painted in Dieppe in 1885. However, the handling of this portrait is inconceivable in the

context of Sickert's work of the mid-1880s. The main reason for asserting the portrait to be of Ellen is that it looks like her, but it looks far more like Mrs. Leverson as drawn by Sickert for the *Yellow Book* (Fig. 33). Moreover, the handling of the painting is a direct translation, in terms of oil paint, of the technique of the drawing. The rich black chalk lines accenting the features in the drawing are repeated in paint in the canvas; the nervous strokes defining the hair, and even the suggestion of cross-hatching in the background, are also repeated in the painting. Finally the mood of tenderness and sympathy is common to both. Just as Sickert's pen and ink drawing technique was reflected in his portrait of George Moore, so his new style of softer, chalk drawing was reflected in this portrait.

Landscapes

Although Sickert's main energies from 1890 until 1895 were concentrated on portraits he painted landscapes when he was in Dieppe. From the 1890s until 1914 almost all Sickert's landscape paintings are of Dieppe subjects, perhaps because Sickert spent nearly every summer in Dieppe and if he wanted to devote only a part of his time to landscape painting the summer was the most congenial season to do so. However, this practical argument oversimplifies the case, for when Sickert lived in Dieppe all the year round, from 1898 until 1905, he studied landscape all the year round. There was clearly something in Dieppe, in its picturesque jumble of narrow streets and sombre architecture, that Sickert could not resist, whatever the season. Blanche, with reason, called Sickert the Canaletto of Dieppe[18]. Naturally, on and after his visits to Venice Venetian subjects temporarily superseded Dieppe subjects, but London or English scenes became less common after the 1880s[19].

Sickert continued to paint little tonal studies of Dieppe on panel or small canvases and in some he evidently attempted to disguise their Whistlerian derivation by experimenting with much freer brushwork. For example, in one small picture of *Le Mont de Neuville* (Fig. 50), a very Whistlerian motif of a little climbing street in the old quarter of Dieppe which Sickert frequently studied (C.66), the confused brushwork reduces the subject to an almost illegible muddle of paint. However, the style of this and similar sketches was not reflected in Sickert's larger-scale landscapes, most of which were executed with limpid refinement and economy.

In the last chapter, dealing with Sickert's work from 1887 until 1890, only his music hall paintings were discussed. Although music halls dominated his production during this period Sickert did continue to paint landscapes and tackle a few figure subjects. A sheet of studies of *A Woman Ironing* (C.16), inscribed 'S. Valery en Caux' and dated '1887–8–9?', is an interesting example of Sickert's meticulous Degas-inspired examination of a *genre* subject, a *blanchisseuse*. We left Sickert's landscapes with the Manet-influenced Scheveningen pictures of 1887 and of later works mentioned only *The Red Shop* (Fig. 20). There is, however, one curious experiment in a non-Whistlerian style and handling of landscapes during this period which deserves note. It is *Dunford. The Residence of the late Richard Cobden M.P.* (C.37), shown by Sickert at the 'London Impressionists' exhibition in 1889. It is, for Sickert, a large picture (three feet square); its brushwork is smooth, the paint flat, and the definition tight and clear. The colours are bright and light in tone with a pale blue sky, some violet and grey clouds, and a wide expanse of bright green grass in the foreground; the trees are brown and the blossom suggested by scattered dashes of light colours. The whole picture is remarkably pedantic. Although the tonal values are well related Sickert's main concern seems to have been to repeat the exact local colours of his subject without, at the same time, making any 'Impressionist' attempt to break the colours down to their component tints. In summary, the picture weakly resembles a very early Monet.

Sickert must have concluded that his several attempts (in his Scheveningen pictures of 1887, and in *Dunford*, painted some time between 1887 and 1889) to break with the tonal tradition in which he had

been trained were not right for him at this stage. In *The Theatre of the Young Artists* (Fig. 41), dated 1890, the shallow horizontal composition, the broadly slashed application of the thin paint, the notation of the figures as a patchwork of small stains of colour, the limited neutral colour range (based on greys and cool blues), and the muted tonal register are once again close to Whistler's example. In a picture of *The Café des Tribunaux* (C.69), also painted *c.* 1890, the treatment is similar but the composition is closer to Whistler's little street scenes in which the figures are disposed like stepping-stones receding into the distance. In both pictures the handling is sustained throughout so that there are no dead passages; scale and content are perfectly matched and a balanced compromise is achieved between definition and economy in the use of tone, colour, and drawing. In short, Sickert manipulated the Whistlerian manner for his own ends with confidence and sophistication. A second version of *The Café des Tribunaux* (Fig. 43), shown at the N.E.A.C. in spring 1891 under the title *Dieppe*, presents a different aspect of the scene, and is horizontal instead of vertical in format. The paint is still floated across the canvas in broad planes, but it is less slippery and liquid in consistency. The slight increase in the substantiality of the paint is complemented by an increased clarity in the demarcations of the tonal contrasts, and these two qualities combine to give new firmness and weight to the picture.

Sickert was evidently satisfied with this manner of handling for the painting of landscape because for the next few years it remained typical of most of his Dieppe subjects, an example being *The Hôtel Royal* of *c.*1894 (Fig. 48). However, in an earlier picture of *The Hôtel Royal* (Fig. 42) painted in 1893, he did indulge in one unique and unexpected experiment in style. Unfortunately this picture, exhibited at the N.E.A.C. in the winter of 1893, is now known only from its reproduction in the *Yellow Book* in 1895[20]. Possibly the reproduction has exaggerated the tonal contrasts, and in particular deepened the darks (as is the case with other Sickert paintings illustrated in the same periodical), but even allowing for these exaggerations the painting is singular. According to the *Spectator*[21] the picture was painted in a mixture of sallow and rosy colours. The hotel, set parallel to but far back from the surface, is caught in the reflected light of the setting sun, and in its reproduction it glows strangely through the general gloom. The wide foreground is punctuated by a few ladies, dressed in crinolines, aptly described by the *Spectator* as 'pawn figures'. They are treated as simplified, unrealistic silhouettes, and that this stylization was deliberate is proved by Sickert dressing them in the clothes of a bygone age. The picture is unique to Sickert's work in its reflection of the decorative artificiality of taste characteristic of the 'decadent' nineties. Although it antedates the birth of the *Yellow Book*, the main literary and artistic organ of that taste in England, it is probable that Sickert was influenced in this painting by the *Yellow Book*'s future art editor, Aubrey Beardsley. According to Sickert it was he who 'had given Beardsley his first and last lesson in painting and that Beardsley's incursion into oil, now in the Tate Gallery, had been done in Sickert's studio under Sickert's fatherly eyes'[22]. This painting by Beardsley is *A Caprice*; it too represents ladies wearing crinolines in a landscape. Sickert may have advised Beardsley about the practical technique of painting, but the choice of subject (a variant of a black-and-white design published in the *Yellow Book* in 1894[23]) and the stylization of its expression clearly emanated from Beardsley. It is possible that Sickert's 1893 *Hôtel Royal* was conceived as a sort of complement to *A Caprice*, representing the obverse side of their collaboration on that painting, that is to say that Sickert in his picture tried to emulate Beardsley's descriptive stylization, an experiment as unique as was Beardsley's incursion into oil painting.

Music halls

Portrait painting and graphic work in London, and landscape painting in Dieppe, left Sickert little time for the intensive preparatory study that was demanded for the painting of music hall subjects.

Of the four music hall paintings he showed at the N.E.A.C. during the period 1890 to 1895 only one was a totally new subject, *The Boy I Love is up in the Gallery*, exhibited in November 1895. George Moore described this picture in the *Speaker*[24]:

> For its very rare beauty of tone I admire Mr. Walter Sickert's picture representing the gallery of a music hall. I like it because of its beauty; it has a beauty of tone, colour, and composition. I admire it for the fine battle the painter has fought against the stubborn difficulty of the subject. For to have discovered that architecture and to have fitted it into his canvas was no little feat—that grey space of ceiling with its coloured panel, and that space of grey-blue beneath the gallery with just sufficient pillar to explain, are they not admirably balanced? That pilaster, too, about which the boys crowd and cling keeps its place in the composition—the red paint with which it is decorated is low in tone and harmonious; the shadow, too, that floats over the gold ornaments is in its right place: it is as transparent as a real shadow, and therefore redeems the vulgar painting and gilding. . . . The great mirror in which vague shadows are reflected, is it not a triumph?

Moore's appreciation is extensively quoted here first because in spite of its undercurrent of naïve wonder (an aspect of Moore's approach to art which much irritated Sickert) it can hardly be improved, and second because it serves to identify *The Boy I Love is up in the Gallery* with the version of *The Gallery of the Old Bedford* now in Liverpool (Fig. 45). The original title of the picture suggests that Sickert conceived it as a pendant to his earlier painting of *Little Dot Hetherington* on the stage of the Bedford singing this song and pointing up to this very gallery.

Although *The Gallery of the Old Bedford* is Sickert's only major music hall composition of the first half —or indeed the whole span—of the 1890s, he painted it many times. Some versions are preparatory studies for the exhibited picture, while others are later reworkings of the composition. There are also etchings and many drawings, ranging from minor notes to complete composition studies, of the Old Bedford gallery.

An earlier *terminus ante quem* for the conception and composition of the picture than its exhibition in November 1895 is provided by the publication of an etching dated 1894 in the *Idler* in March 1895[25]. This etching included all the main features of the composition studied in the more complete drawings and in the paintings of this subject.

A comparison of the different painted versions of *The Gallery of the Old Bedford* provides a striking illustration of the variety of Sickert's style not only within a single *genre* in a single decade, but also within a single subject. Moreover, enough preparatory drawings survive for this important and famous composition to enable its evolution to be studied in some detail. (In the summary below the numbers in brackets refer to the catalogue numbers given under Fig. 45, C.73.) It is interesting that, unlike the studies for *Gatti's*, most of those for *The Old Bedford* are records of the whole composition rather than notes of individual figures or isolated parts. Perhaps the earliest idea for the composition is contained in a horizontally aligned drawn study of the architecture of the gallery with its sweeping curves and elaborate ornamentation (1). The representation of the architecture is superimposed on several notes of a music hall *artiste*, and the drawing is inscribed with a series of apparently unconnected letters which were in fact an *aide-mémoire* denoting the initial letters of the song *Oh Bermondsey Flo*, later inscribed in full to one side. Sickert's casual records of music halls are often inscribed with lines of lyrics which helped him to recall the flavour of the original atmosphere. Although this drawing is not yet a study of the boys in the gallery but of the gallery itself the first inspiration for the later composition was noted; a boy, peering over the gallery, is sketched in and it was he who was to become the focal point of Sickert's full representations, giving them the alternative title *Cupid in the Gallery*; he is not resting his head on his hand but his basic position is already established. In two more studies (4, 5) Sickert drew the gallery architecture and roughly indicated the figures and their placing within it; their disposition and attitudes approximate to those he was to examine in more detail later. In both he

represented more of the lower architecture than appears in the later studies or in the paintings. Two drawings (2, 3) are devoted to studies of individual figures, some from the stage and some from the gallery, and both include studies of the boy with a round face, wearing a cap. A sketch on one study sheet (2) shows him with his head resting on his hand as in the paintings. The other study sheet (3) includes, besides the boy, other gallery figures, and is extensively documented with colour and tone notes. However, none of these figures is readily identifiable with those in the completed paintings except a man in profile who may be an embryonic representation of the rather sinister figure in a bowler hat on the extreme right of most of the paintings. There must have been many more studies for individual figures but the only other extant study of a small part of the composition is a drawing (6) of the mirror, inscribed with colour notes, in which is reflected a single standing figure. The only finished version to include the reflection of this figure alone is the *Idler* etching.

Besides these partial records of *The Gallery of the Old Bedford* there are extant a watercolour, an unsquared drawing, and two squared drawings of the whole composition. None of the drawn or painted versions of the complete composition is identical to the others. However, minor variations in the figure dispositions and architectural framework suggest a certain chronological pattern of development.

The watercolour (8) was probably done as an experiment to establish the main figure massing within the architecture in a medium which gave some idea of colour and tonal effects. The large, unsquared drawing (Fig. 44) represents an effort to place the figures more definitely. The painting which most closely reflects this drawing is the version in the Fitzwilliam Museum (C.73, Version 2). Painting and drawing are the same size and the extent of the architecture shown is identical. However, the figure disposition of the painting was only partly derived from the drawing; it is closer to one of the squared drawings (9) which, however, differs from Fig. 44 and the Fitzwilliam painting in showing more of the ceiling architecture to include the grille.

The Fitzwilliam painting is smaller and more sketchily executed than the Liverpool version (Fig. 45). It is perhaps a rehearsal for the more elaborate exhibited picture although Sickert's first attempt to paint the scene was probably on panel (C.73, Version 1). The figure disposition in this panel again reflects the squared drawing (9). The *Idler* etching seems to have been executed at about this stage of the developing composition because its figure disposition (with minor variations) and the extent of the architecture shown also reflect this squared study.

The next stage in the development of the composition was an elaboration of the figure disposition. The second squared drawing (10) is basically similar to the first (9) but extra figures have been added. The Liverpool painting (Fig. 45) also represents an elaboration of the figure composition. It is not taken directly from any of the studies but represents an amalgam of information derived from them all, put together to create yet another grouping of the gallery figures. At the same time the composition has been slightly contracted to place greater emphasis on the figures. The real ceiling is excluded altogether, unlike any other version, and the height of the mirror behind the gallery is diminished so that it distracts attention away from the figures much less.

These drawings, paintings, and etching of *The Gallery of the Old Bedford*, executed in approximately the order given above from *c.*1894 to 1895, illustrate a compositional development which culminated in the painting now in Liverpool. The remaining versions were probably later reworkings of this subject; two paintings on panel and one on canvas seem to be works of *c.*1897–8 and yet another version on canvas was perhaps painted as late as 1915–20.

The handling of the Fitzwilliam and Liverpool paintings—with the proviso that the first was more sketchily executed—is similar. The paint is smooth, loosely and fluently applied in superimpositions of flat, irregular patches; the tonal value of each wash or patch of paint is carefully chosen so that the form is described more by the interlocking and overlapping of these areas of tone than by the

intermittently employed, broadly swept-in, outline drawing. The drawing and modelling of the faces, with the brushstrokes and shadow pattern following the direction of the form and somehow accentuating the gaping simplicity of the characterization, recalls the portrait of *George Moore*. In comparison with the music halls of the 1880s, also painted from drawings in the studio, Sickert's ability to plan the execution of his painting had clearly developed. The *Bedford Gallery* pictures show much greater sophistication and subtlety in the progressive construction of the forms. The essential definition is sustained throughout the superimpositions of paint of varying colour and tone without Sickert having to keep, in his succeeding coats, to the original boundaries. Thus the clear-cut jigsaw juxtapositions of the tones used in *Katie Lawrence at Gatti's* are no longer necessary, nor are the exaggerated highlit accents partly used to recover the definition of form in *Little Dot* and *The P.S. Wings*. The colour harmony of the *Old Bedford Gallery* paintings is more subtle; effects of colour and light are achieved without the use of isolated brilliant colours, such as the vermilion and emerald employed in some of the music halls of the 1880s; instead the harmony is based on low-toned greens blending into ochres against which the brighter touches of yellow-gold highlights in the florid gilt architecture, and the touches of salmon-red in the cartouche and pilaster, tell effectively but without exaggeration.

In its conception *The Gallery of the Old Bedford* also marks an important new departure for Sickert's music halls. Sickert represented the audience alone—although his fascination with the stage is still recorded in the sketches of *artistes* included on the early study sheets. From this date onwards, with only a few exceptions[26], Sickert's music hall paintings were to show the audience alone, and it was not until the 1920s that Sickert once again studied the stage in isolation. *The Old Bedford* is also the first composition by Sickert to represent the gallery. In his earlier music halls, representing both stage and audience, the scene is the main auditorium, as it is in the several drawings and a painting on panel of the audience in the stalls of the Bedford probably studied in the early 1890s (Fig. 49, C.72). It is true that the gallery is indicated in the background of this subject, just as it was seen in reflection in the *Vesta Victoria* panels (Fig. 36, C.48), but never before had Sickert represented the gallery exclusively. It is possible that the idea for painting the gallery and its gawping occupants was suggested to Sickert by a memory of Diez's woodcut, *Peasants at the Opera*, a brilliant impression of peasants leaning over a gallery to see the stage far below, which bears the caption 'The artful devils. They're singing in fours to get through with it more quickly.' Sickert illustrated this woodcut in his article of 1922, 'Diez, Busch and Oberländer', a nostalgic recollection of his early familiarity with these German illustrators[27]. The woodcuts he chose as illustrations were obviously his old favourites. The humorously acute observation of Diez's work, as well as its composition with the gallery pushed to one side, anticipates Sickert's representation of the *Old Bedford*. While the woodcut may not have influenced Sickert directly, an unconscious memory of it must have influenced his conception of the subject.

Sickert's paintings of *The Old Bedford Gallery* are distinguished not only by the subtlety of their handling and the innovation of their subject matter, but also by the exceptionally skilful construction of their composition. A mirror and reflection are once again an integral part of the composition but they are no longer a self-conscious device used to complicate the spatial description and create ambiguities in its interpretation. In *The Old Bedford Gallery* the mirror and reflection are used with much greater purpose and legitimacy. The mirror, with its angled reflection of the gallery ceiling and of the audience perched precariously to peer down at the stage, helps to explain the main subject and the spatial definition, and it greatly enhances the impression of the height at which the gallery is placed. The fact that the reflected image is directly related to the main subject of the painting, and not to something outside the picture as in Sickert's earlier music halls, means that not only is his subject explained in two of its aspects but that the surface is enlivened by a sophisticated formal counterpoint of colours, lines, and patterns, created by the echoes and variations of the true image and its distorted reflection.

When Sickert returned to this subject, after his visit to Venice of 1895–6, he retained the vertical composition and format and much of the incidental detail worked out in the series of paintings and drawings which had culminated in the picture he had exhibited at the N.E.A.C. in November 1895. The largest of all versions of this subject, now in Ottawa, was probably painted c.1897–8, and yet another painting on canvas was painted much later still (C.78 and Version). Both seem to have been closely based on the squared drawing in Capetown (Fig. 45, C.73, Drawing 10). The latter picture is broadly handled as a basically two-coloured map of the tonal fields. The arbitrary choice of colours (a salmon pink and a turquoise green) and the open-handed quality of the figure definition suggest it is a work of c.1915–20. A comparison of the Ottawa picture with the earlier versions of the subject reveals that it is treated much more precisely; the general level of the tones is lighter, their contrasts harder and sharper, and the drawing is tighter. Sickert sacrificed the smoky atmospheric reality of the earlier versions in order to emphasize the decorative quality of the flat surface of the picture. The stylistic experiment illustrated by this painting was taken further in the large and pedestrian picture *The Pork Pie Hat. Hilda Spong in 'Trelawny of the Wells'* (Fig. 64), painted in 1898[28]. It is interesting that the *Saturday Review*[29], in a criticism of the N.E.A.C. exhibition of April 1898 where Sickert showed *The Pork Pie Hat*, noted its simplified handling, the treatment of the shot silk dress and the background wall and commented that the design might be for 'a large poster or wall painting'; the reviewer added that Sickert had grasped the principles of flat decoration. The same is true, in a lesser degree, of the Ottawa version of *The Gallery of the Old Bedford*. Possibly both pictures were influenced by the contemporary revolution in poster design and treatment in France and in England, although the style of *The Pork Pie Hat* may also have been influenced by the fact that it was painted from a photograph[30].

Sickert repeated this experiment with flat, bright, decorative colours and sharp delineation, on a smaller scale, in yet another version of *The Gallery of the Old Bedford* (Fig. 47). This picture and another (Fig. 46), probably executed as a preparatory sketch, are painted on panel. Both differ from the other versions of the subject in that the composition is considerably extended to the left and contracted to the right; thus more figures are admitted to the gallery and the mirror is prematurely cut off by the frame. The scale of both panels is identical but the sketchy preparatory version includes more of the mirror and is therefore three inches wider. There are minor variations in the figure disposition used in each picture but the extra figures admitted to the extended gallery are the same in both.

The relationship of the figures depicted in both these panels to those in the other (earlier) versions is curious. Sickert repeated the basic gestures and grouping of the figures worked out in the 1894–5 paintings and drawings (combining elements derived from different versions representing the entire span of the developing composition) but he totally altered the details of the figures. He translated men into boys, he removed bowler hats in favour of bare heads or caps, and the four extra figures are quite out of character with the former gallery filled with gawping simpletons. They are more fantastic and sophisticated and include a man in trim uniform and a woman in an immense extravagant hat. The different character of the gallery audience suggests that the panels may have been painted as a deliberately playful and imaginative variation on a theme which was in danger of becoming stale.

Although these two panels are related to each other compositionally the style of the preparatory sketch is quite different from the tight and glossy finished version. It is painted loosely in low-toned combinations of colours; the figures are very briefly described as patches of colour and tone with no drawing except a few darker marks to suggest their features. The clean, sharp colour and the precise delineation of the finished panel, of *The Pork Pie Hat*, and of the Ottawa *Gallery of the Old Bedford* were by no means typical of all Sickert's theatrical and music hall pictures of c. 1898. The loose, free brushwork and definition of the preparatory sketch on panel of the *Gallery of the Old Bedford* subject demonstrates how Sickert was accommodating a very different stylistic and technical approach at the same

time. If a date of 1898 is accepted for *The Toast* (C.79), another representation of a subject from *Trelawny of the Wells*, the wide variation in his methods of handling in this year is even more strongly revealed. In *The Toast* the neatness of *The Pork Pie Hat* is discarded in favour of an untidy vigour. The paint is roughly slashed on in broken planes. The composition is so crowded as to be almost illegible. The drawing is violent in its crude simplifications. The somewhat brutal expressive force of this painting—so different from the clear, clean, uncomplicated style of *The Pork Pie Hat*—was not, however, unique to Sickert's work in the later 1890s. It was closely anticipated by his *Self-Portrait* of *c*.1896 (Fig. 61), to be discussed below. Indeed, this sort of vacillation between two logically incompatible stylistic extremes can be stated to be characteristic of Sickert's work at different periods. It is illustrated again, most clearly, in the paintings from the nude and the music halls done in Paris in the autumn of 1906. Perhaps when Sickert was working in a particularly restrained and moderate manner he needed some sort of emotional outlet and therefore, in a few pictures, he deliberately indulged in a kind of violent expressionism.

NOTES

1. For example at *Les XX*, Brussels, 1887; Paris Universal Exhibition, 1889.
2. *The Diary of an Art Student of the Nineties*, London, Isaac Pitman, 1938, p. 45.
3. The Islington Public Libraries, in their collection of Sickertiana, have several letters written by Sickert to Miss Pash (later Mrs. Humphrey, later still Mrs. Holland) referring to their school, as well as comments and reminiscences by Miss Pash which help fill in such details as the appearance of the models.
4. Essay written in 1891, published in *Jules Bastien-Lepage and his Art*, ed. A. Theuriet, London, Fisher Unwin, 1892, pp. 133–43. Sickert's essay is a passionate and beautifully written polemic in favour of Millet's methods of painting nature from memory and sustained observation (his 'execution was the singing of a song learned by heart') as opposed to Bastien-Lepage's laborious transcriptions *en plein air*.
5. Whistler appeared as a witness for Joseph Pennell who brought a libel suit against Sickert and Frank Harris (editor of the *Saturday Review*) on account of an article by Sickert (the *Saturday Review*, 26 December 1896, 'Transfer Lithography', pp. 667–8) in which he wrote that the prints made by Pennell using transfer paper applied to stone were not true lithographs. Whistler also used this method of transfer lithography. Pennell won the action.
6. *Miss Minnie Cunningham 'I'm an old hand at love though I'm young in years'*, winter 1892 (91); *The Sisters Lloyd*, spring 1894 (54); *Sam Collin's Islington*, winter 1894 (37).
7. 28 June 1890.
8. Sickert's work for the *New Age* was similar to that he did for the *Whirlwind* in that he held a dual post, as illustrator and critic, with both periodicals.
9. *Henry Labouchere, M.P.*, the *Whirlwind*, 12 July 1890, the *Pall Mall Budget*, 9 February 1893; *The Stuart Heiress Queen Mary*, the *Whirlwind*, 2 August 1890, the *Pall Mall Budget*, 9 March 1893.
10. 13 April 1893; 4 May 1893 respectively. The details of all the *Whirlwind* and *Pall Mall Budget* portraits are listed under C.52.
11. IV, January 1895, p. 83; V, April 1895, p. 231 respectively.
12. *Magazine of Art*, 1893, p. xxx, in a review of the N.E.A.C. exhibition.
13. The *Speaker*, 20 February 1892, a review of Sickert's essay 'Modern Realism in Painting' (see note 4), in which Moore compared Sickert's practice to that of Millet.
14. The *Pall Mall Budget*, 23 February 1893; the *Cambridge Observer*, 28 February 1893.
15. The Tate Gallery Catalogue, *Modern British Paintings, Drawings and Sculpture*, London, Oldbourne, 1964, Vol. II, p. 625, implies that the picture is in oil. However, when the picture was reproduced in the *Burlington Magazine*, 44, April 1924, p. 197, it was described as in tempera (p. 202).
16. Under the pseudonym 'Sic' he published caricatures of George Moore (*Esther Waters*), 21 January (C.98), Israel Zangwill (*A Child of the Ghetto*), 25 February (C.96), and Max Beerbohm (*Max*), 9 December (C.99).
17. *Miss Beerbohm* is Agnes Mary, not *Evelyn Clarence Beerbohm* shown at the N.E.A.C. in spring 1895 (19). The other untraced female portraits shown at the N.E.A.C. are *Miss Fancourt* (C.15), spring 1890 (9); *Miss Geraldine Blunt* and *Mrs. Roussel*, spring 1893 (52, 99); *Mrs. Von Tunzelman*, spring 1894 (66); *Mrs. Walter Cave*, spring 1895 (79). *La Femme au dé*, winter 1895 (9) may also have been a portrait. *Study of Expression*, winter 1892 (43), could have been a male or female portrait.
18. *Portraits of a Lifetime*, p. 45.
19. Sickert did make a few drawings of London scenes in the 1890s, such as *Marlboro' Square* (C.70), dated 'Nov.92'. The sharp wavering quality of the pen strokes in this drawing was typical of many of Sickert's published drawings of this period, landscapes, e.g. *Dieppe Harbour* (C.71) of 1893, and figures, e.g. *A Lady Reading* (C.60). Later in the 1890s he painted a group of London landscapes in the Cumberland Market area where he had a studio (Robert Street) and in the Camden Town period he occasionally painted landscape subjects chosen from his immediate neighbourhood. However, it was not until the First World War confined him to England that he painted English landscape extensively.
20. IV, January 1895, p. 81.
21. 23 December 1893.

22. C. Lewis Hind, *The Uncollected Work of Aubrey Beardsley*, London, John Lane The Bodley Head, 1925, p. x, and *Naphtali: being influences and adventures while earning a living by writing*, London, John Lane The Bodley Head, 1926, p. 100. Hind repeated this story, told to John Lane by Sickert, in both books, and in the earlier book added that Sickert set out the colours for Beardsley on a marble slab and showed him how to paint.

23. II, July 1894, p. 87, as the first of '*The Comedy-Ballet of Marionettes, as performed by a troupe of the Theatre-Impossible, posed in three drawings*'. *A Caprice* is generally dated *c*.1894 because of its relationship to this drawing published in 1894 but there is no good reason to contradict the suggestion that it and the drawing were executed a year earlier, or even that the drawing was a later derivation from the design of the painting.

24. 23 November 1895.

25. p. 169.

26. The *Trelawny* pictures (not music halls but theatre scenes) of 1898, to be discussed below, show the stage only; another exception is the little trapeze *artiste* in the background of *La Gaieté Rochechouart* (C.243) of *c*.1906.

27. The *Burlington Magazine*, 41, October 1922, pp. 180–8, ref. p. 185, illus. p. 186.

28. The production of the play which this picture represents opened at the Royal Court Theatre on 20 January 1898.

29. 23 April 1898.

30. William Rothenstein, *Men and Memories*, Vol. 1, London, Faber, 1931, p. 335, told how Sickert had Miss Spong photographed and painted the life-size portrait from a small print with few sittings.

V

1895–6. First Visit to Venice

ICKERT went to Venice for the first time in 1895. It is usually thought that he was there for only two or three months during the winter of 1895–6[1], but in fact this first visit perhaps lasted as long as a year. In May 1895 Oswald Sickert wrote to Edward Marsh, 'Walter is in Venice wearing white kid gloves'[2]. Sickert was still there in November or December when he wrote to Steer from 788 Zattere asking for gossip of the current N.E.A.C. exhibition and 'how my work looks and whether you like the Afghan'[3]. A letter of condolence to Whistler[4] on the death of his wife (she died on 10 May 1896) proves that this visit lasted well into the following year. This letter is addressed from 940 Calle dei Frati where Sickert was to stay on his later visits to Venice.

An explanation for the confusion which prevails about the length of Sickert's first visit to Venice and for his change of address may be found in the problems of his private life. The breakdown of his marriage was precipitated at precisely this time, 1895–6. In 1895 Ellen Sickert found a compromising letter sent to Sickert, but she forgave him and they evidently went to Venice together because Sickert's letters from Venice are written in the plural. For instance he wrote to Steer, 'Miss Leigh Smith . . . has lent us a "very nice flat" '[5]. However, it became clear that Sickert would not mend his ways and in February 1896 he and his wife separated. In May 1896 Sickert rejoined his wife in Switzerland, at Fluellen on Lake Lucerne, but a final separation took place in September 1896 when they were still in Fluellen[6].

We cannot chart Sickert's exact movements during this period between May 1895 and September 1896. Possibly he made more than one visit to Venice; he could have gone there in May 1895, returned home and then gone back again with his wife in the winter. It is probable that they were both still there in February 1896 at the time of their separation. Whether Sickert then returned to London is also uncertain but he was definitely in Venice in May when he wrote to Whistler from 940 Calle dei Frati—a room more suited to his bachelor and financial status than his former 'very nice flat'. It must have been from Venice that Sickert went to rejoin his wife in Fluellen. Between May and their final separation in September he might either have stayed in Fluellen continuously or gone to London, Venice, or Dieppe for a time. Whatever his exact movements it is clear that Sickert undertook crossing frontiers more casually than is allowed by his historians. Thus, although it is possible that Sickert was not in Venice all the time from May 1895 until May 1896 he was clearly there for much of this period.

Sickert's first visit to Venice stimulated his interest in landscape painting, which had been partly subordinated to portraiture between 1890 and 1895. This interest survived the visit itself so that on his return to London in 1896 Sickert continued to spend much of his time painting versions of Venetian subjects in the studio, from drawings, oil studies, and from photographs. His use of photographs is implied in a letter written to his friend Mrs. Humphrey (formerly Miss Pash) in 1899 referring to a little parcel of 'small scale drawings, of panels of Venice that is to say of St. Mark's façade and the

Rialto, pen drawings and photographs of sitters and photographs of Venice'[7].

There are certain problems in sorting out the chronology of Sickert's many Venetian landscapes. During his several visits to Venice (he was there again in 1900, 1901, and 1903-4) he produced a very large number of paintings. Although documentary evidence and dated works prove that almost all the Venetian figure subjects were executed on his last visit, the landscapes are not so readily datable. Stylistic analysis on its own is not enough to date them. It is unsafe to classify the Venetian landscapes as earlier or later works by making a simple distinction between the sketchily executed paintings, which are often limpid in texture and mood, limited in tonal range, and sometimes calligraphic in approach, and the more exciting fullness and richness of tone and colour found in other Venetian paintings. A picture of *The Doge's Palace* seen across the lagoon (Fig. 87) is an effective demonstration of how such a classification could break down. The horizontally banded composition, the thin fluid paint laid smoothly over a fine canvas, the vague blurred definition, the colours employed (grey-green water, sandy buildings, pale blue and violet sky), all point to a vivid memory of Whistler's methods and would seem to indicate a date at the very beginning of Sickert's first visit to Venice, even before he had developed the fine calligraphy with which he accented his thinly painted landscapes of this time. However, this painting is dated 1900 on the reverse.

Only one painting of Sickert's first visit to Venice is dated, a view of *The Dogana and the Salute* across the lagoon (Fig. 53), painted in 1896. However, documentary as opposed to stylistic evidence for attributing other pictures to this visit is obtained from the exhibition of Venetian landscapes at the N.E.A.C. between 1896 and his next visit to Venice, and from two letters which refer to the subjects on which he worked on this first visit. In the letter to Mrs. Humphrey, quoted above, he wrote of panels of St. Mark's façade and the Rialto. In the letter to Steer, quoted above, he wrote, 'It is mostly sunny and warmish and on cold days I do interiors of St. Mark's', and 'St. Mark's is engrossing, and the Ducal Palace, and 2 or 3 Renaissance gems, The Miracoli and S. Zaccharia and the Scuola di San Marco.'

The combined result of this evidence (taken together with a stylistic assessment of the works concerned) allows reasonable accuracy in attributing a considerable number of Sickert's extant Venetian landscapes to this visit. Among the most important are the many paintings on panel and on canvas of *The Rialto Bridge* (a pen drawing of this subject was also published in the *Savoy* in 1896[8]) and of *St. Mark's* (the Tate Gallery version was exhibited, under the title *Pax Tibi Marce Evangelista Meus*, at the N.E.A.C. in April 1897), always remembering that some versions of these subjects were probably painted after Sickert's return to London; and paintings of the *Interior of St. Mark's*, of *The Lion of St. Mark* (one version of this subject which also represents the Ducal Palace was exhibited at the N.E.A.C. in April 1896), and of the *Scuola di San Marco*. There are many paintings of the *Scuola di San Marco* and they are generally all dated *c*.1901. However, Sickert exhibited two pictures of this subject at the N.E.A.C. in 1896 under the perverse labels *Sirocco* (in April) and *From the hospital to the grave*, 'a pseudo-romantic title such as we generally associate with the provincial contributors to the Royal Academy'[9] (in November). The press descriptions of both these pictures identify their subject and suggest which of the extant versions of the *Scuola di San Marco* they might be (Fig. 54, C.83).

This list of the landscapes Sickert painted on, or as a result of, his first visit to Venice is not complete. It excludes many more pictures of miscellaneous subjects. Nevertheless, the number of motifs Sickert chose to study in Venice was relatively small. Instead he painted his favourite subjects, such as St. Mark's façade, again and again. Sickert's production of so many versions of a single subject was an aspect of his professionalism, and it remained characteristic of his work throughout his career. He developed the habit primarily in his landscape paintings, of Venice, Dieppe, and later Bath, but he was also to apply the same exhaustive treatment to his Venetian and Camden Town figure paintings

as well as to certain music hall subjects. In fact the first extensive series of pictures of a single subject is that of *The Gallery of the Old Bedford* painted from 1894 onwards.

Sickert's down-to-earth attitude to the production of paintings was initially inspired by Degas's example, but it is probable that the Impressionist series of pictures by Monet and Pissarro also influenced him. Indeed Sickert, on his way to Venice, may well have stopped in Paris to see the Monet exhibition at Durand-Ruel in May 1895, which included twenty paintings of Rouen Cathedral. Monet's series could have inspired him to tackle his own series of a great cathedral, St. Mark's. However, Sickert's motives were usually very different from those of the Impressionists. As he was to write much later in criticism of the Impressionists, 'The theory that it is the main business of an artist to paint half a dozen views of one object in different lights cannot be seriously maintained. It would be nearer the truth to say that the artist existed to disentangle from nature the illumination that brings out most clearly the character of each scene.'[10] His relative lack of concern with capturing transient light effects is most effectively demonstrated by his habit of painting from drawings and other documents in the studio. For Sickert the chief interest in painting was the handling of paint; having found a motif of sufficient interest it did not matter to him how often it was repeated, under the same light conditions, if it was primarily considered as an excuse for the act of painting itself, for the manipulation of style and for experiments in technique. A motif was dropped from his vocabulary only when it had been worked so hard as to cause staleness and uninspired repetitiveness in the handling of further reproductions.

St. Mark's was a marvellous subject for such repeated exercises. The fascinating variety of its silhouette, the constantly changing planes of its façade, and the richness of its colour, were all calculated to stimulate and preserve Sickert's interest. He evidently considered it of sufficient interest in itself to obviate the necessity of providing it with a context, unlike earlier painters of Venice who generally showed St. Mark's as seen across the Piazza. Nor did Sickert think it necessary to represent it through the medium of a complex composition. He met the subject full on; it spreads horizontally across the surface of his pictures which is just large enough to contain it and no more. This concentration, combined with Sickert's simplification of detail, of colour, and of tone, dignifies the subject and restores to St. Mark's its original character of a 'Byzantine goldsmith's casket on an Imperial scale'[11]. It also tones down the garishness of its Victorian embellishments, although possibly the splendid vulgarity of the glaring mosaics accounts for some of Sickert's fascination with the subject.

Stylistic distinctions must be used to separate the versions of *St. Mark's* probably executed while he was in Venice from those painted after his return to London. The former group (Fig. 52, C.82 and versions) are fluently painted in thin washes accented by crisp drawing with a fine pen or brush. Their sharp calligraphy, which gives them something of the quality of a tinted drawing, was perhaps employed to avoid any tendency towards Whistlerian vagueness of definition, particularly as the colours used (turquoise blues, purply-greys and pinks) in the two preparatory oil sketches (Fig. 51, C.81) and in one of the finished paintings (C.82, Version 1) are still reminiscent of Whistler. In another version known as *Red Sky at Night* (Fig. 52) an Impressionist inspiration behind Sickert's decision to paint the subject in a late summer evening light instead of in the crisp cool light of day must be considered. Nevertheless the illumination of Sickert's picture has none of the instantly perceived and swiftly translated naturalism of Impressionism. Its theatrical and almost arbitrary use of a rich, deep, glowing pink to irradiate the sky and suffuse the general colour harmony is highly conceptual. The picture represents the distilled essence of the drama of a Venetian twilight but is hardly credible as a detached record of one particular evening. In four more paintings of *St. Mark's* (Fig. 68, C.100 and versions) Sickert experimented in another direction with a technique specifically designed to emphasize, even exaggerate, the uncompromising rigidity of his composition and to give to his pictures an

unmistakably monumental character. These paintings were probably executed in London in 1896–7 and the large size of three of them supports this supposition[12]. The tonality of these pictures is sombre, the colours heavy and opaque, the paint surface is dense, the drawing explicitly stated in thick dark lines. There are, of course, minor variations in the handling of these four pictures. For example, the paint in the British Council version is less heavy than in the Tate or Leeds versions, and Sickert also modified the composition of this version, bringing the façade right up to the surface and cutting off the canvas at the top; this concentration on the close-up mass of St. Mark's, combined with the very sombre and gloomy tonality of the painting, projects a much more forbidding image of the basilica than do the other versions. The smaller version (private collection, Scotland) is painted more thinly to reveal traces of squaring. However, it is related, in its simplifications of the tonal pattern and consequent rejection of mobility and luminosity, to the static monumental character and the stylized pedantry of the larger pictures. The device, also employed in the Tate and Leeds pictures, of contrasting the sharp clarity of the building's contours with the blurred suggestion of moving figures in the foreground is carried even further here so that the figures resemble out-of-focus photographic images, indicating that photographic documents may indeed have been used in the production of these pictures.

The handling of the versions of *St. Mark's* painted in Venice was only one of many with which Sickert experimented on this visit. Monet's influence, already suggested as a possible source of inspiration for the conception of Sickert's series of pictures of *St. Mark's Façade*, is indicated in the handling of several of Sickert's Venetian scenes which include stretches of water. The light-toned pastel-like colour harmonies of, for example, one version of *The Rialto Bridge* (Fig. 55) and the dated *The Dogana and the Salute* (Fig. 53) are reminiscent of Monet's work of the 1880s, although the composition and handling of the latter picture, its streaky brushwork and wriggling reflections, also recall Whistler's Venetian paintings. Monet's influence is more explicit still in *Sailing Boats on the Grand Canal* (Fig. 57) and in a version of the *Scuola di San Marco* (C.83, Version 1); it is apparent in their brightly pretty, even lyrical, colour schemes full of blues, greens, violets, pale pinks and white, and above all in the way the paint is applied in feathery, separated, dashed strokes of the brush. In another version of *The Rialto Bridge* (Fig. 55, C.84, Version 3) the broken brushwork in blocks of cobalt and greens and white describing the disturbed surface of the canal recalls Monet's work of the early 1870s. Sickert had many opportunities to see Monet's work both in London and Paris and we can assume that he was familiar with examples from all periods. Apart from Monet's Durand-Ruel exhibition in Paris in 1895, which Sickert may or may not have seen, Monet had shown twenty paintings at Goupil's Gallery in London in 1889 and exhibited pictures with such English groups as the R.B.A. in 1887 and the N.E.A.C. in 1891.

The broken colour and brushwork used in painting the water of *The Rialto Bridge* (Version 3) is found again in two pictures of the *Lion of St. Mark* (Fig. 56, C.86). Both pictures are similar in their composition, colour scheme, and handling. The paint is smooth and fluid; it is applied in small touches as is demanded by the rich detailing of the architecture so that the effect is of a more broken and shimmering paint surface than ever before in Sickert's work. The Doge's Palace is painted in a sensitive and varied range of tones, quite unlike the simplified tonal oppositions found in most of Sickert's Venetian paintings of this visit. The varied tonal pattern is complemented by a fairly wide colour range; greys and buffs tinged with mauve, rose, and yellow ochre are used in the buildings, with the sharpest lines of drawing or shadow in black, while the water is painted in cobalt blues with some reflected greens and ochres. The swift, free brushwork, the tones, and the colours are all used constructively so that Sickert did not depend upon drawing to rediscover the form. In fact, the treatment of these two pictures reveals that Sickert possessed a much greater technical virtuosity than might have been supposed at this period, as well as considerable ability to vary and adapt his technique to the needs of his subject.

The constructive use of varied colour, tone, and brushwork which distinguishes the paintings of *The Lion of St. Mark* is also found in the *Interior of St. Mark's* (Fig. 59). In this picture Sickert did not attempt to define the detail or the textures—as he did in *The Lion of St. Mark*—but was content to give a sketchy impressionistic view of the vast interior which did not necessitate such controlled organization of the brushwork. An interesting comparison can be made with another church interior, *Gli Scalzi* (C.91), which we know was painted on or just after this visit to Venice because it was exhibited at the N.E.A.C. in November 1897 under the title *The Church of the Barefoot Friars*. The paint in *Gli Scalzi* is also loosely and sketchily applied, but the brushwork and colour do not themselves create the form. Instead they follow the drawing with pedantic faithfulness, filling in a niche with a patch of uniform dark here, outlining the edge of a pilaster or cornice with a strip of highlight or shadow there, and never breaking away from the known boundaries of the separate objects to convey a more subjective impression of the whole scene. The painting, in fact, adds nothing to the watercolour drawing on which it was probably based.

Because the *Interior of St. Mark's* is an interior subject and not a landscape, and indeed a subject of theatrical splendour, some comparison is possible with Sickert's most important recent pre-Venetian work, *The Gallery of the Old Bedford*. The free but meaningful juxtapositions of patches of paint, varied in tone and colour, and the colour harmony employed (dull ochres, yellow-greys tinged with olive green, enlivened by touches of sparkling gold) recall the London paintings.

The painterly handling of these pictures is probably that to which Sickert referred in his letter to Steer from Venice when he wrote:

> for all practical purposes the more experience I have, the more I find that the only things that seem to me to have a direct bearing on the practical purpose of painting my pictures are the things that I have learnt from you. To see the thing all at once. To work open and loose, freely, with a full brush and full colour. And to understand that when, with that full colour, the drawing has been got, the picture is done.[13]

It was characteristic of Sickert's gallantry to pay his correspondents handsome compliments; how far it is true that Steer's example was responsible for these qualities in Sickert's painting is thus uncertain. Steer's painting, from the later 1880s onwards, was much looser, freer, and more full of colour than Sickert's. His probable influence on *The Sisters Lloyd* has already been mentioned. Sickert's Old Bedford pictures of 1894–5 were, however, the earliest examples of the type of free fluent execution and constructive use of colour found in the *Interior of St. Mark's* and *The Lion of St. Mark*. Possibly Steer had something to do with Sickert's development of this handling, and perhaps his example also persuaded Sickert to adopt the Monet-type broken colour and brushwork used to paint the water in *The Lion of St. Mark* and *The Rialto Bridge*. It is, however, undeniable that only a few of Sickert's Venetian works of 1895–6 were painted in the manner he outlined to Steer. There is another example, a little panel of *The Doge's Palace and the Campanile* (Fig. 58), which is interesting in that it formerly belonged to Steer and may have been given or sold to him just because it demonstrated, on a small scale, the results of the lessons Sickert acknowledged he had learnt from Steer. The horizontal banded composition and the colours (a pale blue sky and purple tinged buildings) are Whistlerian. However, the definition has none of the watery vagueness of Whistler, nor is it graphically accented as in other Sickert panels of this visit to Venice. The definition depends on the open, free brushwork and the relatively full colour, and the subject has been seen 'all at once' in so far as the whole panel is uniformly treated with no part finished or emphasized more than another.

The range and variety of styles and handling employed by Sickert on this first visit to Venice may be explained as representing a series of experiments in different idioms designed to help him find the expression of his own particular talent in landscape painting. Paintings such as the dated *The Dogana*

and the Salute are still heavily dependent upon Whistler's influence in mood, composition, and treatment, but Sickert's deeply serious, almost pedantic attack upon *St. Mark's Façade*, the courageous *bravura* of *The Lion of St. Mark*, the lyrical impressionism of *Sailing Boats on the Grand Canal*, and the fresh ingenuity of the *Interior of St. Mark's*, all represent determined efforts by Sickert to see and describe Venice independently.

NOTES

1. Most writers have accepted Emmons's account of the duration of Sickert's first visit to Venice, p. 108.

2. From a letter quoted by Christopher Hassall, *Edward Marsh, Patron of the Arts*, London, Longman's, 1959, p. 59.

3. Letter quoted by Emmons, pp. 107–9. The reference to the Afghan, that is *Portrait of an Afghan Gentleman*, shown at the N.E.A.C. in November–December 1895 (24) proves the date of the letter. A postcard negotiating the sale of a panel of the *Dogana and Santa Maria della Salute* (catalogued C.80, Version 2) is indistinctly postmarked with a date in August 1895. It was sent from Venice to Miss Lillian Richardson by a mutual friend of artist and buyer and its content proves that Sickert was then in Venice but that he intended to come to England in September (the card offers Miss Richardson the alternative, to have Sickert send the panel at once or to wait until early September when Sickert could post the panel to her in England). Whether or not Sickert did return to England in September as planned is unknown, but he was certainly back in Venice a couple of months later when he wrote to Steer.

4. Letter in the collection of Whistleriana belonging to the Department of Fine Art, University of Glasgow.

5. See note 3.

6. The events leading to the breakdown of Sickert's marriage are recorded in the divorce proceedings in July 1899.

7. This letter concerns the disposal of Sickert's Robert Street studio; its place in the context of a series of letters to Mrs. Humphrey on similar matters indicates its date as 1899.

8. II, April 1896, p. 145 (whereabouts of original unknown).

9. The *Daily Telegraph*, 19 November 1896.

10. The *Burlington Magazine*, 43, July 1923, pp. 39–40, 'French Pictures at Messrs. Knoedler's Gallery'.

11. Sir Philip Hendy, unpublished MS. on Sickert.

12. The size is not conclusive evidence because Sickert in his painting school in Manchester in 1925 recalled that he 'had once set up Gargantuan canvases on the piazza before St. Mark's' (quoted by Malcolm Easton, 'Of Sickert and the North', essay printed as Appendix to Catalogue of Sickert exhibition held at the University of Hull, 1968, p. vii).

13. See note 3.

VI

1896–8. Portraits and Landscapes

SICKERT left Venice in May 1896 to join his wife in Switzerland. From there he may have gone to Dieppe, returned to London, or possibly stayed on with his wife in Fluellen until their final separation in September. If so their relationship does not seem to have encouraged his work, as no pictures of Swiss subjects by him are known except for a small watercolour, *The Skittle Alley, San Moritz* (C.103).

The next two years were, on the whole, unsettled and unhappy for Sickert. He was very short of money and forced to rely on his writing for newspapers and on his teaching—it was at this period that he collaborated with Miss Pash in running a painting school in Victoria Street—to earn money enough to continue working[1]. He was deeply distressed by the breakdown of his marriage and the impending scandal of his divorce; although his own unrepentant promiscuity had been the cause he was, rather perversely, gravely disturbed by its results. He wrote to William Rothenstein in 1899, 'My nerve is shaken and I am going through such a terrible time, the never-ending grind and agony of this loathsome divorce affair', and during the proceedings themselves he told Rothenstein, 'The tension of suspense is awful to me, for what I know *she* must be undergoing. I have really forgotten myself in the contemplation of the sufferings I have inflicted on that unhappy woman.' The lithography trial in 1897 contributed to his public humiliation[2]. At last his general sense of depression and disillusionment led him to try a change of scene. In the winter of 1898 he went to Dieppe and did not return to London again for nearly seven years.

The nature of Sickert's work from the time of his departure from Venice in 1896 until his move to Dieppe in 1898 is exceptionally difficult to chart. There are no dated paintings to help plot the chronology of this period, during which he indulged in stylistic experiments as wildly incongruous as the savagely rough *The Toast* (C.79) and the bright, slickly finished *The Pork Pie Hat* (Fig. 64). He also spent some time during these years painting larger versions of successful earlier compositions, notably *St. Mark's* (Fig. 68, C.100) and *The Old Bedford Gallery* (Figs. 46, 47, and C.78), in which his rest from problems of construction allowed him to make further stylistic experiments between these two extremes.

Apart from the Trelawny pictures the only major new compositions which can, with reasonable conviction, be attributed to this period are a small group of portraits and (with slightly less conviction) a group of night landscapes. If both the portraits and the night landscapes belong to the years between 1896 and 1898 nothing could better illustrate the wild fluctuations of Sickert's style at this time. In the portraits Sickert evolved a new approach to the realization of the human face based upon the independent and very personal structure of his brushwork: in the landscapes he virtually eradicated all trace of individuality from his handwriting and concentrated instead on the simplified statement of their designs and tonal patterns.

Sickert's portraits from 1896 to 1898 are among the finest of his whole career but, with typical

perversity, he was to announce in the winter of 1898 that portraits were not his line. In *Miss Heath* (Fig. 60) and his own *Self-Portrait* (Fig. 61), both admittedly small informal works, he rejected entirely the method of handling he had used earlier in the decade whereby his concern to catch a superficial likeness led him to draw the features in accents of highlight or shadow over a flat, almost uniform tonal field representing the head. In these later portraits of *c.*1896[3] he virtually neglected drawing as a means of definition and concentrated on constructing the volume of the head, its planes and angles, in separated, tonally distinct, block-like marks of the brush. The coarse fabric of the brushmarks creates a loosely webbed pattern with a positive enough texture and weave to constitute a pictorial reality of its own. The independent structure of this brushwork was probably initially inspired by French Impressionism; indeed it can be regarded as an extension of the more broken technique found in some of Sickert's Venetian pictures. However, in a sense it also anticipates a *Fauve facture*, as can be recognized more easily in the *Self-Portrait*, with its savage *bravura* of handling and characterization, than in the relatively pure and restrained *Miss Heath*. This development in Sickert's painting is especially remarkable in view of his training within the softly blended tonal tradition of Whistler, whereby the individual marks of the brush were so often deliberately smoothed away to preserve a calm, remote surface. It is, in fact, the vestiges of this training, the very low tonality and the rejection of bright colour (both portraits are near-monochrome studies) which disguise the daring, even prophetic quality of Sickert's handling.

Nevertheless, Sickert's pursuit of this method of handling to a conclusion led him away from the future extravagances of Fauvism. The half-length portrait of *Fred Winter* (Fig. 62) may be interpreted as the culmination of his portrait style of 1896–8. In this picture head and body are again constructed through the interwoven fabric of block strokes, but the brushwork is thoroughly controlled and self-contained. Moreover, discipline is explicitly asserted by the fine outline drawing used to accent and inform the painted structure, and no longer, as in the earlier portraits of this decade, to define.

The style and handling of these informal half-lengths was not Sickert's only approach to the painting of portraits at this time. The simple presentation of figure and background in his full-length study of Fred Winter, seated in profile on a chair (listed C.94), has distinct echoes of Whistler's portraits of his *Mother* and of *Carlyle*. It is also probable, but not certain, that the superbly achieved portrait of *Israel Zangwill* (Fig. 65) was painted during this period. The unusual conception of this portrait, with a figure set against an open-air landscape background, probably represented a conscious revival of the traditions of fifteenth-century Italian, particularly Venetian, portraiture. Sickert adopted this format rarely, but on each occasion he used a Venetian background[4]. The other examples, three portraits of *Mrs. Swinton* of 1905 and 1906 and a *Self-Portrait* drawing (Fig. 63) of 1897[5]—which perhaps reflects a lost painting—were certainly not painted in Venice, and although we do not know exactly when and where *Zangwill* was painted it too was probably not done in Venice. In each portrait the background resembles a theatrical backcloth rather than a convincing setting for the figure, and indeed the Zangwill background, if it represents the Venetian ghetto as is traditionally supposed, is inaccurately rendered[6]. The handling of the portrait, particularly of the face with its simplified tonal planes, may be seen as a distillation of the method used in *Fred Winter*. The background supports the figure and helps to transform the economically rendered portrait into an image of enduring dignity and monumentality.

The attribution of the night landscapes to the period between 1896 and 1898 must remain tentative until a dated example or documentary evidence is discovered. Sickert generally preferred to paint landscapes under the soft grey light of dusk but he did on occasion paint night landscapes, for instance *The Fair at Night* in 1902 (C.158) and *Sargent's Studio in the Rue Notre Dame des Champs, Paris*, probably in 1906 (Fig. 195). However, stylistically, the night landscapes under discussion—the Venetian scenes,

the *Fondamenta del Malconton* (Fig. 66) and the *Ponte della Guglie sul Cannaregio* (C.90)[7]; a Dieppe subject, the *Quai Duquesne and the Rue Notre Dame* (Fig. 70), and the London scenes, *Cumberland Market* (Fig. 71, C.101) and nearby *Munster Square* (C.104), form a distinct self-contained group. The general basis of their stylistic character, that is, the over-riding importance of their designs projected through the forceful statement of their simplified tonal patterns conveyed in a flat, tight, impersonal manner of handling, was a recurrent feature of Sickert's work. From time to time, notably in his Dieppe landscapes of 1902, it seems that Sickert used this type of execution and constructive pattern-making as a deliberate refuge from the problems of working within an increasingly free and expressive idiom. Nevertheless, Sickert's 1902 landscapes were not carried off in quite so deadpan a manner as were the night landscapes; neither their execution nor the statement of their designs has the almost primitive simplicity and directness of this group of night subjects. *The Pork Pie Hat* and some versions of *The Bedford Gallery* subject (Fig. 47 and C.78) prove that Sickert could and did experiment with an exaggeratedly tight, flat (although also highly coloured) handling in about 1898, and the larger versions of *St. Mark's Façade* suggest that this sort of execution was an active alternative to the freely expressive idiom seen in Sickert's portraits between 1896 and 1898. The most conclusive reason for dating the night landscapes to this period is the different subjects they represent. The only time when Sickert was in Venice, Dieppe, and London all within a short time of each other was before or after his first visit to Venice of 1895–6. On the whole, the London landscapes—subjects from the Cumberland Market area where Sickert had his Robert Street studio from the winter of 1894 until 1898—and the Dieppe example are more likely to have followed than to have preceded the Venetian visit.

These night landscapes may have been a deliberate challenge to Whistler's nocturnes. Instead of treating his subjects impressionistically and romantically, as did Whistler, Sickert carried through his night pieces in an absolutely deadpan and prosaic manner. The darkness, instead of enveloping and blurring the individual forms, reduces each object to a clearly defined silhouette. The lighting effects, instead of being haphazard and muted, are concentrated with geometrical severity and throw separate shapes—the wall of a building here, a pavement there—into sharp relief. Sickert's nocturnes are almost crudely dramatic where Whistler's were poetically romantic. Nevertheless, the masterly reduction and simplification of the tonal values and the complete understanding of their mutual relationships make Sickert's vivid and curious images of urban night scenes just as satisfying and, in a sense, more realistic than Whistler's.

NOTES

1. He had to refuse an appeal from Miss Pash to help Holloway, a former disciple of Whistler, who eventually died in penury in 1897, saying he himself had 'nothing just now but my landlady's credit' (letter in the Islington Public Libraries Collection). The uncharacteristic *Vanity Fair* caricatures of 1897 were probably undertaken, like his writings for newspapers such as the *Sun*, to eke out a living. But, as he told Miss Pash, 'My papers delay paying'.

2. See Chapter IV, note 5.

3. See catalogue note for a discussion of the chronological problem.

4. The examples of portraits against non-Venetian open-air backgrounds painted much later in his career belong to a different category of his work, as they were derived from newspaper photographs or Victorian black-and-white illustrations.

5. The *Self-Portrait* drawing was published in *The Year's Art, 1898*, Nineteenth Annual Issue. 'A concise Epitome of all matters relating to the arts of Painting, Sculpture, and Architecture and to Schools of Design, which have occurred during the year 1897, together with information respecting the events of the year 1898.' Compiled by A. C. R. Carter, London, Virtue, 1898. Rep. facing p. 132. This drawing in its use of a profile pose and an architectural background is closer to the portrait of Zangwill than are the Swinton portraits with their near-frontal representation against a lagoon background.

6. Pointed out by R. Pickvance, *The Listener*, 24 August 1961, pp. 281–2 (letter). This letter is one of a series published in *The Listener* following Michael Ayrton's broadcast talk on the *Portrait of Zangwill* published in *The Listener*, 18 May 1961, pp. 868–70. I have since revised my opinion, expressed in this correspondence (27 July), that the portrait was painted *c.*1903–4.

7. Neither of these subjects is a well-known Venetian landmark, and in this they are uncharacteristic of Sickert's Venetian work of 1895–6.

VII

1898–1900. Dieppe Landscapes

I N the winter of 1898 Sickert went to Dieppe and did not return to live in London until 1905. Sickert's removal to Dieppe is traditionally supposed to have followed—and been caused by—his divorce. However, although his decision to break off ties with London by giving up his studio in Robert Street was not finalized until after the decree was granted in July 1899, Sickert had by then already been living in Dieppe for at least nine months[1]. The impending divorce no doubt contributed to his general sense of depression in 1898 with life and work in London ('I cannot stand another winter in London. It is too dark and life is too short'[2]), but his chief motive for leaving was that he felt the need for a change of subject matter. London, to Sickert, meant figure work, in particular portrait painting. But Sickert was evidently tired of portraits. He wrote from Dieppe early in 1899[3], 'I see my line. *Not portraits*. Picturesque work', and later in the year[4] he explained, 'Except for portraits there is not light enough in London. For my style of work that is, from drawings.'

By 'picturesque work' Sickert meant landscape painting and his move to Dieppe heralded a period of intense and prolific activity in this field. His concentration on landscape painting was almost exclusive until, on his last visit to Venice in 1903–4, he suddenly became absorbed in figure work. On earlier Venetian visits in 1900 and 1901, and in Dieppe from 1898 until 1903, Sickert's interest in landscape was only very occasionally interrupted by portrait painting or drawing and, in 1902, by a small series of drawings of the nude (Figs. 98, 104, 101, C.142–7).

Sickert's choice of the word 'picturesque' to describe his Dieppe landscape work is curious; the adjective, with its eighteenth-century connotations, suggests romantic or rugged pastoral scenes rather than Sickert's pictures of an urban environment. The informal naturalism of Sickert's Dieppe subjects and compositions (which depended upon the pioneering example of Impressionism) seems to be the opposite of picturesque artificiality. Sickert may be called the topographer of Dieppe. Although many painters came and worked in Dieppe, particularly in the summer months, few studied its architecture with the concentration of Sickert. As Blanche wrote, 'No other artist has so perfectly felt and expressed the character of the town, whose Canaletto he has become'[5]. Sickert's pictures of Dieppe's waterfront, streets, churches, and old houses constitute an enduring and reliable record of its aspect. Sickert wrote to Mrs. Humphrey[6], 'this place Dieppe, is my only up to now, goldmine, and I must work it a bit till I can get a little decent comfort'. There is a singular lack of romantic sensibility in Sickert's use of this mining metaphor to describe his approach to the painting of Dieppe. Indeed, Sickert's pictures of Dieppe do not even possess the grandeur of many of his Venetian landscapes. In Venice Sickert's main subjects, St. Mark's and its Piazza, the Salute, the Rialto, and the Lagoon, belong to the category of what Sickert later called 'August-site motifs'[7]. In the old and crumbling town of Dieppe there were no such sites. Even its main church, St. Jacques, hemmed in by crooked narrow streets often filled with market stalls, has a relatively humble domestic character. Sickert's

subjects in Dieppe were not august sites but ordinary shabby streets and houses, which foreshadow his later bias as a figure painter towards ordinary shabby people and rooms rather than towards what he was later to call the 'smartened-up-young-person motif'[8].

When Sickert moved to Dieppe he recast his handling as regards landscape painting. Having exhausted his Venetian repertoire, which had probably in some measure restrained his technical and stylistic development in this area of his work, it is as if he stood back and rethought his approach to landscape. Most of the landscapes of this Dieppe period reveal a much greater freedom in the application of the paint compared with the tightly organized Venetian and night landscapes of 1896–8. Sickert's strong tonal contrasts remain but they are often more fluctuating. Drawing in loose, open lines of black is used, but this drawing is no longer precise, restrictive, and containing in function; it is not the basis of the description but is used to accent and enliven the surface of the picture. The general quality of the handling of these landscapes is closer to that of Sickert's 1896–8 portraits than to his former landscape work.

Although there are variations in Sickert's handling from year to year, and within each year, there is an overall stylistic similarity between his landscapes of the whole Dieppe period which makes an accurate chronology of his work at this time difficult. This difficulty is aggravated by the uneven distribution of dated paintings which has tended to distort a just evaluation of his yearly production. The fortuitous preponderance of pictures dated 1900 has led to nearly all the extant undated pictures similar to them in handling (including paintings derived from dated drawings of 1899) being assigned to the same year. Such a weighted chronology ignores the fact that Sickert could have developed the handling found in the 1900 pictures at an earlier date.

Descriptions in the newspapers of the two Dieppe landscapes Sickert showed at the N.E.A.C. in the winter of 1898, *The Rag Fair* and *The Sea Front*[9], suggest that by 1898 he had indeed already developed the essentials of the style and handling characteristic of his 1900 pictures. The press reviews describe neither picture fully enough to permit their definite identification with any known painting but they do suggest the possibilities (and in my opinion probabilities) that *The Rag Fair* is *The Flower Market* (Fig. 74) and *The Sea Front* is *Les Arcades et la Darse* (Fig. 75). Even if these identifications are mistaken the reviewers' comments indicate that the pictures exhibited in 1898 were similar in general appearance and style to paintings usually dated 1900. *The Rag Fair* was 'a study of an architectural scene, broadly treated and low in tone, and in a subtle grey colour-scheme'[10]: it was of 'blue-black tonality'[11]: it was 'vigorous and artistic' although 'the grey sky' was 'too flat and curtain like'[12]. *The Sea Front* possessed 'striking effects of tone and colour'[13] and 'audacious truthfulness of illumination'[14], which another critic less flatteringly found coarse and crude[15]. These qualities, broad handling, blue-black tonalities, the use of grey as the dominant colour, curtain-like skies, and dramatic and fluctuating light effects, are all typical of Sickert's landscape style throughout this Dieppe period, but particularly from 1898 to 1900.

The broad handling and grey-based colour schemes are found in the only dated Dieppe landscape of 1898, *Une Rue à Dieppe* (Fig. 69), although the unusual composition of this picture—a very close view of the junction of two streets—sets it somewhat apart from Sickert's other landscapes of this time, and dictated a rather less dramatic stylistic approach. All the qualities listed above, as well as the use of free, loose drawing in black, are found in most of the many versions Sickert painted in 1899 and 1900 of his favourite Dieppe subjects. The scenes he painted most often were the Hôtel Royal, the statue of Admiral Duquesne, the Rue Notre Dame running off the arcaded Quai Duquesne, La Rue Ste. Catherine and the Halle au Lin, and of course many aspects of the main church of Dieppe, St. Jacques, its west façade, its south front seen direct and down the Rue Pecquet, and countless glimpses of odd corners of its crumbling stone walls.

The informal naturalism of the compositions and subject matter of these Dieppe scenes has already been noted but a study of Sickert's approach to their representation helps to elucidate what he may have implied when he wrote of his intention to do 'picturesque work'. Firstly he may have meant that his subjects, the higgledy-piggledy conglomeration of streets and buildings of old Dieppe, were quaint; indeed he often deliberately encouraged and emphasized their picturesque quaintness by darkly silhouetting the intricate patterns of their jumbled architecture against the backcloth of flat, opaque, unrealistically vivid skies. But it is also possible that he used the word picturesque with its literal as well as its common meaning in mind. The skies are only one aspect of Sickert's deliberate use of artifice in his presentation of these pictures. The dramatic simplification of their tone and colour schemes and the casual offhand character of their handling are contrived for their aesthetic rather than their representational advantages; they help to express the mood, tempo, and rhythm rather than the definition of his subjects.

In spite of their overall stylistic similarity there are many minor variations in the individual treatment of Sickert's landscapes of 1899 and 1900. The paint is applied sometimes more, sometimes less, freely; drawing is more or less extensively used and is sometimes sharper, sometimes clumsier in quality; the highlights are sometimes fitfully scattered over the surface of the picture and sometimes concentrated into larger, more contained areas. For example, the extremely loose, fluid application of the paint, and the scattered dispersal of the highlights, in the dated version of *Le Grand Duquesne* of 1900 (Fig. 77) and in *The South Façade of St. Jacques* (Fig. 82) give these paintings a quality of fragile mobility different from the solid monumentality of *La Halle au Lin* (Fig. 88), with its more heavily applied paint and fewer, larger, more concentrated areas of highlight. The handling of the *Hôtel Royal* paintings (Fig. 80, C.110) and of the *Boulevard Aguado* (C.125)—which is related to the former subject in location, in its diagonally orientated composition[16], and in its treatment—is broader and clumsier than in any of the other Dieppe subjects. This very broad and clumsy handling is, however, found in another picture of this period, *Le Petit Trianon* (Fig. 73)—a Paris subject probably painted in July 1899 when Sickert visited Versailles and must have painted *Le Grand Trianon*[17]. *Le Grand Trianon* is now untraced, but when Sickert showed it at the N.E.A.C. in the winter of 1899 a critic described it as 'wilfully aggressive' and added that Sickert's pictures 'always seem to be thrown at the heads of a philistine public, as according to Mr. Ruskin, Mr. Whistler's paint-pot once was'[18].

Writing to Mrs. Humphrey from Dieppe in 1900 or 1901[19] Sickert outlined, in the form of advice to a fellow painter, what was probably his own technique at that time:

> Don't try and make too *certain* in painting. Go *loosely* and *lightly* and *quickly*, and don't tell *any* of the painters what I tell you.
> (i) Prepare a canvas grey.
> (ii) When it is dry varnish it with *vernis Vibert à retoucher* and let it dry.
> (iii) Sketch loosely with very thin black lines and turpentine and paint in shadows the transparent darks that they are all first then lights. Try to finish in one sitting if you can.
> (iv) Get a strong concentrated light like a Hals or Reynolds or Raeburn.

This recipe is perhaps not exactly the one Sickert used in all the paintings mentioned above of 1898–1900 but it must reflect the general basis of his procedure at this time. The grey ground to impart a sombre glow to the tones and colours, the varnish to encourage the glossy texture of the paint surface, the strong concentrated light to create the emphatic effects of illumination, and of course the loose drawing and the open painting, are essential to the treatment of them all. It is also interesting that Sickert wrote of trying to finish in one sitting, a regressive step as far as his own technical development is concerned, but perhaps suited to his current desire to achieve directness and spontaneity in the handling of these paintings.

It is also possible that French Impressionism was again in Sickert's mind at this time. Although the general basis of his method of painting from drawings in the studio was the reverse of Impressionist practice, Impressionism may have influenced details of his technique such as the independent structure of his brushwork and his attempt to work so swiftly. Certainly a French Impressionist inspiration behind Sickert's habit of producing repeated variations of a single subject is more clearly indicated in his Dieppe pictures, particularly in his long series of paintings of the *St. Jacques Façade*, than it was in the series of *St. Mark's*. In his paintings of *St. Jacques* Sickert's interest was definitely directed towards the expression of the scene under different effects of light. He painted it in sunlight (e.g. C.118, Canvas Version 3) and on gloomy grey days (e.g. C.118, Canvas Version 7): he painted it by moonlight (C.118, Canvas Version 1): he painted it with a brilliant light catching its upper façade (Fig. 85): and again caught in the rosy glow of a vivid setting sun (C.118, Canvas Version 2). However, Sickert's Impressionism, even in the most dramatically illuminated of these versions of *St. Jacques*, remained almost entirely tonal and thus essentially within the Whistlerian tradition; it largely rejected the French Impressionist approach to the expression of light through colour.

Although the kind of technique Sickert described to Mrs. Humphrey was evidently the basis of the majority of his paintings of 1898 to 1900, this technique was not the only one he employed during this time. For example, *La Rue Pecquet* (Fig. 81), a painting dated with unusual precision 'le 5 novembre 1900', is treated with more restraint than was usual in this period. The brushwork is more tightly organized with the strokes more smoothly blended, and the separate areas of different tone and colour are juxtaposed more cleanly and tidily. The comparatively tight, clean handling of *La Rue Pecquet* is also found in the versions of *La Maison qui fait le Coin* (Fig. 72, C.108), one of which—the most freely treated—is dated 1899. As in *La Rue Pecquet* Sickert retained the glossy surface, the dramatic silhouetting of dark buildings against a flat, opaque sky, and the strong light and shade effects typical of his landscapes at this period, while sharpening and tightening his definition. A more extreme form of this type of handling is seen in *Le Grand Duquesne*, painted c.1899 (Fig. 78). The outlines of the severely rectilinear composition are defined with an exact straightness from which only the swaggering silhouette of the statue is free. The few linear accents have the sharpness of a pen drawing. The brushwork is smoothly blended to create a flat, even surface. The colour range is quite wide and each unit of the composition is painted in cleanly differentiated areas of simplified tone and colour. For example, the house behind the statue is yellow, with a pink border around the windows and a pinky-brown roof; its neighbour on the left is stone-coloured with a violet roof. Each unit of the composition is thus completely self-contained in outline, colour, and tone. The disparate elements of the picture are integrated by the uniformity of the smooth surface texture, by balancing the colours (for instance the violet horizon on the right echoes the violet roof on the left) and by the exact grading and relating of the tones to conform to a scale governing the whole painting. The handling of this landscape is, in fact, more closely related to Sickert's small group of flat, decorative, brightly coloured music hall paintings of 1898, and, except for the importance of local colour, to the night landscapes of 1896–8, than to his Dieppe work of 1898 to 1900.

The handling of *Le Grand Duquesne* can be regarded as a survival into 1899 of one of Sickert's pre-Dieppe methods and styles of painting. It thus represents a temporary reversion from his usual treatment, rather than a new development disturbing the overall consistent pattern of the technical and stylistic character of his work at this time. However, in 1900, as can be seen in *Les Arcades de la Bourse* (Fig. 90), Sickert did begin to evolve a new method of treating landscape. The colours of this picture are much the same as those found in the other paintings of 1900, maroon, ochres, black, and grey, and the tonality is similarly sombre; but the strongly stated tonal contrasts are now missing. There is almost no drawing as such, although some thick smudged strips of black shadow help to indicate the

architecture. The paint itself is substantial, sometimes impasted, and it is coarse and rather dry in texture, quite unlike the thin, smooth, glossy paint found in the other landscapes of 1898–1900. The handling, although sketchy, is not fluent; the paint is applied in squarish dabs rather than sweeping longer strokes. In *Les Vieux Arcades, La Rue Ste. Catherine* (listed under C.124) Sickert again used more substantial, grainy-textured, rather dry paint, applied in squarish dabs although in some passages (notably the pavement) he floated the paint across the canvas in a manner reminiscent of his earlier Whistlerian painting. In 1900 Sickert went to Venice and when on his return he resumed painting Dieppe landscapes he was to develop both these methods of treatment, the smooth, glossy-textured, dramatically illuminated method found in the majority of his pre-Venetian pictures and the rougher, more broken, and less emphatically stated method with which he had experimented in a few paintings of 1900.

There is one further aspect of Sickert's work in Dieppe, before he went to Venice, which needs some explanation. In 1899 and 1900 he made a large number of drawings of his favourite landscape subjects which are unusual in that they are highly finished, coloured, and obviously not intended as working documents for paintings done in the studio. Their lack of *pentimenti*, their finish, as well as the multiplicity of almost identical versions of the same subject, clearly distinguish them from working drawings, although probably all these coloured drawings reflect compositions Sickert studied in paintings[20]. Some are drawn in charcoal and tinted with wash, others are drawn in pastel, a few in pen and wash, or pen and pastel, or pastel and wash. It is probable that when working on a subject for a painting Sickert capitalized on his effort by executing such coloured drawings at the same time from the same preliminary documents. For instance, only about half of the many drawings of the *St. Jacques Façade* were executed as preparatory studies for the paintings (Fig. 84, C.119). The rest of the drawings, all of them coloured (Fig. 86, C.120), are themselves derived from the squared preparatory drawings rather than from direct reference to the subject. Indeed, the soft rubbed quality of the outline drawing in some of these coloured versions suggests that Sickert traced them.

Letters written in 1899 by Sickert to William Rothenstein, who was then working for the Carfax Gallery which dealt in Sickert's production, explain these drawings as inspired by purely commercial motives. At first, in the spring of 1899[21], he wrote to Rothenstein of his intention to concentrate on small panels and asked if Carfax would be interested in 'a small picture about 8 or 9 inches square . . . I have an idea of things at £10 or £15 about that size . . . I don't think I should do drawings that would sell. Might I make small panels fulfil somewhat the function that drawings do to others, to get, as it were an occasional fiver or tenner by?' Further letters prove that Sickert followed up this idea and sent Rothenstein several panels, but by August he had already changed his mind about his inability to produce saleable drawings. He told Rothenstein how he had been encouraged by Brown of the Fine Art Society who came to Dieppe and advised him that 'watercolours sold always like fire'[22]. Sickert reported that Brown might arrange to show a little group of such drawings, and a little later that Brown 'has now 4 tinted drawings of mine out of a group of 6 which I propose that they should exhibit'[23]. Sickert also told Jacques-Émile Blanche of his new activity when he wrote that 'Mr. Brown of the Fine Art Society (best *shop* in London) has taken away on the steamer two charcoal drawings tinted with watercolour to show the manager and discuss an exhibition of 12 or 20 similar ones'[24].

These tinted drawings are uncharacteristic of Sickert's graphic work in their treatment, their quality, indeed their whole conception. Their tidy prettiness is alien to Sickert's style of drawing which was more usually informed by his urgent quest for visual information. But he did not disdain their execution. His assurance by a dealer that they would sell easily and profitably was sufficient reason for him to undertake their manufacture. They take their place as part of his plan to work 'his

goldmine' Dieppe. It was not until 1900 that he felt he could interrupt this endeavour and leave to find fresh inspiration in Venice.

NOTES

1. Letters from a series written to Mrs. Humphrey (née Pash, married 1898) prove that Sickert spent the entire winter of 1898 in Dieppe. The different addresses of the letters help to date them. (i) 1 Rue de l'Hôtel de Ville (Sickert's address as listed in the winter 1898 N.E.A.C. catalogue): Sickert considered himself 'settled half here and half at Robert Street'. (ii) 9 Quai Henri IV (Sickert's address as listed in the spring 1899 N.E.A.C. catalogue): Sickert asked Mrs. Humphrey to tell enquiring creditors that he would be over to London in the spring but that he 'had to borrow money to get abroad . . . so that you may realize it isn't want of desire to come to London that restrains me'. He wrote also of his hesitation about keeping Robert Street: 'If I made a little money I would keep it. If I don't I must give it up as I shan't do much work there. . . . I should like to keep Robert Street if I did any selling at all to bring pictures to and show them in.' Evidently Sickert did not get to London in the spring because his letters to Mrs. Humphrey, arranging the disposal of his effects, indicate that he did not personally supervise his removal. He did make a trip to Newhaven, 'on affairs' as he told William Rothenstein in a letter, in fact to furnish evidence of his adultery with an unnamed woman in a Newhaven hotel to be cited in his divorce action against him because he did not want his Dieppe mistress involved. (iii) Maison Villain (Mme Villain's house in Neuville where he lived only after his divorce was decreed in July 1899): he wrote, 'No I am decided to give up Robert Street'. This marked his final break with London. Robert Street, still listed as an alternative to his Dieppe address in the spring 1899 N.E.A.C. catalogue, was omitted from the winter catalogue. Nevertheless, Sickert's voluntary exile from London between 1898 and 1905 was not as total as is generally supposed. In a letter to Mrs. Hulton of February or March 1903 (letter dated Chapter II, note 15) he mentioned visiting London the previous Christmas (that is 1902) when he went with his ex-wife to an exhibition at Agnew's where they met Whistler.

2. Letter (i), note 1.
3. Letter (ii), note 1.
4. Letter (iii), note 1.
5. *Portraits of a Lifetime*, p. 45.
6. Letter (ii), note 1.
7. The *New Age*, 2 June 1910, 'The New English—and After'.
8. Ibid.

9. These pictures were the first Dieppe landscapes Sickert had shown at the N.E.A.C. since 1894.
10. *St. James Gazette*, 21 November 1898.
11. The *Saturday Review*, 19 November 1898.
12. The *Daily Telegraph*, 17 November 1898.
13. The *Saturday Review*, 19 November 1898.
14. The *Daily Telegraph*, 17 November 1898.
15. *Athenaeum*, 26 November 1898.
16. Most of Sickert's Dieppe townscapes of this period were composed as planar arrangements parallel to the picture surface but in a few pictures he preferred a diagonally receding construction used not only in the *Hôtel Royal* and *Boulevard Aguado* pictures (Fig. 80, C.110 and C.125) but also in *The South Façade of St. Jacques* (Fig. 82) and *Les Arcades de la Poissonnerie* (C.123).
17. Sickert's visit to Versailles is documented by a letter to William Rothenstein: 'We went to Versailles yesterday. Blanche said Aubrey adored the Grand Trianon which I can imagine.' The letter (and thus Sickert's visit) can be dated from references to going to the *Vente* Chocquet, which took place on 1, 2, 3 July 1899.
18. *Truth*, 25 November 1899.
19. The only clue to the date of this letter is the address, 38 Rue Aguado, used by Sickert in 1900 and 1901.
20. Examples of the coloured drawings are listed in the catalogue under the related paintings. There are some coloured drawings of subjects not known in any extant painting, *Le Vieux Château* (C.127) and *La Place du Moulin à Vent* (C.126)—a little known square behind Dieppe harbour. Sickert exhibited a painting of the *Place du Moulin à Vent* at the N.E.A.C. in the winter of 1900 and it is reasonable to suppose that the coloured drawings reflect the composition of this painting (indeed one of these drawings may have been a preliminary document for the painting as it is squared). It is probable that there is also an untraced painting of *Le Vieux Château*.
21. Letter dated from Sickert's reference to booking a room in a Dieppe hotel for the Rothensteins' honeymoon following their marriage in spring 1899.
22. Letter written shortly after Sickert's divorce in July 1899.
23. Letter probably written about August 1899 because of its relationship to the letter dated in note 22. Both these letters were sent to Vattetot where the newly married Rothensteins spent the summer of 1899.
24. Letter dated 1899 because of references to the Dreyfus trial.

1900 and 1901. Visits to Venice

SICKERT's so-called 'second visit' to Venice, which is traditionally supposed to have lasted about eight months over the winter of 1900–1[1], was probably two different visits separated by a return to France. Letters Sickert wrote to William Rothenstein indicate that he was indeed in Venice during this winter but that he did not arrive there until shortly after the start of the new year, 1901[2]. The volume of work he produced in Venice, which includes three dated paintings and three dated drawings[3], suggests that Sickert then stayed a considerable time, perhaps the full eight months until August[4]. However, Sickert must also have been in Venice the previous year because there are two Venetian pictures dated 1900[5], and because Sickert showed a painting with the apparently Venetian title *Maria Bionda* at the N.E.A.C., winter 1900 (11), as well as a drawing of the same name at his exhibition at Durand-Ruel in December 1900 (43)[6]. Maria Bionda was the name of one of Sickert's Venetian models but the only extant picture of this girl (Fig. 126) must, for stylistic reasons, have been executed on Sickert's last visit to Venice of 1903–4. Nevertheless, the untraced painting and drawing called *Maria Bionda* may have represented a rare and premature excursion by Sickert into the realm of figure painting before his last visit to Venice, and in any event it surely represented an Italian subject of recent execution (that is, not a work of 1895–6). The only hypothesis which fits the few facts known about Sickert's stay in Venice in 1900–1 is that he went there, probably for a short time only, in 1900 but returned to France in the autumn. We know, for instance, that he was in Dieppe in November from the painting of *La Rue Pecquet* (Fig. 81) dated 'le 5 Novembre 1900'. Possibly Sickert cut short his Venetian visit in 1900 in order to arrange and view his first important one-man exhibition in Paris, held at Durand-Ruel, 6–22 December[7]. After this exhibition he went back to Venice to resume the work which his abbreviated visit in 1900 had not given him time to tackle.

The paintings Sickert executed in Venice in 1900 and 1901 can be broadly defined as falling into two distinct stylistic groups. In the landscapes of one group the paint is applied more lightly, fluently, and loosely than in the other group—in which the paint is not only heavier and more opaque but also has a drier and coarser consistency. The tonal contrasts of the first group are strong, and the pattern emphatic, but the opposition of light and shade is not as sudden and exaggerated as it often is in the second group. The drawn accents of the first group are sharper and finer than those of the other group —in which they are not only thicker and heavier but less frequently employed. The overall tonality of the paintings in the first group is lighter and the colours used are brighter and prettier (with much use of pale blue and pinky-buff); the more sombre tonality of the paintings in the second group is complemented by the use of more brilliant and resonant colours (especially a glowing green and a deep purple).

The fact that Sickert made two separate visits to Venice in 1900 and 1901 is probably relevant to these stylistic distinctions. The general quality of the paint and handling (although not of the colour

and tonal schemes) found in the first group of Venetian paintings is more closely related to Sickert's Dieppe landscape work of 1898–1900, whereas the same qualities in the second group, particularly the drier, coarser paint texture and the rough execution, were anticipated in just a few Dieppe paintings of 1900, such as *Les Arcades de la Bourse* (Fig. 90), which may, in fact, have been painted after Sickert's brief visit to Venice in 1900. These relationships to Sickert's Dieppe work permit the tentative assumption that the paintings of the first group belong to his visit of 1900 and those of the second group to the later visit of 1901 when Sickert began to develop the new manner with which he had recently experimented in Dieppe. Certainly the two dated Venetian paintings of 1900, *The Doge's Palace* (Fig. 87) and *The Piazza San Marco* (Fig. 89), are handled in the first manner, and one of the two dated Venetian landscape paintings of 1901, *The Horses of St. Mark's* (Fig. 93), is handled in the second. The other dated Venetian landscape painting of 1901, *St. Mark's* (Fig. 92), is one of several exceptions to the bipartite grouping of Sickert's Venetian landscapes. In this picture Sickert combined the coarser paint and heavier application typical of the second group with the lighter tonality and brighter colours typical of the first group.

The mundane facts of the times of Sickert's two separate visits to Venice may have influenced his style and handling. In 1900 Sickert was probably in Venice during the summer and the manner of painting used in the first group is suited to the representation of sunlit effects. In 1901 he was there for the winter as well as the summer and his second manner of painting was better calculated to convey the gloomy effects of the short winter days. It is possible that pictures like *St. Mark's* (Fig. 92) and *The Scuola di San Marco* (C.141), in which he combined these two manners, were painted in the summer of 1901.

As usual Sickert's output in Venice was large but the number of subjects he studied relatively small. He painted a few less well-known churches such as *San Barnaba* (C.139) and *Santa Maria Formosa* (Fig. 91), and odd corners of Venice such as *The Bridge of Sighs* (Fig. 95) and the *Ponte della Paglia* (C.140), but his main subjects, each painted in many versions, were the *Piazza San Marco* (Fig. 89, C.130), the *Doge's Palace and the Campanile* (Fig. 87 and Fig. 99, C.138), *Santa Maria della Salute* (Fig. 94, C.134; Fig. 96, C.135), and aspects of *St. Mark's* (Fig. 92, C.132; Fig. 93, C.133). There is a certain difference in the type of views Sickert represented in Venice in 1900 and 1901 as compared with those of his earlier visit. In 1895–6 nearly all his pictures were what may be called panoramic landscapes, wide-sweeping views of the Venetian scene such as Canaletto, Guardi, and later Turner and Whistler had painted. Even when he painted the façade of St. Mark's divorced from its spatial context he drew it with calligraphic precision as if it were itself a vast, infinitely varied panorama. The panoramic tradition for representing Venice was so strong that it must have been difficult for an artist approaching Venice for the first time to see, let alone paint, its architecture in an independent manner. On Sickert's later visits to Venice he continued to paint such panoramas, *San Giorgio Maggiore* (Fig. 97), the *Doge's Palace and Campanile* (Figs. 87, 99), the *Piazza di San Marco* (Fig. 89), and *Santa Maria Formosa* seen across its spacious square (Fig. 91). However, he also frequently studied much smaller segments of the Venetian scene and his architectural subjects often seem to have been deliberately chosen for their pronounced effects of sculptural plasticity and movement. In these closer, more concentrated views of Venetian landmarks he sought to render the richly complex massing of solid surfaces instead of giving a two-dimensional, calligraphically conceived map of their lines and planes. For instance, instead of giving the whole panorama of the façade of St. Mark's as in 1895–6 he chose to paint isolated fragments, the splendidly dramatic bronze horses beneath the central lunette flanked by intricate pinnacles (Fig. 93, C.133), or the north-west corner of the façade (Fig. 92, C. 132). In the same way, whereas in 1896 he had painted the Guardi-like view of *Santa Maria della Salute* as an incident in the mid-ground horizon seen across a deep stretch of the lagoon (Fig. 53), in 1901 he came right up

and under the church to paint it rising up out of the water like a massive piece of organic sculpture (Fig. 94, C.134). An even closer, more overwhelming view of this church is given in the two versions of *The Steps of the Salute* (Fig. 96, C.135), showing only a part of the lower storey, in which the baroque plasticity of the architecture is further emphasized by its contrast to the severe rectilinear shapes of the Dogana and the steps themselves. The handling of these paintings, with their heavy paint, thick drawing, gloomy tones, and resonant colours, contributes powerfully to the representation of the sculptural character of the Salute. Indeed, Sickert used this type of handling in most of his pictures of closely-viewed subjects, including less grandiose scenes like *The Bridge of Sighs* (Fig. 95) and the *Ponte della Paglia* (C.140). The deep purple used in the shadows, the flat and sudden oppositions of dark and light tones, the rich painterly treatment of such passages as the sculptured ornament of the buildings which suggests but does not explicitly define the forms, give these pictures an impressively monumental character.

It is probable that Sickert felt encouraged to develop and use this heavier handling in 1901 precisely because it was suited to translate such richly plastic effects as the solid massed forms of baroque Venice or the ornate splendour of St. Mark's. Too light a touch, too crisp a definition, could have destroyed their wonderful complexities. It is significant that when Sickert treated subjects of more simple volume, such as the rectilinear façade of *Santa Maria Formosa* (Fig. 91) or the severely classical *San Barnaba* (C.139), his handling was of the type here ascribed to 1900. He painted both churches in bright sunlight; his touch was much lighter; the clean paint and clear differentiation of the strokes and patches of colour and tone make the pictures easily legible. It does not, however, follow that Sickert always reserved the light handling for his panoramas and for his subjects of more simple form and the other heavier handling for motifs of greater plastic complexity. He painted *San Giorgio Maggiore* (Fig. 97) and *Le Palais des Doges au Crépuscule* (Fig. 99)—both panoramically conceived landscapes—in the second manner, and other subjects which he tackled in more than one version display alternative approaches to their handling. For example, the Royal Academy version of *Santa Maria della Salute* (Fig. 94) is painted in the heavy manner; its colours are deep and glowing and their resonance is intensified by the traces of close squaring in vermilion paint which gleam through the final coats[8]. Two other versions of this subject (2 and 3) are painted with so light a touch, in soft neutral colours, as to give the church something of the appearance of a fairy-tale castle.

The different handlings found in Sickert's separate versions of the same subject reflect, not only his love of variety in matters of style and technique, but also the chronological separation of the various pictures. For example, among three pictures of *The Piazza di San Marco* similar in composition to the dated picture of 1900 (Fig. 89, C.130) only Version 1 can be considered a work of this Venetian period, probably of 1901. This version is so closely related compositionally to the dated picture that it even repeats its tonal pattern and cloud structure. However, whereas Fig. 89 is handled in a light, fluent, and unemphatic manner, the contrasts of light and shade in Version 1 are much more exaggerated, the paint is heavier and drier, the drawing thicker, and the colour scheme—dominated by bright purple shadows contrasting with vivid green—is far more brilliant. This handling is characteristic of the type here attributed to Sickert's Venice pictures of 1901 and it is interesting that in a letter to Mrs. Hulton written in Venice during the summer of 1901[9] Sickert mentioned the 'neo-French violet shadows' of his current landscapes. The other two pictures of *The Piazza di San Marco* (Versions 2 and 3) must have been painted at a considerably later date. In Version 3 the scene is shown after the collapse of the Campanile, an event which occurred in July 1902. This picture must therefore have been executed on, or more probably some time after, Sickert's next and last visit to Venice in 1903–4, although he may have derived some of his information from earlier paintings of this subject. In Version 2 Sickert included, in the right foreground, the head and shoulders of La Giuseppina, his favourite

model in Venice in 1903–4. The way in which the figure is cut off at the lower frame is reminiscent of Impressionist usage but Sickert's picture is almost certainly not a literal translation of a casually perceived glimpse from nature. It is an artificially composite work probably executed after Sickert's return to London. The representation of La Giuseppina herself could have been taken from one of the many similar studies Sickert made of her in 1903–4[10]. The broad outline of the picture, its composition (which shows the Campanile still upright—not collapsed as it was during Sickert's last visit to Venice), its tonal pattern, and its cloud structure are very close to Fig. 89 and Version 1. The figure of a woman in peasant dress behind and to the right of La Giuseppina seems to have been based upon a figure drawing (Study 3) which itself gives no indication of any architectural background and might have been a miscellaneous study originally unconnected with this composition. The almost expressionist quality of the bold assured handling of this picture, particularly the charged atmosphere of the landscape and the dissipated, harsh characterization of La Giuseppina, suggests a date of *c.*1906 for its execution. The assumption that the picture was painted after Sickert's return to London is supported by the English size of the canvas (16 × 20 inches) and its English stamp (Shea and Co., Fitzroy Street).

The *Horses of St. Mark's* (Fig. 93, C.133) is another example of a subject first studied in Venice and then repeated in versions of later date. Sickert studied this subject in 1901, the date inscribed on Fig. 93 and on a fully realized watercolour drawing (Study 2). There are six more undated paintings of this subject. Of these only two (Versions 1 and 2) are similar in handling to the 1901 painting, and can be considered as works of approximately the same date. The description of all three is built up from juxtaposed areas of flat, often opaque paint which is rather heavy in tone, colour, and consistency, and all three are articulated by fairly thick drawing in black lines. A clue to the date of the four remaining pictures (Versions 3, 4, 5, 6) is provided by the label on the back of Version 6 which reads '*Walter Sickert, Venise St Marc, Les Chevaux de Bronze, ou 1904 ou 1905*'. The doubt expressed in the dating of the painting indicates that this label was affixed some time after its execution, but exactly when, why, and by whom is unknown. Nevertheless, some authority must have dictated the presumption that the picture was painted later than Sickert's first versions of this subject and this is supported by its handling. It is difficult to date derivative versions of earlier subjects on stylistic grounds; frequently such versions do not strictly reflect Sickert's current method of treatment but were either influenced by previous versions or were executed as perfunctorily as possible. The latter seems to have been the case with Version 6 of the *Horses of St. Mark's*. As was typical of Sickert's more mechanical reproductions of his popular subjects it is much more tidily finished than the earlier versions; the definition of detail is sharper, mainly because of the precision of the drawing which is executed in places in pen and ink: the general tonality is much lighter, the colours brighter, and the application of the paint in areas of different colour and tone fully respects the boundaries of each object: the individual brushmarks are smoothed away to create a clean, flat, even surface. Versions 3 and 4, although less thinly painted and tidily finished, are nevertheless close to Version 6 in the qualities of their paint, and their colour and tonal schemes. The two large chalk and watercolour drawings (one of them dated 1901) and the carefully defined squared drawing (Studies 1, 2, and 3) were probably primary sources for all these versions. The dated drawing is highly finished both in its colour and in its drawing. The ornate detail is more precisely defined than in any of the paintings; the colour is broadly indicated in the brilliant blue sky, gold ornament, blue and gold starred mosaic, and the black and red divisions of the leaded window. The large coloured, undated drawing is only a little less finished. All the information needed to paint further studio versions was included in the two coloured drawings and the squared study. In fact the scale of Versions 4 and 6 is the same as that of the coloured drawings and just double that of the squared study, allowing for slight dimensional variations resulting from the different points at which the composition is cut. However, one version (5) is executed on a different scale altogether. It

is a tiny canvas ($8\frac{1}{2} \times 6\frac{3}{4}$ inches) and because of its size it is more sketchily finished than the others. The squaring beneath the paint indicates that it was not a small study done on the spot, and the qualities of its paint texture are closer to the later than to the 1901 versions. A comment Sickert made in a letter, written in Dieppe early in 1903[11] to Mrs. Hulton in Venice, illuminates his habit of painting versions of subjects studied much earlier. He wrote, 'I have just been doing a new batch of Venice subjects and better away than on the spot, so it is time I came to Venice to do some Dieppe ones'.

We have seen that Sickert often produced repeated versions of his favourite subjects, in London and Dieppe as well as in Venice. Nevertheless, some further explanation of the great number of versions of particular Venetian subjects may be needed because, it must be remembered, Sickert spent comparatively little time in Venice. Sickert was undoubtedly encouraged to paint Venetian subjects by their great popularity in France. Collectors like Paul Robert, a Paris dealer and friend of Sickert, and André Gide owned many Venetian pictures. Durand-Ruel showed seven Venetian pictures in the summer of 1901 after Sickert's return from Venice about which he wrote to Mrs. Hulton[12], 'apart from purely aesthetic considerations, the firm considers them about the right article, which is encouraging. . . . If they go off, back I come.' Bernheim-Jeune were eager to show Sickert's Venetian work. He had an exhibition with them in May 1903, of which I can trace no record except references in letters to Mrs. Hulton, but in a letter to Mrs. Hulton written in Venice and dated 1 January 1904 he told how Bernheim were begging for pictures and now wanted to buy his whole production. In their June 1904 Sickert exhibition thirty-two out of ninety-six paintings were Venetian landscapes, of which twenty already belonged to private owners. Sickert would also repeat versions of earlier subjects on commission and the popularity of Venetian subjects, not only in France but also in England, may account for some of the many versions of particular subjects. Sickert regarded painting as his trade and was quite prepared to undertake what amounted to 'hack-work' if it was commercially practical. This has already been illustrated by his manufacture of tinted drawings. A letter written to Miss Ethel Sands in 1915 baldly states Sickert's attitude. He reported, 'When I have done S. Mark's and the Rialto I shall be through with this chewing of old cud under which I chafe. But it is necessary to constitute bulk and without bulk no commercial painter can be made.' His approach to painting on commission is nicely underlined by Mrs. Evans's recollection of her husband's patronage of Sickert[13]. Judge Evans began to collect Sickert's work after his return to London, and Mrs. Evans remembers how when she and her husband 'went to Sickert's studio he would show them a pile of small sketches and drawings and ask them to take their pick. He would then paint an oil from whatever they chose, usually for £25.' One version of *Santa Maria della Salute* (C.134, Version 4), which formerly belonged to Judge Evans, must have been a product of such a commission. Its execution and drawing have a systematic quality akin to that of Version 6 of *The Horses of St. Mark's* (C.133). The paint is flat and thin, with little attempt to build up the paint surface. The drawing, which was possibly traced onto the canvas, looks as if it were done in pen and ink, and the detail, including the reflected patterns in the water, is clearly derivative. This is not to say that Sickert made identical mass-produced pictures: he did contrive to endow each version of a subject with an individual quality, however closely derived it was in composition, drawing, and detail from earlier pictures. In this version of *Santa Maria della Salute*, by some remarkable power of memory and evocation of atmosphere, his choice of tints and colours (the warm pink glow which suffuses the sky and envelops the building) created a magical image of a Venetian twilight.

In Venice in 1900 and 1901 Sickert concentrated upon landscape painting. The only figure works known to me are the portrait painting of *Signor de Rossi* (Fig. 98), the portrait drawing of *Mrs. William Hulton* (C.146), and some studies of a theatrical scene showing a *Pierrot and Woman Embracing* (Fig. 104, C.143). Sickert must have been referring to a study of this subject, possibly the chalk and wash drawing

listed in the catalogue, when he remarked in a letter to Mrs. Hulton written in Venice during the summer of 1901[14] that he had sent 'the Pierrot and popolana' among other works 'all on paper' to the Fine Arts Society.

The particular problem raised by these few figure works is to decide whether they were uncharacteristic incursions into figure painting in Venice in 1900–1 or whether Sickert painted other figure subjects, in particular more intimate scenes, at this period. This problem has been touched upon with regard to the painting and drawing of *Maria Bionda* exhibited in 1900, but the coincidence that both had the same title may indicate that the Maria Bionda subject was a unique example of Sickert's figure work at this time.

Emmons, whose account of Sickert's Venetian visits of 1900–1 and 1903–4 is interwoven[15], assumes that he painted figure subjects at both periods. However, Emmons's narrative of these visits amounts to little more than an imaginative reconstruction illustrated by, and even built around, extracts from a letter written by Sickert from Venice. Emmons did not acknowledge that all these extracts were taken from a single letter, he did not identify its recipient, nor did he attempt to date the letter. Indeed, he used separate extracts to illustrate events from the earlier and the later visits. In fact the letter was written to Jacques-Émile Blanche who quoted it in full in *Portraits of a Lifetime,* published in 1937— several years before Emmons's book appeared[16]. This letter is admittedly undated but references to various matters within it are sufficient to prove conclusively that it was written during Sickert's last visit to Venice[17]. Therefore, Emmons's quotation of such an extract as 'this study from the model is a change, prevents me wasting time worrying for the spring' in a context which implies it referred to the winter of 1900–1, is totally misleading[18]. The only real means of ascertaining whether Sickert tackled figure subjects before his last visit is to study the pictures themselves. All the intimate Venetian figure pictures which are dated are works of 1903. This in itself is not conclusive; Sickert worked on figure pictures in 1904 and none is dated that year either. However, nearly all the extant Venetian figure pictures fall into cohesive series and in almost every series there is at least one work dated 1903, which serves to place the rest of the group as works of his last visit to Venice. The handling of the remaining figure paintings, which cannot be directly related to any dated work, is much more compatible with Sickert's Venetian work of 1903–4 than with his work of 1900–1.

NOTES

1. This dating, given by Emmons, p. 108, has been repeated by later writers. B.60, p. 26 states that there 'seems to be no factual record of this second visit, except that one of the five versions of *The Horses of St. Mark's* is dated 1901'. In fact there are several dated Venetian paintings of both 1900 and 1901. Dated 1900 paintings: *The Doge's Palace* (Fig. 87) inscribed on the reverse; *Piazza San Marco* (Fig. 89). Dated 1901 paintings: *The Horses of St. Mark's* (Fig. 93); *St. Mark's* (Fig. 92); *Signor de Rossi* (Fig. 98). Dated 1901 drawings: *The Horses of St. Mark's* (Fig. 93, C.133, Study 1); *Scuola di San Marco* (listed under C.141); *Mrs. William Hulton* (C.146).

2. The relevant letter for dating purposes is addressed Poste Restante, Venezia ('*Ach Venedig!* Kilburn-in-the-sea as it were'). It is undated, but certain references narrow its date-bracket. Sickert sent his love to Mrs. Rothenstein, who did not marry William until 1899. Sickert mentioned that he and Degas had spoken together of 'Rickettes and Shannoine . . . with the beautiful old Pizzarro whose pizzicato is better than ever'. Pissarro died in 1903. This reference is only one of many to indicate that Sickert had just come from Paris.

Indeed almost the entire letter concerns Paris: '*Pariess. Der Ziel meiner Hoffnungen! Der Mecca meines Traumes!!!*' The most significant of these Paris references for dating purposes is Sickert's remark that Degas had said of Monet's *Nymphéas*, '*Je n'éprouve pas le besoin de perdre connaissance devant la nature*'. The first series of Monet's *Nymphéas* was shown at Durand-Ruel from 22 November until 15 December 1900, that is, dates overlapping Sickert's own exhibition (mentioned below) at the same gallery. Not only is it likely that Degas's comment was made at this exhibition, but many years later, in a letter to the *Sunday Times* (14 July 1935), Sickert recalled that Degas had said this to him at the first exhibition of the *Nymphéas* at Durand-Ruel's. Evidence that the Venice letter was written at the appropriate time of the year to accord with this suggestion is provided by the opening words of the letter: 'I felt, directly I had written to you asking for quotations of the market in Boudin . . .'. This almost certainly refers to another letter to Rothenstein written from Paris asking whether Carfax would want to buy a Boudin because 'If they do I may be able to sell them one, cheap. Give me an idea of the price, if any,

cash, that they would pay for one.' In this Paris letter Sickert ended by wishing the Rothensteins a happy New Year. The Venice letter must therefore have been written shortly after a New Year between 1899 and 1903, that is at the beginning of 1900, 1901, 1902, or 1903. There is no other evidence to suggest that Sickert was in Venice at the beginning of 1902 or 1903 and the reference to the *Nymphéas* is sufficiently decisive also to exclude 1900. These two letters must therefore have been written, one from Paris in December 1900, the other from Venice a little later.

3. See note 1.

4. The postscript of a letter written by Sickert to Jacques-Émile Blanche from Dieppe may contain the clue to the date of his return there from Venice. He wrote, '*Clouet vient encadrer les dessins que je lui ai donnés avant d'aller à Venise comme urgents et dont j'ai reparlé journellement depuis le 1 août 1901!!!!*' The implication of this remark may be that Sickert arrived back from Venice on 1 August 1901, since when he had been urging Clouet to get on with framing his drawings. A letter written to Mrs. William Hulton shortly after Sickert's return to Dieppe confirms the suggestion that Sickert left Venice in high summer because he remarked how he now felt better as Venice had been growing hotter and hotter.

5. See note 1.

6. Sickert showed other Venetian pictures besides *Maria Bionda* at this Durand-Ruel exhibition but these either were or, in the absence of details other than their titles, could have been, works of his first visit of 1895–6.

7. Tantalizingly inconclusive support for the hypothesis of two separate visits to Venice, and particularly for the earlier 1900 visit, is contained in a letter to Mrs. Humphrey again addressed from Poste Restante, Venezia. Sickert wrote in this letter, 'Had to do a picture for the Salon in a month, besides many others . . . I shall have an important exhibition at Durand-Ruel's in the winter. Six biggish canvases.' At first glance it seems that this letter proves Sickert was in Venice in 1900 before the winter on the grounds that the forthcoming Durand-Ruel winter exhibition was that of December 1900. However, no picture by Sickert was shown at the *Salon* in 1900. In 1903 Sickert did show a Venetian picture at the *Salon*, *Le Palais des Doges* (1187), but he had no exhibition at Durand-Ruel the following winter (he had shown fifteen paintings at Durand-Ruel with the *Société Nouvelle de Peintres et de Sculpteurs* in February–March 1903 but this took place before the *Salon* and, if the letter was written in 1903, presumably before it was written). It is, therefore, impossible to state whether the letter was written in 1900 or 1903. If it was written in 1900 perhaps the *Salon* picture was rejected after he had sent his letter: if it was written in 1903 perhaps the Durand-Ruel exhibition was abandoned.

8. This close squaring-up in vermilion, which shows through the succeeding coats of paint, is a feature of several Venice paintings, another example being *Le Palais des Doges au Crépuscule* (Fig. 99). Sickert evidently did not intend the squaring to show because in a letter to Jacques-Émile Blanche written in Venice (probably in 1903) he told how he refused to accept money from Paul Robert for some pictures because 'there are certain alterations to be made, those cursed lines in paint of the squaring-up, I suspect, and the preparation showing too much'.

9. This letter, sent by Sickert to Mrs. Hulton when she was on holiday in the Dolomites with her children (to escape the heat of Venice), was dated 1901 by Lady Berwick (Mrs. Hulton's daughter) who knew when this holiday took place.

10. She even wears the turquoise lace blouse in which she was painted in many of the 1903–4 pictures, e.g. *La Giuseppina in a Lace Blouse* (C.193).

11. Letter dated in Chapter II, note 15.

12. Letter referred to in note 4.

13. Quoted B.60, p. 20.

14. See note 9.

15. pp. 108–16.

16. pp. 46–7.

17. The reasons for dating this letter to early 1904 depend primarily on a comparison of the information it contains about Sickert's life and work in Venice with that contained in three more (unpublished) letters to Blanche. These unpublished letters are also undated but they can be ascribed, from internal references, to Sickert's last Venetian visit. For instance in the published letter from which Emmons quoted (p. 112) Sickert wrote of selling two pictures to Gonse, 'A nude on a bed and a girl in a shawl sitting on a sofa'. In one of the unpublished letters written early in 1904 (its date is established by Sickert's report that his brother Robert had written to him that 'Blanche's pictures at the Internat[1]. seem so serious and honourably painted . . .': Blanche exhibited with the International Society of Sculptors, Painters and Engravers from January to March 1904—the first time he had done so since 1899) Sickert wrote, '*J'ai livré à Gonse à Rome un vrai petit chef d'œuvre . . . Une femme maigre dans un jupon écossais . . . qui joue avec un médaillon*'. Sickert included a pen sketch of this picture in his letter and it shows the girl sitting on a sofa (Fig. 116). It is, therefore, possible that this picture is the same one as that mentioned in the published letter as having been sold to Gonse. Even if it is not, Sickert's pictures of girls in shawls sitting on sofas all belong to a series that was painted on his last Venetian visit. In the unpublished 1904 letter Sickert also wrote of working on '*une femme couchée*' which might even be the nude on a bed sold to Gonse. Moreover, in the published letter Sickert referred not only to Gonse as his patron but also to Schlesinger, to his dealings with Bernheims, and to his social visits with the Fortuny family. There is no evidence that he knew any of these people or had begun dealing with Bernheim-Jeune in 1900 or 1901, whereas he had certainly switched to Bernheim as opposed to Durand-Ruel as his main dealer by 1903–4; and his unpublished letters to Blanche written on his last Venetian visit make frequent reference to Gonse, Schlesinger, and the Fortunys.

18. Emmons slightly misquoted this remark (p. 113); the correct version is given here. Indeed, Sickert's very preoccupation with figure painting and the reasons he gave for doing them in 'the 2 cold months that remain' (Blanche, *Portraits of a Lifetime*, p. 46) are directly comparable with information contained in his unpublished letter to Blanche of early 1904 (dated above, note 17): '*Je n'attends qu'un peu de printemps . . . ça ne vaut pas encore la peine de lutter avec les éléments. D'abord ça me rend malade, et ensuite, on ne fait rien de bien, et, en plus, Venise même a l'air d'une tombe jusqu'à ce que vienne l'été, le vrai été, et que tout nage en opale et saphir. C'est pour cela, et pas par ambition démesurée, que je ne leur [Bernheim] ai fondu que des personnages.*'

IX

1902-3. Dieppe Landscapes

ICKERT returned to Dieppe from Venice in the summer of 1901 (perhaps on 1 August[1]). In spite of the fact that he stayed there until 1905, only leaving to make a long visit to Venice from 1903 to 1904, the great period of his Dieppe landscapes was virtually over[2]. On his return from Venice he devoted much of his time to painting more versions of his Venetian compositions, and in Dieppe in 1904 and 1905 (after his final visit to Venice) he pursued his newly stimulated interest in intimate figure subjects in a series of paintings of nude French models. Indeed, he had already begun to study such subjects in Dieppe before his last Venetian visit when, in 1902, he made a number of drawings of a nude woman on a bed (Fig. 101, C.144).

Nevertheless, one of Sickert's major achievements between 1901 and 1903 was his attack upon the problem of painting landscapes on a large scale. Sickert, whose natural preference was for small-scale pictures, was impelled to try his hand at much larger works when he was commissioned in 1902 by a Dieppe hotel-keeper to paint some Dieppe scenes as café decorations. Although it transpired that the hotel-keeper so little liked the pictures Sickert painted for him at '40 fr. a piece' that he sold them immediately to Frederick Fairbanks, an American resident in Dieppe, these four paintings, *La Rue Notre Dame* (Fig. 102), *The Statue of Duquesne* (C.156), *St. Jacques* (C.157), and *The Bathers* (Fig. 100), in a sense consummate Sickert's landscape style of 1898 onwards[3].

The general evolution of Sickert's landscape style during this period depended upon the clever manipulation of the tonal values to project his compositional designs with the utmost force. He had been led towards a method of description based primarily upon the strong statement of the tonal pattern achieved by extracting, from the infinite gradations of the tones of nature, the essential simplified values and then relating these exactly one to the other. This method represented a very significant reaction from the Whistlerian approach which was also based upon the exact relationships of the simplified tonal values. Whereas Whistler's simplifications lay in the narrow reduction of the tonal range he chose to describe, within which he translated the gradations and modulations with exact truth, Sickert adopted a very wide tonal range and simplified the intermediate values. Whistler's method resulted in a cloudy atmospheric vagueness which shrouded the forms; Sickert's method, on the contrary, led to the bold outlining of his subject, the emphatic presentation of his design in strong contrasts of light and dark. At the same time Sickert's use of colour was arbitrary and totally subservient to his conception of the overall tonal pattern. Occasionally after 1898 he did employ a fairly wide colour range, as in the *Statue of Duquesne* of *c*.1899 (Fig. 78), but perhaps only because he felt that in certain cases the opposition of large areas of local colour was even better calculated to render a sharp, boldly patterned effect. More often Sickert seems to have found large areas of bright local colour a distraction, diminishing the impact of the tonal pattern. Therefore he chose his colours, with only marginal reference to their local hues, mainly for their ability to represent the equivalent tonal

values of his subject—an approach similar to that of the Impressionists although Sickert's palette was very different from that of his French predecessors. It was, above all, severely limited. His main harmony was generally based on hardly more than two colours corresponding to the dark and mid-tones, with the addition of creamy buff for the lights. For instance in Dieppe from 1898 to 1900 he often used blue-black with brown or mauve, in Venice in 1900 a brighter scheme based on paler blue and pinky-buff and in 1901 purple and emerald green. Even his skies, painted in daring unnatural hues such as purple-violet or duck-egg green, were made to conform to his arbitrary colour harmonies.

The four commissioned landscapes of 1902 represent the distilled essence of Sickert's experiments and experience since 1898 with this method of presentation and stylistic expression. The statement of their design is direct and simple; it can be comprehended at a single glance. Detail is subordinated to a generalized scheme translated in the strong tonal pattern of simplified areas of different values. Neat sharp drawing in black further clarifies the essential patterns. *The Statue of Duquesne* (C.156) and *The Bathers* (Fig. 100) are quite bright in colour and light in tone, but *St. Jacques* (C.157) and *La Rue Notre Dame* (Fig. 102) are sombre paintings made more so by the inclusion of so few figures. Although they lack the intimate sense of actuality found in his smaller versions, the projection of their design and form by means of the controlled manipulation of their tonal patterns is much more forceful and uncompromising on this larger scale (each picture measures approximately $51\frac{1}{2} \times 40$ inches).

Some of the power of these paintings must be due to the fact that Sickert was able to concentrate almost exclusively on their stylistic expression. Usually his preoccupation with style was diluted by his intense concern for the handling of his paintings, that is the manner of his brushwork and the textural qualities of his paint. In these pictures, however, Sickert could afford to pay only minimal attention to handling because their size and their intended function as mural decorations to a large extent pre-determined the flat, smooth, unobtrusive manner of their execution. Moreover, except when painting *The Bathers* Sickert did not have to stop and work out compositional problems. The three townscapes are all closely derivative versions of earlier compositions[4]. *The Bathers*, however, was unique both in subject and composition. It is entirely unlike the conventional beach scenes and seascapes of Sickert's early Whistlerian days. No point of reference, in the form of the shore or horizon, is included. The perspective depends on the diminution of the figures in the water who are deployed like stepping stones, roughly in two parallel receding orthogonals. The sea is painted in a wide variety of greens and blues, mixed with white, to give a brilliant turquoise effect to the whole, but in the foreground it is deep purple, an intense colour harmony which recalls the Venetian pictures of 1901. The bathers' costumes provide further vivid notes of colour (vermilion, black, blue and white and red and white stripes), their flesh is painted rust in the shadows and yellow ochre in the lights, and the strong sun-light reduces their forms to very simplified statements of light and dark tones. Sickert's basic method of expression, the direct projection of his design by the strong patterning of colour and tone, is the same in *The Bathers* as in the townscapes, but the bright colour, the glaring costumes, and the composition without horizon or linear perspective which tells as much on the surface as in depth, make this picture seem much more modern, more of this century, than most of Sickert's work at this period. In a sense *The Bathers* anticipates the later sporting pictures of Delaunay and the bathing pictures of Vallotton.

The four commissioned landscapes of 1902 are not the only examples of Sickert's work on a large scale at this time. *The Fair at Night* (C. 158) is approximately the same size as the commissioned pictures and *La Darse, Dieppe* (Fig. 103), although narrow, is nearly five feet high. It is possible that these pictures also belonged to the commissioned series. Fairbanks did not necessarily buy all the rejected pictures. The size of *The Fair at Night* certainly supports this suggestion and the unusual dimensions of *La Darse* (there were originally two pictures of this subject and size but one is now lost) suggests that they were also executed with some specific purpose and position in mind. The predominant feature of

the stylistic character of these paintings is once again the bold projection of their designs through the emphatic statement of their strong and simple tonal patterns. However, their finish is not as neat (the drawing in particular is much clumsier) and their handling is less mechanical than the commissioned landscapes[5]. This suggests that, whatever were Sickert's original intentions, he did not finally offer these pictures to his patron. Perhaps they were never envisaged as part of the café series but were instead inspired by them. Sickert's work on the commissioned pictures could have led him to recognize that large canvases were the natural vehicle for his current desire to paint boldly patterned landscapes.

This is not to say that in 1902 or thereabouts Sickert always painted landscapes of this stylistic type on a large scale. One of the many versions of *La Rue de la Boucherie* (C.151, Version 1), with its flat, heavy paint and its strong, tight, and simplified tonal pattern, is very close stylistically to the large paintings but is itself carried out on a small scale. Moreover, by 1903 Sickert's concern with the exploration of different methods of handling had revived. In 1902 his handling, being subservient to the expression of an overriding stylistic conception of landscape painting, had been relatively uniform and mechanical. By 1903 the roles of style and handling were once again reversed. The revival of Sickert's love of experiment with various manners of execution is clearly illustrated in the different versions of *La Rue de la Boucherie* (Fig. 105, C.151). The dated panel of 1903 (Fig. 105), for example, could not be more different from the *c.*1902 picture (Version 1). The paint is thinner and floated loosely across the surface; nervously sharp drawing accents the definition; the tonality is lighter and lacks sudden contrasts; the colour is bright, pretty, and varied; in certain passages, for instance the tender foliage of the young saplings[6], it is applied in softly touched dots and dabs. Version 2, a small painting on canvas of this subject (almost identical to the panel in composition although the disposition of the flimsily indicated little figures is different) has a similar lightness of touch which marvellously conveys the springlike quality of the scene. The crisp drawing of a watercolour of this subject (Drawing 4) and the colourful effect of its purple, blue, yellow and pink washes on the blue-toned paper, echo the sparkling gaiety of Fig. 105, and Version 2. However, this light, gay treatment was totally rejected in three further versions of *La Rue de la Boucherie* (Fig. 110, C.154), two painted on canvas and one (an upright representation of part of the subject) on panel. The two paintings on canvas show the slightly extended view of the scene found in the watercolour described above and one shows the market figures included in that drawing. The panel also represents these figures. In all three pictures the paint is heavily, even clumsily applied, the black drawing is thick and smudged, and the tonal schemes are sombre and gloomy. The execution of each version varies in detail but a general impression of disturbance and violence is common to them all. There is no area of calm in any of them; the tonal pattern and brushwork are brutally fragmented. In Fig. 110 nearly the entire surface is broken up into separate jabbed strokes of contrasting tone and colour. In the other version this treatment obtains less exclusively (although it is used extensively in such passages as the sky and part of the ground), but the surface has an oddly smudged, blotted quality, which together with the thick, clumsy drawing gives a violent Expressionist character to the painting. (The upright panel, which was almost certainly used as a study for this painting, is treated in a similar manner.)

Although the similarities of the compositions and of such details as the extent of the tree growth suggest that these three pictures were executed at about the same time as the dated 1903 panel and associated versions, it is hard to reconcile the crude, violent handling of the one group with the light crisp touch of the other. This violent manner of handling is similar to that found in Sickert's paintings of 1905–6. It is therefore possible that these three landscapes were executed at about that time, perhaps from earlier studies and drawings. However, a dated painting of 1903 showing one of the quays of Dieppe (Fig. 106) proves that Sickert did experiment in that year with a much more untidy,

disturbed, and clumsy *facture*. Unfortunately for chronologists the dated painting is unfinished but its treatment, so far as it goes, is entirely compatible with that of the rough, violently handled versions of *La Rue de la Boucherie*.

In some paintings of *La Rue Ste. Catherine et les Vieux Arcades* (Fig. 108, C.155) Sickert again used heavy thick drawing and swirling untidy brushwork, combined with extensive passages of more broken separated marks. The paint in the small study (Version 2) is quite thin and the drawing fairly sharp but the brushwork has the untidy character found in the unfinished dated painting of 1903 (Fig. 106). Broken dabs of paint, reminiscent of the *La Rue de la Boucherie* pictures, are used in certain passages. In Fig. 108 itself the paint surface is built up more thickly and constructively. There are extensive passages of broken brushwork (notably in the sky, the crumbling buttress of St. Jacques, and the side of the street). The use of this broken brushwork is related more specifically to the effective representation of the total scene than it is in the *La Rue de la Boucherie* pictures, but the actual handling is similar in character. However, it must always be remembered, when trying to date Sickert's work on stylistic grounds, that he frequently painted later versions of earlier subjects and, when he did so, that he was liable to revive his earlier style and handling. The pitfalls awaiting a chronologist are nicely illustrated by Version 3 of *La Rue Ste. Catherine et Les Vieux Arcades*. This version is very close in handling and composition to Fig. 108, yet it was commissioned and painted in 1910[7].

It is impossible to state with any certainty whether the different uses of what was virtually the same manner of handling illustrated by the *La Rue de la Boucherie* (Fig. 110, C.154) and the *La Rue Ste. Catherine* (Fig. 108, C.155) paintings were the work of one single year, 1903, or were chronologically separated experiments. It is, however, possible that the violent brutality of the former pictures was a temporary, premature experiment with the expressive potential of this form of handling which Sickert was to take up again in Venice and yet again in London from 1905 to 1906.

NOTES

1. See Chapter VIII, note 4.

2. The record of Sickert's pictures at the N.E.A.C. exhibitions (which is generally helpful in its reflection of his current interests) is of little use during this period. Sickert ceased to exhibit with the Club between spring 1902 (*Nocturne, St. Mark's*; see note to Fig. 92, C.132) and winter 1904 (*Portrait of Zangwill*, Fig. 65, and an untraced picture, *Der Fliederbaum*). Then he did not exhibit with the N.E.A.C. again until 1906. Thus, with the doubtful exception of *Der Fliederbaum*, the last Dieppe landscape Sickert showed at the N.E.A.C. was *St. Jacques*, winter 1901 (125).

3. In a letter written in 1916 to Miss Ethel Sands Sickert recounted the history of this commission: 'The pictures belong to my friend Frederick Fairbanks an American . . . who bought them of an hôtel-keeper who had commissioned me to do them at 40 fr. a piece and then didn't like them'. Simona Pakenham, *60 Miles from England. The English at Dieppe 1814–1914*, p. 202, wrote that the hotel-keeper paid 100 francs for each picture. Sickert did not mention the year of this commission, but there is much to support the tradition that it took place in 1902. All four pictures, when already in Fairbanks's possession, were exhibited at the *Salon des Indépendants* in March 1903 (Nos. 2232–5 inclusive). A letter written to Jacques-Émile Blanche may be interpreted as providing further support for dating the pictures to 1902. In this letter Sickert wrote, '*Alors j'ai dit à Fairbanks qu'il y avait une bonne*

affaire à faire avec M. Mantren'. The letter is dated '*Mardi 5 Août*'. Tuesday fell on August 5 in 1902 and it is probable that M. Mantren was the hotel-keeper and Fairbanks's business with him concerned the purchase of the commissioned pictures.

4. Not one of these townscapes is identical with any of the earlier versions of the same subject, but each depends for its composition primarily upon a single earlier painting (see Catalogue notes) with variations in its detail introduced from a selection of alternative versions.

5. The broken treatment of the water in *La Darse* recalls *The Bathers* but the quality of its paint is closer to the textural richness of Sickert's Venetian work of 1901.

6. These trees, freshly planted young saplings, provide evidence to support the stylistic reasons for dating the flat, tightly painted version of *La Rue de la Boucherie* c.1902. They are absent from that picture but present in all the other paintings of this subject.

7. A letter written by Sickert to Miss Hudson in 1910 (it describes the early stages of Sickert's school at Rowlandson House) reports: 'I have been overworked. Finished a Dieppe for Johannesburg for Sir Hugh.' This can only be the picture presented by Sir Otto Beit to the Johannesburg Art Gallery in 1910. The Beit Trustees informed me that Sir Otto did not himself own the picture but could have presented it through the agency of Sir Hugh Lane. The letter to Miss Hudson provides independent confirmation of this hypothesis.

X

1903-4. Venice

SICKERT'S return to Venice in 1903 was inevitable. It is only surprising that it was so long delayed. Immediately he returned to Dieppe from Venice in 1901 he had written to Mrs. Hulton[1], 'when I was in Venice I was under the impression that I lived in Dieppe, and had *gone* to Venice, and now I feel as if I lived in Venice, and had *gone* to Dieppe'. He added, 'I am now sometimes rather tired of Dieppe and see it a little as that terrible compliment, the watering-place-out-of-the-season'. Early in 1903[2] he wrote to Mrs. Hulton that his recent success in exhibiting and selling 'will, thank goodness, waft me again to the Zattere shortly'. His jocular remark in another letter of early 1903, that he had been doing a batch of Venetian subjects in Dieppe 'so it is time I came to Venice to do some Dieppe ones' has already been quoted[3].

We know that on Sickert's last visit to Venice of 1903-4 the bad winter weather kept him indoors much of the time, working from the model. Only one landscape work of this visit is dated, a rough drawing of the *Scuola del Rialto* (C.163) done on 2 January 1904. Nevertheless, during his time in Venice Sickert must have painted many more landscapes than are either traced or generally credited to him. He told Blanche, '*J'ai commencé le paysage. J'ai un bateau de 9 à 7 heures six jours de semaine. J'ai douze ou quinze à moitié faits. Dix jours de temps superbe*'[4]. In another letter he wrote of 'eighteen genrebilder on the stocks, and sixteen landscapes. The landscapes are interrupted sometimes by cold and rain and wind. But there are many days when one can work out of doors'[5].

Perhaps two of these sixteen landscapes interrupted by cold and rain and wind are *Il Traghetto* (Fig. 109) and *San Trovaso* (C.161), informal canal scenes which are the Venetian equivalent of the back streets of Dieppe. They are virtuoso performances. There are very few earlier landscapes by Sickert in which the paint is applied so surely, directly, and economically, to express with such savage concentration the mood as well as the external appearance of the subject. The tonality of these pictures is sombre, the range of their colours very restricted, the paint is roughly scrubbed or broadly swept onto the canvas, the drawing is only loosely associated with precise forms. The violence of their mood and handling immediately recalls the *Rue de la Boucherie* landscapes (Fig. 110, C.154), perhaps painted just before this Venetian visit. They are in fact related to this Dieppe experiment not only in the general character of their handling but also in details of their handwriting. The quality of the drawing in heavy dark lines is similar; the harsh economy with which the Venetian buildings are suggested, for instance the slashes of dark indicating the windows, recalls the way Sickert painted St. Jacques in the Dieppe pictures; their tonal pattern and their brushwork are again fragmented. However, the canal scenes are treated with much greater freedom. All these features of their handling are used with much less pedantry than in the Dieppe paintings on canvas, so that the general similarities of their approach are best appreciated by comparing the Venetian scenes with the study for *La Rue de la*

Boucherie (Version 2) which is handled with more of the loose-wristed freedom of movement characteristic of *Il Traghetto* and *San Trovaso*.

Among other landscapes probably painted on this visit to Venice is *Rio di San Paolo* (C.162), again an informal canal scene but this time painted in sparkling sunshine perhaps during those '*dix jours de temps superbe*'. The most distinctive feature common to all three canal scenes is the instability of their atmospheric conditions. *San Trovaso* and *Il Traghetto* suggest the fitful light of a threatening storm; the sunlight in *Rio di San Paolo* has the transparent mobility of a fine spring day. Stylistically *Rio di San Paolo* is different from the other two landscapes. Its tonality is light, its colours clear and bright, and it is much more fully defined both in drawing and colour. Whereas the handling of *Il Traghetto* and *San Trovaso* is characterized by its dashing *bravura*, *Rio di San Paolo* is painted with fragile delicacy. Buildings, water, and sky are defined with small separate strokes and stains of paint, each subtly varied in tone and colour, which, combined with the dry texture of the paint, produces an effect similar to that of a pastel drawing.[6]

The different methods of handling illustrated by these canal landscapes were also used in Sickert's figure paintings of this last Venetian visit. His most important works of this visit, prophetic of his later Camden Town pictures, were figure subjects. It was in his paintings of little Venetian models that he worked out so many problems of handling as well as of subject and of composition. Although early in 1904 Sickert gave Blanche the relatively flippant excuse of the dismal Venetian winter, even telling him in connection with his pictures currently held by Bernheim, '*Envoyez-y du monde. Et dites surtout, pour le moment, que vous le pensiez ou non, que vous aimez même mieux les personnages que les paysages. Je ne peux pas geler*'[7], a much more fundamental alteration in his aesthetic interests must have been responsible for his switch to figure painting. The drawings from the nude which Sickert made in Neuville, Dieppe, in 1902 (Fig. 101, C.144) indicate that even before he went to Venice he was experimenting with this new subject matter. It is, indeed, probable that Sickert did paintings as well as drawings from the nude in 1902 because he rarely studied a subject without at least intending to paint it. Sickert painted several nude subjects in France before his return to England in 1905 but, on the whole, the handling of the extant examples seems to presuppose his Venetian experience and closely anticipates his work of 1905–6. Sickert's association with Mme Villain[8], who may have been the model for the 1902 drawings and for some if not all of the paintings, continued until his return to London, so these paintings could well have been done in 1904–5 although the possibility that they were brilliant premature experiments cannot be completely rejected.

Sickert's drawings of Venetian figure subjects dated 1903 (together with the one painting so dated) represent the largest group of dated works in his entire *œuvre*. Moreover the sheer quantity of drawings and paintings produced by Sickert on this last visit to Venice is unparalleled. Possibly the survival of so much of his Venetian work is fortuitous, but more probably Sickert worked with greater concentration and fewer distractions in Venice. His social life was active but ordered (the Fortunys' every Sunday, for example[9]), and having a model come to his room must have saved considerable time usually spent hunting for landscape subjects. His working day was now simple; he outlined it in a letter to Blanche: '*De 9 à 4, c'est la joie, ininterrompue de ces gentilles petites modèles obligeantes qui rient et me content des sâletés, en posant comme des anges. Qui sont contentes d'être là, et pas pressées. À quatre heures je ne pense que de fermer les volets, me mettre sur mon lit et dormir comme un juste jusqu'à sept heures.*'[10]

In his letter of 1 January 1904 to Mrs. Hulton (who had left Venice to take her daughter to Munich) Sickert wrote how he did 'models from 9 to 11 and 1 to 4, and when the weather is fine a landscape or so'. Emmons's statement that Sickert obtained his models through his landlady at 940 Calle dei Frati is contradicted by Sickert's remark in this letter to Mrs. Hulton that he got most of his 'splendid models' from the Giorgione, the *trattoria* run by Signor de Rossi (see note to Fig. 98) where he often ate. La

Giuseppina was perhaps Sickert's favourite little model and she brought members of her immediate circle, her mother (*mamma mia poveretta*) and her friend La Carolina dell'Acqua, to Sickert's room at 940 Calle dei Frati. Sickert repeatedly drew and painted these three, as well as a few more Venetian girls, amongst the familiar surroundings of these rooms, seated on his couch with its curved arms, and in front of his washstand decorated with ribbons. Sickert remarked in his January 1904 letter to Mrs. Hulton, 'I am just now much concerned with the chiaroscuro of washstands and other domestic intimate objects of furniture. An unkind friend calls me "*le maître de la table de nuit*"!' As usual, in spite of the size of his Venetian production, the number of themes and compositions which Sickert studied was relatively small. He was content to draw and paint the same models, in the same settings, and in much the same poses, over and over again.

In the letter to Blanche in which he wrote about his models he also detailed his method of working:

> *Voici, jusqu'ici, ma manière perfectionnée. Des toiles de 8 preparées en gris (blanc et noir) avec essence. Une bonne couche. Première séance mettre tout en place d'après nature couvrant toute la toile et ne pas laissant bouger la modèle pour un pli jusqu'à ce que tout y soit. Ça veut d'ou à peu près une heure, plus ou moins, sans bouger. La toile une fois couverte je commence une autre. Trois jours ou plus après (toiles toutes autour d'une poêle toujours allumée) je reprends la série. Avec une grande brosse je baigne le tableau à l'huile de lin, que j'enlève après avec du papier buvard, et alors je finis, me laissant guider plutôt par mon propre travail de première impression, que par la modèle, en restant dans les rapports indiqués d'abord, qu'ils me semblent justes ou non. Ce que vous voyez maintenant chez les Bernheims sont des marches, et quelquefois des égarements, qui m'ont amené vers ce que je fais maintenant—une femme couchée et bien peinte avec de l'huile —j'en viens de conter quarante toiles en route.*[11]

This passage is very illuminating about all sorts of aspects of Sickert's work and objectives. His account of how he worked at a number of paintings simultaneously—or rather in rotation—explains why so many of his Venetian pictures form series possessing common themes and similar compositions. His huge production is not at all surprising because by his own reckoning he could manage the first sitting of about four to five pictures a day (allowing roughly an hour each between nine and eleven and one and four o'clock) and each picture only required one further sitting three days later. This could work out at about twelve pictures a week. Most important of all, his remarks prove that his main preoccupation when working on these series was with handling and technique. Each picture was an experiment. He wrote of painting forty canvases '*en route*' before arriving at a result which satisfied him (a '*femme couchée*'[12]), and these forty were regarded as steps, sometimes misguided, towards achieving the perfect method. The actual statement of his current method is less significant, at least in its detail. Although on the day he wrote this particular letter to Blanche Sickert thought it perfect, it was characteristic of his enthusiasm for experiment that on another day he was liable to change his mind and decide that some other method was ideal. Indeed in a different letter to Blanche written on this same Venetian visit Sickert detailed another recipe for painting which differs in several essentials from his '*manière perfectionnée*'. He wrote:

> I have gained a great deal of experience working every day from 9 to 4. I have learned many things. *Not* to paint in varnish. *Not* to embarrass the canvas with any preparations. And so to give the paint every possible chance of drying *from the back of the canvas*. To paint with ½ raw oil and ½ turps. To state general tones once and *once only*. And when the first coat is dry, to *finish*, bit by bit. I had the bad habit of re-stating the tones all over an indefinite number of times, and getting no further, not improving the colour, and making the canvas, especially in the darks, more and more disagreeable. And after twenty such sittings the canvas remains a sketch.[13]

Although this recipe differs in detail from the other given to Blanche, common to them both is a fundamental trend towards economy when painting. Both methods were designed to help Sickert

finish his pictures quickly, in about two sittings, with the minimum amount of fuss. In the first sitting he stated the subject in general terms as a pattern of the main tones, in the second he finished.

The variation in the handling of different paintings from any one of the Venetian series of pictures illustrates the range of Sickert's experiments. The most extensive series, studied in a great number of paintings and drawings (a few of which are dated and inscribed 'Sickert Venezia 1903'), shows a model—sometimes La Giuseppina, sometimes La Carolina—seated on a floral couch. Sickert's description to Blanche of his method of working implies that he painted direct from the model instead of from drawn documents. His room was his studio and his subject was in there with him. Therefore few of the Venetian paintings accurately reflect individual drawings. The drawings were independent works in another medium, executed at the same time as the paintings. Thus, although some of the paintings in, for example, the model on the couch series are related in composition and pose to particular drawings, none is an exact repetition of a drawing, or, for that matter, of another painting. Instead, if the drawings and paintings from this series are studied together elaborate interrelationships between them can be discerned which must reflect Sickert's method of passing from one picture to another in rotation. For example, a painting showing *La Giuseppina* three-quarter length, hands folded in her lap, seated on the couch which runs diagonally into the picture (C.164, Version 1) is closely related to one of the dated drawings (Drawing 1); this painting was also the point of departure for the portrait of *La Giuseppina against a Map of Venice* (Fig. 111) which can be regarded as a variation upon the central portion of the three-quarter length picture. *La Giuseppina against a Map of Venice* was itself perhaps the point of departure for another picture (C.164, Version 2) which repeats its format and pose but is very different in mood and handling. Meanwhile the last picture mentioned seems to be related to a roughly drawn pencil sketch (Drawing 2). Similar interrelationships can be established between any number of Sickert's Venetian series of drawings and paintings but it is hoped this one example will suffice in the text.

The series of paintings of a model seated on a couch also provides the best illustration of the range of Sickert's experiments in style and handling in Venice. In *La Giuseppina against a Map of Venice* and in the three-quarter length portrait of *La Giuseppina* Sickert used dry, thin paint and soft, pale colours. The characterization of the model is extraordinarily fragile and tender in both pictures. The brushwork is light and feathery; the drawing is sharp and fine. However, in *La Giuseppina against a Map of Venice* Sickert chose not only to concentrate upon a smaller fragment of his subject, but also to distil the essence of his means of expression. He showed only La Giuseppina's head and shoulders; in pursuit of simplicity he uncharacteristically distorted her setting, flattening out the angle of the couch by the irrational representation of what should be its diagonal back as an extension of the horizontal of the far arm. He simplified his use of colour, retaining the cool grey-greens and olives and the warmer pinks and reds used to paint the background room and the floral couch, but rejecting the notes of stronger colour (touches of turquoise in the blouse and blue in the skirt) found in the three-quarter length portrait. The figure in *La Giuseppina against a Map of Venice* is painted in the same colours as the background; indeed the transition from figure to background is so understated in terms of colour that the definition relies mainly upon the fine drawn accents. The influence of Degas and of Japanese art (perhaps transmitted through the agency of Degas) seems to have helped Sickert towards the refined economy of statement found in this picture. La Giuseppina is posed so as to emphasize the oriental qualities of her sharp features, and the orange and green markings in the map behind her head deliberately suggest a geisha's ornaments in her dark high-piled hair. The graceful calligraphy, the flattened two-dimensional representation, and the abrupt cutting of the figure, are all reminiscent of Japanese conventions. Sickert's choice of colours (particularly the warm rust-red ground colour used as a positive ingredient of the total scheme) and the way in which the background colours run,

as it were, through the figure, and also the definitive function and manner of the sharp drawing, are strongly reminiscent of Degas. Perhaps these qualities were directly inspired by Degas's *Femme à la Fenêtre* (Courtauld Collection), a picture which once belonged to Sickert and his first wife. Nevertheless this picture cannot be interpreted as a lovely but unique and in a sense plagiaristic work. Its economy of treatment was entirely in keeping with what we know Sickert was trying to do at this period. Indeed, his whole approach to the picture, the way in which he yielded to aesthetic rather than observed reality, may have been a result of his methods of finishing a painting. He told Blanche that when finishing he let himself be guided '*plutôt par* mon propre travail *de première impression, que par la modèle, en restant dans les rapports indiqués d'abord, qu'ils me* semblent justes ou non'. It is possible that the statement of the broad map of tones and accents which Sickert made during his first sitting suggested, even dictated, the arbitrary independence of colour and spatial construction found in this picture.

In three more pictures from this series, *Le Châle Vénitien* (Fig. 112) and two other pictures of *La Carolina* (listed under Fig. 112, C.165), Sickert experimented with a very different method of expression. All the pictures show the model leaning against one arm of the now horizontally placed couch; *Le Châle Vénitien* and one of the *La Carolina* pictures show her full-length; the third picture is a three-quarter length. In these pictures of La Carolina Sickert rejected the fragile, delicate mood of the La Giuseppina portraits in favour of a much more abrupt and expressive treatment. In each picture he painted the model wrapped up in her long black clothes as a simplified silhouette of an almost uniform deep dark tone with only her hands and face, caught unevenly in the light, telling in harsh contrast. The sinuous contours of the silhouettes, particularly in *Le Châle Vénitien*, are compelling and coyly expressive.

La Giuseppina. La Bague (Fig. 114) is related compositionally to these La Carolina pictures. The couch and model are similarly placed, the sinuous contour of the figure is again emphasized, and even the triangular shadow cast on the background wall recurs as an integral part of the composition. Its handling represents a more restrained use of the same method. The tonal description of the figure is again simplified to create a compact silhouette but, being painted mainly in mid-tone greys, it presents a less exaggeratedly dark contrast to the rest of the picture. The head is painted equally economically but the few accents are more muted and placed with greater delicacy. The grey background is touched with pastel colours, not applied in distinct hatched strokes as in the similarly coloured background of *La Giuseppina against a Map of Venice*, but blended together indistinctly. The unusual softness of the juxtapositions of colour and tone in this picture was perhaps achieved by Sickert blotting the picture after he had bathed it in oil (as he described to Blanche) before the underlying paint was quite dry. It is, however, primarily in the finish that this picture differs from others in the same series. In *La Giuseppina against a Map of Venice* the finish was primarily a function of the drawing; in the La Carolina pictures such as *Le Châle Vénitien* it was more or less lacking. In *La Giuseppina. La Bague* the finish consists in the brilliant notes of colour which give meaning to its subject, the royal blue of La Giuseppina's sleeve leading the eye to the bright yellow of her ring. The effective use of sharp, acid colours (often lemon, peacock blue, a sappy green, and a bitter red) is characteristic of several of Sickert's Venetian figure pictures, but on his return to Dieppe he reverted to his usual muddier colour harmonies.

He used yet another method of handling in two more interrelated pictures from this series (one is a study for the other) showing *La Giuseppina* seated on the couch with her head resting on her hand (C.185). He laid the paint on in small dabs and smudges, rejecting the use of both drawn accents and linear pattern-making.

The drawings related to this series of pictures of a girl on a couch reveal that Sickert also experi-

mented with his graphic techniques. He was able to do this more freely because his drawings were not executed primarily as studies for painting. In several of the drawings, but most clearly in a dated drawing of *La Carolina* (C.165, Drawing 1), Sickert emphasized the chalk modelling with little dots and dashes of the pen. The surface variety that this combination of media and modelling techniques creates anticipates the (much greater) variety found in the Camden Town drawings of 1910 onwards. The little dots and dashes of the pen used to model the faces in some of the Venetian drawings were to become a particularly important feature of these Camden Town drawings. Sickert experimented with this manner of drawing seriously in Venice. In a *Self-Portrait* drawing (Fig. 130) set against the background of the beribboned washstand, in *La Chiozotta*—a dated study of 1903 for the portrait of *La Inez* (C.194)—and in another dated sheet of 1903 containing two studies of a girl's head seen in sharp foreshortening (C.187), the chalk modelling is extensively reinforced by tiny little dots of the pen. Nevertheless, after his return from Venice Sickert seems to have left this graphic technique in abeyance until its reintroduction some six years later.

The series of paintings of a girl on a couch reveals a wider range of experiments in handling than any other single Venetian series. The paintings in another series, representing *La Carolina* either standing or seated in a room containing a chest of drawers, mirror, and washstand (Fig. 115, C.168), are all perfunctorily treated with the figure and setting stated in general terms as equal components of a broadly based tonal pattern. Sickert's main concern in these pictures seems to have been with problems of composition. The interior setting is more fully represented than in any other of the Venetian figure series and the use of a background mirror, especially in the pictures with standing figures, introduces a certain amount of counterpoint in the spatial relationships of figure and setting. Nevertheless, the integration of figure and setting is very tentative and awkward in comparison with Sickert's later Camden Town figure subjects. Firstly, the figure in each picture appears as an arbitrary and artificial insertion into the setting rather than as a real girl casually glimpsed in her natural surroundings. Secondly, the compositions have an obtrusively rectangular character. The furniture is lined up along the background wall which is parallel to the picture plane. When La Carolina is seated she is set frontally: when she is standing the simplified silhouette treatment of her figure makes it read on the surface as a planar object. The rectilinear conception of the compositions is a constant reminder of the rectangular two-dimensional physical structure of the canvas. This rectilinearity and consequent emphasis on the surface of the picture is a feature common to nearly all Sickert's Venetian compositions. Indeed, he sometimes manipulated his figures into exceedingly awkward positions just to preserve the planar parallel effect. In *Le Châle Vénitien*, for example, the figure is almost dislocated at the waist and suffers another painful twist at the neck, so that she will face frontally out of the picture. In *Putana Veneziana* and in *Putana a Casa* (Fig. 113, C.169) the fall of clothes and the line of the chair back is arranged to form a rectangular surface pattern which conceals the effect of the three-quarter pose in depth of the model. The treatment of the figure in, for example, *Le Châle Vénitien* as a virtually two-dimensional silhouette was perhaps another manifestation of Sickert's insistence on the rectangular planar character of his pictures. Sickert himself evidently recognized this quality in his Venetian pictures because he wrote to Blanche, 'The Hôtel Royal, Dieppe, has left its mark on my talent. I am perhaps only a rectangular painter'[14].

Another series of Venetian paintings represents variations on the theme of a girl in bed. Several of these paintings are remarkable for Sickert's use of simplified angular outline drawing. The most extreme example is *La Carolina in a Tartan Shawl* (Fig. 119), in which the whole description resolves into a pattern of block shapes; the figure, her clothing, the bed, even the pillow, are all defined by heavy schematic black outlines which are only very roughly filled in with colour. In other pictures from this series such drawing is used more selectively, to define the face and hands in *Resting* (C.171,

Version 2) and for one hand only in *The Siesta* (Version 3). In *Vénitienne Allongée à la Jupe Rouge* (Fig. 117) the schematic drawing (very much in evidence in a study for this picture—*Girl in a Yellow Dress Asleep*) is overlaid by the application of the paint in small broken dabs and smudges which recalls the handling of the two pictures of *La Giuseppina* seated on a couch (C.185).

All these paintings of a girl in bed show the model fully clothed, whereas the '*femme couchée*' sketched by Sickert in his letter to Blanche showed the model with her dress pulled up to display her legs and hips. Sickert often drew from the nude in Venice. He made formal studies, such as *Triple Study of a Standing Nude* (C.188), and many informal studies of the Degas type, such as *Putana Veneziana* (Fig. 121, C.176). But relatively few Venetian paintings represent nude subjects. These few include two paintings from a series of two-figure scenes showing La Giuseppina clothed, seated on a bed, talking to a reclining nude model viewed in abrupt foreshortening (Fig. 122, C.174), and a more formal single figure painting of a seated nude called *The Beribboned Washstand* (Fig. 120).

The setting of *The Beribboned Washstand* is identical to that used for the pictures of La Carolina seated in an interior (listed under Fig. 115, C.168). The nude (who is probably again La Carolina) is even placed on the same chair and has something of the same self-consciously posed quality. Cézanne's influence has been suggested[15] as responsible for the formal relationship between the figure and the setting in this picture. I prefer to interpret the curtains above the washstand as an observed incident in the interior which delighted Sickert's eye, and which he recognized quite independently as helpful both to the formal integration of his composition and to the creation of a natural background. I cannot see these curtains as the *raison d'être* of the picture, which is surely the lovely body of the nude. The somewhat formal geometry of *The Beribboned Washstand* was probably a consequence of Sickert's inexperience with—and thus comparatively gauche resolution of—the problems of integrating figure and setting; it is unlikely to have been the deliberate result of an attempt to imitate Cézanne.

The handling of *The Beribboned Washstand* is rich. The body of the nude, particularly where it catches the light, is modelled in separate hatched strokes of different colour and tone (mainly shades of brown, soft salmon, and rose pinks) and the strokes themselves, following here the contours and there the undulations of the form, are used to create and define the figure. This network of coloured hatched strokes (reminiscent of the technique of pastel drawing) may reflect the influence of Veronese, a painter Sickert much admired and whose work he could easily study in Venice.

The handling of the two-figure subjects showing La Giuseppina with a nude model (Fig. 122, C.174) is equally rich and accomplished, but their compositions are more intimate and informal. The handling of the two pictures is different in detail but common to them both is the confident drawing of the difficult foreshortened body of the nude, with sweeping linear strokes used to define her rib-cage, breasts, shoulders, and stomach. In the version not here illustrated Sickert's execution was more broken. He used small dabs of paint, such as those seen in the face of La Giuseppina in the version illustrated (Fig. 122), consistently over the entire picture; he fragmented his brushwork especially boldly in describing La Giuseppina in her lace blouse to give her something of a flickering out-of-focus quality, an effect which further enhances the casual, intimate mood of the subject.

Sickert also painted a number of pictures of semi-nude models, some of which are more intimate, even more erotic, than the wholly nude subjects. A lovely example is *Fille Vénitienne Allongée* (Fig. 118), a two-figure subject closely related in theme and composition to the paintings of La Giuseppina with a nude model. La Giuseppina's head is now cut off by the frame and the model, still sprawled across the bed in abrupt foreshortening, is clothed. However, her dress has ridden up over her thighs, and her legs are opened wide. When I last saw the picture (in 1965) the Musée de Rouen considered it too *scabreux* to be publicly displayed. This reaction is curious because Sickert's own approach to the subject was totally dispassionate and objective. The picture has none of the sexual undertones, such as hints

at a Lesbian attachment, that Courbet or Toulouse-Lautrec might have given it; it has none of the sensuality that Renoir might have portrayed; and it has none of the hypocritical ambiguousness that so many of Sickert's more repressed English contemporaries commonly gave their pictures of similar content. Sickert's approach to the nude and semi-nude was the same as that of Degas. Women were objects to be painted, with complete detachment, and it was best, metaphorically, to peep through a keyhole in order to catch them unawares and unselfconscious. In *Maria Bionda* (Fig. 126), showing a girl pulling on (or off) her stockings, Sickert painted a more specifically Degas-type subject, although the rough handling with its broadly slashed modelling owes nothing to Degas. In an equally roughly and broadly painted picture, *The Large Hat* (Fig. 124), Sickert's inspiration for the half-length presentation of a woman with breasts bared may have been the traditional Renaissance Venetian formula for portraits of courtesans.

Sickert painted many portraits in Venice and his work in this *genre* was as various as his Venetian landscapes and figure subjects. *The Large Hat* may be called a portrait and two other portraits of now unidentified women, similarly shown in profile, were probably also done in Venice. They are *Danseuse de Memphis U.S.A.* (Fig. 123) and *Woman with Downcast Eyes* (C.191). Sickert's choice of a pure profile pose for these three portraits was unusual. Perhaps he chose this viewpoint for its advantageous presentation of the character of his sitters. The regular profile of *Woman with Downcast Eyes*, and the shading of her face, suggest the sitter as a refined, demure woman; the cheeky tipped nose and the full light on her face and body combine to emphasize the brazen exhibitionism of the sitter in *The Large Hat*; the enigmatic character of *Danseuse de Memphis* is conveyed in the delicate absurdity of her profile silhouette beginning with the huge bang of her hair or hat, continuing through her long nose, and ending with her indeterminately receding chin. In these, as in many others of his Venetian portraits, Sickert seems to have been more concerned with conveying the mood or character of his sitters than with giving an objective transcription of their likenesses. Many of the miscellaneous figure drawings Sickert made in Venice are essentially and primarily character sketches. *The Gondolier* (C.190) is a picture of typically Italian swaggering male vanity; *Superb Stupidity*, a dated drawing of 1903 (C.189), is self-explanatory; *Giorgione S. Silvestre* (Fig. 127) is almost a caricature of a hen-pecked husband and his scolding wife.

The communication of mood and character was clearly of great importance to Sickert when he studied more familiar sitters, himself, and above all La Giuseppina. He could take the same sitter but so alter the mood and the emphasis that he or she appeared as totally different people. For instance in a *Self-Portrait* drawing (Fig. 130) he wore glasses and presented himself as a somewhat owlish, donnish man. In a painted *Self-Portrait* (Fig. 128) he showed himself as haggard and dissolute. The representation of La Giuseppina as a gaunt, hunched, Munch-like apparition squeezed up in the background not only enhances the mood of this painting but also suggests that the Expressionist element noticeable in several of Sickert's Venetian pictures (such as *Le Châle Vénitien*) may have been consciously introduced. In his picture of *La Giuseppina against a Map of Venice* (Fig. 111) Sickert showed her as a tender, young, and innocent creature. In a full-face portrait (C.192) she is still pensive but prematurely tired and haggard, closer in mood and characterization to the figure studies Sickert made of her in her true role, *Putana a Casa* (Fig. 113) and *Putana Veneziana*. In a three-quarter portrait, *La Giuseppina in a Lace Blouse* (C.193), the characterization is less harsh, the colours warmer, the modelling more detailed, and the girl emerges as a very ordinary, mature woman of the Venetian people.

Sickert's three portrayals of La Giuseppina's aged mother, variously called *Mamma mia Poveretta* or *La Vecchia* (Fig. 125, C.182), again show his interest in emphatic characterization. He represented the old woman against his typical backgrounds, once on the floral couch (Fig. 125), once in front of the beribboned washstand (Version 1), and once in the bedroom setting (Version 2) used for *Maria*

Bionda. In all three Sickert concentrated on the head and modelled the face in considerable detail. In Version 1 he painted the gaunt skeletal head with the same curved hatched strokes he used for the lovely ripe nude girl shown in the same setting before the washstand. Possibly the two pictures were somehow related in their conception, showing the traditional contrast of youth and age. In Fig. 125 and Version 2 the paint is applied in small dabs and touches; in texture it has a more solid crumbling quality than is found in any other picture of this period. Perhaps Sickert found this texture useful to communicate the decaying physical reality of this sitter. In all three portraits the extreme age of the face is conveyed by the exaggerated emphasis on its dominant features, the bony nose from which the flesh has all but fallen away, and the hollow reddened eyes. In a sense these portraits must have shocked his contemporaries in England as much as his more explicitly disreputable bedroom scenes. Portraits of old age were generally acceptable if they were unparticularized and wrapped in an aura of deference or sentimentality. Sickert's portraits were brutally frank so that when he showed one of these portraits, *La Vecchia*, at the N.E.A.C. in May 1907, *Truth*, in an hysterical attack, called it 'the "spook" of Rameses the Great . . . converted into a well-preserved mummy'[16], and even the *Pall Mall Gazette* commented that 'Sickert is still young enough to be . . . bent on shocking the Philistine with his over-stated ugliness of the old blear-eyed face'[17].

Two portraits of the same girl known simply as *La Jolie Vénitienne* (Fig. 129, C.183), and a portrait of *La Inez* (C.194) provide a total contrast to these portraits of old age. They are all perfect expressions of the vital beauty of youth, achieved without apparent distortion or exaggeration. As in the portraits of the old woman Sickert adopted a handling ideally suited to his subject. The brushwork has a direct and silky fluency. The faces are modelled in a network of fairly high-coloured hatched strokes which is particularly apt in its expression of life and mobility. This type of handling has been remarked in several of Sickert's Venetian paintings and was perhaps inspired by the broken colour of Veronese.

The paintings showing La Giuseppina with a model are among the two-figure groups which Sickert tackled for the first time during this extraordinarily fertile visit to Venice. *Le Tose* (C.196), showing two girls seated side by side on the couch; *A Marengo* (C.197), showing them seated on the bed gossiping; *Les Vénitiennes* (listed under C.173), a picture related to the La Giuseppina and the model subjects except that both girls are modestly clothed, are more examples of two-figure groups. It is probable that in all these paintings Sickert saw and studied both figures together. This, however, was probably not the case with other two-figure paintings such as *Conversation* (C.195)—the only dated Venetian figure painting of 1903—and *Caquetoères* (Fig. 131). The theme of both paintings is of two women absorbed in gossip. In both the psychological communication between the figures, conveyed in the inclination of their bodies and the direction of their gaze, is intense. However, it is possible that these pictures were expansions of single-figure works and that the compositional and psychological relationships between the individual figures were contrived rather than originally perceived. The standing figure in *Conversation* certainly seems to have been taken from a slightly more detailed study of *La Giuseppina* and there may well have been similar sources for the other figures. The dichotomy in the handling of *Caquetoères*, with the figure on the left represented as a solid silhouette of deep black and prussian blue, her face a flat brown shadow with the eye outlined in black, and the figure on the right painted in broken, juxtaposed dabs of blue and rose, her face in pale pinks and greys, supports the suggestion that the two figures were derived from separate, unrelated sources.

The work Sickert did in Venice in 1903-4 was exceptionally significant in the light of his later development. At the age of 43 he initiated his exploration of the type of subject which was to become characteristic of his work after his return to London, those figure paintings for which he is perhaps best known today and which had, in their own time, a profound influence on a whole generation of younger English painters. In Venice he tackled not only single figures in the intimacy of domestic surroundings

but also two-figure groups which foreshadow the Camden Town 'conversation It pieces'. is true that the compositional integration of figures and settings in many of the Venetian pictures was tentative in comparison with his London work but these first experiments acted as a springboard and a catalyst for his later attempts to resolve this problem. When Sickert wrote to Blanche of being 'perhaps only a rectangular painter' he continued, 'And like everyone else, I am considerably annoyed at not being a "*Universalgenie*"'. Sickert's Venetian experience had made him realize the extent of his attraction towards a rectangular planar disposition of his compositions but this recognition was itself a step towards its solution. The compositions of Sickert's later figure pictures tend to fall into two groups, those in which he accepted his innate 'rectangularity' as a painter and those in which he consciously sought to become a '*Universalgenie*' and dominate the natural rectangular emphasis of his canvas by constructing pictures in depth with a strong diagonal orientation. Moreover, in his alternation between these two compositional formulae Sickert constantly developed greater sophistication and subtlety in contriving the relationships of his figures and their settings. The wide range of Sickert's experiments in handling when in Venice was also of great importance to his later development. Particular usages—such as the dotted and dashed notation employed in some of his pen drawings—were relevant to his later techniques. However, the overall direction of his experiments with different methods of painting was of greater relevance to his general evolution than any one method considered in isolation. Nearly all the methods of handling he employed in Venice were designed to help him discover a shorthand system for stating the essential tones, patterns, and character of his subjects. Swiftness, directness, and economy were the qualities he sought and these were the qualities he continued to develop in his handling of paint over the next few years.

NOTES

1. Letter referred to in Chapter VIII, notes 4 and 12.
2. Letter dated from a remark that Sickert was 'going to exhibit a life sized actress in a crinoline at the *Salon des Indépendants*', that is, *The Pork Pie Hat* (Fig. 64), exhibited in March 1903 (2231).
3. Chapter VIII, p. 65; letter dated in Chapter II, note 15.
4. The entire content of this letter suggests that it was written during Sickert's last visit to Venice and conclusive proof of this dating is Sickert's report that he had offered Bernheim '*la femme en Crinoline des Indépendants*', that is, *The Pork Pie Hat* (see note 2). Bernheim must have accepted the offer because the picture was included in their Sickert exhibition of 1904 (35).
5. Extract from the letter published in *Portraits of a Lifetime*, pp. 46–7, discussed and dated in Chapter VIII, note 17.
6. It is possible that many of the untraced Venetian landscapes are still in private collections in France. Sickert sold many of his Venetian works to Bernheim-Jeune who presumably disposed of them to various French clients. Of the very few Venetian landscapes of this visit which are now known, three were formerly in Parisian collections (*Il Traghetto, San Trovaso,* and *Rio di San Paolo*).
7. This information is contained in the letter of early 1904, dated from the reference to Blanche's pictures at the International, discussed in Chapter VIII, note 17.
8. Emmons, discussing Mme Villain (pp. 82–3), suggests that Sickert was merely a close family friend of the Villain household. This was evidently Sickert's official version of their

association. In a letter of 1901 to Mrs. Hulton, for example' Sickert described Mme Villain as his 'landlady-housekeeper' and told how, for about three years, he had helped to bring up her children for want of anyone else to do so. However, Sickert's letters to close men friends disclose the true nature of his relationship with Mme Augustine Eugénie Villain, known in Dieppe as *La Belle Rousse* because of her handsome appearance and flaming red hair.
9. As he told Blanche in the letter published in *Portraits of a Lifetime*, pp. 46–7.
10. In a letter of early 1904, see note 7 above.
11. 'This is my perfected method up to now. Canvases size 8 prepared in grey (black and white) with oil. A good coat. The first session: everything is laid in from nature covering all the canvas and not permitting the model to move until it is all down. That takes about an hour more or less without moving. When the canvas is covered I start another. Three days or more later (canvases kept round a stove that is always lit) I take up the series again. With a large brush I wash the canvas with linseed oil, which I remove afterwards with blotting-paper, and then I finish off, being guided more by *my own work* from the first impression, than by the model, and keeping within the proportions first indicated, whether they *seem right to me or not*. What you see now at Bernheim's are steps, and sometimes mistaken ones, which have led me to what I am doing *now*—a reclining woman, well painted in oils—I have just counted up 40 canvases on the way.'
12. A sketch of a half-nude woman sprawled on a bed included in

this letter may reflect the painting of which Sickert wrote. Sickert also sketched another painting he had sold to Gonse (Fig. 116).

13. In the letter published in *Portraits of a Lifetime*, pp. 46–7.
14. Ibid.
15. B.43, p. 23. Essay by R. H. Wilenski on Sickert's art.

16. 29 May 1907. We do not know which portrait of the old woman was shown on this occasion. Sickert had shown a *Mamma mia Poareta* at the N.E.A.C. in winter 1906, and was to show another *La Vecchia* in summer 1909.
17. 29 May 1907.

XI

1904-5, Dieppe; 1905-6, London

SICKERT left Venice and returned to France during the summer of 1904[1]. At first, as he explained in a letter to Mrs. Humphrey[2], Sickert regarded his return to France as temporary and he intended to go back to Venice as soon as he could; he seems to have retained his room at 940 Calle dei Frati because this address was listed as an alternative to Neuville in the winter 1904 N.E.A.C. catalogue[3]. It is possible that he returned to France in the summer to help arrange his big exhibition at Bernheim-Jeune in June, although seventy-two of the ninety-six exhibits were on loan from private collectors and only a handful of the remainder (ten pictures) may have been recent Venetian figure pictures[4]. However, pressure of work in France seems not only to have delayed but ultimately to have prevented his return to Venice[5]. Instead, after one more year in Dieppe, Sickert moved back to London.

Dieppe, for Sickert, was primarily a source of landscape subjects and in Venice he had developed a taste for figure painting. It is possible that his eye was weary of Dieppe. The repetition of familiar subjects was often echoed by the repetition of their handling so that a continued succession of Dieppe landscapes might easily have degenerated into a long series of stale versions of old pictures, and there was a real danger that the experimental impetus behind Sickert's stylistic and technical development would be severely cramped. After his return to England, when Sickert spent each summer until the outbreak of war in 1914 once again painting the architecture of Dieppe and the countryside around it, he came refreshed by his rest from landscape work. He painted the old Dieppe scenes with a technique immensely enriched by his experience in other fields, for as he was to write later, 'What landscape by a pure "landscape-man" can you set beside a landscape by Rubens?'[6].

In 1904 Sickert, weary of Dieppe, the 'watering-place-out-of-the-season' as he had called it in 1901[7], yet not ready to go back to Venice, was visited by the young Spencer Gore, nearly twenty years his junior. The enthusiasm with which Gore viewed his work and listened to his accounts of French painting, as well as Gore's reports of a potential renaissance in England with the N.E.A.C. revitalized by new blood from the Slade, must have greatly influenced Sickert's decision to return to London as his next move. Sickert, who always enjoyed the excitement of working together with a group of enthusiastic colleagues, had been rather isolated in Dieppe. There were still the summer visitors—of whom Gore was one—but otherwise the social and artistic circle in Dieppe had hardly altered (except to be thinned) since his first visits in the 1880s. Gore must have told Sickert of Lucien Pissarro who now exhibited with the N.E.A.C. and of the work of such recently graduated Slade talents as John, Gilman, and himself. If Sickert returned to London he could take part in this resurgence of English painting and, in view of his superior age, experience, and knowledge of French painting, he could undoubtedly help direct its efforts.

Nevertheless, Sickert did not return to London at once. He spent a further year in Dieppe, continued to paint landscapes, but also devoted a considerable proportion of his time to figure painting. There are,

in fact, very few landscapes which can be accurately attributed to 1904–5. An exception is a rough sketch on panel of *The Casino* (Fig. 107), dated 1904, in which the paint is smoothly scrubbed in over a reddish ground in patches of blues, greens, purples, and stone colours. There are also a few pictures such as *Corner in Dieppe* (C.159) in which the definition is somewhat casual, the drawing careless, heavy, and imprecisely related to the objects it defines, and the paint fairly dry, qualities which recall the Venetian canal scenes *Il Traghetto* (Fig. 109) and *San Trovaso* (C.161). Such pictures may have been done in 1904. Whereas these landscapes look back, in the broad tonal basis of their approach to Sickert's work of 1898–1900, and in certain details of their handwriting to his Venetian scenes of 1903–4, his figure work of 1904–5 looks forward, in subject, style, and technique, to his later development in this field. He began to tackle what was to become one of his favourite and constantly recurring themes over the next ten years—pictures of nude women lying on metal bedsteads.

As was usual in Sickert's work there are clear compositional interrelationships between the various bedstead pictures which, in this case, extend even beyond those executed at about the same date. For instance the precise details of the setting in *La Belle Rousse* (Fig. 133)—the bed and its placing, the hoop-backed chair glimpsed behind the iron head-rail and the shadow of this chair cast on the wall— are also found in the pastel drawing *Le Lit de Fer* (Fig. 132), although the figure is differently posed. On the other hand, the pose of the figure in *Le Lit de Fer* is very close to that used in *Nude on a Bed* (C.202), but this time the setting, incorporating a brass bedstead, is different. Over the next year or two Sickert then painted several pictures in which he posed the figure in precisely the same attitude as in *Le Lit de Fer* but placed her on the brass bedstead used in *Nude on a Bed* (C.202): examples are *Le Lit de Cuivre* and *Le Lit* (Fig. 142, C.209), probably both painted in 1906, and *Reclining Nude* (C.209) of about 1907 (in which, however, the close view of the figure excludes the setting).

In the nudes painted in France from 1904 to 1905 Sickert overcame the somewhat rigid and formal quality characteristic of much of his Venetian work. He managed, in the first place, to dominate his attraction towards a rectangular planar disposition of his compositions (found not only in most of the Venetian figure pictures but also in the Neuville drawings from the nude of 1902) by constructing pictures with an emphatic diagonal recession. In each picture the bed—which provides the skeleton of the compositional construction—runs right across and up the surface in diagonal receding perspective. In the second place he posed his figures in more relaxed attitudes so that his pictures are more convincing as intimate glimpses into the privacy of a woman's bedroom. In the pastel drawing *Nude Sprawling on a Bed* (Fig. 134), in a painting of a *Nude* and in the preliminary pencil study for this painting (Fig. 136, C.201) the poses, seen from foreshortened angles, are exceptionally informal. These nudes were anticipated by a few Venetian paintings (e.g. Figs. 118, 122) but the abandoned sensuality communicated in the pose of the *Nude* (Fig. 136), and the unusually high viewpoint from which she is presented, are even more reminiscent of Bonnard's work, in particular of his *L'Indolente: Femme assoupie sur un Lit* of 1899. Sickert, of course, had many opportunities to see Bonnard's work. Not only did they both deal with Bernheim-Jeune but they shared many private collectors (such as André Gide)[8].

The suggestion that Bonnard may have been a valuable source of inspiration, perhaps not only for this *Nude* painting but for the entire series of the Dieppe nude pictures, is supported by certain characteristics of their handling. Their muted tonalities, the dominance of olive green in their colour schemes, and especially the way Sickert tended to build up the contours of his figures in linear smudged strokes of shadow recall, for example, the undated (Bowers Coll., Paris) version of *L'Indolente*. However, the general character of the development of Sickert's style and technique in these paintings is of more interest than specific, possibly derivative, features of their handwriting. Sickert seems to have been influenced by the tendency, common to many French painters at this time, towards an increasingly

expressive freedom in their handling of paint. In *La Belle Rousse* (Fig. 133), for example, Sickert applied the paint more loosely than ever before in free juxtapositions of squarish dabs; he also continued to evolve the expressive shorthand notation of the details which he had begun to use in Venice. The face of *La Belle Rousse* is painted as an area of uniform shadow with the features suggested by carelessly applied dark gashes. The genesis of this type of handling as a whole may be recognized in some of his Venetian work and, when it had been further developed and refined, it was to reach a magnificent culmination in the nude paintings of 1906.

The exact date at which Sickert returned to London in 1905 is unknown[9], but he was evidently there before the autumn because the address he gave the *Salon d'Automne* in that year was in Fitzroy Street and he included several London works among his exhibits. *Chambre dans Bloomsbury* (1430) is unidentifiable from its title alone but the pastel *Cocotte de Soho* must be the drawing of that name showing a half-length woman with shoulders and breasts bared (Fig. 135). Sickert evidently favoured pastel as a medium at this period. Four of the eight works he showed at the *Salon d'Automne* were done in pastel (one of them being *Le Lit de Fer* discussed above). The rich broken effects obtained with strokes of pastel probably suited his current tendency to work swiftly and loosely. Another London work shown in Paris was *Une Tasse de Thé*, which must be one of the two versions of a composition showing a figure seated by the table in Sickert's Fitzroy Street studio alternatively known as *A Cup of Tea* or *A Cup of Coffee* (Fig. 140, C.205). It is interesting that in these two pictures Sickert reverted to the severely parallel rectilinear organization of his canvas typical of his Venetian work, although in other pictures of the same date such as *The Visitor* and *La Russe* (Fig. 139, C.206) showing the same corner of the studio with its table, bentwood chair, and two pictures on the wall behind, he maintained his current preference for a diagonally orientated construction. Moreover, whereas in *La Russe* and more particularly in *The Visitor* the paint is applied with a certain fluency, and the figure definition is graceful, in the two versions of *Une Tasse de Thé* the painting and the drawing have a crudely violent quality. The tonality of both pictures is sombre, the colours used are predominantly dark, olive greens, prussian blue and black. The paint is smooth, flat, and rather messily applied but in some passages, notably in Version 1, a more disturbed broken *facture* is employed. The drawing in both versions is explicitly stated in rather thick black outlines, and the faces are defined by casual jabs of paint denoting the features. The result is an ugly, although expressive, distortion of the faces and figures which is further emphasized by the curiously ambiguous relationship of the cast shadows to the figures.

The crude, expressionistic quality of these two paintings suggests that Sickert was aware of the work of several of his younger French contemporaries, who were soon to astound the public with the exhibition of their pictures at the same *Salon d'Automne* where Sickert showed *Une Tasse de Thé*. Indeed, the mood, character, and handling of another painting of a *Nude* (Fig. 141) suggest that Sickert may well have returned to Paris in the autumn to see this *Salon d'Automne*[10]. This picture is related to the nude paintings Sickert had executed in France from 1904 to 1905 in its subject—a woman lying sprawled on a bed; in the diagonal alignment of its composition; and in the precise pose of the figure (which is very close to that of *La Belle Rousse*). It was, however, probably painted in London because, unlike the nudes painted in France, it is executed on an English size canvas. Its mood and handling are also different from the French nudes. It is a fierce, brutal painting. Jabs of broken colour are thickly scattered over the first smooth but messily applied coats of paint; heavy dark lines crudely define the contours of the body; lopsided dark gashes denoting the features cruelly distort the face. All these qualities represent the harshest exaggerations of features individually present in Sickert's handling after his last visit to Venice, and the brutal character of this handling was certainly closely anticipated by *Une Tasse de Thé*. However, something more, the impact of a recent visual experience, must have sparked off the particularly harsh brutality found in this *Nude* (Fig. 141). The most tempting

explanation is that its violent expressionism was a direct result of Sickert's encounter with the contents of the notorious *Fauve* room at the *Salon d'Automne*, although Sickert's rejection of bright colour in favour of a muddy scheme of rusts, salmon, and grey-blacks tends to disguise the similarity between his own work and that of the *Fauves*. Possibly Sickert was most deeply and directly influenced by Rouault. Rouault's subject matter—shabby whores instead of gorgeous courtesans—was the type that attracted Sickert: Rouault also denied the bright colour and the joyful hedonism of Matisse and his colleagues. Sickert's use of crude, thick outline drawing, the cruel distortions resulting from his short-hand notation, and his harsh brutality of mood and means of expression, could all have been inspired by Rouault's work[11].

Sickert did not repeat the particularly violent experiment in style and handling of this *Nude*, although he did continue to develop methods of applying the paint freely, directly, and expressively. His nude paintings of early 1906 can be roughly divided into two stylistic groups, both direct and expressive although in one group the handling is exuberant, in the other it is concise, even summary. Examples of paintings belonging to the former group are *Le Lit de Cuivre*, *Le Lit* (Fig. 142, C.209) and *Nude Stretching* (Fig. 143). The paint is drier, more crusty, and more opaque than in the 1904–5 nudes; explicit drawing is abandoned; and above all much greater variety obtains in the brushwork. The surface of each of these pictures is a complicated interlocking pattern of irregular stains, slashed and scraped strokes (some probably laid on with a knife), and broken dots and dabs of different colour and tonal values. The exciting *bravura* of this handling gives the impression that the pictures were dashed off with all speed but in fact the constructive relevance of each stroke is immeasurably greater than in Sickert's earlier nude paintings. The integration of the brushwork and the precision of the placing and tonal value of each mark must have necessitated very careful planning to communicate so complete an understanding of the forms represented.

La Hollandaise (Fig. 144) and *Nuit d'Été* (Fig. 147) are examples of nude paintings belonging to the second stylistic group. The most remarkable aspect of these pictures is the extreme economy of their treatment. The paint has the same dryness and opacity as in the *Le Lit de Cuivre* group but it is less crusty; the brushwork is extraordinarily direct and spontaneous but it totally lacks the exuberant variety of *Le Lit de Cuivre*. Sickert used mainly linear strokes, broad scrapes and slashes in the bedclothes and in the highlights defining the contours of the body, smaller parallel hatched strokes to model individual forms and, in *La Hollandaise*, a revival of drawn dark outlines in certain passages. The economical execution of these paintings does not in any way diminish their descriptive force. The execution is so disciplined that every mark is relevant to the picture as a whole and there are no super-fluous touches. The use Sickert made of the dead-colour preparation was an important factor in permitting this concentration. It is an active ingredient of the total tonal scheme, acting as a middle tone which shows through the thinly scraped whites of all but the brightest highlights. The condensed quality of the handling is brilliantly demonstrated by such ruthless elisions as the dark stroke of the bed-rail in *La Hollandaise* which also indicates the tonal caesura between the twin highlights of the model's cheek and ear. One feels that this type of conciseness was the effect Sickert aimed at in pictures like *La Belle Rousse* (Fig. 133), but his handling then lacked the necessary discipline. For example, the highlights in *La Belle Rousse* were rather amorphous and meaningless whereas in *Nuit d'Été* and *La Hollandaise* they explain the form by their shape, quality, and direction; similarly the dark accents in the face of *La Belle Rousse* were more carelessly placed than in the 1906 pictures.

The economy of *La Hollandaise* was taken to a further extreme in *Mornington Crescent, Reclining Nude* (C.225) and *Mornington Crescent, Contre-Jour Nude* (Fig. 146). The paint in these pictures is floated onto the canvas very smoothly and thinly. The definition is radically simplified, the forms are flat un-particularized shapes of light and shadow. The nude in the *contre-jour* picture is a true silhouette and

when painting it Sickert must have recalled Degas's *Femme à la Fenêtre* which belonged to his former wife. The simplification of *Reclining Nude*, and especially the schematic outline drawing, look back to Sickert's Venetian figure pictures. Miss Browse[12] perceptively noted the similarity of *Reclining Nude* to a Braque of the mid-twenties; the rhythms, the colours (chocolate, olive green, white, tomato, and black), the patterns of lines and shapes, do indeed remind one of Braque's later lyrical work; but in the context of Sickert's development both these pictures were sterile. Sickert's development for the next few years was to be towards the enrichment of his pictures, in terms of their compositions, the texture and quality of their paint, and the communication of the nuances of form and light. Nevertheless, it may be said that these *Mornington Crescent Nudes* provided a point of departure for Sickert's younger contemporaries. Gore's *Behind the Blind* of 1906 is so close to the *contre-jour* picture in conception, composition, and handling, that he must have painted it alongside Sickert in his studio. There are indeed several examples of pictures painted by Sickert and Gore at this period which may have been the result of some sort of collaboration or co-operation between the two artists. Sickert's *Nude behind Flowers* (Fig. 148), which consists of a summarily painted nude in the background (similar in its radical tonal simplification to *Mornington Crescent, Reclining Nude*) with a vase of flowers in the foreground, was probably painted at approximately the same time as Gore's *Self-Portrait* with a still life of flowers in the foreground. The device used by both artists of making the figure play a subordinate role to the still life may have been inspired by Degas (e.g. *The Woman with Chrysanthemums*). Whether Gore or Sickert first had the idea of using the device is uncertain but it is probable that each encouraged the other to experiment with a painting of this kind.

The settings and compositions of most of Sickert's 1906 nudes were much less simple and empty than his earlier metal bedstead pictures. In *Le Lit de Cuivre* and *Le Lit* the compositions, taken directly from the pastel *Le Lit de Fer* and related pictures, contain only the bed and nude, but in *Nude Stretching* the setting is the diagonally aligned corner of Sickert's Fitzroy Street studio, with its table, chair, and pictures on the wall, as well as the bed. In *La Hollandaise* and *Nuit d'Été* Sickert used a new setting and composition. He reverted to a parallel planar arrangement, but now he gave it great depth by placing the bed, and the figure on it, in full foreshortening. He also suggested a complete bedroom setting, so that these nudes more closely anticipate similar subjects of his mature Camden Town period. This is also true of the two *Mornington Crescent Nudes* in spite of their planar construction and shallow space.

Sickert's clothed figure subjects of the first half of 1906 show a parallel development. The settings grew more elaborate, the spatial constructions more complex, and the handling richer and fuller. He painted single-figure subjects, *Easter Monday—Hélène Daurment* (Fig. 151), *Fancy Dress—Miss Beerbohm* (Fig. 149), *Woman in Red against Green—Mrs. Neville* (C.226), and he resumed his interest in two-figure groups of women in conversation which he had first tackled in Venice, *Belgian Cocottes* (C.227) and *Les Petites Belges* (Fig. 150), both representing the sisters Jeanne and Hélène Daurment, who sat for Sickert intensively for about three months[13]. There is unusually complete documentary evidence for dating these pictures. At Easter 1906 Sickert sent his friend Mrs. Swinton postcards on which he sketched the pictures he was currently painting. Each of the figure subjects named above was sketched for Mrs. Swinton.

The setting for all these pictures is once again the Fitzroy Street studio used in 1905 for the two versions of *Une Tasse de Thé*, *The Visitor*, and *La Russe*, and in 1906 for *Nude Stretching*. However, in all but *Woman in Red* which strongly recalls the Venetian women on couch pictures, the setting is more elaborate than in the 1905 pictures. This is even true of *Easter Monday* in which Sickert revived the shallow horizontal planar format characteristic of his Venetian compositions and of *Une Tasse de Thé*. In all the pictures, *Easter Monday* included, the space is completely filled in every dimension; the separate components of the compositions—figures and furniture—are represented on overlapping planes

and this helps the full integration of figures and settings. The simplified but dislocated rhythm of many of Sickert's earlier figure pictures—resulting from the isolation of the individual units of their compositions—is entirely overcome. Moreover, much greater surface interest is created in these pictures by the addition of a couch—sometimes covered in a floral material, sometimes by a striped silk spread—to the usual Fitzroy Street studio properties. Sickert's delight in the consequent contrasts of patterns and textures anticipates his later Camden Town figure pictures.

The handling of *Belgian Cocottes, Easter Monday*, and *Woman in Red* is closely related to Sickert's work of 1904–5. The paint is similarly applied in slightly smudged stains overlaid by smaller dots and dashes of more broken colour, although the brushwork, especially in *Easter Monday*, is slightly more delicate and explicit drawing is omitted. The underlying hint of expressionist violence, recognized in several of the 1905 pictures which were handled in a similarly summary manner, is also lacking. In *Fancy Dress* and *Les Petites Belges* Sickert used the more exuberant, richer techniques seen in such nudes of 1906 as *Le Lit de Cuivre*. The forms are dissolved by the consistent application of thicker, more crusty paint in smaller broken dots, dashes, and slashed strokes.

After his return to London Sickert also resumed his interest in portraiture. During his Camden Town period, from 1905 to 1914, Sickert painted very many portraits. These were usually not formal commissioned works, although *Lady Noble* (Fig. 138) may have been ordered through the agency of Jacques Blanche. Some were portraits of his friends and colleagues and even more were portrait studies of members of his studio *ménage*, his cleaners, odd-job men, and the models he employed for his interior figure subjects. In 1905–6, for instance, he painted at least three portraits of his friend Mrs. Swinton, and two pastel portrait studies (C.224) as well as two oil portraits of a model said to be his charwoman Mrs. Barrett. *Lady Noble* was probably painted *c*.1905–6. It is an exquisitely delicate portrait, sombre in tone but glowing in colour (the dress is scarlet with grey lapels; the black hair is set off by a brilliant yellow bandeau). The hatched brushwork used to model the face in coloured strokes of grey and pink is similar to that used in the *Mrs. Swinton* portraits of 1905 (Fig. 137, C.203) although the qualities of tone and colour anticipate the *Mrs. Swinton* of *c*.1906 (Fig. 157). The portraits of Mrs. Swinton are highly stylized and formal in conception, if not in execution. In the two versions painted in 1905 (the smaller picture, Fig. 137, is so dated) and in the third, somewhat different composition painted *c*.1906, Sickert set off the very dignified and gracious figure of his sitter (head and shoulders in the 1905 versions, half-length in the 1906 picture) against a background of the Venetian lagoon. This was, however, an entirely artificial, even theatrical conception because Mrs. Swinton had never been to Venice. The portraits were painted in Sickert's Fitzroy Street studio, from life, from drawings taken on the spot, and from photographs[14]. The posture of the sitter, and in the 1905 versions the severe cut of her dress, give her an air of aloofness but this is counteracted by the tenderness of Sickert's execution. The faces in particular are modelled in a fine network of parallel hatched strokes of blues, pinks, and greys which closely resembles the pastel-like technique Sickert had used in Venice for such portraits as *La Jolie Vénitienne* (Fig. 129, C.183). The treatment of the 1906 version of *Mrs. Swinton* is different. The brushwork is much freer and more haphazard; it approaches the exuberance of such paintings as *Le Lit de Cuivre*. Most remarkable, however, is the way Sickert transformed his original document (a sedate photograph of Mrs. Swinton in formal day dress, sitting in a studio) into this highly dramatic, even romantic portrait; the black and white severity of the sitter's dress was translated into a brilliant fiery scarlet evening gown; the studio has become a storm-tossed sea. The whole conception of the portrait is immensely theatrical and imaginative. The portrait studies of *Mrs. Barrett*, on the other hand, are intimate, natural, and casual. The sitter is shown within a bedroom setting and one of the two portraits even has an alternative anecdotal title, *Blackmail*, which anticipates the later Camden Town subjects.

Mrs. Barrett was one of Sickert's favourite sitters. There are two painted portraits of her (Figs. 152 and 153) among the group of portraits on which we know he was working around Easter 1906 from the sketches he sent to Mrs. Swinton, and he painted yet more portraits of her in 1907–8. The Swinton sketch sheets also prove that two portraits of the Daurment sisters, one called *The Belgian Cocotte* (Fig. 154), the other, *Jeanne—The Cigarette* (Fig. 155), and a *Head of a Woman* (C.228) were also works of around Easter 1906. *Le Journal* (C.229), a foreshortened head of a woman reading a newspaper lying on the same striped-silk-covered couch used in several of the Fitzroy Street figure subjects of Easter 1906 as well as in C.228, is clearly a contemporary work.

All these head and shoulder portraits except *Le Journal* are very directly and simply presented with none of the theatrical trappings of the *Mrs. Swinton* portraits and no hint of the pervasive serpentine rhythms which Sickert was to introduce into his bust portraits of 1907–8. The pure profile presentation of *Jeanne—The Cigarette*, one picture of *Mrs. Barrett* (Fig. 153), and the *Head of a Woman*, recalls Sickert's Venetian portraits, as does the somewhat racy, high-handed characterization of all but the full-face version of *Mrs. Barrett* (Fig. 152). The handling of the whole group is basically similar although it differs in emphasis from portrait to portrait. The olive greens and black or brown colour schemes, the sombre tonality, the dark underpainting incompletely covered by smooth overlapping stains of paint, the softly smudged uneven dark lines used to outline the shadowed side of the faces and features, and the superimposition of little dots and dabs of paint to define the more detailed passages of modelling, are qualities common in greater or lesser degree to the handling of all the portraits. The kind of difference between them is illustrated by the way the small dabs of paint used to model the lights in the full face of *Mrs. Barrett* are more boldly and coarsely stippled in *The Belgian Cocotte* and the profile *Mrs. Barrett*. *Head of a Woman* is the most summary of the group and is especially close to such 1905 paintings as *Une Tasse de Thé*, although the drawing is less harsh and the definition less distorted. In general, however, the handling of these portraits reveals the same kind of constructive quality as is found in the contemporary figure pictures. Sickert's rejection of the graphically conceived hatched modelling, used for the faces of the 1905 *Mrs. Swinton* portraits and for many of his earlier Venetian portraits, in favour of a much more painterly application in little stains, dots, and dabs, could have resulted in a disintegration of the form had he not thoroughly planned his execution. The broken dots and dabs of paint are not mere gestures to demonstrate Sickert's awareness of, and ability to use, a currently fashionable handwriting (as one feels was partly the case in the *Fauve*-like *Nude*, Fig. 141, of 1905). Each touch of paint is relevant to the total plastic realization of his subject, although each mark only takes on its significance when seen in relation to the surrounding touches. The integrated constructive quality of Sickert's brushwork in the full face of *Mrs. Barrett* is particularly mature and confident. Although it is handled in the same manner as the other 1906 portraits the paint is applied with more apparent care and delicacy and the characterization is more tender. These qualities, however, were not unique in 1906 to *Mrs. Barrett*. *The Old Model* (Fig. 158) displays the same relatively high degree of finish and the same delicate definition of the face with its carefully placed constructive dabs of stippled paint.

By the first half of 1906 Sickert had established much of his repertoire for the Camden Town period, informal portraits of both nude and clothed figure subjects, although his figure pictures, particularly the nudes, did not yet possess the anecdotal undertones characteristic of the later Camden Town period. The anecdotal content of these later pictures was largely a consequence of the psychological relationships of his figures to each other, particularly of the women, clothed and nude, to the men, whereas in 1906 his clothed conversation groups were of women only and his nudes (apart from the odd Venetian example) were as yet shown alone. Nevertheless, by mastering the problems of integrating figures and settings, and by experimenting with various methods of expressing the form and character of his figures, he had established the necessary basis for his future development.

In the summer of 1906 Sickert also rejoined the N.E.A.C., from which he had resigned in the winter of 1897. Although he had continued to exhibit regularly with the Club as a non-member until spring 1902 he had shown only two pictures since then, both in the winter of 1904. Sickert's rejoining is a sign that he was ready to accept the implications of his return to London and enter the fray once again as a leading member of the new generation of progressive painters.

Sickert showed only one picture at the N.E.A.C. in the summer of 1906 but by the winter he was elected to the executive committee and selecting jury[15] and showed four pictures, three of which were earlier Venetian works. The picture he showed in the summer was *Noctes Ambrosianae* (Fig. 159), one of the group of music hall paintings which Sickert painted in London in the first half of 1906. As far as is known, Sickert had painted no music hall pictures except *Ta-ra-ra-bom-de-ay* (a version of *Katie Lawrence at Gatti's* listed under Fig. 28, C.42) since he had left London in 1898, so that *Noctes Ambrosianae* and its contemporaries were a belated but magnificent reintroduction of such subjects into his repertoire. In a sense his exhibition of *Noctes Ambrosianae* at the N.E.A.C. stands in the same relationship to his future production and fame in this *genre* as did the exhibition of *Katie Lawrence at Gatti's* when he first joined the N.E.A.C. in 1888. However, the position of the N.E.A.C. in 1906 was not the same as it was in the late 1880s and the 1890s. Then it had been a rebellious young society and the object of critical contumely. Now, although there was as yet no alternative forum for the *avant-garde*, it was almost respectable. Its former young progressives were members of the establishment, teachers (especially at the Slade where Brown, Steer, and Thompson all taught) and critics. Those who still exhibited with the Club, like the ever-faithful Steer, painted in an acceptably traditional English manner, while new stars such as John had qualities which even the most philistine could appreciate. Only the most old-guard critics still indulged in the former-style invective (the reviewer of *Truth* was such a one) and the new tone of acceptance was set by such enlightened periodicals as the *Saturday Review* (with Arthur Symons as its critic) and the *Athenaeum* (with Roger Fry and then Walter Bayes). Indeed in the winter of 1906 the *Athenaeum*, welcoming Sickert's contributions to the N.E.A.C., remarked that his *Mamma mia Poareta* made Mr. John's *In the Tent* appear 'a little tame' and continued, 'May we look to Mr. Sickert for a revival of that diablerie which we associate with his name, and which is a little wanting in the heavier-handed New English Artists of this generation?'[16]

Noctes Ambrosianae is a representation of the gallery of the Middlesex Music Hall of which Sickert painted two nearly identical versions. In 1906 he also painted another view of the gallery of the Middlesex showing the audience from behind, standing to look towards the stage, and in this or perhaps the next year he painted its orchestra pit. The Old Bedford, formerly Sickert's favourite music hall, had been burned down in 1899 while he was living in Dieppe; evidently when he returned he did not transfer his affections at once to the extravagantly ornate and splendid palace which replaced it, although from 1907 onwards he was to frequent and paint the New Bedford as assiduously as he had the Old.

Sickert welcomed his renewed activity as a painter of music halls with great enthusiasm. He wrote to Blanche in 1906, 'I have started many beautiful music-hall pictures. I go to the Mogul Tavern every night', and in another letter of the same year, 'I am night and day absorbed in two magnificent Mogul Tavern pictures each measuring 30 inches by 25. Every night drawing'[17]. All Sickert's Middlesex—Mogul Tavern as this hall was affectionately nicknamed[18]—paintings were done on canvases of this size (although all are horizontally aligned) so that it is impossible to decide which were the two 'magnificent' pictures among the 'many' mentioned in the first letter. However, it is probable that one was the version of *Noctes Ambrosianae* shown at the N.E.A.C. in 1906 and later in the same year at the *Salon d'Automne* (Fig. 159), a painting to which Sickert was to refer repeatedly, and with great pride, in his letters to William Rothenstein written from Paris in the autumn of 1906[19]. The other may

well have been the *Gallery of the Old Mogul* (C.240) which Sickert was also to exhibit in Paris at Bernheim-Jeune in January 1907, and which Blanche himself was later to buy from the sale of Sickert's pictures held at the Hôtel Drouot sponsored by Bernheim-Jeune in 1909.

Like the *Old Bedford Gallery* pictures of the 1890s *Noctes Ambrosianae* and the *Old Mogul* show the gallery audience only. In the *Old Mogul*, by representing the figures from the back, Sickert carried the isolation of this segment of the interior even further although his inclusion of part of the stage—or cinema screen[20]—in the background as their focus of interest helps to substantiate the relationship of the figures to their setting. The fertility of Sickert's invention when he returned to music hall subjects was exceptional. The compositions of *Noctes Ambrosianae*, *The Old Mogul Gallery*, and *The Old Middlesex* (Fig. 160, C.230) are all different. *Noctes* is a rectilinear picture, constructed in parallel planes, and in this construction it recalls Sickert's early music hall arrangements, although it no longer represents the stage and stalls. *The Old Mogul* is constructed along an emphatic diagonal recession, a new departure for Sickert's music halls. *The Old Middlesex* is even more daring and sophisticated. It represents a segment of the audience and orchestra, seen again in diagonal recession, but arbitrarily excised from their surroundings. There is no horizon to the picture and its claustrophobic conception is mitigated only by minimal indications of the architectural framework, the shallow curve of the stage-box rail in the foreground, and the rail dividing audience and orchestra. In both *The Old Mogul* and *The Old Middlesex* Sickert retained his Degas-inspired conception of thrusting the spectator right into the picture, but he heightened the immediacy of this confrontation by representing much less formally contrived views of his subject than he had ever done before. The colours and tonal schemes of all three subjects are very dark and gloomy—more so indeed than any of Sickert's earlier music halls with the possible exception of the *Katie Lawrence at Gatti's*. Black is much used in all the pictures. The individual definition of the figures, especially in *Noctes Ambrosianae* and *The Old Middlesex*, is much more careless than in Sickert's early music halls and betrays the same kind of expressive, free notation as in the 1906 figure paintings. *The Mogul Gallery* is also summarily executed but the spare economical paint surface is accented by the use of sharp, somewhat schematic drawing. This type of drawing, which was to recur in several of Sickert's Paris music hall paintings of 1906 and 1907, is also found in some of his music hall drawings of this period. Black chalk with white heightening, often supplemented with pen and ink drawing, became his preferred medium for music hall sketches. Many of these are quick on-the-spot notes similar in character to his early music hall sketches but others have a new pictorial richness and softness, and one, a full compositional study for *The Old Middlesex* (Fig. 161), is drawn with an exciting variety of stroke new to Sickert's drawing in general; most remarkable is his use of small, erratic, dashed pen and ink strokes to suggest the gloomy ambience of the audience in the pit.

Sickert's renewed study of the London music halls so far revived his interest in this type of subject that when he went to Paris in the autumn of 1906 he spent a large part of his time painting the halls of Paris—a subject he had not tackled during the time he actually lived in France.

NOTES

1. André Gide met him in Dieppe on 8 September 1904 (see *Journals*, Vol. I, 1899–1913 in the four-volume edition, trans. and ed. J. O'Brien, London, Secker and Warburg, 1947, p. 120), and Sickert mentioned in a letter to Mrs. Humphrey that he had been visited by Mrs. Neville in Dieppe 'in the summer before your baby was born' (the baby, Cecil Albert Humphrey, was born 17 October 1904).

2. In his letter to Mrs. Humphrey written from Dieppe after 17 October 1904 (see note 1) Sickert wrote, 'I am hard at work and off back to Venice soon'.

3. The listing of this address in Venice misled Miss Browse (B.60, pp. 26, 60) into believing that Sickert stayed in Venice until at least December 1904.

4. The titles of Nos. 10–19 inclusive were of figure pictures

although nothing in their brief descriptions proves that they were of Venetian origin (e.g. *Devant la Glace, Jeune Femme, Le Déshabillé* etc.). The private collectors who lent works to this exhibition were all French. They included Jacques-Émile Blanche (32 pictures) who also wrote the catalogue preface, Gide (6 pictures) and Tavernier (10 pictures).

5. In another later letter to Mrs. Humphrey (it refers to some Whistler paintings mentioned in the letter written after 17 October) Sickert wrote, 'It strikes me you may think I am in Venice. But I have been kept here finishing some work.' There is no evidence to suggest Sickert did eventually get back to Venice.

6. The *English Review*, March 1912, pp. 713–20, 'A Critical Calendar', p. 717.

7. Letter to Mrs. Hulton, quoted in Chapter X.

8. Neither version of *L'Indolente* (that is the dated version in the Musée National d'Art Moderne, Paris, or the undated version in the Bowers Collection, Paris) was publicly exhibited between their execution and 1904–5.

9. It has been suggested (Emmons, p. 119) that Sickert's return was prompted by the Whistler Memorial Exhibition held in London from February to April 1905. Sickert was not, however, concerned with the exhibition in any official capacity as his name is not acknowledged in the catalogue.

10. Once again, the fact that Sickert crossed the channel quite casually, for visits unrecorded in the literature, must be stressed. His mother's letter of June 1886 mentioning a trip to Paris for a few days to see the *Salon* was quoted in Chapter II, note 24. His trip to Newhaven 'on affairs' in 1899 and his visit to London at Christmas 1902 were quoted in Chapter VII, note 1.

11. Even if Sickert did not see the 1905 *Salon d'Automne* he could have seen Rouault's work in Paris before his return to London, for example at the earlier *Salon d'Automne* exhibitions of 1903 and 1904. An interesting comment on his awareness of European Expressionism is the inscription on a rare soft-ground etching of c.1906, 'Souvenir of Simplicissimus'.

12. p. 73.

13. Stanley Smith interviewed Jeanne Daurment for a programme broadcast by the B.B.C. on 18 August 1960 in which she recalled her time as Sickert's model. Mr. Smith also kindly acted as an intermediary between myself and Miss Daurment to answer further questions.

14. Information given to me by Mrs. Swinton. The Fitzwilliam Museum have a photograph of Mrs. Swinton which was used as a document for their painting of her (Fig. 157). The photograph is described in the text.

15. Although elected to the jury Sickert did not in fact serve as he was delayed in Paris. He wrote to William Rothenstein, 'I can't alas serve on the N.E.A.C. jury. Have written Bute. Sent 6 pictures' (only four were eventually exhibited). This letter is third in a series of six written during the autumn of 1906 from Paris to Rothenstein (for dating see Chapter XII, note 1).

16. 15 December 1906.

17. The first letter is neither addressed nor dated but references to a Conder exhibition in Paris and Blanche's preface to its catalogue prove it was written in 1906 when a Conder exhibition, with a catalogue preface by Blanche, was held at Durand-Ruel, 2–14 April. The other letter is addressed 'Mgnt Cres./6/Camden Town/N.W.' and Sickert's remark that he had lent 'Neuville to a talented young painter called Gore' proves its date as 1906. Further confirmation for this dating is contained in the postscript in which Sickert expressed a desire to become an English member of the *Salon d'Automne*. He was elected *sociétaire* in 1907; it was probably too late for Blanche to arrange his election for 1906.

18. The Mogul Tavern had been renamed the Middlesex Music Hall in the 1870s but it seems familiars of the hall continued to call it the Mogul Tavern, the Old Mo', or the compound the Old Middlesex (for a history of the hall see MacQueen Pope, *The Melodies Linger On! The Story of Music Hall*, London, Allen, 1950, pp. 140–1).

19. He wrote of painting pictures 'as good as Noctes Ambrosianae', and remarked, 'it is odd that the painter of Noctes Ambrosianae should have to produce under conditions resembling the suppleness and rapidity of a sword-swallower'.

20. Music halls did sometimes give cinematic performances and the background of this picture certainly resembles a cinema screen. At the N.E.A.C. in the winter of 1912 Sickert showed a painting called *Cinematograph*.

XII

1906–7. Paris

I N the autumn of 1906 Sickert went to Paris. In a series of six letters to William Rothenstein he described his current work[1]. In the first letter he reported that he was 'doing a whole set of interiors in the hotel, mostly nudes' and 'a picture of the Montmartre theatre'. In the third letter he wrote that he was 'finishing important music halls here 6 canvases'. In the next letter, full of confidence and enthusiasm, he told Rothenstein, 'I am finishing some *busters*', and in the sixth letter he was more explicit, writing, 'I want another fortnight here to finish 4 or 5 pictures as good as Noctes Ambrosianae, only red and blue places, instead of black ones. The Eldorado, the Gaieté Rochechouart, the théâtre de Montmartre.' By December Sickert was back in London—perhaps only briefly to see to 'subletting Fitzroy Street or selling the furniture there. I shall keep Mornington Crescent only'; it is probable that he returned to Paris in January to supervise his big exhibition at Bernheim-Jeune[2].

Examples from the set of nudes painted in Sickert's hotel—the Hôtel du Quai Voltaire—include *Woman Washing her Hair* (Fig. 170, C.248), *Le Cabinet de Toilette* (C.253), *Seated Nude* (Fig. 171), and *Jeanne* (Fig. 168). They are most unexpected in composition, style, and technique. In comparison with Sickert's figure paintings of 1904 onwards their whole conception, in terms of composition and execution, has a classical restraint and formality. The almost expressionist violence of mood and handling and the dramatic compositional constructions which Sickert developed in different measures in his nude paintings of these years are rejected. In the Paris hotel nudes of autumn 1906 Sickert reverted to a shallow, horizontal planar arrangement of his picture space. In *Jeanne* the model lies along a bed set parallel to the surface; the depth of the picture, closed at the back by a curtain or wall, is sufficient only to contain this bed. In the other three pictures the space is again limited but the model is out of bed engaged in her *toilette*. These are not just studies of the nude but are truly *intimiste* pictures in the tradition of Degas (of whom Sickert told Rothenstein he saw 'a good deal'[3]) and more particularly of Bonnard. Their spatial constructions, with the vertical divisions of the background wall affording glimpses into the small closets beyond, are directly derived from Bonnard as is their virtual *horror vacui*—a most significant feature in view of Sickert's earlier difficulties with the problem of adequately filling the space in his figure pictures. When Sickert was painting this series of nudes the *Salon d'Automne* exhibition (containing ten of his own pictures) was currently on view. It included three pictures by Bonnard, one of which—*Le Cabinet de Toilette* (from the Katia Granof Collection) is especially close to Sickert's *toilette* pictures in subject and composition[4]. The landscape, *La Seine du Balcon* (Fig. 196), a view taken from the Hôtel du Quai Voltaire, confirms that Bonnard and his circle were a primary source of inspiration to Sickert at this period. It is unique among Sickert's landscapes in the decorative formality of its conception; the horizontal planar arrangement of balcony, embankment, and river are made to read as bands climbing the surface rather than receding into depth; the surface

pattern created by these bands is dominated by the decorative iron-work motif of the balcony which covers over half the picture, while in the upper segment Sickert forced the interest to remain on the surface with the verticals of the trees and the quaint little frontal figures. The artificial decorative stylization of this landscape is wholly within the *Nabi* manner.

The nude paintings, however, are more than just pastiches of Bonnard. Their subject matter and compositions are perhaps less significant than is the linear basis of their stylistic character. The rectilinear formality of their compositional constructions is complemented by the linear treatment of the figures. Sickert had often before used drawing to indicate or accent his figure definition but in these pictures, particularly in the *toilette* subjects, the outline drawing is used more deliberately to establish the rhythms and counterpoint of the compositional structure. It forces the figures to be read in abstract terms as integral elements of the total composition, much as if they were part of a still life. It is this which constitutes the basis of their formal and restrained classical quality and which reminds us at once of Cézanne. The quality of the outline drawing with its feeling for the direction of the form it circumscribes—especially in *Le Cabinet de Toilette* (C.253)—is very like Cézanne and is quite different from the more Bonnard-like smudged linear strokes of shadow which define the contours of many of Sickert's 1904–5 nudes, and different from the cruder Rouault-type outline drawing he had used towards the end of that period. The faceted modelling of the figures—again especially in *Le Cabinet de Toilette* but also in passages of *Woman Washing her Hair* and *Seated Nude*—with its controlled interlocking of somewhat angular stains of closely-related tones, is also remarkably like Cézanne. Sickert's opinions of Cézanne are generally believed to have been very adverse, but this is a false impression created by the extreme position he felt impelled to occupy in his public writings to counter the ferocity of the Cézanne mania which swept England a few years later[5]. In fact Sickert had great respect for Cézanne's achievements and was particularly impressed by his ability to paint with '*des minces couches superposées*'[6] which was the basis of his modelling technique. In 1906 there were ten pictures by Cézanne at the *Salon d'Automne* which Sickert undoubtedly saw, although among them were only two figure subjects, both portraits. Nevertheless the qualities which Sickert seems to have taken over from Cézanne into his own work could have been derived from landscape pictures. The inscription 'Cézanne's model'[7] on one of Sickert's Quai Voltaire drawings from the nude (Fig. 172) confirms the suggestion that Cézanne was indeed in Sickert's mind at this time.

This drawing, which is a full preparatory study for the painting *Jeanne*, and other drawings of the same time and place (e.g. C.254) are, like the *toilette* paintings, characterized by their emphasis on line. The figures are totally circumscribed by the decisively drawn contours which, however, are different in quality from those found in the paintings; they are smooth, even, and flowing and their closed character is more reminiscent of a sculptor's than a painter's drawing. The drawings are executed in black chalk with white heightening, but he used this medium without his usual rough *brio*; instead the modelling, softly rubbed in places, is very discreet and emphasizes the sculptural character of the drawings. Nevertheless, in *Jeanne* Sickert translated the technique of this drawing, with its gentle modelling and flowing outlines, into a very fully worked painting.

Jeanne (Fig. 168) is handled differently from the *toilette* paintings. The paint is more substantial and closely covers the surface in small crusty dabs and stains; in this it recalls the Easter 1906 figure pictures, although the tonal contrasts are softer and merge so gently together that the surface has a smudged effect instead of the flickering quality of the earlier pictures.

In his letters to Rothenstein Sickert did not mention which paintings or which artists he saw in Paris (other than Degas)[8], nor did he explain what he was trying to achieve in terms of style in his present work. However, he did give Rothenstein what we can assume was his own current recipe for painting. He wrote, in the same letter as that telling of his hotel nudes:

I want to give you a magnificent receipt . . .
Take an absorbent canvas white
Prepare 4 tones
One of ochre and prussian blue and white
Three gradations of ultramarine, indian ink and white mixed and
work from nature with *4 brushes* till your whole picture is prepared
Let it dry and paint
Just give this a trial
Do, do try. It will save you years of tears.

. . .

The above plan has this advantage: your lights are prepared *lower in tone* than they will be and your darks *lighter* than they will be Q.E.V.

The colours advocated by Sickert for this preparation, which when mixed create a dull autumnal green and a warm greyish cyclamen, underlie the harmonies of all the Paris nudes and the finishing touches of local colour often accord with their components. Nevertheless, this recipe was obviously capable of great variation in the extent of tightness expressed in the underlying tonal preparation while the finish was a matter of choice. To obtain the smudged close-knit quality of *Jeanne* Sickert must have worked up the four-toned preparation very fully and in finishing he probably allowed himself to be guided by the slight reversal in the values of the lights and darks, hence the very soft tonal transitions and the unusually unemphatic pattern of contrasts. In the *toilette* paintings he probably stated the preparation more loosely and finished more vividly and less closely.

There is, however, another Parisian nude, *Reclining Nude* (Fig. 169), which proves that in his figure work of this visit Sickert did not wholly reject his recent experiments with violently expressive methods of handling. The compositional layout of *Reclining Nude* is close to that of *Jeanne*, although the model is posed with more abandon. Its mood and treatment are absolutely different. The tonal contrasts are emphatic, the colours strident (with scarlet, vivid greens, and purple liberally used), the contour drawing is thicker, and the modelling, especially in the lights, jagged. In the harsh violence of its handling *Reclining Nude* recalls many of Sickert's 1905-6 paintings, but it is also allied in character and style to several of his Paris music hall paintings of this autumn.

More than six pictures of the particular Paris music halls which Sickert told Rothenstein he was painting in the autumn of 1906 are known today. There is only one picture of the *Théâtre de Montmartre*, but there are four of the *Gaieté Rochechouart* and three of the *Eldorado*, as well as a squared drawing of the *Rochechouart* and another of the *Eldorado* (C.244, C.246) which do not reflect the compositions of any of the pictures of these halls yet traced. None, with the striking exception of the *Théâtre de Montmartre*, fully justifies its description as a red or blue place, although none is so black as *Noctes Ambrosianae*. The dominant colour in most of these paintings is the dull green of the Paris nudes, although a smoky grey-blue is more widely used in the *Eldorado* pictures and permeates the atmospheric description of the *Rochechouart* paintings as well. It is probable that some of these pictures were painted in 1907 when Sickert returned to Paris in January. There are two Parisian music hall drawings dated 1907 to confirm the supposition that he continued to work on such subjects in that year, although the only one also inscribed with the name of the theatre was done in the Gaieté Montparnasse.

The chronological separation of Sickert's Paris music halls of autumn 1906 from those of early 1907 is of no great consequence because they probably belong to one series, briefly interrupted. The *Théâtre de Montmartre* (Fig. 162), however, must have been painted in 1906. It is perhaps the reddest of all Sickert's paintings, although the portrait of *Mrs. Swinton* painted *c*.1906 (Fig. 157) is a close contender

for this title. The background architecture is painted vivid scarlet while the figures are mainly painted in glowing but sombre-toned greens. This colour harmony and the harsh violence of its execution are immediately reminiscent of the Paris *Reclining Nude* (Fig. 169). It is indeed extraordinary that Sickert could accommodate the formal restrained classicism of the *toilette* nudes and indulge in the dramatic expressionism of the *Théâtre de Montmartre* simultaneously. The violence of this music hall is not confined to its colour. Its composition is complex and dynamic; the sudden diagonal recession recalls *The Gallery of the Old Mogul* (C.240) but the straightforward perspective of the London hall is repudiated in favour of a construction based on an overlapping series of segmented concave and convex curves. Its handling, particularly the treatment of the audience, is wholly expressionist. The figures are painted as dark amorphous stains of greens and black undisciplined by any trace of linear definition. They take on strangely intangible vegetable shapes, particularly in the further row where the scarlet background grins through their flesh tones and where the dark stains of the figures have been wetly smudged into this scarlet at their edges. The faces, painted as slippery blobs of ochres and browns accented by darting jabs of black, resemble sinister, grotesque, leering masks which foreshadow Francis Bacon. Something of the same character, but in a much less brutally exaggerated form, can be seen in the figure definition of *Noctes Ambrosianae* (Fig. 159) and in some of Sickert's more violently expressive paintings of 1905–6 (e.g. Fig. 141). Rouault's influence, suggested in these figure pictures, was perhaps also instrumental in dictating the style of the *Théâtre de Montmartre*. The cruelty of the figure definition and the emotional impact of the use of strong glowing colours could have been learned from Rouault although Sickert may also have been, consciously or unconsciously, inspired by Ensor.

The total violence of the *Théâtre de Montmartre* was a unique experiment among Sickert's music halls. The definition of the figures in versions of *The Eldorado* (C.245) and *The Gaieté Rochechouart* (C.241) is achieved in a similar manner but the reduced scale (and thus importance) of the individual figures in these pictures, as well as their quieter colour schemes and compositions, communicates an impression closer to *Noctes Ambrosianae*. One small vertical picture of a trapeze *artiste* at *The Gaieté Rochechouart* (C.243), the only one of Sickert's music hall pictures of this period to include the stage, has a direct expressive quality which more closely compares with the *Théâtre de Montmartre* although it is handled very differently. The paint is applied in a free variety of broken dots and dashes; scattered touches of bright red and green further enliven its aspect. Once again no drawing is used and passages such as the face of the man in the audience are suggested by the direct application of small, roughly placed blobs of colour. The small scale of this painting may have dictated its treatment which has, in fact, more of the character of an Impressionist sketch (except for its palette) than of a sustained expressionist painting.

In other music hall paintings of this period, such as two more versions of *The Eldorado* (Fig. 163, C.235) and *Les Loges* (C.242), a picture of the Gaieté Rochechouart, Sickert adopted a totally different method of figure definition. Instead of building up the surface in successive layers of paint and encouraging the figures to emerge during this process Sickert employed a more summary approach. He left his underlying preparation to tell quite plainly and relied very heavily on drawing to make this mainly two-coloured patchwork pattern of tones legible. He articulated the figures in particular with the curiously angular, schematic drawing also found in several of his music hall drawings of 1906–7 as well as (less obtrusively) in *The Gallery of the Old Mogul* (C.240). But for the black drawing one version of *The Eldorado* is little more than a tonal study in greys, blues, and stone colour. In *Les Loges* the audience in the foreground is stated as an arbitrarily coloured (purple and turquoise green) tonal pattern, articulated once again by means of the drawing only. This choice of colours is unexpected. Their extreme arbitrariness and their sharp clean quality anticipate Sickert's later work, although the colours of his later tonal preparations were usually chalkier. Indeed the background portion of *Les*

Loges is treated differently; the *loges* and their occupants are suggested by softly blurred stains of sombre blacks, browns, and dull greens with no hint of any linear accents; this handling is found again in another version of *The Gaieté Rochechouart* (Fig. 156). Nevertheless, the bright and sonorous turquoise and purple colour scheme of the foreground of *Les Loges* was not unique at this period; Sickert also used it for a Paris landscape, *La Rue Notre Dame des Champs* (Fig. 195), probably painted on his autumn visit to Paris in 1906.

The compositional schemes of Sickert's Paris music halls echo the experimental variety of their handling. Some are constructed within a restrained rectilinear framework as straightforward horizontal planar arrangements. *Noctes Ambrosianae* was of this type and so are the three main versions of *The Gaieté Rochechouart*, although each is different in its conception. The way in which the profile view of the audience in the foreground of *Les Loges* is set against the frontal view of the audience in the background *loges* recalls *The P.S. Wings in an O.P. Mirror* (Fig. 30), although it has none of the earlier picture's ambiguity of content. On the other hand, another painting of *The Gaieté Rochechouart* (Fig. 156) does possess an echo of that ambiguity because the stage *artiste* is seen reflected in the mirror behind the occupants of the stage-box whom we see looking in the other direction. This picture, which represents just over half the stage-box, is an unusual close-up view of a small part of a theatre interior. In 1906-7 Sickert almost always painted more general impressions of wide stretches of theatres and music halls. The epitome of this approach is found in another version of *The Gaieté Rochechouart* (C.241), a curiously phlegmatic representation of the whole panorama of the theatre as seen from the stage; it embraces the stalls, the *loges*, the balcony and gallery, with the faces of the entire audience indicated as tiny blobs of light peering from the general gloom. Only the ornate light bracket in the foreground disturbs the monotony of this arrangement (and a richly pictorial drawing of this light betrays Sickert's delight in its form).

In the *Eldorado* paintings Sickert also represented comprehensive sweeps of the interior, but instead of giving a distant and detached impression of his subject, he attacked it head-on from a position which brings the spectator in as a participating member of the audience[9]. This immediate involvement with the subject recalls *The Gallery of the Old Mogul* (C.240) and *The Old Middlesex* (Fig. 160), but the compositional schemes of the Paris scenes are very different from those of the London pictures. The Paris subjects are constructed with hardly a straight line anywhere, as a series of segmented, often divergent, sweeping curves. No doubt the architecture of the Eldorado itself helped to determine Sickert's approach to its expression, but a delight in curved lines and a tendency to experiment with an asymmetric, unstable, compositional construction were also noticed in the *Théâtre de Montmartre* and seem to have been characteristic of this period as an alternative to the rigid rectilinear classicism of his Paris nudes and other music halls. Ronald Pickvance made the fascinating suggestion that Sickert was influenced by, was even trying to rival, Carrière's *Théâtre de Belleville*, which like Sickert's pictures also represented the swing of balcony and gallery and showed the rapt audience glimmering from the darkened interior. The *Théâtre de Belleville* was Carrière's only theatre painting, but as Pickvance pointed out it was very well known, having been frequently exhibited, not only in Paris but also in London and Venice, all at dates when Sickert could have seen it[10]. The fact that Carrière had died in March 1906 and was consequently much talked of in that year and his work posthumously exhibited (for instance at Bernheim-Jeune followed by a sale at the Hôtel Drouot in June and at the *Salon d'Automne*) supports Pickvance's suggestion. Sickert, it is true, was no great admirer of Carrière, finding his painting hollow and decadent[11], but this does not argue against the supposition that he might have been inspired by Carrière's compositional conception of a theatre interior. Indeed Sickert frequently found inspiration in painters whose work he scarcely admired, and he rarely acknowledged his sources (possibly deliberately, but probably because he just did not accept them as such). When painting the

Eldorado Sickert may also have remembered a reproduction of a picture called *In the Upper Circle*, showing the Ulster Delegates in the Albert Hall, executed (as Sickert would have approved) with 'drawings and instantaneous photographs', published in the *Pall Mall Gazette* in 1893[12], that is, at a time when Sickert was working for the paper and must have seen each copy. *In the Upper Circle* strikingly anticipates the composition of the *Eldorado* paintings.

The paint in one version of the *Eldorado* (C.245) is thicker and crustier in texture than in any other Paris painting of 1906. Its colour scheme of greens and black (with just a few touches of thick white and peacock blue in the hats and gloves of the women on the right), and its overall very dark tonality, make it difficult to accept as one of the music halls Sickert described to Rothenstein in 1906 as not so black as *Noctes Ambrosianae*. It is, therefore, possible that this painting was done in 1907. Some support for this hypothesis is offered by a drawn study of heads at a music hall inscribed and dated 'Paris 1907' (C.245, Study 1); although none of the drawn heads exactly tallies with those in the *Eldorado* painting they are seen in very similar poses and are viewed from the same angle. Moreover the three pictures of the *Gaieté Montparnasse* (Fig. 164, Fig. 165, C.237) which we can assume were painted in 1907—because (i) this theatre was not mentioned to Rothenstein in 1906; (ii) a dated drawing of 1907 (listed under Fig. 164, C.236) is inscribed with the name of this hall; and (iii) no painting of the Gaieté Montparnasse was shown at Bernheim-Jeune in January 1907, but two of the extant pictures were shown in 1909 (Fig. 165, C.237)—are similar to the *Eldorado* in handling. They have the same crusty paint texture, the same sombre tonalities and the same colour schemes. In all three *Gaieté Montparnasse* paintings Sickert continued to explore his interest in curved rhythms. The full-blown serpentine curve of the gallery dominates not only *Dernière Galerie de Gauche* and *Dernière Galerie de Droite* (Fig. 165) but also the more comprehensive representation of the interior as seen in a rectangular mirror set parallel to and just behind the surface plane (Fig. 164). The picture of *La Gaieté Montparnasse* illustrated as Fig. 164 represents a synthesis of the alternative types of compositional layouts with which Sickert experimented in his Paris music halls. A sustained tension is created by balancing the forces of the receding asymmetrical serpentine curve of the gallery against the uncompromisingly planar rectangle of the mirror. Something of the same sort of tension, established in a less subtle manner, is obtained in the *Dernière Galerie de Gauche* and *de Droite* pictures by the opposition of the serpentine gallery to the vertical divisions of the background wall. A sense of tension, even contrariness, is apparent not only in the compositional schemes but also in the general conception of these *Gaieté Montparnasse* pictures. Sickert was obviously delighted with the decorative potential of his subject. In his studies for *Dernière Galerie de Gauche* he lovingly particularized the detail of the ornate festoon; in all his pictures of this theatre he betrayed an almost sensuous joy in the serpentine rhythms of its architecture. Yet his handling seems positively contrived to deny the beauty of his subject. The muted, often muddy colours, the dark tonalities, the summary execution, and the unpleasant texture of the oily, crusty, impasted passages seem to have been deliberately employed to avoid creating pictures which were immediately attractive and decorative. Sickert, having been reared by Whistler and having witnessed the vapid prettinesses concocted by some of his more aesthetic English contemporaries, was acutely aware of the pitfalls which surrounded the painter of frankly decorative and appealing pictures. Perhaps his execution in the *Gaieté Montparnasse* paintings was in part an intuitive defence against such dangers, although it must also be stressed that it accords with Sickert's general technical development at this period and was in no sense specially devised for, or unique to, the music hall pictures.

Sickert's visits to Paris in 1906 and 1907 did not supplant his visits to Dieppe. Before going to Paris in the autumn of 1906 he spent some time in Dieppe where Gore, to whom he had lent his house in Neuville for the entire summer, was staying. They were also joined for a few weeks by Hubert

Wellington, who took rooms nearby and later recalled their time together[13]. They all went their separate ways to paint during the daytime but they met each evening to talk. Wellington remembered Sickert saying repeatedly, 'All good modern painting derives from France'; he stimulated his young colleagues with countless anecdotes about the great painters he had known, with illuminating and often provocative comments about their work and techniques, and with more challenging claims for the qualities of lesser talents. He spoke to them of Whistler, Manet, Degas, Millet and others but they listened most eagerly to what he could tell them of the more recent generation about whom so little was known in England before Roger Fry's exhibition of Post-Impressionist work in 1910. Wellington told how Gore's talent ripened in this stimulating atmosphere, how his painting became more confident and positive, and how he adopted Sickert's method of painting with deliberation, from small well-documented drawings, in the studio instead of on the spot. Sickert in turn was refreshed by his contact with Gore and began to explore variations of colour in shadows and brightened the whole range of colour and key in his pictures.

Some of Sickert's Paris figure paintings, for example *Jeanne* (Fig. 168), possess a luminosity and soft subtlety of colour which could have been inspired by Sickert's recent contact with Gore. However, few of the landscapes Sickert may have painted in Dieppe when in daily contact with Gore in 1906 reflect this influence. It is very difficult to date Sickert's post-1905 Dieppe landscapes with accuracy. They are seldom dated, and as Sickert painted figure subjects for the rest of the year there is little continuity in their stylistic character so that few effective chronological assessments can be made on these grounds. For example, the dating of a group of pictures of a corner in Dieppe showing a junk shop (Fig. 194, C.283)—the pictures are called *The Print Shop* or *The Antique Shop*—depends primarily upon elimination; two of the four versions are almost inconceivable as the work of any time other than 1906 or possibly 1907. The texture of the paint in the version illustrated (Fig. 194), a study on panel, and in the one painting on canvas of this subject, is thick and oily; it is applied in some passages in a heavy churned impasto. The colours are dark and muddy. The quality of the paint and of its handling, although more exaggeratedly clumsy, is similar in character to that found in several of Sickert's London figure paintings of late 1905 and Easter 1906, for instance *Une Tasse de Thé* (Fig. 140) and *Head of a Woman* (C.228), and anticipates some of Sickert's Paris music halls of 1906-7, for instance *The Eldorado* (C.245) and the *Gaieté Montparnasse* pictures (Figs. 164, 165). It is certainly hard to believe that Sickert would have used such heavy impasto before 1905, and although from 1907-8 onwards he did use impasto liberally his brushwork was then more deliberate and broken, the definition less compact, and the forms more dissolved in light. Several other small paintings, such as a tree-screened representation of *La Rue du Mortier d'Or* (Fig. 201), may also be works of 1906. The paint surface in these pictures is crusty but the brushwork is more broken and the colour more varied than in *The Print Shop* pictures. This handling was perhaps encouraged by Gore, and it presages the development in Sickert's technique from 1907 to 1909.

NOTES

1. None of these letters is dated but they clearly belong to one series because they all concern Sickert buying pictures in Paris for Rothenstein to sell in London. The order of the letters can be deduced from the progress of these dealing transactions which began with a lion by Delacroix and a *tricoteuse* drawing by Millet and grew to include a charcoal drawing by Daumier, a pen drawing by Daubigny, an oil by Gérôme, another by Lami, and a painting of Étretat by Delacroix. The first four letters are addressed from the Hôtel du Quai Voltaire, Paris,

the fifth 16 Boulevard St. Jacques, Paris (XIVᵉ) and the sixth is not addressed. Several references prove that the whole series belongs to 1906: in the first letter Sickert told of his ten pictures at the *Salon d'Automne*, the number he showed in 1906 only; in the second he told how 'Mrs. fucking Lawrence of Constables studio has obtained a bloody judgement in my absence for ¼ rent . . .'—Sickert rented this studio in 1905 and gave it up in 1906; in the third letter, besides saying that *Noctes Ambrosianae* was 'here' (it was among Sickert's *Salon*

d'Automne exhibits in 1906), he wrote of 'probable business with Bernheims', no doubt a reference to his forthcoming exhibition in January 1907; in the fifth letter he told how his show had been booked at Bernheims for January 18 to 22 (the show eventually took place from 10 to 19 January 1907). The importance of establishing the date of this series of letters lies in their references to his current work. Unfortunately Rothenstein himself quoted lines from these letters, together with extracts from other Sickert letters of 1899–1900, in Vol. I of his *Men and Memories* (London, Faber, 1934, p. 341); the period covered by this volume ended in 1900. The implication that the 1906 letters were also written *c.*1899–1900 has been partly responsible for the subsequent misdating, not only of the paintings they mention but also of roughly contemporary works. Thus the chronology of Sickert's entire music hall production has been distorted.

Sickert's letters to Rothenstein are now in the Houghton Library, Harvard University.

2. Two cards addressed from 8 Fitzroy Street and postmarked 14.12.06 and 22.12.06 respectively, written to Mrs. Humphrey, prove that Sickert was then in London. In the first card he implied that he was leaving England soon, and the probability was that he intended to return to Paris. (Sickert wrote of how he wished to leave his collection of Conder drawings and pictures with Mrs. Humphrey 'before I leave England'.) If he went to France at the beginning of 1907 he was back in London by March (the envelope of a card to Miss Hudson is postmarked).

3. In the first letter of the series of six.

4. Bonnard's picture was reproduced in *Gazette des Beaux-Arts*, Tome 36, 1906, p. 475. Its vertical format with a nude girl standing in a narrowly enclosed space is especially close to Sickert's *Le Cabinet de Toilette*.

5. In a letter Sickert wrote to Miss Ethel Sands he admitted as much. With probable reference to his review of Clive Bell's *Art*, published under the title 'Mesopotamia-Cézanne', the *New Age*, 5 March 1914, he wrote to Miss Sands, 'I agree with your criticism of Bell's book and of my attitude to Cézanne. But I was *solely* concerned to counter the folly of the *soi-disant* followers of Cézanne.'

6. In the *New Age*, 18 June 1914, 'The Thickest Painters in London', an attack upon Gilman and Ginner's use of impasto, Sickert wrote, 'They talk a good deal about Cézanne. I admire what is good in Cézanne perhaps as much as they do. But I think I have looked at him more carefully. What is the classic phrase in France about Cézanne's execution? "*Des minces*

couches *superposées*".' In a letter to Miss Sands of about the same date Sickert again advocated Cézanne's '*minces couches*'.

7. The precise meaning of this inscription is uncertain. Perhaps the model had sat for Cézanne, or perhaps the title merely recorded the name of the artist of whom Sickert was thinking. Possibly the inscription containing these words was written later, at the same time as the signature 'Rd St A.R.A.' which is likewise in pen and ink, because there is another pencil inscription noting the name of the hotel and the words 'old model'. If the pen and ink inscription was added later it could imply Sickert's recognition of the artist who had then inspired him.

8. Hubert Wellington, in a broadcast, 'With Sickert at Dieppe', published in *The Listener*, 23 December 1954, pp. 1110–12, remembered that when Gore, then borrowing Sickert's Neuville studio in the summer to autumn of 1906, told Sickert (who spent some time in Neuville as well) how he wanted to see the big Gauguin show in Paris at the *Salon d'Automne*, Sickert answered, 'By all means . . . see the Gauguin show, but it would be even more worth-while to run up to Paris for the day to see a picture by Jean François Millet'. On the whole, although Wellington and Gore wanted to hear Sickert's views of contemporary French art, Sickert talked of the French Impressionist generation and of the qualities of Victorian academic artists.

9. C.245 represents the circle of the Eldorado from the opposite side and without the *repoussoir* figures shown in the two other paintings (Fig. 163, C.235).

10. *Apollo*, 76, April 1962, pp. 107–15, 'The Magic of the Halls and Sickert', p. 113. Carrière's painting was shown at the Paris *Salon* in 1895, at the Continental Gallery, London, in May 1898, and at the Venice *Biennale* in 1901.

11. Sickert discussed Carrière's painting in the *English Review*, May 1912, pp. 316–22, 'The International Society'. Sickert also made a rather ambiguous reference to Carrière in the *Art News*, 7 April 1910, 'Fathers and Sons', when (referring to the 'incantations of Mr. Claude Phillips') he wrote, 'Either he will warn me that only Carrière or Whistler (who never painted such subjects) must paint the gallery of a music-hall!' It is impossible to decide whether Sickert's parenthesis applied to both artists or only to Whistler. If it applied to both it means Sickert was either covering up his sources or was truly ignorant of Carrière's theatre picture—the latter alternative is almost inconceivable.

12. 27 April 1893.

13. See note 8.

XIII

1907–9. Camden Town Period

IN 1906, in some of his London figure pictures and in some of his Paris music halls, Sickert had begun to increase the substance of his paint and to break up his brushwork into smaller, closely juxtaposed and overlapping touches. In the same year he had also experimented, in the *La Hollandaise* group of nudes (Figs. 144, 147) and in the Paris hotel interiors (Figs. 170, 171, and C.253), with handlings which depended upon the constructive application of linearly conceived strokes. For a time in 1907 Sickert seems to have vacillated between these two courses. A dated figure picture, *Woman Seated on a Bed* (Fig. 176), painted in Dieppe in 1907, can be interpreted as a symptom of Sickert's uncertainty about how he should develop his style and technique. Were it not for its inscription 'Dieppe 1907' *Woman Seated on a Bed* might be mistaken for a Venetian work of 1903–4, although the diagonal alignment of the space would argue against such a dating. It is thinly and summarily painted and, except in the upper body and head of the woman, the realization of its content depends upon the loose-wristed drawing. The head and upper body are modelled a little more fully in hatched strokes but this modelling remains calligraphic in conception. Another dated Dieppe picture of 1907, this time a landscape of *The Road to the Casino* (C.292), is also very summarily treated with the paint broadly slashed onto the canvas. *The Road to the Casino*, although admittedly a broader panoramic view, is very different from *La Rue du Mortier d'Or* (Fig. 201) of *c.*1906, in which the forms, textures, and light are conveyed by the constructive application of small touches of paint, varied in their tones, colours, and consistency. A dated drawing of a nude inscribed 'Paris 1907' suggests that *The Poet and his Muse. Collaboration* (Fig. 173, C.256), a painting of this nude accompanied by a clothed seated man, may be another work of 1907. The picture is again summarily treated. As in *Woman Seated on a Bed* the interior setting is almost empty. It is painted thinly, with only a few individual marks of highlight in the far arm of the nude mitigating the slightness of its execution. Nevertheless, this picture is important in the context of Sickert's development. It introduces the theme of a nude woman shown together with a clothed man which Sickert was soon to treat so often, although in the Paris picture (perhaps Sickert's first attempt at this theme) the compositional and psychological links between the figures are uncertain.

However, despite the summary execution of these French paintings of 1907, it was in this year that Sickert seriously committed himself to the development of his handling of thicker paint applied in a mosaic of small broken touches. If, as was suggested when the Paris music halls were discussed, Sickert returned to France very early in the year of 1907 these pictures may all have been painted then. If they were painted when Sickert went again to Paris and Dieppe in the autumn of 1907 they can only be interpreted as a deliberate relaxation from the strains of working in the highly planned, constructive manner which he developed in London in 1907.

In a letter to Anna Hope (Nan) Hudson (like her friend Miss Sands a painter of American origin)

addressed from 6 Mornington Crescent, Sickert evaluated his position as a painter in 1907[1]:

> I am clear-sighted enough to realize that the backward position I am in, for my age, and my talent, is partly my own fault. I have done too many slight sketches, and too few considered, elaborated works. Too much study for the sake of study, and too few résumés of the results of study. . . . I shall try this summer to do a few really complete and cumulated canvases in Dieppe and Paris . . . I wonder if you saw a picture of boys in the Gallery at the Middlesex [referring to Walter Taylor's possession of *Noctes Ambrosianae*]. . . . I reflect, not without shame, that it is one of, perhaps, not more than half a dozen museum-pieces that I have done in twenty-seven years! And that is *too few*. It would be unjust to expect my right place yet on such slender claims. But repentance is only useful in as much as it furnishes a guide for the future. I rather hope that when I come back in the autumn [he reported in this letter that he hoped to go to Dieppe early in July] I may take the floor above my lodgings here as a room-studio and do the interiors that I love . . . As a punching-ball I am working at a life-sized head of myself in a cross-light which will I think become something in time.

This head, painted in the first half of 1907, is *The Juvenile Lead* (Fig. 174). It was exhibited at the *Salon d'Automne* in 1907 as *L'Homme au Chapeau Melon*[2]. It is sombre in tone, painted over a dark ground in the dull olive and sap greens of the 1907 Paris music halls. Its surface is rough and crusty but not more so than many of Sickert's 1906 pictures. The simple presentation of the bust-length figure, the device of contrasting its curved contours and three-dimensional volume with the rectilinear shapes of the picture frames on the flat background wall, the sensitivity of its observation, and the delicacy of its handling, all recall Sickert's Easter 1906 portrait series. However, the modelling, especially where the obliquely falling light is reflected in the face, is much more consistently and constructively built up in small overlapping dabs and smears than in the 1906 series—in which the bold stippled execution was both superficial and more sporadically employed. Drawing is of less functional importance in *The Juvenile Lead* than in the earlier portraits, because the component volumes of the head are fully realized in terms of this broken application, and their individual contours blend together to create an integrated complex form dissolved in light.

The Juvenile Lead was not unique in 1907 in its considered, constructive use of thicker paint applied in small touches. Newly discovered, objective documentary evidence makes it necessary to alter the whole chronology of Sickert's 1907–8 work and bring forward by a year the generally accepted date of many of his paintings. This re-dating is so important that the evidence is placed here, in the footnotes to the text, rather than being relegated to the catalogue. The paintings involved include the series representing a young girl known as Little Rachel and the extensive group of Mornington Crescent bedroom nudes, all of them paintings which have been regarded (by myself as well) as works of 1908.

As a prelude to this re-dating another self-portrait, *The Painter in his Studio* (Fig. 178), must have been painted at about the same time or shortly before *The Juvenile Lead* because it was exhibited at the N.E.A.C. in the summer (May–June) as *The Parlour Mantelpiece*[3]. It shows Sickert reflected in a mantelpiece mirror in his studio with plaster casts on the mantelshelf. The angle of the head, the obliquely falling light, and the sombre tonality are related to *The Juvenile Lead* but the colour harmony is cooler with the olive greens and ochres of the background set off by the broken touches of cold greys and pale blue in the plaster casts. The canvas is also more thickly covered than in *The Juvenile Lead* and the emergence of the tightly organized, delicately stippled brushwork characteristic of the Mornington Crescent interiors can be clearly recognized in such passages as the plaster casts.

When Sickert wrote to Miss Hudson that he was painting his 'punching-ball' self-portrait (*The Juvenile Lead*) he commented that he hoped to paint interiors in Mornington Crescent when he returned from France in the autumn. In fact he revised his plans. A sequence of letters to Miss Hudson from Mornington Crescent proves that he put off going abroad until late summer 1907[4] because he 'got

entangled in a batch of a dozen or so interiors on the first floor here . . . I should so like to show you a set of Studies of illumination half-done. I am very much interested and shall stay till they are done. A little Jewish girl of 13 or so with red hair and a nude alternate days.'

These interiors done in Mornington Crescent are among the most immediately attractive pictures of Sickert's entire career. The quality and texture of their paint is rich and sensuous, their definition strikes a perfect balance between summariness and detailed particularization, their tonality is light enough to ensure easy legibility, the colours are bright without being discordant, and even Sickert's subjects, such as the young Jewish girl known as Little Rachel whom he painted repeatedly in different settings and poses, are attractive. A typical painting of this time is the graceful nude seated on a bed seen from the back called *Mornington Crescent Nude* (Fig. 175). Indeed, no sooner was it painted than Hugh Hammersley, one of Sickert's most faithful patrons, bought it[5]. The close stippling of the paint gives it a rich, crumbling texture. The subtle variations in the tones and colours of the small touches perfectly suggest the faint nuances of form. The scene is shaded and the tonal scheme muted but the individual colours used are lively—the shutters are prussian blue and emerald green, the bed and wall are in gradations of lilac-tinged grey-blue, the back of the nude is painted in ochres and grey-green, her arms and right hip in chocolate browns, pinks, and flesh tints. In spite of this varied colour scheme the relationships of the tones and colours are so delicately achieved that the impression one retains on turning away from the picture is of a soft harmony of grey-violet and green.

The concept of a seated nude seen from the back is one which interested Sickert at this time. *Mornington Crescent Nude* is, in fact, a stage in the development of a two-figure composition (Fig. 188, C.268) showing a similarly posed nude together with a clothed seated man called, in Sickert's etching dated 1908 of this subject, *The Camden Town Murder*. Sickert made several independent series of drawings and paintings from 1907 to 1909, each of which includes compositions called *The Camden Town Murder*[6]. The development of the series including *Mornington Crescent Nude* began with this painting and a softly pictorial black chalk drawing (Fig. 175, C.259, Drawing 1) which was probably a preparatory study for the painting; the nude is similarly posed; the feeling for the gentle serpentine curves of her body is the same; only the background is different with a table and washstand included in the drawing as well as the chest of drawers found in the painting. This drawing is related to others (Drawings 2, 3) showing a seated nude seen from the back, in which, however, she sits up straighter, her hair now falls loosely, and less of the background furnishing is shown. The relationship between Drawings 1 and 3 is made explicit by the emphasis in both on the shadow cast by the figure on the chest of drawers. Drawings 2 and 3 in their turn were clearly used later, probably in 1908 rather than 1907, as preparatory studies for the female figure in both *The Camden Town Murder* etching and the richly pictorial drawing of the same two-figure composition (Fig. 188). Furthermore, in this two-figure composition Sickert reintroduced the table and washstand from Drawing 1 to elaborate the interior setting. The sort of sequential interrelationships illustrated by this series of figure compositions was typical of Sickert. The development from one composition to another took no account of the mood of individual works but was solely a matter of manipulating their formal constructions. The pure and tender *Mornington Crescent Nude* painting is, as we have seen, very nearly related to the more suggestively threatening *Camden Town Murder* composition (Fig. 188)—although it should be noted that were it not for its title *The Camden Town Murder* could be interpreted as showing a moment of peace, intimacy, and love between man and woman.

The nude picture is similar in mood and technique to the many pictures of *Little Rachel*. One learns from the title of one of her portraits (C.263, Painting 3) that she was his framemaker's daughter and her youthful innocence led him to inscribe one of the drawings he made of her (Drawing 4) '*le petit Jesus*'[7].

All the drawings of *Little Rachel* are executed in black chalk or charcoal heightened with white, and they have the softly pictorial quality of the drawings from the nude related to the *Camden Town Murder* series discussed above. Another characteristic common to the nudes and the *Little Rachel* pictures is the insistent parallelism of their compositions. Sickert used the furniture and architecture of his setting (a chest of drawers, a paned window, and sometimes the closed shutters of this window) to emphasize this rectilinear parallelism, and he even disposed the figures to encourage this effect. For example in one picture (C.263, Painting 2) Little Rachel sits squarely in the foreground plane; in *The Framemaker's Daughter* (Painting 3) she sits frontally with her head turned almost awkwardly to profile; in *Girl at a Window* (Fig. 182) and in an unfinished portrait head (Fig. 184) she is seen in pure profile which, especially in the latter painting, has a *quattrocento* precision.

Sickert's attraction, and recurrent reversion, to rectangular paintings has already been discussed. It is, however, possible that the severe classical geometry of the *Little Rachel* paintings was dictated by the necessity of giving structural stability to pictures which would otherwise dissolve in the flickering luminosity which informs their entire surface. The *Little Rachel* canvases (except the unfinished portrait head—Fig. 184) crumble with a rich impasto. Their tonality is, for Sickert, fairly light. They are painted directly onto the primed canvas, with no dark underpainting, and their colour harmonies are characterized by recurring purples and violets, combined in different measures with green, rusts, browns, and grey-blue. The paint is thick and tightly stippled so that one form merges imperceptibly with another, and no lines of drawing serve to demarcate the boundaries between one object and another. Sickert's interest in these paintings is in light, light which, for the first time in his interiors, is natural. In no earlier painting of a figure in an interior seen in daylight is the source of light shown within the picture. However, in *Chez Verney* and *Girl at a Window*, all the unexpected effects of reflected light, filtering obliquely through the smoky glass of an upper bedroom window, bypassing furniture to fall upon the figure, are translated with infinite subtlety in terms of a richly varied mosaic of paint. It could be that in these paintings Sickert remembered the painting by von Schwind of which he wrote in 1914:

> It may be that the windows, framing and limiting the light, act on the indoor landscape as the frame of the sonnet-form acts on a stream of poetic light. . . . We all know the picture of Moritz von Schwind, of the little German girl in plaits who throws open the casement of her bedroom to greet the sounds and scents of the morning. The everlasting matutinal is enshrined in it once for all and for ever.[8]

While von Schwind's painting perhaps suggested to Sickert the theme of a young girl at a window, the handling of the *Little Rachel* paintings is the one which Sickert described in 1910[9] as the N.E.A.C. method of painting 'with a clean and solid mosaic of thick paint in a light key'. In the same article he attributed the evolution of this method to the combined efforts of a group of artists ('for these things are done in gangs, not by individuals') belonging to the New English Art Club. Because the method of painting described by Sickert was evolved continuously by this group of artists, and because it was common in greater or lesser degree to their technique at different times, Sickert's description in 1910 obviously had retrospective reference. It is interesting that the *Athenaeum*[10], in a review of the summer exhibition at the N.E.A.C., commented that Sickert's *Parlour Mantelpiece* (that is, *The Painter in the Studio*) had the same 'crumbling *facture*' as a Tonks picture in the same exhibition, but added that Sickert's picture had this *facture* 'more completely throughout, thus making of this kind of handling a formal decoration' (the critic also found Sickert's design 'larger, calmer, more self-supporting').

When Sickert wrote of this group of N.E.A.C. artists in 1910 he was probably thinking of the particular group which centred around himself and met to discuss and show their work on Saturdays at 19 Fitzroy Street. The actual membership of the Fitzroy Street group changed and fluctuated over

the years but its solid core included (besides Sickert) Gore, Gilman, and a little after its foundation Lucien Pissarro[11]. It was for several years the centre of English *avant-garde* art (using the term with purely English reference). Its meetings gave birth to most of the artists' associations which proliferated in London from 1908 until 1914 or so. For example, one of the landmarks of the common interests of the Fitzroy Street artists occurred in 1908 with the foundation of the Allied Artists' Association[12], a non-jury exhibiting body which they felt would counteract the exclusiveness of the New English Art Club (still prone to reject the work of some of the Fitzroy Street members) and be an English version of the *Salon des Indépendants*. The Camden Town Group was a sort of refinement of the Fitzroy Street group and, as distinct from the larger, more amorphous body, an all-male preserve. The Fitzroy Street group held so important a place in English art in the 1900s that some account of its origins should be given. Fortunately Sickert's letters to Miss Hudson deal extensively with its foundation and the reasons behind it. They also prove that it started, as a semi-formal society, early in spring 1907[13]. When Sickert invited Miss Hudson and Miss Sands to join the group he told them who were the other original members: William Rothenstein, Walter Russell, Albert Rothenstein (later Rutherston), Gore, Gilman and himself. He explained that they intended to show pictures 'year in, year out under the formula "Mr. Sickert at home"'. They shared the expenses, of a first floor and a store room for their work at Fitzroy Street, equally. Sickert also explained his own motives as the prime mover in the venture: 'I want to keep up an incessant proselytizing agency to accustom people to mine and other painters' work of a modern character' and 'I want to create a *Salon d'automne* milieu in London'. He expanded on these ideas in other letters to Miss Hudson: 'I want . . . to get together a milieu rich or poor, refined or even to some extent vulgar, which is interested in painting'; and in another letter: 'I believe we shall slowly do very useful things in London. Accustom people weekly to *see* work in a different notation from the current English one. Make it clear that we all have work for sale at prices that people of moderate means could afford. (That a picture costs less than a supper at the Savoy). Make known the work of painters who already are producing *ripe* work, but who are still elbowed or kept out by timidity . . . Further I particularly believe that I am sent from heaven to finish *all* your educations.'

Although the development of Sickert's handling in 1907 clearly depended upon the interaction of many influences and ideas current within this group of colleagues, Sickert also attempted to explain the development of his own painting individually. Again in 1910 he wrote: 'About six or seven years ago, under the influence of Pissarro in France, himself a pupil of Corot, aided in England by Lucien Pissarro and by Gore (the latter a pupil of Steer, who in turn learned much from Monet), I have tried to recast my painting entirely and to observe colour in the shadows.'[14] The germinal stages of this effort to recast his painting may perhaps be recognized in a few paintings done as much as six or seven years before 1910, for example in a few of his Venetian and Dieppe landscapes of 1903 and 1904. However, Sickert could not have been influenced by Gore until 1905; their contact was not close until 1906, and as we have seen, had little effect upon Sickert's work in that year. Although Sickert's *Contre-Jour Mornington Crescent Nude* (Fig. 146) and *Nude behind Flowers* (Fig. 148) were, in a sense, companion works to Gore's *Behind the Blind* and *Self-Portrait with Still Life*, the influence at this stage in their careers was more from Sickert to Gore than vice versa. The most that can be said is that, given Sickert's desire to paint considered, elaborated pictures, his decision to paint them with a broken touch, broken colour, and thicker paint, must have been confirmed by his close association with painters whose touch was also somewhat *pointilliste*, such as Gore and Pissarro.

In 1908 Sickert articulated his definition of '*la peinture*':

As much as, and the kind of truth . . . as can be expressed by the clean and frank juxtaposition of pastes (*pâtes*), considered as opaque, rather than as transparent, and related to each other in colour and values by

the deliberate and conscious act of the painter . . . The staining of a white canvas in the manner of a water-colour is not 'la peinture': nor is the muffling-up of the painting in the indecision of universal glaze.[15]

This concept of 'la peinture' was the basis of the N.E.A.C. method of painting. In another article, written in 1910, Sickert made it clear that he attributed its development to the efforts of the French Impressionists who, by rejecting glazing techniques, 'returned to the practice of the great primitives and secured their effects by the juxtaposition of definitely intentional colours'[16].

Thus the origins of Sickert's and the New English method of painting can be traced back, if not to Impressionism, at least to Sickert's interpretation of Impressionism. Sickert acknowledged that he himself was helped by Pissarro and at two removes—via Steer and Gore—by Monet. In his paintings of 1907 Sickert perhaps came closest to justifying his title as an English Impressionist. He observed and painted colour in the shadows, his palette somewhat lightened and brightened, and his main interest was in the effects of light on animate and inanimate objects. Nevertheless, Sickert's relationship to Impressionism was more tenuous than he himself seems to have realized. His method of painting from drawings in the studio, instead of directly from nature, was contrary to the basic precept of Impressionism. Whereas the Impressionists sought to render their impression of a transient glimpse of nature on canvases dashed off on the spot, Sickert carefully constructed his compositions from drawn documents and planned his execution in separate stages. Whereas an Impressionist painting was often finished in a single sitting from nature, so that its loaded stippled surface might be created from only one coat of thick paint, Sickert built up his pictures in separate sittings from coat upon dry coat of paint. The unfinished profile head of *Little Rachel* (Fig. 184), which would probably have been finished in the same stippled manner as the other pictures of the same sitter, demonstrates that Sickert painted the underlying coats (which define the form and modelling in considerable detail) in smooth, thin paint. This indicates that the stippled mosaic of thicker paint, typical of Sickert's work at this time, was used only as a covering.

Sickert's passionate concern with the natural qualities and properties of his medium and his constant temptation to rationalize, even mechanize technique, were probably responsible for his biased interpretation of Impressionist practice. It led him to overlook the fact that the characteristic Impressionist *facture* was empirical in origin, that it resulted primarily from the speed at which the artist had to work to capture fleeting images, rather than from any intellectual concept of the right handling of the medium[17]. The Impressionists did not glaze because they had no time to do so, but Sickert, working in the studio, could have done so had he wished.

Sickert was possibly tempted to imply that his and the New English method of painting was essentially that of the Impressionists because the group as a whole was most deeply influenced by Lucien Pissarro. Pissarro *père* was regarded in England as the classic French Impressionist and the fact that Lucien derived his handling mainly from his father's later style (after it had been somewhat modified by Neo-Impressionist *facture*, if not theory) was overlooked. Lucien used solid pigment, applied in stippled separately coloured touches (ignoring the scientific motive which originally underlay the choice of this form of execution) before his English colleagues. Gore, whom Sickert regarded as a near relative of the French Impressionists, possibly adopted a lighter and brighter palette and a slightly *pointilliste* execution before Sickert. His *Woman in a Flowered Hat* in front of a window with a portrait of Sickert tucked away in the bottom right corner, painted in 1907, may have had a specific influence on Sickert's *Little Rachel* paintings. Sickert's main contribution to the group evolution of the New English method of painting was that it was he, by his definition of '*la peinture*', who attempted to rationalize the use of this handling and provide it with an historical context.

Sickert did not confine himself to any one mood or style of work in his 1907 Mornington Crescent interiors. In many of the paintings and drawings of a nude woman in the bedroom he rejected the

fragile delicacy of mood, handling, and figure characterization found in the *Little Rachel* pictures and in the *Mornington Crescent Nude* seen from the back. The paintings from this series include the *Contre-Jour Mornington Crescent Nude* (Fig. 179), bought soon after its execution by Hugh Hammersley[18], and *Petit Matin* (C.277), which is probably the picture exhibited in the 1907 *Salon d'Automne* as *Nu*[19]. These two paintings, and others from the same series (e.g. Fig. 177, and C.276), are similar to the *Little Rachel* pictures in the insistent parallelism of their compositions, in their immobile quality, and in the consistent uniformity of their surface texture which does so much to integrate figure and setting. However, in these paintings Sickert's paint became even more thickly impasted, and his handling much tighter. This handling, unlike that of the *Little Rachel* paintings, was not devised to translate the flickering effects of natural daylight (only in the *Contre-Jour Nude* is the source of light shown within the picture). Instead Sickert concentrated on conveying a strong sense of the plastic mass and weight of his generously proportioned model. He described the figure in each picture as a compact integrated mass, and directed the light—in the drawings as well as in the paintings—in such a way as to simplify the component volumes of the figure and reduce them to basic three-dimensional geometric shapes.

The treatment of the figure as a single compact mass is perhaps most radical in *Mornington Crescent Nude* (Fig. 179). The light, coming from a window behind the figure, explicitly defines its contours, but otherwise the figure is barely modelled. One volume merges almost imperceptibly in tone and colour with the next, and there is a total absence of particularization such as markings on the face or body. The figure, which is neither more nor less important visually than its setting, tends to assume the role of a massive still-life object. This still-life quality is encouraged by the immobility of the atmosphere, which is itself largely dependent on the rigidly rectilinear compositional structure; even the figure is manipulated to create a right-angle.

This new approach to the description of the figure as a compact mass composed of simplified geometrical shapes is also illustrated in the drawings related to this series of nudes. For example, in studies for another painting from this series (C.276) precisely spaced curved strokes accentuate the dome of the stomach and the cylinder of the torso; softly rubbed shading emphasizes the spherical purity of the breasts; finally the whole figure is united by a firm contour line which bounds without interruption over the swell of the breast, dips at the waist, before rising again to follow the full curve of the thigh. A close-up study of the head and shoulders of a reclining nude (Fig. 180) known as *No. 21* (from the number inscribed in one corner) proves that this schematic simplified approach was not confined to Sickert's attempts to define the essential articulation of an entire figure. In *No. 21* Sickert reduced the head to an egg-shaped volume, the eyes are sharply drawn almonds, and the upper arm, shoulder, and circular breast recall the curious shape of a leg-o'-mutton sleeve.

Sickert's music hall paintings and Dieppe landscapes of 1907-9 are discussed below. It is more convenient to treat his London figure paintings of this period consecutively, particularly as 1908 seems to have been a time for consolidation for him. He continued to paint portraits, of which *L'Américaine* (Fig. 185), a dated picture of a coster-girl wearing an 'American Sailor' hat, is a typical example. It recalls *The Juvenile Lead* in its presentation and handling. The sinuous serpentine curves of the girl in her hat are set off by the rectilinear shapes within the background plane (a shuttered window); the figure is again lit obliquely. The paint is even a little thinner than in *The Juvenile Lead* and the patchwork application of small smears is a little looser, but in some passages, particularly the hat and hand, this execution gives way to a more broken, dotted, and crustily impasted technique. The main difference between *L'Américaine* and *The Juvenile Lead* is in their colour. Strong notes of vermilion and peacock blue are introduced into the female portrait. The deliberate introduction of notes of strong colour is found in many of Sickert's paintings in 1908 and by 1908-9 he often used colour schemes and contrasts which seem harsh and discordant when compared to the softer harmonies of

violet and emerald-tinted green typical of 1907. It is probable that several portraits said to represent Mrs. Barrett were painted in 1907–8 (Fig. 183, C.265). In *The Red Blouse* and *Le Collier de Perles* his delicate, closely stippled application of paint beautifully rendered her gentle features. In *Contemplation* his handling was richer and broader; the paint was more thickly impasted and the colours stronger.[20]

Sickert did not limit himself in 1908 to any single method of execution. In *The New Home* (Fig. 181), painted in the first half of the year because it was exhibited at the N.E.A.C. in the summer, the paint, although solid and impasted in some passages, lacks the crumbling texture of the *Little Rachel* pictures and the Mornington Crescent interiors of 1907. It is painted in rich, juicy smears, rather than in crusty dots, and only the accents of highlight and shadow in the face and hands are noted in smaller, broken, dabbed strokes. The blond, rather honey-coloured tonality of the painting is also different from the more typically Impressionist violet and greens of many of the 1907–8 paintings.

It was probably in 1908 that Sickert took up many of his single-figure nude studies of 1907 and, combining them with a clothed man, turned them into the more anecdotal subjects often labelled as *The Camden Town Murder*. The development of the studies related to the *Mornington Crescent Nude* seen from the back into the two-figure drawing and dated etching of 1908 called *The Camden Town Murder* (Fig. 188) was traced above. Much the same sort of development can be seen from the tightly organized Mornington Crescent nudes, such as the *contre-jour* picture, to the *Camden Town Murder* (Fig. 192). This two-figure subject is identical in style and handling to the single figure nudes. The texture of the thickly impasted paint is the same, as is the use of strongly directed light to simplify the tonal fields, and they thus emphasize such essential shapes and volumes as the massive leg-o'-mutton upper body of the woman. The parallelism and the rectilinear geometry of the composition, with the figures disposed in a right-angled relationship echoing the right-angle of the bed, are the same, as is the curiously immobile atmosphere of the picture—a quality all the more surprising in a subject from whose title one expects violent action. (The later alternative title, *What Shall we do for the Rent?*, better suits its mood of hopeless apathy and dejection.)

The preparatory drawings for *The Camden Town Murder* are rather richer and rougher than the very precisely delineated and modelled drawings related to the single figure nude paintings. The shading in black chalk is more untidy and Sickert made fuller use of white heightening. The only similar drawing related to the single figures is of a reclining nude (C.269, Study 3) which in fact provides a compositional link with the two-figure subject. The pose of the nude, except for the lower arm, is very close to that represented in C.276, but the bed is now the one with vertical bars (also found in *No. 21*), and the space is closed by a curtain, both features of *The Camden Town Murder* painting (Fig. 192).

The more painterly handling of the drawings related to *The Camden Town Murder* subject was developed further in a drawing of another clothed man and nude woman subject (Fig. 187), in which the whole sheet is described in tone and the modelling techniques are richly varied. The drawing is again called *The Camden Town Murder* but the etching, dated 1908, of the same scene is called *La Belle Gâtée*. *La Belle Gâtée* introduces a whole new sequence of drawings and paintings wherein Sickert explored very different problems from those which had occupied him in 1907–8. In *La Belle Gâtée* Sickert rejected the rectilinear planar geometry typical of 1907–8 and reverted to a diagonally organized composition; the bed is seen in abrupt recession and the lines of the floorboards create counter orthogonals. He also renounced the immobile aloofness characteristic of his 1907 pictures and represented the figures as both psychologically and physically involved with each other. Indeed, in *La Belle Gâtée* the figures are shown in unusually explicit movement. The lines of curved hatching which model the woman's body are not used to emphasize the geometrical purity of her rounded volumes, but to create an impression of movement, and to this end they are placed somewhat apart from the forms which they define. This is especially true of the concentric sweeps of white heightening in her arm and

shoulder, which read as visual symbols for the atmospheric ambience disturbed by the sudden movement of her lifting arm; they represent the equivalent of the blur on a photograph of continuous movement and anticipate the devices used by Futurist artists to suggest the same effect.

This drawing seems to represent a coquette inviting the attentions of her lover, rather than being murdered by him, so that the title *La Belle Gâtée* is more appropriate than the alternative murder caption. Although the nature of the action of the protagonists in *La Belle Gâtée* is ambiguous, its suggestion of an illustrative or anecdotal content is far stronger than in any of Sickert's earlier two-figure compositions. This too is characteristic of Sickert's pictures of 1908–9 onwards when his domestic dramas, with their quaint titles, can be recognized, with two important provisos, as late inheritors of the Victorian *genre* tradition. The provisos are, one, that the scene of action is shifted from the drawing-room to the bedroom or shabby parlour, and two, that Sickert's initial inspiration was not to illustrate a particular story but to explore the purely plastic and formal relations of the figures to each other and to their setting. It was only when he had completed a work that he examined it for its literary potential and christened it with a title to direct the story it seemed to tell.

Sickert's attitude to his subject matter will be discussed in detail at the end of this chronological résumé of his stylistic and technical development, when its relevance to his career as a whole can be better appreciated. It is, however, necessary to state here that it was from 1908 to 1912 that he published his often quoted opinions on the proper subject matter for the artist: 'Taste is the death of a painter'[21]; 'The more our art is serious, the more will it tend to avoid the drawing-room and stick to the kitchen. The plastic arts are gross arts, dealing joyously with gross material facts . . . and while they will flourish in the scullery, or on the dunghill, they fade at a breath from the drawing-room'[22]; the artist should follow 'Tilly Pullen' into the first shabby little house, into the kitchen, or better still into the bedroom[23]; and 'Our insular decadence in painting can be traced back . . . to puritan standards of propriety. If you may not treat pictorially the ways of men and women, and their resultant babies, as one enchained comedy or tragedy, human and *de mœurs*, the artist must needs draw inanimate objects—picturesque if possible. We must affect to be thrilled by scaffolding or seduced by oranges. But if the old masters had confined themselves to scaffolding by night, and oranges by day, we should have had neither Rubens nor Tintoretto'[24]. Sickert knew well that the Old Masters had frequently treated so-called 'improper' themes and that in France artists since Degas had been assiduously following 'Tilly Pullen' into her bedroom. The last passage quoted emphasizes that Sickert was primarily concerned with asserting that English artists should also paint such themes, and his own writings and paintings did affect the tone and character of English art. Newspaper comment was full of shocked disapproval of Sickert's Camden Town pictures. Fred Brown wrote to Sickert that the sordid nature of his pictures since the Camden Town Murder series made it impossible for there to be any friendship between them[25]. So violent a reaction from a man who had been, like Sickert, a member of the advanced 'Impressionist' nucleus of the N.E.A.C., and who later taught at the progressive Westminster School of Art, and who from 1892 was Professor of Painting at the Slade, is a valuable indication of the effect Sickert's subjects must have had on prudish or innocent English eyes. Nevertheless, many of Sickert's younger colleagues who attended his Saturday 'At Homes' in Fitzroy Street were influenced to paint bedroom scenes. When they found that their individual identities were submerged in the monolithic and anarchic Allied Artists' Association and realized that it was necessary to band together into a more intimate society for selling and exhibiting purposes, they christened themselves 'The Camden Town Group' because of Sickert's association with that area of London. The paintings which they did both before the Group was formally created in 1911 and within its short life (in 1913 it was swallowed up by the larger and more amorphous London Group) introduced a new tradition of intimate *genre* scenes into English painting.

La Belle Gâtée (as well as the earlier nudes *La Hollandaise* and *Nuit d'Été*, Figs. 144, 147) were the compositional springboards for the development of a new composition representing the Camden Town Murder which culminated in perhaps Sickert's most famous picture on this theme, *L'Affaire de Camden Town* (Fig. 190); this painting was bought by Signac from the sale of his work sponsored by Bernheim-Jeune at the Hôtel Drouot in June 1909.

The first drawing related to *L'Affaire de Camden Town* is probably a study of a nude (listed under Fig. 190, C.271 as Study 1) roughly sketched in black chalk but largely defined in pen and ink. The pen is used to criss-cross the contours with short jabbed strokes and to model the torso with dots and flecks. The technical brutality of this drawing, compared with the soft and painterly chalk drawings of 1907–8, anticipates the handling of the painting. Next came *Conversation* (Fig. 189), a richly luminous black and white chalk drawing accented with touches of sepia ink, which is related to *La Belle Gâtée* in its handling and in its setting. At this stage Sickert did not have an illustration of the Camden Town Murder in mind because the drawing shows two women, one lying naked on the bed in precisely the pose of Study 1, the other clothed, standing beside her; they are looking at each other and presumably talking. The metamorphosis of *Conversation* into *L'Affaire de Camden Town* was, however, immediate. The dramatic potentialities of the psychological relationship between two figures, one naked, supine, and vulnerable, with the arm flung across her neck already suggestive of a defensive action, the other clothed and towering over her, were obvious. A squared study (8), dated 1909 and inscribed 'A Signac', is close to *Conversation* in its rich handling, in the basic layout of its composition, and in the pose of the nude, but the clothed figure is now male, and stands with arms folded in belligerent profile. In other rough chalk sketches showing the disposition of the figures and the compositional plan Sickert drew further back and incorporated more space around the main subject, thus making it at once less intimate and more sinister. In *Dettaglio The Camden Town Murder* (3), which omits the nude, he divided the background (as in the painting) into two halves, a diamond-patterned wallpaper behind the bed, and a figured curtain behind the man. This division is an important factor in projecting the mood of the painting. It emphasizes the separation of the two figures and their inability to communicate with each other. However, none of the drawings has the convincing brutality of the painting. In the painting details such as the chamber pot under the bed, roughly suggested in the drawing *Crisis* (4) but fully defined in one careful study of the nude (5), and the chair on which some clothes are flung, add substance to the interior and significance to the dramatic situation. Minor alterations in the poses of the figures also increase the dramatic effect. The man's head is bent down lower which makes him appear more hostile; the woman's body is more twisted, even contorted, which heightens the impression of her cowering fear (Studies 5 and 6 examine this more contorted pose). Although the basic changes are few, the relaxed intimacy of *Conversation* is translated into a theatrically grotesque scene of shame and violence.

As usual with all Sickert's representations of this subject the painting bears no identifiable relationship with any of the known episodes of this notorious murder. However, *L'Affaire de Camden Town* alone has no alternative title and it is the most convincing in its brutality. It may well be Sickert's one conscious attempt to portray the murder, as opposed to borrowing its name as title for his two-figure pictures. It could be an imaginative re-creation of the moment immediately prior to the killing— the events leading up to this were never established with certainty—although there are many discrepancies between the murder as published in the press and Sickert's picture. The naked body was found lying face downwards; it was assumed at the inquest, from the lack of signs of resistance, that her throat was cut while she slept; the woman was blonde and her hair was in curling pins; all facts at variance with Sickert's picture. Nevertheless, a lurid touch of macabre reality is introduced into this picture, as well as into all the others on this theme, in that Sickert's model for the male figure is said

to have been the commercial artist who was accused but finally acquitted of Emily Dimmock's murder[26].

The technique and handling of *L'Affaire de Camden Town* is partly responsible for its brutal effect. The attractive surface of Sickert's 1907–8 pictures is gone. The heavily impasted paint is applied more crudely. The separately coloured brushstrokes are no longer closely stippled so as to blend together, but each tells in distinct contrast to the others. The bedclothes and the nude are restlessly painted in small squared blocks of colour and all the complex twists of the body are accentuated by a continuous purple outline. This type of continuous outline drawing was found in some of Sickert's Mornington Crescent paintings and drawings of 1907–8 but in *L'Affaire de Camden Town*, instead of choosing a relaxed pose in which all the small disturbances of form are smoothed out to allow their circumscription by a flowing and even line, the pose is so contorted that the contour is a succession of ugly bulges. The way the surface is broken up into differently patterned areas also emphasizes the restlessness of this picture. Nevertheless, the handling of *L'Affaire de Camden Town* is still closely related to Sickert's work of 1907–8. The plastic volumes of the figures are reduced to simplified generalized shapes; the grey and mauve colour harmony recalls the *Mornington Crescent Nude* seen from the back and the *Little Rachel* pictures; above all the impasted surface and the concept of painting with small touches of different colours grew out of Sickert's experience in 1907–8. It is primarily Sickert's brutal exaggeration of this handling which distinguishes *L'Affaire de Camden Town* and illustrates the development in his technique characteristic of his painting *c*.1909.

Sickert continued to pursue the theme of a clothed man and a naked woman in such pictures as *Home Life* (C.278) and *Dawn, Camden Town* (Fig. 191). The female figure in *Dawn* is the same corpulent woman represented in *L'Affaire de Camden Town*. The male model in both pictures, shown in waistcoat and shirtsleeves, is also the same as in *L'Affaire*. In both pictures Sickert remained interested in linear perspective, and he drew the floorboards, as he had done in *La Belle Gâtée*, with didactic accuracy. The thick, crusty paint, applied in small separate touches, and the outline drawing, also recall *L'Affaire*. However, the texture of the paint is now so thick and oily that it has become unpleasantly clumsy and turgid. Similarly the colour, which was sharp and clear in *L'Affaire de Camden Town*, is now exaggeratedly bright and crude, especially in its startling oppositions of brilliant emerald and turquoise green with purple and black. A painting of *Reflected Ornaments* (C.279) on a mantelshelf was probably painted at about this time. The nature of the subject, the very broken *facture*, the thick oily paint, the dark tonality but brilliant colours (especially emerald greens and different reds—rust, orange and vermilion) make the picture scarcely legible. It presents an almost abstract mosaic of glowing colours which could have been influenced by Monticelli.

The deliberate crudity of colour and handling found in these paintings represents the technical dead-end to which Sickert's experiments with painting in a mosaic of small separately coloured touches of thick paint had led him. He was not forced, except by some sort of inner compulsion, to go to the extremes illustrated by *Dawn* and *Home Life* and in some paintings of *c*.1909 he did manage to stop just short of the brink. In *Sally. The Hat* (Fig. 186), a picture of a single nude identical in its setting to *Home Life*, the paint is thick, oily, and crustily impasted but it just avoids being clumsy; the colour harmony is very bright but not strident. The painting of the face and body in shimmering dots of colour aligned in strips of light and dark tones recalls the *Little Rachel* series. Sickert also recaptured some of the reflective tenderness of those pictures as well as reviving his interest (as he did to a lesser extent in *Dawn* and *Home Life*) in the effects of natural daylight on figure and furniture. The background of *Sally. The Hat* is painted, as in *Dawn* and *Home Life*, in high-pitched greens ranging from emerald to turquoise, but the only purple tones are found in the touches of violet where the dress hanging on the arm of the couch catches the light. The figure is painted in strong pinks, with chocolate

browns in the darks, and cream, ochre and olive in the lights. The total effect is a little restless and glaring but not shocking to the eye.

A preparatory drawing for *Sally. The Hat* (C.274, Study 1) in charcoal heightened with white chalks has the rich luminosity of Sickert's 1907–8 drawings, but another (Study 2) is drawn in pencil and the outlines have something of the disjointed schematic angular quality also found in *Despair* (C.273), a study for the male figure in *Dawn, Camden Town*. This type of drawing is found in many of Sickert's figure studies of *c.*1909. Examples include *Wellington House Standing Nude* (C.281), a pencil study of Sally holding a bedrail in front of the rectangular washstand seen in *Home Life*; *Man Washing his Hands* (C.282), a drawing of a man by the same washstand; and *Stemmo Insieme* (listed under C.275), a black charcoal drawing of a man and a woman lying on a bed which is related, in its setting, to two paintings now known as *Summer Afternoon* (Fig. 193, C.275), but exhibited at the first Camden Town Group exhibition in June 1911 as *The Camden Town Murder Series, No. 1* and *No. 2*.

The *Summer Afternoon* paintings were the first Camden Town Murder pictures Sickert showed publicly in London (*L'Affaire de Camden Town* was sent straight to France for exhibition and sale). They are curiously elusive paintings. As pictures of a dramatic situation they are only impressions, with none of the explicit brutality of mood and definition found in *L'Affaire de Camden Town*. The disposition of the figures, with the man seated on the bed and the woman lying on it, recalls the 1908 *Camden Town Murder. What Shall we do for the Rent?* painting (Fig. 192), although more of the setting is shown. The parallel planar arrangement of the composition also recalls Sickert's 1907–8 pictures although the insistent drawing of the floorboards in the fuller version (Fig. 193) is typical of *c.*1909. Sickert's consuming interest in the effects of natural daylight streaming through the dusty glass of the background window onto the woman's body is another throwback to 1907–8. Light is the main subject of these paintings; it is the medium of reportage and heightens the drama of the emotional relationship of the figures. It strips the woman naked and by-passing the man transforms him into a threatening, brooding silhouette. Nevertheless, the trace of clumsiness in the definition and handling of both pictures (despite their different treatments) is typical of Sickert's work *c.*1909. The more contracted version is quite thinly and loosely painted in roughly scattered sweeping strokes but Fig. 193 has a more closely worked surface texture. There is a tentative quality about these pictures and it is possible that they represent two chronologically separate experiments, one of 1908–9 (Fig. 193), the other of 1910–11 when Sickert abandoned his attempt to work in a mosaic of thick paint and explored different methods of painting in a more free and summary manner.

Sickert's interest in intimate bedroom scenes in the period 1907–9 did not lead him to neglect music hall and landscape painting. It was in these years that he conceived the brilliant composition of his representation of the rebuilt New Bedford, a triumphant illustration of its gaudy splendour from pit to ceiling, from the hugger-mugger audience below, through the huge pilasters up to the giant caryatids who bear the weight of the springing vaulted arches on their heads. Plush curtains, decorative gilt plasterwork, festoons everywhere, *The New Bedford* (Fig. 166) makes Sickert's early London music halls and the Paris and London halls of 1906–7 seem almost utilitarian. Sickert clearly revelled in its unashamed vulgarity. Two of the studies related to his first fully realized painting of this scene (C.238, Study 5 and Fig. 167) show an attention to minute detail which is very rare in his work, which is indeed rare in this century, but which strongly recalls a Victorian artist's pedantic transcription of observed reality.

Sickert was to draw and paint the New Bedford many times, especially from 1914 to 1916 when he was working on the six-foot-high tempera picture (Fig. 255, C.365) originally projected as one of a series to decorate the dining room of his friend Miss Ethel Sands. Then, for long periods of time, Sickert drew at the New Bedford nearly every night, and he painted, besides the large picture, a

smaller rehearsal for it. He also etched *The New Bedford* in 1915, and several of his drawings were clearly used as studies for the etched, not the painted, composition. However, in spite of his renewed studies, in both these paintings and in the etching Sickert retained the basic compositional format he had devised *c.*1909 for Fig. 166.

Fig. 166 is not Sickert's earliest painting of *The New Bedford*. A small painting on canvas, representing one of the upper boxes in the theatre (C.247), must antedate it by about two years. This box was to become the focal point of the later paintings but the small picture lacks the pronounced verticality of the compositions showing the whole height of the interior. The handling of C.247, with its dark tonality, its limited colour range (maroon, ochres, and black), and its shorthand description of the faces of the audience, suggests a date close to Sickert's London and Paris music halls of 1906–7. This dating is supported by the exhibition of a drawing of *The New Bedford* at the N.E.A.C. in the summer of 1907, which a thumb-nail sketch in the annotated catalogue of this exhibition in the Tate Gallery archives proves was similar to the painting in composition[27].

The New Bedford (Fig. 166) was probably the picture Sickert exhibited at the Allied Artists' Association in 1909 and at the winter show of the N.E.A.C. in the same year. Contemporary press descriptions are not detailed enough to prove this identification definitively, but the *Saturday Review* noted that Sickert's 'vision of a music-hall interior, is one of the most original pictures in the gallery, one of the things by which this exhibition will be remembered'[28]. In this painting Sickert brilliantly exploited his current technique. The very substantial texture of the paint, the consistent and deliberately broken *facture*, the choice of colours—greens, purple, maroon, pink and yellow ochre, the intermittent use of drawing in heavy black lines, are typical of 1908–9, but whereas they seemed disturbing and clumsy in paintings of murky bedroom interiors, they are admirably suited to convey the shimmering mosaic of colour in this gaudy music hall.

Sickert also painted the architecture of Dieppe during 1907–9. It will be remembered that in his letter to Miss Hudson written in the first half of 1907 he had said he intended to paint 'a few really complete and cumulated canvases in Dieppe'. It is probable that many of the paintings of St. Jacques seen down *La Rue Pecquet* (Fig. 197, C.287) belong to these years. It is instructive to compare these later paintings—in which the paint is thick and often impasted, drawing is minimal, and the surface of the church is alive with scattered dots of broken colour—with his paintings of the same scene executed around 1900 (e.g. Fig. 81). A drawing of *La Rue Pecquet*, which may be a preparatory study for these later paintings, shows the church wall described in little dots of the pen, a graphic equivalent of the broken brushwork of the paintings. But the most extreme example of Sickert's use of a broken *facture* in a landscape is *St. Jacques, South Façade* (Fig. 198). A squared working drawing for this picture (C.288) is dated 1907 and the painting itself must be considered as a direct result of Sickert's recent decision to paint 'complete and cumulated' pictures in Dieppe. Once again a striking comparison can be made with the earlier 1900 painting of the same scene (Fig. 82) with its dramatic illumination, strong tonal contrasts, and fluent loose handling. In the later picture the whole surface is thickly covered with tightly stippled crusty paint; the tonality is consistently light and the colours bright—the sky pale blue, pink, and pink-grey, the ground purply-grey, pink, and olive, and the church is touched in with small broken dots of purple-violet in the shade and pale pink and olive in the lights. This picture stands in the same relationship to the 1900 version as does the work of the classic French Impressionists to the tonal painters who preceded them. Indeed, the overwhelming influence of Camille Pissarro must be responsible for this picture, the most truly Impressionist that Sickert ever painted.

NOTES

1. The reference to the self-portrait which Sickert was currently painting, quoted below in the text, proves when this letter was written.

2. The present title of this picture is an allusion to Sickert's early career as an actor. The portrait, which shows Sickert wearing a bowler hat, has had other titles—*L'Homme à la Billicoque* when reproduced in the *Studio*, 127, May 1944, p. 142. Proof that it was indeed *L'Homme au Chapeau Melon* is provided by another letter written by Sickert to Miss Hudson telling her 'I have sent my portrait and the heavy woman sitting on the edge of the bed' to the *Salon d'Automne*; these two pictures can only refer to *L'Homme au Chapeau Melon* and *Nu* exhibited in 1907.

3. The identification of this self-portrait with *The Parlour Mantelpiece* is based on two pieces of evidence: (i) the annotated comment on the picture in the N.E.A.C. catalogue of the exhibition in the Tate Gallery archives, 'blue specks in face and casts'; (ii) mentions of the picture in two letters to Miss Hudson. In the first Sickert wrote, 'the New English is open, and to my amazement and joy my friend Hammersley bought my *autorittrato* at once', and in a later one telling of other purchases by Hammersley, Sickert noted he already had 'my portrait with the casts in the last New English'. It should be noted that Hugh Hammersley has always been known as the first owner of *The Painter in his Studio*.

4. The dating of this sequence of letters is of crucial importance. None of the letters is dated but the year they were written can be deduced from several references to different events in a group of four letters. Their dating is interdependent. All are addressed from 6 Mornington Crescent. First letter: Sickert noted that it was a miserable summer, that the N.E.A.C. was open and Hammersley bought his '*autorittrato*' (see note 3), that the Gilmans were in Sickert's house in Dieppe (it is known Gilman was in Dieppe in 1907). Second letter: this is the one quoted in the text mentioning the interiors, the little Jewish girl and the nude: Sickert noted it was cold, that Gore was in a cottage in Yorkshire (it is known Gore painted in Yorkshire in 1907), that a Mr. Butler had bought an old Sickert 'Notre Dame' painting at a recent Saturday 'at home' in Fitzroy Street. Third letter: still summer ('London in the summer is really ideal for work, light and peace and convenience'); Sickert reported that the Gilmans had quarrelled with his *bonne* and left his house in Dieppe, he mentioned again that Mr. Butler had bought an old Notre Dame, that he wanted to finish 'about seven more [paintings] before I get away, to take to Paris', and that Hammersley, who already had several Sickert paintings as well as 'my portrait with the casts in the last New English [see note 3], came on Tuesday and bought 3 new ones, two nudes and a child at a window'. The two nudes can only be *Mornington Crescent Nude* (Fig. 175) and the *Contre-Jour Mornington Crescent Nude* (Fig. 179) of which Hammersley was the first known owner. The child at the window may be *Girl at a Window* (Fig. 182), of which the first owner known to me was Robert Emmons, who could not have acquired it until the 1920s. More evidence for dating this letter 1907 is a remark by Sickert (*à propos* of Miss Hudson fiddling over the frames of her pictures) that women are '"aesthetes". *Pour moi c'est* le plus gros mot *que je connaisse*'. Miss Hudson clearly took exception to this label because in the fourth letter Sickert had to say, 'I didn't apply the term

"aesthete" to you . . . I hold it vaguely *in terrorem* over everybody as the worst "*gros mot*".' This letter was written the night Sickert was to cross to Dieppe 'to do landscapes for the weaker brethren' and is the one quoted in note 2 telling of the two pictures he had sent to the *Salon d'Automne*, pictures which can only be the two exhibited in 1907 (in every other year Sickert sent more than two pictures to the *Salon d'Automne* except in 1909 when his two pictures were both Camden Town Murder subjects).

5. See note 4, third letter.

6. The murder of Emily Dimmock, christened by the press 'The Camden Town Murder', took place in September 1907. Sickert used this title loosely, for various compositions featuring a nude woman and a clothed man. He could not, of course, have used the title for his 1907 Mornington Crescent interiors done before he left for France because the murder had not yet occurred. Moreover, there is no evidence to suppose that he did two-figure man and woman subjects before the French visit.

7. Others read this inscription as '*le petit Jewess*' which makes sense with regard to the model. But I can only read the word in question as 'Jesus' and infer that Sickert found that the semitic features of his model and her wavy hair with long locks falling by her ears reminded him of pictures of the young Jesus.

8. The *New Age*, 19 March 1914, 'A Stone Ginger'.

9. The *New Age*, 2 June 1910, 'The New English—and After'.

10. 1 June 1907.

11. In second letter, note 4.

12. Frank Rutter was supported by many members of the group when he started the society, in particular by Sickert, Gore, and Pissarro.

13. The reasons for dating the letters dealing with the foundation of the Fitzroy Street group early 1907 are too numerous, and taken individually, too inconclusive, to list. But taken together they could only have been written at this time.

14. The *New Age*, 26 May 1910, 'The Spirit of the Hive'.

15. The *Fortnightly Review*, 84, December 1908, pp. 1017–28, 'The New Life of Whistler', p. 1024.

16. The *New Age*, 30 June 1910, 'Impressionism'.

17. The Neo-Impressionist generation did rationalize the characteristic Impressionist *facture* and construct a pragmatic theory which governed every touch of paint and colour more nearly in accord with 'the juxtaposition of definitely intentional colours' described by Sickert. However, Neo-Impressionist theory and practice were scientifically inspired and were not at all related to any abstract theory of '*la peinture*', that is the right handling of oil paint.

18. See note 4, third letter.

19. It fits the description 'the heavy woman sitting on the edge of the bed' which Sickert told Miss Hudson he had sent to Paris with his self-portrait (see note 2).

20. *The Red Blouse* is also known as *Mrs. Barrett*; the sitter in the other two portraits resembles Mrs. Barrett.

21. The *Fortnightly Review*, 84, December 1908, pp. 1017–28, 'The New Life of Whistler', p. 1026.

22. *Art News*, 12 May 1910, 'Idealism'.

23. The *New Age*, 16 June 1910, 'The Study of Drawing'.

24. The *English Review*, March 1912, pp. 713–20, 'A Critical Calendar', p. 717.

25. Sickert reported this in a letter to Miss Ethel Sands written during the 1914–18 War.

26. Information given to me by Mr. Rex NanKivell who was told this by Sickert.

27. The medium (pencil and charcoal) of the exhibited work was also noted in the margin of this catalogue, otherwise it would have been tempting to suppose it to have been the painting (C.247). Frank Rutter, *Art in My Time*, London, Rich and Cowan, 1933, p. 122, was clearly mistaken when he implied that Sickert's *The New Bedford* painting ('an unquestionable masterpiece, as brilliant in the flashing, glittering polychrome of its highlights, as it is magnificently original and arresting in design') was shown at the N.E.A.C. in 1907. He clearly remembered the painting well, and remembered it was shown at the N.E.A.C., but must have used a catalogue to refresh his memory as to the year of its exhibition and selected that of 1907 instead of 1909. The 1907 catalogue does not acknowledge *The New Bedford* as a drawing.

28. 11 December 1909.

1910–13. Camden Town Period

THE entire development of Sickert's handling between 1907 and 1909 was, in a sense, a paradoxical interlude in the context of his technical evolution. Sickert had been reared by Whistler; the recurring theme of his technical development and the mainspring of his search for the ideal handling of his medium was refined economy in the application of his paint. This quality had been forgotten while he was experimenting with the N.E.A.C. method of painting 'with a clean and solid mosaic of thick paint' (the following words, 'in a light key', have only intermittent and relative reference to his own work). By 1909, in paintings such as *Dawn, Camden Town* and *Home Life*, an exaggerated and exclusive adherence to this method resulted in canvases overloaded with thick, clumsy paint. The heavy stippling obscured the underlying definition and necessitated the repeated application of coat upon coat of paint in an effort to recover the form. This overworking led precisely to one of the pitfalls Sickert most feared in the handling of paint. In a letter to Nina Hamnett, Sickert expressed his horror of the 'beastly' darks which resulted from overloading the canvas in this manner: 'All experienced good painters know that . . . the very shoving about and altering of a picture (within the limits of a clear plan) gives it weight and quality. Now if you shove it about . . . in its true colour you lose the beauty of the colour and have every day dozens of brushes and your darks, *being dark on dark*, get *beastly*.'

From 1907 until 1909 Sickert had also been using paint which in quality and texture was innately antipathetic to him. In 1914 he attacked the use of impasto as 'a manner of shouting and gesticulating' which to some extent veils 'exaggerations of colour or coarseness of drawing'[2], and later he complained to Miss Hamnett, 'The difficulty in oils is we don't like it clumsy with thickness'[3]. On the other hand the 'clean and frank juxtaposition of pastes (*pâtes*) considered as opaque' which the N.E.A.C. method also involved remained vital to his development. Sickert perhaps needed this experimental interlude, during which he played about on the line dividing the cleanness of a solid mosaic of paint from the clumsy beastliness of overworked pigment. It provided a practical demonstration of how thick paint led him to a technique incapable of expansion; it helped him to realize that his own natural attraction was not towards the closely stippled application of thick paint practised by many of his contemporaries and friends, but towards the integrated juxtaposition of clean, quite flat and thin stains of opaque paint.

The years from 1910 until 1913 can be interpreted as a period of gradual retrenchment. Sickert retained certain qualities typical of his work in 1907–9, notably the somewhat lighter key, the brighter and more varied colours, and the broken application of the paint, but his handling became more summary and he usually worked with much thinner, flatter paint. *Girl doing Embroidery* of *c.*1912 (Fig. 208) demonstrates a characteristic synthesis of elements distilled from his 1907–9 experience and his new use of thinner paint. It presents a very colourful pattern of interlocking stains of purple, olive-

green and blue which are thin enough for the rust ground to tell in places; the dazzle of light is described in splashes of white and red on the chair back and in scattered dashes of vermilion on the face, blouse, and skirt of the figure. The technique of this picture, with its summary generalized underlying preparation over which dabs and dashes of lively colour are superimposed, is typical of many of Sickert's paintings from 1910 to 1912, for example the two-figure bedroom scene *Shuttered Sunlight* of 1912 (Fig. 209, C.301) and the *Portrait of Gilman* (Fig. 207) of about the same time. In the portrait the paint is drier and more thinly and roughly applied than in *Girl doing Embroidery* so that much of the pale grey ground shows through; the face is alive with scattered dots of colour which in their destruction of the planes and contours of the face serve to convey the vibrant quality of light. It is possible that in this portrait of his friend and colleague Sickert was demonstrating, half ironically, how Gilman's own style should be used; how much more successful was the almost off-hand application of broken colour than Gilman's own rather laborious and self-conscious accumulation of thick touches.

Sickert did not achieve the casual fluency of *Girl doing Embroidery*, *Shuttered Sunlight*, and *Gilman*, all at once. In his portrait of *Jacques-Émile Blanche* (Fig. 204), painted *c.*1910, the direct confrontation of sitter and spectator, the summary, broadly painted, tonal preparation, and the broken dots of colour all over the face, resemble the *Gilman* portrait. However, the broken touches of paint are slightly impasted, they are distributed in closer juxtapositions with more regard for the underlying definition of form than in the *Portrait of Gilman*, and their colours are more subdued. Nevertheless, while Sickert's brushwork in this portrait is demonstrably more discriminate, deliberate, and finished than in the Gilman, a certain wayward tendency is already noticeable. For instance, although the dots of colour in *Blanche* are more directly related to the local colour of the subject, it is doubtful whether Blanche had one black eye and one blue.

In a Dieppe landscape of 1910, *The Elephant Poster* (Fig. 199), Sickert retained the high tonality, the bright colours (greens, purple, yellow, pale orange, blue, with salmon and pinks in the lights), the heavy drawing, and the thick paint of 1909, but he applied the paint more smoothly; although there are some passages of crusty impasto he did not make much use of broken brushwork so that the surface is less overworked and thus cleaner. The English landscape, *The Garden of Rowlandson House, Sunset* (Fig. 200), was probably also painted *c.*1910. Its bright colour scheme dominated by purples and greens, its high tonality, the rather heavy drawing of the buildings, and the thick and pasty texture of the paint again recall Sickert's work of 1909 but, as in *The Elephant Poster*, the paint is applied fairly smoothly with only a few passages of crusty impasto, and the broken brushwork is confined to the description of the shrubs.

The relative tightness of handling in all three of these pictures, and the somewhat self-conscious heavy precision of definition particularly noticeable in the two landscapes, are hangovers from 1909 which were soon to disappear in the more off-hand fluency and summariness of Sickert's painting in 1911. In paintings of this year such as two pictures of coster women in boater hats, *Two Women* (Fig. 203) and *Lou! Lou! I Love You* (C.315), in the two bust studies of a woman on a bed, *Oeuillade* and *Woman with Ringlets* (C.316, 317), and in *Off to the Pub* (Fig. 205), the texture of the opaque paint is still fairly substantial but it is almost never applied in impasted touches so that the surface of the pictures is smoother than it had been in Sickert's work for several years. The brushwork is an untidy fabric of short broad strokes, undisciplined by any drawn definition except for the occasional mark on the faces. Instead necessary accents are indicated by slight changes in the *facture*, such as the use of smaller dabbed touches in the faces and hands, or some broadly scraped highlights along the contours. There are, of course, certain differences in the handling of these pictures. In *Two Women* Sickert's touch was more delicate and broken, especially in describing the head of the foreground

model. In *Off to the Pub* the brushwork is more sweeping, smooth, and broad. In *Lou* the paint is applied in a softer patchwork of flat, rather blotted-looking stains. *Oeuillade* is a chaotic jumble of untidy strokes. Common to them all, however, is Sickert's method of treating his subjects as summarily simplified statements of tone. For instance the background women in the three two-figure subjects are all painted in a manner virtually resembling a two-tone photographic negative with the features materializing only as light projections from an area of uniform shadow.

Sickert soon found he was able to extract from his experience during the last few years exactly what he needed for a particular painting. Pictures such as the magnificent portrait of *Miss Hudson at Rowlandson House* (C.318) and *The Studio. The Painting of a Nude* (Fig. 206) represent the climax of the Camden Town period, when Sickert achieved the perfect compromise between thin and thick paint, between summary and laboured definition, between broadly swept untidy brushwork and a delicately precise touch. In these paintings he produced an ideal synthesis of all these qualities of paint and its handling. The paint in the backgrounds is quite flat and dry; the definition is broad but clear. The figures are not highly particularized, indeed they are described quite summarily, but their handling is so rich and varied that detail is suggested without being stated. The nude in *The Studio* is treated with a controlled and integrated variety of stroke almost unmatched in Sickert's work. There are full smooth passages in her thighs and shoulders, more hatched linear strokes in her torso, dabs of slightly impasted paint down her flank and round one breast, and dry scrapes where her shoulder, arm, and thigh catch the light. The colour of *The Studio* is neither bright and strident nor dull and muddy. It repeats the muted greens, maroons, and purples of *Two Women* with the addition of more creamy touches (*Lou* also is painted in a warm creamy key) while the rich blue in the painter's jacket gives it just enough vitality to sharpen the spectator's awareness of and reaction to the picture. Compositionally *The Studio* is remarkably complex and sophisticated. The setting is organized parallel to the surface, but pronounced diagonal emphases are created by the implicit spatial relationship of the two figures (implicit because the painter is only partially viewed) and the explicit surface diagonal of the painter's arm. The space surrounding the figures is contracted so that they appear projected very large upon the surface. This type of compositional plan, and this contraction of the spatial setting, are features found in many of Sickert's works—particularly in his drawings—of this period. The near focus on a *repoussoir* object—here the giant arm of the painter, in *Miss Hudson* the circular table—to define the position of the main subject within the interior is another device often seen in Sickert's work at this time[4]. *The Studio* can be read as a single figure (the nude), a two-figure (the nude and the painter), or a three-figure subject (nude, painter, and reflection). In formal terms it is a study of the relationship of the three figures on the surface and in space. In two of his drawings of this period, *The Comb* (C.337), dated 1911, and *The Proposal* (C.339), Sickert used the device of a mirror reflection to turn a two-figure into a three-figure composition and in each of these subjects the reflection not only enhances its formal content by permitting the exploration of a new facet of the scene, but it also enriches its psychological meaning. In *The Comb*, for example, the rapt concentration of the girl as reflected in the mirror underlines the significance of the mutual action of the two figures. In *The Studio* the arm of the painter cutting diagonally across the surface divides it into two triangular halves: one contains the painter—the explanation of the picture; the other contains the nude—the subject of the picture. The double representation of the nude not only helps to fill the entire space in this half but it also emphasizes the formal and psychological significance of her body as the painter's inspiration.

The period 1910–11 was a very busy time for Sickert. He courted three women. One refused him, another jilted him on their wedding day; the third, Christine Drummond Angus, a quiet student at Rowlandson House and seventeen years his junior, married him in 1911[5]. Christine was the perfect wife for Sickert. Submissive and undemanding, with a compassionate intelligence, her temperament

and personality did not clash with his own, and they lived together harmoniously until her death in Envermeu in 1920. An immediate consequence of their marriage was that Sickert had to set up a new home. He was still teaching at the Westminster Technical Institute at this period, '4 nights a week of 3 hours', as he told Miss Hudson in 1910. And in that year Rowlandson House was founded, the longest-lived of all Sickert's private schools of art. The enterprise had started at 209 Hampstead Road as a school of etching run by Sickert in partnership with the young Madeline Knox (afterwards Mrs. Clifton who herself told me the early history of the school). Sickert had met Miss Knox a year before when she was a pupil and he a teacher at the Westminster Technical Institute. She had then gone, together with Ambrose McEvoy, to Sickert's etching studio in Augustus Street to learn more of the craft. At the beginning of 1910 Sickert decided he might as well start an etching school and Miss Knox might help him both run and finance it. At Easter 1910 the house across the road, 140 Hampstead Road, became vacant and they took it, deciding that they could then expand the curriculum to include painting, drawing, and even associated applied arts. The school was christened Rowlandson House and continued in existence until 1914, nurturing the talents of countless students—many of them women and some even children (mostly the offspring of Sickert's friends). However, in 1910 Sickert was unwell. For a time Bevan took over the duties as host at Fitzroy Street, and Sickert had to leave much of the teaching load as well as all the chaotic financial and administrative problems of Rowlandson House to Miss Knox. She was barely twenty years old and broke down under the strain. Sickert reported in a letter to Miss Hudson at Christmas 1910 that Jacques-Émile Blanche had sold some of his pictures in Paris, and in an earlier letter that his portrait of George Moore had been bought: these sales enabled him to buy Miss Knox out of Rowlandson House (although in fact Sickert could repay only a proportion of what he owed her since she had for some time been settling the day-to-day expenses of the school out of her own pocket). In any event when Miss Knox left Miss Sylvia Gosse took over the practical management of the school (she put no stake into it but was to receive half the profits had there been any). Miss Gosse, who had already been a pupil at Rowlandson House, remained one of Sickert's most steadfast supporters for the rest of his life.[6]

In 1911 Sickert was closely involved with the formation of the Camden Town Group and with the organization of its first two exhibitions at the Carfax Gallery in June and December. The Camden Town Group grew out of the need still felt by several members of the Fitzroy Street circle to exhibit their work in a sympathetic and to some extent exclusive environment. Sickert's Saturday 'At Homes' did not draw in a wide enough public, but the work of members of the Fitzroy Street circle tended to be submerged in the larger, more amorphous exhibitions of the Allied Artists' Association and the N.E.A.C. It was decided to limit membership of the Group to sixteen invited artists, all of them men (perhaps a precautionary measure to prevent jealousies among Sickert's many lady disciples of varying talents). The sixteen were Sickert, Gore (the first President), Gilman, Ginner, Lightfoot (who died after the first exhibition; Duncan Grant was elected in his place), Bevan, Bayes, Drummond, Lucien Pissarro, Manson, Wyndham Lewis, Innes, John, Lamb, Ratcliffe, and Doman-Turner. All these members were frequenters—some more and some less constant—of the Fitzroy Street meetings, although only the solid core of the group were intimately associated with the development of the brand of Camden Town painting which may be said to represent the last, mainly Sickertian-inspired fling of English Impressionism. Ironically the formation of the Camden Town Group coincided with the moment when this core ceased to describe the shabby reality of life in Camden Town in terms of colour and light, and instead tried to adapt their art to encompass the lessons of Post-Impressionism. The Camden Town Group survived as an entity from 1911 until the end of 1913. This period saw the two Post-Impressionist exhibitions organized by Roger Fry, the first held in the winter of 1910–11, just before the group was formed, the second in the winter of 1912 (when Gore was among the

group of English Post-Impressionists who contributed to the exhibition). In 1911 an exhibition of the Italian Futurists was held at the Sackville Gallery and an exhibition of Gauguin and Cézanne at the Stafford Gallery. In 1913 Frank Rutter organized an exhibition of Post-Impressionists and Futurists. Not surprisingly, the individual members of the Camden Town Group formed new allegiances during this crucial period and the identity of the group as a whole lost all meaning and crumbled. The exhibition of 'English Post-Impressionists, Cubists and Others' organized by the Camden Town Group at Brighton in the winter of 1913–14 in a sense acknowledged the *fait accompli*. Even without the sudden influx of modern French art into London the quick disintegration of the Camden Town Group was inevitable, so diverse and opposed were the personalities and aims of its individual members. Duncan Grant, and to a certain extent Lamb, represented the Bloomsbury link. John and Innes were never more than peripherally connected with either Fitzroy Street or Camden Town. Lewis was already feeling his course towards Vorticism. Drummond, Bayes, Ratcliffe, Manson, and Doman-Turner were all minor talents, circling in the orbits of one or other of the more forceful members of the group. Drummond had studied at the Slade and had then been taught by Sickert at the Westminster in 1908. Bayes was art-critic for the *Athenaeum* from 1906 to 1916, and was later headmaster of the Westminster School of Art. Ratcliffe was persuaded by Gilman to take up painting and had studied for one term, part-time, at the Slade. Manson, a friend of Lucien Pissarro, later became Director of the Tate Gallery (1930–8). Doman-Turner was an amateur watercolourist. The solid core of the group were the painters who had been the backbone of the Fitzroy Street circle, Gore, Gilman, Ginner, Bevan, Pissarro, and Sickert, but by 1911 the period of their close sympathy and artistic co-operation was really over. The Post-Impressionist exhibitions of these years confirmed tendencies already present in Gore's art before this time; the influences of Gauguin and Cézanne in particular encouraged his innate preoccupation with pattern and shape in the compositional construction of his pictures and he became increasingly interested in analysing objects in terms of their angular structure rather than through the play of light and colour. Bevan, who had worked in France and painted at Pont-Aven in 1893–4, knew French Post-Impressionist, and particularly Gauguin's, work at first-hand; he had used bright colours and a *pointilliste* technique since the 1890s. He joined the Fitzroy Street group in 1908 but was by then already drawing away from all the current idioms to develop his own angular formulas for the description of London townscapes and equine subjects. By 1911 Gilman was associating more closely with Ginner than with Gore or Sickert. Ginner was born and had studied in France; he joined the Fitzroy Street group in 1910 when he came to England. Like Bevan he was aware of the developments in modern French art long before most of his English colleagues and his use of very thick paint applied in separated touches, and of bright, strident colours, was ultimately derived from van Gogh. He, and under his influence Gilman, observed the most meticulous objectivity when painting scenes of English life; they called their products Neo-Realist. The pompous pedantry of their theories greatly irritated Sickert. Pissarro and Sickert, the two oldest members of the Camden Town Group, were the only important painters from the Fitzroy Street circle who appeared to be unaffected by French Post-Impressionist art.

However, although it may be true that Sickert's prestige as the acknowledged *maître* of a large group of talented, younger painters diminished during this period, his reputation as an individual artist, relentlessly pursuing his own course, grew. He exhibited a great deal from 1911 until 1914. He had several one-man exhibitions, his first in London, apart from the early show as 'pupil of Whistler' at Dowdeswell's in 1886 and the show he shared with his brother Bernhard in 1895. In January 1911 he had an exhibition of drawings at the Carfax Gallery, and in July 1911 he exhibited paintings and pastels at the Stafford Gallery. In the next three years more exhibitions followed at the Carfax Gallery, 'Paintings and Drawings' (May 1912), 'Studies and Etchings' (March 1913), and 'Paintings

and Drawings' again (April 1914). All were retrospective and included only a small proportion of his more recent work[7]. Sickert also exhibited with many groups during this period. The Camden Town Group held a third exhibition in December 1912, their last as an exclusive well-defined group.

Sickert's contributions to the N.E.A.C. and the Allied Artists' Association became fewer during this period of involvement with the Camden Town Group. He also exhibited two pictures at the Dunmow Artists' Picture Show in November 1911, and six etchings (welcomed as bringing in 'the Whistlerian touch' in the catalogue preface) and six drawings (some early works) with the Society of Twelve in 1912[8]. Apart from all these activities from 1910 onwards he worked regularly for various periodicals. Between 1897 (when he had given up his position as art critic on the *Sun*) and 1910 Sickert had written only occasionally, his most important contribution being a review of the Pennells' *Life of Whistler*, published in the *Fortnightly Review* in December 1908. But in 1910 Sickert resumed his career as the writer of provocative critical essays on art. From January to May he published an article nearly every week in the *Art News*, and from April until early August he did the same in the *New Age*. In 1911 he wrote less frequently, although one important publication was his review of the first Post-Impressionist exhibition, published in January[9]; in 1911 instead of writing for periodicals he published drawings in the *New Age* (from June until August). In 1912 he both wrote and published drawings. He wrote a series of important articles in the monthly *English Review*, and nearly every issue of the weekly *New Age* from January to June 1912 contained a Sickert drawing (although a high proportion of these had been executed in 1911). Thereafter, until 1914, Sickert published only an occasional drawing or essay in the *New Age*.

Sickert's output of drawings in 1911 and in 1912 was huge. It is possible that the diversity of his interests in 1911 gave him little time for prolonged concentration on painting but did allow him to make more quickly prepared and finished drawings. It was primarily in his drawings that he continued to develop his ability to organize groups of figures, illustrating domestic situations, into relationships which were dramatically and compositionally effective. The character and mood of his subjects changed a little. He treated intimate bedroom scenes less frequently and never with undertones of brutality or violence. Instead his man/woman subjects, whether in the bedroom or more often in the 'parlour', illustrate the drab apathy or the petty conflicts of tired alliances. *Ennui* (Fig. 223), which epitomizes this type of subject matter, had its ancestry in drawings like *Preoccupation* (C.336).

Sickert's drawings, especially those which were published in the *New Age* (and presumably designed from the start for future reproduction) were often very elaborate in content and technique. He sometimes executed paintings of the same compositions; *Lou! Lou! I Love You* (C.315) is one example; *The Objection*, a dated painting of 1917 derived from the drawing *The Argument* (Fig. 230, C.328), is another; but the drawings were essentially ends in themselves, complete pictures rather than sketches studied as preparatory documents for a painting. Many of the drawings of 1911 and 1912, and nearly all those published in the *New Age*, were executed in pen and ink. Among the very few exceptions to this rule are two simple bust-length profiles of a woman—probably his new wife Christine—seen by a window. One, a chalk and pencil drawing called *Morning*, is dated 1911; the other, a chalk drawing called *Who did you say?*, is almost certainly of the same date (Fig. 225, C.322)[10]. Both were published in 1912, but it is probable that Sickert found that pen and ink reproduced better than chalk or pencil drawings.

In his pen and ink drawings of 1911 and 1912 Sickert experimented with all sorts of highly individual techniques. One method, devised and used in 1911, involved the combination of a wide variety of hatching techniques, often further enlivened by little dots and flecks. *Alice* (Fig. 228), a drawing published in and dated June 1911, shows how he covered almost all the paper in rich black lines, and combined within a single sheet passages of straight line hatching, straight and curved cross-hatching,

tight diagonal cross-hatching overlaid by vertical strokes, dots, and dashes. *Lou! Lou! I Love You*, published in July (listed C.315), is similarly handled although the paper is not so fully covered. Sickert did not confine his use of this elaborate technique to his published drawings only. He used it in *Sally* (Fig. 229, C.327), a profile full-length nude by a washstand, where the modelling methods are the same and as richly varied as in *Alice* although the shadowed areas are less black, and short flecks and dashes were more consistently employed.

The variety of touch and stroke found in these drawings, in a sense, deputized for brushwork. The drawings assume the character of graphic paintings. Indeed, Sickert sometimes forced his graphic technique to take over some of the functions proper to colour and handling in a painting. In his dated full-length portrait of *Mrs. Styan* (Fig. 222) of 1910 Sickert had supplemented the soft and luminous black and white chalk drawing with little pen and ink dots, especially in the more particularized areas of face and hands. This dotted execution recalls several of Sickert's Venetian drawings of 1903–4, such as his *Self-Portrait* (Fig. 130), but he had not employed so broken a technique again until 1907–9 when he used dashed strokes to destroy the contours in the study of a nude related to *L'Affaire de Camden Town* (C.271, Study 1), and dots to translate the texture of the crumbling façade of *St. Jacques* in a drawing of *La Rue Pecquet* (listed Fig. 197, C.287). In *Mrs. Styan*, however, the dotted execution, besides giving superficial variety to the surface, also has a painterly function. The dots are the equivalent of the little dabs Sickert used in the faces and hands of many of his painted figure studies from 1906 onwards. They describe, in monochromatic terms, the shifting quality of light on the figure. In several drawings of 1911 and 1912 Sickert exploited the painterly potential of this dotted pen and ink technique much further. The most extreme example, *Mr. Gilman Speaks* (Fig. 232), dated 1912, a complex three-figure subject, is like an Impressionist painting translated into monochrome. The very broken touch is the equivalent of a closely stippled application of paint. It dissolves the boundaries of form and suggests the vibration of atmosphere. It allows the eye to move freely from one object to another and thus helps the formal integration of figure and setting—a quality which was always important to Sickert. He once criticized Nina Hamnett's drawings because they 'may rather be called a sculptor's than a painter's drawings, in these senses that the form of the figure is studied in contour and the modelling mostly apart from relation to any pictorial background'[11]. In *Mr. Gilman Speaks* line, as such, is completely dissolved.

The total integration of figures and setting in *Mr. Gilman Speaks* is also encouraged by the limited range of its tonal pattern which is another by-product of the overall use of a very broken technique. In his essay, 'The Future of Engraving', written in 1915[12], Sickert commended Pissarro's advice, '*Peindre avec des tons aussi rapprochés que possible!*' It is clear from the context of this sentence that Sickert considered this advice applicable to works in media other than oil paint. The consistently broken touch used in *Mr. Gilman Speaks* represents one method of drawing in this way.

Another passage from 'The Future of Engraving' is relevant to the development of Sickert's drawing technique at this time. He wrote:

> Drawings, being made of black and white, may be divided into two kinds. There are drawings in which the character is of a black pattern on a white ground, and there are drawings in which the excess of black pattern results, in effect, in a white pattern on a dark ground . . . I would suggest that there is a law of aesthetic satisfaction that may be stated thus: Where an effect is obtained by placing black lines, patches, patterns or dots on a white ground, the pleasure of the observer begins to be lessened as soon as the amount of black, being the pattern, tends to exceed the amount of white, being the ground.[13]

In drawings of 1911, such as *Alice* (Fig. 228) and *The Comb* (C.337), the black pattern swamps the white ground. However, in other drawings of 1911, probably executed towards the end of the year because they anticipate Sickert's drawing style of 1912, he rejected the virtuoso combination of hatch-

ing techniques and left more of the paper blank. In the drawings of this type, such as *The Argument* (Fig. 230) and *Where can it be?* (C.335), there are fewer blocks of darkly patterned hatching so that a nearer balance obtains between blacks and whites. The drawing is also looser and freer in accordance with the more dynamic character of subjects in which Sickert represented transitory movements and fleeting expressions. In *Mr. Gilman Speaks* the very broken technique helps to achieve a perfect balance between the darks and the lights because the overall dots and flecks tend to neutralize the assertion of both the black pattern and the white ground. The style and handling of other drawings of 1912, such as *An Argument* (listed C.301, Drawing 1) and *The Tiff* (listed C.331), recall *The Argument* and *Where can it be?* of late 1911, but in *Amantium Irae* (Fig. 234), a more concentrated version of *The Tiff*, broken line as opposed to patterned shapes is definitely the principal means of expression. The graceful silhouette of the woman's body is barely modelled and her form is instead suggested by a delicate, wandering, frequently interrupted contour of varying weight which sometimes dissolves into neat files of dots and dashes. The subsidiary male figure is more suggested than defined. The lines of drawing are suspended at every point at which the spectator could conceivably continue them in imagination. The economy and purity of this drawing is very different from the rich, black, tightly treated drawings of the previous year. This development in Sickert's drawing technique can be compared with the development in his painting when, having experimented in 1908 and 1909 with thick, loaded, closely worked pictures he gradually refined his handling from 1910 onwards towards greater cleanness, summariness, and economy. The parallel development in his drawing technique, however, took place within a twelve-month period, perhaps because the nature of the graphic medium permitted the whole process of experiment to be worked out more quickly than was possible in paintings.

Sickert's essay, 'The Future of Engraving', from which passages have been quoted above, makes it clear that he regarded the different graphic techniques of etching, engraving, and drawing as governed by the same principles. He believed that drawings, whether on paper or copper, should be handled in the same way. Sickert's pen and ink drawings of 1911 and 1912 demonstrate more clearly than his drawings of any other period the closeness of their relationship to his own etching. He himself was an etcher rather than an engraver and had, as he wrote in a letter to Miss Ethel Sands of 1915, been 'dabbling with copper off and on for 30 years'[14]. The dense hatching of the 'black' drawings is found in several of Sickert's more thoroughly worked plates. The little dots and dashes seen in most of his drawings of 1911 onwards may have been suggested to him by flickwork, which had been characteristic of the incised techniques for centuries. The broken scribbled strokes of the pen, found in Sickert's looser drawings such as *The Argument*, have much in common with the light runaway freedom of the etched as opposed to the more continuous character of the engraved line. A comparison of the drawing and the etching of *Sally* (Fig. 229) reveals that the graphic technique used is identical. The same wavering vertical lines, the same cross-hatching, the same dots and flecks, are found in drawing and etching. Moreover, Sickert's rejection of the technique used in the densely hatched black drawings such as *Alice* is paralleled in his etching. In 1915 he told Miss Sands how he hated 'rich black picturesque etching'[15]. In another letter he explained that he only did 'a few complete tone plates . . . to show one can and for money and an undisputed reputation at the Brit. Mus. etc.' This method was not his 'ideal'. He considered '*Quai Henri Quatre*, *Le Bon Dodo* and *Mr. Johnson* for what they are as perfect etchings'[16]. Thus in his etchings, as in his drawings, Sickert's preference was for pale-toned lucidity with the definition and expression depending upon the spare concentration of the linear accents against the mainly blank paper.

It is also possible that Sickert's pen drawing style in 1911 reflects the influence of Post-Impressionism. Sickert had long been familiar with Post-Impressionist art, and appeared unmoved by the impact of the current exhibitions of French art except to warn his contemporaries against too wholesale an

acceptance and assimilation of Post-Impressionism[17]. His enthusiastic younger colleagues took Cézanne, Gauguin, and van Gogh as their new models, instead of Sickert who still seemed to be geared to the generation of Degas and the Impressionists. In fact Sickert's deliberately constructive approach to painting had a tenuous relationship to some aspects of Post-Impressionism. The direction in which his handling of 1910 onwards was leading him, in its summary simplifications of tone, colour, and drawing, was towards a style of painting which could itself be interpreted as a manifestation of Post-Impressionism, more novel and individual than that of most of his basically plagiaristic English contemporaries. In 1911 this development in his painting was still embryonic but a more clearly defined element of Post-Impressionism may be discerned in his drawings. The varied patterning of his pen and ink drawings, achieved by the combination of shading techniques, distinctly recalls van Gogh's reed pen drawings. However, this influence was not acknowledged by Sickert, nor was it recognized by his contemporaries as Sickert's gesture of homage to the current rage.

In his drawings of 1911–12 Sickert not only experimented with new and adventurous techniques, but he also developed the compositional organization, and thus the dramatic and psychological effectiveness, of his figure groups. His preferred compositional formula was for a spatial setting arranged parallel to the surface plane, often viewed in abruptly foreshortened recession, with the figures generally stepped back in different planes of depth along a receding diagonal perspective. The foreshortened recession helped bring the whole composition forward to read clearly on the surface, and on this plane the figures were generally united by a strong diagonal relationship. In his earlier figure groups Sickert had alternated his preference for a parallel frontal recession with one which was diagonally orientated, but a significant difference between the majority of his 1911–12 compositions and those of earlier date is that before 1911–12 he had usually disposed the figures to echo the geometry of the spatial structure. The right-angled relationship of the figures in *The Camden Town Murder/ What Shall we do for the Rent?* (Fig. 192) echoed its rectilinear composition; the stepped-back diagonal relationship of the figures in *Home Life* (C.278) echoed its receding perspective. The diagonal disposition of the figures within the parallel, frontally receding settings of such typical 1911–12 compositions as *Preoccupation* (C.336), *Mr. Johnson* (C.334), *The Proposal* (C.339) and *The Tiff* (listed C.331), represents a subtle synthesis of his earlier compositional types. Naturally there are exceptions to this rule. For example, *A Weak Defence* (Fig. 224) of 1911 recalls the subject and composition of *La Belle Gâtée* (Fig. 187), with two figures seated on a diagonally receding bed. In *Two Women in a Bedroom* (C.340) of 1912 Sickert reversed his usual formula and placed the two figures in the same plane in depth in a basically rectilinear relationship, but arranged the setting along two crossing diagonals (the head-rail and background wall run from right to left, the bed from left to right).

Another significant development in Sickert's compositions of this date is the constriction of the spatial setting in relation to the figures. There is only sufficient space to contain the figures and explain their action, and the figures themselves occupy a far greater proportion of the surface space. This characteristic was probably encouraged by Sickert's experience with drawing for reproduction. He must have realized that, in order to be effective, his drawings should project themselves powerfully on the page. It is interesting to compare the drawing *The Argument* (Fig. 230), published in the *New Age*, with *The Visitor* (Fig. 231), a chalk and pen preparatory study for the published version. In *The Visitor* the setting contains a curtain, a couch on which a man sits in the background, and a chair in the immediate foreground in front of the standing woman; the figures occupy only a part of this complete interior. In *The Argument* Sickert telescoped attention onto one small part of this composition, the standing woman who now occupies almost the full height of the page. He ruthlessly excised the peripheral space, even removing the second figure who is now only implied by the title and by the determined belligerence of the woman's expression. Similar comparisons can be made

between the chalk and pen drawing called *The Toilet at the Window* and the contracted published version of this subject, *The Comb* (C.337), or between *The Tiff* and the published drawing *Amantium Irae* (Fig. 234). The difference between the proportions of figures and objects in relation to the surface space before and after 1911 is further illustrated by comparing such similarly conceived and composed drawings as *La Belle Gâtée* (Fig. 187) and *A Weak Defence* (Fig. 224). In the later drawing the figures are much larger, the bed is frankly recognized as the arena for the action, and all peripheral space is excluded. The contraction of the setting, the focused concentration on the figures, and the strong compositional relationships between them in the two- and three-figure groups, all helped to increase the psychological impact of Sickert's subjects. For instance, nothing could better express the relationship between the two figures in *Preoccupation*, their indifference to each other which belies their true intimacy, than the ambiguity of their spatial separation in depth and their binding diagonal alliance on the surface.

When the touch in Sickert's pen drawings of 1912 grew more broken and disintegrated, and when, at the same time, he virtually ceased to model individual forms, the function of the shadow blocks increased in importance. In *Two Women in a Bedroom* (C.340) and *Mr. Gilman Speaks* (Fig. 232) the placing of the few patches of shadow is the principal means of creating form and space. The figures themselves are hardly modelled but their cast shadows suggest their volumes and location. The relationship of darks to lights in Sickert's drawings of this period has an almost independent, abstract quality. For example, the basic pattern of the map of tones in the drawing *Hubby and Marie* is more or less taken over into the painting *Shuttered Sunlight* (Fig. 209), in spite of great changes in the disposition of the figures. This approach to the construction of a picture, whether drawn or painted, as a simplified map of tones with little attempt to go beyond the most summary statement of individual details, is characteristic of much of Sickert's work in 1912. In *The Old Soldier* (Fig. 211), inscribed 'Le Pollet 1912', the paint is flat and thin, the colours are few (mainly greys, ochres, salmon pinks, and purple), and the subject is described almost entirely as values of tone with no recourse to drawing and minimal reference to local colour. The man's face, for instance, is a salmon patch with ochre lights and purple shadows. The extreme summariness of this picture could be attributed to the fact that it is probably unfinished, except that other pictures are treated in an identical manner. In paintings like *Off to the Pub* (Fig. 212) the paint is equally thin and flat, the definition equally summary, and the whole description again depends on the interlocking pattern of stains of lights and darks. Such pictures give the impression that they were dashed off, impromptu, on to the canvas. In fact, whereas the paintings may have been swiftly executed in the sense that Sickert did not build them up in many coats or finish their definition with linear accents, they clearly needed very thorough preparation. In a picture as summarily defined and as thinly painted as *Off to the Pub* mistakes in the placing of a patch of shadow or a touch of light could not easily be worked over, yet such misplacements could destroy the whole meaning of the structure. Because Sickert could not alter or 'shove about' while painting, every detail had to be worked out in advance in his preparatory drawings. There are many such studies for *Off to the Pub*. The most complete study of the whole composition, in which Sickert reverted to the use of chalk with white heightening on toned paper, contains almost all the information finally incorporated into the painting.

Hubby and Marie, the models for *Shuttered Sunlight* and *Off to the Pub*, reappear in nearly all Sickert's figure pictures of 1912-14. Hubby, who was rumoured to have had a colourful past at sea, seems to have joined Sickert's ménage as odd-job man around the studio late in 1911[18]. His middle-aged stolidity dominates the character of Sickert's paintings and drawings of this period. He looms out of *Sunday Afternoon* (Fig. 214), a painting which was the point of departure for a long series of variations, both drawn and painted, which occupied Sickert in 1912 and perhaps into 1913.

Sunday Afternoon, in common with other pictures of 1912, is constructed as a broadly generalized but closely integrated map of tone colour patches. The definition is casual and the paint is swept in roughly. However, the texture of the paint is somewhat more coarse, dry, and full-bodied than in *Off to the Pub*. Its flatness is here and there disturbed by a swirling brushstroke or a thickly scraped highlight. Its quality and texture already look forward to Sickert's painting of 1913 and after, when he tended to abandon the extreme thinness of his summary 1912 handling.

The two figures in *Sunday Afternoon*, Marie leaning slightly backwards to grasp the bedrail behind her, and Hubby seated squarely in the foreground to stare quizzically at the spectator, were each separately incorporated into different two-figure relationships and compositions. *Sunday Afternoon* itself is perhaps the least successful of these compositions. The frontal setting and the diagonal relationships of the figures both on the surface and in depth, the telescoped focus of interest on the figures and the exclusion of the peripheral space, are all typical of Sickert's work from 1911 onwards. However, the verticality of its format is so steep—Sickert favoured narrow vertical canvases at this time—and the proportional diminution of Marie is so exaggerated (she holds the rail of the bed on which Hubby sits and cannot be far behind him) that *Sunday Afternoon* fails to read convincingly in depth. It remains a surface painting and consequently lacks the tension between the two- and three-dimensional aspects of a picture characteristic of Sickert's work. The failure accurately to judge the relationship between the two figures was possibly a result of Sickert's method of preparation. He studied his subject very thoroughly in drawings but among the extant studies there is none showing the two figures together except for one very slight note indicating Marie's hand and a bare outline of Hubby's shoulder. They are all single figure sketches and the artificially contrived combination of these separate studies may account for the failure of the composition as a whole.

Nevertheless, the realization of the two figures individually, and the underlying concept of the role each plays within a two-figure domestic situation, were both successful and capable of further exploitation. Marie re-emerged in a different context in the drawing *Vacerra* (C.341)[19]. She was transferred to the foreground, an arrangement better suited to the high viewpoint. Her monumental figure, a splendid *repoussoir* for Hubby reclining in the background, fills the whole height of the drawing. The swing of her body is more relaxed and the placing of her hands less awkward than in *Sunday Afternoon*. The complete certainty in the drawing of her figure would seem to imply the groundwork of experiment provided by the studies for that painting. Moreover the formal organization of *Vacerra* has none of the rigidity of *Sunday Afternoon*. The figures are beautifully related on the surface and in depth. The divergent angles help to express the psychological content of the drawing as clearly as do the four blurred dashes of Hubby's features with which Sickert indicates the fleeting lust of the old man as he contemplates the magnificently aloof and disdainful woman in his bedroom. In two more drawings, one inscribed 'My awful dad' and the other uninscribed (Fig. 235, C.332), Sickert produced a variation upon *Vacerra*. He preserved the setting and the background figure of Hubby but translated Marie into a young girl, which quite altered the mood and meaning of the subject. A very slight change in the disposition of the figures, whereby they hardly touch on the surface, may be significant. The overlapping of the figures in *Vacerra* was consistent with the physical implications of the subject but out of place in representations of a sulky girl and her irascible parent. There are also paintings related to these drawings, as well as another version of *Sunday Afternoon*. The two paintings of *My Awful Dad* are much later works, probably executed in the 1930s. The second version of *Sunday Afternoon* is handled in rather a perfunctory manner. *Granby Street* (Fig. 216), a painting related to *Vacerra*, is similar in style; the placing of the broken dabs and dashes of paint appears off-hand but must, in fact, have been the result of deliberate and controlled planning. Both pictures were probably painted between 1912 and 1915.

The figure of Hubby, seated in the foreground of a two-figure composition to loom out at the spectator, was, like the standing Marie, a motif capable of further exploitation. Sickert used it again, with Hubby now resting his chin on his hand, in a drawing called *Second Officer* (listed C.308). The second figure in this drawing is so absurdly diminished in size in the background that she resembles a pygmy on a giant's shoulder. The title may even be a humorous reference to her subordinate position. This drawing is related to a painting called *Hubby and Emily* (Fig. 217). Hubby's pose and placing are exactly as in the drawing but Emily is now uncomfortably squeezed in close behind his shoulder on the right. *Hubby and Emily* disturbs the hypothesis of Sickert's consistent development away from thick paint, broken colour, and tight definition. The texture of its paint is thick, coarse, and dry although not much more so than in *Sunday Afternoon*. However, ridges of impasto now trickle over the surface. The description is no longer summary and dependent upon an interlocking map of tones; it is tight and precise, with the definition built up from square broken dashes of bright colour (hot pinks, sappy greens, and notes of lemon yellow, cream, vermilion, white, maroon, and grey), especially in the faces and in Hubby's hand. This picture, probably painted in the winter of 1913[20], was clearly experimental, and in the details of its execution, unique to Sickert's work; but it does suggest that he felt considerable uncertainty in accepting the development of his handling from 1910 onwards. Perhaps Sickert was afraid that the degree of summariness permitted in paintings like *Off to the Pub* (Fig. 212) was leading him to sacrifice much of the quality of his paint, that his paintings were becoming poor and thin. Therefore in *Hubby and Emily* he attempted to revert to a more solidly worked broken execution. However, he did not at the same time recover the urgent sense of fitness, the discipline that had given his delicately laboured touches a real formal significance in his paintings of 1907–9.

Hubby and Emily is not the only example of vacillation in Sickert's handling around 1913. The paintings *Jack Ashore* (C.319), a telescoped view of the figures Sickert studied in several drawings showing a more comprehensive setting, and *Lady of the Chorus* (Fig. 215), are equally curious and paradoxical. The colour schemes of the two paintings are different—purples and blues predominate in *Lady of the Chorus*, ochres and browns in *Jack Ashore*. Otherwise their handling is similar. Both are unusual in the deliberately clumsy quality of their execution. The paint is applied in heavy splodges accented with some drawing in thick dark lines. They recall the picture of a *Girl in a White Dress* (C.314) which, according to the inscribed label on the back, was painted by Sickert before the students of the Westminster Technical Institute, presumably in one sitting, as a demonstration piece. It too is built up to a heavy impasto in layers of thick paint. The only explanation for this handling is that, as in *Hubby and Emily*, Sickert was consciously seeking some method of avoiding the thinness and poverty of his summarily executed work of 1912. To this end, while he maintained his perfunctory approach to the particularization of his subject, and therefore retained the simplification of its drawing, colours, and tonal values, he increased the substance of his paint and attempted to improve its quality by working several passages in a layered hotchpotch of patches.

Hubby and Emily, *Jack Ashore*, and *Lady of the Chorus* illustrate only a temporary, inconsistent interlude in the progress of Sickert's stylistic development from 1910 to 1914. In paintings from 'a whole series of direct little pictures 20 × 16 on the way' early in 1914[21] Sickert continued this development with more logic. The series included two pictures, related to a drawing, *Wellington House Academy*, showing Marie seated in an armchair with Hubby in the background (Fig. 218, C.309). The handling of one of these pictures, the version in Hamilton, Ontario (Fig. 218), is close to that of *Sunday Afternoon*. Sickert again used paint of considerable substance and his brushwork, particularly in the fairly elaborate modelling of Marie in swirling full strokes, strongly recalls such passages of *Sunday Afternoon* as Hubby's face. The other picture (City Art Gallery, Manchester) is more distantly related to the Wellington House drawing. Hubby's pose is closer to that seen in *Second Officer* except that he leans his

chin on the other hand and Marie is turned more to profile. The figures are reduced in scale as compared to the Hamilton version, and the paint is handled quite differently. The modelling is achieved by the juxtaposition of flat uniform stains of tone and colour, varying in size from small dabs to large blocks. Some fairly sharp drawing in dark lines is used to accent this scheme. The main respect in which this painting differs not only from the Hamilton version, but also from the more summary pictures of 1912, is that the stains of paint do not completely cover the canvas surface. This was clearly deliberate because the gaps in the paint surface through which the white canvas shines are made to function in the tonal scheme as highlights. This method of painting is close to that outlined by Sickert in a letter written to Miss Sands. The letter is undated but it belongs to a series written from 1913 to 1915 and it fits into the context of Sickert's ideas as expressed to Miss Sands in letters written in 1913–14[22]. Sickert's letter was concerned with advising Miss Sands on her own painting. In particular Sickert sought to discourage Miss Sands's liking for *alla prima* painting and he told her to keep at least one or two paintings going at the same time, to be '*poussées*' (pushed or taken) much further. He detailed the best technique for this: 'Touches ranging from the size of postage stamps to the size of a pea. And *perfect drying between*. Which means keep 2 at least going for time to dry. Don't revise the day's touches. *Let them be* and let them dry and forget them'. There followed a diagram or map with the explanation:

> First sitting touches represented by black lines.
> Second sitting touches by red lines.
> So that where there are no touches is bare canvas (or if you like scumbled preparation.)
> See how *few* places are twice covered in 2 sittings. And twice is not very much.
> Now as you know not till all the canvas is several times covered do you get a beginning of the quality on which everything *takes*.
> Don't fill up gaps for the sake of filling up.
> If you have the infinite patience to put free loose coat on free loose coat and *not to join up* you will suddenly find after x sittings 'something will happen'.

The Manchester painting of *Hubby and Marie* follows the method given in this letter in the virtually abstract quality of its map of overlapping stains of paint, in the varying size of these stains, and in the cleanness of the paint resulting from the perfect drying between each freely applied coat. Nevertheless the canvas is not completely covered and the gaps suggest that Sickert did not put on quite as many coats of paint as he believed essential to achieve perfect quality. In another painting from the series of direct little pictures done early in 1914, *Nude Seated on a Couch* (Fig. 220), Sickert does seem to have followed the recipe given above exactly. The overlapping thin stains of paint are now completely integrated so that no gaps of canvas remain. Sickert evidently applied more coats of paint, in more sittings, than he had allowed for *Hubby and Marie* and the quality of the painting of the nude is indeed a little richer and more beautiful.

The definition of both these paintings is basically summary but the handling, although economical, is never perfunctory. The economy is the result of very careful planning so that no touch is superfluous even though 'an infinity of series of touches are needed' (to use a phrase of Sickert's from the letter quoted above). Compared to most of Sickert's paintings of 1911–13 these two pictures are less untidy; the brushwork is less haphazard and the modelling, particularly the modelling of the nude, more carefully realized. The whole process appears to have been more deliberate and organized.

The compositional conception of *Nude Seated on a Couch* is also complex and sophisticated. Sickert once again used a looking-glass reflection to add new dimensions, compositional and psychological, to what was basically a straightforward, quite formal study of a nude. The shallow interior is expanded by the glimpse of the room on the near side, and the presence of a clothed male figure who is evidently

looking at the woman gives the picture a different meaning. Sickert used the same setting, with similar effect, in *Army and Navy* (Fig. 219), showing a corpulent man in the 'real' foreground in conversation with a companion seen standing in the reflection. The conception of these pictures recalls the early music halls in which Sickert had represented the object of the audience's attention in terms of a reflected image; the audience was unaware of the reflection and looked at the real thing outside the picture, but the spectator (unable to see the real scene) viewed it only as a reflection. The same device is used in *Army and Navy* and *Nude Seated on a Couch*. The woman and the man respectively are in communication with a real person whom we see only as reflected images. During the Camden Town period Sickert had not made use of this device but had tended, when he used a reflection, also to include its real source within his picture.

Between 1910 and 1914 Sickert had cast off his thick, broken, laboured execution. In some paintings of 1911–12 such as *The Studio. The Painting of a Nude* (Fig. 206) he appeared to have achieved a perfect execution, representing a synthesis of the best qualities from his work of the past few years. Nevertheless he had still found it necessary to push on further to explore the opposite extreme and paint in a manner as summary and perfunctory as possible. Then, with intervals for odd experiments designed to recover something of the former richness of his surface, by 1913–14 he began to devise methods of planning his execution in sufficient stages to achieve beauty and richness of quality without using paint which was too dense and thick in texture.

NOTES

1. Written in 1918, the date being inscribed on the back of the envelope. This letter is part of a short sequence, all written to Nina Hamnett at about the same time, but their contents have relevance to Sickert's lifelong attitude to paint, its properties and handling.

2. The *New Age*, 4 June 1914, 'The New English—and After'.

3. Undated letter from sequence (see note 1).

4. Another example is the chair in the foreground of a drawing, *The Argument*, dated 1911, published in the *New Age*, 13 June 1912 (Fig. 230).

5. B.60, pp. 32–3, tells of the refusal and I have had the story confirmed by the lady in question. George Moore, *Conversations in Ebury Street*, London, Heinemann, 1930, pp. 125–9, tells of the jilting (in his 'Sickert' chapter, pp. 113–30); his story is confirmed by a telegram sent by Sickert to Mr. and Mrs. Humphrey, 3 July 1911, with the cryptic message 'Sorry marriage off' and other letters and telegrams sent by Sickert to Miss Sands and Miss Hudson repeat this message and give more details of the unsuccessful relationship; I have also had the story confirmed by someone who knew Sickert at this time. Sickert's eventual marriage was also somewhat sudden. Sickert wrote to Mr. Humphrey declining a previously accepted invitation because 'I did not know that I was going to marry rather suddenly'.

6. Emmons, pp. 138–9, gives a substantially correct account of the history of Rowlandson House but was mistaken in several trivial details. For example Sickert's etching class was at 209, not 208, Hampstead Road. Frank Griffith (not Griffiths) was not a foundation member but first attended in 1913–14 (information given to me by Mr. Griffith).

7. Professor Constable annotated the Courtauld Institute Library copy of the January 1911 drawings exhibition at the Carfax Gallery, but despite his notes few of the works with Camden Town titles can now be identified (the other drawings included early music halls, Venetian figure studies, etc.). The Stafford Gallery exhibition of paintings and pastels in July 1911 included Venetian and Dieppe landscapes, Venetian figure subjects, and three earlier music halls; the few Camden Town paintings mostly seem to have been earlier works, for instance *The Map of London* (29), i.e. *Belgian Cocottes* of 1906. Of the seventeen oils shown at the Carfax Gallery in May 1912 only *Oeuillade* (18) and *The Basket Shop* (55) can be identified with extant pictures of this period (C.316, C.293 respectively). Several of the fifty-two drawings in this exhibition were recent studies. The studies and etchings exhibition, Carfax Gallery, March 1913, was again mainly retrospective. Only the exhibition of paintings and drawings held at the Carfax Gallery in April 1914 seems to have contained a high proportion of his recent work, especially of his Dieppe landscapes of 1913, to be discussed in the next chapter.

8. Sickert ceased to be a member of the N.E.A.C. after the winter 1909 exhibition and did not rejoin until summer 1914. This detachment from the club coincided with the period of his involvement with the Camden Town Group which by 1914 had been swallowed up by the larger London Group with its different, less Sickertian allegiances. Sickert did show a few pictures with the club and continued to serve on the jury during this time (he showed one picture at each of the 1911 shows, two in summer and one in winter 1912, and one in summer 1913, but of these only the portrait of *Jacques Blanche* is certainly identifiable). Sickert's contributions to the Allied Artists' Association likewise declined in number and importance. He seems to have grown disenchanted with the idea of himself contributing to an entirely open, non-selective, exhibiting forum, although he encouraged his lady disciples (e.g. Miss Sands, Miss Hudson) to take the chance to show their

work there. In 1911 he showed three drawings at the A.A.A.; in 1912 and 1913, although his name is listed as an exhibitor, no work is listed in the body of the catalogue. Sickert showed a mixture of recent and earlier work at the three Camden Town Group exhibitions and at the Brighton show. Some of his contributions are now lost and/or unidentified, but those which are known are listed in the catalogue section. The two drawings which can be identified among the six shown with the Society of Twelve in 1912 are likewise in the catalogue. Sickert's exhibition with the Dunmow Artists' Picture Show in 1911 is explained in the catalogue under *Off to the Pub* (Fig. 205, C.296).

9. The *Fortnightly Review*, 89, January 1911, pp. 79–89, 'Post-Impressionists'. Other important publications in 1911 were one article in the *New Age*, 15 June, 'L'Affaire Greaves' and a catalogue preface to a Camille Pissarro exhibition held at the Stafford Gallery.

10. The other exceptions are among the earlier works Sickert chose to publish in the *New Age*: *A Pail of Slops*, 13 July 1911 (Fig. 67); *La Vecchia*, 22 February 1912 (C.182, Drawing 2); *Giorgione San Silvestre*, 14 March 1912 (Fig. 127); *Superb Stupidity*, 28 March 1912 (C.189); *San Marco*, 29 February 1912 (C.133, Drawing 6); *La Merceria*, 2 May 1912, a Venetian landscape, not catalogued here, possibly *Venice—An Archway*, charcoal heightened with white, 12 × 8 (30·5 × 20·3), Mrs. George Swinton/present whereabouts unknown, Exh. Edinburgh 53 (83); and *And I Drive the Bus that Mary Rides on*, 20 July 1911 (original untraced, a character study). Sickert also published two earlier pen and ink drawings: *Dieppe*, 10 August 1911 (listed under C.106) and *The New Bedford*, 29 June 1911 (C.238, Study 5).

11. The *Cambridge Magazine*, 8 June 1918, 'Nina Hamnett'. Enid Bagnold, *Autobiography*, London, Heinemann, 1969, relates on pp. 75, 77 that when she brought her 'Sickert-produced' drawings home (she then studied under Sickert at Rowlandson House) her father demanded 'Where's the *outline*?' She answered, 'You map the lights and shadows, you bounce the light off it. And if you manage it right there sits the creature, living, in the middle! You don't *need* an outline.'

12. The *Burlington Magazine*, 27 September 1915, pp. 224–31, quoted on p. 230.

13. p. 229. The basis of this law was not invented by Sickert. He himself acknowledged that it was common in the nineteenth century and cited Samuel Palmer's belief that a fine etching 'was a print in which the glitter of the white paper was never lost, even in the densest shadows'. Sickert only propounded a general rule which he felt expressed the right balance between darks and lights.

14. Letter dated from Sickert's reference to finishing a plate of *Ennui*.

15. Letter dated in note 14.

16. An isolated sheet from a letter written during the war (Sickert slept through a Zeppelin raid), probably in 1915.

17. In his article published in the *Fortnightly Review* (see note 9) Sickert commented on most of the painters represented in Roger Fry's 'Manet and the Post-Impressionists' exhibition.

He wrote of Matisse's 'school-facility'; Picasso a Whistler follower and a 'sort of minor international painter'; Vlaminck who shows '*la blague extérieure de la chose*'; Marquet 'a real painter'; Vallotton whom 'we know and respect'; Cézanne 'overrated' but of 'gigantic sincerity' and capable of superb masterpieces; the 'strange grandeur' of Gauguin's figures; and van Gogh whose execution Sickert has 'always disliked . . . most cordially' but who worked with 'fury and sincerity and . . . was a colourist'. But all these artists, Sickert remarked patronizingly, 'have been known in Europe for a decade, and some for a quarter of a century'.

18. Emmons, p. 139. Hubby is the male model in both the 1911 and 1912 pictures of *Off to the Pub* (Figs. 205 and 212), and probably in *Preoccupation* (C.336) and *Where can it Be?* (C.335) of 1911. These seem to be his first appearances in Sickert's work. Towards summer 1914 Sickert had to break with Hubby. He reported to Miss Hudson that Hubby had begun to arrive at work drunk. His former criminal associates had been at him and he had obtained money from them. Sickert went on, 'It is like a death, only worse, and I miss his kind silly old face and his sympathetic pomposity. Of course it means drink and, eventually, prison.' In fact the war may have saved Hubby from this fate because in a letter written during the war to Miss Sands Sickert reported that Hubby was at Aldershot in khaki in the Army Service Corps. Gilman also appears as a model in several works of 1911–12, for example, *Mr. Gilman Speaks* (Fig. 232), *The Proposal* (C.339), and *The Visitor* (Fig. 231).

19. The title *Vacerra* is taken from a character in Martial's *Epigrams*, XI, lxvi (*Et delator es* . . .). An etching of this composition is inscribed with the full text of the epigram characterizing Vacerra, a man, as a mean and petty swindler. The title and inscription on drawing and etching respectively were, in a sense, an instance of Sickert showing off by casually demonstrating how he was just as much at home with classical scholarship as with the sleazy depths of Cockney life.

20. A letter to Miss Sands, probably written in the winter of 1913 (see Chapter XV, note 43), discussing the advantages of painting life-size rather than on the scale of vision, reports, 'Yesterday after tea I repainted the life sized head of Hubby. . . . On that scale the execution becomes beautiful, the surface no longer congested.' This head may be Fig. 217.

21. In a letter to Miss Hudson which, most unusually, was preserved in its envelope postmarked 22 Feb. 1914, Sickert sketched six of these 'direct little pictures 20 × 16 on the way'. One is the piano picture dedicated to W. H. Davies (listed under C.352); another is *Nude Seated on a Couch* (Fig. 220); another *Hubby and Marie* (Fig. 218—the Hamilton, Ontario version rather than the Manchester picture, though both were probably done at about the same time); and *The Blue Hat* (C.320). Two more sketches are of pictures unknown to me.

22. The letter was sent from Envermeu, Dieppe, so that it must have been written during the summer of 1913 or 1914. The earlier dating is preferable.

1913–14. Sickert's Problems with Paint —and their Solution

THE climax of Sickert's life-long search for the ideal handling of his medium was not a sudden event. It happened gradually during 1913–14 and its evolution can, most fortunately, be traced with the help of many letters Sickert wrote during this time to Miss Ethel Sands. Further retrospective clarification of Sickert's technical problems and their solution is contained in the letters he wrote in 1918 to Nina Hamnett.

Sickert delighted in his friendships with women. Miss Sands was an American by birth but her parents had settled in London. She was of gentle class and breeding and her *salon* was one of the most brilliant in London. Although never a pupil, in the strictest sense, she belonged to Sickert's devoted band of lady disciples. Sickert enjoyed exchanging gossip with her and he relished her sharp intelligence; he told her, 'one of the reasons why I cultivate you is that I find you informing'. Neither was Nina Hamnett a pupil of Sickert, but on matters of art Sickert addressed both ladies with a slight air of patronage, as a *maître* advising very junior colleagues.

The amount of information relating to Sickert's ideas on art, and to his attitude to paint and its handling, contained in his sixty-nine letters to Miss Sands (plus others addressed to both Miss Sands and Miss Hudson and a few isolated pages from further letters[1]) is unequalled among his correspondence. The letters to Miss Hamnett are fewer in number but they provide valuable information to supplement the content of the Sands collection. Many of Sickert's correspondents were artists but Sickert could hardly lecture colleagues and equals like William Rothenstein or Jacques-Émile Blanche on how to paint, as he could a lady-amateur like Miss Sands and his junior Miss Hamnett. Sickert stated his didactic motive for writing to Miss Sands. In the only dated letter from the collection, written on Easter Monday 1913, he apologized for pestering Miss Sands with notes, 'but I am a person of one idea at a time and your technical salvation is my present mission', and added as a postscript, 'This letter is part of my competitive wooing versus *your* infernal G.M.! Can *he* help you in your work, *Allez*? Could he have, even in the days of his boasted "potency"?'[2]

The same letter provides another explanation for the unique character of the collection of letters to Miss Sands. Down the side of the page Sickert scrawled, 'Pedantic request to keep these notes because I think that you alone are destined to drag out of me notes for *a book*'. Later that year[3] Sickert wrote in more detail of his plan:

> I am going if it doesn't bore you to put down as they occur things I think of, bearing on our painting and send them to you and ask you to keep them as they accumulate. They will serve me as a sort of dictionary for my eventual book . . . They may sometimes only be a line. I shouldn't otherwise put them down. In accordance with my theory on art nothing but a human interest a motive of helping a living being is capable

of overcoming my sluggish disinclination to the pen, or in fact to any effort. I went to Macmillans' again. If they give me a commission I shall *loathe* it and *writhe under* it. So let us hope they won't. If they won't I shall try Methuen of whom I happen to have a very grateful recollection.[4]

In one further letter written in Dieppe in 1913[5] Sickert mentioned his projected book: 'I shall be sending you more "Notes". They may seem very trivial, one by one, but the essential collection will make heads for chapters if ever I do write a book'. After 1913 Sickert never again referred to his book in letters to Miss Sands; possibly there was no point in repeating himself or possibly he had abandoned the idea. His enthusiasms were often short-lived. Nevertheless in 1918 Sickert either still had or had renewed his intention of writing a book, because he told Miss Hamnett, 'Roger is an angel. I am taking out all the nasty bits about him in my book which depletes it rather'[6]. The book was never published and if actually written in a preliminary draft the manuscript is now lost.

The pretext of most of Sickert's notes to Miss Sands was to advise and criticize her painting. They nearly all concern the technique and method of painting. Sickert's intention that they were to form the skeleton of a book gives great authority to the information they contain. However, the book project was obviously at an early stage when the letters were written and its outline cannot be discerned from them except in so far as they suggest that Sickert intended to write a textbook of practical instruction for the student of painting.

The most extensive discussions of technique contained in the Sands letters are related to the solution of what Sickert evidently recognized by 1913 to be the core of his problem with paint. On Easter Monday 1913 Sickert warned Miss Sands of the dreadful alternatives in painting, 'starving' or 'slopping': 'You know how ugly *full* oil-painting is unless the edges are brushed well over and into each other many times, over and over again till the grain of the canvas is filled . . . One or the other thing is apt to happen. Either the brush stops *short* of, or exactly *at* the boundary of a form . . . or . . . the paint leaves a too exuberant ridge of wet paint . . . which is "beastly".'

However, Sickert went on, 'this very tendency of exuberant paint is a sign of redundant health', and to illustrate his repugnance for the alternative he quoted Holloway, who would roar out of the blue at the old Chelsea Arts Club, 'I hate to see a canvas *starved*'. Sickert expressed the same problem, more succinctly but less picturesquely, to Miss Hamnett in 1918: 'The difficulty in oils is we don't like it clumsy with thickness but if we thin it with medium it gets nasty and poor'. Sickert's dislike of paintings 'clumsy with thickness' had led him from 1910 onwards to thin down his paintings drastically, but the vacillation of his handling in 1913–14 was probably symptomatic of his hesitation in accepting the starved quality which accompanied his increasingly summary execution. He tried thick full paint again but still could not avoid clumsiness. In 1914, as we have seen, Sickert bitterly attacked the use of impasto. It is also probable that Sickert revolted against the apparent greasiness as well as against the thick bumpiness of impasted paint. A telegram to Miss Hamnett, dated 2 July 1918, provides a touching illustration of Sickert's wish to eradicate as far as possible the greasiness of his medium: 'If you use a colourman's or any canvas prepared with oil-paint, always, always, always, wash it with soap and a sponge till the surface grease is attacked'. Oil paint is not in fact greasy; washing it is only recommended when the gloss of oil prevents a subsequent glaze from lying. Sickert did not use glazes so the whole business was probably a private 'antiseptic' ritual, of no actual validity but of psychological relevance to Sickert alone.

It is clear from Sickert's letters to Miss Sands that of the two alternatives, starving and slopping, the former was the worst. In his Easter Monday 1913 letter he explained that one of his reasons for disliking *alla prima* painting was that it resulted in a 'painting . . . finished from nature as far as *statement* goes. But the transitions are poor in *quality*. And you have felt that you must say the *same thing*, on top, *again purely for reasons of quality*, or leave the thing poor.'

This indictment of painting *alla prima*[7] articulates Sickert's mature reaction to the method of painting in which he had been trained, that is liquid tonal painting on the Whistler model which Sickert soon realized had a facile, unworked character which by absolute standards was recognizably poor. He repeated the same view in 1925 when he wrote how Whistler's paintings were not '*amenées*'[8]. Since 1885 he had been trying to invent a fuller, more systematic, and more worked execution in paintings built up in a series of stages, with each superimposition contributing something new to the process. His various technical experiments over the years had been designed to discover the ideal system but he had constantly been confronted with his basic dilemma. Thick paint was ugly; thin paint was poor. The answer was the accumulation of many touches of colour in thin coat upon thin coat of paint such as that outlined in the recipe he gave Miss Sands in 1913, quoted in Chapter XIV in connection with *Nude Seated on a Couch*. He wrote of that recipe:

> On a series of apparently tiresome, flat sittings *seeming* to lead nowhere—one day *something happens*, the touches seem to '*take*', the deaf canvas *listens*, your words *flow* and you have done *something*. There are technical reasons. For what we want to do, . . . such an infinity of series of touches are needed before even the quality is made on which the touches 'take', on which they become *visible* and *sonorous*.

In other letters to Miss Sands Sickert outlined similar recipes, each varying in their detail but all based on the supposition that a painting should be built up in an indefinite number of coats, each conceived as a pattern of coloured patches equivalent to the tonal fields of the subject. However, Sickert was still faced with a problem, for the accumulation of many touches presented a particular difficulty for him. He later expressed this difficulty to Miss Hamnett:

> All experienced good painters know that for some mysterious reason the very shoving about and altering of a picture (within the limits of a clear plan) gives it weight and quality. Now as you shove it about (knock it about in the classic professional phrase) in its true colour you lose the beauty of the colour and have every day dozens of brushes and your darks, *being dark on dark*, get *beastly*.

Sickert could not resort to the traditional expedient with the darks, that is to darken them slowly and transparently so that they keep their radiance until the last moment, because he rejected the use of truly transparent colour. To Sickert, it will be remembered, '*la peinture*' was 'as much as, and the kind of truth . . . as can be expressed by the clean and frank juxtaposition of pastes (*pâtes*) considered as opaque, rather than as transparent'[9]. He could not take the easiest solution for the beastly darks, that is to avoid altogether the shoving about of a picture and paint in as summary a manner as possible with paint thinned with medium. He had to devise a method whereby he could accumulate an infinity of series of touches in many coats (in each of which his picture was 'knocked' about) while still retaining the clearness, cleanness, and luminosity of his colours.

In Dieppe in the summer of 1913 Sickert began to paint in a manner which represented the solution to his problem in embryo. In his work of the following year, 1914, he fully developed the method of painting which was for him the true solution, the ideal system of handling for which he had been searching over the past thirty years. The method of painting evolved in 1913–14 was to remain the basis of his painting (barring a few minor variations involving such details as his choice of colours and the general tonality of his pictures) for the rest of his life.

It is extremely fortunate that in Sickert's letters to Miss Sands we have an accurate, sometimes day to day report of his work during this vital period. The letters written in Dieppe are more numerous and more informative than those written in London, probably because when in London Sickert could talk to Miss Sands in person.

Envermeu, where Sickert and his wife lived during the summers of 1913 and 1914, is a village set in the valley of the Eaulne some miles inland from Dieppe. Sickert went to Dieppe itself only once a week 'every Saturday morning to see my colourman and take a sea-bath'[10]. The subjects for painting

easily accessible to him were, perhaps for the first time since his Whistlerian days, exclusively rural. Sickert revelled in this rest from painting urban scenes. In July[11] he 'started studies of an old farmyard with a dovecot raised up on one beam of timber, innumerable mossy timber beams, writhing like snakes on the ground, a "*fond*" of fat rich dark chestnut trees going out of the picture and posts and gates and barrels in shadow showing mysterious *clairière* effect of leafage in the distance. A Corot-Millet subject Germanised a little—Schubert and Klaus Groth *in Stimmung*.' In a letter dated 'Jy 27' Sickert reported, 'I am painting the dovecot in the saw-mills subject 108 × 66. I have worked into the drawing and water-colour study with a great deal of fine pen-work and also on two sectional studies in oils, *toiles de six*, each, half the picture.' By the beginning of the next month[12] he was doing this timber yard picture 'large and deadly interested in it'. He also started work on a new subject, 'the Château of Hibouville peeping from its woods with an avenue and a cornfield in front', but by the middle of the month[13] he reported that 'they have cut the cornfield *comme de piste*. So I shall perhaps lay in a large canvas to finish next summer.' Early in August[14] he also 'had a sitting in my little woods . . . on a new subject which is like a dream out of Midsummer Night's Dream! An oval gap among trees framed at the bottom with sprinkled tiny flowers like Waldmeister. Through the gap the path continues between trunks, the whole inside like a glowing transparent green cave . . . The rhythm and swing is incredibly beautiful. Will my canvas give you an echo of its loveliness? I think it will. There must be something in heredity. My grandfather and my father did endless drawings and paintings of such subjects. I feel so at home in them.' By the middle of the month[15] the 'gap in the trees' was 'going on well' and, with reference to this and similar subjects, Sickert commented, 'You will like my wood pictures, friendship apart, on their merits. *Le lyrisme dans la peinture il n'y a que cela!*' At the same time he began another new subject, 'a motive that interests me very much. An obelisk on rising ground. I am looking down on it and the plain below rises above the whole length of the obelisk with a river and willows. So the obelisk serves as a measure of the receding plain.'

Shortly before his return to London Sickert wrote that he had 'had a most interesting summer's work'[16] and that he had safely 'now two important pictures The Scierie de Torqueville and the obelisk'. He continued to have his 'usual sitting from the forest at the obelisk picture' until his departure[17].

The timber-yard picture, *La Scierie de Torqueville* (Torqueville is a hamlet adjoining Envermeu and the *Scierie* is its main feature), is the painting often known as *Le Vieux Colombier* (Fig. 236, C.342). Smaller oil sketches of aspects of the subject exist and these were probably the sectional preliminary studies mentioned in the 27 July letter. There are two drawings of *Le Château de Hibouville* (Fig. 238, C.343) but I know of no painting. A painting was shown at the Carfax Gallery in April 1914 (2) but its moderate price (30 guineas as opposed to 250 guineas for *Le Vieux Colombier*) suggests it was only a sketch. Indeed Sickert said he intended to put off finishing the subject until the following year because of the ruined cornfield; it is doubtful whether he did resume the picture in 1914 because it is not mentioned in his letters to Miss Sands of that summer. I do not know any picture which exactly corresponds to the verbal account, and the sketch which accompanied it, of the *Gap in the Trees*. However, besides several drawings there are also other woods pictures of similar motives which were almost certainly painted at this time, for example *La Vallée de L'Eaulne* (Fig. 237) and a green *Forest Glade* with the light catching the trees (listed C.345). Three versions of Sickert's other important picture of summer 1913, the Arques *Obelisk* (Fig. 240, C.346) high above the mouth of the Eaulne valley, are extant, but Sickert returned to this subject in 1914. Two of these pictures were probably works of that year but one, a rough flatly painted sketch of the scene, was perhaps done in 1913.

Sickert's verbal descriptions of the motives which interested him have an importance independent of the help they give in identifying his current work. They explain what it was in a subject that caught his attention. He sensed a Germanic character in both *La Scierie de Torqueville* and *A Gap in the Trees*.

In the letter of 27 July Sickert explained: 'I have always wanted to paint streams and willows and *sous-bois* more than anything since I was five years old. . . . I have tried again and again. In Kensington Gardens in 1877 or so. But the gouache seemed too dry and I had not yet worked in oils . . . Now I have got the whole theatre I always wanted "under a hat" . . . I think the loveliest thing in all nature is a *sous-bois* (if one excludes portraits) . . . There is a little wood over a château called Hibouville . . . close by with a carpet of silver gilt dead leaves and tiny bushes that are or suggest myrtle berries and little faggots of cut wood and the tall thin stems catching a splash of sun merging into the green confusion of cool blue-grey leafage. It passes all comprehension for beauty. Do you remember the Schumann-Heine I think it is "*Und über mir schwebt die schöne stille Waldeinsamkeit. Die schöne Waldeinsamkeit.*" I can less and less understand the neo-pedants with their "no-meaning" theories of art.' Given these clues one can recognize a certain affinity between Sickert's pictures of woody, lushly overgrown corners of nature and the landscapes of some mid-nineteenth-century German painters (the *Biedermeier* Romantics) such as Spitzweg. In spite of the obvious differences in their style and handling, Spitzweg and Sickert reveal in their landscapes a comparable capacity for romantic lyricism before nature; they show a similar ability to transform an ordinary but overlooked scene into something magical largely through emphasis on the contrasting effects of light and shade playing on the vegetation (the 'mysterious *clairière* effect of leafage' noted by Sickert when studying *La Scierie de Torqueville*). The conception of these landscapes is less remote and refined than that of the *sous-bois* scenes of mid-nineteenth-century French artists such as Corot although, like Corot, Sickert sought to convey the lyrical quality of his subjects—'*le lyrisme dans la peinture il n'y a que cela*'. Sickert interpreted lyricism in an earthily Romantic German idiom, not in terms of the cool poetry of Corot. Sickert saw *La Scierie de Torqueville* as a 'Corot-Millet subject Germanised a little', 'Schubert and Klaus Groth *in Stimmung*'[18] and he actually inscribed a little sketch, *Petit bois de Hibouville* (Fig. 239), which he sent to Miss Sands, '*Die schöne stille Waldeinsamkeit*'.

Sickert's description of the obelisk subject, which interested him as intensely as *La Scierie de Torqueville*, is not at all lyrical. He was caught by the constructional aspect of the view in which 'the obelisk serves as a measure of the receding plain' and his pictures of this subject have a carefully planned geometrical character. The drawings of *Le Château de Hibouville*, a parallel landscape composed of receding rectangular fields with the château as a small background incident, are similarly prosaic in conception. The differences between the lyrical and the geometrical landscapes studied by Sickert during this one summer are a valuable reminder of how various were his interests even within a very short time-bracket.

Sickert did not often describe his method of painting the Envermeu landscapes to Miss Sands but in his 27 July letter he noted he was painting his studies for *La Scierie de Torqueville* 'freely with turpentine in my dipper which is certainly *expéditif*'. He soon reconsidered this method and in another letter[19] stated: 'I was, I think, wrong in admitting that a turpentine rub-in is admissible.' He then told of painting the large picture: 'Yesterday I gave the first coat to a large canvas of the "Scierie de Torqueville" which is the name of the *colombier* picture. . . . P. Foriet sent me a *lovely* coarse canvas with a coat of white tempera. Yesterday I squared up the drawing and laid in, without medium, the large tones which now lie *flat* and thick like a bed of porphyry or granite and then onto that I expect I shall easily paint the delicate finish'.

In order to evaluate how far Sickert's method and the effects at which he aimed, as described in this letter and seen in the finished painting, had already evolved towards the solution of his technical problems it is necessary to jump ahead and give some account of what this solution entailed. Once again it was in a letter to Miss Hamnett of 1918 (the one in which he had summed up the 'difficulty in oils') that he expressed most clearly what he called 'the ideal use of oil paint':

I have certainly solved the question of technique and if you would all listen it would save you 15 years

muddling. . . . It is extraordinary how agreeable undiluted paint *scrubbed hard* over a coarse bone-dry *camaieu* . . . becomes. It tells semi-transparent like a powder or a wash, and this with no dilutant; of course, this is for the earlier coats of the true colour, as one finishes one can't scrub and, in consequence the touches become fatter. Then in the end nothing is prettier than the non-coloured spaces semi-transparent and the laboured ones fatter and more opaque. I believe technically that is the ideal use of oil paint. . . . All this is of course for painting from drawings. Painting from life *prima* over and over again can only be done in the one way. But this is one of the chief of the 1000 arguments against it.

In another letter to Miss Hamnett (the one mentioning the 'beastly darks') Sickert again advised a *camaieu* as the answer to the problem of how to shove about and alter the picture without messing it up. With a *camaieu* preparation he told her: 'the oftener you correct, the more solid and luminous paint you get on your canvas. Consequently . . . the more difficulty you have and the more you redraw, the better the quality becomes.'

A *camaieu* is like a *grisaille* underpainting but it is composed of two colours. Sickert recommended to Miss Hamnett white with cobalt for the lights and white with three strengths of indian red for the shadows. With these mixtures he mapped out his entire canvas as a shaggy jigsaw. He kept the colours very light in tone, as he wrote, 'practically all white, only just enough coloured to distinguish light from shade'. This very pale blue and pale pink preparation imparted to his canvases the uniform chalky whiteness characteristic of so much of his later work.

Sickert, always fond of rationalizing his own methods by quoting historical precedents, believed that his use of *camaieu* was a return to the practice of the Old Masters. In 1918[20] he quoted 'the innumerable cameos, from the cold grey of Rubens and Hogarth, to the vermilion and prussian-blue of the "dead-colours" at the beginning of the nineteenth century'. In 1929[21] he stated that El Greco built up his paintings over a *camaieu*. Art school teachers before the Second World War, influenced directly by Sickert, continued to advise, and historically to justify, this practice. In fact, Sickert's arbitrary choice of two colours, uncompromisingly applied over the entire surface of his canvases with no reference to the true colour of the objects to be painted over them, was very uncommon in the history of painting. Although some Old Masters did use *grisaille* or *camaieu* underpaintings as a preparation for their figure paintings they did not use them for landscapes. Furthermore, Sickert's preparation was not applied as the usual thin monochrome wash but was often a ground worked up in several layers until it achieved a certain degree of movement and coarse consistency.

Sickert's enthusiastic adoption of the method of scumbling over a *camaieu* preparation is responsible for the clean, dry patchwork of bright paint characteristic of his wartime Bath landscapes and, with slight modifications, of much of his later work. The Sands letters prove, however, that the announcement of Sickert's solution to Miss Hamnett in 1918 did not mark the exact moment when this solution was discovered and Sickert's later style was born.

When we refer back to Sickert's account of his work on *La Scierie de Torqueville* it will be seen that in the large picture (but not the studies) he was already using undiluted paint on a coarse canvas. His account referred only to his first day's painting. Theoretically it could have been finished so as to lack the kind of effects which the description of his method suggests he considered desirable. However, the handling of the finished picture with its matt, rather gritty surface closely worked in an overlapping patchwork of dry, flat stains of high-toned purples and greens creates a total effect very similar to that characteristic of his later development. The size of *La Scierie* also anticipates Sickert's later work when he often worked on a larger scale to accommodate the increased breadth of his handling. There are, of course, many respects in which the method of painting *La Scierie de Torqueville* differs from the ideal technique later described to Miss Hamnett. The paint is not yet scrubbed thinly onto the canvas because after only one day's work it already lay 'thick' as well as 'flat'. (This emphasis on

flatness is interesting in its suggestion of a positive reaction against the rough bumpiness of impasted paint.) The colours of *La Scierie* are bright and high-toned but they lack his later chalky whiteness. Finally, Sickert did not use a *camaieu* preparation for this landscape.

He may have done so, however, in other paintings of 1913 because he mentioned a *camaieu* as an alternative to a dead-colour preparation in his letter to Miss Sands of Easter Monday. Moreover, Sickert's emphatic advocacy, expressed in several letters of 1913 to Miss Sands, that paintings should be prepared in the early coats as a simple map of the large tonal fields foreshadows the development of the more arbitrarily coloured and systematic *camaieu*. Sickert's use of a canvas prepared with a coat of tempera for *La Scierie* shows how he was already attracted to bone-dry, rather coarsely textured preparations. Sickert used tempera for several of his later pictures, notably for the large version of *The New Bedford* (only the final touches were executed in oil) painted in 1915–16 as one of a series of decorations for Miss Sands's dining-room (Fig. 255, C.365). He also laid in the preparations for the other pictures intended for Miss Sands (C.367) in tempera[22] and set up one of his studios, in Brecknock Street, especially for tempera painting[23]. Sickert possibly felt that his revival of tempera painting, like his use of *camaieu*, was a return to the practice of the Old Masters.

When Sickert summed up his summer's work to Miss Sands he overlooked his romantic woodland scenes and mentioned only *La Scierie de Torqueville* and *The Obelisk* as 'important' pictures. He did not describe his method of painting *The Obelisk* to Miss Sands, but the handling of the extant pictures of this subject is basically similar to that of *La Scierie*. However, in the *Obelisk* paintings (Fig. 240, C.346) the juxtapositions of the flat patches of paint are cleaner, the individual patches of colour tend to be larger, and the general tonality is much lighter. The greens, purples, and browns of the landscape, and the pale blue sky are all mixed liberally with white to give the overall colouring a much more chalky quality. The handling of these pictures is typical of the development in Sickert's style which is generally believed to have taken place during his Bath period, 1917–18. Indeed, on the two occasions that one of the smaller versions of *The Obelisk* (Version 2) passed through Sotheby's saleroom its handling so misled the catalogue compilers that it was listed as '*An Obelisk Near Bath*'.

Nude Seated on a Couch (Fig. 220) and *Army and Navy* (Fig. 219) are probably examples of the figure pictures Sickert painted after his return to London from Dieppe. In the winter of 1913–14 he began to study the two-figure composition of *Ennui* (Fig. 223, C.313). However, because of the documentation provided by the Sands letters, the history of his technical development is best explained by an account of his next summer's work in Dieppe.

Once again Sickert told Miss Sands which pictures he was working on. Early in the summer he wrote that he had 'done some studies already for the café-arcade picture. I think I will do some small oil panels', and in another letter, 'I shall probably come into Dieppe every Saturday. To study my arcade café picture'[24]. He wrote of the obelisk subject again in five letters. In July[25] he said, 'My pilgrimage . . . to Martin Église put the obelisk subject back again into my mind and I have had a good day's work at it. It is so delightful painting from yesterday as it were. You carry away just the dose you want. Technically also it means one coat of paint.' In other letters he wrote, 'I have just had a sitting on my obelisk picture began it on a small canvas'[26]; 'Yesterday I had my sunshine and the afternoon in the forest at the obelisk subject'[27]; 'I have been up in the forest again. I was reading a letter you wrote to me last year about a sketch I sent you of the obelisk design and I see you liked it. I think I shall make the valley in shadow so as to make the silver river tell more'[28]; and lastly, 'I shall be glad to be on the hill again above the Arques obelisk. I will make a fine canvas of that *toile de 12F*. And finish it here, while I can still refer to nature. One war at a time'[29]. When war broke out Sickert moved from Envermeu back to Dieppe and his letters suggest that he welcomed the return to urban subjects: 'An odd result of the war is that I am now compelled to do architecture instead of *sous-bois* which result

will more than pay for my *dérangement*'; in another letter he told Miss Sands, 'I am enjoying immensely the enforced study again of countless subjects here I have always loved. I do very elaborate pen drawings and then small *pochade* panels.'[30] He was particularly entranced by *La Rue Aguado*, a subject which he called *The Flags on the Front*, showing 'the stars and stripes flying with the Union Jack and the *tricolore* in front of the (new) Hôtel Royal'. He often told Miss Sands of his drawings of this subject and in one letter of how he had 'squared up a *toile de 12F*' of the scene[31]. When he moved back to Dieppe he also began an indoor scene, 'a study of Tavernier's daughter at the piano, which I am going to paint life-sized for him. . . . It is pleasant to draw and listen to Beethoven and makes one forget the war.'

The handling of the *Obelisk* pictures, as we have seen, so closely anticipated Sickert's later style and handling that one version was actually mistaken for a Bath landscape. The same kind of misdating has occurred in the case of Sickert's *Café des Arcades* paintings. There are four versions of this subject (Fig. 241, C.347); two are sketches on canvas (no panel study is as yet discovered), and two are highly finished pictures. The finished paintings possess all the characteristics of style and handling associated with Sickert's wartime landscapes. They are painted in a flat, clean patchwork of thick, dry, coarsely textured paint. Their colouring is very bright (full of lilacs, greens, pinky cyclamens, orange, cream, and sky blue with notes of deeper blue and scarlet) and their tonality is light and chalky. The *Café des Arcades* pictures are therefore generally assumed to be post-war works, painted when Sickert returned to Dieppe in 1919 after his enforced absence during the war. The alternative explanation, that these Dieppe landscapes and others of 1913–14 were the stylistic precursors of Sickert's wartime pictures, has been overlooked.

Exactly the same characteristics of style and handling are found in the other Dieppe subjects Sickert began to study at the outbreak of war. One of the two extant sketches for *La Rue Aguado*, that is, *The Flags on the Front* (Fig. 243, C.348), is dated 'August 1914'. The handling of this dated study, with its flat, thin, roughly scrubbed paint indicated by a few lines of drawing and its clear bright colouring (greens, pale brown, pale blue and purple), closely resembles the handling of the oil on canvas sketches of the *Café des Arcades* subject. A drawing for this subject is a perfect example of the 'very elaborate pen drawings' Sickert told Miss Sands he executed as well as 'small *pochade* panels' as preparations for his pictures. The treatment of the finished picture of *La Rue Aguado* closely resembles the finished *Café des Arcades* pictures. The paint is similarly applied in neat juxtapositions of flat, clean patches, its tonality is very light and the colours are bright.

The precise and detailed pen drawing of *La Rue Aguado*, which is squared and inscribed with colour notes, recalls the drawings Sickert made many years before in Dieppe in 1899–1900. It is indeed impossible to be certain whether two studies of *St. Jacques Façade* were done at the earlier date or in 1914 as fresh studies for a new version of this subject (Fig. 244, C.349). In style and treatment this new version of *St. Jacques* is the same as *La Rue Aguado* and the *Café des Arcades*. Another example of a once familiar Dieppe subject to which Sickert returned in 1914 is *Le Chevet de L'Église* (Fig. 242, C.350). The subject and composition, which Sickert accurately drew in squared studies, sketched on panel, and then painted on canvas, recalls the painting of *c*.1900 (Fig. 83). However, the handling of the 1914 picture is totally different from the earlier version. The low tones, muddy colours, and fluent application of thin paint of the earlier picture are replaced by a brightly coloured, light-toned map of coarse gritty patches of matt opaque paint.

It might be argued that Sickert only did the pen drawings and panel studies of these subjects in Dieppe in 1914 but that the finished paintings were executed some time afterwards and thus represent the later maturity of his handling. However, this practice of working from earlier studies is one of the things which Sickert decided to abandon in 1914. In connection with *La Rue Aguado* he told Miss Sands: 'I am very keen to see how I get on with this painting indoors under the immediate influence of

the recollection. That is how I did my music-halls. Big canvases are too unwieldy to drag about. And accumulations of studies lose their sharpness of impression in the winter in London.' In another letter written at the beginning of the summer (the one mentioning the *Café des Arcades* subject) he had stressed the error committed by working on big canvases in London 'after all the savour has been forgotten'. He continued by outlining his resolutions for the summer and stated: 'I shall . . . *here*, at home, at Envermeu, paint larger studies (*toiles de 12* or so) from my drawings and *pochades* while the memory is *fresh*.'

The letters Sickert wrote to Miss Sands from Dieppe in 1914 reveal how excited and confident he was about his summer's work. At the beginning of the summer[32] he had written, 'My history just now is that of intensified thought about method . . . I have been thinking and staring at nature from morning to night trying to get a clear view of how to proceed'. When describing his work on *La Rue Aguado* he remarked, 'I literally as Whistler used to say "rattled it off". Something has given me back my youth and my talent.' Later in the summer[33] he was able to write: 'I don't mind telling you that I have done some really good painting since I wrote to you. The execution reminds me of Corot at his best period only weightier and with more possibility of cumulated intensification in added sittings. How absurd it sounds to talk of oneself thus, but the truth is the truth.' And in another letter[34]: 'I feel so sure of my progress on the lines I have laid down. Deliberately finished elaborate canvases carried out in paint suavely, as delicately and as nervously sharp as my drawings. Shall I have 20 years more just to show what I have been educating myself for?' Sickert was to have more than twenty years' painting life ahead of him, and the work he produced depended essentially upon the method and handling he perfected in Dieppe during the summer of 1914.

He outlined his method in several letters. It was clear and simple. 'Finish a drawing . . . of a subject in which there is a distinct effect of light and shade. Then square it up and paint on the canvas in the studio away from the subject. Then look at the subject again and so on . . . I'll tell you what happens. Your execution becomes so clean and normal and you do not do too many things in one coat.'[35] And again in another letter[36], 'I really think my working indoors from drawing and immediate memory is what I have been looking for for years'.

Sickert had been painting indoors from drawings and from memory since the 1880s. He had done music halls 'under the immediate influence of the recollection'. His practice of working in this way in 1914 was not an innovation but for some time prior to 1914 Sickert had relied, in his outdoor subjects, less on immediate memory and more on drawings. He had tended, as he told Miss Sands, only to begin canvases in Dieppe and finish them in London when 'all the savour has been forgotten'. In his figure subjects too, of recent years, he had painted from drawings and probably also from the live model, rather than from memory. Sickert's method in 1914 can, therefore, be regarded as a return to his earlier emphasis on the importance of memory to the painter.

The novel significance of Sickert's method of painting from drawings and memory in 1914 is not immediately clear. He had, after all, worked in this way, with greater or lesser consistency, for about thirty years. The real importance, indeed the absolute necessity, of his adherence to this method in 1914 can only be understood in relation to the actual technique of painting he then employed. Sickert hinted at the relationship between his method and technique when he told Miss Sands[37], 'I find this painting from drawings works out very well. You work in such properly ordered stages from general to particular statement. It also naturally dictates a somewhat larger scale as drawings can be so delicate and paint is so thick. I expect it is the solution to that puzzle.' It is the plaintive remark 'paint is so thick' which is the crux of the matter. By 1913, having rejected paint thinned with medium, he had accepted, when painting *La Scierie de Torqueville*, the use of undiluted pigment. He found that it could lie flat and thick. In 1914 he reported to Miss Sands[38], 'undiluted paint can be brushed on

quite smoothly and any number of coats would arrive at being both thick *and* smooth. Degas commended, I remember my panels in '85 because they were *"peint comme une porte"*. *"La nature est lisse"* he used to say.' But thick, smooth, undiluted paint is relatively intractable; it is not easy to work delicately with paint of such consistency. Only by working from drawings and from memory (a method which entailed, as he wrote, working in properly ordered consecutive stages from general to particular statement, and which simultaneously prevented him from doing too many things in one coat because the information stored in a drawing or in the memory is partial and selective) could he discipline his execution, keep the paint 'clean and normal', and the definition precise.

Not only did Sickert's successful manipulation of undiluted paint depend upon the discipline inherent in his method of working from drawings and memory, but the style of the drawings themselves influenced his paintings. The effort to transcribe delicately detailed pen drawings onto canvas in terms of thick undiluted pigment led him to increase the scale of his paintings. The fluent *écriture* of his paintings was influenced by the sharp precision of his drawings. In a letter written from Envermeu in 1914[39] to Miss Hudson, Sickert expressed much the same opinions. He wrote, 'This eternal pochading leads to our peddling too much in the paint; a subject on a fairly large scale brings you back to the real object of a picture, design and light and shade. Also in painting from drawings you give *one coat at a time* to your pictures and accumulate the finest possible quality, like Millet, the absence of all paint-manner, just as good manners are the apparent absence of manners.'

In both his drawings and his paintings Sickert sought to convey strong light and shade effects. His remarks to Miss Hudson that the real object of a picture was 'design and light and shade' and to Miss Sands that a subject should have 'a distinct effect of light and shade' anticipate his comment to Miss Hamnett on the back of the envelope containing the *camaieu* recipe, 'Of course all that *camaieu* business is only for painters who conceive in terms of light and shade—delicate or violent—but always light and shade, the others *don't wist*'.

All the Envermeu and Dieppe landscapes of 1914 are painted in bright sunlight. The sunlight allowed Sickert to express the component areas of his subjects as large, tonally simplified patches of pure bright colour. It must have been the frank, clean quality of his execution which led Sickert to compare his paintings with Corot's work; he probably had in mind Corot's sunlit *études* painted in France and Italy in the late 1820s and early 1830s. The beautifully simple quality of the oppositions of flat patches of clear colour in Corot's studies was just what Sickert was trying to achieve in 1914. However, the handling of Corot's *études* was conditioned by his method of painting them directly in the open air; Sickert's pictures, painted in the studio, were built up to a fuller consistency which explains his remark that he considered his own work 'weightier and with more possibility of cumulated intensification in added sittings'. Although Sickert's letters to Miss Sands prove that Corot was on Sickert's mind in 1913 (his *sous-bois*) and in 1914, it is probable that his recollections of Corot were coincidental rather than evidence of a conscious effort to model his work on the Frenchman's example. The same applies to his recollection of Millet in his letter to Miss Hudson. Sickert desired to eradicate, as far as possible, the visual evidence of eccentricity or individuality in the handling of paint. It was to Sickert a vulgar distraction, peripheral to the real object of painting. Impasto, it will be remembered, he found extravagant, a manner of shouting and gesticulating. He evidently recognized the same distaste for affectation of 'paint-manner' in Millet but it is doubtful whether he used Millet as a guide or inspiration. It is more likely that Sickert, with his love for quoting historical precedents, used Millet's name as a justification for his own endeavour.

It has been seen that the broad stylistic characteristics of Sickert's Dieppe landscapes of 1914 were very similar to those of his later paintings, but how far had the details of his method of painting developed towards the ideal solution described to Miss Hamnett in 1918? By 1913 Sickert was already using

undiluted pigment on a coarse canvas. By 1914 the chalky quality of his colour harmonies suggests that the colours of his underlying tonal preparation, although not necessarily limited to a two-coloured *camaieu*, were mixed liberally with white. Sickert's advice to Miss Sands in a letter written in London, probably in 1914[40], 'see that your touches of light don't seem like the white canvas *dirtied* but *coloured. That is let them be white plus *ever so little* bright clean colour*', hints at the pale-toned preparation recommended to Miss Hamnett. The increased size and tonal simplifications of the individual stains of paint show Sickert reaching for the wide-open paint spaces characteristic of his later work. His constant reiteration of how he did not do too many things in one coat suggests that he was already applying his paint in each separate coat thinly. Certainly in the preparatory sketches for pictures like the *Café des Arcades* and *La Rue Aguado* he scrubbed the paint on thinly and it is probable that the thick and smooth surface of his finished pictures represented the superimposition of an indefinite number of thinly scrubbed coats of undiluted paint. In 1914, in his article 'The Thickest Painters in London', Sickert had quoted 'the classic phrase in France about Cézanne's execution'—'*Des minces couches superposées*'[41]—and it must have been at about the same time that he told Miss Sands[42] to drive on the paint 'as thin as a stiff big brush will rasp it across the canvas. PAINT LIKE A VERY STIFF STREET SWEEPING MACHINE ON MACADAM. So we come to Cézanne's "MINCES COUCHES".' This was but a forceful and picturesque way of saying that paint should be scrubbed hard and thin over the canvas, advice which was one of the chief factors in Sickert's recipe for 'the ideal use of oil paint' as later detailed to Miss Hamnett.

Other letters to Miss Sands improve our understanding of the impetus behind several of the stylistic characteristics of Sickert's Dieppe and London paintings of 1914. His adoption of larger canvases in order to retain delicacy in the application of undiluted paint is explained further in a letter written in London, probably towards the end of 1913[43]. Sickert wrote: 'I made a step in a problem that is yours as well as mine yesterday. My small (scale of vision) groups have always stopped short of delicate finish from my inability to carry undiluted paste beyond a certain point of delicate shape. Yesterday after tea I repainted the life-sized head of Hubby ... On that scale the execution becomes beautiful, the surface no longer congested.'

Possibly this letter marks the precise moment when Sickert realized the advantages of an increased scale for his figure pictures. The landscape *La Scierie de Torqueville* had already been painted on a larger scale, but most of Sickert's figure pictures in 1913 did not show a comparable increase in size. The head of Hubby may be the evidently experimental picture discussed in the last chapter (Fig. 217). It is a small picture but Hubby's head occupies much of the space and is approximately life-size. If this is the picture referred to in the letter, Sickert's adoption of a thick broken touch was a deliberate experiment to see whether the increase in scale would avoid the congestion and clumsiness which resulted from the use of this kind of handling on a smaller scale. But, although Sickert's letter implies that he was pleased with the result, he did not repeat this particular experiment. In 1914 he intended to paint a life-size portrait of Tavernier's daughter at the piano in Dieppe[44]. The main version of *Ennui* (Fig. 223), exhibited at the N.E.A.C. in summer 1914 and almost certainly painted earlier in that year, may also be called life-size in that the foreground objects—the table, tumbler, and matchbox—are painted on this scale with the figures diminished in size according to the perspective recession.

Sickert's advocacy of a larger, even life-size scale is an important reversal of his former teaching. Before 1914 he had frequently asserted the necessity of using the scale of vision without which 'the natural and normal communication between eye and hand is ... broken, and drawing, losing its instinctive objectivity, comparison of forms is no longer direct but proportional'[45]. In the essays Sickert wrote in 1914 he introduced several important provisos, representing rationalizations of his current practice, into his advocacy of this scale. He now wrote that 'Drawing on the scale of vision is only

necessary in work done direct from nature . . . I have no preference for a small scale in itself . . . the real art quality of drawing is frequently strangled by treating subjects that are too comprehensive on too small a scale'[46]. He urged that students, having made their studies on the scale of vision, should be taught 'to square up their compositions' and 'nurse an impression they have received, to completion'[47].

When Sickert enlarged the scale of his own work beyond that governed by what he called 'the law of optics', when he broke 'the natural and normal communication between eye and hand' so that the comparison of forms in his own work became 'no longer direct but proportional', it became essential for him to devise some external objective means for checking the accuracy of the relationships he established between his figures, objects, and backgrounds. How he did this is again clarified by his letters to Miss Sands. In the letter telling her that he had discovered the advantages of an increased scale he remarked, 'What was good in my scale of vision canvases is always the tense, the close-knit *holding* of one object with another and with their common *ambiente*'. He went on to recommend the use of the '*grille* or *grata ditilo*' (a rectilinear grid-like construction which could be expanded or contracted according to the proportional differences in the scale of the preparatory documents and the painted canvas). The *grille* permitted the painter 'to *readjust* EVERYTIME EVERYTHING to renewed information from 2 constant tests *horizontal* and *perpendicular*'. The *grille* was only one of the devices Sickert employed to make sure of objectivity in relating his figures or objects to each other and to their *ambiente* with accuracy. He was enchanted by Solomon J. Solomon's 'insistence on drawing by the "background shapes"' which he wrote had always 'been the main article of my constructive creed'[48], and he advised Miss Sands always to 'paint in patches consisting of *a bit of three contiguous objects* and *never* of one object at a time'[49]. His method of working from squared drawings, the squaring-up of his paintings, his preferences at some periods for drawing on account or arithmetic paper, are all manifestations of his desire to have constant horizontal and vertical checkpoints. It should also be noted that the *grille* helped Sickert to superimpose the sharp drawing, characteristic of many of his paintings at this period, onto his thick, flat, semi-abstract patchwork of colour and tone. He told Miss Sands how when painting you can lose the forms without fear 'BECAUSE you pop the *grille* on and with a wet dark line when the thing is dry you can get back the sharpest and most accurate drawing by means of the *grille*. And till you have done this you do not know what pleasure is!'[50]

Sickert's preoccupations in 1914, with his execution, with increasing the scale of his work, and with establishing accurate interrelationships between the component objects of his compositions, all help to explain the character and achievement of *Ennui* (Fig. 223, C.313). An explanation is needed, because *Ennui* is a perplexing picture. Although not the most attractive it is certainly the best known of all Sickert's paintings. Several factors have contributed to its fame. Its anecdotal subject matter can be appreciated at a glance; its title, most unusually for Sickert, exactly expresses its content. The number of versions Sickert painted of *Ennui* is unmatched by any other of his subject pictures with anecdotal interest. He painted three versions in 1913–14, another concentrated view dated 1916, and an elaborated version *c.*1918. The main version in the Tate Gallery is readily accessible and by virtue of its size (60 × 44 inches), compared with the pictures which generally surround it, can hardly be overlooked. The elaborated later picture is also in a public gallery, and the other two 1913–14 versions have been frequently exhibited. All of these circumstances have helped to popularize the subject, as opposed to any one specific version. Finally, Virginia Woolf made the picture the centre point of her brilliant essay on Sickert occasioned by an exhibition of his work at Agnew's in 1933. The essay was originally published as a pamphlet in 1934, but has since been reprinted twice, in 1950 and 1960[51]. *Ennui* is unforgettably described, although not named, by Mrs. Woolf. No doubt the essay was read and talked about by her public in the 1930s and some knowledge of its content may have filtered through even

to those who had not themselves read it. The immediate association of Sickert and *Ennui*, once established by Virginia Woolf, was self-perpetuating.

The composition of *Ennui* grew out of a long line of Sickert's two-figure interiors, so that it becomes difficult to say which pictures can be considered as preliminary studies for the main version. The pictures listed as Versions 1 and 2 in the catalogue were definitely rehearsals for the big Tate Gallery picture. They were probably painted late in 1913. The paint is scrubbed roughly onto the canvas in thin, flat patches, accented here and there by drawing; in Version 2 Hubby's face and hands are finished with some small dabs of highlight.

In relation to these studies, indeed in relation to Sickert's figure paintings of the past few years, the finished painting of *Ennui* in the Tate Gallery represents a climactic achievement, in which Sickert expressed his current solution to all sorts of problems of handling and composition. Sickert painted the subject entirely from drawings, of which a great number are extant: there are several studies of the whole composition, squared and unsquared, and numerous studies of details, figures and objects. He painted it large, with the foreground life-size objects determining the scale. He applied the undiluted paint in coat upon coat, each scrubbed on thinly until he had built up a thick, smooth surface of large flat patches of uniform colour and tone. He probably used the *grille* to help him recover the definition in fine sharp lines of drawing.

The enlarged scale of *Ennui* enabled Sickert to keep his execution almost obsessively clean and tidy. The amount of information contained in the drawn and painted studies is, however, insufficient to justify the increased scale. The scale of *Ennui* is much larger than that of the more detailed and comprehensive landscape subjects he was to paint in Dieppe in the coming summer of 1914[52]. The size of the individual patches of uniform tone and colour is stretched beyond endurance in view of the almost mechanical execution in which variations of texture and brushwork have been eradicated. The neatness of the patchwork juxtapositions of these areas of uniform tone and colour, the sharpness of the drawing—its fineness slightly absurd in so large and empty a picture—the formal tidiness with which even the highlit accents have been applied, cannot be supported on this large scale. It was possibly Sickert's recognition of this fact which led him, when painting the later version of *Ennui* (Version 4), not only to halve its scale, but also to transform most of the large uniformly coloured areas into busily patterned passages.

The composition of *Ennui* can be interpreted as the climax of the long series of drawings and paintings done in 1912 and 1913 in which Sickert explored the compositional and psychological relationships of two figures, man and woman, in a domestic setting. In many of these subjects he had tackled the problem of the relationships on the surface and in space of one seated and one standing figure. He experimented with various possibilities of diminution, he constantly adjusted the placing of these figures, one now above, now behind, now beside the other, viewing the surface of his composition rather as a chessboard with his figures as the pieces. The experimental nature of this series naturally led him to exaggerations, in the proportional scales of the figures (as in *Second Officer*, listed C.308), or in the emphasis on the surface construction (as in *Sunday Afternoon*, Fig. 214), or on the spatial realization of his compositions (as in the very deep recession of the drawings of *Jack Ashore* listed under C.319). In *Ennui* the problems are sorted out and there are no exaggerations. Each figure is perfectly realized in relation to the other, to their common *ambiente*, and to the picture surface. The scale of the different components is mathematically consistent, so much so that critics often believe the tumbler is distorted in scale and larger than it ought to be. In fact this is just because the spectator has a falsely preconceived notion as to how small a tumbler is in relation to a human figure whereas Sickert has measured it with complete objectivity, and thus total accuracy, in its true perspective. However, while most of the exploratory compositions of 1912 and 1913 have a quality of spontaneity, as if they were informed

by the excitement of searching for the right moment to record, the objectivity, accuracy, and thorough planning of *Ennui* give it a self-conscious flavour. Nevertheless, the accurate placing of the figures has resulted in a compositional tension which perfectly realized the psychological tension between them; it is perhaps instructive that Virginia Woolf concentrated on this aspect of the picture. It is the method by which Sickert achieved these dual tensions, compositional and psychological, which underlines how profoundly he differed from the Impressionists. The contrived character of Sickert's figure painting, the way in which he juggled with two figures in a series of studies until the maximum compositional and emotional tensions were achieved, produced results far removed from the casual naturalism of Impressionism.

The paradox of the strange contrast between the achievement and character of *Ennui*—in one sense the successful climax of Sickert's figure paintings over the past years, in another sense the least successful in its self-conscious mechanical quality—occurs again, even more emphatically, in another of his 1914 paintings. In the autumn of 1914, inspired by an incident of Belgian heroism in the defence of Liège, Sickert painted *The Soldiers of King Albert the Ready* (Fig. 245). The picture was ready for exhibition at the N.E.A.C. by November.

Like *Ennui*, and for much the same reasons, *The Soldiers of King Albert the Ready*, although arresting and rewarding on close study, is not an immediately attractive picture (particularly in reproduction). It stands over six feet tall, and as Sickert remarked to Miss Sands[53] was 'only suitable for a public gallery'. This remark is interesting because it was an essential part of Sickert's creed that pictures should be executed on a scale suitable for the decoration of private houses. He argued that 'the main and real sore' of the exhibition system was that 'We are forced into painting the exhibition picture, on a scale that does not suit either our modern technique, or our modern architecture'[54]. Sickert, as we have seen, had increased the scale of his pictures in 1914. His work was not conditioned to a small scale by his method, as that of the Impressionists had been, because he did not paint from nature. Therefore, while his drawn and painted studies for pictures were generally small and executed on the scale of vision he found that he could with advantage enlarge the scale of his final paintings to avoid congestion of the thick paint. Nevertheless, most of these paintings were still well within the limits imposed by 'modern technique' and 'modern architecture'. His landscapes always are, nor did he paint many figure paintings life-size even in his first enthusiasm for this scale in 1914. The paintings of *Chicken* at the piano, done in the winter, are relatively small in scale as are most of his later informal domestic subjects (although a proportion of his late full-length portraits were to be painted life-size). His view on scale remained such that he remarked to Miss Sands in 1914–15[55], 'I was enchanted at Chelsea to find my job an altogether lighter and easier one than I thought. The scale is after all *small* so I shall have it well in hand and not suffer from the deterioration a much larger scale than the habitual one often brings with it (Hogarth for instance).' Sickert's quarrel with a large scale in this context depended on whether the artist was used to it. He himself was not. Nevertheless, in 1914 he did reserve the use of a large scale for 'important' pictures. The special nature of the subject of *The Soldiers of King Albert the Ready*, its propaganda character, must also have led him to paint it as a classic large exhibition picture[56].

Another reason for the unsympathetic character of *The Soldiers of King Albert the Ready* may be the still-life quality of its composition. Emmons[57] relates that it was derived from a photograph. Sickert's letters do not mention this derivation but the newspapers of the time were full of photographs similar to Sickert's picture in subject and composition, although I have been unable to trace the precise photograph used. Sickert also made studies from living models, Belgian soldiers whom he met in cafés, so that 'for a while his room was tripping full of rifles, boots and other military accoutrements'[58]. Sickert's letters to Miss Sands frequently mention the acquisition of uniforms and his delight in such

things as 'the artilleryman's forage cap with a little gold tassel' which is 'the sauciest thing in the world'. He also introduced new elements into the composition beyond those presumably present in the original photograph. He told Miss Sands, for instance, that 'A great waggon wheel and a bit of a sack-full of corn or cement have done wonders for what Ricketts and Shannon call the "compo".' As in *Ennui*, the self-conscious quality of the composition may have resulted from Sickert over-studying it, labouring at its detail, until the original savour of the large design had been subdued. Sickert described his method of studying the picture to Miss Sands: 'The model takes up his very strenuous and tense pose. I draw for a few minutes till he can't hold it and breaks out in a sweat poor man. Then in the next room, instantly, I paint on little separate studies the detail passage I have just drawn and observed.' It is possible that the piecemeal nature of this method of working was also not conducive to the sustained inspiration of the whole composition. Nevertheless *The Soldiers of King Albert* occupies a very important place in the history of Sickert's technical development. It can be regarded as the climax of his career, the moment when he discovered the complete solution to his problem with paint and developed in full his ideal handling. Sickert wrote to Miss Sands:

> I have got my whole big canvas laid in in a very inviting *camaieu*. It looks like some 1830 classic frieze. It is the best way on earth to do a picture. After 10 minutes of strenuous pose by the man in uniform with his gun I walk into the next room and put on the canvas still always in *camaieu* the bit I have just drawn and observed while it is fresh. All the messes[?] we made in the Whistlerian days of the *reprises* of blacks and browns and all dark colours which never dry etc. are avoided. These blond shadows like some Empire dinner service being nearly all white dry . . . and the more you repaint them the better. Then when the whole thing is absolutely complete in light and shade and drawing you just slip the last skin of colour on. In that way also you guide the effect more surely in pure line and light and shade.

The actual colours of the *camaieu* in *The Soldiers of King Albert* seem, where they can be glimpsed shining through the upper coats of paint, to have been a very pale blue and a very pale pink, the colours Sickert was to recommend to Miss Hamnett in 1918. Most important, Sickert had already discovered the great advantages of this method of preparation, the answer to his problem of how to alter a picture without messing it up, especially in the darks; he had found that with a *camaieu* preparation the more you repaint the shadows the better, which is just what he told Miss Hamnett in 1918: 'the oftener you correct, the more solid and luminous paint you get on your canvas'. Each passage in *The Soldiers of King Albert* is built up to a solid consistency in countless separate coats of bright clean colour. It is impossible to say what the true colour of any one area is because glimpses of one patch of colour shine through the thinly scrubbed colour of the succeeding coats. Sickert's confidence in and enthusiasm for this method of painting were communicated to Miss Sands. He wrote, 'There is an odd thing about oil-paint. By some odd law which I can't account for if one will repaint often enough and allow sufficient intervals for drying the quality becomes so beautiful that it hardly seems to matter what the form and the colour are. Does it amount to a trick? Who knows? I wish I understood the philosophy of it as well as being able to do it.'

The composition of *The Soldiers of King Albert* may seem self-conscious but Sickert's remarks to Miss Sands indicate that his first concern was with the quality of his paint surface which, in this picture with its multi-layered coats of singing colours, is undeniably beautiful. And Sickert did go on trying to understand the 'philosophy' of his technique. By 1918 Sickert could give Miss Hamnett reasons why scumbling over a *camaieu* preparation was ideal, but this rationalizing of his own technique was the only real development that took place between 1914 and 1918.

Sickert's remarks that his *camaieu* preparation reminded him of some 1830 classic frieze, and of an Empire dinner service, are informative. Possibly the style of that period was an inspiration to him in the evolution of his own handling. This suggestion is supported by his comment to Miss Sands[59]:

'I am sure decorations on walls should be in 2 or 3 tones as little Pissarro as possible rather more Flandrinesque . . . I adore something camaieuesque. Light and shade—the shade very fair and coloured'.

Sickert's search for the ideal handling had led him backwards in time. He had at last realized that an Impressionist *facture* was hardly the answer for a painter whose chief principle was the rejection of *alla prima* or direct painting. Pissarro was abandoned. It was perhaps inevitable that Sickert, with his method of working from drawings, slowly constructing his pictures with infinite care, should have finally discovered the essentials of his ideal handling in a method of painting which was of pre-Impressionist origin. Sickert's early training as a tonal Impressionist gave him the ability to conceive his subject in terms of light and shade and this ability was the basis of his *camaieu* construction. It will be remembered that Sickert's father had studied under Couture, whose studio practice anticipated many of the features of Sickert's method as developed from 1913 onwards. Couture stressed the separate, controlled and premeditated processes of preparation and finish, and his preparation was also used as an active ingredient of the final picture. Couture used scumbling, in a grainy dry brush technique, over his preparation. However, this is not to say that Sickert merely revived the traditional methods wholesale. His light-toned, arbitrarily two-coloured *camaieu* was very different from Couture's multi-coloured dark preparation.[60]

It is perhaps another of the paradoxes typical of Sickert's art that his later pictures, technically dependent upon an old-fashioned method of painting, should seem to our eyes the most 'modern' of his *œuvre*. This is partly because the later paintings are much more colourful. It may also be because the style Sickert created from his new handling, based on the juxtaposition and relationships of wide-open flat patches of tone and colour, each individually unembarrassed by variations of brushwork, texture, and tone, can be easily appreciated in abstract terms; the main interest and beauty of these pictures is found in the rhythms of the spaces and intervals between his paint patches and in the patterns of their shapes and colours. How the painting is done, not what is done, is the basis of his style. Sickert's use of photographs and other impersonal documents later in his career was only an even more uncompromising assertion of the irrelevance of subject as opposed to handling.

Nevertheless, this statement of Sickert's objectives is oversimplified. It ignores the central inconsistency or paradox of his artistic character. Sickert's whole development can be interpreted as a series of experiments designed not only to discover the ideal handling of his medium but also to find out how far the method of painting devised to express this handling, and its outcome—style—can and cannot be programmed and systematized. The value Sickert placed on handling and his intense emotional involvement with paint were constantly at war with his desire to tame his medium so as to make the execution of a painting almost mechanical. His various recipes belie his desire to systematize technique. Having found his solution in 1914 Sickert devoted much of the rest of his career to exploiting and exploring the potentials of his programmed formula for painting. When, later in his life, he left much of the preparatory work and execution of his paintings to studio assistants he was simply demonstrating, with extreme irony, even impertinence, the ultimate subjection of his medium and its handling. The conflict between Sickert's deeply personal and emotional involvement with handling and his intellectual belief that handling could and should be so systematized as to eradicate the need for the personal discrimination and taste of the intermediary, the artist, is largely responsible for the uneven quality of his later work. His style and handling were established, he had 'arrived' as Clive Bell wrote in 1919[61], but within these limits Sickert vacillated constantly between highly personal and totally mechanical manipulations of his paint.

NOTES

1. Miss Sands censored her collection of letters to remove references to purely private matters, which accounts for the isolated sheets.
2. G. M. is George Moore whom Sickert always regarded as a somewhat ridiculous person.
3. Letter dated from Sickert's description of a 'glorious Fitzroy Street' at which he introduced Theodore Duret. Duret asked, *'Combien de temps que vous êtes remarié? Deux ans! Ah alors ça ira'*, which makes the year 1913. Sickert also remarked that he was about to cross to Dieppe so the letter must have been written in the summer.
4. Neither publisher has any record of transactions with Sickert on this matter.
5. Letter dated from Sickert's enclosure of a copy of his letter to the *Star*, published 23 July 1913, in reply to an article by A. J. Finberg, published 15 July 1913, criticizing the A.A.A.
6. Roger must be Roger Fry.
7. He did condescend that 'There is a great beauty of *prima* painting. For flower sketches etc.', in another letter to Miss Sands.
8. The *Daily Telegraph*, 1 April 1925, 'With Wisest Sorrow'.
9. The *Fortnightly Review*, 84, December 1908, pp. 1017–28, 'The New Life of Whistler', p. 1024.
10. Letter dated in note 5.
11. Letter dated in note 5.
12. Sickert referred to the *Star* letter (see note 5) and to another published in *The Times*, 30 July 1913, in reply to an article 'Apprentice or Student' of 26 July. He told Miss Sands, 'I am only at one thing in them to influence and convert the "plain man"'.
13. Dated 1913 because of the pictures it mentions and mid-August because Sickert wrote 'Half August and then September'.
14. Date assumed from its place in the sequence referring to Sickert's progress on *La Scierie de Torqueville*, the timber yard picture.
15. Letter dated in note 13.
16. Mention of *La Scierie* and the *Obelisk* pictures dates the letter 1913 and the dating is confirmed by Sickert's remark, *à propos* the ladies finding his newly grown beard attractive, '*A cinquante-trois ans c'est déjà pas mal!*' In the letter dated in note 5 Sickert had invited himself to stay at Miss Sands' country house at Newington before his school started. Term started on 6 October (as was also noted in an earlier letter). This letter must have been written towards the end of September because Sickert wrote, 'How enchanting to think that I will be dining with you on Monday week'.
17. Written just before his return ('I shall cross on Sunday night') and dated 1913 because of his apologia for his new beard (see note 16).
18. Schubert needs no explanation. Klaus Groth wrote folk poems and fables in verse: his main work, *Quickborn*, published in 1856, was illustrated by Otto Spekter who perfectly communicated the mood of the poems in his charmingly simple but romantic scenes of peasant life.
19. Letter dated in note 14.
20. Catalogue preface to the 'Thérèse Lessore' exhibition, The Eldar Gallery, 1918.
21. The *Nation and Athenaeum*, 16 February 1929, 44, No. 20, 'Duncan Grant'.
22. This dining-room scheme is discussed in detail in Chapter XVI (text and notes 21, 32).
23. Sickert mentions this studio and its use in several letters to Miss Sands.
24. The dating of these letters is crucial to establish the date of the paintings. It can be assumed that both were written in the same year because (i) they mention the same subject, (ii) both were written shortly after Sickert's arrival (in the first he referred to his sea crossing, in the second to his plans for the summer). The first letter, by itself, is undatable. In the second, however, Sickert reviewed the errors he deduced from his last year's work in Dieppe: 'Too many direct canvases *begun*. Too few *finished*. And then the big ones worked on in England after all the savour has been forgotten'. Thus the letter could not have been written in 1919 (when the *Café des Arcades* pictures are sometimes dated) because Sickert was not in Dieppe in 1918, and had not been there since 1914. It could hardly have been written in 1920 or later because Sickert wrote, 'My history just now is that of intensified thought about method. One can't work at over 50 like one did at under 40'; by 1920 Sickert was 60, not merely 'over 50'. Finally Sickert's self-criticism for not finishing his Dieppe canvases in Dieppe is repeated in other datable letters of 1914. It should be noted that the handling of the *Café des Arcades* pictures precludes a dating earlier than 1914.
25. Letter dated from Sickert's comments on the judge's findings against Robert Ross at the end of a case, heard from April until July 1914, in which Ross summoned a journalist named Crosland for criminal conspiracy against him.
26. Letter dated 1914 from Sickert's first description of another subject, *The Flags on the Front*, that is, *La Rue Aguado* described in a certainly datable letter of 1914.
27. Letter dated 1914 because Sickert referred to the financial problems of Gore's widow; Gore died in March 1914.
28. The mention of the sketch done the year before proves that the letter was written in 1914.
29. Letter dated from reference to the war and the plans Sickert had made for his return to London where he had taken rooms in Red Lion Square. In 1914 Sickert often wrote of painting on a *toile de 12F*—that is a French canvas size, 'F' meaning *figure* or upright in format (although Sickert usually turned the canvas the other way to be 'landscape' shaped). The dimensions were 61 × 50 cm. (24 × 20 inches approximately).
30. Letter written after war broke out because Sickert reported that he had to 'call 3 days a week at the red cross to show I am ready for my turn but as yet we have no wounded'.
31. Sickert referred to the subject in many letters, one of which is definitely datable 1914. It is inscribed 'Tuesday' and mentioned that Christine had fallen down some stairs. Another letter inscribed 'Wednesday' reported that she was not badly hurt and this is the letter dated in note 27.
32. Letter dated and quoted in note 24.
33. Letter dated in note 26.
34. The 'Tuesday' letter in note 31.
35. Letter written towards the end of the summer because Sickert reported that Sylvia Gosse had found him new rooms in Red Lion Square—rooms he was to use as his studio on his return to London.
36. Letter dated 1914 because Sickert wrote, 'Life will be interesting if I now at 54 *at last* do some things worthy of a

matured intelligence'. Written on 'July 15'.

37. Letter written just before the war because Sickert reported that nobody talks of anything but probable war.

38. Letter dated in note 36.

39. Letter dated from references to the Robert Ross case (see note 25).

40. Letter undatable in itself but its technical content, particularly its recommendation of Cézanne's 'minces couches', suggests it was written in 1914.

41. The New Age, 18 June 1914.

42. Letter discussed in note 40.

43. The evidence for dating this letter c.1913 is not conclusive although its content fits best into the context of Sickert's ideas at that time. Some support for this dating is contained in Sickert's play with a verse from 'The Lady of Lyons' by Lytton in which he changed the word 'adorer' to 'enmerdeur'. 'Enmerdeux' was his Envermeu telegraphic address, as he had announced to Miss Sands in his July 1913 letter (see note 5). This letter, being written in London, must post-date his 1913 summer in Dieppe when he had assumed this telegraphic code.

44. A pen and ink drawing of a girl leaning on a piano, listed under C.352, may be an early idea for the Tavernier composition.

45. The English Review, January 1912, pp. 301–12, 'The Old Ladies of Etching Needle Street', p. 310.

46. The New Age, 25 April 1914, 'Drawing from the Cast'.

47. The New Age, 11 June 1914, 'On the Conduct of a Talent'.

48. The Art News, 10 March 1910, 'Solomon J. Solomon' (a review of Solomon's book The Practice of Oil Painting and of Drawing Associated with it). Sickert also published 'Solomon J. Solomon, An Amplification' in the Art News, 17 March 1910, in which he elaborated on this theme.

49. Letter probably written in 1915 because it is headed 'Monday' and Sickert wrote that he had spent the previous day in bed because of having diarrhoea 'induced by plum pudding and a little Xmas champagne'. Christmas fell on Saturday in 1915, which gave him Sunday in bed and Monday to write his letter.

50. Letter of Easter Monday 1913.

51. Walter Sickert. A Conversation, London, Hogarth Press, 1934; reprinted in The Captain's Death Bed in 1950 and as the preface to the Agnew Sickert exhibition in 1960. The context of Mrs. Woolf's description of Ennui in a discussion of Sickert's current exhibition at Agnew's implies that she was referring to the version there exhibited, that is, the picture then lent by F. Hindley Smith and now in the Ashmolean Museum, Oxford. However, she probably also used her recollection of the Tate picture (presented to the gallery in 1924 by the C.A.S. who had bought it in 1914, probably from the N.E.A.C. exhibition).

52. These Dieppe landscapes were bigger than most of his earlier landscapes but still relatively small pictures (see catalogue for details of their sizes).

53. All the letters to Miss Sands mentioning the Belgian picture can automatically be dated autumn 1914.

54. The New Age, 28 April 1910, 'Exhibititis'.

55. The job at Chelsea was to produce the decorations for Miss Sands's dining-room. This letter mentions studies of Chicken whom Sickert painted at the piano during the winter of 1914–15 in his Red Lion Square studio.

56. Sickert wanted to sell the picture to help the Belgian Relief Fund.

57. p. 179.

58. Ibid.

59. Letter undatable.

60. This information about Couture's practice is taken from Albert Boimé, The Academy and French Painting in the Nineteenth Century, London, Phaidon, 1971.

61. Preface to the catalogue of The Eldar Gallery 'Sickert' exhibition in 1919. Bell explained that 'An artist is said to have "arrived" when, after working through all the experimental stages, he at last discovers, not a formula, but a style in which he is perfectly at ease. At a certain age wise beauties make up their minds as to what suits them best and cease to follow fashion; that is what Sickert did some time ago. Having elaborated a style in which he could be seen to the greatest advantage, he stuck to it.' I agree that Sickert found a style but disagree that he found no formula; indeed, I maintain that the style grew out of the formula.

XVI

1914–18. England

SICKERT was confined to England during the 1914–18 War. He spent the first winter of the war in London, working in his new studio in Red Lion Square. Some of the works he painted there, the piano pictures and *The Soldiers of King Albert the Ready*, have been discussed in the last chapter. In the big picture he tried out his new method, covering an underlying *camaieu* preparation with a solid patchwork of clean, bright, and variously coloured stains of undiluted paint, in a large-scale figure composition. But in the smaller, less formal piano pictures he still worked with thinner paint diluted with turpentine. He told Miss Sands how mobilization seemed to have condensed his talent: ' I have at last got what I wanted. I am *painting* quite as well and as sharply as my best *drawings*. Thin free hard rubs of paint mixed with turpentine.' Sickert's work during the war can be divided into those pictures, mostly small and informal, which he painted in thin, free coats of diluted paint, and the others, more planned and larger in scale, painted by his new method.

In spite of Sickert's evident confidence in his recent London work during the first winter of the war he already fretted at his confinement to London. He wrote to Miss Sands[1] of how he contemplated dropping his 'London *house*' and settling with his wife 'either in Dieppe or Brighton or somewhere out of the London fog. I should keep my Red Lion Sq. rooms and we would come to London in the light months and take other people's furnished flats.' In the event Sickert decided[2] 'not to leave London till the end of the war' (by 'leave London' he meant setting up house with his wife), but he did spend considerable periods away from the city. He visited Chagford in Devon and Brighton in 1915 and lived in Bath for long periods in the years between 1916 and 1919.

Sickert's work during the war period is comparatively well documented. Chagford, Brighton, and Bath subjects can be dated with reasonable accuracy from the known dates of Sickert's visits to these places. But the war did herald one virtually unknown episode in his career, his attempt to become a military painter. When war broke out Sickert fretted that he was not a soldier. He wrote to Miss Sands, 'It is a lesson to me that every man should be—as well as his own business—a soldier as well. If I had been in the Volunteers and the Territorial all my life I should now have been eligible for service.' By the time Sickert began work on *The Soldiers of King Albert the Ready* he already regarded himself as a military painter, which compensated for his ineligibility as a soldier. For example, he wrote to Miss Sands of how he bought the kit of a private soldier for 'ninety five shillings so I am well set up as a military painter'. In another letter he told her that he was going to borrow uniforms from Belgians in hospital: 'One has a kind of distaste for using misfortunes to further one's own ends. But pictures of Belgian incidents so far as they have any effect can be useful. Besides if military painters had always been too bloody delicate they never would have got anything done at all.' It was probably his visits to Belgians in hospital that inspired his painting of *The Red Cross Nurse* or *Wounded* (Fig. 247). It is a very spare picture, uncluttered in composition, executed in thick smooth paint, and closely based on a

squared dated drawing of 1914. Sickert also painted another major subject picture of military content called *The Integrity of Belgium* which he exhibited at the War Relief Exhibition at the Royal Academy from January to February 1915. This picture is now lost but it was similar in subject and probably similar in style to *The Soldiers of King Albert the Ready* (C.351). In a letter to Miss Sands and Miss Hudson written in December 1914[3] Sickert reported, 'I have laid in my R.A. picture in *camaieu*. I have got a magnificent platform 7 foot by 7 to get Veronese-like foreshortenings.' Possibly, after his first enthusiasm for such grand and dramatic subjects, Sickert himself came to realize the artificiality of his war pictures and agreed with the comment in the *Athenaeum* review[4] upon his own and his fellow-artists' pictures in this exhibition, that they were examples of 'picture-making on familiar lines for which the war has been utilized as a pretext'.

But he did not realize this at once. In the letter telling of the preparation of this 'R.A. picture' Sickert also asked Miss Sands and Miss Hudson—who were then nursing in France—not to 'forget I am a "military painter". So if you can send me a *Képi* tunic, haversack and *pantalon rouge*, and if possible a *pickelhaube* do.' And he went on, 'Make me little pencil drawings of bits of background (in sunlight) but don't go into the firing line to do them. For my war-pictures. And photographs, and *ideas*.'

Whether Miss Sands and Miss Hudson managed to send Sickert military paraphernalia, background drawings, ideas and so forth is unknown, but in any case it was not long before Sickert's plan to paint military subject pictures was superseded by another project. In January 1915 or thereabouts, Sickert wrote to Miss Sands[5] that he was 'now taken up in the *pompes funèbres* department of my work. Orders for deceased officers' portraits are coming in through Clifton, which interest me to do. I get the uniforms and make separate studies of them on a model.' A particular example was first quoted to Miss Sands in a letter written early in 1915[6]: 'I have a portrait of an officer to do with a charming head, poor chap, which is lying low. It will interest me. A Colonel Grant Duff.' He referred to this same portrait in many other letters to Miss Sands. He evidently painted it over a *camaieu* or similar preparation because in one letter he wrote, 'I have nearly finished Colonel Grant Duff's portrait. The system of preparations is such a good one. The touches of real colour go on the dead colour like a fresh slight sketch.'

I have been unable to trace the portrait of Colonel Grant Duff or of any other deceased officer painted by Sickert during the war[7]. Sickert's letters to Miss Sands prove that etching began to claim more and more of his time in 1915 and led him to neglect his military portraits as well as other aspects of his painting work. Finally a more specifically military task was considered for Sickert. In a letter to Miss Sands, probably written during the early autumn of 1915[8], he reported, 'There is just a chance that the Prime Minister may send me to sketch for him at the front (*out* of danger . . .). Nothing is settled. He expressed a wish to know if I would go and I wired to say I would and await orders. So you may see me in Khaki yet!' This project came to nothing and must have aborted early because the Imperial War Museum's archives contain no reference to Sickert in an official capacity as a war painter.

Sickert's decision not to set up home away from London must have been influenced by his absorption in teaching. Rowlandson House had been disbanded but he continued to teach in various of his private studios[9]; his Saturday 'At Homes' continued, although they were depleted by the absence of many colleagues who were at the front and by the sad loss of Gore who had died in March 1914; but his particular interest was in his classes at the Westminster Technical Institute. He gave great thought to his lectures there and was constantly telling Miss Sands of their preparation and reception. In about August 1915[10] he told Miss Sands how the L.C.C. inspector came and asked him to make of Westminster '*the* school of painting and I shall . . . I am to have a free hand and direct the art school

entirely. I shall visit 2 or 3 evenings a week.' Early in 1916[11] he reported to Miss Sands, 'One of the chief inspectors of the council told me that my views [as expressed in his current lecture course] would cause him to modify his reports on methods in drawing as applied to all the schools.' He continued to write a great deal. In 1914, from March to June he had contributed an important series of articles to the *New Age*. In the summer of 1915 he began to write for the *Burlington Magazine*, contributing an article (often on contemporary art) to nearly every issue for about a year. And he etched. Sickert loved teaching, writing, and etching. He had told Miss Sands in January 1915[12] (with particular reference to his etching and portraits of deceased officers), 'My happiness depends so on my knowing the full field for deploying my different branches of work', but he prefaced this remark by saying, 'I am very grateful to be able to make my rather large expenses easily'. He called his commission from the *Burlington Magazine* to write an article on the Whistler exhibition at Colnaghi's (published in July 1915) '3000 words in sterling'. Money worries at the outset of the war led him to consider going to America. He wrote to Miss Sands that Nevinson had told him, 'one easily gets £10 a lecture and I should take over a stock of 50 drawings or so. I think any first rate American paper would like articles by me on their collections. I imagine Freer of Detroit might like me to do a *catalogue raisonné* of his collection.' America lost these benefits when Sickert, rather prematurely and optimistically, saw the end of the war in sight (in 1914[13]) and dropped the project. Clifton of the Carfax Gallery guaranteed Sickert a small fixed income[14] in return for being Sickert's main dealer. In a sense Clifton was Sickert's manager. He directed Sickert's activities. It was Clifton who arranged for the deceased officers' portraits. It was the Carfax Gallery which published a series of Sickert etchings in 1915, the result of several months' concentrated effort by Sickert at his etching desk.

It can be argued that the most valuable part of Sickert's Whistlerian inheritance was his ability as an etcher. He was a real master of the technique. His very sensitive and delicately drawn etchings of the early 1880s constitute the finest part of his work at the period when he was still completely dominated by Whistler's example. In the context of the discussion of Sickert's drawing styles and techniques of 1911–12 many of his comments in letters to Miss Sands in 1915 on his current etching were quoted, as well as passages from his essay 'The Future of Engraving' written in that year. It was in 1915 that Sickert announced to Miss Sands, 'I have always known that I was, potentially, the only living etcher, but I was quite prepared never to have the energy to prove it'. Early in 1915 he affirmed to Miss Sands, 'I . . . am going to etch everything I draw'[15]. He etched earlier subjects as well as current compositions. He found it 'absorbingly interesting' but after a time very tiring; he stood at his etching desk 'from 10 to 5 with very little break'. It was, therefore, with a sense of great relief that in the autumn, following a trip to Brighton[16], Sickert told Miss Sands, 'Clifton says he must have paintings so now I am arranged for 3 months at the palette'; he explained, 'On these lovely days I am already at work having turned out all my etching friends and converted the front room here [26 Red Lion Square] into my picture theatre. With the sunlight all the morning and Marie to pose it is *divine*. . . . My printer for the present goes I hope into munitions.'

The paintings Sickert did in Brighton, or immediately after his visit there, affirm his delighted release from black-and-white work. Indeed, he wrote to Miss Sands in August[17], shortly before the Brighton visit, that he would do 'some spiffing paintings after all this etching' and that 'the restraints of etching have given me a new letch for the brush'. In Brighton Sickert told Miss Sands[18] he went 'every night for five weeks to the Pierrot theatre. It has been delightful and interesting', and he called the picture which resulted from these visits, *The Brighton Pierrots* (Fig. 254, C.364), 'a bit of all right'. There are two versions of this subject; one was sold at once to Ethel Sands's brother, Morton; the second picture was the result of an immediate commission from another patron. Both are full of rich, singing colours, hot pinks, greens, yellow, orange, and red among them. They are painted in a solidly

worked jigsaw of fat, smooth patches of opaque colour. Technically and stylistically these paintings are similar to the Dieppe landscapes of 1914 such as *The Café Suisse* (Fig. 241), but never before had Sickert painted a figure subject with so rich a palette. At some time during the summer of 1915 Sickert evidently went to Chagford[19], where he made a large number of drawings, many of them touched with wash or more fully tinted in watercolour and squared for transfer. He painted many oil studies of village streets and cottages on board or panel, with a light touch and a fresh and pretty palette. However, on his return he used only a few of these studies to paint full-scale pictures on canvas. Perhaps his favourite motif for painting on a larger scale was the churchyard. The terse treatment of these paintings echoes the asceticism of their subject. In one unfinished painting on canvas of this churchyard he gave a prosaic and precise account of the geometry of the overlapping perspective of severe stone crosses (C.369, listed painting 1); but in another view of this subject (Fig. 259) the treatment of the rolling landscape as a series of receding angular planes, each expressed as a thin coat of pale colour (mainly in yellows, lime green, and muddy pink), and the method of outline drawing used to define the forms and construction of his composition, are distinctly reminiscent of Cézanne. Sickert's public position as adversary to Roger Fry and Clive Bell in their passionate proclamations of the genius of Cézanne was, as we have seen, not a true reflection of his private opinions about the French painter for whose work he had a sincere, if temperate, regard. It is interesting to see that at the height of the Cézanne mania Sickert, like so many of his English contemporaries, painted in a manner inspired by Cézanne. This picture was, however, exceptional. In *Rushford Mill*, another Chagford subject (Fig. 258), usually called *The Mill Pool* and believed (mistakenly) to be a French landscape of *c*.1919, his treatment and approach is more reminiscent of the lusher Dieppe landscapes of 1913.

In 1914 and 1915 Sickert spent many evenings drawing in the New Bedford music hall. He had been commissioned by Miss Sands in 1914, before the war, to paint a series of pictures to decorate the dining-room of her Chelsea house[20]. The history of this commission is unclear. It is probable that Miss Sands had asked for a series of music hall paintings to decorate all the walls of her dining-room[21]; in the event Sickert completed only one picture, *The New Bedford* (Fig. 255), and Miss Sands did not buy it—her disappointment at Sickert's failure to execute the commission perhaps accounting for the rejection.

Sickert was at first delighted with the project. His letters to Miss Sands constantly tell of his drawing expeditions. In the summer of 1914[22] he wrote, 'Bedford again tonight. I am at least *allumé* . . . I now *know* that dining room will be.' He ordered the canvases, which were much larger than his usual size, in the winter of 1914[23] and at the turn of the year[24] he was still reporting, 'usual agreeable routine. You know how I adore routine. Bedford every night.' The result of these expeditions was a large number of drawings, many of which are now in the Walker Art Gallery, Liverpool. But as etching claimed more and more of his time Sickert put off evaluating the results of this constant study. By about July 1915[25] he told how etching was leading him to neglect his 'beloved decorations' as well as Grant Duff's portrait. Indeed the main result of his Bedford drawings was that Sickert got etchings out of his studies (as he told Miss Sands[26]). It is uncertain how far the project for the decorations was defined in its early stages. The letters mention only the Bedford, which suggests that all the pictures were to represent this music hall. The canvases were ordered in the winter of 1914, which suggests Sickert had some plan in mind. Yet in about August 1915[27] he sent Miss Sands 'a specimen of a design you have seen too often'—presumably a sketch showing her how he currently envisaged the whole scheme of her decorations, a stage in the affair which should already have been completed. In two undatable letters to Miss Hudson Sickert discussed the scheme in more detail. In one he wrote, 'I have arrived at a definite result about the decorations. I cannot fit the drawings I have into the spaces.

They are not suited to them and were not intended for them and it would be a botch. I am not sorry as I have a profound instinct to do you something new. So I shall go tonight to the Bedford and make studies with the dining room in my mind of course, of course the only possible way. Why should I, with my fine instinct for filling a space, compile a patchwork of dead drawings.' In the other letter Sickert remarked, almost certainly *à propos* of his commission, 'I saw the architect today. Things are *en train*. I shall probably do the panels in a scene-painter's dock nr. St. Giles's', and as a post-script 'The mirror-door is a perfect idea. I have covered a big canvas 33 × 15 with oil paint for a finished study of the mantelpiece side of the room. That will incidentally make a saleable picture for Clifton.'

It is not possible to state whether these two letters were written at a very early stage in the commission, that is in the summer of 1914, or a year later at about the time that Sickert sent Miss Sands a specimen of the design. In view of Sickert's express desire to do something new it is strange that the only completed picture was so heavily dependent on the earlier 1908–9 picture of *The New Bedford* (Fig. 166). The compositions of the commissioned and the earlier picture are almost identical, except that the later version shows a fractionally narrower slice of the interior and the incidental figures are slightly different (in dress rather than in placing). It is also strange that, in spite of his earlier experience of painting this subject, Sickert found it necessary to paint a finished rehearsal (C.365, version). It is possible that this rehearsal is the picture mentioned to Miss Hudson (although it measures only 30 × 15) and it did make a saleable picture for Clifton. Sir Edward Marsh bought it from the Carfax Gallery in 1916. Sickert's use of tempera as the preparation for the large *New Bedford* is interesting. With probable reference to this picture he told Miss Sands[28]: 'I have begun painting in oil on my big tempera picture, it goes on with an exquisite velvety quality. The tempera is certainly a most convenient preparation owing to the ease in drawing in chalk or charcoal on it till the *place* for everything is absolutely settled.' Sickert's attraction to the dryness of tempera is another aspect of his discovery of the virtues of any coarse, bone-dry preparation such as the *camaieux* he had been using since 1914. Sickert even told Miss Sands that he had had his studio in Brecknock Street converted for tempera painting, although it is doubtful whether he executed many more paintings over a tempera base[29]. It is probable that he felt this use of tempera was a proper return to traditional, even Old Master, practice because Sickert, as has been emphasized before, was sincerely interested in both quoting and reviving historical precedents. In a letter to Miss Hudson in 1916[30] Sickert remarked, 'I learn a great deal from a friend who is a restorer. It is extraordinary how the old ones *all* knew their business and *all* worked from drawings.' It is probable that the full extent of Sickert's lessons from the restorer was not merely confirmation of his usual practice of working from drawings, and one can speculate about what else he learned.

The big picture of *The New Bedford*, at first intended as part of the series of pictures for Miss Sands, was probably painted in 1915–16. There are, however, other *New Bedford* paintings, some large in scale, all summarily treated and lacking in finish, which could have been studies for, or the preparation stages of, more pictures for Miss Sands's dining-room. These pictures include another vertical interior (Fig. 256) a little taller and narrower than the rehearsal for the completed commissioned painting. It shows a slice of the interior incorporating most of the right half of the scene as shown in the finished picture but it continues beyond on the right to show the full width of the box beneath the gallery which is just glimpsed in the large picture. Many of Sickert's *New Bedford* drawings of 1914–15 study this part of the theatre and this is the view of the subject he etched in a plate published in 1915. Sickert had told Miss Sands in December 1914 that he was utilizing his studies for her dining-room for etchings. In one letter written at the turn of the year 1914–15[31] he had specifically stated, 'Out of your room has grown a plate', and in another which is not accurately datable he promised to send her a proof of a Bedford subject, 'a bit of your dining-room in copper'. This suggests that the painting which

shows the same view of *The New Bedford* as that Sickert etched was at least originally intended to take its place in the scheme of decorations for Miss Sands. Without knowing the architecture of her dining-room it is impossible to envisage the placing and relative proportions of the pictures which were to decorate it, but they were not necessarily intended to fill spaces of either the same size or width[32]. The handling of *The New Bedford* (Fig. 256) is similar to that of the rehearsal for the large picture; the paint has the same matt, opaque quality, the drawing has the same breadth; it is only the lack of finish which gives it a more schematic quality which, in the context of Sickert's stylistic development, anticipates some of his later paintings. There are also three large studies on canvas related to a land-scape-shaped view of *The New Bedford* (Fig. 257, C.367) as well as to a highly particularized squared drawing of the whole subject. The landscape-shaped version is quite small in scale and is so broadly and thinly treated that it can be regarded as no more than an outline sketch for a projected picture. The three large studies, like the squared drawing, omit the lower storey of the theatre below the boxes which is represented in Fig. 257; and each represents a third of the subject studied in the squared draw-ing and the landscape-shaped painting. When they are juxtaposed they complete the view of the interior of the theatre studied in the drawing and painting except that two are a little less tall (the box on the far left is larger and set lower in the theatre than the adjoining box and upper auditorium so that, to complete the picture of the theatre studied in the drawing, two of the studies would need a strip of canvas representing the balustrade along their lower edges). The fact that the large size of these studies is so unusual for Sickert, and the coincidence that the three placed side by side (except for the missing strip at the lower edges of two of them) exactly re-create a view studied in a detailed squared drawing and an oil on canvas sketch, suggest that the paintings were not only intended for a specific purpose but were also designed to be juxtaposed. It is, therefore, very tempting to suppose that the three pictures were part of the scheme of decoration commissioned by Miss Sands and that, for some reason now unknown, they were left unfinished and separated. It is also tempting to suggest that Sickert deliberately omitted a strip from the lower edge of two pictures because they were intended to run above the mantelpiece, which could have been made to function as the missing balustrade. The style and handling of all these paintings is compatible with a date of *c*.1916–20[33].

The diversification of Sickert's talents during the first year of the war had led him to neglect painting the sort of domestic figure subjects which had been his main occupation from his return to London in 1905 until 1914. By the summer of 1915 Sickert abandoned his pretensions as a military painter; he also ceased his activity as an etcher although he did not clear out his etching room at Red Lion Square until 1916 ('a rather depressing job. I hoped so much from my plates and I don't suppose I have made the price of the press with them'[34]). His 'new letch for the brush' had been partially satisfied in Brighton and Chagford but, as Sickert wrote to Miss Sands, he could not 'conceive heaven' without

1. painting in a sunny room an iron bedstead in the morning
2. painting in a North light studio from drawings till tea-time
3. giving a few lessons to eager students of both sexes at night.[35]

Clifton's demands for paintings which arranged Sickert for three months at the palette ratified this ideal[36]. *Reverie* (C.360), *Camden Town* (C.361) and *The Iron Bedstead* (Fig. 246, C.355) are examples of iron bedstead pictures of 1915–16. They are all broadly painted angled views of a corner of a room with the bed pushed back from the foreground plane. In *Camden Town* the foreground is occupied by a quite fully realized portrait of a girl but in the other two pictures half-glimpsed objects of furniture fill this premier position and reinforce the casual impression induced by their seemingly off-hand treatment. *Camden Town* can be regarded more as a portrait than as a figure subject; in the other bedstead pictures the figures are almost incidental. The dramatic quality of Sickert's pre-war Camden

Town figure subjects is quite lacking; there is nothing for the imagination to turn into a story.

With very few exceptions Sickert's war-time figure subjects (excluding portraits) can be classified as interiors with figures rather than figures in an interior. An important exception is *Suspense* (Fig. 249, C.356), a rare attempt by Sickert to convey a positive, explicit, strong emotion. Much more typical of his work at this time, 1915–16, are the various pictures done in his Warren Street studio where he painted a series of subjects featuring a circular table in the foreground (on which a Napoleon III tobacco jar was often placed) with a Victorian chaise-longue behind it (Fig. 253, C.357). In a drawing of this subject he described a young girl seated and fully visible, but in the paintings the figure is lying curled up on the couch and is barely noticed. Indeed Sickert took an almost contrary delight in objects during this period. In the Warren Street interiors the subject is the furniture and the Napoleon III tobacco jar. In the other pictures, it is the marble bust of the boxer Tom Sayers placed on a mantelshelf in front of a large glass. There are many drawings of the room with this imposing fireplace (it is the same room in which Sickert painted *Ennui* and probably *Nude Seated on a Couch* and *Army and Navy*[37]). They all have figures variously disposed in fairly formal arrangements: in one tea things are on a circular table (listed C.354, Drawing 1), in another perversely called *Degas at New Orleans* (Drawing 2) a negro butler holds a tray to his master and a lady visitor or hostess reclines on a couch, and in another closer view a woman sits regarding the ornament (Drawing 3). In all the core of the drawing is, in a sense, this bust of Tom Sayers. However, the only painting known to me featuring this bust is the magnificent *Self Portrait* of a heavily bearded Sickert reflected in the mantelglass flanked by Tom Sayers on the one side and a large vase on the other (Fig. 250). The painting is hardly more than a broad sketch with the portrait itself of no more importance than the flanking ornaments but it achieves a truly monumental quality from the sure dramatic instinct which conditioned the placing and the compositional relationships of the component objects. This instinct for the effective arrangement of his subject, the detached objective way in which Sickert manipulated and presented its components whether animate or inanimate, is probably the most crucial feature of his war-time figure subjects. The drama of his pictures of this period resides in their compositions, in the relationship and interplay of one shape to another; with a few exceptions such as *Suspense* it is not found in, it is not even a by-product of, their human interest. That is why the figures are so incidental to the iron bedstead pictures and to the Warren Street interiors. This objective interest in compositional relationships was not, of course, new to Sickert; it was of great importance to all his pictures of the Camden Town period when the relationships of the figures to each other and to their common ambience was a primary factor in the development of his domestic dramas. But never before were the figures recognized as of peripheral importance and their role subordinated so completely in the context of his interior compositions. Even the handling of his pictures seems to have taken second place to their construction. Most of these figure pictures are treated in a broad, summary manner in a limited range of dull, neither dark nor light colours (with much use of different shades of browns and greens); the sketchy map of tones is articulated by free, loose drawing.

This is not to say that Sickert lost his interest in human beings, in the fascination of their physiognomies and expressions. In 1913 Sickert had written to Miss Hudson[38], 'London is spiffing! Such evil racy little faces and such a comfortable feeling of the solid basis of beef and beer. O the whiff of leather and stout from the swing-doors of the pubs!' But during the war, instead of re-creating the private lives of these same Londoners as he had done in the pre-war period, he expressed his fascination with them in his portraits. He painted a group of pictures of a beggar fiddler, *Old Heffel of Rowton House* (Fig. 251, C.359). His finest picture of Marie Hayes, the model for many of his iron bedstead pictures, is *The Fur Boa* (Fig. 252). He painted his friends and colleagues such as the French painter *Maurice Asselin* who shared Sickert's Red Lion Square studio for a time and helped Sickert preside

over his Saturday 'At Homes' (C.362), and a dual portrait of Nina Hamnett and Roald Kristian at 8 Fitzroy Street called *The Little Tea Party* (C.363). But in none of his figure pictures, portraits included, did Sickert make full use of the technical discoveries which he had developed in Dieppe in 1914 and had revived only in *The Soldiers of King Albert the Ready* (and apparently in *The Integrity of Belgium*) and in the Brighton pictures. He was content in all the figure pictures to paint summarily and swiftly in diluted paint, instead of building up his canvases in a cumulation of coats of dry pigment. It was not until Sickert went to Bath, probably in the summer of 1916, that he revived the style and technique of his 1914 Dieppe landscapes.

Sickert spent much of the time between 1916 and 1918 in Bath, although he retained a studio in London to which he frequently returned, especially to fulfil his teaching duties, throughout this period. In Bath he concentrated on landscape (or townscape) painting. Sickert had maintained an interest in landscape painting during the war before he went to Bath. Besides his Chagford pictures of 1915 he had painted a few London landscapes such as the station at *Queens Road Bayswater* (Fig. 260), a formal uncluttered composition which is primarily an arrangement of rectangles (with one unobtrusive figure seated in the shadows of the waiting room). The picture may well have been influenced by the current enthusiasm for cubist art. Indeed this landscape, and the 1915–16 figure pictures as well, could all be interpreted as a demonstration by Sickert that a painter need not divorce himself too far from representational considerations in order to express the abstract constructional aspect of a picture.

In a letter to Miss Sands written in 1918[39] Sickert expressed his love of Bath. In answer to a question from her about why he had lived in Envermeu rather than in Dieppe proper he went on, 'But Bath is *it*. There never was such a place for rest and comfort and leisurely work. Such country, and *such* town.' As he had done in Venice and Dieppe, but with even greater exclusiveness, Sickert chose a few motifs and drew and painted them over and over again. His main subjects were *Beechen Cliff* or *The Belvedere* (C.372), *Lansdown Crescent* (C.373), *Mr. Sheepshank's House* or *Camden Crescent* (C.374), and above all *Pulteney Bridge* (Fig. 261, C.371). It is impossible to date the Bath pictures with any greater accuracy than 1916–18, always remembering that their popularity led Sickert to paint further versions at a later date. Passages from Sickert's letters written from Bath in 1918 to Miss Hamnett, in which he conveyed his enthusiasm for painting over a *camaieu*, were quoted in Chapter XV. Some recapitulation is necessary because the method of painting he then described has particular relevance to these Bath paintings. Sickert gave Miss Hamnett detailed recipes for the preparation of a *camaieu* in four tones of palest blue and palest pink underlying successive hard scrubbed coats of clean, coloured, undiluted paint. He recommended the use of coarse canvases and his abhorrence of any trace of greasiness in his medium reached its climax. He extolled the quality of the paint surface that was achieved by following this method. He emphasized that the method was only possible to a painter who worked from drawings, and from drawings conceived in terms of light and shade. The Bath pictures, with their glowing colours (pinks, pale blue, greens, and violets), the rich quality of their surface built up in countless superimpositions of shaggy patchwork coats of paint, and their strong sense of design set off by the pattern of light and shade, are the practical results of this method. They recall the Dieppe landscapes of 1914 but some stylistic distinctions between the earlier and the later works can be made. Although he often painted his favourite subjects on a large scale he also painted finished pictures (as opposed to oil studies) on small canvases. Indeed, in a letter to Miss Hamnett he wrote, 'I have given up the two pictures on the large scale and am using all the information acquired to do a couple of small sparkling canvases like one sees in the windows of Boussod & Valadon *et cie*'. Unfortunately he did not specify what was his subject in this instance. Certainly several of the *Pulteney Bridge* pictures are small and sparkling (C.371, Versions 4, 5), as is Version 2 of *The Belvedere* (C.372). The Bath

pictures are also less tight and precise than the earlier Dieppe landscapes. The definition and design is clear but the handling is a little looser and freer as Sickert gained more experience in his handling of undiluted paint. A letter to Miss Hamnett helps to explain the interesting contrasts of precisely defined areas in Sickert's Bath pictures with more open and ambiguous passages. He wrote:

> if you draw into your first study (which is squared up) and when your preparations are dry, resquare it up with a wedge of nice blackboard chalk, both your study and your preparation are kept *incessantly loose* ('Keep it moving' Steer used to say to his students of painting) and yet *incessantly firmer* . . . part of your study being precise and some of it still tentative, you must not wait to lay in the *camaieu* till you have all your study precise . . . and the tentative parts as exactly copied as the precise. It is in copying the tentative parts that you will learn what to look for when you go back to those bits in Nature. And moreover, it is thus that you will get your personal *trouvailles* and find *perhaps* that you want some parts to remain tentative in the finished work.

Sickert painted the Georgian grandeur of Bath, which so admirably suited his new method of painting, for two years, but when the war ended and he was free to settle where he chose he and his wife decided to return to Envermeu. He did not return to live in Bath until another twenty years had passed, when he made his last home in nearby Bathampton.

NOTES

1. Letter written late in 1914 (the letter mentions that 'Chicken comes every day at 10 and 4 and I am doing some beauties' with probable reference to the piano pictures painted in Red Lion Square during this winter, C.352).
2. Letter to Miss Sands written early in 1916 (it refers to an exhibition of Gore's pictures at the Carfax Gallery held in February 1916).
3. Letter dated from a postscript reporting that Robert Ross lost his case, the jury disagreeing. Thus must refer to the outcome of Ross's prosecution of Lord Alfred Douglas for criminal libel when, in December 1914, the jury disagreed and the case was dismissed (*nolle prosequi*).
4. 9 January 1915.
5. Letter dated from Sickert's enclosure (now lost) of 'a notice of the R.A.' (which must have been a review of the War Relief Exhibition in January 1915). Dating supported by another comment on the unsatisfactory termination of the Ross case (see note 3): 'No I don't think the R. case will make any difference . . . We all like him and none of us had the least desire for him to whitewash himself.'
6. Letter dated from the remark: 'Thursday is the sending in day of the Socy. of Twelve'. Sickert exhibited with this society from February to March 1915.
7. The only military portrait painted during the war of which I have knowledge is *Maurice Villain, Croix Militaire*, Exh. London Group 1916 (21), but in this case the sitter, as the son of Mme Villain, was known to Sickert. I have seen a photograph of this picture but do not know its whereabouts or details.
8. This letter was sent from Brighton and can therefore probably be dated early autumn 1915 when we know Sickert stayed with his friend Walter Taylor in Brighton and studied for his picture *The Brighton Pierrots* (Fig. 254).
9. In a letter to Miss Sands, for example, Sickert wrote that he taught at his private *atelier* at No. 8 [Fitzroy Street] at 10 am and 'the usual 6.30–9.30 at night'. Sickert had a

bewildering number of studios during the war. This letter was addressed from 15 Fitzroy Street, where he had a room. Letters to Miss Sands prove he acquired No. 8 during the late summer of 1915. When Sickert moved his home from the Kentish/Camden Town area (where Christine felt isolated) to Westbourne Grove, he found that his painting studio in Brecknock Street near Tufnell Park was inconveniently far. In a letter to Miss Sands written in about September 1915 (it mentions he had done a long article on the future of engraving, that is, the article published in the *Burlington Magazine* in that month) Sickert told Miss Sands he had got 'Whistler's old studio . . . rather cheap' and that he was moving there from Brecknock Street. He also acquired a studio in Warren Street *c.*1915–16, and had a large studio at 26 Red Lion Square from the outset of the war until 1916. He used the last studio mainly for etching (after the first months of the war when he painted the piano pictures there).
10. Letter dated from a reference to his articles on Whistler and on Maris and Mauve for the *Burlington Magazine*, which must be 'A Monthly Chronicle: The Whistler Exhibition' and 'An Early Landscape by William Maris' published in Vol. 27, July and August 1915 respectively.
11. Letter dated in note 2.
12. Letter dated in note 5.
13. The dating of the letter detailing the American project is self-evident from its whole content; the letter deciding to drop the plan is dated in note 1.
14. Sickert explained his arrangement with Clifton to Miss Sands. He received £200 a year minimum maintenance, plus all sales Sickert made to Clifton at the latter's price, plus the money minus Clifton's commission for all other sales of his work arranged by either Clifton or himself; arrangement terminable at six months' notice. In 1916 Sickert broke his arrangement with Clifton for personal reasons.
15. Letter dated from the remark that Clifton was pricing his *envois* to the Society of Twelve (see note 6).

16. The date of Sickert's Brighton visit is established as September or thereabouts because in the letter quoted in note 9, telling of his acquisition of 8 Fitzroy Street, he noted that he was going to Brighton in a few days where 'I shall do some drawings for painting and etching'. The letter quoted in the text telling of his arrangement at the palette refers to this Brighton visit.

17. Letter dated in note 10.

18. Letter discussing his work in Brighton is dated in note 16 (it is the one telling of his arrangement at the palette).

19. I know of no documentary evidence of this visit to Chagford (it is never mentioned in the letters to Miss Sands). It is traditionally supposed to have taken place during the summer of 1915 to help Sickert recuperate after a bout of 'flu, and Chagford subjects were certainly exhibited at the Carfax Gallery in November 1916.

20. Miss Sands also commissioned Anrep to do a mosaic decoration for the house. This commission was fulfilled. The house was bombed and destroyed during the Second World War.

21. Sir Philip Hendy, in an unpublished manuscript on Sickert which he kindly lent me, gave some details of this scheme. He wrote that Miss Sands intended to turn her room into a replica of a music hall interior, with groups painted all around the walls as if looking down from boxes and galleries. At least five large canvases were laid in, in tempera, in a broad *chiaroscuro*. Only *The New Bedford* was completed. Sickert procrastinated over the completion of the other pictures and the scheme was abandoned with the end of the war. Unfortunately, Sir Philip has forgotten the source of this information which may, however, have been Miss Sands herself.

22. Letter dated from a postscript, 'Mrs. Finch's "Reginald" is at last hung. Reginald is rather violet. Reginald seems cold'. The letter as a whole deals with an A.A.A. exhibition and Mme Renée Finch showed *Reginald* at the A.A.A. in the summer of 1914.

23. In one letter to Miss Sands Sickert wrote, 'I chose the canvas for your dining room yesterday'; this letter is the one telling how mobilization had condensed his talent and how he was painting Chicken's reflection at the piano. In another letter he reported, 'I shall be able to have your dining room canvases in a week'; this letter is the one telling how he wanted to get his 'big Belgium canvas done for the New English'.

24. Letter dated in note 6. In another letter of about January 1915 (dated in note 5) he wrote, 'Bedford Bedford Bedford every bloody night. "For you, for you my darling" as the song says.'

25. Letter dated because he told Miss Sands he was to write an article on the Whistler exhibition at Colnaghi's for the *Burlington Magazine* (see note 10).

26. In January 1915 (in the letter dated in note 5).

27. Letter dated in note 10.

28. Letter dated Christmas 1915 in Chapter XV, note 49.

29. The letter to Miss Sands telling her of his tempera studio is not accurately datable but it probably antedates the dining-room commission because Hubby is mentioned as a model and he seems to have left Sickert's employ around the summer of 1914 (see Chapter XIV, note 18). Moreover, Sickert left his Brecknock Street studio in the summer of 1915 (see note 9). Sir Philip Hendy (see note 21) thought all the projected paintings for Miss Sands were laid in in tempera.

30. Letter dated from Sickert's remarks that he was clearing out Red Lion Square which was to be re-let as offices (Sickert left this studio in 1916) and that he was sending a picture to the London Group (with whom he first exhibited in June 1916, having previously abstained because of his disapproval of Epstein's drawings which he thought pornographic).

31. Letter dated in note 6.

32. Miss Browse, *Sickert*, 1943, op. cit. p. 46, stated that photographs of the unfinished pictures together with a drawing for the dining-room with the position of the pictures indicated were at the Temple Newsam Gallery, Leeds. Unfortunately, the gallery has lost trace of these documents.

33. Support for this hypothesis is that Sir Philip Hendy sent me photographs of these three paintings with a note to the effect that he believed they were connected with the decorations for Miss Sands. Sir Philip was a former director of the Leeds and Temple Newsam Galleries where (see note 32) photographs of the unfinished pictures were once to be found. I do not know the present whereabouts of these pictures and therefore cannot verify that they are painted in tempera (see note 21); however, the medium of one of the pictures, when it was sold at Christie's, 22 February 1957 (14), was listed in the catalogue as tempera.

34. Letter to Miss Hudson dated in note 30.

35. Letter not accurately datable but a new term had just started at the Westminster Technical Institute and Sickert still had his Red Lion Square studio. The most probable date of the letter is October 1915.

36. Quoted above in a letter dated autumn 1915 (see note 16).

37. I cannot identify the studio with any certainty. It is not 8 Fitzroy Street because Sickert did not acquire the premises until autumn 1915. Nor is it 26 Red Lion Square, which Sickert acquired after the outbreak of war (he had formerly had another studio in this square but preferred to move to the south-facing rooms at No. 26 found for him by Miss Gosse). It is most probably Wellington House Academy, that is, Sickert's studio on the corner of Hampstead Road and Mornington Crescent.

38. The letter is dated in pencil, possibly by Miss Hudson rather than by Sickert, 6 October 1913.

39. Letter dated from Sickert's references to writing articles on Nina Hamnett and Thérèse Lessore. The former must be the article published in the *Cambridge Magazine*, 8 June 1918; the latter was published in *Arts and Letters*, 1, No. 3, January 1918 and reprinted as a preface to a Thérèse Lessore exhibition held at the Eldar Gallery in November 1918.

XVII

1919–26. Dieppe and London

THE end of the war permitted Sickert to travel abroad again. In 1918 he gave up teaching at the Westminster Technical Institute and was succeeded by Nina Hamnett[1]. In the summer of 1919, despite his delight in Bath[2] as an escape from London, he and his wife decided to go back to France and settle permanently in Envermeu. The tragedy of his wife's death there in the autumn of 1920, following a period of increasing frailty and ill health, prevented the realization of this ambition. Sickert stayed on in France until 1922 but he left the country village where he and Christine had been so happy and where they had just bought a new house[3]. He took rooms in Dieppe. In 1922 Sickert decided to return to London. He never lived again in the town which had been his second and sometimes his first home[4].

The 'Dieppe period' of 1919–22 was among the most productive of Sickert's career as a painter. He did not confine himself to landscape painting, which was generally his habit in Dieppe; instead the range of his subject matter is a microcosm of his lifetime's interests. He painted still lifes, landscapes, portraits, cafés-concerts, bedroom scenes, and figure subjects of a less intimate nature.

At Envermeu, from 1919 until autumn 1920, Sickert drew and painted a group of still-life subjects of food. He rarely painted still lifes. He had done some still-life subjects in the 1880s, of which very few examples survive, and there are a number of pictures of fish which were probably painted in the early years of the twentieth century when Sickert was mixing with the fishermen and women of Dieppe. But the culinary still lifes done in Envermeu after the war represent the only well-defined, stylistically cohesive group of still lifes in his entire œuvre. They reflect his sense of well-being, the happy acceptance of his domestic life during the brief time which he and his wife enjoyed together in their French home after the privations of the war. He did not paint prodigal arrangements of gastronomic delicacies. He drew and painted the simple fare to be found in any French country kitchen, *Lobster on a Tray* (Fig. 262), *Red Currants* (C.378), *Roquefort* (C.377), *The Makings of an Omelette* (C.376). The still-life pictures are all freshly observed works, swiftly and directly painted in dry thin scrubs of colour. In each painting the composition has a slight diagonal alignment with the base (table or trolley) set at an angle to the surface; the objects placed on it are seen from above. Although there are drawings as well as paintings, and although the drawings are sometimes of the same subject as the paintings, it is probable that Sickert worked from nature and completed the pictures in one sitting. The still lifes ceased with Christine's death, as did the Envermeu landscapes. In a letter written to Christine's younger sister, Mrs. Schweder, after his wife's death, Sickert wrote of Envermeu: 'When Christine was alive I loved the landscapes there, because they seemed to belong to her, and the still-lifes, etc., because they were seen in her house. One of my last Envermeu pictures was called The Happy Valley. But I can't bear the sight of those scenes now. They are like still-born children.'[5]

Many of the Envermeu landscapes of this period closely resemble the Chagford and the Bath

paintings in style and technique. *The Happy Valley* (C.386) is very close to the Chagford rolling land-scape pictures. The *Gate to the Château d'Auberville* of 1919 (C.385) in its choice of colours (purples and violets, greens and clear blue), in the dry texture of the flat patchwork application of its opaque stains of paint, even in the choice of a subject affording a contrast of old stone and brickwork with lush vegetation, and the frontal presentation of the scene, recalls, in particular, the *Pulteney Bridge* paintings. There is, however, one Dieppe landscape which is unique and can only be regarded as an experimental *tour de force*. It is *Dieppe Races* (Fig. 264), an extraordinarily vivid impression of horses and jockeys racing across the downs. When the picture was included in the London Group Retrospective exhibition of 1928 its date was given as 1926. It is possible that the whole picture was painted from a photograph in 1926 but, in view of Sickert's habit of finishing many of his Dieppe paintings of this period in London, it is probable that this date referred only to its completion. However, it should be added that, even if Sickert began this picture in Dieppe between 1919 and 1922 and finished it in London, he must have used photographic documents from the beginning to help capture the galloping action of the horses. *Dieppe Races* is perhaps the most Impressionist painting ever attempted by Sickert in that it is carried out almost exclusively in terms of broken, prismatic, pure colour instead of in tone. Sickert used no earth colours; his palette was unusually varied. The grass is painted in pale leafy greens and sky blue; the horses are painted in pale and deeper blues with the fuzzy glimmer of indian red providing just enough accent to define their form and movement; the jockeys are bright notes of green, yellow, pink, red, and white; the background fields are honey-yellow with green trees on the horizon; the sky has a band of pinky-purple as it meets the horizon and then fades to pale blue. Many sources of inspiration can be suggested for this picture, among them Monet and Bonnard (its palette and broken touch), Turner (in the impression it gives of speed, colour, and light), but above all Sickert must have been remembering Degas's pastel race-course scenes such as *Jockeys in the Rain* of *c*.1881. The colouring, the hatched, broken strokes, the arbitrary cutting of the planar composition, the quality and function of such drawing as there is, all recall Degas. The explicit nature of this recollection is unexpected so late in Sickert's career. When Sickert was an immature artist, struggling to overcome the limitations of his Whistlerian training by expanding his vocabulary and devising a more construc-tive method of working, he had turned to Degas with similar directness. But he had long since assimi-lated the lessons he had learned from Degas into his general approach to art and into his system of working. However, *Dieppe Races* is not the only picture of this post-war period to owe much to Degas. There are scenes of the promenade and *plage* of Dieppe painted in light, creamy-toned bright colours which are also reminiscent of him. The witty relationships of the shapes of the figures and the beach tent to the empty spaces in *Dieppe Sands* (Fig. 263) also recall Degas. *The Prevaricator* (Fig. 270), one of the Rue Aguado bedroom subjects painted between 1920 and 1922, has the same haunted simplicity as Degas's *Interior: The Rape*. The portrait of *Victor Lecour* (Fig. 269) possesses a completeness of presen-tation, an integration of figure and setting, and a *bravura* of handling, which call many of Degas's portraits to mind. Sickert took up the Degas theme of *cafés-concerts* (as distinct from music halls) in his many paintings and drawings of Vernet's. Finally, there is one subject, painted in two versions, which is unthinkable without Degas's example. It is *The Trapeze* (Fig. 276, C.396), showing a trapeze *artiste* high in the big top. It can only be regarded as Sickert's version of *Miss Lala at the Cirque Fernando*, and it may have been undertaken partly as a gesture of homage to Degas. An interesting aside on Sickert's knowledge of this Degas painting is provided by his annotation in his copy of Jamot's *Degas*, that Degas '*nous a dit 1885 qu'il a dû faire faire la perspective par un professionel*'[6]. Sickert probably did not need such outside help because the architecture of his big top is much less elaborate.

It was probably Degas's death in September 1917 which led to this revival in Sickert's work of explicit and directly translated influences from the French master. In November 1917 Sickert published

an important article on Degas in the *Burlington Magazine*[7]. The mental review of his relationship with Degas which this article clearly involved may have given him a renewed and acute urge to try to do more of the things which Degas had done. Degas's death and his own article could have jolted Sickert into a more active contemplation of the greatness of his French master which he had long since tended to take for granted; perhaps these circumstances made him feel more strongly that the painting of his day (of which he generally disapproved for its laxness and abandonment of traditional methods) needed the reassertion of the kind of principles of construction and objective representation which was the basis of Degas's art.

Although the influence of Degas can be discerned in much of Sickert's work from 1919 to 1922, his style and technique also continued to develop along its individual lines. When Sickert and his wife spent a few months in London during the first half of 1920 he made many drawings and some paintings of the music halls in Shoreditch—the London (sometimes called the Empire) and the Olympia. The conception and composition of a painting of the former music hall (Fig. 274) strongly recall the vertical interiors of *The New Bedford*, although its handling is less rich and the lighting effects more schematic (with a strong spotlight upon a standing figure in a box). At about the same time Sickert also revived his early interest in drawing and painting the stage *artistes* instead of the audience and the music hall interiors. Although Sickert had often made notes of the *artistes* in his many music hall sketches over the past thirty years his only painting to include an entertainer was his rough sketch of the *Gaieté Rochechouart* of *c.*1906 with a little trapeze *artiste* glimpsed in the background (C.243). In 1920 he drew the stage of *The Shoreditch Olympia* showing a singer set before a large ornate backcloth. A painting of similar subject called *That Old-Fashioned Mother of Mine* (C.400) was probably done at the same time. In conception it recalls *The Lion Comique* of 1887 (Fig. 25), except that now even the *repoussoir* orchestra figures are omitted. In handling it is very free, even loose, with the colour (mostly different tones of very bright blue) scrubbed onto the canvas roughly and thinly. From this time onwards Sickert's paintings of music halls and theatres all show the stage and its performers; the audience is forgotten.

Soon after his wife's death in the autumn of 1920 Sickert moved from Envermeu to rooms in Dieppe. His scenes of night life, the *cafés-concerts* at *Vernet's* (Fig. 275, C.397) and the *Baccarat* subjects studied in the Casino (Fig. 278, C.398) had probably been started before he left Envermeu but Sickert continued to paint these subjects throughout his stay in Dieppe and he completed more after his return to London. There is a distinct echo of Degas in the *Vernet's* paintings but this is partly attributable to the nature of their subject matter; the rectangular French café tables, the bentwood chairs, and the confused illumination from the scattered hanging lights inevitably recall similar Degas subjects. However, there is nothing of Degas in the *Baccarat* paintings which are Sickert's only representations of the high-life of the still fashionable town of Dieppe. Sickert drew, surreptitiously, in pencil (often on small cards) in the Casino; in view of the slightness of his documents it is amazing that the paintings so successfully convey the atmosphere of the gaming tables. He used dry, rough paint applied as a broad patchwork of colour and tone with little attempt at precise definition. In one painting, however (C.398, related painting 3), Sickert used another style and technique, filling in his sharp drawing with colour in a manner reminiscent of Matisse. Sickert did not try to give a comprehensive view of the Casino interior; in his many *Baccarat* pictures he either represented one table surrounded by a group of figures, or he gave an even more concentrated portrait of a single figure (*The Fur Cape*, *The Old Fool*, and *The System*, all listed under C.398). The arbitrary points of cutting of each scene mean that the flanking figures are often sliced through. Sickert was evidently fascinated by the illumination with the figures and tables caught full in the glare from the overhead hanging lamps. The brilliant colours suited the recent emancipation of his palette; he loved the sharp green of the baize-covered tables and repeated it

throughout the pictures, in the backgrounds and as an undercoat which shows through later applications of colours. The dresses of the ladies provided further rich notes of colour. But possibly Sickert's greatest interest was in the figures themselves. There was often an element of caricature in Sickert's sketches of human figures observed at random and he exploited this talent in the *Baccarat* paintings. The figures are treated broadly; their features and dress are hardly particularized; but each is an individual, or at least an individual type. Sickert used gesture and attitude, with trenchant wit, to express their characters. The sharp jut of a shoulder rising high from an elongated back expresses the young sophisticate of the twenties (Fig. 278); the relaxed back view of a woman whose chair is pushed a little further away from the table than her companions' expresses her blasé ennui (related painting 3); the hunched profile of a man expresses his total concentration and even goes further and suggests he has had a run of bad luck and must recoup (related painting 1). The compositions of all the pictures reflect the total absorption of the gamblers. In each picture, except *The Old Fool* of 1924 (4) and *The System* (5), probably of the same date, the spectator views the tables from behind the gamblers, who present a tight little enclave united by their common passion and oblivious to the world around them. Sickert approached the subject with complete detachment, treating his scenes rather as if they were theatrical set-pieces. Indeed, the mood and character of the *Baccarat* paintings recall the Trelawny subject *The Toast* of 1898 (C.79) and *The Rehearsal* of 1915 (C.364); they also look forward to the *Echoes*, painted from the later 1920s onwards, many of which also portray grandly dressed figures engaged in artificial pursuits.

The stark simplicity of the contemporary bedroom subjects presents a total contrast to the colourful and witty *Baccarat* paintings. Although detachment from his subject matter was a cardinal principle of Sickert's approach to painting, his own sadness at this period of his life somehow seems to have permeated his bedroom scenes. They convey a haunted sense of loneliness. The humorous title *The Prevaricator* (Fig. 270) is at odds with the mood of the picture which suggests that a real, if ambiguously stated, emotional drama is taking place. This dramatic undertone, combined with the simplicity of its presentation and treatment, recalls Degas's *Interior: The Rape*. In *L'Armoire à Glace* (Fig. 271), a picture Sickert studied in many drawings in 1922 but delayed painting until after his return to London, he conveyed his intuitive understanding of his model's pride in her fine wardrobe. Sickert's attitude to his subject matter is discussed in a separate section of this book but on the whole it can be stated that the illustrative content of a painting usually played a very subordinate role in the creation of his figure pictures. *L'Armoire à Glace*, however, can be regarded as a piece of social realism and this, if we can trust Sickert's letter to W. H. Stephenson who bought the picture in 1924—the year of its completion— was the painter's deliberate intention. Sickert explained to Stephenson that the painting 'is a sort of study à la Balzac. The little lower middle-class woman in the stays that will make her a client for the surgeon and the boots for the chiropodist, fed probably largely on "Ersatz" or "improved" flour, salt-substitutes, dyed drinks, prolonged fish, tinned things, etc., sitting by the wardrobe which is her idol and her bank, so devised that the overweight of the mirror-door would bring the whole structure down on her if it were not temporarily held back by a wire hitched on an insecure nail in insecure plaster. But a devoted, unselfish, uncomplaining wife and mother, inefficient shopper and atrocious cook'[8]. It is probable that this long description of his picture was not simply a gloss to satisfy a particular client. When he studied the subject Sickert felt its social implications. This sort of humanity was a new development in his approach to figure painting. He was no longer purely a reporter.

Early in 1922 Sickert began to study two portraits, one of *Victor Lecour*, 'a superb great creature like a bear' and another, identical in setting, of the 'Sous-Prefet, who is a beautiful gracious creature, like a "lion" of the time of Gavarni'[9] (Fig. 269, C.389). *Victor Lecour* was finished in London in 1924. The simplicity and asceticism of treatment found in the bedroom subjects are abandoned in these

portraits. The bedroom scenes were painted flatly and thinly in a limited range of colours, olive greens, salmon pinks, and purple-greys in the shadows. The portraits are rich in texture; the paint is applied with breadth, variety of stroke, and generosity; a wide range of high-keyed colours is used, purples, sap green, indian red, turquoise, and sharp yellow. *Victor Lecour* is the richer and more finished portrait and the way the setting helps to suggest the character of the sitter recalls Degas. The room, with its patterned carpet, plush couch, bulbous chair and table, and view over the promenade and *plage*, seems to express the assertive complacency of the fat French *restaurateur* (even though the room was rented by Sickert and had nothing to do with Lecour whose real setting was a charming restaurant in the village of Martin Église). The way Sickert abandoned himself to the delights of sharp, sweet colour in this portrait inevitably recalls *Fauve* paintings; the background of the picture with its window-framed view over the promenade to the sea, treated as a pattern of flat colours punctuated by the decorative linear motif of the wrought-iron balcony and the lamp-post, the whole passage set off by a chair and table of bulbous shape, is particularly reminiscent of Matisse. This recollection may be fortuitous but it is a valuable illustration of the range of Sickert's style during his last period in Dieppe.

Sickert completed several of his Dieppe figure pictures in London from 1922 to 1924; he also painted a few new Dieppe subjects (such as *The Old Fool*, a Casino picture listed under C.398) from his collection of miscellaneous notes and sketches. Indeed, in retrospect these years seem like a winding-up period not only for his Dieppe work but also for his career as the painter of Camden Town. From 1922 to 1923, using Cicely Hey[10] as model, he painted the last of his Camden Town bedroom scenes. He retained his old props—the patterned wallpaper and the iron bedstead—in the most finished picture of this series (Fig. 273) and in the curious two-figure group (a self-portrait with Miss Hey) called *Death and the Maiden* (listed under C.390). *Death and the Maiden* was an Expressionist caprice but the other Cicely Hey pictures, like *Camden Town* (C.361), painted during the war, were portraits rather than domestic subject pictures. Sickert pared away at the bedroom setting until he had reduced it to nothing but a constructed frame for Miss Hey's face. The informal snap-shot presentation of the model (or sitter) caught off-guard in a bedroom in Fig. 273 underwent a process similar to that of a photographic enlargement in further pictures from the same series. In another picture Sickert more or less dispensed with a setting altogether and painted Miss Hey with her *jolie-laide* face dramatically illuminated from below (Fig. 272).

There are no drawings related to the Cicely Hey pictures extant; the photographic conception of these pictures is very striking. It is, therefore, natural to conclude that Sickert painted from photographs. This conclusion is, however, contradicted by Miss Hey's own very precise recollection of Sickert's method when painting these pictures of her. She remembered Sickert making many drawings which he squared up in red ink and transferred to cartoons the size of his canvas; he then turned the cartoon over and applied a thin wash of paint and watery turps to the back to enable ihm to trace the cartoon onto the canvas (which was rock hard, having been previously prepared with china clay and size). Using his thin layer of traced drawing as a guide he painted his subject in a *camaieu* of cold bright blue and hot flannel-petticoat pink. Miss Hey also remembered that, after his drawings, Sickert made one oil sketch entirely for the colour. Such studies for these pictures as are known look as if they were painted directly from nature, *à premier coup*. It must, therefore, be accepted that Sickert was still working from personal observation and not from photographs when he painted these pictures.

Sickert also painted the last of his personally conceived subject pictures, for example *The Bar Parlour* (C.393) and *Amphitryon* (C.394), in the two or three years following his return from Dieppe. *The Bar Parlour* of 1922 betrays how Sickert's interest in the creation of such figure subjects had slackened. It is a very large and self-conscious picture. It looks like an exercise in composition. The two

women seated back to back who fill the foreground are unrelated to their ambience except that the background sets off the striking pattern of their shapes. *Amphitryon*, although much smaller and more intimate in handling, has a similarly enigmatic quality. In its portrayal of a moment of strong emotion it recalls the war-time *Suspense* (Fig. 249). However, *Amphitryon* (its alternative title was *X's Affiliation Order*) is both more cynical and more flippant than *Suspense*. It represents Sickert's ultimate statement on the subject which he had avowed was the proper subject for the artist, 'the ways of men and women, and their resultant babies'[11].

During the few years following his return to London from Dieppe Sickert also wound up his career as a graphic artist. It is impossible to state exactly when Sickert ceased to draw, and in particular ceased to make drawings for paintings. Emmons[12] stated that he gradually abandoned drawing after 1923 and cited the brilliant impression of *Signor Battistini Singing* (Fig. 280) of 1925, painted from a drawing scribbled on the back of a programme, as one of the few later paintings done from a personally observed and executed document. There are watercolour sketches and detailed pen and ink squared drawings of Hyde Park and Regent's Park but it is difficult to date either the paintings of these subjects or the drawings for them with accuracy. The Envermeu rural landscapes of 1919–20 are the technical and stylistic precursors of such pictures as *The Wonderful Month of May* (a Regent's Park subject, Fig. 266) and *The Serpentine* (listed under Fig. 265, C.381). These London park landscapes could themselves have been executed in 1920 when Sickert was in London for a few months; or they could have been painted later from drawings made in 1920; or the drawings and paintings could all have been executed in 1922–4. On the whole the last alternative is the least probable. The method of notation in pen and ink of a drawing of *The Serpentine* (Fig. 265) is identical to that used by Sickert in his Envermeu drawings of 1919–20 and suggests that the London subject was done at about the same time. An engraving, *Sussex Place, Regent's Park*, dated 1920, provides more concrete evidence for dating at least the London parks drawings to that year. The engraving was clearly derived from a squared pen and ink drawing of the subject, of the same size as the etching (listed under C.382) which also seems to have been Sickert's main document for the painting of this scene noted above—*The Wonderful Month of May* (Fig. 266).

Sickert was very active as an etcher and engraver during the period covered by this chapter. He engraved earlier subjects (e.g. *Jack Ashore*); he etched and engraved his current Dieppe figure subjects (e.g. *L'Armoire à Glace*); his music halls (e.g. *That Old-Fashioned Mother of Mine*); his portraits of *Cicely Hey*; and his London landscapes, not only in 1920 (e.g. *Sussex Place, Regent's Park*) but also his later Islington garden and canal subjects of 1924–6 such as *The Hanging Gardens of Islington*. The end of Sickert's career as an etcher and engraver naturally coincided with the end of his practice of making drawings from nature. Sickert could paint, but he could not etch or engrave, from photographs. The last of his prints were published by the Leicester Galleries in 1928 and 1929. It is also significant that during the 1920s Sickert chose, more and more frequently as the decade progressed, to engrave rather than to etch. As the process of spontaneous drawing became of less and less interest to him so he forsook the more spontaneous freedom of the etched line in favour of the more planned quality of the engraved composition.

There are a few drawings related to the Islington landscapes of the middle 1920s. There is, for example, a drawing of *The Garden of Love* (Fig. 267, C.383), and there are sketches of Islington houses and gardens. Sickert engraved *The Hanging Gardens of Islington* (Fig. 268) and possibly his drawings were connected with plans to make prints of the Islington landscapes. But by this time it is certain that Sickert used photographs as the general basis of his pictures. At this stage in his career Sickert took the photographs himself. They were the snapshots of an amateur[13]. Perhaps he still supplemented his information with drawings because his photographic documents were often poor. Later in his career,

when he used professional photographers and/or his wife's snapshots, his need for personal confirmation of the aspect of his subjects ceased altogether.

Sickert was also very busy teaching and writing during this period following his return from Dieppe. In 1923 he was approached by W. H. Stephenson of Southport who became a faithful patron. Stephenson bought Sickert's work and commissioned a series of articles for his own newspaper, the *Southport Visitor*[14]. Sickert wrote another series of important and perceptive articles in the *Daily Telegraph* in 1925 and 1926 which included his critical review of Whistler's art, 'With Wisest Sorrow'[15]. From 1922 to 1924 he frequently contributed to the *Burlington Magazine*. In 1925 Sickert undertook to direct, and weekly to attend, a painting class in Manchester, although once the class was well established his enthusiasm for the venture waned and he ceased to attend[16]. He lectured and rather as Whistler had once done with his 'Ten O'Clock', Sickert travelled around with 'Straws from Cumberland Market'. He delivered the lecture, in somewhat different versions, to audiences in Edinburgh and Oxford in 1923, and in Hanley, London, Manchester, and Southport in 1924[17]. As an Associate of the Royal Academy he taught for a period in 1926 at the Academy schools. His election as an Associate member had occurred in 1924 and was the first of several marks of official recognition and distinction which, in retrospect, seem absurdly trivial and belated as reward for his long-standing achievement. It was following this election that Sickert signed the paintings and drawings lying around his studio 'Rd.St.A.R.A.' (for it happened that Sickert's delayed acceptance by the establishment coincided with his change of identity when, with typical perversity, he adopted his second name 'Richard' in place of the familiar 'Walter'). In 1925 the New English Art Club honoured its former member with a small retrospective exhibition of loaned works, although Sickert had ceased to exhibit with the Club ten years before. In 1927 he became President of the Royal Society of British Artists (only to resign in 1929, by which time he had signed another batch of works 'Rd.St.A.R.A., P.R.B.A.'). He had to wait until 1934 for full membership of the Royal Academy, but once again he resigned a year later. In the 1930s he received honorary degrees from the Universities of Manchester and Reading. In 1932 the Louvre bought one of his paintings (C.437). But he never received any civil honour. Steer, his exact contemporary, was awarded the Order of Merit in 1931. Sickert, probably because of his divorce, was denied such a distinction which it was in his nature to have enjoyed.

NOTES

1. On Sickert's and Augustus John's recommendations (see Nina Hamnett, *Laughing Torso*, London, Constable, 1932, p. 111).

2. Sickert loved the people as well as the architecture of Bath. In his letter to Miss Sands about Bath quoted in Chapter XVI he wrote of 'the mellifluous amiability of the west-country gaffers and maidens'.

3. In 1920 they sold the Villa d'Aumale which they had owned since before the war and bought the Maison Mouton. The painting *Christine buys a Gendarmerie* (C.392) records the purchase.

4. He made some fleeting visits to Dieppe after 1922 on business (in 1923) and to attend Mme Villain's funeral some twelve years later (see B.60, p. 38).

5. Quoted Emmons, p. 191. The envelope of this letter is postmarked 1922. Emmons gives a good and accurate selection of the most interesting letters sent to Mrs. Schweder between 1920 and 1922.

6. p. 93 of the copy of the book, ex-libris Sickert, in the Court-

auld Institute of Art Library. The annotation presents Sickert's reaction to Jamot's comment that *Miss Lala* was a *tour de force* of painting equal to that of the acrobat. In 1946 Mrs. Louise Powell (sister of Thérèse Lessore, Sickert's third wife), in her capacity as administrator of the Sickert Trust which disposed of Sickert's studio effects after Thérèse's death, presented many of Sickert's books to the Courtauld Institute of Art Library. These books are copiously annotated and are a valuable source for discovering Sickert's reactions to art and its literature.

7. Vol. 31, pp. 183–91.

8. Quoted W. H. Stephenson, *Sickert: the Man; and his Art: Random Reminiscences*, Southport, Johnson, 1940, p. 17. Perhaps from a sense of slight embarrassment at this exposure of his sentiment Sickert concluded, 'There's patter' (misread by Stephenson as 'Tige's patter' but the correct reading can be divined from the reproduction of the original letter, p. 16).

9. Letter to Mrs. Schweder of 19 January 1922, quoted Emmons, p. 189.

10. Cicely Hey (Mrs. Tatlock) presented her recollections of Sickert to John Russell and he kindly allowed me to make use of them. Sickert met Cicely Hey when she was taking the door money at a lecture by Roger Fry. She was herself a painter. In 1924 she married R. R. Tatlock, art critic of the *Daily Telegraph* and later editor of the *Burlington Magazine*.

11. The *English Review*, March 1912, pp. 713–20, 'A Critical Calendar', p. 717.

12. p. 200.

13. Cicely Hey remembered Sickert's method of taking photographs ('Come with me and I'll show you how to get copy') and his frequent failures.

14. Stephenson, *Random Reminiscences*, op. cit., gives an account of their relationship and reprints Sickert's articles for the *Southport Visitor* published in 1924.

15. 1 April 1925.

16. Malcolm Easton, 'Sickert in the North', appendix to the exhibition catalogue 'Of Sickert and the North', University of Hull 1968, gives a very good account of the history of this class. This appendix contains material new to the literature on Sickert. It also summarizes Sickert's relationship with W. H. Stephenson and Southport.

17. Transcripts of the lecture are published by Emmons (the Hanley version), pp. 242–52, and by Stephenson, *Random Reminiscences*, op. cit. (the Southport version), pp. 55–71. See Malcolm Easton, 'Sickert in the North', op. cit., for a comparison of these two versions.

XVIII

1927 onwards. General Discussion
of Late Work

THE bare facts of Sickert's public distinctions during the last period of his life were outlined in the last chapter. The bare facts of his life will be summarized here. In 1926 he married the painter Thérèse Lessore (formerly Mrs. Bernard Adeney), a long-standing friend and neighbour in Fitzroy Street. After staying in Margate and Newbury they went to Brighton where Sickert took a studio (in Kemp Town). In 1927 they returned to London and settled in Islington (Quadrant Road) where Sickert already had a studio (Noel Street). Sickert opened the last of his private *ateliers* in Islington in 1927, at 1 Highbury Place. A small group, including Lord Methuen, Morland Lewis, his future biographer Robert Emmons, and Mark Oliver, answered his advertisement for male students only. Mark Oliver went into partnership with R. E. A. Wilson who ran the Savile Gallery. The Savile, together with the Leicester and Beaux Arts Galleries, became Sickert's main dealers from the later 1920s onwards. The Beaux Arts Gallery was run by Sickert's brother-in-law. Other dealers, among them the Redfern Gallery, Barbizon House, and the Adams Gallery, stocked his work and Agnew's held a major retrospective loan exhibition in 1933. In 1938 a selection of Sickert's works was sent to the United States of America for exhibition in Chicago and Pittsburgh, Sickert's first major exhibitions outside Paris and London. The school at Highbury Place soon evaporated but Sickert not only kept the room as his main studio; he also kept the students as lifetime friends, supporters, and enthusiasts for his work. In 1931 Sickert and his wife moved house from Quadrant Road to Barnsbury Park. In the summer of 1934 they went to Margate for a holiday, but Sickert soon took a studio there and began to teach at the Thanet School of Art, and at the end of the year they decided to leave London and settle near Margate (at Hauteville, St. Peter's-in-Thanet). They stayed there for four years, moving for the last time at Christmas 1938 to St. George's Hill House, Bathampton. Until war broke out Sickert taught weekly at the Bath School of Art. He went on painting, with the help of his wife, virtually until his death in January 1942.

General discussion of Sickert's late works

During the last fifteen years of his working life Sickert painted landscapes, theatre scenes, and portraits from photographs; he derived his subject pictures, the famous 'Echoes', from Victorian black-and-white illustrations. There are two conflicting current attitudes to Sickert's late work. Either his later production is disparaged as revealing a marked decline in his powers, and this decline is in great measure attributed to his reliance upon impersonal, pre-existing documents as the basis for painting; or, just because the second-hand nature of his subject matter demonstrated its subordinate importance, the late works are extolled for their abstract values, especially Sickert's feeling for the

matière of his paint, and his feeling for the shapes, patterns, and rhythms created by his patchwork of colours.

The problems presented by the critical appreciation of Sickert's late work cannot be side-stepped without direct comment. It is indisputable that the quality of his late work is even more erratic than at any earlier period. The proportion of poor paintings is higher, especially during the 1930s. But the merits or demerits of the late paintings do not depend upon his choice of preliminary documents. Sickert had used photographs all his working life. Photographs were certainly used by Degas and by artists in Whistler's circle. In 1890[1] Sickert wrote sarcastically how 'nothing would have been more amusing to me than to have been interviewed by a professional art-critic, who . . . criticised Mr. Menpes's sketches of Japan, without taking into account the vital share that instantaneous photography had in their production.' One can only speculate on the use Sickert made of the photographs sent to him by Degas, via Ludovic Halévy, in 1885 ('*Voici en trois enveloppes, . . . les photographies pour le jeune et beau Sickert*'[2]). Sickert painted the head in his large posthumous portrait of *Charles Bradlaugh at the Bar of the House of Commons* (Fig. 38) from a photograph. He used photographs to help him paint his portraits of *Mrs. Swinton* in 1905 and 1906 (Figs. 137, 157), and he used a photograph to paint the theatrical portrait of *Hilda Spong in 'Trelawny of the Wells'* in 1898 (Fig. 64). He painted Miss Ethel Sands's portraits from photographs. The portrait of Miss Sands reproduced in Fig. 221 may have been painted after she had complied with Sickert's request to get herself 'realistically and *confidentially* photographed, laughing if possible. . . . I want "perceptual" information.'[3] In another letter to Miss Sands Sickert wrote of a different photograph of her: 'You can't think how it shortened my work in the big head I began at Newington, having already drawn the lines and proportions.'[4] All these are examples of Sickert's use of photographs for portrait painting. However, in a letter to Mrs. Humphrey written in 1899 after his removal to Dieppe, he had referred not only to his 'photographs of sitters' but also to his 'photographs of Venice'[5]. Sickert probably sometimes used photographs of landscape subjects to help him recollect foreign scenes when painting in his London studios. This hypothesis is supported by Sickert's remark to Jacques-Émile Blanche in a letter written from Venice early in 1904, 'I need not say I have not taken a single photograph', with the implication that it was only the bad weather which had prevented him from doing so[6].

Sickert's attitude to the use of photographs before the 1920s is summed up by his statement in 1912[7]: 'The camera, like alcohol, or a cork jacket, may be an excellent occasional servant to the draftsman, which only he may use who can do without it. And further, the healthier a man is as a draftsman, the more inclined will he be to do without it altogether.' This cautious appraisal is hardly the note struck by Sickert's enthusiastic assertion to Cicely Hey in 1924 that 'artists *must* use cameras'[8] and to the world at large in 1929[9] that 'a photograph is the most precious document obtainable by a sculptor, a painter, or a draughtsman'. Sickert had totally revised his opinion that photographs were to be used only as an occasional aid to the painter. Nevertheless, Sickert's exclusive reliance upon photographs cannot be held responsible for the failures among his late works. He painted the superb series of self-portraits in the 1920s from photographs; the brilliant portrait of *Hugh Walpole* painted in 1929 is far more expressive than the portrait painted a year earlier for which Walpole actually gave Sickert some sittings; and the list of successes could go on to include the impression of *King George V and Queen Mary* of the mid-1930s and the magnificent picture of *Sir Thomas Beecham Conducting* of 1938, besides several other paintings.

The quality of Sickert's best pictures during this period is undeniable. However, to maintain that this quality was a by-product of Sickert's gradual detachment from concerns with subject matter is a little quixotic. Sickert had always been passionately concerned with style, technique, paint and its handling. In his later works it is not so much that the abstract qualities of his work improved as that

they became easier to recognize. Sickert's use of impersonal documents was a frank acknowledgement that subject matter was of secondary importance to him; the spectator, sensing or knowing this, can concentrate his full attention—with no peripheral distractions—on the style and handling of each work. However, although Sickert's deliberate simplifications of the whole creative process of picture-making by excision of the problems of composition and theme do not diminish from his achievement, they can hardly be said to have enhanced it.

It is possible that the advocates of the quality of Sickert's late pictures are merely confused in their reasoning. Perhaps they are attracted to a feature of his handling which probably was encouraged by his use of photographs rather than drawings as his preliminary documents for painting. The purely tonal, a-linear character of photographs seems to have confirmed the only real development in Sickert's style during his later career. In many of his paintings derived from photographs, for example the self-portraits *Lazarus Breaks his Fast* (Fig. 279) and *The Servant of Abraham* (Fig. 283), and the 1929 portrait of *Hugh Walpole* (Fig. 282), Sickert dispensed with the linear accents which inform and define the detail of many of his earlier works. In these paintings Sickert manipulated his paint so as to convey the full sense of plastic form solely by means of tone, colour, and the direction of his brushwork. In many of his earlier works, derived from drawings, the drawn accents were taken over and transferred to canvas, but photographs totally lack concrete linear definition. However, Sickert's rejection of linear accents was not confined to paintings derived from photographs. They are virtually absent from the portrait of *Victor Lecour* (Fig. 269), for example. The most that can be said is that the gradual elimination in the 1920s of the characteristic sharp calligraphy, found in so many of his paintings executed up to and including the earlier years of that decade, may well have been influenced by his method of working more and more from photographs. When Sickert wished to revive linear notation—as in his portrait of *Sir Thomas Beecham Conducting*—he did so.

Photographs, however, were only one influence on this late development in Sickert's handling. He had always been deeply interested in the respective roles of drawing and colour in painting. In 1914, in a review of Clive Bell's *Art* called 'Mesopotamia-Cézanne'[10], Sickert praised Sir Edward Poynter's painting and commented: 'the painters of the future are much more likely to turn for guidance to the excellent Ingres tradition that lingers in Sir Edward's painting.' He went on to quote Degas's remark to him in 1885, 'a thing I have never forgotten, a thing of the highest historical interest. He said, "I have always urged my contemporaries to look for interest and inspiration to the development and study of drawing. But they would not listen. They thought the road to salvation lay by the way of colour".'[11]

Emotionally Sickert was very much drawn to the dry world of draughtsmanship. His contact with Degas at an early and impressionable age confirmed this bias towards the tradition of painting exemplified by Poussin, Ingres, and Degas. It was Degas who taught Sickert to approach the execution of his paintings through drawings and who had encouraged him to concentrate on the architectonic, constructive aspect of his compositions.

However, the role of drawing as opposed to colour was subject to frequent changes of emphasis in the actual execution of Sickert's paintings. The general rule can be formulated that Sickert's work until after his return to London in 1905 was primarily calligraphic in inspiration and effect. Then, during the Camden Town period, Sickert began his enquiries into the intrinsic character of 'modern painting'. In 1908 he had announced that '*la peinture*' was 'the clean and frank juxtaposition of pastes (*pâtes*), considered as opaque'[12], and in 1910 he attributed the enlargement of our understanding of colour to the Impressionists who 'secured their effects by the juxtaposition of definitely intentional colours'[13]. (It was these Impressionists whom Degas had condemned for seeking their salvation by way of colour.) It was also in 1910 that Sickert had described the evolution of the N.E.A.C. method

of painting 'with a clean and solid mosaic of thick paint in a light key'[14], a method inspired by Impressionist *facture*. In accordance with this method the character of Sickert's painting changed at this period and lost its calligraphic, though not its architectonic, quality. Among the influences which encouraged Sickert in this direction was Gore, and it is relevant to quote Sickert's comment that Gore (whom he called 'A Perfect Modern') 'became a great draughtsman by the road of colour'[15], that is by the opposite route to Degas. In 1913[16] Sickert wrote to Miss Sands, 'above everything don't think about the drawing but about the creative colours of the patches of paint you put on. We all draw more than well enough to paint. Nothing spoils painting like *thinking* of drawing.' And in 1924[17] Sickert defined 'post-tube painting' as 'conceived in terms of patches of colour. . . . this is not to say that the new painting was necessarily deficient either in line or design. It is only to say that the order from line to colour was reversed.'

All these statements by Sickert imply the theoretical dominance of colour in painting, which agrees with Sickert's main concern as a painter—the manipulation of paint in its tone, colour, and texture in order to create a beautiful and meaningful pattern of coloured patches upon his canvas. They suggest that Sickert, trained initially to painting by the road of draughtsmanship, now also sought the road to salvation by way of colour. Once Sickert had overcome his problem with the consistency of coloured paint and its tendency to get out of hand, to become dirty and ugly if too richly applied, he could accept colour and use it freely without having to fall back on the safe dry path of draughtsmanship. For some years after 1914 Sickert still felt the necessity to state the drawing but he gradually realized that its statement was superfluous to the creative image constituted by coloured patches of paint.

However, this interpretation of Sickert's position with regard to the functions of drawing and colour in his painting is oversimplified. His initial standpoint, as opposed to his execution, has only apparently changed. In 'Mesopotamia-Cézanne' Sickert especially commended the place which Clive Bell had assigned to colour. He doubted if this place had ever been more justly assigned than in Bell's words: '"Colour becomes significant only when it has been made subservient to form".' It was the artist trained in the discipline of draughtsmanship who wrote to Miss Sands, 'We all draw more than well enough to paint', and that it was therefore not necessary to *think* about drawing. Sickert's problems were with paint and colour, not with drawing. From one angle his whole career can be viewed as an attempt to persuade his intractable material to act as an agent in the creation of design and form, that is, to express the drawing, in its true sense, of his pictures.

The accentuation of Sickert's personal eccentricities as he grew older may be partly responsible for the impassioned attitudes to his later work. The abundance of anecdotes relating to his private and working life has contributed to the growth of a Sickert 'legend' which distracts attention away from the appreciation of his continuing seriousness as a painter. The anecdotes are frequently amusing but they sometimes have a deeper meaning. For instance, one can laugh at the story of how Sickert, asked to paint the portrait of an eminent gentleman's wife, did nothing for some months, then unexpectedly arrived one morning with his photographer to invade the privacy of the lady's bedroom as she was reading her newspaper in bed; then there was silence again from Sickert until the gentleman got a message to meet his wife's portrait off a certain train. When he commissioned a portrait of his wife from Sickert he could hardly have envisaged the big picture he received in this fashion. It showed the lady's head, painted large and looking very startled, in the upper left half of the canvas; the rest of the picture showed the bed and the unfolded newspaper[18]. However, one can also interpret this story as showing how Sickert used the camera to trap, not just a portrait likeness, but a truly living, natural, if unconventional, aspect of his sitter such as he could never have captured in formal sittings from life. His adoption of the name Richard in later life may not have been a mere caprice. It could evidence a deep desire to change his identity. Sickert was fed up with Walter Sickert and his battles

with paint and with the public. Richard Sickert was a new *persona*, the grand old man of English painting, well-loved and respected by the general public and the establishment.

None of these explanations successfully confronts the undeniable issue of the extraordinarily uneven quality of Sickert's late work. Some of his paintings from photographs or black-and-white illustrations are bare and lifeless transcriptions. Others are full of vitality both in the painting and in the interpretation of the subject. It is probable that the amount of preparatory editing to which Sickert subjected his documents had bearing on the ultimate quality of his painting. Sometimes he just squared up an enlarged photograph and transferred it directly to canvas. At other times he drew upon the photograph, as Cicely Hey remembered him doing on the prints taken by a professional photographer of his lay figure being carried upstairs to his studio 'just to emphasize certain points'; the painting from these photographs is the magnificent *The Raising of Lazarus* (for which Sickert also made preliminary painted studies). Sickert certainly edited, and presumably directed, the photographs for his own self-portraits in the 1920s. These portraits were conceived in his own mind and eye, not just transcribed from impersonal data. Sickert's self-portraits throughout his career are the best illustrations of his talents as a sort of actor-manager. In *L'Homme à la Palette* (Fig. 4) he posed as an elegant dandy who dabbled in paint; in *The Juvenile Lead* (Fig. 174) he was self-critical; in his portrait with *The Bust of Tom Sayers* (Fig. 250) he was flamboyant and confident. In the great series of self-portraits in the 1920s, *Lazarus Breaks his Fast* of 1927 (Fig. 279), *The Raising of Lazarus* of c.1929 (Fig. 284), and *The Servant of Abraham* of 1929 (Fig. 283), he cast himself in a patriarchal, biblical mould and was not even abashed at acting the part of Christ. It is possible his obsession with Lazarus, reborn from the dead, had something to do with the birth of Richard Sickert from the dead Walter. The extraordinary grandeur and flamboyance of their conception is matched by the self-confidence of their execution. The 1929 portrait of *Hugh Walpole* (Fig. 282) and the earlier portrait of *The Rt. Hon. Winston Churchill* (Fig. 281) have the same sort of exuberance and confidence which enabled Sickert to present a totally recognizable portrait of Walpole with one eye and of Churchill from a chaotic jumble of dry patches of pink and green coloured paint. Sickert did in fact make some preparatory drawings from life for his portrait of Churchill, and he had already painted Walpole from life in 1928. Thus, it is possible that his knowledge and sympathy with the subject of his portraits affected his paintings just as his editing of photographs must have done. But this again is not the whole answer. It does not explain why some of his formally commissioned portraits done from photographs should 'come off' and others fail, why *Viscount Castlerosse* (Fig. 285) is a satisfactory, even arresting, image, and the portraits of *Sir Alec Martin* and his family (with whom Sickert was very friendly) are empty and lifeless (C.415). I believe there is no complete answer, only several partial explanations. Sometimes the success or otherwise of his paintings done from photographs depended upon the scale of his transcription. Some photographs, which were slight in the amount of incident they contained, were blown up by Sickert to fill huge canvases. The poorness of the original document could not sustain the enlargement. But above all I believe that the merits or demerits of Sickert's late works, particularly in the 1930s, depend primarily upon how much of the painting, from its inception to its completion, was done by Sickert himself rather than by one of his studio assistants[19]. The authorship of late Sickerts is impossible to prove in retrospect and the citation of individual doubtful examples would be invidious. Thérèse Lessore, Sylvia Gosse, Morland Lewis, and several others helped Sickert produce his late pictures. Sickert chose a subject from a photograph or print and they squared it up and transferred it to canvas. As Sickert grew older his assistants undertook more and more of the preparation themselves and even completed pictures (under Sickert's direction) to await his signature. It must be emphatically stated that there was no attempt on Sickert's or his assistants' part to forge his pictures or defraud the public. The studio procedure whereby his students and disciples did more and more of

the preparation and even completion of a picture was a logical development from Sickert's continual attempts, from his earliest days, to mechanize and systematize the process of painting. Once the method of doing this was discovered by Sickert the actual execution of a picture was a mechanical thing, as well done by one person as by another. Sickert perhaps pushed this idea beyond its tenable limits. In theory it is acceptable. In practice there is something in the touch of a master which no one else can imitate.

The 'Echoes'

In about 1927 Sickert began to paint his 'English Echoes'. His first subject was taken from the design on a pot lid so that the painting, *Suisque Praesidium* (C.429—a farewell scene of a Highland soldier off to battle) is circular[20]. Thereafter he used black-and-white illustrations from the pages of papers like the *Penny Magazine* and the *London Journal* as spring-boards to paint his 'fancy pictures'. Sickert had long admired the Victorian illustrators whose work he chose to revive; he had known John Gilbert personally and drawn his portrait in 1893 (under C.52). He often acknowledged the derivation of his themes in an inscription, adding (with typical humour) '*Sickert pinxit*' or '*Sickert transcripsit*'.

Critical reaction to the 'Echoes' has varied. As fast as Sickert painted them the Leicester, Savile and Beaux Arts Galleries exhibited them and they enjoyed immediate popularity. Helen Brook commented in 1932[21] that the title 'Echoes' was a misnomer, because Sickert's paintings, far from being fainter, were amplifications or developments of their originals. Miss Browse in 1960[22] found the name 'Echoes' only too apt. She remarked that they were often 'gay and amusing, but how slighting it is to have to speak of Sickert's work in such a manner. Trying to recapture the spirit of an earlier era whose story-telling morality was by then out of date, they are false in sentiment, relatively poor in quality, and they became progressively weaker.' She attributed their commercial success to 'the easy attraction of primary colours', perceptively noting that people blind to the more subtle beauties and truths of Sickert's earlier works could welcome these pictures as part of their décor.

It is probable that nostalgia for the Victorian age of his boyhood did inspire Sickert towards the idea of creating individual evocations of the life and humour of that time. *The Beautiful Mrs. Swears* (C.432), for example, recalls the lady who had been the beauty of the season at Lowestoft during the early 1870s and whom Sickert had admired when he spent his summer holidays there as a boy[23]. However, to accuse these pictures of falseness of sentiment presupposes that Sickert was seriously trying to recapture the spirit and morality of the Victorian age. Sickert used these Victorian themes and designs only as spring-boards; the liberties he took with them and his easy familiarity with them were entirely modern. The 'Echoes' were a kind of Pop Art. Their subjects were sometimes charming, sometimes witty, but always easy to understand. The themes of course varied according to the interests of the author of the original designs: landscapes after Francesco Sargent[24]; opulent and romantic idylls after Kenny Meadows[25] and Adelaide Claxton[26]; sentiment, romance, but often more trenchant comment on social *mores* and comic situations after John Gilbert[27] and comic caricature again after Georgie Bowers[28]. Sickert translated the originals with verve and evident enjoyment. His canvases are frequently seductive with their gay colours and attractive broad handling of dry scumbled paint. A comparison of a monochrome original (precisely defined in its detail, modelled with cross-hatching) with Sickert's transcription in colour demonstrates his incredible mastery of tonal values[29]. Sickert did not, as it were, hand-colour a black-and-white print. He visualized the scene of the original in full, modelled, atmospheric colour (a talent also demonstrated in his paintings from photographs). He suggested all the detail of the originals without at any time having to repeat their linear particularization. He eliminated their lines and replaced them by planes and touches of colour not only of

equivalent values but also of exact atmospheric truth. In this sense the 'Echoes' are *tours de force* of painting, only possible for a supreme craftsman in the medium. But Miss Browse's comment that the pictures were welcomed by contemporaries as part of their décor is illuminating. These 'Echoes' now seem very much a part of the 'thirties, in accord with the decorating taste of that decade. This may be one reason for the partial revival of their popularity today when nostalgia for the fashions of this pre-war era is growing.

Sickert went on painting 'Echoes' in huge numbers well into the 1930s. It is not possible to date them accurately (except that terminal dates are established for the many examples exhibited in the 1920s and 1930s). Stylistically they show no real development, with thin perfunctory pictures apparently painted at the same time as richly seductive examples.

Portraits

Sickert was very active as a portrait painter during the last period of his career. Portraiture had always interested him—often more than any other field of his work—but he had hitherto attracted few formal commissions. Most of his portraits had been of models, friends, and colleagues. This situation changed from about 1927 onwards. Sickert's method of working from photographs enabled him, even when living away from London, to undertake commissions. His life-size portrait of *Viscount Castlerosse* (Fig. 285), the talking point of the Royal Academy in 1935, was painted in St. Peter's-in-Thanet. It was one of a series of portraits commissioned by Sir James Dunn and Lord Castlerosse himself never saw the picture before its exhibition. In an interview published in the *Sunday Express*[30] Lord Castlerosse explained, 'All I did was to have luncheon with Sir James Dunn, and there I met Mr. and Mrs. Sickert. Mrs. Sickert took a snapshot or two, and that is all that was asked of me.' Lord Castlerosse went on to say that Sickert told him his practice was a kind of return to eighteenth-century procedure, that sitters in those days did not sit in a fixed pose. By working from photographs Sickert could also paint non-commissioned portraits of whomsoever in public life he chose. He could paint figures from the past, such as *The Tichborne Claimant* (C.431), which is part portrait, part 'Echo'; and he could paint eminent contemporaries, as in his several portraits of members of the Royal Family. He painted *King George V with his Trainer at Aintree* (under C.408) and recorded his debt to the Topical Press in a detailed inscription. He painted *King George V with Queen Mary* (Fig. 286) from a press photograph showing the royal couple in their car during one of the 1935 Jubilee drives. He captured the image of *King Edward VIII* (Fig. 287, C.409) during his brief reign, showing him in the uniform of the Welsh Guards alighting from a carriage to go to a church parade service of the Welsh Guards on St. David's Day, 1936. Each of these portraits attracted great publicity and was much admired. The portraits with King George V were relatively small-scale informal works; indeed the picture of the king with his trainer at the races was called *A Conversation Piece at Aintree*, and when offered as a gift by the Beaux Arts Gallery to the Glasgow Art Gallery in 1931 it was turned down by the corporation as not majestic enough. The portrait of *Edward VIII*, which Sickert painted in two versions, was approximately life-size.

Sickert had discovered (or re-discovered if his pictures of *Charles Bradlaugh at the Bar of the House of Commons* and the lost *Miss Fancourt* are remembered) a taste for this sort of scale and style in 1927 when he painted the eight-foot-high portrait of *Rear-Admiral Lumsden* (Fig. 277). The scale and the three-quarter back-view presentation of the sitter were Whistlerian revivals; Sickert's full-blooded approach to the portrayal of the Admiral resplendent in his uniform, his use of strong colour and broad brush-work, and his method of making the silhouette of the figure stand out from, instead of blending into, the background, are totally different from Whistler. Most of Sickert's later large-scale full-length

portraits are less successful than *Admiral Lumsden*. Possibly, once the excitement of treating a portrait for the first time on this scale and in this style had passed, Sickert became bored with the exercise. Moreover, the portrait of Lumsden was not commissioned. The story goes that Sickert had met the Admiral when they were both swimming in the baths at Hove, that he had been impressed by his fine figure and liberal tattoos and without knowing who his acquaintance was had invited him to come to his studio to be painted. He was amazed when his swimming-companion arrived in the uniform of an Admiral[31]. Whatever the truth of this story it is probable that Sickert, besides working from a photograph of the Admiral, also had sittings from life. Sickert showed the portrait of *Admiral Lumsden* at the Royal Academy in 1928, where it attracted much notice. Its success presumably persuaded him to continue using the same formula for later commissioned portraits, or possibly his clients themselves demanded something in the manner of *Lumsden*. Indeed, the *Glasgow Herald*[32] commented that *Viscount Castlerosse* at the 1935 Royal Academy was like Sickert's *Admiral* of a few years before. However, whereas *Lumsden* and the broad pink, brown, and blue *Castlerosse* were strong and lively portraits, many of the later commissioned examples—both life-size and smaller in scale—were more literal and pedantic in their transcription of Sickert's photographic documents. This seems to have been the case even when the sitters were Sickert's friends and attended his studio for sittings. For example, the portraits of *Sir Alec Martin*, *Lady Martin*, and their son *Claude Phillip Martin* (C.415) painted in Thanet were partly studied from life, but the portraits look as if they were done entirely from the photographs taken of all three by Thérèse Lessore[33]. The figures are frozen in movement and expression, and the painting seems to be tied to the tonal register of a photograph, so that the portraits resemble gigantically enlarged coloured snapshots. Indeed, in several of his late portraits Sickert reproduced the tonality and instantaneous expressions and poses of his snapshot documents so faithfully that in black-and-white reproduction the paintings can themselves almost be taken for photographs. He even sought the same kind of informality as a holiday snapshot in some examples, such as *Peggy Ashcroft* in her bathing costume sitting on a diving plank (C.413).

Sickert also painted relatively small, half- or bust-length portraits, especially in the late 1920s, among them the portraits of *Hugh Walpole* (Fig. 282, C.406) and of *The Rt. Hon. Winston Churchill* (Fig. 281). His 1928 portrait of Walpole was painted partly from photographs and partly with the help of sittings from life when, according to Sir Hugh, Sickert painted direct onto the canvas without making preliminary drawings or studies[34]. Sickert also studied Churchill from life as well as from photographs. He did make preliminary drawings for this portrait, possibly taking the drawings from a photograph. One of the drawings is the same size as the painting, squared, and its back is washed over with a thin coat of indian red which enabled Sickert to trace it onto the canvas (the method Cicely Hey remembered him using for her own portraits earlier in the decade).

The relative importance of photographs and life sittings in Sickert's late portraits is difficult to assess. It is probable that the sitter came to Sickert's studio, that Sickert painted the rough outline of his likeness and form onto the canvas in what seemed to him a characteristic pose, that he then had the sitter photographed in the same pose and worked thereafter mainly from the photograph. The 1929 portrait of *Hugh Walpole* was painted entirely from photographs (possibly from prints taken in 1928 but not utilized), and presumably also from the impression Walpole made on Sickert's memory. Sickert treated these sources with audacious freedom, and compounded a total integrated portrait from almost nothing. He used no drawing; his palette was limited to pale blue throughout the underlying preparation, different shades of wine red (from rich maroon to pale pink) for the main part of the picture, passages of very dark purple in the extreme darks, and white for the highlights; the chair is prussian blue and a lighter olive is used in the background. At close quarters the broad planes and slashes of colour mean nothing; but their tonal relationships and gradations are so superbly judged that at a

certain distance they resolve into a complete portrait which gives a far more satisfying image of the sitter than the much more literal portrait painted a year earlier. A comparison of these two pictures of *Walpole* suggests that the style of Sickert's late portraits in general was not conditioned by his preliminary documents (whether or not he worked from photographs); it was more a result of whether or not a work was commissioned. The 1928 portrait of *Walpole* was commissioned and Sickert felt obliged to give the sitter an accurate rendering of his features. The 1929 portrait was presumably done for Sickert's own pleasure; with the constraints of conventional portraiture removed Sickert could do what he liked with his material.

Sickert obviously had the same freedom when he painted his self-portraits during the later 1920s. Their conception and method have already been noted. They were also painted from photographs, although there is one drawing related to *Lazarus Breaks his Fast* (probably itself taken from a photograph) and there are two painted studies, one done directly on the wallpaper of Sickert's Highbury Place studio, for *The Raising of Lazarus*. However, *The Raising of Lazarus* (Fig. 284) is not a simple portrait. It is a grandiose visionary picture. It was inspired by a relatively mundane actual event— a lay figure being transported up the narrow gloomy stairs to Sickert's studio, with Sickert waiting at the top of the stairs to receive it and Cicely Hey watching from below. The scene acted as a catalyst on Sickert's imagination. He must have had it re-enacted to have it professionally photographed but the photograph did not in any way constrain his original visionary interpretation. In his final painting the fierce inspiration of that moment is allowed to prevail, so that critics carped that Christ (Sickert) had six fingers.

Sickert's non-commissioned portraits of the 1930s are also relatively free in handling and in the interpretation of their photographic originals. The handling of the portrait of *George V and Queen Mary* (Fig. 286) is bold; it is painted in high-toned bright colours scrubbed very roughly over an extremely coarse canvas so that the bumps of the canvas are coloured and the dips between left white. It is possible that Sickert's use of newspaper photographs helped him towards his effects, because such photographs, being poor in quality, are altogether fuzzier and less detailed than proper prints. The portrait of *Sir Thomas Beecham Conducting* (Fig. 289), another non-commissioned work executed for Sickert's own pleasure, is handled in something of the same manner although the paint is smoother and Sickert introduced linear definition to accent the design. As in the portrait of the royal couple it is the placing of the figure which gives the painting its impact. Beecham, arms outstretched, cuts a jagged pattern against the deep red background which is large enough to incorporate the full length of his baton. This portrait was probably painted as late as 1938[35] and proves that Sickert's powers, and above all his sense of design, had in no way diminished. The same superb sense of design is illustrated in *The Miner* (Fig. 290) of *c*.1935–6, a rare contemporary (as opposed to Victorian) figure subject of the period, which was also painted from a newspaper photograph. Whereas in his portrait of Beecham Sickert allowed the figure to tell against a generous amount of empty space, in *The Miner* the two embracing figures are barely contained by the canvas, which makes their action the more poignant, fierce, and intimate.

Theatre subjects

Sickert continued to paint many theatre subjects during this last period of his career, but his interest shifted from music hall to the legitimate theatre. The last of his pictures of lighter, more common entertainment were the two versions of *The Plaza Tiller Girls* (C.420) painted in 1928 and a third larger picture called *The High Steppers* (listed under C.420), perhaps painted some years later, which may also represent the Plaza Tiller girls although this time the chorus face the opposite way and are kicking

their legs up. He also painted *Sir Nigel Playfair as Tony Lumpkin in 'She Stoops to Conquer'* in 1928 (C.421). Although it was loosely, almost carelessly painted, Sickert asked Munnings for a sketch to show him the proper distribution of mud splashes on the boots of a postilion[36], a concern over detail the more curious in as much as the painting was of a theatrical presentation, not a real event.

When Sickert was still living in Islington he began to go frequently to the theatre. Many famous actors and actresses became his friends, Gwen Ffrangcon-Davies, Peggy Ashcroft, John Gielgud, and others too numerous to mention. He thus revived his early contact with the classic stage and its players. Sickert's portraits of these actors in their classic roles, for example his nostalgic recollection of *Johnstone Forbes-Robertson as Hamlet* (C.422), *Gwen Ffrangcon-Davies as Isabella of France in Marlowe's Edward II* (Fig. 288), etc., represent a revival of an English tradition in painting which had been comparatively dormant since Whistler. With the possible exception of some drawings of *Peggy Ashcroft, Valerie Tudor and William Fox in 'As You Like It'* (C.423) done at Sadler's Wells in 1933 Sickert did not make studies in the theatre. He painted his theatrical subjects from press photographs, supported by occasional sittings from the players who were his friends. Because he painted from photographs he could go on painting theatre scenes after he left London and the majority were executed while he was living in St. Peter's-in-Thanet between 1934 and 1938. The quality of the theatrical paintings varies enormously. Some are totally lifeless and dull; others have real grandeur and power. In a few paintings, for example *Othello* with Peggy Ashcroft and Paul Robeson (Fig. 293) and the very grand full-length presentation of Gwen Ffrangcon-Davies called *Gwen Again* (C.425), Sickert used a particularly effective and vivid colour combination of emerald and scarlet.

As a general rule the theatre pictures representing close-up views of the players—usually a two-figure group—at some dramatic moment in the action of the play are much more successful than the comprehensive representations of the whole set. The distribution of the figures in their respective positions on the stage in the latter pictures is comprehensible within the context of the actual production but not when captured in isolation upon canvas. These pictures look like failed conversation pieces, failed because in a true conversation piece the artist has a hand in the construction of the figure groups whereas Sickert transcribed existing, unplanned photographic documents. In the close-up views the interaction of the figures is easier to understand. In paintings such as *Juliet and her Nurse* (Fig. 292), *The Taming of the Shrew* (Fig. 294), and *Othello* (Fig. 293) the placing of the figure groups in relation to the canvas space is planned to give the design maximum force. These pictures illustrate the same talent for dramatic *mise-en-page* as do *Sir Thomas Beecham Conducting* and *The Miner*. Even the frozen aspect, typical of all the theatre pictures as a consequence of their derivation from photographs, becomes an advantage. These paintings of dramatic moments are not intended to resemble real life; they are theatrical, and the way Sickert represented the players frozen in mid-action (whether deliberately on his part or not) heightens the impression of theatricality and gives the pictures something of the quality of a close-up cinematic still. The inscriptions on some of his pictures certainly suggest that their stylized, formal character was intended by the artist: the long Italian quotation in large script on *Gwen Again* (C.425); the inscriptions in capitals on several other pictures, sometimes identifying the play and players[37], and once on the very grand, huge full-length of *Gwen Ffrangcon-Davies as Isabella of France* (Fig. 288) not only giving the title 'LA LOUVE' but also acknowledging the photographer from whom the design was taken.

Landscapes

Sickert painted relatively few landscapes during the last period of his career. In London he painted the small group of Islington scenes discussed in the last chapter. His painting *Barnsbury*, painted *c.*1928–30

(Fig. 297), was probably derived from an old photograph[38]. It is richly and broadly painted in different shades of blue and pink, a choice of colours similar to that used for the 1929 portrait of *Hugh Walpole*. *The Front at Hove* (C.447) of 1930 must have been painted on or shortly after a visit there. Its light tonality and clear chalky colouring, and the scumbled handling of the dry paint, relate it stylistically to the 'Echoes'. The figure seated on a bench in the foreground, trying to engage the lady alongside in conversation (which explains the alternative title from Ovid's *Amores*, '*Turpe senex miles turpe senilis amor*'[39]), is Sickert himself. The device of including himself as an incident in his landscapes was to recur many times in the 1930s.

Sickert's method of painting from photographs did not encourage landscape painting. Landscape subjects, unlike photographs of eminent public figures or theatrical productions, were not often found in newspapers. Sickert did sometimes unearth old drawings and make new paintings from them. Just as he painted *My Awful Dad* (Fig. 291, C.411) twice in the 1930s from drawings of *c.*1912 so he may have found a drawing, or perhaps an old photograph, of *Il Cannaregio* in Venice which inspired him to paint the subject twice (C.449)—somewhat crudely in strident colours and thick paint. In another picture called *Viscere Mei* (listed under C.449), painted in the late 1920s, he had used the Il Cannaregio landscape as a background to a mother and child group, derived from a photograph, and painted in a richly glowing green monochrome. The formal, stylized treatment of this figure group before a landscape is unusual but not unique. Sickert repeated the experiment in a painting of Peggy Ashcroft (called *Variation on Peggy*—listed under C.449) in which he portrayed Miss Ashcroft as a similar green monochrome silhouette against a Venetian background.

In some of Sickert's Thanet landscapes, for example *Baird's Hill House* (Fig. 298), the texture of the dry paint and the rich overlapping application of touches and stains of tone and colour are reminiscent of the Envermeu landscapes of 1919 such as *The Gate to the Château d'Auberville* (C.385). He also painted several pictures of a group of workers' cottages in Broadstairs, fenced in by paling and set behind rows of allotments. The deliberate choice of so unpromising a motif, and his inclusion of an abandoned bicycle as a prominent incident in some of the pictures, testify to Sickert's continuing desire to find beauty in prosaic, even ugly, aspects of his environment. The perfunctory, but discreet, handling of several of these Broadstairs cottage pictures saves them from total tedium, but other examples are painted with unique crudity. In a few pictures even Sickert's signature is clumsily defined in childish capital letters[40]. How much of these pictures was Sickert's work is open to argument. The scumbled underpainting of certain passages is similar to that used by Sickert and his assistants, but the crude drawing is not. Possibly Sickert acquired a new and untalented assistant for a brief while (and specially signed himself in an odd manner to warn posterity that this was not a true Sickert product); possibly he was suffering, when he painted this group of pictures, from an attack of the optical disability which is hinted at in the literature[41]. Whatever the case, when Sickert moved to Bathampton he painted more landscapes (and fewer pictures of other subjects) and his facility revived. He painted many views of Bath. Some were late versions of old favourites such as *Pulteney Bridge* but most of his motifs were new, painted from recent photographs. A few little motor cars and hurrying figures accent the wide sweeping views of the hilly streets and regulated architecture of Bath, such as *The Vineyards* (Fig. 301) and *Bladup Crescent* (C.445). These pictures are painted cleanly and drily in pale, cool, almost monochromatic colours, scrubbed dry and thin over his very coarse canvases. He also painted many views of his own house and gardens at Bathampton. He probably painted these from snapshots taken by his wife but he could also refresh his eye with the actual scenes. Whereas the atmospheric quality of the Bath urban views is unreal in its cool purity, and the pictures tend to lack incident, some of the Bathampton landscapes are teeming with life and their tonal patterns have much more veracity. This is especially true of his paintings of the garden with its pergolas and arbours of roses and his paintings

of the house with its trellised walls (for example *The Garden of St. George's Hill House*, Fig. 300, and *The Open Window*, C.451).

Sickert's inclusion of himself as an incident in several of his Thanet and Bathampton landscapes has been noted. He sits on his front porch in *Home Sweet Home* (C.448), he stomps up his garden, stick in hand, to survey the view in *The Invalid* (C.450), he slips off to his wine cellar in *Home Life* of 1937 (C.405, Painting 4), which is more a portrait study than a landscape. In other pictures he incorporated different figures from his home surroundings: his wife in *The Open Window*; a maid in two versions of *A Scrubbing of the Doorstep* (Fig. 299, C.446), one of his latest subjects painted towards the end of 1941. This gives these pictures value, irrespective of their individual merits and qualities as paintings. They are intimate documents of his domestic life in old age.

Sickert died at Bathampton after a short illness in January 1942. I do not intend to make a formal statement eulogizing his lifetime's achievement. I would not have undertaken this book or my earlier research on him if I did not greatly admire his work, but it is up to each individual to judge the paintings and drawings for himself. This book is really an attempt to help students and enthusiasts to appreciate his work by giving them an account of his technical and stylistic development within a reasoned chronological framework. And as such it ends with his death.

NOTES

1. The *Whirlwind*, 23 August 1890.
2. Letter of Degas to Ludovic Halévy of September 1885, *Lettres de Degas*, collected and annotated by Marcel Guérin, preface by Daniel Halévy, Paris, Bernard Grasset, 1931, p. 31. It is of course possible that the photographs were simply of the pastel group of Sickert and others which Degas had executed in the summer of 1885 in Dieppe, of which Sickert later sent a print to Miss Sands (see note 3).
3. This request was contained in a letter written shortly before Sickert's visit to Dieppe in 1913 (letter dated from Sickert's reference in it to a photograph he was sending Miss Sands of 'Degas's portrait of me and others'; in a letter written from Envermeu in July 1913, dated in Chapter XV, note 5, Sickert responded to Miss Sands's acknowledgement of the receipt of the photograph).
4. Letter of 1913, dated in Chapter XV, note 3. The big head of Miss Sands done at Newington (her country house near Oxford) is lost.
5. Letter dated in Chapter V, note 7.
6. From a letter published by Blanche, *Portraits of a Lifetime*, pp. 46–7; for the dating of this letter see Chapter VIII, note 17.
7. The *English Review*, January 1912, pp. 301–12, 'The Old Ladies of Etching-Needle Street', p. 301.
8. From Cicely Hey's unpublished recollections.
9. *The Times*, 15 August 1929, letter to the editor on the Haig statue, 'Artists and the Camera'.
10. The *New Age*, 5 March 1914.
11. Sickert translated these words slightly differently in the *Burlington Magazine*, 31, November 1917, pp. 183–91, 'Degas', p. 184–5, as 'I have always tried to urge my colleagues to seek for new combinations along the path of draughtsmanship, which I consider a more fruitful field than that of colour.'
12. The *Fortnightly Review*, 84, December 1908, pp. 1017–28, 'The New Life of Whistler', p. 1024.
13. The *New Age*, 30 June 1910, 'Impressionism'.

14. The *New Age*, 2 June 1910, 'The New English—and After'.
15. The *New Age*, 9 April 1914, 'A Perfect Modern'.
16. Letter dated in Chapter XV, note 13.
17. The *Southport Visitor*, 26 April 1924, 'Fantin and Van Huysum'.
18. The picture is *The Hon. Lady Fry* (C.414). Its story was told to me by a friend and pupil of Sickert.
19. Richard Seddon, *Apollo*, 38, 1943, p. 173, 'The Technical Methods of Richard Sickert', reprinted as preface to the Graves Art Gallery, Sheffield, Sickert exhibition in 1957, gave an interesting account of Sickert's studio procedure and his use of assistants. Many former pupils of Sickert have told me of his studio practice and have even cited pictures not touched by his hand which yet bear his signature.
20. Emmons, p. 211, quoted an 'Echo' done from a pot lid as the first of the series. The owner of *Suisque Praesidium* (who knew Sickert well) told me it was done from the lid of a pomade pot (and its shape confirms this).
21. The *Studio*, 103, May 1932, pp. 266–72, 'Richard Sickert "Originals" and "Echoes"', p. 266.
22. B.60, p. 49.
23. Emmons, p. 21.
24. E.g. *Dover* (C.438); *Dublin from Phoenix Park* (C.433).
25. E.g. *Her Serene Highness* (C.439); *Vicinique Pecus* (C.435).
26. E.g. *She was the Belle of the Ball* (C.434).
27. E.g. *Summer Lightning* (C.440); *The Idyll* (C.441); *A Nativity* (C.430); *The Seducer* (Fig. 296).
28. E.g. *The Private View* (C.436). The examples of 'Echoes' after various masters given in notes 24–8 are a random selection. There are countless other examples. The student of Sickert's 'Echoes' will find the best source material in the exhibition catalogues (often illustrated) of the Beaux Arts, Savile, and Leicester Galleries.
29. The *Illustrated London News*, 9 April 1932, published reproductions of several of Sickert's 'Echoes' side by side with their Victorian originals. The *Studio*, 99, May 1930, p. 368, illustrated another such opposition.

30. 12 May 1935.

31. B.60, p. 41.

32. 4 May 1935.

33. Tate Gallery Catalogue, *Modern British Paintings, Drawings and Sculpture*, London, Oldbourne, 1964, Vol. II, pp. 639–40, published the information that Sir Alec and Lady Martin gave Sickert sittings in St. Peter's-in-Thanet, that their son was studied in the garden of the Martins' house at nearby Kingsgate, and that Thérèse Lessore took photographs of all three.

34. Information from Jack Goodison, manuscript of the Fitz-william Museum catalogue of British paintings.

35. In a letter to Irene Scharrer, written from Broadstairs and postmarked 15 March 1938, Sickert reported, 'I am at work on dear Beecham conducting.' I am indebted to Mr. d'Offay for showing me this letter.

36. Emmons, p. 212. Emmons got this information from a letter written by Sickert to Mrs. Schweder which she kindly showed me: 'I am sending Sir Nigel Playfair as Tony Lumpkin to the Academy. Munnings has kindly given me a chart for the splashes of mud which will therefore be correct.'

37. E.g. a version of *Peggy Ashcroft as Miss Hardcastle* (C.424).

38. Mr. George Buchanan of the Glasgow Art Gallery told me of a letter he received from Mr. Geoffrey S. Fletcher (12 January 1965) which informed him that the premises of Thorne & Co. (the subject of *Barnsbury*), at what is now 365 Caledonian Road, were occupied by the firm from 1890 until 1913.

39. 'An old soldier is a wretched thing, so also is senile love.'

40. I prefer, for obvious reasons, not to quote the details of these pictures which are privately owned. Their history and provenance ensures their authenticity as products at least of Sickert's studio.

41. Malcolm Easton, 'Of Sickert and the North', Appendix to 'Sickert in the North' exhibition, University of Hull, 1968, p. xii and note 33.

Appendix

Sickert's Attitude to his Subject Matter

ICKERT's attitude to his subject matter is an aspect of his artistic personality which naturally conditioned his work of all periods. It is, therefore, discussed here, as an appendix to the preceding chronological study of his development, where its relevance to his entire career can be appreciated retrospectively, even though this will entail some recapitulation.

Before attempting to explain the interwoven motives (some practical, some aesthetic) which governed Sickert's choice of subject matter, it is necessary to stress his fundamental conviction that the artist must approach his subjects—whatever they are—with complete emotional detachment. Sickert's case for detachment is passionately presented in a letter[1] in which he tried to dissuade Miss Sands and Miss Hudson from painting each other. The letter, as was usual with Sickert's letters to Miss Sands, took the form of advice but it is also a personal manifesto:

> find . . . someone whose aspect is interesting and sympathetic to *you* but who is *paid* . . . place them in lights and attitudes where you have seen, *come upon* effects you like and work from them regularly. . . . I don't want to see any more *only* you or Nan by yourself or by Nan. I stick to it that it gives a want of variety to your *œuvre* and something amateurish as if your *art* were subordinate to your *establishment*. . . . Your own tastes in dress and your personalities should be banished as much as possible from your *œuvre*. '*Parler de soi c'est ce qu'il y a de moins fort*' Flaubert says. . . . Don't you see if you had a paid person doing another paid person's hair, or whatever you like, at *10* or *3* you would, to begin with, . . . *have to* work. You wouldn't *waste* them. And this is a great principle, a recipe, if you like, for inspiration. *Banish your own person, your life and that means you and your affections and yourself from your theatre. During the hours you paint*, by using paid models you will forget that you are you and that Nan is Nan and that is *good artistic hygiene*. . . . There is a constant snare in painting what is part of your life. You cannot avoid with yourself or another artist or a member of your own house or family a spoken or silent dialogue which is *irrelevant* to *light and shade* irrelevant to colour. . . . I feel so strongly about it . . . and I know I am right. The *nullity* and *irrelevance* to yourself of the personality of a model is *tonic*, has *incredible virtues*.

This belief, that one's art and one's life must be ruthlessly separated if the former is not to suffer, is of great importance to an understanding of Sickert's painting. It was a basic condition if the artist was to approach his work as a professional. Sickert constantly reiterated that to help himself in this respect the artist should work regular office hours, '10 to 4 or whatever it is', as he wrote in one letter to Miss Sands. It is relevant to the present discussion that in this same letter Sickert remarked, 'Pictures, to apply the rather tiresome line of Emily Bronte's can certainly be "cherished, strengthened and fed without the aid of joy".' Sickert organized his life into a strict routine, and several of his letters outline the routine of the moment. For example he wrote to Miss Sands during the war, 'I work in the big studio till 3 and then from 3 to 6 models in the small one.' Except when in Envermeu, and when he was an old man in Thanet and Bathampton, Sickert rarely worked at home. He preferred to keep his studios quite separate, and it is possible he rented so many studios at the same time, and changed them

so frequently, in order better to remain detached from his place of work. Sickert almost always used paid models (who did, however, sometimes double as studio servants) for his figure subjects. He became attached to them solely for their value as models but was never more than superficially involved with them in any emotional sense. Even his distress at having to part company with Hubby[2] was probably little more than a conventional display of grief for the benefit of a lady of sensibility. He picked his models casually from the street. Jeanne Daurment, the model, with her sister Hélène, for the Easter 1906 interiors, remembered how Sickert asked her to model for him when he overheard her asking a policeman—in French—where she could buy coffee in Soho[3].

There are, of course, a few exceptions in Sickert's work to the rule of banishing his person, his life, and his affections from his art. In the early years of the twentieth century his mistress Mme Villain sometimes posed for him (e.g. *La Belle Rousse*). In 1912–13 he incorporated the figure of Gilman into several of his drawings (e.g. *Mr. Gilman Speaks*, *The Visitor*). In later life we have seen how he included himself as an incident in his landscapes and these landscapes reflected his own domestic environment; but in his old age Sickert's failing physical powers naturally led to a narrowing of his world and he was forced to turn inwards and find his subjects within an ever more limited radius. Sickert's interest in painting the portraits of his intimate friends and in painting self-portraits seems to be a denial of this rule. However, in a sense, the liberties he took with their conception (his own actor-manager self-portraits, his flamboyant theatrical presentations of Mrs. Swinton) were made possible only by his almost ironically detached attitude towards his own or his intimate friends' identities.

It is on the whole remarkable how little Sickert's personality or emotions can be interpreted from his paintings. Blanche[4] wrote of Sickert that there is in his *genre* scenes 'principally a disdainful discretion, a sort of self-defence, in his attitude towards human contacts—*noli me tangere*'. Sickert jealously guarded his detachment, possibly not only in his art but also in his private life[5], and the value he placed upon his independent separateness is perhaps what is implied by his confession to Nina Hamnett in 1918 that 'the one thing in all my experience that I cling to is my coolness and leisurely exhilarated contemplation'.

Sickert's insistence on the irrelevance of personal tastes and affections to art must have been, in part, an acute reaction against his Whistlerian upbringing. While Sickert owed much to Whistler for his example in stressing that the formal and aesthetic qualities of a subject should be the artist's main consideration, he still felt that Whistler's own work was vitiated by the infiltration of his ultra-refined taste and dandified personality. He wrote of Whistler in 1908[6]:

> Taste is the death of a painter. He has all his work cut out for him, observing and recording. His poetry is in the interpretation of ready-made life. He has no business to have time for preferences. Of the greatest artists in literary presentation, we have heard it said, that, at the end they leave us ignorant of their own opinion, or of the direction of their sympathies with the characters they present.

This quotation clearly states the connection between Sickert's case for detachment, that the artist must not reveal himself, his tastes, and preferences, and his approach to artistic subject matter in general, which was to be found in dispassionately recording ready-made life. This connection was again made explicit when Sickert wrote in 1910[7] that Rodin pointed out, 'while work based on the study of nature had the infinite circle of nature herself as its field, what is called ideal work was limited to the miserably limited source that is to be found in the preference of a finite individual. I was endeavouring to express the same truth when I said . . . on Whistler . . . that taste was the death of a painter.'

Sickert's belief that the artist's 'poetry is in the interpretation of ready-made life' as stated in 1908 is the same as that expressed in 1889 when he wrote[8] that 'the most fruitful course of study' for the painter 'lies in a persistent effort to render the magic and the poetry which they daily see around them'.

At different periods Sickert studied the magic and the poetry of ready-made life in different aspects of his environment. His early music halls, although adapted from foreign themes, were freely translated into a blunt cockney idiom. However, apart from his music hall pictures Sickert did not really discover which aspects of his environment were particularly suited to him as a painter until the early twentieth century. In the 1890s Sickert's emancipation from Whistler was accompanied by a period of groping experiment as he tried to discover the direction of his independent talents. In about 1899, it will be remembered, he had written to Mrs. Humphrey, 'I see my line. *Not portraits*. Picturesque work.'

It was not until after Sickert's return to London that he published his defiant declarations of his emancipation from the refined tastefulness of the nineteenth-century English tradition in which he had been reared. They have already been quoted but must be repeated here. In 1910[9]:

> The more our art is serious, the more will it tend to avoid the drawing-room and stick to the kitchen. The plastic arts are gross arts, dealing joyously with gross material facts . . . and while they will flourish in the scullery, or on the dunghill, they fade at a breath from the drawing-room.

In 1912[10]:

> Our insular decadence in painting can be traced back . . . to puritan standards of propriety. If you may not treat pictorially the ways of men and women, and their resultant babies, as one enchained comedy or tragedy, human and *de mœurs*, the artist must needs draw inanimate objects—picturesque if possible. We must affect to be thrilled by scaffolding, or seduced by oranges. But if the Old Masters had confined themselves to scaffolding by night, and oranges by day, we should have had neither Rubens nor Tintoretto.

In 1910[11] Sickert had advised the artist to follow 'Tilly Pullen' into the first shabby little house, into the kitchen or better still into the bedroom.

The exaggerated emphasis of Sickert's insistence that the artist should portray the sordid life of the dunghill, and not the tasteful refinement of the drawing-room, was influenced and determined by a variety of factors. As Sickert stated, Old Masters had treated so-called improper themes, French painters since Degas had been following their Tilly Pullens into bedrooms, but strong fighting words were needed to dent English puritanism. However, it is also possible that Sickert so strongly stressed his commitment to the sordid precisely because he feared that he, like Whistler, could easily be seduced by the delights of a civilized English drawing-room. Like Whistler, but on the whole unlike his French contemporaries, Sickert mixed with the cultured élite of society in his own city. Although he had many intimate contacts with the working population of London, Dieppe, and Venice I have been told by people who knew him that he was something of a snob.

Not all of Sickert's Camden Town pictures were explicitly sordid, but the majority were at least sufficiently drab to shock English eyes and influence the public conception of his artistic character. Newspaper comment on Sickert's pictures expressed shocked disapproval of his subject matter. Fred Brown, it will be remembered[12], wrote to Sickert that the sordid nature of his pictures since the Camden Town Murder series made it impossible for there to be any friendship between them. Such a reaction from the Professor of Painting at the Slade indicates the effect Sickert's subjects must have had on more innocent English eyes.

While Sickert's subject matter lost him friends it also gained him a sure audience, and there is some evidence for believing that he valued this outcome of notoriety. His remark to Miss Sands in his Easter Monday 1913 letter that he had 'happily decided to hold over the finishing of the blind soldier. It won't do for me to come out just now with an important sentimental work unfinished or *à peu pres*' may have been prompted by his unwillingness to compromise his reputation as the painter of sordid works. Although one implication of his remark may be that he didn't want to show an incomplete work, he could have finished it, but apparently decided not to do so. The other implication is that Sickert was something of a manager of his production, that he calculated the effect of each new work

on his public who presumably, in 1913, expected dreary bedrooms in Camden Town, suggestive of sordid affairs, not sentimental pictures.

The suggestion that this type of practical, possibly commercial, motive helped to determine the content of Sickert's work is supported by advice he gave in 1918 to Nina Hamnett. He told Miss Hamnett to work in England but sell in France, for then her work would be 'in Paris distinctive. Whereas will you be able to whip Marchand say on his own ground? I don't say you won't, only you would be throwing away a unique weapon for the Paris market if you despised English *subjects*. Make these as *canaille* as you like. God, aren't we *canaille* enough for you? Didn't Doré and Géricault find English life sordid enough?' It is probable that this advice to Miss Hamnett reflects Sickert's own practice, that the potential success with French dealers of specifically English subjects was a motive— if only a secondary one—which contributed to the character and content of his own Camden Town pictures.

Sickert probably learned the inclination of the French market while living in France. We have seen that he painted Venetian subjects for Bernheim-Jeune almost to order. When he returned to London, realizing the 'unique weapon' afforded him by English subjects, he concentrated on exploiting all the potentially distinctive and sordid qualities of his chosen area around Camden Town. While the pastels and paintings of Degas and his *intimiste* followers provided a point of departure for Sickert, his unutterably shabby bedroom interiors are completely English in their flavour. Moreover, although the Camden Town figure groups were anticipated by some of the Venetian interiors of 1903–4, and the Camden Town nudes by the Neuville drawings of 1902 and the Venetian studies of 1903–4, none of the foreign subjects possesses the brutality of handling or the undertones of physical wretchedness common to many of the Camden Town paintings. Sickert exhibited and sold many of his Camden Town pictures in Paris, notably through Bernheim-Jeune; he exhibited Camden Town pictures at the *Salon d'Automne* from 1905–9. He showed two versions of *L'Affaire de Camden Town* at this exhibition in 1909 and sold one version to Signac at the sale of his work sponsored by Bernheim-Jeune in the same year, but it was not until 1911 (at the first Camden Town Group exhibition) that Sickert showed a Camden Town Murder picture to the London public. It may also be significant that the war, which impeded Sickert's ability to sell in France, also heralded a change in his subject matter. Not only did he paint many more landscapes but his subject pictures became less '*canaille*'. With the war he became a military painter, and riding the wave of national patriotism he gave other pictures topical titles such as *Tipperary* and *The Prussians in Belgium*, titles which often had no real connection with the subjects represented. Nevertheless, while there is strong reason to suspect that commercial considerations did influence Sickert's production it is certain that he would not have courted the market had this been incompatible with his sincere convictions about the proper subject matter for the artist.

Part of what Sickert's public found so shocking in his figure pictures was the combination of a naked woman and a clothed man, pictures like *Summer in Naples* (*Dawn, Camden Town*) which showed 'a British navvy fully dressed and a dirty complexioned woman with nothing to cover her at all . . .'[13] However, Sickert's liking for the representation of nude and clothed figures together was primarily dictated by his aesthetic principles. Sickert wished to paint pictures which were real in terms of life. He disapproved of too much painting of the nude alone because it 'corresponds to nothing in our modern habits of life. With all his powers of draughtsmanship, when Ingres essayed, in *le bain Turc*, a composition consisting entirely of nude figures, the effect is trivial and a little absurd. So far from giving an impression of life, the picture suggests an effect like a dish of spaghetti or maccheroni'[14]. In 1910[15] Sickert wrote:

> The nude occurs in life often as only partial, and generally in arrangements with the draped (Giorgione, Velasquez, Manet, Degas). Compositions consisting solely of nudes are generally . . . not only repellent, but

slightly absurd. . . . I think all great and sane art tends to present the aspect of life in the sort of proportions in which we are generally made aware of it. I state the law clumsily, but it is a great principle. Perhaps the chief source of pleasure in the aspect of a nude is that it is in the nature of a gleam—a gleam of light and warmth and life. And that it should appear thus, it should be set in surroundings of drapery or other contrasting surfaces.

This law at once explains that Sickert did not combine the nude with the clothed in order to shock puritan susceptibilities, but because he wished to paint scenes which correspond to life as we are generally aware of it, and because he loved the contrasts of colour and texture created by the juxta-position of living flesh and inanimate drapery. The latter reason helps to explain why so many of Sickert's single-figure nude paintings show his model on the bed, gleaming softly from amid the crumpled bedclothes. The location and poses of his figures were chosen not so much for their suggestive innuendoes as for their pictorial possibilities.

Sickert's desire to paint life as we are generally aware of it, and the character of the subjects he painted to this end, have led many critics, in the attempt to define his work, to label him a Realist. Sickert himself hated labels and demanded, 'Let us leave the labels to those who have little else where-with to cover their nakedness'[16]. However, he himself sometimes had recourse to labels when he tried to define his own art and that of his contemporaries. It is interesting that in 1899, when he tried to explain what should properly be understood by the term 'Impressionist' as applied to the group of artists with whom he was currently exhibiting, he wrote: 'Essentially and firstly it is not realism. It has no wish to record anything merely because it exists. It is not occupied in a struggle to make intensely real and solid the sordid or superficial details of the subject it selects'[17]. If Sickert's definition of Realism in 1889 is just and accurate in its general application, then his own work of the Camden Town period, in which such sordid and superficial details as the chamber pots are made real, would have to be considered Realist. There are, however, so many interpretations of the meaning of Realism that it is perhaps the least satisfactory of all labels in art. The variety of interpretations is well illus-trated by the different definitions given to the term by different critics of Sickert's work. Manson[18] gave the umbrella definition, that 'Sickert is a realist of the true kind. That is to say, the source of his art is life'. Miss Browse[19] gave a definition charged with moral or sociological overtones: 'Sickert was what is known as a Realist. Realism in painting means that the refinements and niceties of life are stripped away so that man is starkly depicted in his battle to survive. Should he be a peasant, his struggle is a noble one, tilling the soil and fighting the elements; but if a city-dweller, then his stature is lowly, his surroundings sordid and his sole recreation the nearby pub.' This definition recalls Sickert's own explanation of the term in 1889, but it is precisely what he said he was not. Moreover, although I suggested that some of Sickert's Camden Town figure pictures could be labelled Realist in terms of Sickert's definition, these paintings never have the moral overtones absent in his own but present in Miss Browse's definition.

Nevertheless, it was in the context of a definition of Realism that Sickert found echoed his own, mature views on subject matter. In July 1914[20] he wrote to Miss Sands:

At last I have found well said what I always felt strongly about choice of artistic subject. It is in a preface by Émile Faguet to *Gil Blas*.

'*Le réalisme consiste à de tenir toujours dans la moyenne de la vie. Car il n'y a que la moyenne qui soit vraisemblable. Les types extraordinaires soit dans le bien, soit dans le mal, sont vrais puisque nous les rencontrons; mais ils ne sont pas vraisemblables*'.

It is true that at the height of his Camden Town period Sickert did sometimes represent scenes and figures who were perhaps not '*vraisemblables*' although they were '*vrais*'. The man accused and acquitted of the Camden Town Murder, used as the male model in the pictures with this title, is the main

example. The character of these pictures has somehow dominated the overall concept of Sickert's production. However, these very sordid themes in fact form a minority of his subjects, even in the period 1908–10. Most of Sickert's subjects were drawn from ordinary lower middle-class cockney life and represented scenes often drab and dreary, but not specifically sordid or extraordinary. Sickert believed it was his job as an artist to draw magic and poetry from such scenes of ordinary ready-made life. He expressed this view not only with great seriousness but also in the piquant and easily memorable epigrams of which he was a master. Emmons[21], recollecting Sickert's teaching when he often used these epigrams, quoted one example, that 'Tintoretto created jewels of painting from the most ordinary subjects: Sargent ordinary paintings from the most jewelled subjects'. In the same context Emmons related how Sickert stressed that:

> The most productive subjects are found in ordinary people in ordinary surroundings: neither too large nor too small, neither very rich nor very poor, neither very beautiful nor very ugly. Rare phenomena or extremes of any sort are bad subjects. A grey sky is better than an impossible sunset.

As Sickert wrote in his essay on Gore[22] 'it is not only out of scenes obviously beautiful in themselves, and of delightful suggestion, that the modern painter can conjure a panel of encrusted enamel'. The true beauty, magic, and poetry of a subject resided, for Sickert, in its treatment. Gore he especially commended because he had 'the digestion of an ostrich' and was able to transform the most dreary and hopeless scenes into things of beauty: 'The artist is he who can take a piece of flint and wring out of it drops of attar of roses.'

Sickert's emphasis on the importance of complete emotional detachment is relevant to the achievement of this transformation. Personal tastes and preferences had to be eliminated before the artist could accept the dreary ordinariness of his subject and concentrate on its true essence, forgetting all that was '*irrelevant* to *light and shade* irrelevant to colour'. As Sickert wrote in an essay called 'Idealism'[23]:

> while volumes are filled with explanations of the sublimity and the significance in the figures of Michelangelo or Veronese, the writers fail to note that these figures are always drawn and painted. The beauty and significance that they express, they are only able to achieve by means of a strong rendering of the gross material facts of bulk and shape, and colour.

Given that the apt expression of the plastic facts was for Sickert one of the most important aspects of painting, it is necessary to enquire whether the subject itself was no more than a pretext, or inspiration, for this treatment, or whether he was also concerned (at least in his figure subjects) with its illustrative content. Roger Fry wrote that things for Sickert 'have only their visual values, they are not symbols, they contain no key to unlock the secrets of the heart and spirit'[24]. Virginia Woolf, on the other hand, in her pamphlet on Sickert[25], elaborated the thesis that Sickert did unlock these secrets; that in his paintings re-creating lower middle-class life he was a great biographer or a novelist of the realist school —like Balzac or Dickens. She wove perfect literary fantasies around several of his pictures. She read a life-history of desolate tedium, and the pathetic breakdown of the marriage of a publican and his wife, in *Ennui*. Is it possible to reconcile these two interpretations of Sickert's art, made by two gifted and sensitive spectators, both of whom belonged to the same intellectual *milieu*, and both of whom knew Sickert personally? Virginia Woolf, of course, approached Sickert from her standpoint as a writer and Roger Fry approached him as a painter. A painting means different things to different people and in a sense any subjective interpretation of what it communicates to a particular individual is valid. It is, however, interesting to know what approach to his art is recommended or encouraged by the painter himself.

The evidence obtained from Sickert's writing and from his work is in apparent conflict. Mrs. Woolf,

in support of her interpretation of Sickert's art, wrote how she had once read a letter of Sickert in which he stated that he had 'always been a literary painter, thank goodness, like all the decent painters'. This statement is echoed in many other published writings. In 1912[26], for example, he wrote:

> It is just about a quarter of a century ago since I ranged myself . . . definitively against the Whistlerian anti-literary theory of drawing. All the greater draughtsmen tell a story. When people, who care about art, criticise the anecdotic 'Picture of the Year', the essence of our criticism is that the story is a poor one, poor in structure or poor as drama, poor as psychology. . . . A painter may tell his story like Balzac, or like Mr. Hichens. He may tell it with relentless impartiality, he may pack it tight, until it is dense with suggestion and refreshment, or his dilute stream may trickle to its appointed crisis of adultery, sown thick with deprecating and extenuating generalisations about 'sweet women'.

(It is interesting here to note that Roger Fry[27], writing about the way Sickert was solely a painter and did not seem to care what he painted, stated: 'It is almost as if the fancy took him to believe, what its author never really did, Whistler's Ten O'Clock.')

In 1925[28] Sickert wrote, 'great painting is illustration, illustration, illustration all the time'. It might be remembered that he made this statement shortly before he began to paint 'Echoes', paintings which unquestionably were illustrative even though the stories they told were of someone else's invention. In 1922[29] Sickert deprecated the modern tendency to dismiss illustrative painting and stated:

> The great paintings of the world are got out of the way by the convenient anathema of 'illustration'. Mantegna, Michelangelo, Veronese, Canaletto, Ford Madox Brown, Hogarth, Leech, Keene, *e tutti quanti*, falling, certainly, under the heading of 'illustration' must, I am afraid, go. Rubens, . . . can still be mentioned in decent company, but only, if you please, as 'the ancestor[s] of Cézanne'!

Not only did Sickert assert that great painting is illustration, he also held that 'One of the things in which it seems to me that we have a right to speak of progress is the intensity of dramatic truth in the modern conversation piece or *genre* picture'[30]. Sickert evidently classified his own figure subjects under this heading. His interpretation of *L'Armoire à Glace* as a 'sort of study à la Balzac' was quoted in full in Chapter XVII and will not be repeated here. Sickert's description of this painting is strictly analogous to those given by Virginia Woolf of other Sickert figure subjects, even in that both compared his work to Balzac.

However, in spite of Sickert's enthusiastic approval of illustrative painting, and in spite of his endorsement of the type of literary interpretation of his pictures presented by Mrs. Woolf, Sickert's method of working was the reverse of that of the illustrative artist. His capricious use of titles proves that his pictures could not have been illustrations of a given, preconceived story. *The Camden Town Murder* and *What Shall we do for the Rent?*, alternative titles for the same composition, do not describe the same story. Sickert's figure subjects were developed independently. He would become obsessed with some particular problem of the purely formal relations of the figures to each other in a group subject, to their setting, and to the spatial and surface construction of his composition; he would pursue the solution to such a problem in a series of drawings and paintings. For example, *Sunday Afternoon*, *Vacerra*, and *My Awful Dad*, to take only a short sequence from a longer series, are progressive variations upon the same formal problem, but the individual and arbitrary nature of their titles makes it obvious that they were not originally conceived as illustrations of a given theme. When Sickert's aesthetic investigations had achieved a satisfactory result which could be interpreted as telling a story he would add a title, as striking and piquant as possible, and thus help to direct the story his composition seemed to tell. If *Ennui*, for example, is placed in its chronological context we find it was the natural culmination of a line of drawings and paintings of two-figure subjects which were primarily probing examinations of the plastic, not the anecdotal, relationship between the protagonists. Sickert's

preparation for the picture did not consist in the study of a publican's life; the title, as well as such incidental details as the tumbler of beer (so important to the literary interpretation of the subject) were in a sense afterthoughts, by-products of its formal construction. Even the psychological tension between the figures is a by-product of the tension inherent in their plastic relationship.

The bare facts, the raw material of a subject, were important to Sickert primarily because they dictated the treatment and posed some of the formal problems to be solved in the painting. Nevertheless, Sickert's deliberate choice of emotionally evocative titles and incidental details indicates that the illustrative content of a picture did have some importance for him. (Sickert's use of these titles was also a part of his playful nostalgia for the Victorian age—later more frankly acknowledged in the 'Echoes'; and his use of literary captions may also have been part of his defiance of Whistler's theories.) It is, therefore, impossible to agree with Fry that things for Sickert had *only* their visual values. W. Egerton Powell's interpretation of Sickert's work[31] perhaps presents the most just balance in assessing the relative importance of content and treatment. He wrote that while Sickert's pictures

> are often a comment on life, we never feel that they have sprung from anything but a true pictorial and plastic emotion. We are convinced that Sickert first visualises his pictures as patterns of light-and-shade and colour, and afterwards perceives their latent philosophy of life and so gives them a witty title. But his wit must never lead us to suppose that Sickert is anything but first and foremost a painter.

Sickert himself, writing in 1910 on 'The Language of Art'[32], anticipated this interpretation. In a passage which carries great conviction, which has none of his characteristic outrageousness, no hint of deliberate shock tactics, he defined what subject and treatment meant to him:

> Criticism has set in opposition the words 'subject' and 'treatment'. Is it not possible that this antithesis is meaningless, and that the two things are one, and that an idea does not exist apart from its exact expression? Pictures, like streets and persons, have to have names to distinguish them. But their names are not definitions of them, or, indeed, anything but the loosest kind of labels that make it possible for us to handle them, that prevent us from mislaying them, or sending them to the wrong address. . . . The subject is something much more precise and much more intimate than the loose title that is equally applicable to a thousand different canvases. The real subject of a picture or a drawing is the plastic facts it succeeds in expressing, and all the world of pathos, of poetry, of sentiment that it succeeds in conveying, is conveyed by means of the plastic facts expressed, by the suggestion of the three dimensions of space, the suggestion of weight, the prelude or the refrain of movement, the promise of movement to come, or the echo of movement past. If the subject of a picture could be stated in words there had been no need to paint it.

NOTES

1. Letter undatable, except that being sent from Envermeu it was probably written in 1913 or 1914.
2. See Chapter XIV, note 18.
3. See Chapter XI, note 13.
4. *More Portraits of a Lifetime*, p. 117. Quoted by Emmons, p. 9.
5. Sickert's relationships with women suggest that he shunned, or was incapable of forming, very deep attachments. At various times in his life he did become sincerely fond of, and as far as his physical comforts were concerned dependent upon, different women. But the fact that within the space of one year (1910–11) he could throw himself into the courtship of three women in quick succession suggests his affections were superficial. He could be a treacherous friend, dropping people without much compunction for inadequate reasons, however helpful and loyal they had been to him in the past (like Jacques-Émile Blanche and Arthur Clifton). Fundamentally Sickert was a very self-centred man.

6. The *Fortnightly Review*, 84, December 1908, pp. 1017–28, 'The New Life of Whistler', p. 1026.
7. The *Art News*, 12 May 1910, 'Idealism'.
8. Preface to the 'London Impressionists' catalogue, Goupil Gallery, December 1889.
9. The *Art News*, 12 May 1910, 'Idealism'.
10. The *English Review*, March 1912, pp. 713–20, 'A Critical Calendar', p. 717.
11. The *New Age*, 16 June 1910, 'The Study of Drawing'.
12. Sickert quoted this story in a letter to Miss Sands written during the 1914–18 War (see Chapter XIII). It is possible that Brown used the unpleasantness of Sickert's subjects only as an excuse to terminate their friendship; it seems from other letters written to Miss Hudson in 1915 that Brown sided with Gilman in his quarrel with Sickert about the teaching job at the Westminster Technical Institute. Sickert had been teaching at the Institute for several years but when he

dropped the job for a year Gilman took over; when Sickert reclaimed the position in October 1915 Gilman lost it.

13. The *Yorkshire Observer*, 1 December 1912.

14. The *English Review*, April 1912, pp. 147–54, 'The Futurist "Devil among the Tailors"', p. 151.

15. The *New Age*, 21 July 1910, 'The Naked and the Nude'.

16. The *New Age*, 30 April 1914, 'Mr. Ginner's Preface'.

17. Preface to the 'London Impressionists' catalogue, Goupil Gallery, December 1889.

18. *Drawing and Design*, 3, No. 13, July 1927, 'Walter Richard Sickert A.R.A.'

19. B.60, p. 29.

20. Letter dated in Chapter XV, note 25.

21. p. 173.

22. The *New Age*, 9 April 1914, 'A Perfect Modern'.

23. The *Art News*, 12 May 1910.

24. The *Nation*, 8 July 1911, 'Mr. Walter Sickert's Pictures at the Stafford Gallery'.

25. *Walter Sickert: a Conversation*, London, Hogarth Press, 1934.

26. The *English Review*, March 1912, pp. 713–20, 'A Critical Calendar', p. 716.

27. The *Nation*, 8 July 1911, 'Mr. Walter Sickert's Pictures at the Stafford Gallery'.

28. The *Daily Telegraph*, 4 November 1925, 'Fairy Food'.

29. The *Burlington Magazine*, 41, December 1922, pp. 276–8, 'The "Derby Day"'.

30. The *Burlington Magazine*, 28, December 1915, pp. 117–21, 'A Monthly Chronicle. Maurice Asselin'.

31. *Artwork*, IV, No. 13, Spring 1928, 'What are we coming to (Some Recent Art Exhibitions)', in which Mr. Powell reviewed, p. 5, Sickert's work currently on view at the Savile Gallery.

32. The *New Age*, 28 July 1910.

Plates

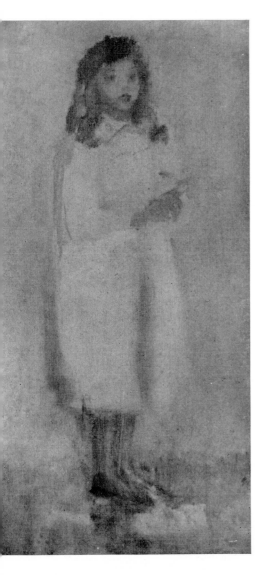

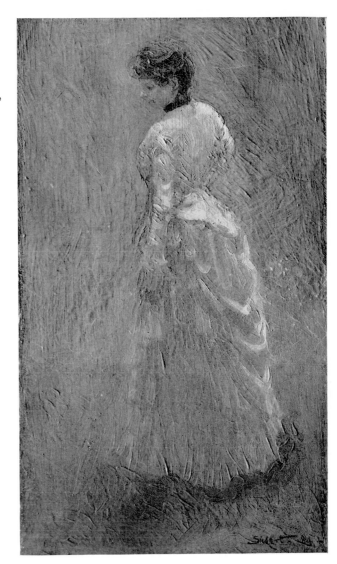

1. *The Little Street Singer* (C.2). Private Collection, Scotland

2. *The Grey Dress* (C.1). Manchester, City Art Gallery

3. *Rehearsal. The End of the Act* or *The Acting Manager* (C.3). Private Collection

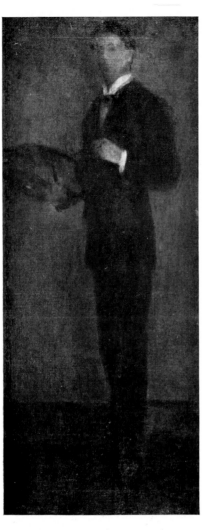

4. *L'Homme à la Palette* (C.5). Sydney, Art Gallery of New South Wales

5. *Girl Sewing* (C.4). Coll. Mrs. Leslie

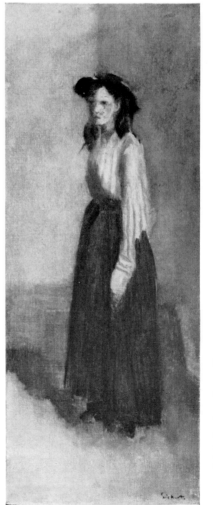

6. Far left: *Martin Église* (C.20). Paris, Mouradian et Valotton

7. Left: *Standing Woman* or *Le Corsage Rayé* (C.6). Coll. Mary Averoff, Paris

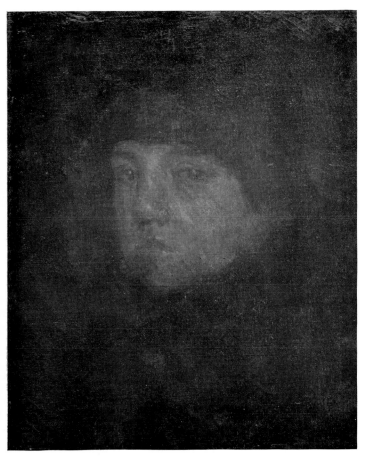

8. *Tête de Femme* (C.7). Musée de Rouen

9. *On the Sands, St. Ives* (C.18). Coll. the Hon. Christopher McLaren Esq.

10. *Violets* (C.17). Bath, Victoria Art Gallery

11. *Clodgy Point, Cornwall* (C.19). University of Glasgow

12. *The Butcher's Shop* (C.21). York, City Art Gallery

13. *La Plage* (C.22). Manchester,
City Art Gallery

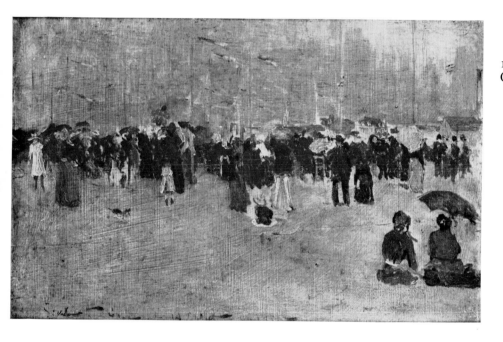

14. *Le 14 Juillet* (C.24). Private
Collection, London

15. *Les Courses de Dieppe* (C.25).
Coll. Mr. and Mrs. Paul Mellon

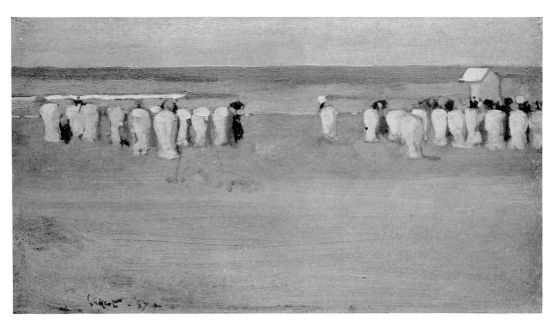

16. *Windstoeln. Scheveningen* (C.27). Private Collection, London

17. *Le Marché aux Bestiaux* (C.26). Private Collection, Los Angeles

18. Opposite, above left: *Seascape* (C.29). Edinburgh, Scottish National Gallery of Modern Art

19. Opposite, above right: *The Laundry Shop* (C.23). Leeds, City Art Gallery

20. Opposite, below: *The Red Shop* or *The October Sun* (C.30). Norwich, Castle Museum

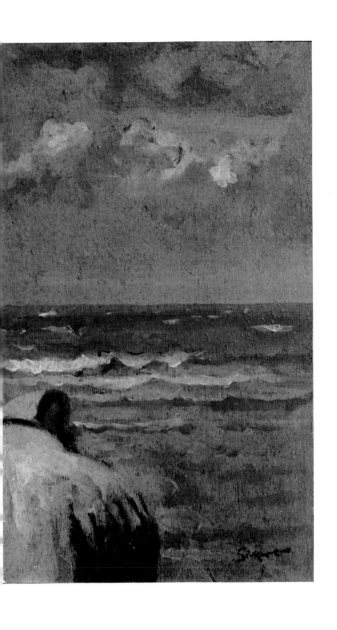

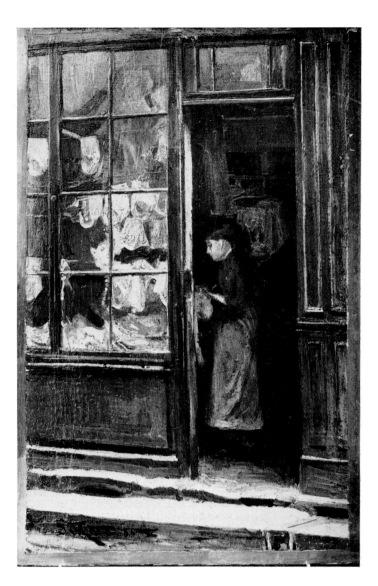

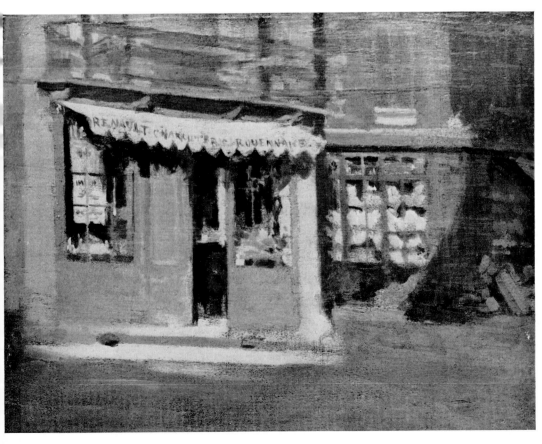

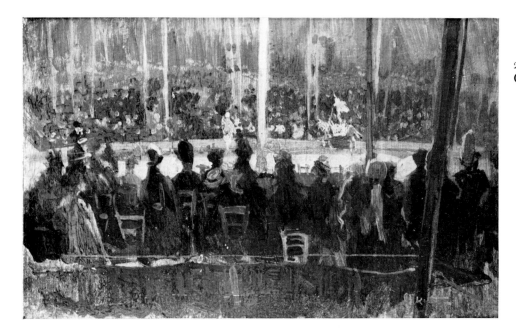

21. *The Circus* (C.38). Private Collection, London

22. *The Beach at Scheveningen* (C.28). Coll. Mr. and Mrs. Paul Mellon

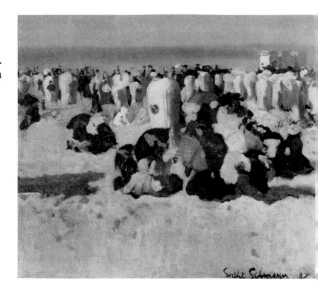

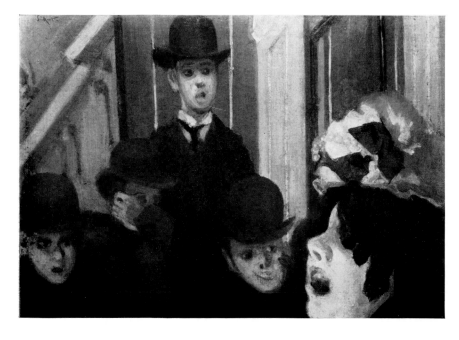

23. *Bonnet et Claque. Ada Lundberg at the Marylebone Music Hall* (C.41). Private Collection, London

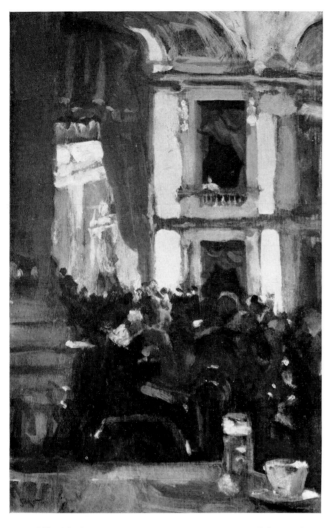

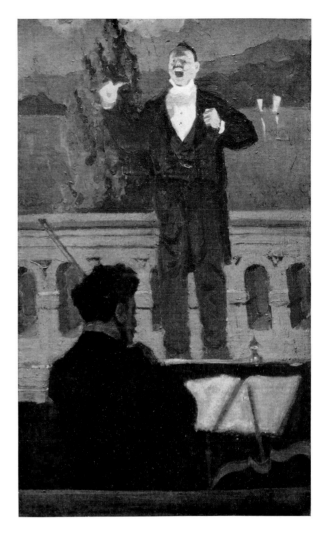

24. *The Kurhuis, Scheveningen* (C.39). Coll. Richard Attenborough Esq.

25. *The Lion Comique* (C.40). Coll. The Cottesloe Trustees

26. *Little Dot Hetherington at the Bedford Music Hall* (C.44). Private Collection, England

27. *Queenie Lawrence at Gatti's Hungerford Palace of Varieties* (C.43). Private Collection, London

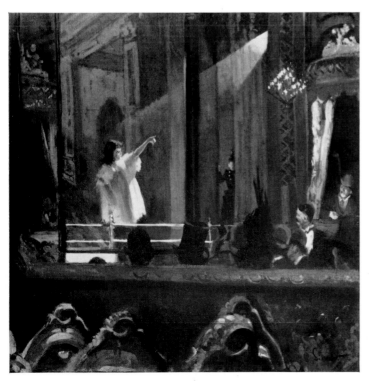

28. *Gatti's Hungerford Palace of Varieties. Second Turn of Katie Lawrence* (C.42). Sydney, Art Gallery of New South Wales

29. *Red, White and Blue* (C.49). Private Collection, England

30. *The P.S. Wings in an O.P. Mirror* (C.45). Musée de Rouen

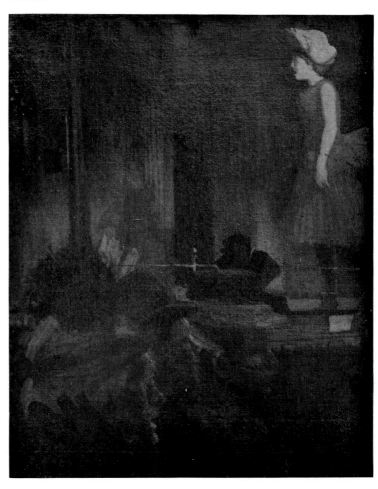

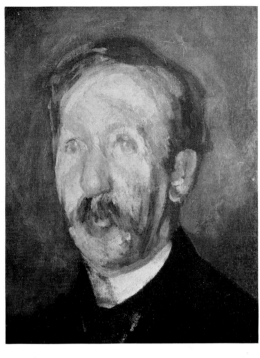

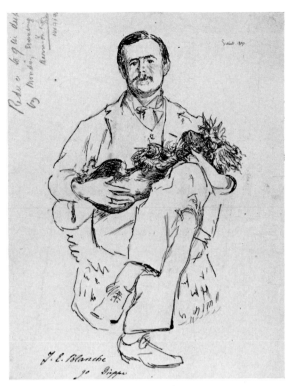

32. *Jacques-Émile Blanche* (C.52). Private Collection, London

31. *George Moore* (C.55). London, Tate Gallery

33. Right: *Mrs. Ernest Leverson* (C.58). Whereabouts unknown

35. Below right: *Charles Bradlaugh* (C.54). London, National Liberal Club

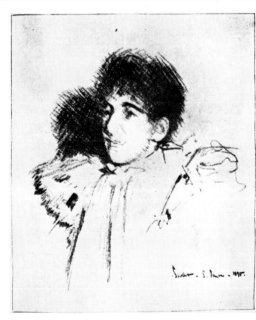

34. *The Sisters Lloyd* (C.47). London, Department of the Environment (location Foreign and Commonwealth Office)

36. *Vesta Victoria at the Old Bedford* (C.48). Private Collection

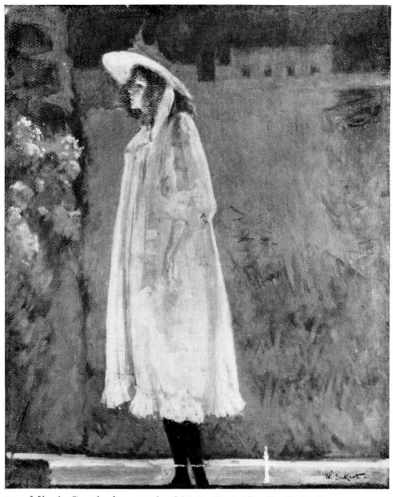

37. *Minnie Cunningham at the Old Bedford* (C.46). Coll. Peter Pears Esq.

38. *Mr. Bradlaugh at the Bar of the House of Commons* (C.56). Manchester, City Art Gallery

39. *Philip Wilson Steer* (C.53). London, National Portrait Gallery

40. *Aubrey Beardsley* (C.57). London, Tate Gallery

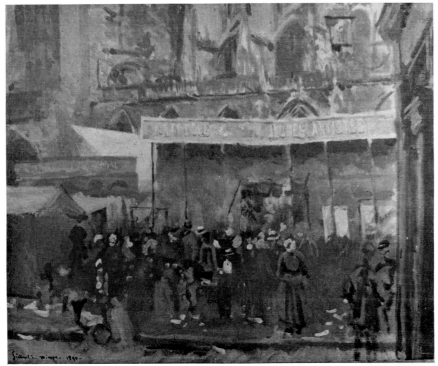

41. *The Theatre of the Young Artists* (C.64).
Southport, Atkinson Art Gallery

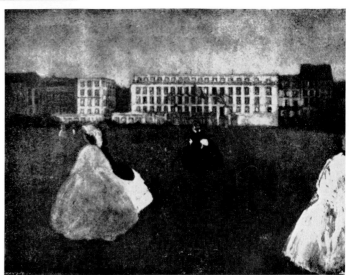

42. *L'Hôtel Royal, Dieppe* (C.67).
Whereabouts unknown

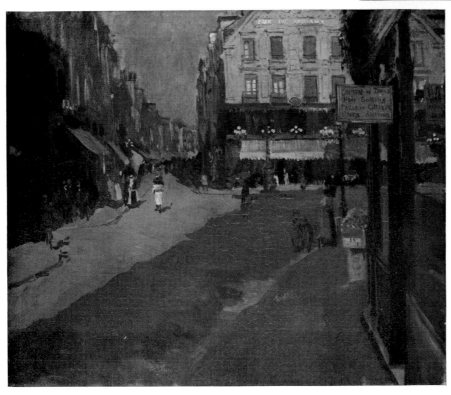

43. *Café des Tribunaux* (C.65). London,
Tate Gallery

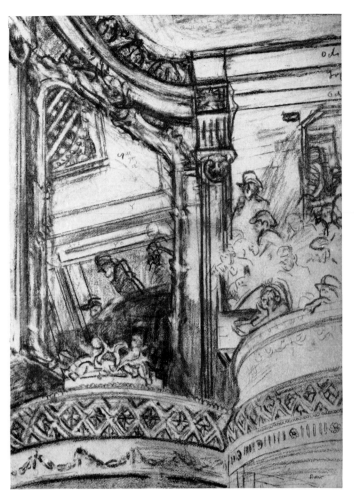

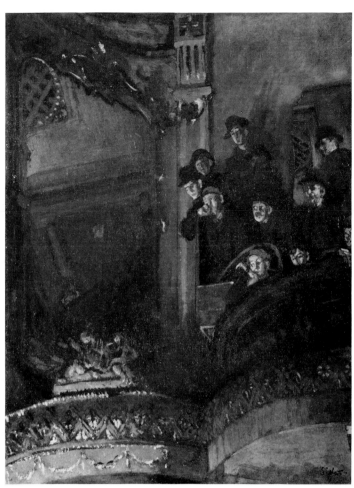

44. *The Gallery of the Old Bedford* (C.74). Private
Collection, England

45. *The Gallery of the Old Bedford* (C.73). Liverpool,
Walker Art Gallery

46. *The Gallery of the Old Bedford* (C.75). Coll. William
Shand-Kydd Esq.

47. *The Gallery of the Old Bedford* (C.76). Private
Collection, London

48. *L'Hôtel Royal,
Dieppe* (C.68). Coll.
M. Georges Mevil-
Blanche, Offranville,
France

49. *The Pit at the Old Bedford* (C.72). London,
British Museum

50. *Le Mont de Neuville* (C.66). Private Collection,
South Africa

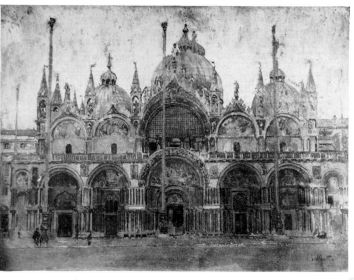

51. *The Façade of St. Mark's* (C.81). Oxford, Ashmolean Museum

52. *The Façade of St. Mark's. Red Sky at Night* (C.82). Southampton Art Gallery

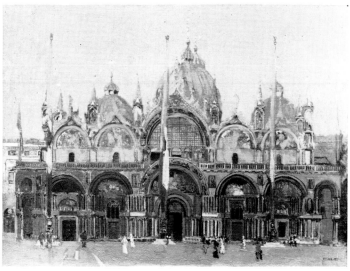

53. *The Dogana and Santa Maria della Salute* (C.80). Private Collection, London

54. *The Scuola di San Marco. Ospedale Civile* (C.83). Private Collection, England

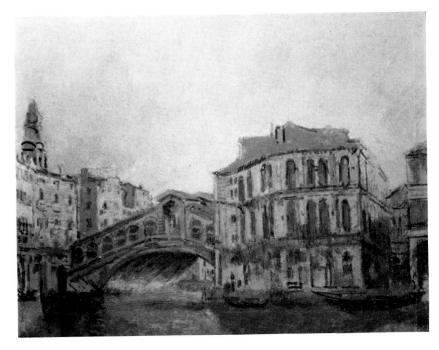

55. *The Rialto Bridge and Palazzo Camerlenghi* (C.84). Private Collection, England

57. Below: *Sailing Boats on the Grand Canal* (C.85). Private Collection

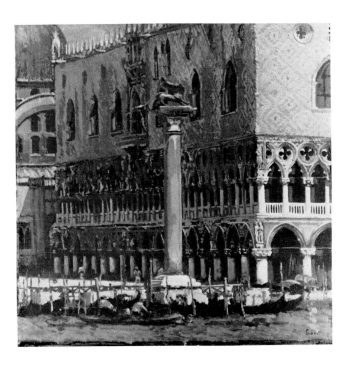

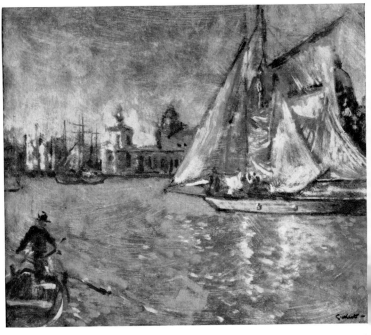

56. Above: *The Lion of St. Mark* (C.86). Cambridge, Fitzwilliam Museum

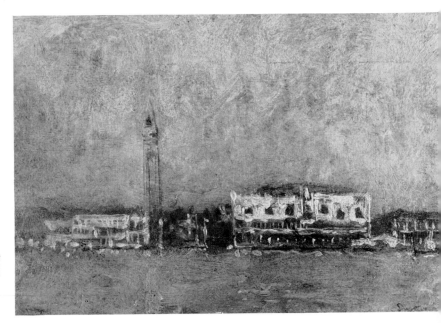

58. *The Doge's Palace and the Campanile* (C.88). Private Collection, England

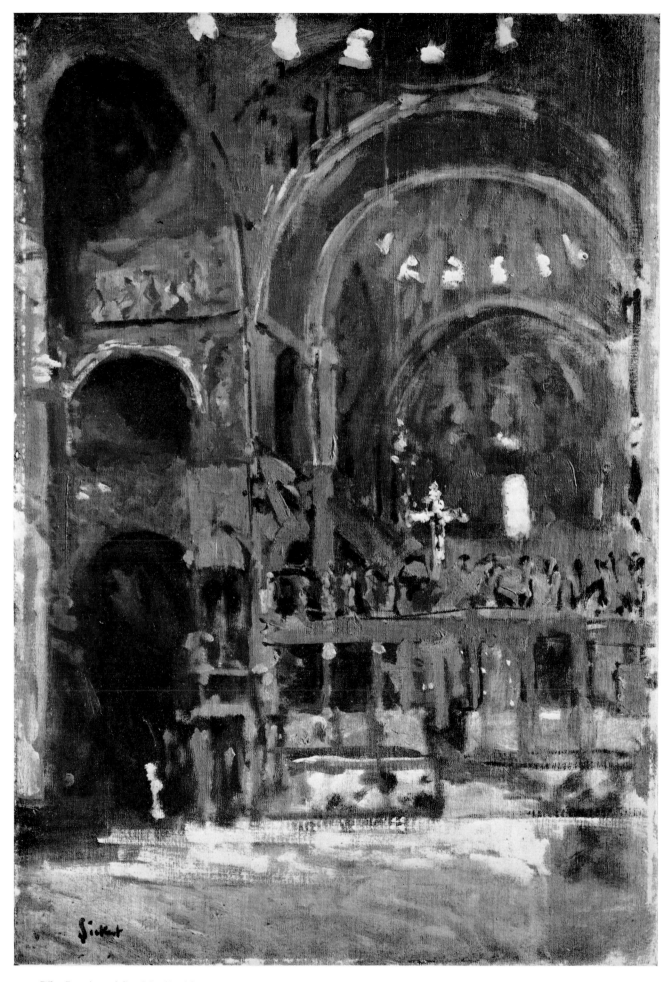

59. *The Interior of St. Mark's* (C.87). London, Tate Gallery

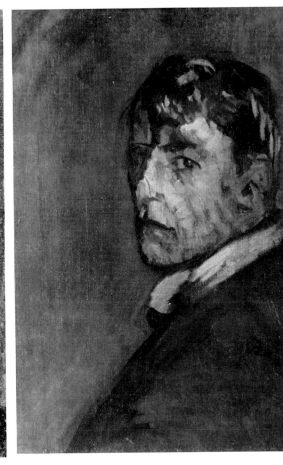

60. *Miss Ellen Heath* (C.92). Leeds, City Art Gallery

61. *Self-Portrait* (C.93). Leeds, City Art Gallery

62. *Fred Winter* (C.94). Washington D.C.,
Phillips Art Gallery

63. *Self-Portrait* (C.95). Coll. Sir John and Lady Witt

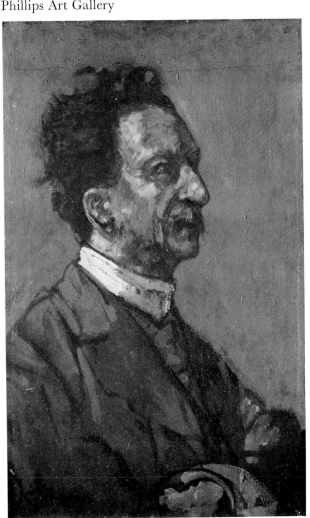

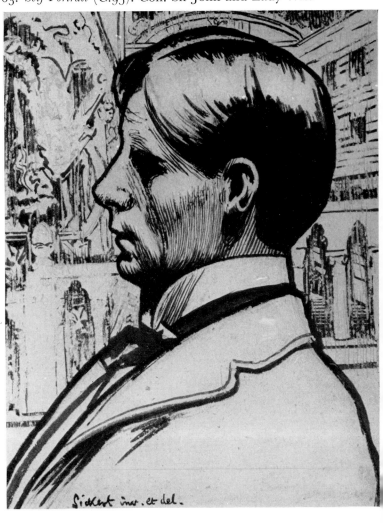

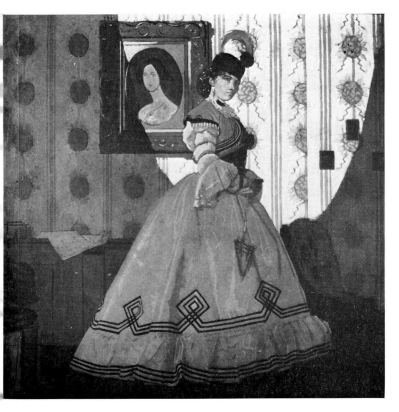

64. *The Pork Pie Hat. Hilda Spong in 'Trelawny of the Wells'* (C.77). Johannesburg Art Gallery

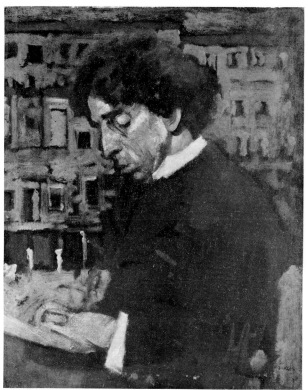

65. *Israel Zangwill* (C.96). Edinburgh, Scottish National Gallery of Modern Art

66. *Fondamenta del Malconton* (C.89). Private Collection, London

67. *A Pail of Slops* (C.97). Private Collection, England

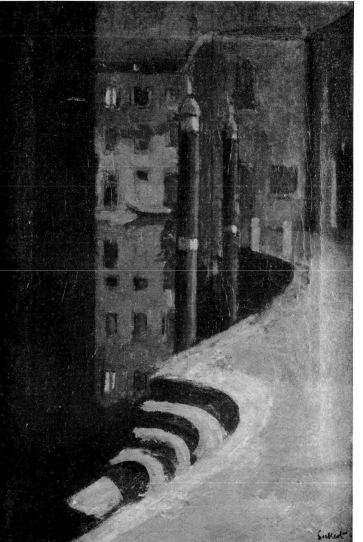

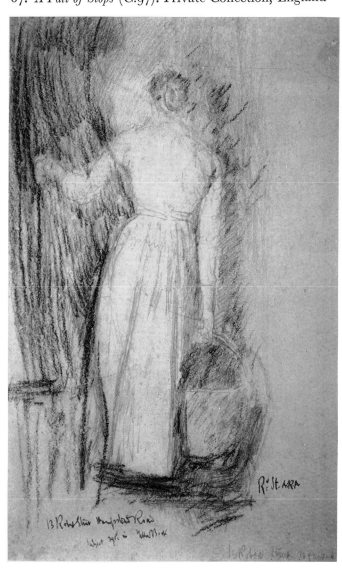

68. *The Façade of St. Mark's. Pax Tibi Marce Evangelista Meus*
(C.100). London, Tate Gallery

69. *Une Rue à Dieppe* (C.105). Private
Collection, London

70. *Quai Duquesne and the Rue Notre Dame* (C.102).
Perth, Art Gallery of Western Australia

71. *Cumberland Market* (C.101). Toronto, Art Gallery
(Gift of Massey Foundation)

73. *Le Petit Trianon* (C.109). Leeds, City Art Gallery

72. *La Maison qui fait le Coin* (C.108). Private Collection, London

74. *The Flower Market* or *Le Marché, Rue de la Boucherie* (C.106). Sydney, Art Gallery of New South Wales

75. *Les Arcades et la Darse* (C.107). Private Collection, London

76. *St. Jacques Façade* (C.113). London, Messrs. Roland, Browse and Delbanco

77. *Le Grand Duquesne* (C.114). Melbourne, National Gallery of Victoria

Le Grand Duquesne (C.111). Coll. Victor Montagu
9.

79. *La Rue Notre Dame and the Quai Duquesne* (C.112).
Private Collection

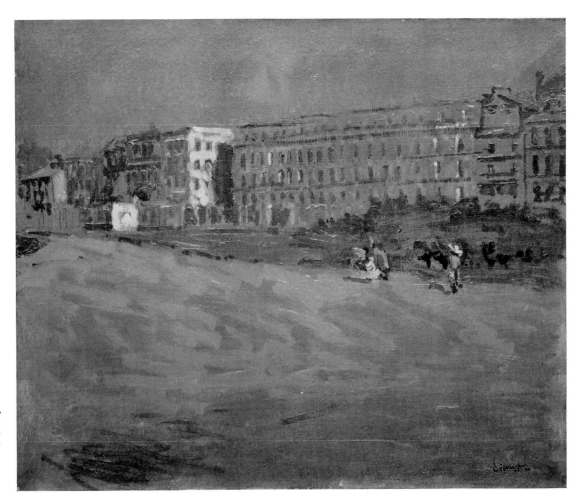

80. *L'Hôtel Royal*
(C.110). Hull, Ferens
Art Gallery

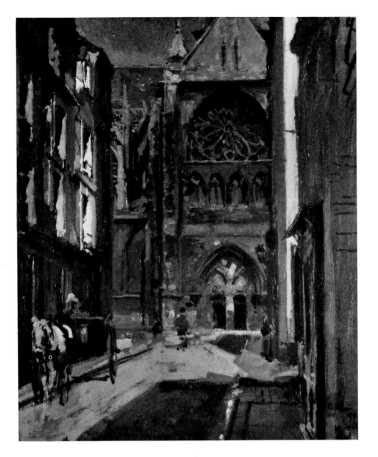

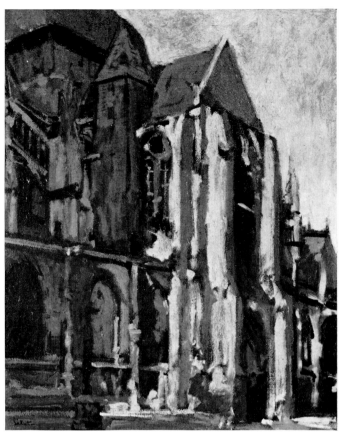

81. *La Rue Pecquet* (C.115). Birmingham, City Art Gallery

82. *South Façade of St. Jacques* (C.116). London, Leicester Galleries

83. *Le Chevet de l'Église* (C.117). Private Collection, London

84. *St. Jacques Façade* (C.119). University of Newcastle upon Tyne, Hatton Gallery

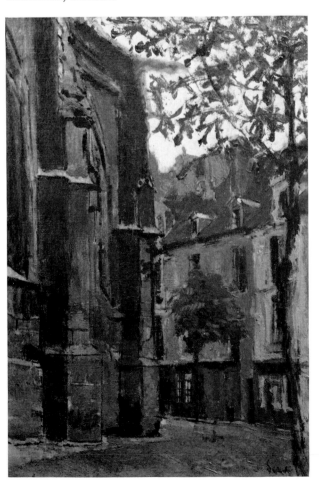

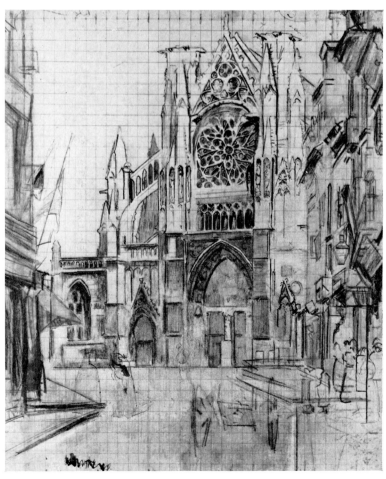

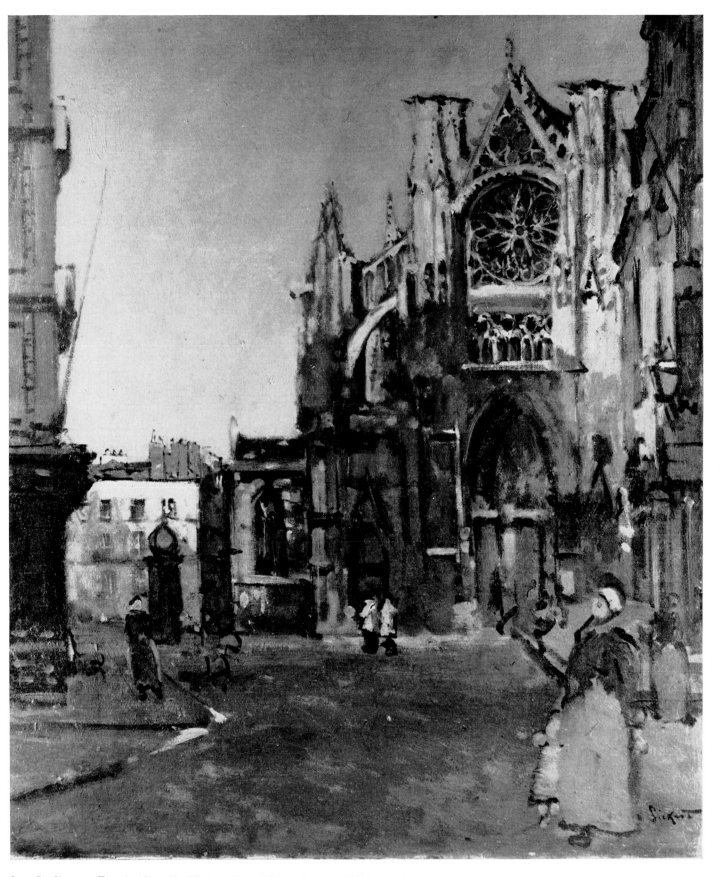

85. *St. Jacques Façade* (C.118). University of Manchester, Whitworth Art Gallery

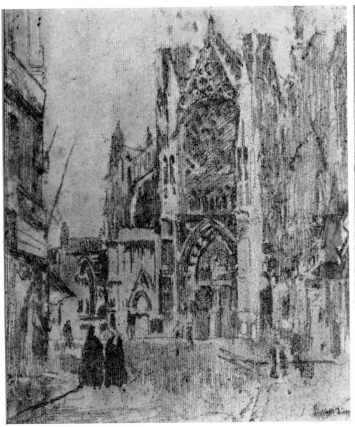

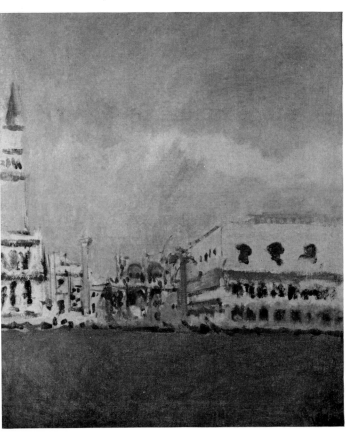

86. *St. Jacques Façade* (C.120). London, British Council

87. *The Doge's Palace and the Campanile* (C.129).
Private Collection, London

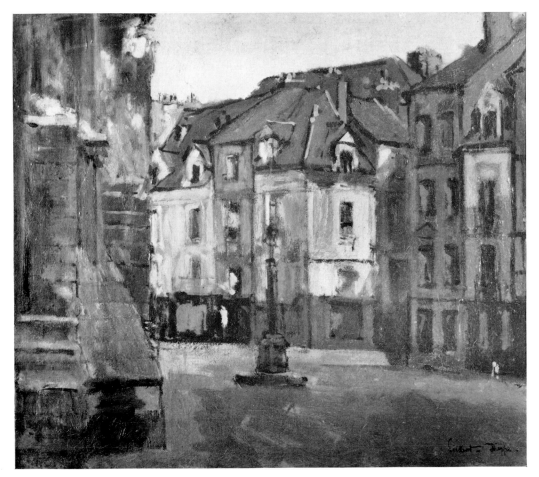

88. *La Halle au Lin* (C.121).
Private Collection

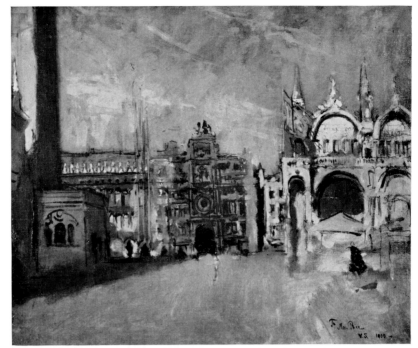

89. *Piazza San Marco* (C.130). Private Collection

90. *Les Arcades de la Bourse* (C.122). Columbus, Ohio, Gallery of Fine Arts (Howald Fund)

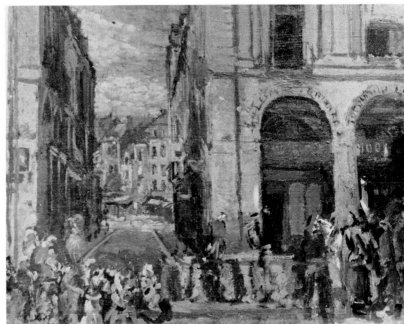

91. *Santa Maria Formosa* (C.131). Private Collection, England

92. *St. Mark's* (C.132). Private Collection, London

93. *The Horses of St. Mark's* (C.133). Private Collection, Scotland

94. *Santa Maria della Salute* (C.134). London, Royal Academy of Arts

95. *The Bridge of Sighs* (C.136). Private Collection

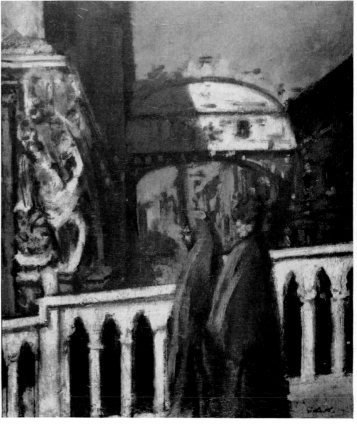

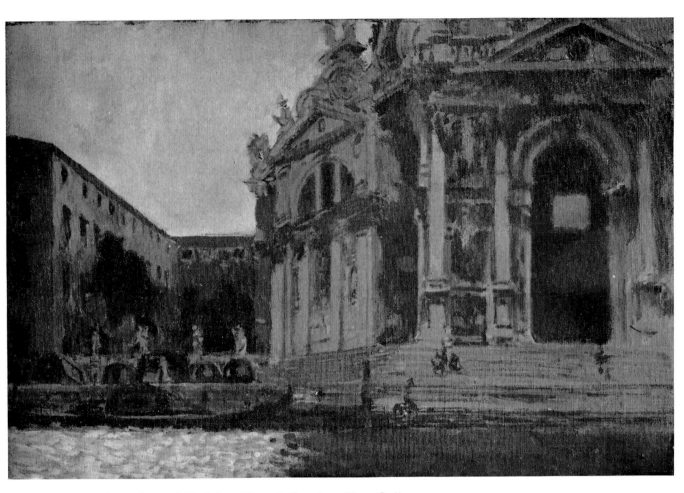

96. *The Steps of Santa Maria della Salute* (C.135). London, Tate Gallery

97. *San Giorgio Maggiore* (C.137). Melbourne, National Gallery of Victoria

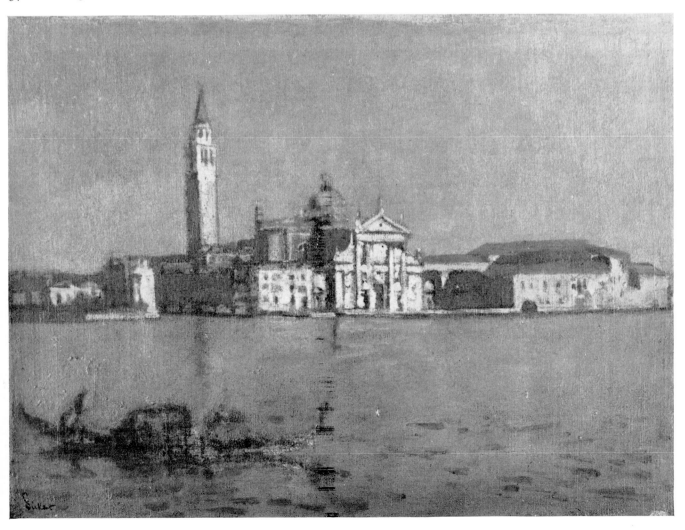

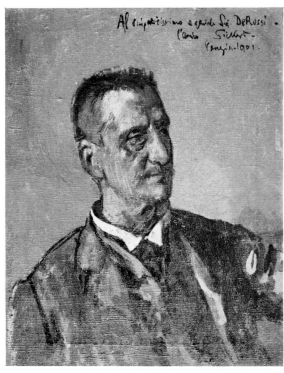

98. *Signor de Rossi* (C.142). Hastings, Museum and Art Gallery

99. Below left: *Le Palais des Doges au Crépuscule* (C.138). Private Collection, London

100. Below: *The Bathers, Dieppe* (C.149). Liverpool, Walker Art Gallery

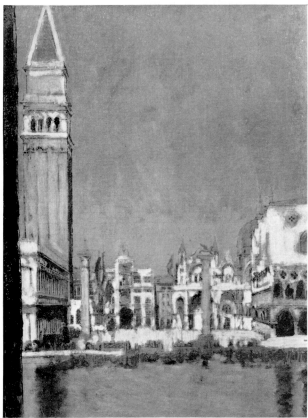

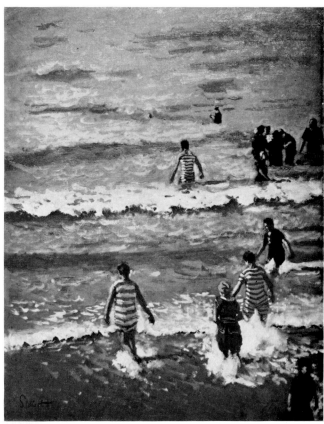

101. *Nude on a Bed* (C.144). Coll. Professor A. Betts

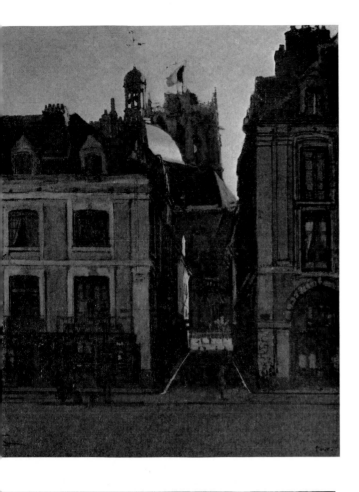

103. *La Darse* (C.150). Glasgow, City Art
Gallery

102. Above left: *La Rue Notre Dame and the Quai Duquesne*
(C.148). Ottawa, National Gallery of Canada
(Massey Coll. of English Painting)

104. Left: *Venetian Stage Scene* (C.143). Coll. Lord Ilford

105. *La Rue de la Boucherie with St. Jacques* (C.151). York, City Art Gallery

106. *Dieppe* (C.152). Private Collection, Scotland

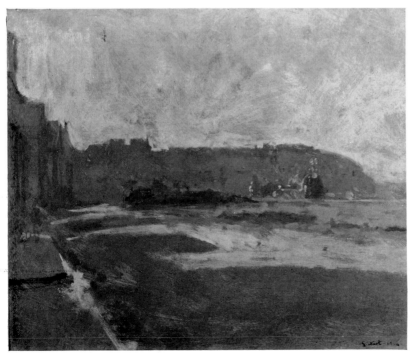

107. *The Casino. Boulevard de Verdun* (C.153). London, Messrs. Roland, Browse and Delbanco

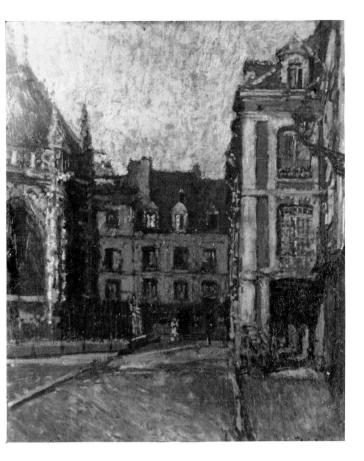

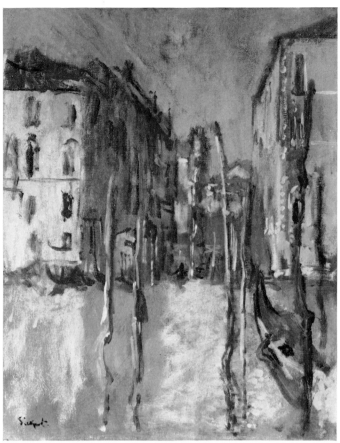

108. *La Rue Ste. Catherine et les Vieux Arcades* (C.155).
Private Collection

109. *Il Traghetto* (C.160). Coll. Dr. Henry M. Roland

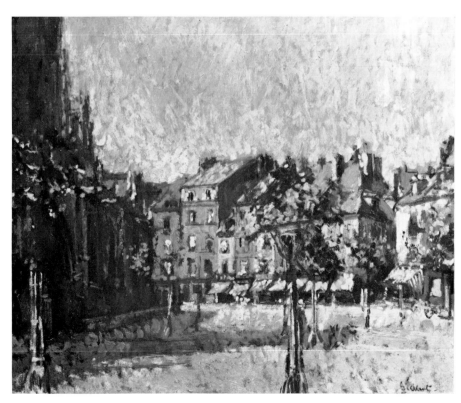

110. *La Rue de la Boucherie* (C.154).
Coll. Dr. S. Cochrane Shanks

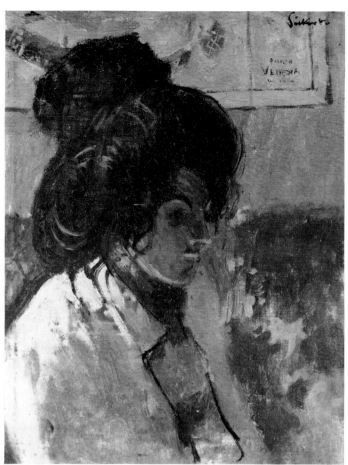

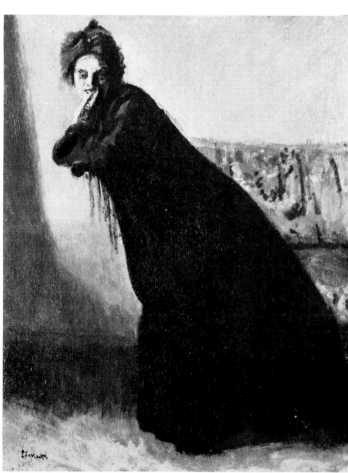

111. *La Giuseppina against a Map of Venice* (C.164). Coll. Mr. and Mrs. Peter Hughes

112. *Le Châle Vénitien* (C.165). Private Collection, England

113. *Putana a Casa* (C.169). London, Messrs. Roland, Browse and Delbanco

114. *La Giuseppina. La Bague* (C.167). Private Collection, London

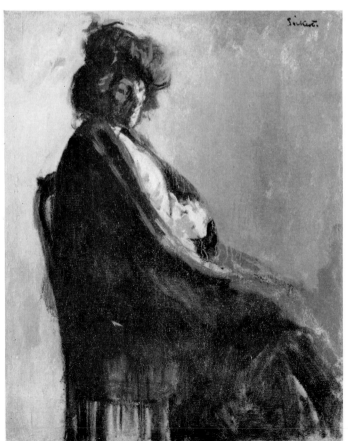

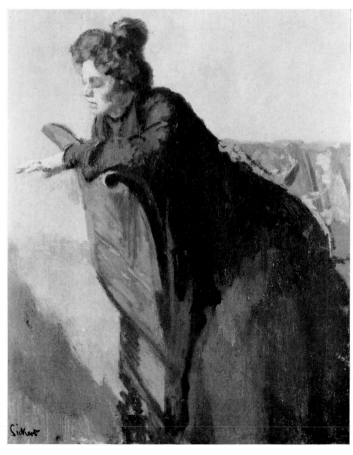

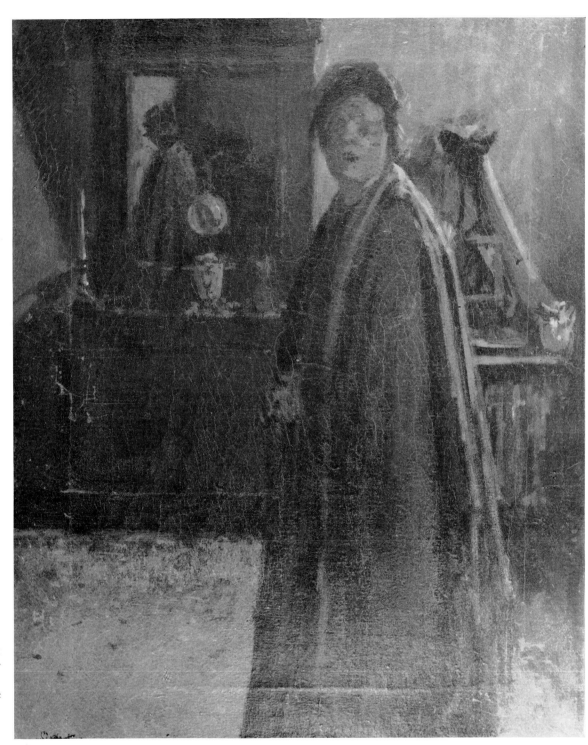

115. *La Carolina
in an Interior*
(C.168). Paris,
Bernheim-Jeune

116. *Venetian Girl on a Couch* (C.166). Coll.
M. Georges Mevil-Blanche, Offranville, France

117. *Vénitienne Allongée à la Jupe Rouge* (C.171).
Musée de Rouen

118. *Fille Vénitienne Allongée* (C.173).
Musée de Rouen

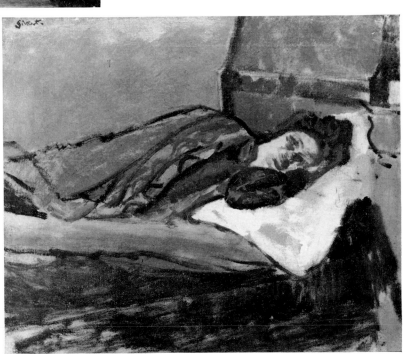

119. *La Carolina in a Tartan Shawl* (C.170).
London, Messrs. Sotheby's 1971

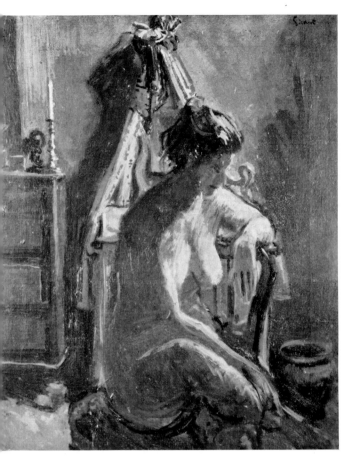

120. *The Beribboned Washstand* (C.172). Private Collection, Eire

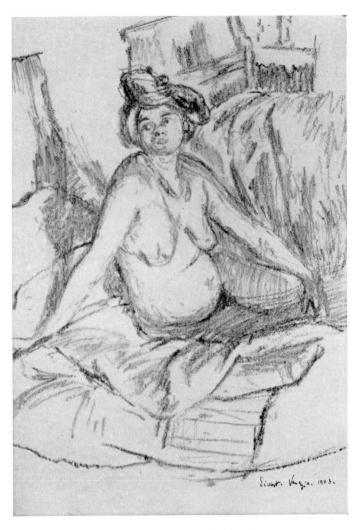

121. *Putana Veneziana* (C.176). Coll. Hugh Beaumont Esq.

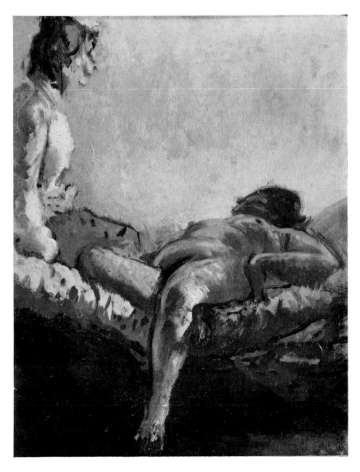

122. *Conversation* (C.174). Private Collection, England

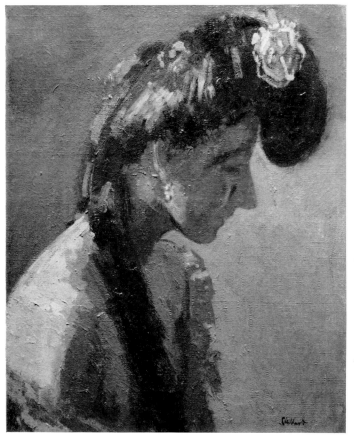

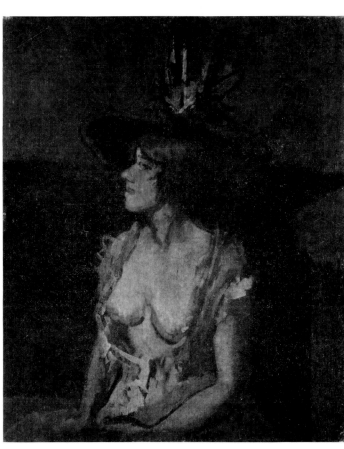

123. *Danseuse de Memphis, U.S.A.* (C.178). Private Collection, London

124. *The Large Hat* (C.177). Private Collection, England

125. *Mamma mia Poveretta* (C.182). Manchester, City Art Gallery

126. *Maria Bionda* (C.175). Coll. Dr. and Mrs. Bernard Brandchaft, Los Angeles

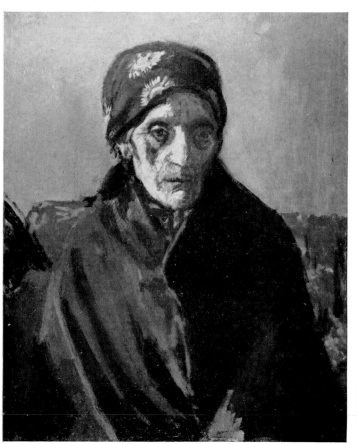

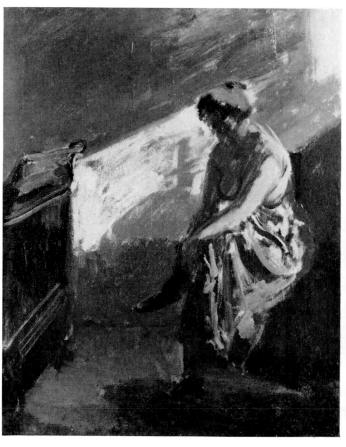

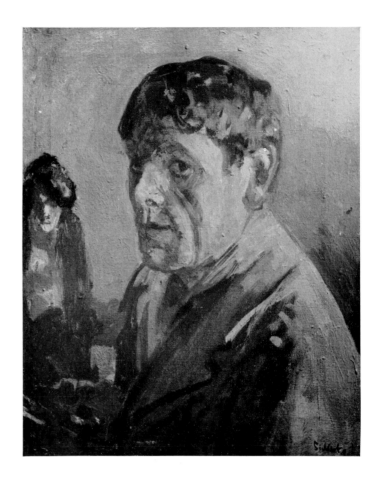

127. *Giorgione San Silvestre* (C.179). Private Collection, London

128. *Self-Portrait with La Giuseppina* (C.181). Private Collection (last known owner Dr. Bevan-Pritchard)

129. *La Jolie Vénitienne* (C.183). Private Collection, Scotland

130. *Self-Portrait* (C.180). Oxford, Ashmolean Museum

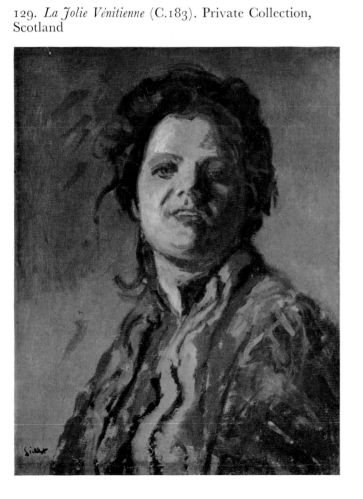

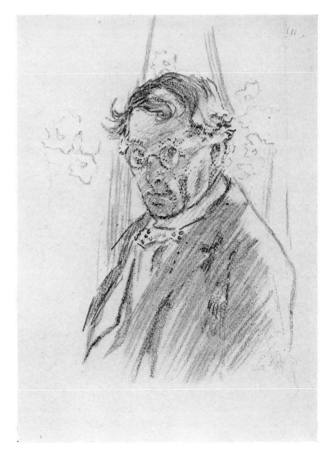

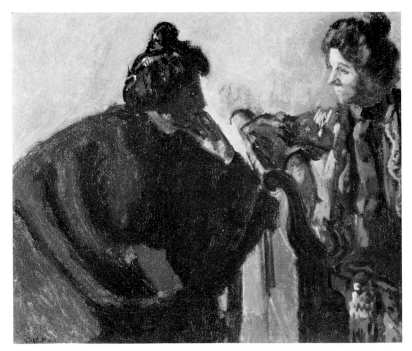

131. *Caquetoëres* (C.184). Private Collection, London

132. *Le Lit de Fer* (C.199). Whereabouts unknown

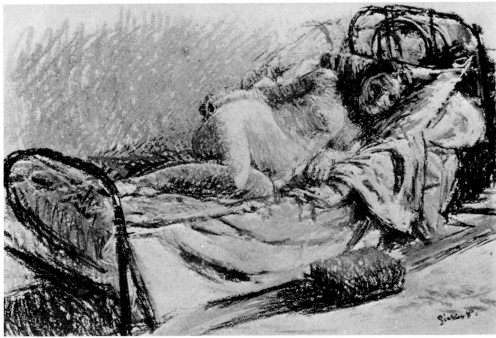

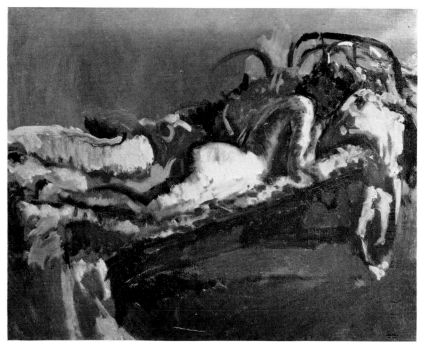

133. *La Belle Rousse* (C.198). Private Collection, London

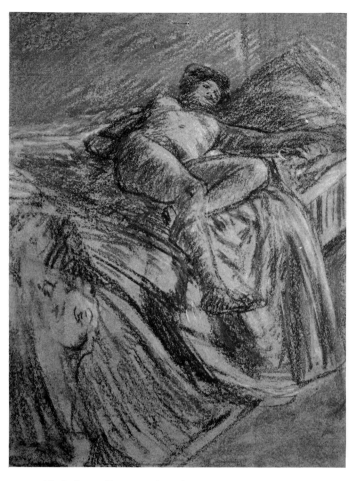

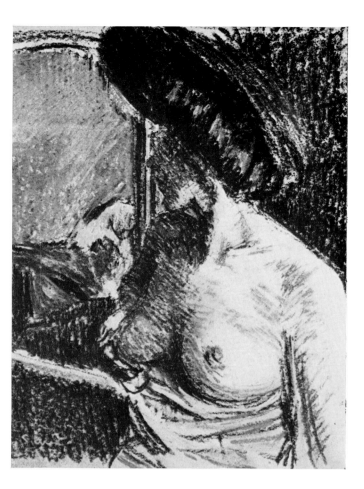

134. *Nude Sprawling on a Bed* (C.200). Coll. Mr. and
Mrs. Hamish Hamilton

135. *Cocotte de Soho* (C.207). Whereabouts unknown

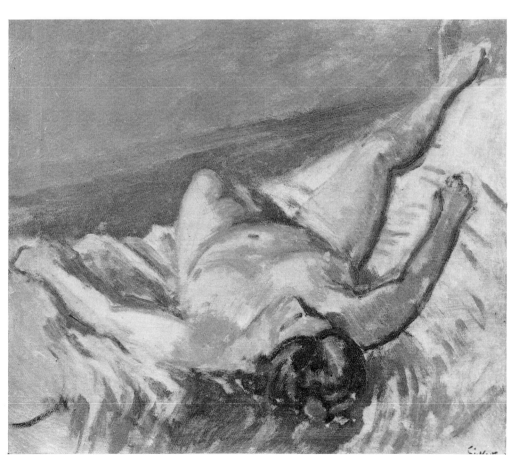

136. *Nude* (C.201). Private
Collection

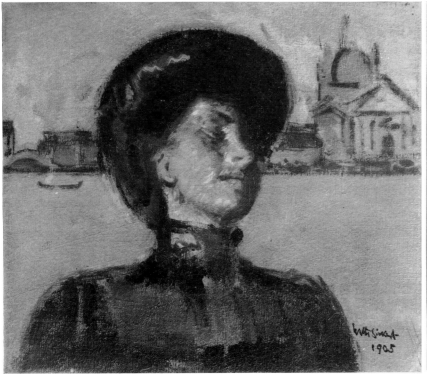

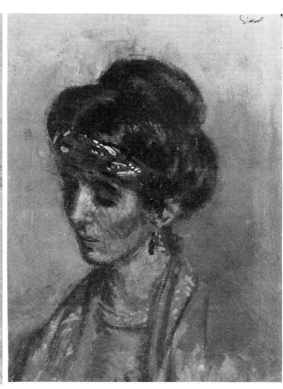

137. *Mrs. Swinton. The Lady in a Gondola* (C.203). Oxford, Ashmolean Museum

138. *Lady Noble* (C.204). Bath, Victoria Art Gallery

140. *Une Tasse de Thé* (C.205). Auckland, City Art Gallery

139. *The Visitor* (C.206). Coll. Lady Lambe

141. *Nude* (C.208). Private Collection

142. *Le Lit de Cuivre* (C.209). Coll. Nigel Haigh Esq.

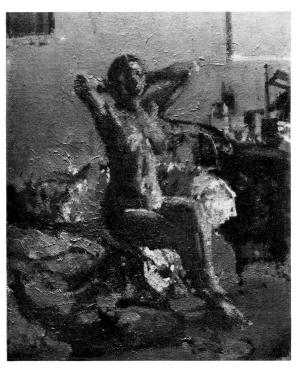

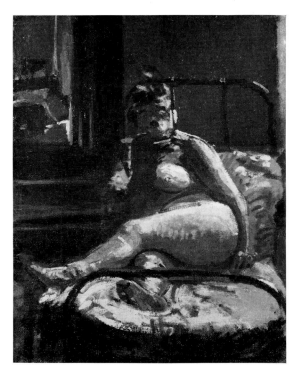

143. *Nude Stretching* (C.210). Private Collection
(last known owner F. B. Hart Jackson Esq.)

144. *La Hollandaise* (C.211). Private
Collection, London

145. *Nude drawing*
(C.211). Ottawa,
National Gallery of
Canada

146. *Mornington Crescent Nude. Contre-Jour* (C.213). Coll. Lord Sainsbury

147. *Nuit d'Été* (C.212). Private Collection, London

148. *Nude behind Flowers* (C.214). London, Messrs. Sotheby's 1971

149. *Fancy Dress. Miss Beerbohm* (C.215). Liverpool, Walker Art Gallery

150. *Les Petites Belges. Jeanne and Hélène Daurment* (C.216). Boston, Museum of Fine Arts

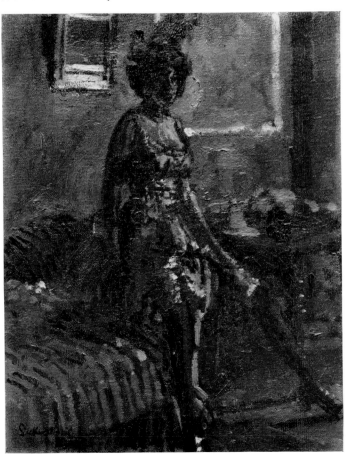

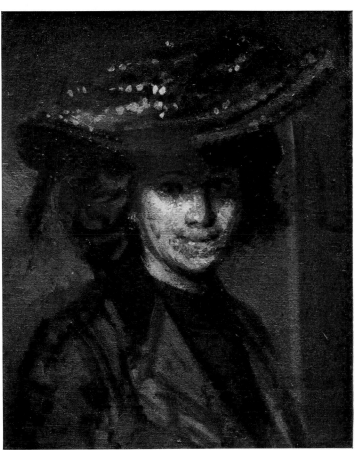

151. *Easter Monday. Hélène Daurment* (C.217). Private Collection, Scotland

152. *Mrs. Barrett* (C.218). Coll. William E. Wallace Esq.

153. *Mrs. Barrett* (C.219). London, Courtauld Institute of Art

154. *The Belgian Cocotte* (C.220). London, Arts Council of Great Britain

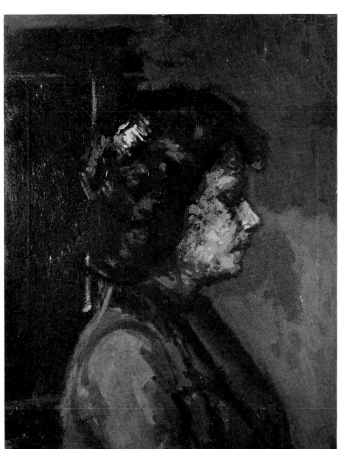

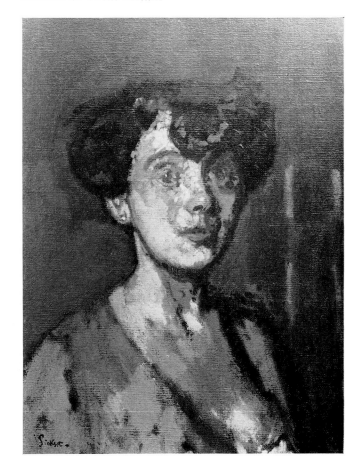

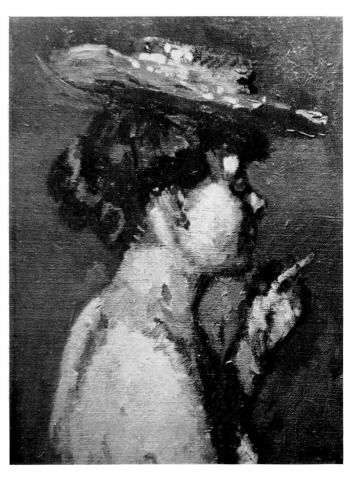

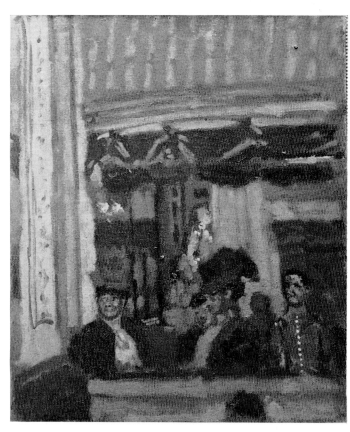

156. *La Gaieté Rochechouart* (C.234). Aberdeen,
City Art Gallery

155. *Jeanne. The Cigarette* (C.221). Private Collection
(last known owners Mr. and Mrs. James Fosburgh,
New York)

157. *Mrs. Swinton* (C.223). Cambridge, Fitzwilliam
Museum

158. *The Old Model* (C.222). Private Collection, London

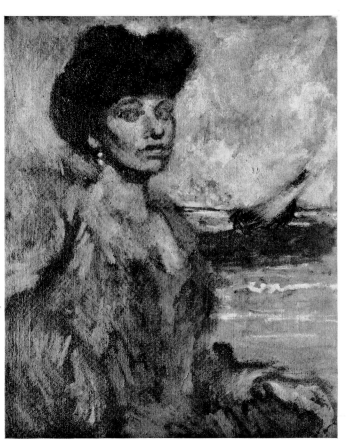

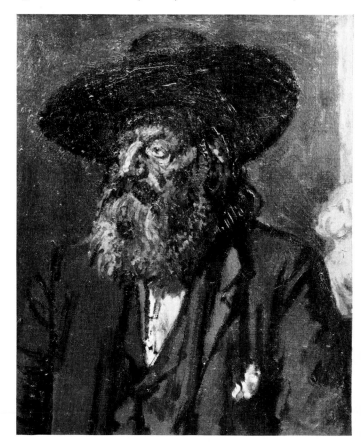

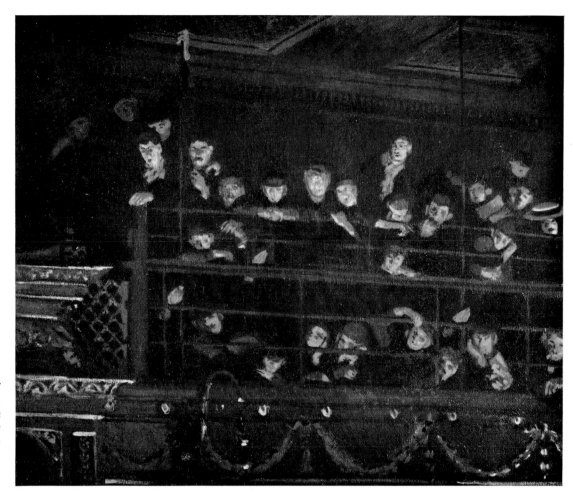

159. *Noctes Ambrosianae* (C.230). Nottingham, Castle Museum and City Art Gallery

160. *The Old Middlesex* (C.231). Fredericton, New Brunswick, Beaverbrook Art Gallery

161. *The Old Middlesex* (C.232). Bedford, Cecil Higgins Art Gallery

162. *Théâtre de Montmartre* (C.233). Coll. Lady Keynes (on loan to King's College, Cambridge)

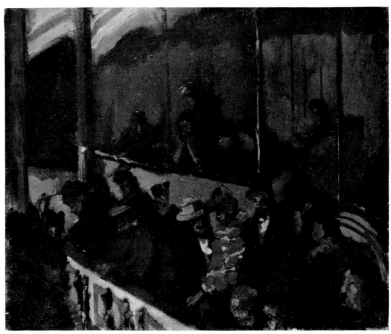

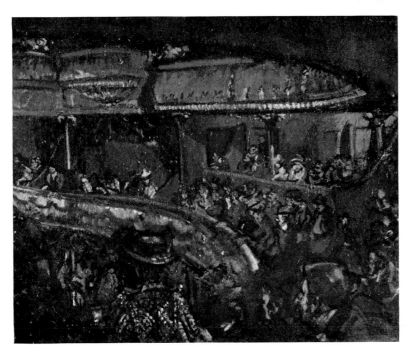

163. *The Eldorado* (C.235). Birmingham, Barber Institute of Fine Arts

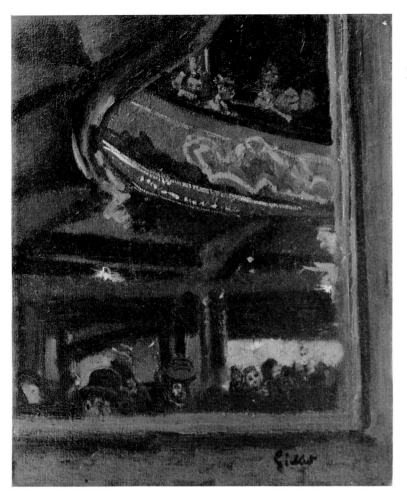

164. *Gaieté Montparnasse* (C.236).
New York, Museum of Modern Art
(Mr. and Mrs. Allan D. Emil Fund)

165. *Gaieté Montparnasse. Dernière Galerie de
Gauche* (C.237). Private Collection

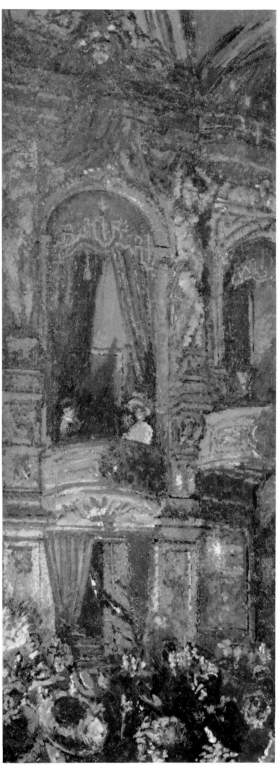

166. *The New Bedford* (C.238).
Coll. A. D. Peters Esq.

167. *The New Bedford* (C.239). Private
Collection, Scotland

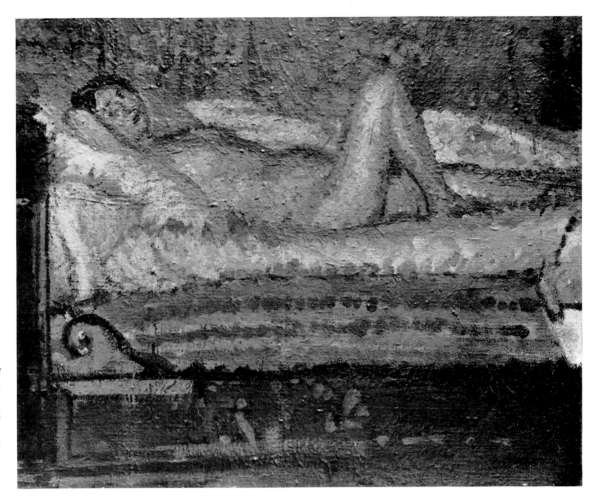

168. *Jeanne* (C.250). Coll. Dr. and Mrs. Warwick Arrowsmith, Brisbane

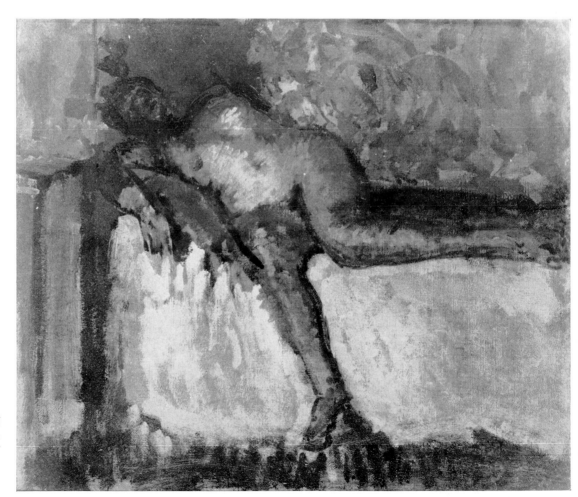

169. *Reclining Nude* (C.252). Coll. Lady Turner

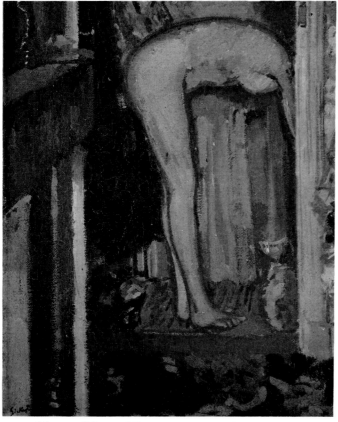

170. Above: *Woman Washing her Hair* (C.248). London, Tate Gallery. Detail

171. Above right: *Seated Nude* (C.249). Private Collection, England

172. Below: *Hôtel du Quai Voltaire Nude* (C.251). Leicester, City Museum and Art Gallery

173. Right: *The Poet and his Muse* or *Collaboration* (C.256). Eastbourne, Towner Art Gallery

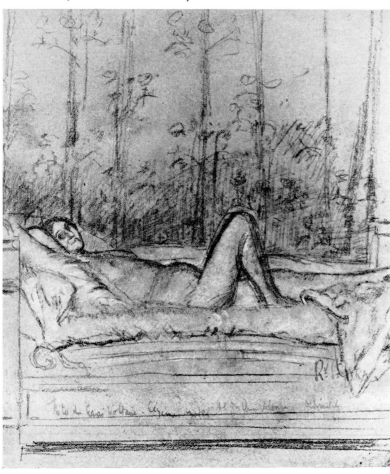

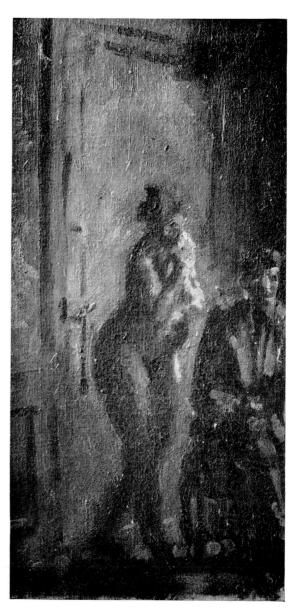

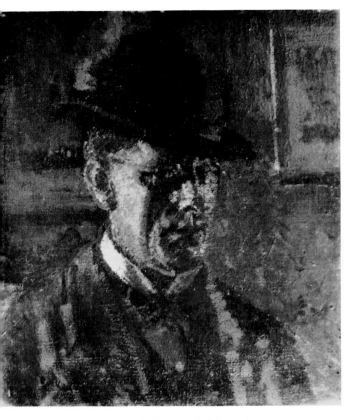

174. *The Juvenile Lead. Self-Portrait* (C.257).
Southampton Art Gallery

175. *Mornington Crescent Nude* (C.259).
Coll. William E. Wallace Esq.

176. *Woman Seated on a Bed*
(C.255). London, Arts
Council of Great Britain

177. *Mornington Crescent Nude* (C.261). Private
Collection, England

178. *The Painter in his Studio* (C.258).
Hamilton, Ontario, Art Gallery

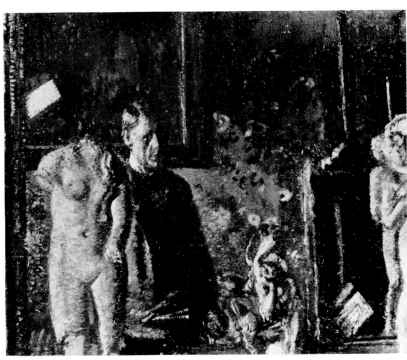

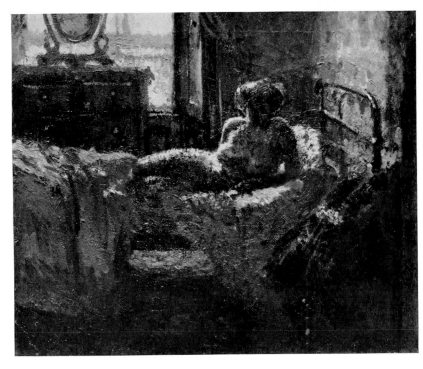

179. *Mornington Crescent Nude. Contre-Jour*
(C.260). Adelaide, Art Gallery of South
Australia

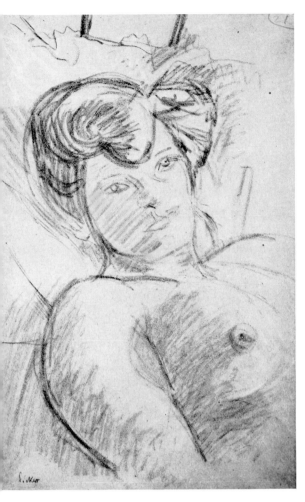

180. *Nude Study: Woman Reclining* (No. 21) (C.262). University of Manchester, Whitworth Art Gallery

181. *The New Home* (C.267). Private Collection (last known owner F. A. Girling Esq.)

182. *Girl at a Window. Little Rachel* (C.263). Coll. William E. Wallace Esq.

183. *Le Collier de Perles* (C.265). Coll. Commander Sir Michael Culme-Seymour, Bt.

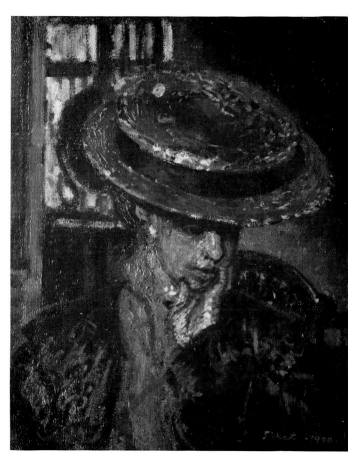

184. *Little Rachel* (C.264). Plymouth, City Museum and Art Gallery

185. *L'Américaine* (C.266). London, Tate Gallery

186. *Sally. The Hat* (C.274). Private Collection, London

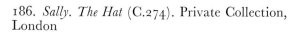

187. *The Camden Town Murder. La Belle Gâtée* (C.270). Coll. H. K. B. Lund Esq.

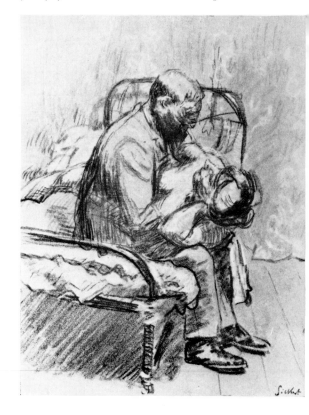

188. *The Camden Town Murder* (C.268). Coll. Dr. S. Charles Lewsen

190. *L'Affaire de Camden Town* (C.271). Coll. Fred Uhlman Esq. (on loan to Hatton Gallery, University of Newcastle upon Tyne)

189. *Conversation* (C.272). London, Royal College of Art

191. *Dawn, Camden Town* (C.273). Coll. The Earl and Countess of Harewood

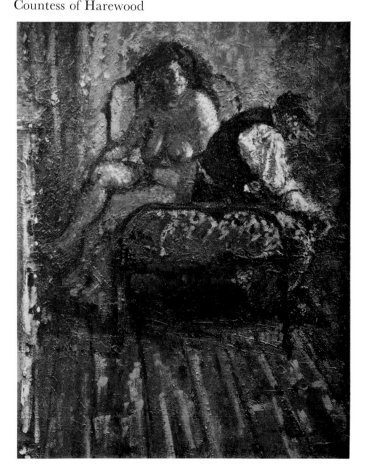

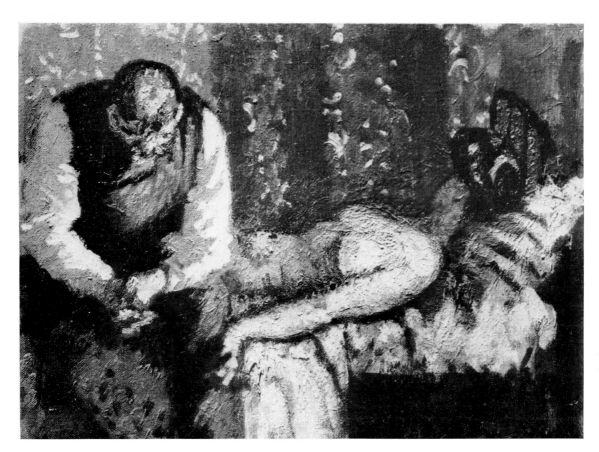

192. *The Camden Town Murder* or *What Shall We Do for the Rent?* (C.269). Private Collection

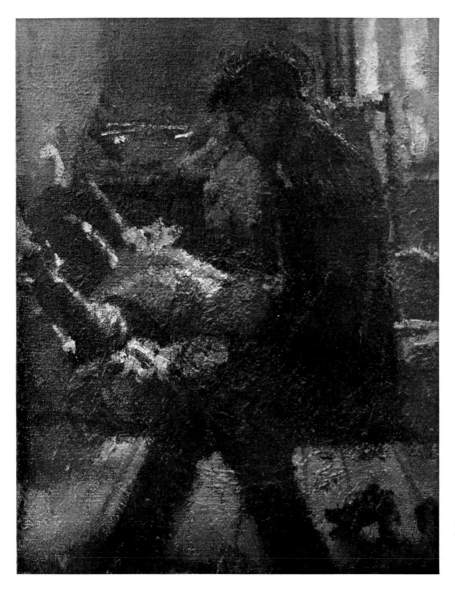

193. *Summer Afternoon* (C.275). Kirkcaldy Art Gallery

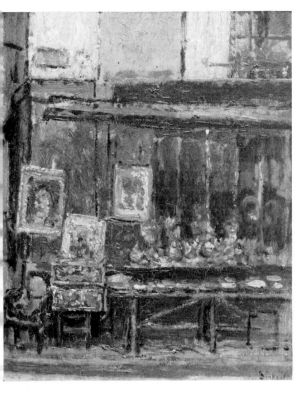

194. *The Antique Shop* (C.283). Private
Collection, England

195. *La Rue Notre Dame des Champs, Paris.*
Entrance to Sargent's Studio (C.286). Private
Collection

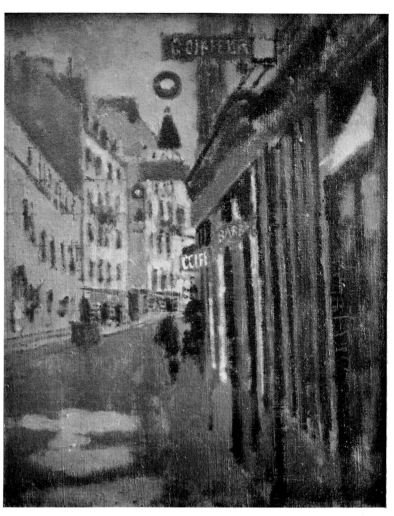

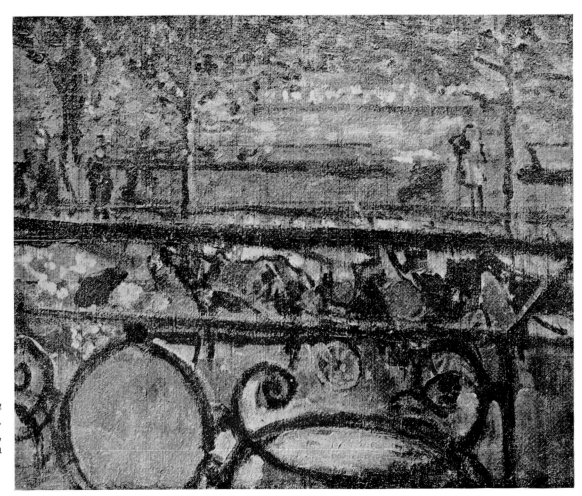

196. *La Seine du*
Balcon (C.285).
Private Collection,
London

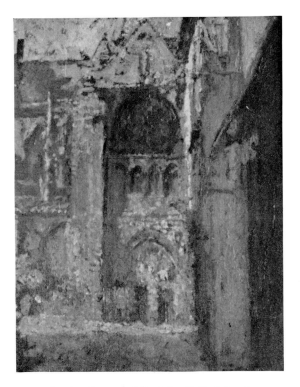

197. *La Rue Pecquet* (C.287). Coll. Martin Halperin Esq.

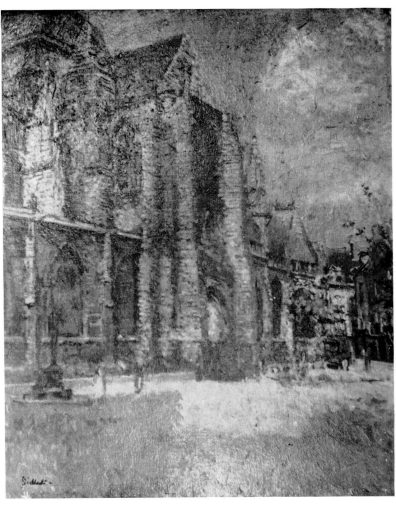

198. *South Façade of St. Jacques* (C.288). Musée de Rouen (on loan to Musée de Dieppe)

199. *The Elephant Poster* (C.289). Private Collection, England

200. *The Garden of Rowlandson House, Sunset* (C.290). London, Tate Gallery

201. *La Rue du Mortier d'Or, Dieppe* (C.284). Private Collection, London

202. *St. Remy* (C.291). Paris, Bernheim-Jeune

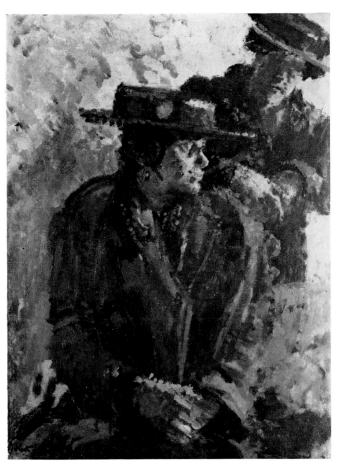

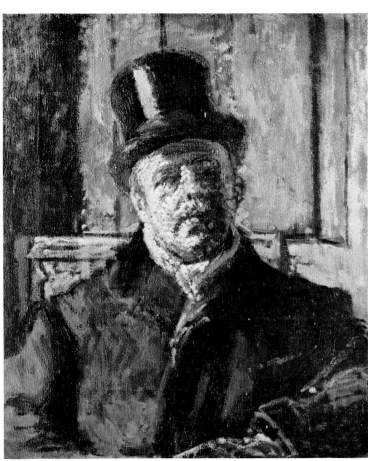

203. *Two Women* (C.295). Preston, Harris Museum and Art Gallery

204. *Jacques-Émile Blanche* (C.294). London, Tate Gallery

205. *Off to the Pub* (C.296). London, Tate Gallery

206. *The Studio. The Painting of a Nude* (C.297). Private Collection

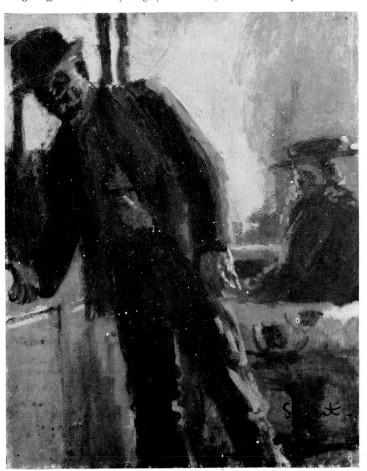

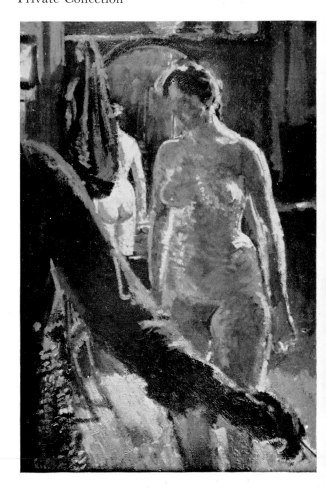

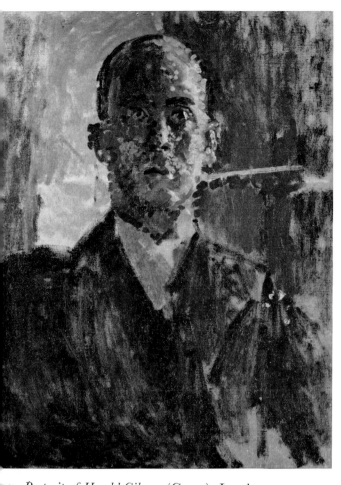

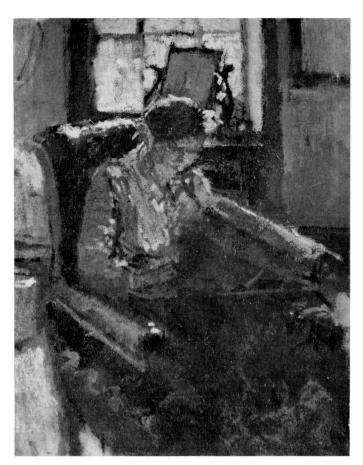

208. *Girl doing Embroidery* (C.300). Private Collection, London

07. *Portrait of Harold Gilman* (C.299). London,
ate Gallery

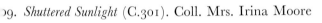
09. *Shuttered Sunlight* (C.301). Coll. Mrs. Irina Moore

210. *The Mantelpiece* (C.298). Southampton
Art Gallery

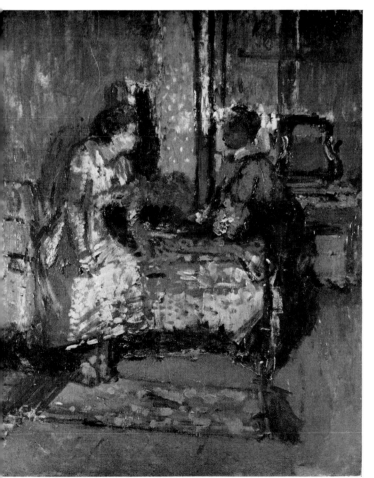

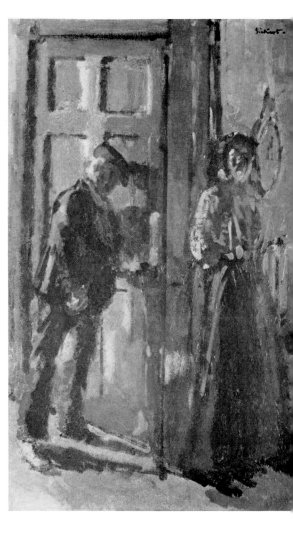

211. Above: *The Old Soldier* (C.302). Coll.
J. B. Priestley Esq.

212. Right: *Off to the Pub* (C.303). Leeds, City Art
Gallery

213. Far left:
A Few Words
(C.304). Privat
Collection,
London

214. Left:
Sunday Afternoor
(C.305).
Fredericton,
New Brunswic
Beaverbrook
Art Gallery

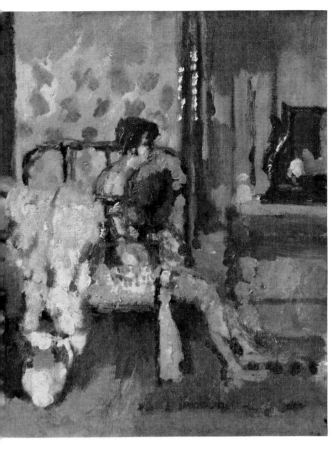

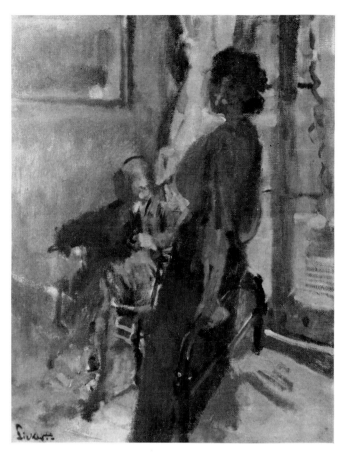

15. *Lady of the Chorus* (C.307). Private Collection, London

216. *Granby Street* (C.306). London, D'Offay-Couper Gallery

17. *Hubby and Emily* (C.308). Private Collection, Scotland

218. *Hubby and Marie* (C.309). Hamilton, Ontario, Art Gallery

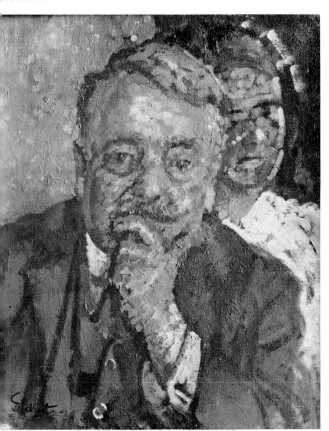

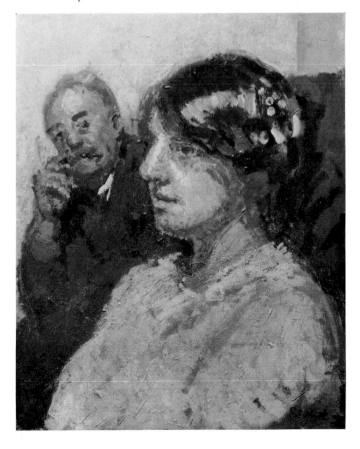

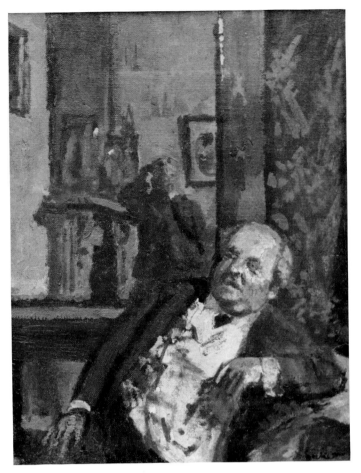

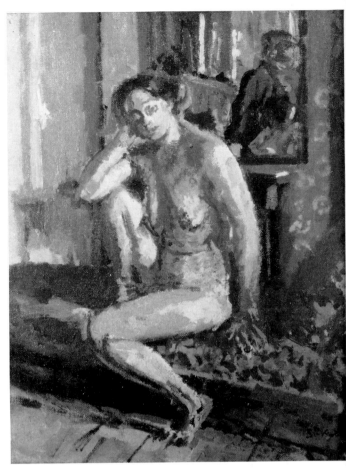

219. *Army and Navy* (C.311). Bristol, City Art Gallery

220. *Nude Seated on a Couch* (C.310). Manchester, City Art Gallery

221. *Portrait of Ethel Sands* (C.312). Private Collection, England

222. *Mrs. Styan* (C.321). Coll. Lord Reigate

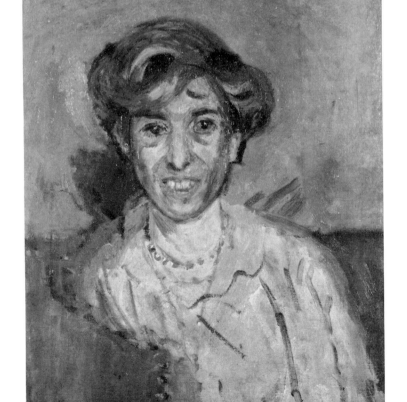

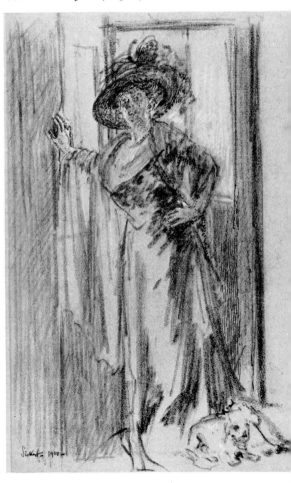

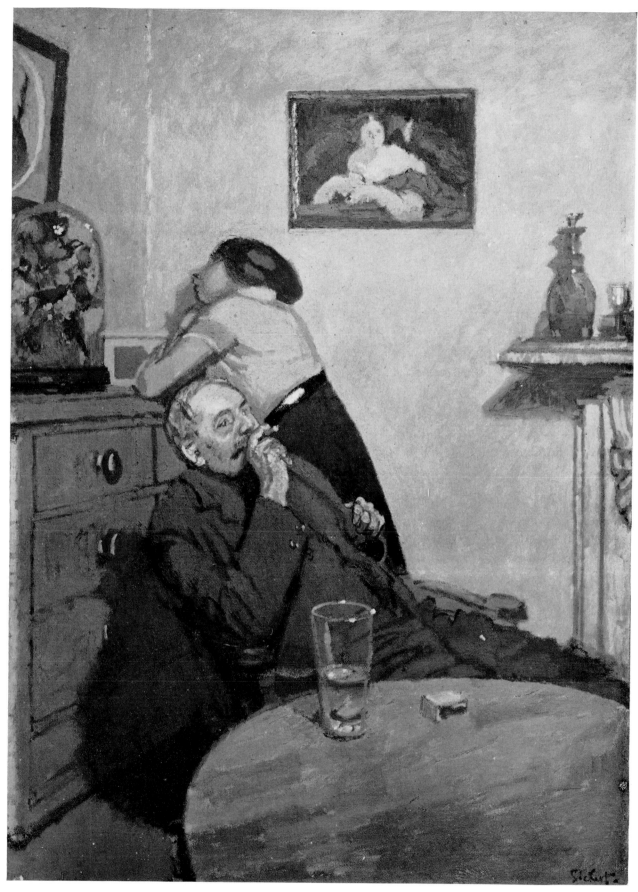

223. *Ennui* (C.313). London, Tate Gallery

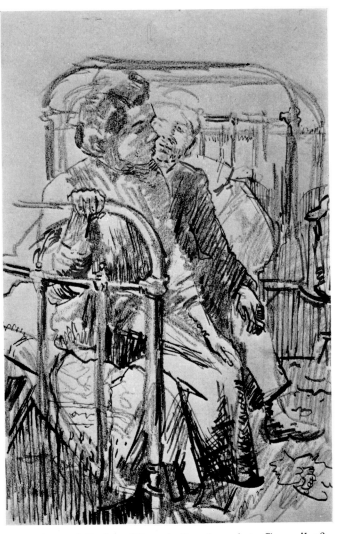

225. *Morning* (C.322). Private Collection, London

224. *A Weak Defence* (C.324). London, Arts Council of Great Britain

226. *Roger Fry. Vision, Volume and Recession* (C.325). London, Islington Public Libraries

227. *To Miss Angus* (C.323). University of Reading

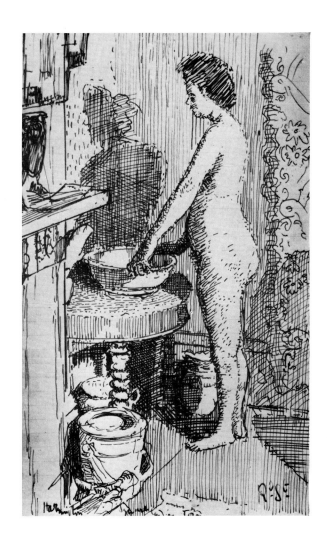

228. *Alice* (C.326). Whereabouts unknown

229. Right: *Sally* (C.327). Bedford, Cecil Higgins Art Gallery

230. *The Argument* (C.328). Auckland, City Art Gallery

231. *The Visitor* (C.329). Huddersfield Art Gallery

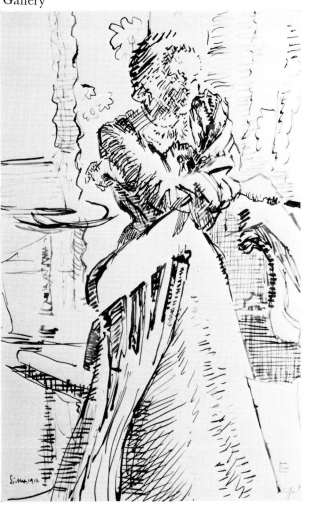

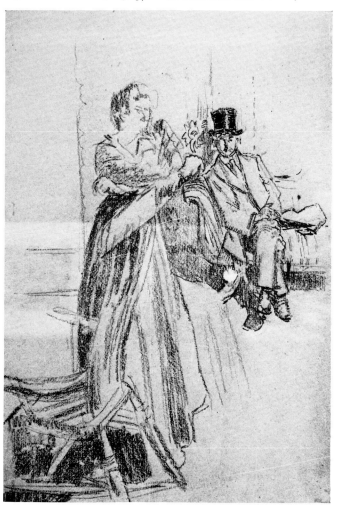

232. Left: *Mr. Gilman Speaks* (C.330). London, Victoria and Albert Museum

233. Above: *Reconciliation* (C.333). Liverpool, Walker Art Gallery

234. Below left: *Amantium Irae* (C.331). Private Collection, London

235. Below right: *My Awful Dad* (C.332). Oxford, Ashmolean Museum

236. *La Scierie de Torqueville* or *Le Vieux Colombier* (C.342). Dundee Art Gallery

237. *La Vallée de l'Eaulne* (C.344). Private Collection, England

238. *Château de Hibouville* (C.343). London, Messrs. Sotheby's 1971

240. *The Obelisk* (C.346). Private Collection (on loan to Whitworth Art Gallery, University of Manchester)

239. *Petit Bois de Hibouville* (C.345). London, Messrs. Roland, Browse and Delbanco

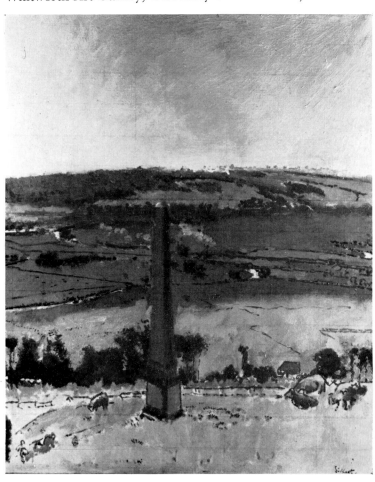

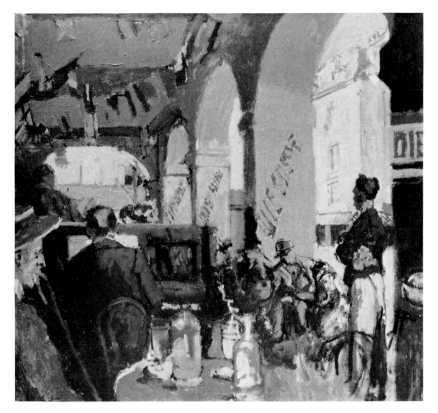

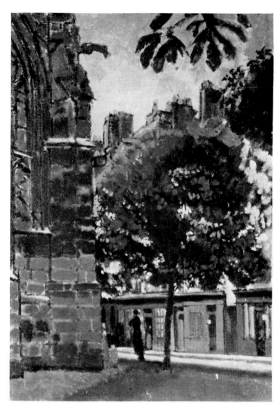

241. *Café des Arcades* or *Café Suisse* (C.347). Private Collection, London

242. *Chevet de l'Église* (C.350). Coll. Vane Ivanovic Esq., Monaco

244. *St. Jacques* (C.349). Toronto, Art Gallery of Ontario (Gift of Contemporary Art Society, London)

243. *Rue Aguado* (C.348). Private Collection, England

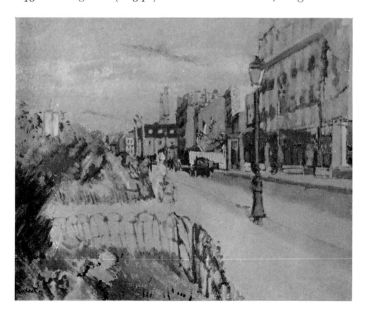

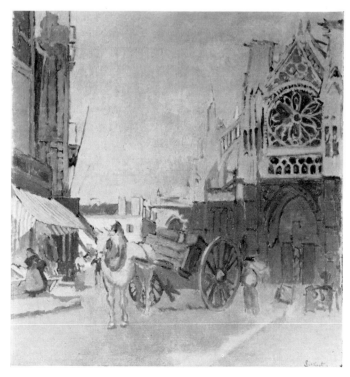

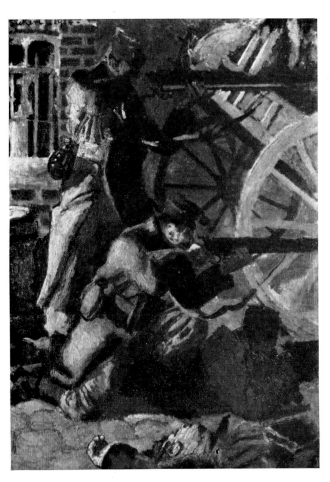

246. *The Iron Bedstead* (C.355). London, Islington Public Libraries

245. *The Soldiers of King Albert the Ready* (C.351). Sheffield, Graves Art Gallery

248. *Tipperary* (C.352). Private Collection, London

247. *Wounded* (C.353). Private Collection, Scotland

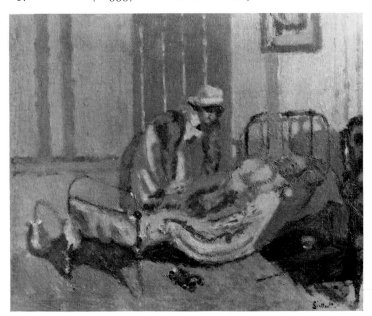

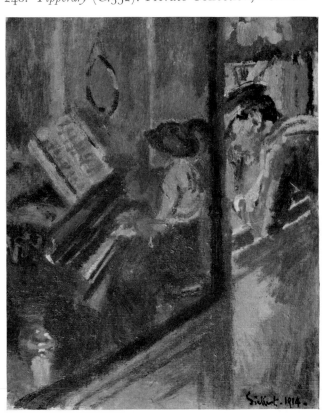

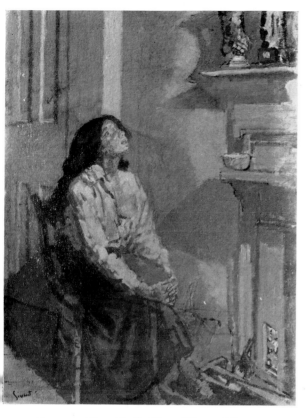

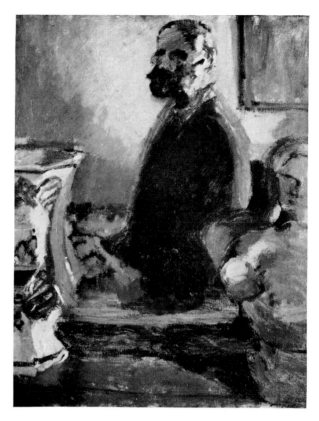

249. *Suspense* (C.356). Belfast, Ulster Museum

250. *The Bust of Tom Sayers. Self-Portrait* (C.354). Private Collection

251. *Old Heffel of Rowton House* (C.359). York, City Art Gallery

252. *The Fur Boa* (C.358). Private Collection, Scotland

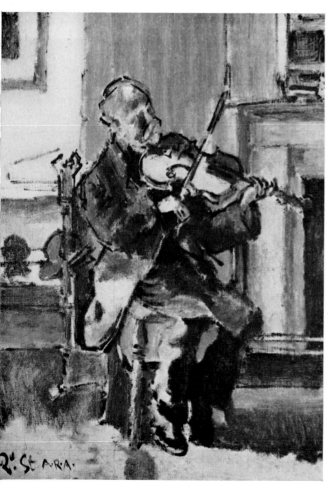

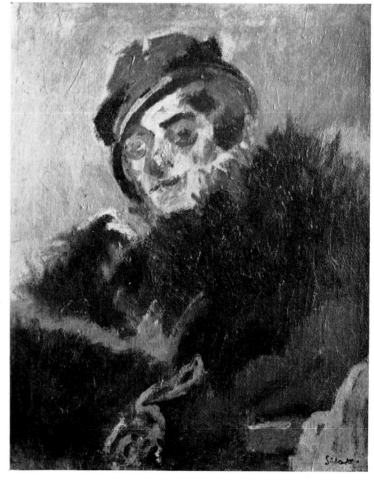

253. *Resting.
The Napoleon
III Tobacco Jar*
(C.357).
Kirkcaldy Art
Gallery

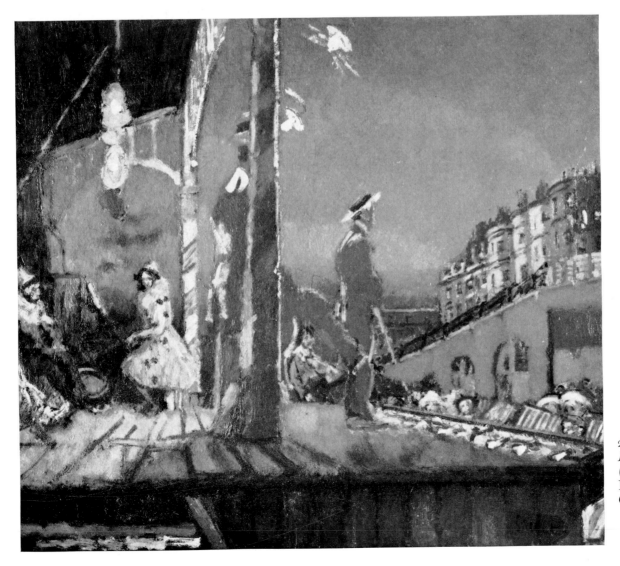

254. *The
Brighton Pierrots*
(C.364).
Private
Collection

255. *The New Bedford* (C.365). Leeds, City Art Gallery

256. *The New Bedford* (C.366). Coll. Count N. Labia, Capetown

257. *The New Bedford* (C.367). Harrogate, Corporation Art Gallery

258. *The Mill Pool* or *Rushford Mill, Devon* (C.368). Cambridge, Fitzwilliam Museum

259. *Chagford Churchyard* (C.369). Coll. Commander Sir Michael Culme-Seymour, Bt.

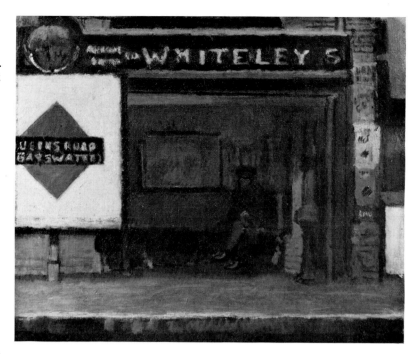

260. *Queen's Road, Bayswater Station* (C.370).
London, Courtauld Institute of Art

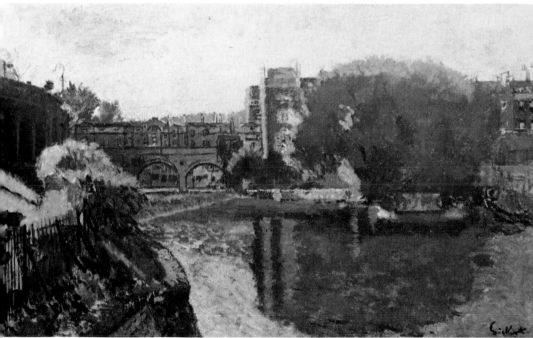

261. *Pulteney Bridge,
Bath* (C.371). Coll.
Mr. and Mrs. Paul
Mellon

262. *Lobster on a Tray* (C.375). Kirkcaldy
Art Gallery

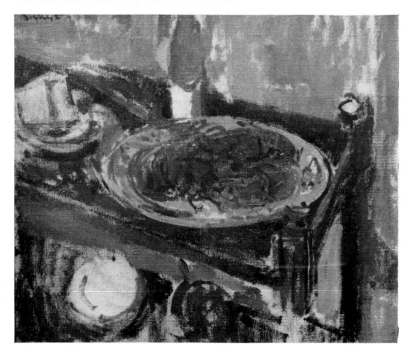

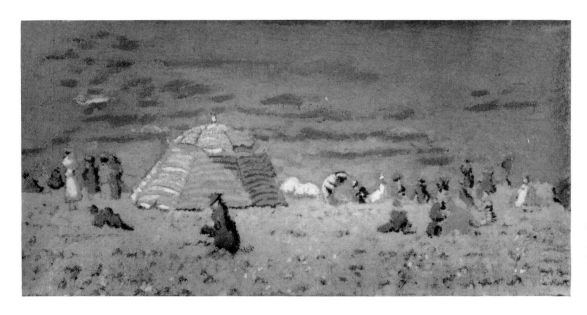

263. *Dieppe Sands* (C.379). Coll. Nicholas Hicks Esq.

264. *Dieppe Races* (C.380). Birmingham, City Art Gallery

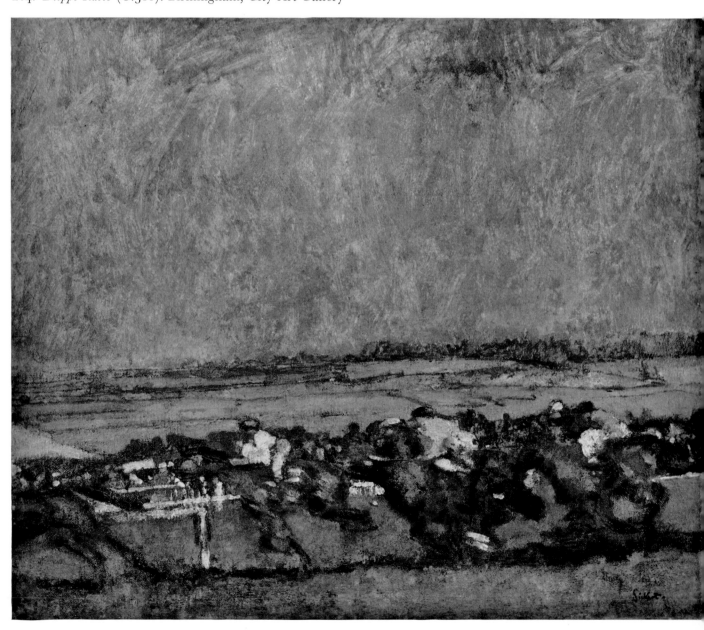

265. *The Serpentine, London* (C.381).
Coll. William B. O'Neal,
Charlottesville, Virginia

266. *In the Wonderful Month of May* (C.382). Boston, Museum of Fine Arts (Thompkins Coll.)

267. *The Garden of Love* or *Lainey's Garden* (C.383). Cambridge, Fitzwilliam Museum

268. *The Hanging Gardens of Islington* (C.384). Private Collection, London

269. *Portrait of Victor Lecour* (C.389). Manchester, City Art Gallery

270. *The Prevaricator* (C.387). Private Collection (last known owners Mr. and Mrs. S. Samuels)

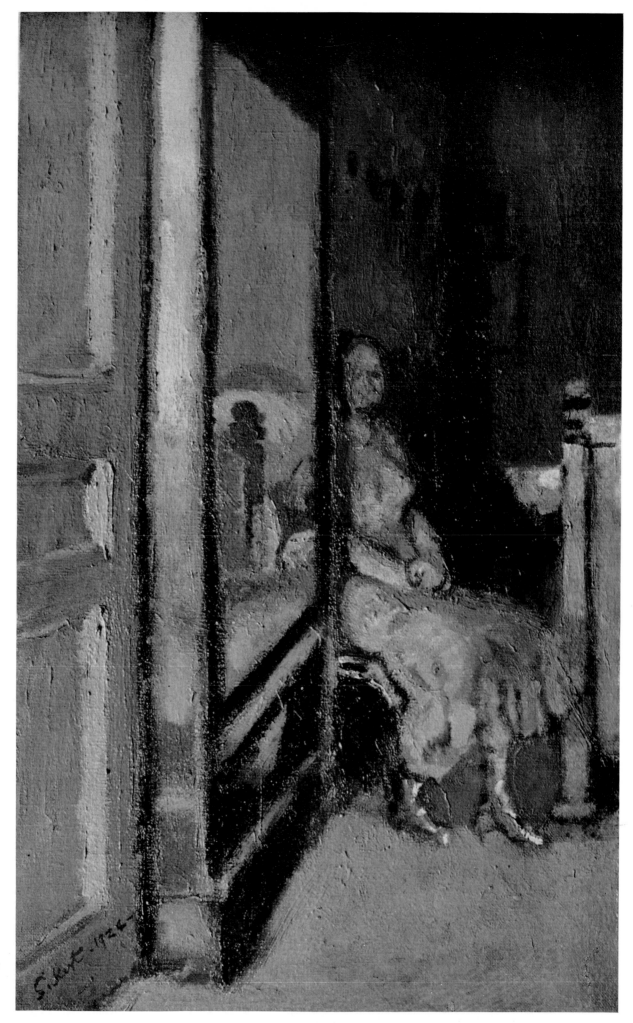

271. *L'Ar-*
moire à Glace
(C.388).
London,
Tate Gallery

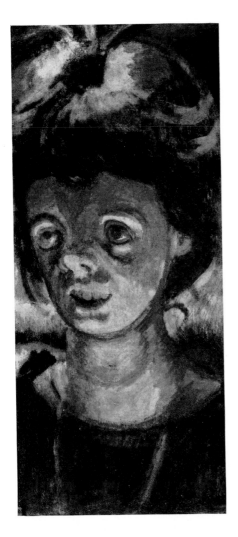

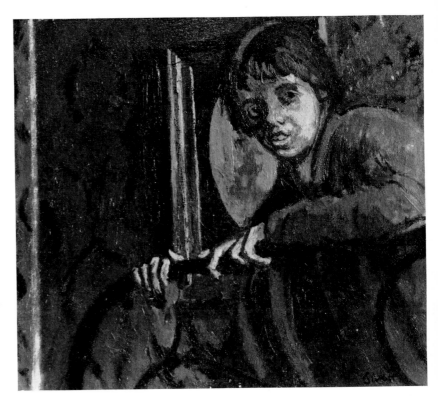

272. Left: *Cicely Hey* (C.391). London, Messrs. Roland, Browse and Delbanco

273. Above: *Cicely Hey* (C.390). London, British Council

274. Below left: *Shoreditch Empire* or *The London, Shoreditch* (C.395). Christchurch, New Zealand, Robert McDougall Art Gallery

275. Below right: *Vernet's* (C.397). Private Collection, England

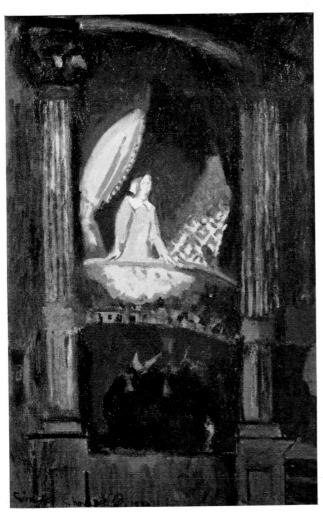

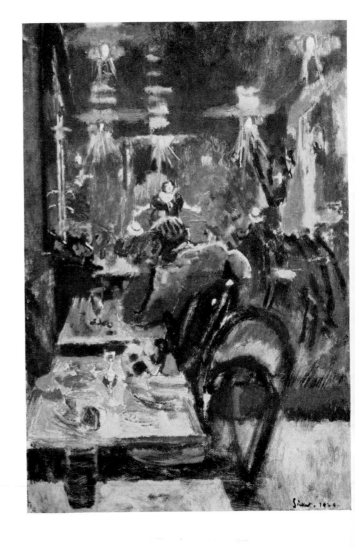

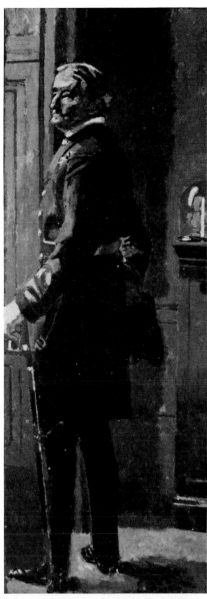

276. Above: *The Trapeze* (C.396). Cambridge, Fitzwilliam Museum

277. Right: *Rear Admiral Lumsden, C.I.E., C.V.O.* (C.402). Minneapolis Institute of Arts (John R. Van Derlip Fund)

278. Below left: *Baccarat* (C.398). Coll. The Cottesloe Trustees

279. Below right: *Lazarus Breaks his Fast. Self-Portrait* (C.401). Coll. Mr. and Mrs. Eric Estorick

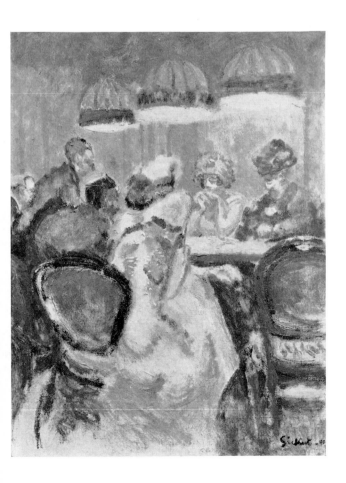

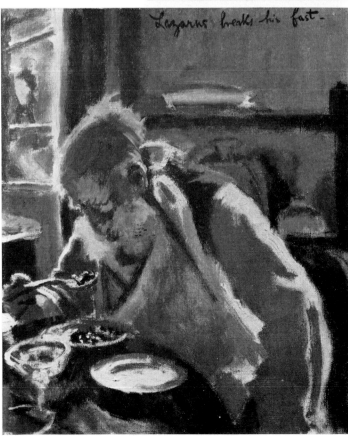

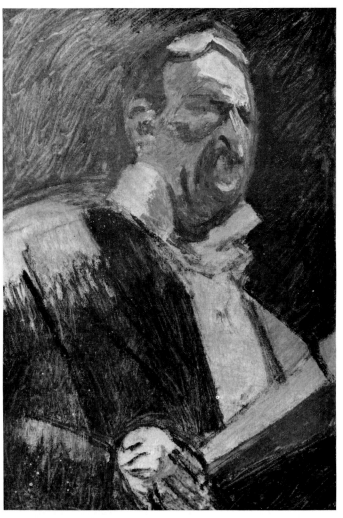

281. *The Rt. Hon. Winston Churchill* (C.403).
London, National Portrait Gallery

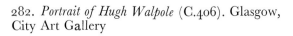
280. *Signor Battistini Singing* (C.399). Coll. The Earl
and Countess of Harewood

282. *Portrait of Hugh Walpole* (C.406). Glasgow,
City Art Gallery

283. *The Servant of Abraham* (C.405). London, Tate
Gallery

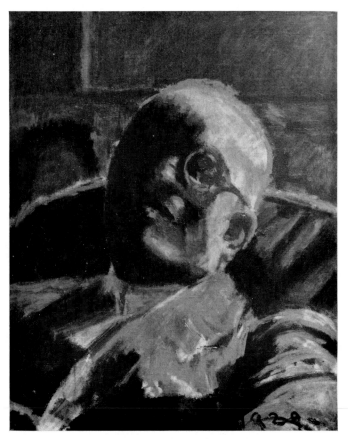

284. Right: *The Raising of Lazarus* (C.404). Melbourne, National Gallery of Victoria

285. Far right: *Viscount Castlerosse* (C.407). Fredericton, New Brunswick, Beaverbrook Art Gallery

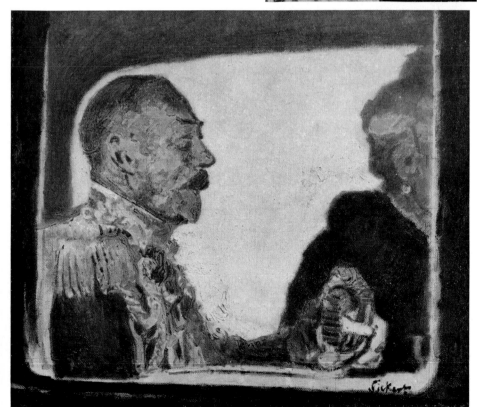

286. *King George V and Queen Mary* (C.408). Coll. The Trustees of Sir Colin and Lady Anderson

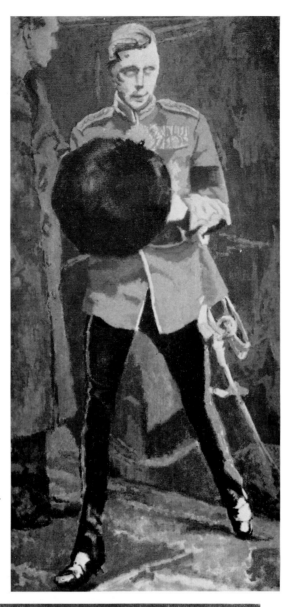

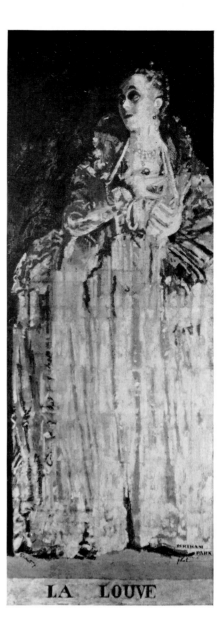

287. Right: *King Edward VIII*
(C.409). Fredericton,
New Brunswick, Beaverbrook
Art Gallery

288. Far right: *Miss Gwen
Ffrangcon-Davies as Isabella of
France in Marlowe's Edward II:
La Louve* (C.416). London,
Tate Gallery

LA LOUVE

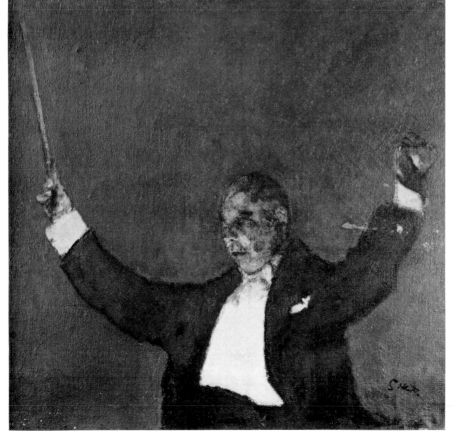

289. Left: *Sir Thomas Beecham
Conducting* (C.412). New York,
Museum of Modern Art
(Bertram F. and Susie Brummer
Foundation Fund)

290. Opposite, above left: *The Miner*
(C.410). Birmingham, City Art
Gallery

291. Opposite, above right: *My Awful
Dad* or *Hubby* (C.411). Coll. Miss
G. Simpson

292. Opposite, below left: *Juliet and
her Nurse* (C.418). Leeds, City Art
Gallery

293. Opposite, below right: *Peggy
Ashcroft and Paul Robeson in Othello*
(C.417). Private Collection, Scotland

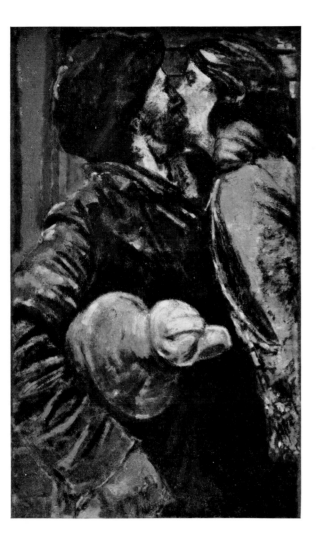

294. *The Taming of the Shrew* (C.419).
Bradford, City Art Gallery

295. *Sirens Abroad* (C.427). Private
Collection (last known owner
Mrs. E. P. Dorian Reed)

296. *The Seducer*
(C.426). London,
Messrs. Sotheby's
1964

297. *Barnsbury* (C.442). Glasgow, City Art Gallery

298. *Baird's Hill House, St. Peter's-in-Thanet* (C.443). Whereabouts unknown

299. *A Scrubbing of the Doorstep* (C.446). Private Collection, England

300. *The Garden. St. George's Hill House, Bathampton* (C.444). Private Collection, Scotland

301. *The Vineyards, Bath* (C.445). Private Collection, Scotland

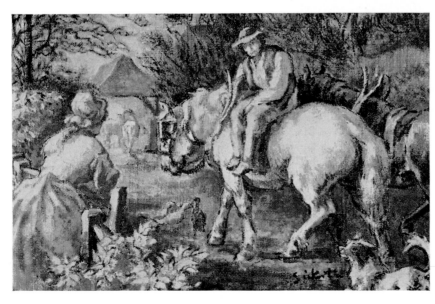

302. *Evening* (C.428). Kirkcaldy Art Gallery

Note on the catalogue

The following is not a *catalogue raisonné* which, considering the size of Sickert's production, would fill several volumes. This catalogue is selective and its arrangement may be called chrono-typological. That is, it presents groups of works, representing different types of subject matter (landscapes, figure subjects, music halls etc.), executed within specified date-brackets, in chronological sequence. The uneven distribution and size of these groups of distinct subjects within a defined period tends to reflect the changes in Sickert's interests from one time to another.

Every picture or drawing mentioned in the text is catalogued, but it has not been possible to reproduce every work. The most important considerations determining the choice of which pictures to illustrate were:

To include dated and/or securely datable works as standards of stylistic comparison.

To place undated examples of Sickert's more characteristic subjects in chronological context and thus help private and public owners, students, and others to date similar pictures with some accuracy.

To illustrate the history of Sickert's stylistic and technical development.

In each section of the catalogue illustrated works, in approximate chronological order, are entered first. Details of versions, studies, and related works are included within the principal catalogue entry devoted to a picture of the same subject. It must be stressed that these lists of versions etc. are not exhaustive.

Medium: paintings are in oil, drawings are on paper, unless otherwise stated.

Measurements: height before width; inches unbracketed, centimetres bracketed.

Ownership: provenance: references to temporary and intermediate ownership of works by dealers are not given unless: (i) a dealer is the current owner of the work (in which case the name of the firm is quoted in full); (ii) the present private owner desires to remain anonymous. In this case, whenever possible, the name of the dealer through whom the owner acquired the work is quoted (abbreviated) as a reference.

The acquisition dates of works in public collections are quoted in brackets after the title of the collection. It will be seen that many drawings were acquired by various public collections in Great Britain in 1947 and 1948. These were presented by Mrs. L. Powell, administrator of the Sickert Trust, who disposed of the contents of Sickert's studio after his wife's death.

Definitions of ownership of Sickerts in private collections: the individual preferences of each owner determine whether or not they are acknowledged by name. The locations of works catalogued as in a Private Collection have been added as advised by the owners. Works which I cannot trace are cited under their last known owner, or failing that as 'whereabouts unknown'.

The substantial collections of the late Morton H. Sands and the late Edward le Bas have remained almost intact but their present owners prefer to remain anonymous. Works in these collections are catalogued as 'From the collection of . . .'.

Inscriptions: quoted for fully catalogued works only. Inscriptions on works listed within a principal catalogue entry (as for example a version or study) are quoted only if they are of particular interest.

Information given under the headings Rep., Lit., and Exh. is given in chronological order and is selective. The principles of selection are as follows.

Rep: for works reproduced in this book: references are provided only to illustrations in other monographs on Sickert.

For works not reproduced in this book: as above. However, when a work is not reproduced in this or in other monographs on Sickert, wherever possible some reference to its illustration within the literature is provided.

Lit: separate page references to plate notes of works reproduced in other monographs on Sickert are not provided. The numerous occasions when a work is mentioned by name in ephemeral articles, exhibition reviews etc. are not listed. References are given to real information about or discussion of a particular work. Articles of general value to the literature, rather than particular value to the study of an individual work, are quoted in the bibliography.

Exh.: references are not comprehensive. The first exhibition of a work is quoted when relevant to the chronology. A selection of official one-man exhibitions and other key exhibitions has been made. Posthumous one-man exhibitions in art-dealers' galleries are included from 1960 onwards. The most recent exhibition of a work is generally quoted.

Abbreviations and conventions

General: p. =page; Fig. =Figure; Rep. =Reproduced; Lit. =Literature; Exh. =Exhibited; Coll. =Collection; *c.* =*circa*.
Inscription abbreviations: b. =bottom; t. =top; c. =centre; r. =right; l. =left.
Lit. and Rep. abbreviations are listed in the bibliography.
Other abbreviations:

A.A.A. =Allied Artists' Association
A.C. =The Arts Council of Great Britain
Agnew =Thomas Agnew and Sons Ltd.
Christie's =Messrs. Christie, Manson and Woods
N.E.A.C. =New English Art Club
R.A. =Royal Academy of Arts, London
R.B.A. =Royal Society of British Artists
R.B.D. =Roland, Browse and Delbanco, London
S.B.A. =Society of British Artists
Sotheby's =Messrs. Sotheby and Co.
Tooth =Arthur Tooth and Sons Ltd.

Selected list of official Sickert exhibitions and of major Sickert exhibitions at art dealers' galleries

Galleries are in London unless otherwise stated. Exhibitions consistently quoted in the catalogue are marked *. Abbreviations used in the catalogue following are cited. It is noted here that several one-man exhibitions held by dealers are quoted in the catalogue by the name of the dealers' galleries and the dates of the exhibitions only (omitting the exhibition titles).

1886 January. Dowdeswell's. 'A score of oil paintings' according to the *Illustrated London News*, 23 January. No catalogue traced.

1895 January. Van Wisselingh's Dutch Gallery. Exhibition shared with his brother Bernhard Sickert. Paintings, drawings and etchings.

1900 December. Durand-Ruel, Paris. 42 paintings, 6 drawings.

1904 June. Bernheim-Jeune, Paris. 96 paintings (some on loan from private owners). Preface to catalogue by Jacques-Émile Blanche.
Abbreviation: Bernheim 1904

1907 January. Bernheim-Jeune, Paris. 81 paintings, 4 pastels.
Abbreviation: Bernheim 1907

1909 18 and 19 June. Bernheim-Jeune, Paris, followed by auction sale at Hôtel Drouot, Paris, on 20 June. 73 paintings, 10 drawings. Catalogue with sizes. Preface by A. Tavernier.
Abbreviation: Bernheim 1909

1911 January. Carfax Gallery. 49 drawings.

1911 July. Stafford Gallery. 34 paintings, 6 pastels.

1912 May. Carfax Gallery. 17 paintings, 52 drawings.

1914 April. Carfax Gallery. 16 paintings, 27 drawings.

1916 November. Carfax Gallery. 26 paintings.

1919 Eldar Gallery. Paintings and drawings. Preface to catalogue by Clive Bell. A large illustrated catalogue was also produced.

1926 February–March. Savile Gallery. 59 drawings. Catalogue with sizes.

1926 May–June. Savile Gallery. 37 paintings, 13 drawings. Retrospective and recent. No catalogue traced.

1928 February. Savile Gallery. 38 paintings, 7 drawings. Retrospective and recent. No catalogue traced.

1929 June. Leicester Galleries. Retrospective exhibition of over 100 paintings and drawings.

1930 Savile Gallery. Paintings and drawings. Catalogue with sizes.

1930 November. Galerie Cardo, Paris.

1931 May. Leicester Galleries. 'English Echoes' (22 paintings).

1932 April–May. Beaux Arts Gallery. Recent paintings (many of them 'Echoes').

1933 Beaux Arts Gallery. 30 paintings, 12 drawings. Retrospective and recent. Catalogue with sizes.

1933 Thomas Agnew and Sons. Retrospective loan exhibition.

1934 November–December. Leicester Galleries. 18 recent paintings.

1935 July. Beaux Arts Gallery. 12 new paintings.

1936 January–February. Redfern Gallery. 24 early paintings.

1937 January–February. Adams Gallery. Sickert and the living French painters.

*1938 The Arts Club, Chicago, moved in February to the Carnegie Institute, Pittsburgh. Retrospective loan exhibition of 30 paintings. Catalogue numbers quoted are from Pittsburgh.
Abbreviation: Chicago: Pittsburgh 1938

1938 March. Leicester Galleries. 21 recent paintings.

1940 April–May. Leicester Galleries. 15 recent paintings.

*1941 National Gallery, London. Major retrospective of 132 paintings and drawings.
Abbreviation: N.G.41

*1942 Temple Newsam House, Leeds. Major retrospective of paintings, drawings and etchings (200 exhibits).
Abbreviation: Leeds 42

1947 Thomas Agnew and Sons. Emmons Collection including 20 paintings and 3 drawings by Sickert.

*1949 The Arts Council, London. Notes and sketches from the collection of Sickert works acquired by the Walker Art Gallery, Liverpool, from the Sickert Trust. A particularly informative catalogue with a preface by Gabriel White.
Abbreviation: A.C.49

1950 Museum of Art, Hove.

1951 Roland, Browse and Delbanco. Forty of Sickert's finest paintings. Loan exhibition.

*1953 The Arts Council, Edinburgh. Paintings and drawings (104 exhibits).
Abbreviation: Edinburgh 53

*1954 Le Musée de Dieppe. Paintings, drawings and etchings (55 exhibits) from local public and private collections. Exhibition shared with Jacques-Émile Blanche. Catalogue preface by Daniel Halévy.
Abbreviation: Dieppe 54

*1957 Graves Art Gallery, Sheffield. Paintings, drawings and etchings.
Abbreviation: Sheffield 57

1957 May–June. Roland, Browse and Delbanco. Paintings (exhibition shared with Delance).
Abbreviation: R.B.D.57

*1960 Roland, Browse and Delbanco. Paintings and drawings.
Abbreviation: R.B.D.60

*1960 Thomas Agnew and Sons. Centenary loan exhibition of 111 pictures from private collections. A concurrent exhibition of etchings and drawings.
Abbreviation: Agnew 60

1960 University of Reading. 79 drawings.

*1960 The Arts Council, Tate Gallery, London (May–June), Southampton Art Gallery (July), Bradford City Art Gallery (August). Paintings and drawings.
Abbreviation: Tate 60

*1962 Royal Pavilion, Brighton (Sussex Festival). Paintings and drawings (84 exhibits, including 14 from French public collections, and 28 from the Sands Collection).
Abbreviation: Brighton 62

*1963 Royal Academy of Arts, Diploma Gallery, 'A Painter's Collection' being the collection of Edward le Bas including 28 works by Sickert.

*1963 Roland, Browse and Delbanco. Paintings and drawings.
Abbreviation: R.B.D.63

*1964 The Arts Council, Midlands Touring Exhibition. Catalogue introduction by Ronald Pickvance. 26 paintngs, 32 drawings.
Abbreviation: A.C.64

*1967 Hirschl and Adler Galleries, New York. Paintings and drawings. Sale and loan exhibition (borrowed from museums and private collections in the United States).
Abbreviation: New York 67

*1968 Art Gallery of South Australia, Adelaide. Sickert, one of the Adelaide Festival exhibitions. Paintings, drawings, and etchings (84 exhibits).
Abbreviation: Adelaide 68

1968 David Jones' Art Gallery, Sydney. Paintings and drawings. Sale and loan exhibition.
Abbreviation: Sydney 68

*1968 University of Hull. 'Sickert in the North'. Paintings, drawings, and etchings borrowed from northern English collections. Catalogue appendix by Malcolm Easton 'Of Sickert and the North'.
Abbreviation: Hull 68

1969 Roland, Browse and Delbanco. Drawings. Exhibition shared with Pernath and Le Sidaner.

1970 Islington Town Hall. 'Our Own Sickerts', being an exhibition of the entire collection of drawings, paintings and etchings belonging to the Islington Public Libraries.

Select list of groups with whom Sickert regularly exhibited

Society of British Artists, later Royal Society of British Artists: 1884–8
New English Art Club: 1888–1914 (with interruptions)
Allied Artists' Association: from 1908
Salon d'Automne, Paris: 1905–9
Camden Town Group: 1911–13
London Group: 1916–34 (with interruptions)

During his lifetime Sickert's work was also frequently included in many group exhibitions in art dealers' galleries (notably the Goupil Gallery, the Grosvenor Gallery, Thomas Agnew and Sons who sent several Sickerts to New York in 1929 in their Contemporary British Artists exhibition, the Leicester Galleries, the Beaux Arts Gallery, the Adams Gallery, and the Redfern Gallery). Sickert's work was also included in many of the Annual International Exhibitions of Paintings held at the Carnegie Institute, Pittsburgh, between 1923 and 1939. His work is frequently represented in (posthumous) official group exhibitions of British art organized by such bodies as the Arts Council of Great Britain and the British Council. The London art dealers' galleries which since his death have most often exhibited Sickert's work in group miscellanies are Thomas Agnew and Sons, Roland, Browse and Delbanco, the Leicester Galleries, Arthur Tooth and Sons, the Redfern Gallery (especially during the 1940s), and the now defunct Beaux Arts Gallery.

Bibliography

This bibliography is perforce selective. It is divided into sections: 1. Monographs. 2. Chapters on Sickert in more general books. 3. Articles in periodicals and catalogue prefaces. 4. General literature of particular value to the study of Sickert, including some catalogue prefaces of group exhibitions.

References to Sickert's own writings are often given in footnotes to the text and are not given again here. Many of his articles are included in Osbert Sitwell's anthology of Sickert's writings, *A Free House*, listed below. References to exhibition reviews (with a few exceptions) are not quoted here but many of them are quoted in the text and catalogue. Similarly articles of particular value to the study of an individual work, rather than of general value to the study of Sickert, are quoted in the catalogue entry to that work and are not listed again here.

1. *Monographs*

BERTRAM, Anthony, *Sickert*, London and New York, Studio Publications, 1955 (World Masters series). A small picture book.
Abbreviation: Bertram

BROWSE, Lillian (with an introduction on Sickert's art by R. H. Wilenski), *Sickert*, London, Faber, 1943.
Abbreviation: B.43

BROWSE, Lillian, *Sickert*, London, Rupert Hart-Davis, 1960. The major illustrated monograph to date on Sickert's work. A useful, if not quite complete, catalogue of Sickert's work in public collections throughout the world is appended.
Abbreviation: B.60

EMMONS, Robert, *The Life and Opinions of Walter Richard Sickert*, London, Faber, 1941. The first book on Sickert, it remains a major source of information about Sickert's life, art, writings and teaching and is still the only comprehensive portrait of the artist.
Abbreviation: Emmons

ISLINGTON PUBLIC LIBRARIES, *Walter Richard Sickert 1860–1942*. A handbook to the drawings, paintings, etchings, engravings and other material in the possession of the Islington Public Libraries, edited by C. A. Elliott, 1964. The Islington collection of Sickertiana is of major value to the study of Sickert. It includes several large cuttings books.

LILLY, Marjorie, *Sickert. The Painter and his Circle*, London, Elek, 1971. The author met Sickert in 1911 and knew him well from 1917 onwards; her book is an interesting recollection of Sickert, Fitzroy Street and its painters, the Slade and its teachers.

Abbreviation: Lilly

PICKVANCE, Ronald, *Sickert*, The Masters series, No. 86, 1967. A picture book; many of the plates are the same as those found in Rothenstein 1961 (see below).
Abbreviation: Pickvance 1967

ROTHENSTEIN, Sir John, *Sickert*, London, Beaverbrook Newspapers, 1961 (An Express Art Book, British Painters series). A picture book.
Abbreviation: Rothenstein 1961

SITWELL, Osbert. *A Free House! or The Artist as Craftsman being the Writings of Walter Richard Sickert*, London, Macmillan, 1947. A selected anthology of Sickert's writings. (Quotations in this book have been taken from the original writings to avoid the slight mistakes published by Sitwell. Sitwell also gave some incorrect references to the dates and places of publication of Sickert's writings.)
Abbreviation: Sitwell

STEPHENSON, W. H., *Sickert: the Man: and his Art: Random Reminiscences*, Southport, Johnson, 1940. Recollections of the author's relationship (as patron) with Sickert, 1923–5.

WOOLF, Virginia, *Walter Sickert: a Conversation*, London, Hogarth Press, 1934. Since reprinted, e.g. as the catalogue preface to the Sickert Centenary loan exhibition held at Agnew's in 1960. The pamphlet is an imagined discussion of Sickert's work inspired by the loan exhibition of his pictures held at Agnew's in 1933.

WRIGHT, Harold, *Sickert's Etchings*, an unfinished manuscript deposited after Mr. Wright's death with the Print Room of the British Museum.

2. *Chapters on Sickert in more general books*

BELL, Clive, *Old Friends. Personal Recollections*, London, Chatto and Windus, 1956. A strangely petulant chapter on Sickert, at variance with Bell's generous and admiring estimation of Sickert (in reviews, catalogue prefaces etc.) earlier in the century.

BELL, Quentin, *Victorian Artists*, London, Routledge and Kegan Paul, 1967. Chapter entitled 'Sickert and the Post-Impressionists'.

MOORE, George, *Conversations in Ebury Street*, London, Heinemann, 1930 (first published 1924 in a limited edition). A gossipy chapter (IX) on Sickert.

ROTHENSTEIN, Sir John, *The Artists of the 1890s*, London, Routledge, 1928. Chapter outlining Sickert's art.

ROTHENSTEIN, Sir John, *Modern English Painters. Sickert to Smith*, London, Eyre and Spottiswoode, 1952.

Chapter giving a rather fuller account of Sickert's art than Rothenstein's earlier book.

SITWELL, Osbert, *Noble Essences or Courteous Revelations*, London, Macmillan, 1950. Chapter Seven on Sickert is a slightly different version of Sitwell's introduction 'A Short Character of Sickert' to *A Free House*, loc. cit. Substantially the same essay was published by Sitwell in *Orion*, Vol. 2, 1945.

TATE GALLERY CATALOGUE, *Modern British Paintings, Drawings and Sculpture*, London, Oldbourne, 1964, Vol. 2, Artists M–Z. The section of the catalogue dealing with Sickert's work is particularly informative and is therefore listed here as if it were a chapter of a book. Abbreviation: Tate Gallery Catalogue 1964

WEDMORE, Frederick, *Some of the Moderns*, London, Virtue, 1909. The earliest account of Sickert's art (to 1909).

3. Articles in periodicals and catalogue prefaces

ARMITAGE, Gilbert, *Arts and Crafts*, August 1929, Scrutinies: 1, Richard Sickert, A.R.A., P.R.B.A.; pp. 101–9. The first in a series in which younger critics examined the works of older living painters in relation to contemporary aesthetics.

BARON, Wendy, *Apollo*, 91, March 1970, 'Sickert's Links with French Painting', pp. 186–97.

BELL, Clive, catalogue preface to the 1919 Eldar Gallery Sickert exhibition.

BELL, Quentin, the *Listener*, 12 February 1953, 'Sickert in Edinburgh', p. 272. Review of the Arts Council exhibition in Edinburgh.

BLUNT, Anthony, *Britain Today*, No. 63, 3 October 1941, 'Walter Richard Sickert', pp. 8–11. A review of Sickert's art occasioned by the National Gallery exhibition.

CONSTANTINE, H. F., the *Burlington Magazine*, 99, October 1957, 'Sickert in Sheffield', pp. 346–7. Review of the Sickert exhibition at the Graves Art Gallery, Sheffield.

DEMPSEY, Andrew, *Apollo*, 83, January 1966, 'Whistler and Sickert: a friendship and its end', pp. 30–7.

DIMSON, Wendy, the *Burlington Magazine*, 102, October 1960, 'Four Sickert Exhibitions', pp. 438–43. A review of the Sickert centenary exhibitions. The author (myself) has since revised her opinion of some of the dates therein quoted.

EARP, T. W., *Apollo*, 11, April 1930, 'The Work of Richard Sickert A.R.A.', pp. 295–300.

EASTON, Malcolm, Appendix to 'Sickert in the North', exhibition held at the University of Hull 1968. A new account of Sickert's activities in the north of England, 1924–5.

FORGE, Andrew, the *Listener*, 16 June 1960, 'The Confident Artist', pp. 1051–3.

HAINES, Robert, *Art Gallery of New South Wales Quarterly*, 10, No. 1, 'Walter Richard Sickert 1860–1942', pp. 422–31. A discussion of the Sickert works in the Sydney Art Gallery.

HALÉVY, Daniel, catalogue preface to the Sickert exhibition held at the Musée de Dieppe 1954.

JONZEN, Basil, *Horizon*, VIII, 45, September 1943, 'A Visit to Mr. Sickert at Broadstairs', pp. 194–203.

MANSON, J. B., *Drawing and Design*, 3, July 1927, 'Walter Richard Sickert A.R.A.', pp. 3–9.

MOORE, George, the *Speaker*, 20 February 1892. A review of Sickert's essay 'Modern Realism in Painting' published in 1892, London, by Fisher Unwin in *Jules Bastien-Lepage and his Art*, edited by André Theuriet.

PICKVANCE, Ronald, *Apollo*, 76, April 1962, 'The Magic of the Halls and Sickert', pp. 107–15.

PICKVANCE, Ronald, catalogue preface to the Arts Council Midland touring exhibition of Sickert's work in 1964.

RUTTER, Frank, *Studio*, 100, November 1930, 'Richard Sickert', pp. 317–24.

SEDDON, Richard, *Apollo*, 38, December 1943, 'The Technical Methods of Richard Sickert', p. 173. Reprinted as preface to the Graves Art Gallery Sickert exhibition in 1957.

THORNTON, Alfred, *Artwork*, VI, No. 21, Spring 1930, 'Walter Richard Sickert', pp. 1–17.

VAUXCELLES, Louis, *Gil Blas*, 12 January 1907, 'La Vie Artistique. Exposition Walter Sickert à Félix Fénéon'. Review of the Sickert exhibition at Bernheim-Jeune, 1907.

WELLINGTON, Hubert, the *Listener*, 23 December 1954, 'With Sickert at Dieppe', pp. 1110–12. An account of the time spent by the author with Sickert and Gore at Dieppe in the summer of 1906.

WESTBROOK, Eric, *Leeds Art Calendar*, No. 8, Spring 1949, 'Walter Richard Sickert. Paintings in the Leeds Collection', pp. 7–14.

WESTBROOK, Eric, *National Gallery of Victoria, Melbourne, Quarterly Bulletin*, X, No. 2, 1956, 'Paintings by Walter Richard Sickert in the National Gallery Collection'.

WHITE, Gabriel, *Image*, No. 7, 1952, 'Sickert Drawings', pp. 4–47. An excellent account of Sickert's drawing processes with thirty-three illustrations.

WHITE, Gabriel, preface to the catalogue of the Arts Council exhibition of notes and sketches by Sickert from the collection of the Walker Art Gallery, Liverpool, 1949.

WHITE, Gabriel, preface to the Arts Council centenary Sickert exhibition, 1960.

4. General literature

BLANCHE, Jacques-Émile, *Portraits of a Lifetime. The Late Victorian Era. The Edwardian Pageant. 1870–1914*, London, Dent, 1937. A primary source of information about Sickert as well as about the period in general in France and England.

BLANCHE, Jacques-Émile, *More Portraits of a Lifetime. 1918–1938*. London, Dent, 1939. As above.

BOWNESS, Alan, and FARR, Dennis, 'Historical Note', preface to the London Group Jubilee Exhibition held at the Tate Gallery in 1964.

BROWN, Frederick, *Artwork*, VI, No. 24, Winter 1930, 'Recollections: The Early Years of the New English Art Club', pp. 269–78.

FORGE, Andrew, 'An Appreciation', preface to the London Group Jubilee Exhibition held at the Tate Gallery in 1964.

GAUNT, William, *The Aesthetic Adventure*, London, Cape, 1945.

HAMNETT, Nina, *Laughing Torso*, London, Constable, 1932. Miss Hamnett's spirited recollections include many of Sickert.

LAIDLEY, William James, *The Origin and First Two Years of the New English Art Club*, London, privately printed, 1907.

LAUGHTON, Bruce, *Apollo*, 86, November 1967, 'The British and American Contribution to Les XX, 1884–1893', pp. 372–9.

LAUGHTON, Bruce, *Philip Wilson Steer*, Oxford, Clarendon Press, 1971. Includes (Chapter IV) a valuable section entitled 'Steer's relationship with Sickert, 1887–94'.

MACCOLL, D. S., *Studio*, 129, March 1945, 'The New English Art Club', pp. 65–73.

MACCOLL, D. S., *The Life, Work and Setting of Philip Wilson Steer*, London, Faber, 1945.

MENPES, Mortimer, *Whistler as I Knew Him*, London, Black, 1904. Chapter entitled 'Master and Followers' especially useful regarding Sickert's early apprenticeship to Whistler.

PAKENHAM, Simona, *60 Miles from England. The English at Dieppe 1814–1914*, London, Macmillan, 1967. A fascinating and detailed account of the English at Dieppe which includes much information about Sickert's family and his own life and circle in the French port.

ROTHENSTEIN, Sir John, *British Art since 1900*, London, Phaidon, 1962.

ROTHENSTEIN, William, *Men and Memories. Recollections of William Rothenstein*, 2 volumes (1872–1900 and 1900–22), London, Faber, 1931 and 1932.

RUTTER, Frank, *Some Contemporary Artists*, London, Leonard Parsons, 1922.

RUTTER, Frank, *Evolution in Modern Art. A Study of Modern Painting 1870–1925*, London, Harrap, 1926.

RUTTER, Frank, 'Camden Town Group', catalogue preface to the exhibition held at the Leicester Galleries, 1930.

RUTTER, Frank, *Art in my Time*, London, Rich and Cowan, 1933.

RUTTER, Frank, *Modern Masterpieces. An Outline of Modern Art*, London, George Newnes, 1940.

SEABROOKE, Elliot, *Studio*, 129, February 1945, 'The London Group', pp. 31–45. (The dates of the Camden Town Group exhibitions are listed incorrectly in this history of the London Group formation.)

SICKERT, Ellen Cobden (pseudonym AMBER, Miles), *Wistons: a Story in Three Parts*, London, Fisher Unwin, 1902. The hero (or villain) of this story is modelled partly on Walter Sickert, the author's former husband.

SWANWICK, H. M., *I Have been Young. An Autobiography*, London, Gollancz, 1935. The author was Sickert's sister.

THORNTON, Alfred, *Fifty Years of the New English Art Club, 1886–1935*, London, New English Art Club, 1935.

THORNTON, Alfred, *The Diary of an Art Student of the Nineties*, London, Pitman, 1938.

WESTBROOK, Eric, catalogue preface to the Arts Council 'Camden Town Group' exhibition of 1951.

WOOD PALMER, J. Preface to the Arts Council 'Drawings of the Camden Town Group' exhibition of 1961.

Catalogue

1880s. PORTRAITS AND FIGURES

1. THE GREY DRESS (Fig. 2) dated 1884

Canvas. 20 × 12 (50·8 × 30·5)
'Sickert 84' b.r.
G. Beatson Blair/
Coll. Manchester, City Art Gallery (1941)
Exh. A.C.64 (1)
Chapter I

2. THE LITTLE STREET SINGER (Fig. 1) c.1883–4

Canvas. 23 × 11½ (58·4 × 29·2)
R. Middleton/
Private Collection, Scotland
Chapter I

Probably Sickert's first painting of a public entertainer.

3. REHEARSAL. THE END OF THE ACT or
THE ACTING MANAGER (Fig. 3) c.1885–6

Canvas. 24 × 20 (61 × 50·8)
'Sickert' b.r.
Mrs. Holland (that is Miss Florence Pash, later Mrs. Humphrey)
Private Collection
Rep. B.43, Pl. 1
Lit. W. Dimson, the *Burlington Magazine*, 107, November 1965, p. 575, 'The Identification of Sickert's "Rehearsal. The End of the Act"', rep. p. 574
Exh. S.B.A.1886–7 (260) as *Rehearsal. The End of the Act*; Brussels, *Les XX* 1887 as *Répétition. La Fin de L'Acte*; R.A.1968–9, 'Bicentenary Exhibition' (449) as *The Acting Manager*
Chapter III

This picture is always published as a portrait of Mrs. D'Oyly Carte. It does indeed depict the lady who was to become—in 1888—the second wife of Richard D'Oyly Carte, but at the time of the painting she was still Miss Helen Couper-Black. Miss Couper-Black, after studying at London University, was for a brief time on the stage as Helen Lenoir. In 1877 she joined the D'Oyly Carte Company in a secretarial capacity but soon became indispensable as a most efficient manager of all aspects of the company's work both in the United States and in England. Apart from other duties she arranged and produced lecture tours for speakers who included Matthew Arnold, Oscar Wilde, and, most interestingly, Whistler. It is perhaps not too fanciful to suggest that Fig. 3 depicts her exhaustion after a rehearsal of Whistler's 'Ten O'Clock' (we know

she staged the 'Ten O'Clocks'), which must have been far more tiring than the opera productions. After her husband's death in 1901 Mrs. D'Oyly Carte managed the affairs of the company alone, and she was responsible for the modernization of the Savoy Hotel. She died in 1913.

The identification of Fig. 3 with the picture shown at the S.B.A. and later at *Les XX* is proved by press reviews of the two exhibitions, e.g.:

St. James Gazette, 1 December 1886, 'a woman among the shadows of a half-lighted room, dropping her weary—or repentant—head on the back of a padded bench'.

L'Indépendance Belge, 25 February 1887, 'l'épisode d'une actrice qui s'est jetée sur un sofa, dans sa loge, pour se reposer des fatigues et des émotions d'une situation dramatique de la fin de l'acte qu'elle vient de jouer'.

The 1968–9 R.A. catalogue mistakenly stated that Fig. 3 was shown at the R.A. in 1885; it was, in fact, the etching of Miss Couper-Black, called *The Acting Manager* and dated 1884, that was exhibited in 1885 (1650). The painting was probably done a little later than the etching, from which it preserved the lamplit effects but changed the whole composition—as well as the title.

4. GIRL SEWING (Fig. 5) c.1885–6

Canvas. 25 × 19 (63·5 × 48·3)
'Walter Sickert' and further illegible inscription b.l.
Coll. Mrs. Leslie
Chapter I

In view of the dearth of early Sickert paintings it is difficult to prove the attribution of Fig. 5 to Sickert. However, I believe that *Girl Sewing* could be a very rare *genre* subject of this period. If so its handling suggests that it was painted at about the same time as *Rehearsal. The End of the Act*.

The model could be Hettie Pettigrew, elder sister to Whistler's and later Steer's model Rosie Pettigrew. Hettie was Millais's model in *Idyll of 1745*, painted in 1884. Sickert etched *Rosie Pettigrew and Another* in 1884.

5. L'HOMME À LA PALETTE (Fig. 4)

Canvas. 29¾ × 12¼ (75·5 × 31·1)
'Sickert' b.l.
Coll. Sydney, Art Gallery of New South Wales (1947)
Rep. *Pall Mall Gazette Extra*, No. 71, 'Pictures of the Year 1894'; B.60, Pl. 5
Lit. Daniel Thomas, *Art Gallery of New South Wales Quarterly*, 10, No. 1, October 1968, pp. 431–2, 'Some Problems of Dating and Identification', rep. p. 423

Exh. N.E.A.C. spring 1894 (69); Tate 60 (6); Adelaide
68 (2); Sydney 68 (1)
Chapter I

This self-portrait could have been painted at any time from
the middle 1880s until its exhibition in 1894. Thomas gives
reasons for dating it in the 1890s (see Chapter I, note 21).
I favour a date in the later 1880s.

6. STANDING WOMAN *or* LE CORSAGE RAYÉ (Fig. 7)

Canvas. 30 × 12¼ (76·2 × 31·1)
'Sickert' b.r.
John Caftanzoglou/
Coll. Mary Averoff, Paris
Exh. Bernheim 1909 (59) as *Le Corsage Rayé*
Chapter I

Probably painted at about the same time as *L'Homme à
la Palette*.
Madame Averoff, in a letter of 14 April 1971, told me that
her father John Caftanzoglou (who lived in Athens)
bought Fig. 7 from Bernheim-Jeune on one of his trips to
Paris in 1909 (at the same time he bought *Regrets*, quoted
under C.252). The only picture among those with Bernheim
in 1909 which agrees in both title and measurements with
Fig. 7 is *Le Corsage Rayé*; it was exhibited at Bernheim in
June 1909 and, according to Sickert's annotated copy of
the catalogue, sold at the sale of this exhibition at the
Hôtel Drouot to Bernheim themselves. Presumably M.
Caftanzoglou immediately bought it from them.

7. TÊTE DE FEMME (Fig. 8)

Canvas. 15½ × 12¾ (39·4 × 32·4)
'Sickert' b.l., 'À mon ami Jacques Blanche/W. Sickert' b.r.
Jacques-Émile Blanche/
Coll. Musée de Rouen (1923)
Lit. R. Pickvance, *Apollo*, 76, July 1962, pp. 404–5,
'Sickert at Brighton', p. 405
Exh. Brighton 62 (4)
Chapter I

Pickvance, not noticing the inscription almost hidden
beneath layers of dirt, believed Fig. 8 to be a genuine
Whistler strayed into the Brighton exhibition—one of the
portraits of *Lilly* of the late 1890s. As a genuine Sickert it is
probably a work of the late 1880s.

8. HUSUM dated 1876

Pencil. 4½ × 3 (11·5 × 7·6)
'Aug. 1 1876' b.c., 'Husum' b.l., and '31/8/1876' b.l.
deleted
Coll. Liverpool, Walker Art Gallery (1948)
Chapter I, note 10

9. THE ARTIST'S MOTHER

Board. 18½ × 15 (47 × 38·1)
'Sickert' b.r.
G. P. Dudley Wallis/Christie's, 17 July 1959 (66) and
5 July 1963 (21)/
Coll. J. S. Steward Esq. (C/o Hilton Gallery, Cambridge
1971)
Exh. Sheffield 57 (5)
Chapter I, note 5

If this portrait is by Sickert it must have been painted very
early, by 1880 at the latest. It cannot represent Sickert's
mother who was a beautiful woman and only fifty years
old by 1880.

10. SELF-PORTRAIT dated 1882

Pen and ink. 6¾ × 4¼ (17·1 × 10·8)
'Dec. 16 1882' b.l.
Coll. London, Islington Public Libraries (1947)
Rep. B.60, Pl. 5a
Exh. Sheffield 57 (100); Tate 60 (27); A.C.64 (27)
Chapter I

11. SHEET WITH FOUR RESTAURANT STUDIES 1884

Pencil. Various sizes approx. 4 × 2½ (10·2 × 6·4) and vice
versa.
One inscribed 'Restaurant Benoit Charlotte St. Fitzroy Sq.
Oct. 6 dejeune'; another inscribed 'The little girl dining'
and 'Moreau's Sunday 9 PM Oct. 5—night before sending
in to Dudley'; another inscribed 'Mme Moreau'. Whole
sheet inscribed '1881 or thereabouts /82?/83?/84?'.
Coll. Leeds, City Art Gallery (1947)
Chapter I, note 24

The inscribed information permits the sheet to be dated
1884 because Sunday fell on 5 October in that year. Studies
possibly used for Sickert's etching *At Moreau's*.

12. WHISTLER'S STUDIO

Watercolour. 8 × 8 (20·3 × 20·3)
Mrs. Cobden-Sanderson/Mrs. Unwin/R.B.D./
Private Collection, London
Exh. R.B.D.1959, 'Christmas Presents' (113)
Chapter I, note 13

13. SKETCH AFTER WHISTLER'S MRS. CASSATT 1885

Pen and ink. 5 × 3¼ (12·7 × 8·2)
'Sickert' b.r.
Percy E. Spielmann/
Coll. London, Victoria and Albert Museum (1949)
Rep. *Pall Mall Budget*, 10 December 1885, as thumb-nail
illustration to a review of the current S.B.A. exhibition
where Whistler showed *Mrs. Cassatt* (362)
Chapter I, note 14

14. LES MODISTES

Canvas. 21¼ × 16¼ (54 × 41·2)
'Sickert' b.r. (the signature is unusually thick)
Coll. Manchester, City Art Gallery (1928)
Rep. Bertram, Pl. 2
Exh. Adelaide 68 (1)
Chapter II, note 26

I think this painting may not be by Sickert.

15. MISS FANCOURT

Canvas. Other details and whereabouts unknown
Exh. N.E.A.C. spring 1890 (9)
Chapter I, note 19
For an idea of this portrait see the portrait of *Wilson Steer*,
Fig. 39. It was a life-size full-length. Sickert etched Queenie
Fancourt *c.*1885.

16. A WOMAN IRONING *c.*1887–9

Pencil, white heightening. $18\frac{1}{2} \times 23\frac{3}{4}$ ($47 \times 60\cdot4$)
'S. Valery en Caux 1887-8-9?' b.l. and colour notes
Mrs. L. Powell/
Coll. Leeds, City Art Gallery (1951)
Exh. Sheffield 57 (145)
Chapter IV

1880s. STILL LIFE

17. VIOLETS (Fig. 10) *c.*1884

Panel. $4\frac{1}{2} \times 8$ ($11\cdot5 \times 20\cdot3$)
'Sickert' t.r.
John Lane/
Coll. Bath, Victoria Art Gallery (1925)
Exh. Possibly Van Wisselingh's Dutch Gallery, 1895 (36)
 as *A Bunch of Violets*; Sheffield 57 (76)
Chapter I, note 5

A rare early still life.
Another example: Panel. $9\frac{1}{8} \times 6\frac{7}{8}$ ($23\cdot2 \times 17\cdot5$), Miss
Sylvia Gosse/Private Collection, London. This panel,
showing a bunch of white and purple violets in a bowl,
could also have been the picture exhibited in 1895. It could
also be *White Flowers*, exhibited S.B.A. 1885 (44).

1880s. LANDSCAPES

18. ON THE SANDS, ST. IVES (Fig. 9) 1883

Panel. $5\frac{3}{4} \times 4\frac{5}{8}$ ($14\cdot6 \times 11\cdot8$)
'Walter Sickert' b.r.
Samuel Courtauld/The Dowager Lady Aberconway/
Coll. The Hon. Christopher McLaren Esq.
Rep. B.60, Pl. 1
Exh. Sheffield 57 (3); Tate 60 (1)
Chapter I

An inscribed label on the back reads 'On the Sands/My
dear Flo/You are to get well quick/Best love from/Walter
Sickert/38 Markham Square/Kings Road Chelsea SW.'
Another label reads 'Painted at St. Ives'. A printed label
reads 'St. Ives 1883'.
Sickert and Mortimer Menpes accompanied Whistler to
St. Ives during the winter of 1883–4. Miss Browse (B.60,
p. 62) identified 'Flo' as Wilson Steer's housekeeper of that
name, but Steer's Flo did not join his household until 1907—
which does not at all fit Sickert's Chelsea address. Lady
Aberconway told me (letter of 23 March 1971) that the
Leicester Galleries from whom the picture was purchased
told her that Flo had been Sickert's own housekeeper and
that she used to tease Sickert by dipping his paint brush
in London mud to darken his pictures. He gave her this
little panel to show her that he could use bright colours.

19. CLODGY POINT, CORNWALL (Fig. 11) 1883–4

Panel. $4\frac{7}{8} \times 8\frac{1}{2}$ ($12\cdot3 \times 21\cdot5$)
'Sickert Sickert' or 'Sickert St Ives' b.r·
Mrs. F. Swanwick (Helena, Walter Sickert's sister)/Mrs.
 Holland (Miss Pash, Mrs. Humphrey)/Rex NanKivell
 /Montague Shearman/Mark Oliver/B. C. Adkin/Palmeira
 Sale Room, Brighton, April 1968/

Coll. University of Glasgow (1969)
Lit. Dennis Farr, the *Burlington Magazine*, 112, January
 1970, pp. 48–51, 'Recent Museum Acquisitions', rep.
 p. 50
Exh. Probably S.B.A.1885 (28) as *Clodgy Cornwall*
Chapter I

Another of the pictures painted on Sickert's visit to St.
Ives 1883–4.

20. MARTIN ÉGLISE (Fig. 6) *c.*1884–5

Panel. $9\frac{3}{8} \times 5\frac{1}{2}$ ($23\cdot8 \times 14$)
'Martin Église' b.l.
Jacques-Émile Blanche/Bernard Lorenceau, Paris/
Mouradian et Valotton, Paris
Exh. R.B.D. 1959, 'Christmas Presents' (25)
Chapter I

21. THE BUTCHER'S SHOP (Fig. 12) *c.*1884

Panel. $9\frac{1}{8} \times 14\frac{1}{2}$ ($23\cdot2 \times 36\cdot8$)
'Sickert' b.l.
Mrs. Holland (Miss Pash, Mrs. Humphrey)/the Very Rev.
 E. Milner-White/
Coll. York, City Art Gallery (1951)
Exh. Sheffield 57 (86)
Chapter II

There is a Whistler panel of a very similar motif (Freer
Gallery of Art, Washington D.C.).

22. LA PLAGE (Fig. 13) *c.*1885

Panel. $8\frac{3}{4} \times 13\frac{3}{4}$ ($22\cdot3 \times 35$)
'Sickert' b.r.
G. Beatson Blair/
Coll. Manchester, City Art Gallery (1941)
Exh. Possibly S.B.A.1885–6 (223) as *The Breakwater*
Chapter I

Faint ciphers next to the signature could be a rubbed
inscription of the date '85'.
The suggestion that Fig. 13 may be *The Breakwater* is put
forward because of its content.

23. THE LAUNDRY SHOP (Fig. 19) dated 1885

Panel. $15\frac{1}{4} \times 9\frac{3}{4}$ ($38\cdot8 \times 24\cdot8$)
'Sickert–85–' b.l.
Miss Beerbohm (presented to her by Sickert)/
Coll. Leeds, City Art Gallery (1937)
Rep. B.60, Pl. 3
Exh. N.G.41 (27); Leeds 42 (116); Tate 60 (3)
Chapter II

I disagree with the reading of the date as '85–6' (as it is
often published).
Version:
Canvas. $19\frac{3}{4} \times 15\frac{1}{2}$ ($50\cdot2 \times 39\cdot4$), J. Schwarz/Christie's,
 26 July 1946 (106)/Lord Ilford/Christie's, 27 April 1964
 (135)/Walter Goetz, Paris/present whereabouts unknown.
Related drawings and studies:
1. gouache. $5\frac{1}{4} \times 6\frac{1}{4}$ ($13\cdot3 \times 15\cdot9$), Mr. J. and Miss S.
 Brandon-Thomas/Coll. Peyton Skipwith Esq. Rep.
 Jeremy Maas, *Victorian Painters*, London, Barrie and
 Rockcliff, 1969, p. 256. Exh. R.B.D. 1966, 'Christmas

Presents' (30) as *Through the Window*; New York 67 (19). This drawing is dated 'Sickert 85'. It is not a study for Fig. 19 but it also shows a laundry shop viewed through a window.

2. pencil, pen and ink, wash, squared. $7\frac{1}{4} \times 10\frac{1}{4}$ (18·4 × 26). Coll. London, Islington Public Libraries (1947). This drawing is related to the gouache drawing listed above and must therefore also be a work of 1885.

Sickert also etched this subject in 1885.

24. LE 14 JUILLET (Fig. 14) dated 1885

Panel. 9 × 14 (22·9 × 35·6)

'Sickert Dieppe le 14 Juillet—1885' b.l.

?Mortimer Menpes/Sir Alec Martin/

Private Collection, London

Exh. Probably S.B.A.1885–6 (66) as *The Fourteenth of July*, and Brussels, *Les XX* 1887 (lent by Menpes), and Van Wisselingh's Dutch Gallery 1895 (31)

Chapter II

25. LES COURSES DE DIEPPE (Fig. 15) dated 1885

Panel. $5\frac{3}{4} \times 8\frac{3}{4}$ (14·6 × 22·3)

'Sickert–85' b.r.

?Theodore Roussel/Miss E. A. Jeffrey/Knight, Frank and Rutley, 19 January 1967 (11)/Edward Seago/

Coll. Mr. and Mrs. Paul Mellon

Exh. Probably Brussels, *Les XX* 1887 as *Les Courses de Dieppe* 1885 (lent by Roussel)

Chapter II

Related painting:

Board. $7\frac{5}{8} \times 9\frac{3}{4}$ (19·4 × 24·8), Sotheby's, 28 March 1962 (127)/Coll. His Excellency Sir Charles Johnston. Exh. Adelaide 68 (25) and Sydney 68 (8) with details misquoted. This is a race-course scene of different composition but of about the same date as Fig. 15.

26. LE MARCHÉ AUX BESTIAUX (Fig. 17) c.1886

Panel. $8\frac{1}{4} \times 14$ (21 × 35·6)

'Sickert' b.r.

Christie's, 5 December 1958 (79)/Martin Cahn/Sotheby's, 14 July 1965 (63)/Saul Leiter. New York/Fine Art Society/

Private Collection, Los Angeles

Rep. B.60, Pl. 2

Exh. R.B.A. 1888 (34); Van Wisselingh's Dutch Gallery 1895 (35); R.B.D.60 (29); Tate 60 (2); Fine Art Society 1971, 'The Slade Tradition' (82)

Chapter II

27. WINDSTOELN. SCHEVENINGEN (Fig. 16)

dated 1887

Panel. $8 \times 14\frac{1}{2}$ (20·3 × 36·8)

'Sickert–87' b.l.

Mrs. M. Clifton/O. T. Falk/Miss A. E. Hubler/

Private Collection, London

Lit. Lillian Browse, *Connoisseur*, 169, September 1968, pp. 9–11, 'A Newly Discovered Sickert', rep. p. 9

Exh. Probably R.B.A. 1887–8 (383) as *Scheveningen (sketch)*; Agnew 60 (28) as *Scheveningen*

Chapter II

Truth, 1 December 1887, called No. 383 at the R.B.A. 'a curious representation of a sack-race', a facetious description which Fig. 16 could well have prompted. Sickert is said to have visited Scheveningen shortly after his marriage in 1885 but no visit is recorded in 1887; however, all the Scheveningen works (etchings included) which are dated are inscribed 1887 and the paintings certainly look like freshly observed works. The catalogue note to No. 28, Agnew 60, mistakenly stated the date as 1897.

28. THE BEACH AT SCHEVENINGEN (Fig. 22)

dated 1887

Canvas. 20 × 24 (50·8 × 61)

'Sickert Scheveningen 87' b.r.

Brandon-Thomas/Mrs. Barnes-Brand/

Coll. Mr. and Mrs. Paul Mellon

Lit. Lillian Browse, *Connoisseur*, 169, September 1968, pp. 9–11, 'A Newly Discovered Sickert', rep. p. 11 (in colour)

Chapter II

29. SEASCAPE (Fig. 18) c.1885–7

Panel. $9\frac{3}{4} \times 5\frac{3}{4}$ (24·7 × 14·6)

'Sickert' b.r.

Sir Hugh Walpole/R. H. Walpole/

Coll. Edinburgh, Scottish National Gallery of Modern Art (1965)

Lit. Andrew Dempsey, *Apollo*, 83, January 1966, pp. 30–7. 'Whistler and Sickert: A Friendship and its End', rep. p. 35

Chapter I

Fig. 18 could have been painted at any time in the mid-1880s although the windbreak and the way the red wood of the panel shines through the paint suggest it may be a Scheveningen work of 1887 (or 1885, see note to C. 27). Fig. 18 was evidently once in the possession of Sickert's wife's family because a pencil inscription on the back reads 'R. Cobden Sanderson, 15, Upper Mall, London W.6'.

30. THE RED SHOP *or* THE OCTOBER SUN (Fig. 20)

c.1888

Board. $10\frac{1}{2} \times 14$ (26·7 × 35·6)

H. B. Broadbent/

Coll. Norwich, Castle Museum (1949)

Exh. Paris Universal Exhibition, British Section 1889 (142) as *The October Sun*; probably R.A.1927 (544) as *St. Valery-en-Caux*; A.C.64 (2)

Chapter II

A label on the back bears the inscription 'The October Sun by Walter Sickert, Paris Univl. Exhibn. 1889'. The exhibition was held in May so if the title accurately described the picture's content it must have been painted October 1888 or an earlier October. I favour 1888 because the vivid red colour used extensively in this landscape was also introduced into Sickert's music hall pictures of that year.

The identification of Fig. 20 as *St. Valery-en-Caux* shown at the R.A. in 1927 is suggested by many press reviews, e.g.: *East Anglian Daily Times*, 2 May 1927, 'small sketch of the front of a foreign shop, a harmony of red and brown'. Many other reviews noted the vermilion colouring. Sickert

drew *Woman Ironing* (C.16) at St. Valery-en-Caux in the later 1880s; the resort is not far along the coast from Dieppe.

Examples of other pictures of shop and house fronts of c.1886–8, which like *The Red Shop* effect a stylistic compromise between the vague definition of *The Butcher's Shop* (Fig. 12) and the more careful particularization of *The Laundry Shop* (Fig. 19) include:

1. *The Little Shop*. Panel. $8\frac{3}{4} \times 12\frac{1}{4}$ (22·3 × 31·1). Sir Cyril Butler/Parkin Gallery 1972. Exh. Parkin Gallery 1972, 'Four for Whistler' (39)
2. *Maison à Vendre*. Panel. $9\frac{1}{2} \times 9\frac{3}{4}$ (24·2 × 24·8). Tooth/ Private Collection, London. Exh. Agnew 60 (68)
3. *A Shop in Dieppe*. Canvas. $13\frac{3}{4} \times 10\frac{1}{2}$ (35 × 26·7) M. Comiot/Coll. University of Glasgow (1955)

31. BATTERSEA PARK 1884
Panel. $4\frac{7}{8} \times 8\frac{1}{2}$ (12·5 × 21·7)
Jacques-Émile Blanche/Bernard Lorenceau, Paris/ Mouradian et Valotton, Paris
Exh. R.B.D. 1959, 'Christmas Presents' (31)
Chapter 1

Inscribed on a label on the back 'Summer 1884. W. Sickert'.

32. BEACH SCENE dated 1884
Panel. $7\frac{5}{8} \times 5\frac{5}{8}$ (19·5 × 14·3)
'Sickert 84' b.l.
Coll. H. Friedenthal Esq., Johannesburg
Chapter I

33. STREET SCENE c.1884
Canvas. $9\frac{1}{2} \times 6\frac{1}{4}$ (24·1 × 15·9)
'To Miss Maud/W. Sickert' b.l.
Sotheby's, 14 December 1960 (129)/David Gibbs/ Coll. The Hon. Mrs. Lyle
Chapter I, note 15

34. THE WATER CART, POURVILLE c.1884–5
Panel. $9\frac{3}{8} \times 5\frac{3}{4}$ (23·8 × 14·7)
Jacques-Émile Blanche/Bernard Lorenceau, Paris/ Mouradian et Valotton, Paris
Exh. R.B.D.1959, 'Christmas Presents' (9)
Chapter I

35. JARDIN EN ANGLETERRE c.1885
Panel. $9\frac{3}{8} \times 14$ (23·8 × 35·6)
'To J. E. Blanche W. Sickert. Poston Hereford' b.r.
Jacques-Émile Blanche/Georges Mevil-Blanche/ Galerie Lorenceau, Paris
Exh. Bernheim 1904 (67) as *Jardin dans le Yorkshire* (lent by Blanche); Dieppe 54 (24)
Chapter II

Inscribed on the back 'Presented to J-E Blanche by Walter Sickert at Hampsteade [sic] June 29 1885'.

36. THE HARBOUR, DIEPPE c.1885
Panel. 9×14 (22·9 × 35·6)
Miss Ellen Heath (given to her by Sickert in 1896)/ Coll. Leeds, City Art Gallery (1942)

Lit. J. Bradshaw, *Leeds Art Calendar*, No. 53, 1964, pp. 12–15, 'A Group of Paintings by Sickert and a Portrait by Ellen Heath', rep. p. 13
Exh. Hull 68 (1), rep. in catalogue
Chapter I

37. DUNFORD. THE RESIDENCE OF THE LATE RICHARD COBDEN M.P. c.1888–9
Canvas. $35\frac{1}{2} \times 35\frac{1}{2}$ (90·2 × 90·2)
'Sickert Dunford' b.r.
Coll. National Council of Y.M.C.A.s, Dunford, Midhurst
Exh. Probably Goupil Gallery, December 1889, 'London Impressionists' (70)
Chapter IV

Sickert's wife Ellen was the daughter of Richard Cobden (1804–65), the prominent advocate of Free Trade.

1880s. MUSIC HALLS AND THEATRICAL SUBJECTS

38. THE CIRCUS (Fig. 21) c.1885
Panel. $8\frac{1}{2} \times 14$ (21·6 × 35·6)
'Sickert' b.r.
Sir Alec Martin/
Private Collection, London
Exh. Possibly R.B.A. 1888 (209) as *Pinner's Circus* [sic] and Van Wisselingh's Dutch Gallery 1895 (39) as *Pinder's Circus*
Chapter II

Sickert's first known painting of a theatrical subject, probably painted in Dieppe in 1885.
It is likely that the subject is Pinder's Circus, a troupe that frequently visited Dieppe. Whether or not Fig. 21 is the picture exhibited at the R.B.A. is unproved. The *Daily Telegraph*, 7 May 1888, described No. 209 at the R.B.A. as 'a comic daub . . . alleged to be a circus'.
Sickert studied Pinder's Circus on several occasions. Besides the picture exhibited at the R.B.A. and/or the Dutch Gallery in 1895 there is an etching of this title showing a girl on a donkey or pony seen from behind; it is inscribed 'Sickert Dieppe Aug 9 1889'.

Study for Fig. 21:
conté crayon and pencil. $13\frac{1}{2} \times 18\frac{1}{4}$ (34·3 × 46·4), Sotheby's, 26 April 1961 (88) as *The Audience*, bought Marshall.

39. THE KURHUIS, SCHEVENINGEN (Fig. 24) c.1887
Panel. $14 \times 9\frac{1}{2}$ (35·6 × 24·2)
'Sickert' b.l.
J. W. Freshfield/
Coll. Richard Attenborough Esq.
Lit. Lillian Browse, *Connoisseur*, 169, September 1968, pp. 9–11, 'A Newly Discovered Sickert', rep. p. 10
Exh. R.B.A.1888 (351); N.G.41 (25); Leeds 42 (117); Tate 60 (4)
Chapter II

The picture shown at the R.B.A. in 1888 was an oil (and therefore almost certainly this panel), not a watercolour as stated by Miss Browse, *Connoisseur*, 1968.

40. THE LION COMIQUE (Fig. 25) 1887

Canvas. 19½ × 11½ (49·6 × 29·2)
'Sickert' b.l.
Mr. J. and Miss S. Brandon-Thomas/
Coll. The Cottesloe Trustees
Rep. The *Yellow Book*, III, October 1894, p. 139; B.60, Pl. 10
Lit. R. Pickvance, *Apollo*, 76, April 1962, pp. 107–15, 'The Magic of the Halls and Sickert', rep. p. 115 (in colour)
Exh. R.B.A. 1887 (147) as *Le Mammoth Comique*; Edinburgh 53 (47); Agnew 60 (6); Tate 60 (11)
Chapter III

The *Daily Telegraph* (not *The Times* as stated by Pickvance), 2 April 1887, description of No. 147 at the R.B.A. proves it was Fig. 25:
'an open-mouthed music-hall singer, against a garish "back-cloth". It is clever, but the effect of the canvas at the back is not quite intelligible. It is meant to be a crudely-painted landscape, and . . . we at first took it as the artist's idea of real nature. The slope of the balustrades is a happy and quaint notion, but there is a lack of distance between the figure of the singer and the somewhat "tricky" background.'
Although *The Lion Comique* is Sickert's earliest known music hall painting, he had studied such subjects before 1887. He etched the audience at the Mogul Tavern in 1884 and at the Queen's Palace of Varieties in 1885 (H. Wright's dating, MS British Museum).
Sickert also drew a music-hall singer *c*.1884: pencil. 4 × 2⅜ (10·3 × 6), Coll. Liverpool, Walker Art Gallery (1948), Exh. A.C.49 (1). Chapter III. This tiny sketch is inscribed, partly illegibly, with the words of a music-hall lyric, 'What a . . . honest/He never goes out on a spree/O such a . . . is he'.

41. BONNET ET CLAQUE. ADA LUNDBERG AT THE MARYLEBONE MUSIC HALL (Fig. 23) *c*.1887

Canvas. 16½ × 23½ (41·9 × 59·7)
'Sickert' t.l.
Dr. Robert Emmons/Agnew/
Private Collection, London
Rep. The *Yellow Book*, II, July 1894, p. 225 as *Ada Lundberg*; Emmons, p. 50 under the title given above with the additional words 'It all comes from sticking to a soldier'
Exh. Possibly Van Wisselingh's Dutch Gallery 1895 (13) as *The Marylebone Music Hall, High Street, Marylebone*; Agnew 60 (7)
Chapter III

Fig. 23 is here dated *c*.1887 on stylistic grounds (its similarity to *The Lion Comique*). Some corroboration for the dating is that Ada Lundberg appeared at the Marylebone Music Hall from February until early April 1887. This evidence taken alone is not conclusive because she was at the Marylebone again in January 1888 and December 1889.

42. GATTI'S HUNGERFORD PALACE OF VARIETIES. SECOND TURN OF KATIE LAWRENCE (Fig. 28) *c*.1887–8

Canvas. 33½ × 39 (85·1 × 99)
'Sickert' b.r.
J. B. Priestley/

Coll. Sydney, Art Gallery of New South Wales (1946)
Rep. B.43, Pl. 3; Bertram, Pl. 3
Lit. Daniel Thomas, *Art Gallery Quarterly of New South Wales*, 10, No. 1, October 1968, pp. 431–2, 'Some Problems of Dating and Identification', rep. p. 427
Exh. Adelaide 68 (4)
Chapter III

R. Pickvance supplied the evidence, quoted by Thomas and discussed in the text, which proves that Fig. 28 is not the picture accorded a place of honour at the N.E.A.C. exhibition in April 1888. The exhibited painting was the object of critical furore; it was upright and much larger. It is now lost (probably destroyed) but its composition may be reflected in a drawing (whereabouts of original unknown) published in the *Idler*, March 1895, 'The Music Hall', p. 170 with the caption 'Kate O'Grady/You're a lady'.
Version of Fig. 28:
Canvas. 15 × 18½ (38·1 × 47), Coll. Yale University Art Gallery, New Haven, Connecticut, U.S.A. (1960). Rep. *Apollo*, 76, April 1962, p. 110.
This version is probably *Ta-ra-ra-bom-de-ay* of which Sickert wrote in a letter to Mrs. Hulton of 1903. He described it as 'a picture of Miss Katie Lawrence singing in "Gatti's Hungerford Palace of Varieties" (The Arches) Villiers Street Charing Cross from drawings executed on the spot in 1888'. Sickert told Mrs. Hulton that he intended to send this picture to the Venice Biennale of 1903 but in a later letter of March 1903 (datable from his reference to his pictures currently on exhibition at the *Salon* and the *Salon des Indépendants*) he wrote, 'My music-hall wasn't finished, so I am sending to Venice 2 small canvases'.
Studies (these were probably originally executed as preparatory documents for the picture exhibited at the N.E.A.C. and then immediately re-used for Fig. 28).
There are at least seventy-two sketches extant related to Fig. 28. With four exceptions—an audience study and three studies of an *artiste* (one certainly, the other two probably, of Katie Lawrence), in the collection of the Walker Art Gallery, Liverpool—they are all mounted in groups on sheets. The sheets all came from Sickert's studio and were presented by the Sickert Trust to the Liverpool, Manchester, and Leeds Art Galleries. In most cases the mounting was done by Sickert at the time of the execution of the drawings because his inscriptions (colour notes, dates, etc.) are often on the mounts. Except for the two single sketches of an *artiste* (probably Katie Lawrence) done in pastel, they are all drawn in pencil. They are all small in size and many are inscribed.
A summary of the main reasons for dating the studies follows. This summary is necessary in order to differentiate the studies for Fig. 28 from the equally large number of studies for Fig. 27 and other Gatti's subjects executed in 1888.

1. Katie Lawrence left England to tour Australia in January 1888 and was away until May 1889. Therefore all the studies of Katie Lawrence must have been drawn in 1887, at Gatti's in May and July (when she appeared there) and/or in other halls at different times that year. This includes one study of Katie Lawrence mounted together with some architecture studies for Fig. 27 done in 1888 (Liverpool).

2. The 'cellist and the woman in the right foreground corner of the *Idler* drawing *Kate O'Grady* (?reflecting similar figures from the N.E.A.C. picture) are studied in a sheet of eleven drawings (Liverpool, Exh.A.C.49 No. 2). This sheet and another of eleven drawings (Leeds) are both inscribed on the mount 'Feb 4 to Mar 24 and after'. The Leeds sheet includes seven studies of Katie Lawrence, four inscribed 'Oxford' and two inscribed 'Gatti's'. If he was interested in an *artiste* Sickert would follow her from hall to hall on the same night. Katie Lawrence played at Gatti's and the Oxford in May 1887 so these studies must represent the 'after' of the inscription. It may be presumed that the remaining sketches (audience, architecture) on this sheet were done from February to March 1887 (when Katie Lawrence was in the provinces) and that the Liverpool sheet, done on the same days and months as the Leeds sheet, was also drawn in 1887.

3. Another sheet of thirteen drawings (Leeds) contains several audience studies inscribed 'May 25'; that the year was 1887 is proved by the inclusion of two studies on the same sheet of an *artiste*, both inscribed 'Whit Monday Nellie Brown', one of which is further inscribed 'Gatti's'. Nellie Brown (and Katie Lawrence) were playing at Gatti's during Whit week 1887 (May 21–26). Four drawings on this sheet were done some months later; this group as a whole is inscribed on the mount 'Florence Hayes "The Patriotic Lady"' and by the side of one is the date 'December'. Florence Hayes (billed as 'The Political Lady') was at Gatti's in December 1887.

4. A study of the 'cellist appears on a sheet of nine drawings (Leeds), the others being four audience and four architecture studies. The 'cellist suggests the sheet as a whole was done in 1887.

5. Two Katie Lawrence studies are included on a sheet together with ten audience studies (Manchester, Exh. Hull 68 No. 28), suggesting the whole sheet was done in 1887.

6. Finally a sheet of seven drawings of the audience (Liverpool, Exh. A.C.49, No. 10), the single audience study noted above (Liverpool), and a sheet of nine drawings (Manchester) of which five at least are of Gatti's (four are audience studies and the fifth a study of the stage architecture) were probably all done in 1887, first because it was in this year that Sickert studied the audience extensively, and second because several of the individual figures are related to others on datable sheets.

43. QUEENIE LAWRENCE AT GATTI'S HUNGERFORD PALACE OF VARIETIES (Fig. 27) *c.*1888

Canvas. 24 × 24 (61 × 61)
'To Jacques Blanche/W. Sickert/Gatti's Hungerford (the Arches)' b.r. 'Queenie Lawrence/Tom Tinsley chairman' b.c.
Jacques-Émile Blanche/Earl Haig/Christie's, 26 July 1957 (42)/David Tomlinson/Sotheby's, 12 July 1961 (163)/ Leicester Galleries/
Private Collection, London
Exh. Sheffield 57 (27); Agnew 60 (8); Tate 60 (10)
Chapter III

This picture is not a version of Fig. 28 but a new subject taken in the same music hall. Contrary to common belief, Queenie was not a pet name for Katie Lawrence. They were unrelated rivals. Queenie (like Katie) was at Gatti's in July 1887; she was at Gatti's again from March to April 1888 (when Katie was in Australia).

Studies:
There are at least seventy-three sketches relating to pictures of Gatti's made in 1888. When painting *Queenie Lawrence* Sickert must also have made use of his earlier Gatti's studies listed above. The general remarks about size, mounting, etc. of the studies for Fig. 28 are applicable here as well.

1. A sheet of five drawings (Leeds) inscribed on the mount 'March 1888' may represent Queenie Lawrence at Gatti's.

2. A sheet of eight drawings (Liverpool, Exh. A.C.49 No. 7) contains seven studies of the stage architecture, one of which is dated 'June 7 1888'; the other six drawings are done on the same kind of paper and are similar in style: they can, therefore, be accepted as works of about the same date. The last drawing on this sheet, done on different paper, is of Katie Lawrence (see note to Fig. 28, C.42, Studies 1) and must have been drawn in 1887.

3. A sheet of nine drawings (Manchester, Exh. Hull 68 No. 29) of the stage architecture includes one dated 'June 8 1888' and another dated 'June 16 1888', suggesting that the remaining seven studies were also drawn in June 1888.

4. A sheet of eight drawings (Leeds) includes three studies of the stage architecture and five of the empty seats in the auditorium; several are dated various days in June. The month can be assumed as June because we know Sickert was drawing at Gatti's in June 1888.

5. Finally there are forty-four studies of three different *artistes*—Kate Harvey, Emily Lyndale, and a third girl who looks like Queenie Lawrence although she is not recorded as having been at Gatti's on the dates in June inscribed on the drawings (see Chapter III, note 31).

These drawings are mounted on three sheets:
(a) seventeen drawings (Liverpool); (b) nine drawings (Liverpool, Exh. A.C.49 No. 8); (c) eighteen drawings (Leeds).
All the drawings on sheet (a) and seven of the drawings on sheet (c) were drawn at Gatti's because they are dated variously from June 4 to June 8, some also inscribed with the year 1888, dates on which we know from other architecture drawings that Sickert was at Gatti's.
The remaining eleven drawings on sheet (c) and all nine drawings on sheet (b) are studies of Emily Lyndale and were not done at Gatti's. They were done later (June 30, July 24, 30, 31, August 1, 4), at the Paragon in June and at the Hammersmith in July. Emily Lyndale evidently caught Sickert's eye at Gatti's in June (there are drawings of her dated 'June 4' and 'June 8') and he followed her from hall to hall afterwards. These studies are inscribed with detailed colour notes but the only extant composition incorporating the mass of information about Emily Lyndale is an etching, showing her as *Sinbad the Sailor*.

44. LITTLE DOT HETHERINGTON AT THE BEDFORD MUSIC HALL (Fig. 26) *c.*1888–9

Canvas. 24 × 24 (61 × 61)

'Sickert' b.r.

Christie's, 28 March 1930 (107)/Dr. Robert Emmons/ Private Collection, England

Rep. The *Yellow Book*, II, July 1894, p. 221 as *The Bedford Music Hall*; Emmons, facing p. 40, as *Joe Haynes and Little Dot Hetherington at the Old Bedford Music Hall* '*The Boy I love is up in the Gallery*'

Exh. Goupil Gallery, December 1889, 'London Impressionists' (65) under title given here; Van Wisselingh's Dutch Gallery 1895 (24) under title given here with song caption added; Agnew 60 (9) as *The Old Bedford*; Tate 60 (12) under title used by Emmons but without the song caption

Chapter III

Studies:

1. Watercolour and black chalk. 12½ × 10½ (31·8 × 26·8) Coll. Mount Trust. Exh. Tate 60 (30). A composition study.

2. Pencil, pen and ink, squared. 12¾ × 10½ (32·2 × 26·6), Coll. Yale University Art Gallery, New Haven, Connecticut, U.S.A. (1961). Exh. New York 67 (41). A composition study.

3. Pencil. 6¼ × 4 (15·9 × 10·2), Coll. Liverpool, Walker Art Gallery (1948). A sketch of the chairman, Joe Haynes.

4. Details and whereabouts of original unknown. Rep. the *Idler*, March 1895, p. 169.

 Sickert also painted this subject on a fan for his friend Miss Pash (later Mrs. Humphrey, then Mrs. Holland), now Private Collection, London. Exh. Leeds 42 (115); Brighton 62 (41) as *Cissy Loftus*.

45. THE P.S. WINGS IN AN O.P. MIRROR (Fig. 30)
 *c.*1888–9

Canvas. 24½ × 20½ (62·2 × 52)

Jacques-Émile Blanche/ Coll. Musée de Rouen (1922)

Rep. B.60. Pl. 7 as *A Singer at the Old Bedford*

Lit. B.60, p. 63 as details unknown, but listed separately under works in public collections (Rouen) p. 89, with details, as *Café Concert*

Exh. Goupil Gallery, December 1889, 'London Impressionists' (69) under title given here; Dieppe 54 (23) as *Londres: Scène de Café-Concert*; Brighton 62 (3) as *Music Hall*

Chapter III

The identification of Fig. 30 with the picture exhibited in 1889 is proved first by an analysis of its subject (see Chapter III, note 38), and second by a review in the *Star*, 3 December 1889, which described but did not name the picture: 'Probably the cleverest of all is the reflection of a figure in red in a mirror; the low-toned audience is admirably contrasted with the reflection of the brilliant red figure, and the FEELING OF REFLECTED LIGHT with which all the picture is filled is perfectly suggested'. Sickert showed three music hall pictures at this exhibition and the *Star* had already named the other two (*The Oxford* and *Little Dot*) so this description could only have applied to *The P.S. Wings*.

Study:
Pencil. 2¾ × 2⅜ (7 × 6), Coll. Manchester, City Art Gallery (1947). This is a sketch of the singer's head included on a sheet of nine studies (Manchester), some for Gatti's (Fig. 28, C.42, Studies 6).

46. MINNIE CUNNINGHAM AT THE OLD BEDFORD (Fig. 37) *c.*1889

Canvas. 30 × 26 (76·2 × 66)

'W. Sickert' b.r.

Coll. Peter Pears Esq.

Exh. N.E.A.C. winter 1892 (91) as *Miss Minnie Cunningham* '*I'm an old hand at love, though I'm young in years*'; Probably Van Wisselingh's Dutch Gallery, 1895 (11)

Chapter III

Minnie Cunningham began her career *c.*1888 and first appeared at the Bedford in July 1889 when this picture was probably studied.

Study:
Details and whereabouts of original unknown. Rep. the *Idler*, March 1895, p. 173.

47. THE SISTERS LLOYD (Fig. 34) *c.*1888–9

Canvas. 21 × 30 (53·3 × 76·2)

'Sickert' b.r.

Sir Augustus Daniel/ Coll. London, Department of Environment (1958), location Foreign and Commonwealth Office

Exh. Probably N.E.A.C. spring 1894 (54)

Chapter III

Sickert painted several pictures of the Sisters Lloyd, each one different in composition and detail. Press reviews of the 1894 N.E.A.C. exhibition, however, suggest that the version here illustrated was the one then on show, e.g.:

The Times, 9 April 1894, 'the only definite fact as to them is that they wear large orange hats'.

Truth, 12 April 1894, 'smudges which look more like a couple of red-headed mops with bifurcated stems than the Sisters anything'.

In Fig. 34 the Sisters are wearing orange-coloured hats, but their dress is different in the other pictures listed below.

The composition of the group who played as 'The Sisters Lloyd' changed over the years. The original two 'Sisters' were Rosie Lloyd (sister of Marie) and her cousin Bella Orchard (see W. MacQueen Pope, *Queen of the Music Hall*, London, Oldbourne, 1957, p. 99). Their career, according to the music hall gazettes, began in 1888. I favour a date of *c.*1888–9 for Fig. 34 in spite of the late *terminus ante quem* of 1894. The scribbled style of several small pencil studies, Coll. Liverpool, Walker Art Gallery (1948), supports this dating. Other paintings of *The Sisters Lloyd*:

1. Board. 8¼ × 10 (20·7 × 25·4), Private Collection, London. The Sisters wear red dresses and the music hall is the Bedford, with the coloured glass frieze in front of the stage a prominent feature as in Figs. 36 and 29. A date of *c.* 1889 is suggested.

2. *The Three Drummers* or *The Three Imperialists*. Canvas. 11½ × 15½ (29·2 × 39·3), Mrs. Phyllis Duveen/Coll. Mrs. Prince Littler. This picture shows three instead of two Sisters, probably Rosie, Gracie, and Alice Lloyd (Bella

Orchard seems to have left the group as soon as Marie's sisters were old enough to go on stage themselves). They wear red dresses and carry drums; the music hall is again the Bedford. A date of *c.*1890 is suggested.

Study for *The Three Drummers*:

Charcoal. 6½ × 10½ (16·5 × 26·7), Coll. University of Reading (1957). Rep. B.60, Pl. 11a.

3. *Over the Footlights*. Canvas. 19½ × 23½ (49·5 × 59·7), W. Rees Jeffreys/Christie's, 26 November 1954 (68)/Dr. P. A. Toller/Coll. R. J. B. Walker Esq. Rep. *Artwork*, VI, No. 21, spring 1930, p. 9. Two Sisters, said to be Alice and Gracie Lloyd, are represented. They wear black and white dresses. The colours and general tonality are darker than in the other Sisters Lloyd paintings; the broad handling suggests that it is close in date to *Charley's Aunt*, Panel. 8½ × 13½ (21·6 × 34·3), Private Collection, London. Rep. the *Yellow Book*, III, October 1894, p. 141. *Charley's Aunt* was first performed at the Royalty Theatre in December 1892 so the painting must have been executed between that date and its reproduction in 1894.

Study for *Over the Footlights*:

Details and whereabouts of original unknown. Rep. the *Idler*, March 1895, p. 172, under the caption 'A very nobby suit, a shiny hat and boot, That's man, that is the cause of all our woes'.

48. VESTA VICTORIA AT THE OLD BEDFORD (Fig. 36)
*c.*1890

Board. 14½ × 9¼ (36·8 × 23·5)

'Sickert' b.l.

Mrs. Cobden-Sanderson/
From the collection of Edward le Bas
Rep. Bertram, Pl. 1; B.60, Pl. 6
Exh. Probably R.A.1898 (801) as *The Stage Box*; Edinburgh 53 (65); Tate 60 (5); Brighton 62 (43); R.A.1963, 'A Painter's Collection' (143)
Chapter III

Suggested as the picture shown at the R.A. in 1898 because Fig. 36 was formerly known as *The Stage Box*, under which title it was reproduced in the *Studio*, 100, November 1930, p. 322. Moreover, writing to William Rothenstein in 1899, Sickert referred to his 'little old Academy picture'. Fig. 36 suits both these adjectives. There are other versions (listed below) but Fig. 36 is the most finished picture of the group. I have been unable to trace Vesta Victoria to the Bedford Music Hall before March 1890, so that the panels and versions may be works of that year.

Versions:

1. Panel. 14½ × 9¼ (36·8 × 23·5), J. P. Cochrane/R.B.D./ Private Collection. Exh. R.B.D.57 (9).
2. Panel. 13½ × 9½ (34·3 × 24·1) Mrs. Eric Oppenheimer/ Christie's, 30 October 1970 (183)/Private Collection, London.

Version 2 shows a man in a bowler hat reflected in the mirror instead of a woman.

Studies:

1. Black and white chalk, pen and ink. 12½ × 9 (31·8 × 22·9), from the collection of Edward le Bas. Exh. R.A. 1963, 'A Painter's Collection' (203).
2. Black and white chalk, pen and ink. Size unknown. Coll.

London, Slade School of Art (inscribed 'Study for the old Bedford in possession of Mrs. Cobden-Sanderson').

3. Pencil and wash. 8⅛ × 4½ (20·6 × 11·5), Miss Helen Saunders/Coll. London, Victoria and Albert Museum (1966). The inscription to Miss Saunders includes the identification 'The Bedford in the nineties', but Sickert had little memory for precise dates so *c.*1890 remains possible.
4. Pencil. Coll. Liverpool, Walker Art Gallery (1948).

Studies 1 and 2 are composition drawings. Study 3 concentrates on the stage *artiste*. Study 1 shows a man reflected in the mirror as does painting Version 2. Study 4 is a Lautrecian drawing of the woman in a large hat reflected in the mirror in Fig. 36 and Version 1. It is small in size.

49. RED, WHITE AND BLUE (Fig. 29) *c.*1889

Panel. 8¾ × 5¾ (22·2 × 14·6)

Lord Cottesloe/Sotheby's, 14 July 1965 (64)/Tooth/
Private Collection, England
Chapter III

Another Bedford subject, possibly representing Miss Fanny Guyton who was singing a song called 'Red, White and Blue' in 1889 and who appeared at the Bedford in September 1889.

Related painting:

Canvas. 8 × 10 (20·3 × 25·4), last known owner G. Harvey Samuel Esq. Rep. B.43, Pl. 4 as *The Old Bedford*. Exh. Edinburgh 53 (88) as *The Orchestra*. This canvas omits the *artiste* and extends the scene to the right to include more of the orchestra and an audience figure.

Related drawing:

Topical and Extempore. Details and whereabouts of original unknown. Rep. the *Idler*, March 1895, p. 171. Similar to Fig. 29 in composition but it shows a male *artiste*. A painting called *Patriotic, Topical and Extempore* was shown at Van Wisselingh's Dutch Gallery in 1895 (16).

50. COLLIN'S MUSIC HALL ISLINGTON GREEN
*c.*1887–8

Details unknown. Destroyed
Rep. Frederick Wedmore, *Some of the Moderns*, London, Virtue, 1909, following p. 50 (by which time the picture was already destroyed)
Exh. N.E.A.C. spring 1889 (44)
Chapter III

Identified as the picture shown at the N.E.A.C. in 1889 by several press reviews and by Sickert's own description in the *Scotsman*, 24 April 1889:

'A graceful girl leaning forward from the stage' who 'evoked a spontaneous movement of sympathy and attention in the audience whose sombre tones threw into more brilliant relief the animated movement of the singer, bathed as she was in a ray of green limelight from the centre of the roof, and from below in the yellow radiance of the footlights'.

Version:

Details and whereabouts unknown. Rep. the *Yellow Book*, III, October 1894, p. 137. Exh. N.E.A.C. winter 1894 (37). The identification of the *Yellow Book* version as the picture shown at the N.E.A.C. in 1894 is proved by the remark

in *Truth*, 15 November 1894: 'the original seems even less satisfactory than its reproduction in the current *Yellow Book*'.

Studies:

1. Sheet of six drawings, various small sizes, Coll. Liverpool, Walker Art Gallery (1948). Exh. Hull 68 (26). This sheet is inscribed on the mount 'From March 1887'. The studies could be early sketches for either version of *Collin's Music Hall*.
2. Pen and ink. Details and whereabouts unknown. Rep. Sitwell, p. 26.

51. THE OXFORD MUSIC HALL c.1888-9

Canvas. 30 × 25 (76·2 × 63·5)
Coll. Sydney, Art Gallery of New South Wales (1949)
Rep. The *Yellow Book*, I, April 1894, p. 85
Exh. Goupil Gallery, December 1889, 'London Impressionists' (67); Van Wisselingh's Dutch Gallery, 1895 (37); Adelaide 68 (3)
Chapter III

1890-5. PORTRAITS AND FIGURES

52. JACQUES-ÉMILE BLANCHE (Fig. 32) dated 1890

Pen and ink. 12¼ × 9½ (31·2 × 24·2)
'Sickert 1890' t.r., autographed and dated by sitter 'J. E. Blanche/90 Dieppe' b.l., and inscribed by printer
Sotheby's, 4 March 1959 (27, one of six drawings)/
 A. Mathews/
Private Collection, London
Rep. The *Whirlwind*, 23 August 1890
Chapter IV

Jacques-Émile Blanche (1860-1941) is discussed in relation to Sickert in Chapter II. He was a French painter and writer.

Fig. 32 is one of the full-page cartoons of persons of distinction, taken from life, which Sickert contributed to the short-lived weekly newspaper the *Whirlwind* in 1890. The rest of the series and their reproduction dates are listed below. All six drawings at Sotheby's in 1959 were bought by A. Mathews of Bournemouth and are noted below. Owners of other originals, where known, are cited.
Charles Bradlaugh, 28 June. Coll. Joe Darracott Esq.
Thomas Bayley Potter, M.P., 5 July
Henry Labouchere, M.P., 12 July. A Mathews/Coll. The University of Glasgow (1959)
Sir John Pope-Hennessy, K.C.M.G., 19 July. A. Mathews
George Lewis, 26 July. Sotheby's. 17 March 1965 (94), mistakenly listed as a portrait of Labouchere, bought O. and P. Johnson.
The Stuart Heiress, Queen Mary, 2 August
R. W. Hanbury, 9 August. A. Mathews
Dr. Kenny, M.P., 16 August. A. Mathews
Lord Lytton, 30 August
John Addison, 6 September. A. Mathews
M. John Lemoinne, 13 September. Rep. *Artwork*, VI, No. 21, spring 1930, p. 2. Exh. Van Wisselingh's Dutch Gallery, 1895 (9).
Sir Charles Rivers Wilson, 20 September
M. Giovanni Boldini, 13 December

All the drawings except for *The Stuart Heiress* and *Addison* are inscribed in some way. Most are signed and dated by Sickert and autographed by the sitter. *Bradlaugh*, *Potter*, and *Labouchere* are the most complete in that a setting is suggested. Fig. 32 is the only full-length and is treated more informally than the rest, showing Blanche with his dog Gyp on his knees. Sickert made preparatory studies for these drawings. He probably utilized studies made for his painted portrait of *Bradlaugh* when drawing the 'cartoon'; a sheet of four studies of *Bayley Potter* and a tiny sketch of *Pope-Hennessy* are in the Walker Art Gallery, Liverpool (1948).

Labouchere and *The Stuart Heiress* were reprinted in the *Pall Mall Budget* in 1893, 9 February and 9 March respectively. The others published in this paper in 1893 are noted below (with reproduction dates etc.).
Henri Rochefort, 16 February. Coll. Courtauld Institute of Art (1952). Exh. A.C.64 (29)
George Moore, 23 February
Professor Dewar, 2 March
Hippolyte Taine, 9 March
Lord Curzon, 16 March
John Gilbert, 13 April. Alfred Wolmark/Christie's, 21 July 1961 (20), bought Platt
The Maharajah of Bhavnagar, 4 May. Coll. Courtauld Institute of Art (1952). Exh. A.C.64 (30)
All except for *Moore*, *Gilbert*, and the *Maharajah* are identical in style to the *Whirlwind* series and were probably drawn in 1890.

A study for *Rochefort* is in the Walker Art Gallery, Liverpool (1948).
Another drawing of *Moore*, wearing the same spotted cravat but seen three-quarter instead of bust-length and facing in the opposite direction, was published in the *Cambridge Observer*, 28 February 1893. Both may have been drawn when Sickert was studying Moore for his painted portrait (Fig. 31) exhibited at the N.E.A.C. winter 1891.
Gilbert and the *Maharajah* were drawn in 1893 at sittings arranged by the newspaper. In both Sickert used wash to enrich his pen and ink drawing. Unless Sickert's knowledge of geography was deficient, or his choice of title exceptionally perverse, the *Maharajah of Bhavnagar* cannot be the *Portrait of an Afghan Gentleman* exhibited N.E.A.C. winter 1895 (24) as stated in the Arts Council 1964 'Sickert' exhibition catalogue (30).

53. PHILIP WILSON STEER (Fig. 39) c.1890

Canvas. 36 × 24 (91·4 × 61)
'Sickert' b.r.
Wilson Steer/
Coll. London, National Portrait Gallery (1942)
Rep. B.43, Pl. 6
Exh. N.E.A.C. spring 1890 (27); Adelaide 68 (5)
Chapter IV

Sickert and Steer (1860-1942) were exact contemporaries and at the time of this portrait close friends. They each exhibited a portrait of the other in the N.E.A.C. exhibition of spring 1890. Dr. Bruce Laughton (*Philip Wilson Steer*, Oxford, Clarendon Press, 1971) has demonstrated that Steer's portrait was not (as popularly supposed) the full-length of Sickert against a studio background (Coll. National Portrait Gallery, London) which in fact he dates

1893; it was a now lost half-length of Sickert sporting a handsome moustache, rep. by Laughton, Plate 82 from the *Pall Mall Gazette*, 'Pictures of the Year', 1890.

54. CHARLES BRADLAUGH (Fig. 35) 1890
Canvas. 29 × 24 (73·7 × 61)
Coll. London, National Liberal Club (given by subscribers in 1891)
Rep. B.43, Pl. 7
Exh. N.E.A.C. spring 1890 (27)
Chapter IV

Sickert's introduction to Bradlaugh, free-thinker and politician (1833–91), and hence his commission to paint this portrait, was probably due to his wife's family connections.
Study:
Chalk and pencil. 7¾ × 6¾ (19·7 × 17·1), Lady Gosse/Coll. London, National Portrait Gallery (1928). Exh. Possibly Van Wisselingh's Dutch Gallery, 1895 (21).
For another portrait of Bradlaugh see Fig. 38; for another drawing see under C.52.

55. GEORGE MOORE (Fig. 31) c.1891
Canvas. 23¾ × 19¾ (60·5 × 50)
'Sickert' b.l.
Philip Wilson Steer (bought from Sickert in 1910)/
Coll. London, Tate Gallery (1917)
Rep. The *Yellow Book*, IV, January 1895, p. 85; Emmons, facing p. 86; Bertram, Pl. 5; Lilly, Pl. 4
Lit. George Moore, the *Speaker*, 20 February 1892; Tate Gallery Catalogue, 1964, p. 621
Exh. N.E.A.C. winter 1891 (48); Tate 60 (13); Adelaide 68 (7)
Chapter IV

Moore (1852–1933), novelist and critic, recalled in the *Speaker* that he only sat twice for his portrait and that Sickert—like Millet—worked by observing intensely and memorizing his impressions. Critical reaction to the portrait was mixed but most reviewers commented upon its caricature qualities, e.g. the *Spectator*, 5 December 1891, 'Whether or not it is like the original, it is a notable piece of character-painting, and suggests how powerful a weapon lies in the hand of the painter if he chooses, in paint, to criticize the critic.'
Miss Browse (B.60, p. 22) noted that Sickert asked a hundred guineas for this portrait in 1891 (which perhaps explains why it remained unsold).
Sickert published a caricature of Moore in *Vanity Fair*, 21 January 1897, under the title (from one of Moore's best-known novels) *Esther Waters*. For two drawings of Moore related to Fig. 31 see under C.52.

56. MR. BRADLAUGH AT THE BAR OF THE HOUSE OF COMMONS (Fig. 38) c.1892-3
Canvas. 89¼ × 47¼ (226·7 × 120)
'Sickert' b.l.
Coll. Manchester, City Art Gallery (1911)
Rep. The *Pall Mall Budget*, 20 April 1893
Exh. N.E.A.C. spring 1893 (8)
Chapter IV
I believe this portrait was painted after the sitter's death (in January 1891). It commemorates Bradlaugh's victory

in 1886, after a long parliamentary struggle since his election to the House of Commons as Radical member for Northampton, in his fight to be allowed to affirm under the Parliamentary Oaths Act at the Bar of the House of Commons.
The *Magazine of Art*, 1893, p. xxx, noted that Fig. 38 was a posthumous portrait, and the N.E.A.C. catalogue acknowledged that the head had been painted from a photograph by Van der Weyde (making it the first documented instance of Sickert's use of photographs for painting).

57. AUBREY BEARDSLEY (Fig. 40) 1894
?Tempera on canvas. 30 × 12¼ (76 × 31)
'Sickert' b.l.
Mrs. E. A. Beardsley/
Coll. London, Tate Gallery (1932)
Rep. The *Yellow Book*, II, July 1894, p. 223; B.43, Pl. 9; Bertram, Pl. 6; Rothenstein 1961, p. 2; Pickvance 1967, Col. Pl. I
Lit. R. R. Tatlock, the *Burlington Magazine*, 44, April 1924, p. 202, 'The Tate Gallery', rep. p. 197; Haldane MacFall, *Aubrey Beardsley, The Man and his Work*, London, Bodley Head, 1928, p. xiii; Tate Gallery Catalogue, 1964, pp. 625–6
Exh. Van Wisselingh's Dutch Gallery, 1895 (3) as *Portrait of Mr. Aubrey Beardsley. Sketch in Distemper*; Tate 60 (16)
Chapter IV

The description 'Sketch in Distemper' used when the painting was exhibited in 1895 could refer to the sitter's health and character. When I enquired from the Tate Gallery whether the picture was in oil or tempera I was told it was oil. However, R. R. Tatlock, writing in the *Burlington Magazine* in 1924, described the picture as in tempera which had escaped the varnish brush.
The picture is said to have been inspired by an incident at the unveiling of a memorial bust to Keats in Hampstead Church in July 1894 when Beardsley, as described by MacFall, broke away from the crowd to take a short-cut out by going over the graveyard: 'There was something strangely fantastic in the ungainly efforts . . . by the loose-limbed, lank figure so immaculately dressed in black cut-away coat and silk hat, who carried his lemon-yellow kid gloves in his long white hands, his lean wrists showing naked beyond his cuffs, his pallid cadaverous face grimly set on avoiding falling over the embarrassing mounds that tripped his feet.'
This description so closely fits Fig. 40 that, as is noted in the Tate Gallery catalogue, it may well have been coloured by Sickert's painting.
One unexplained puzzle about the picture is how it came to be ready for reproduction in the *Yellow Book* issue of July 1894 if it was painted in the same month. Sickert made several drawings of Beardsley (1872–1898), the black-and-white artist and at this period art editor of the *Yellow Book*, but they are not studies for the painted portrait.
e.g.:
1. Pen and ink. Size and whereabouts unknown. Rep. B.43, Pl. 9a. Exh. Van Wisselingh's Dutch Gallery, 1895 (12).
2. Pen and ink. 9¼ × 9 (23·5 × 22·9), Coll. London, National Portrait Gallery (1912).

58. MRS. ERNEST LEVERSON (Fig. 33) dated 1895

Chalk. Size and whereabouts of original unknown
'Sickert. S. Pancras. 1895' b.r.
Rep. The *Yellow Book*, V, April 1895, p. 231
Chapter IV

Ada Leverson, novelist and contributor to the *Yellow Book*, nicknamed 'Sphinx' by her friend Oscar Wilde, is the subject of an essay by Osbert Sitwell, *Noble Essences or Courteous Revelations*, London, Macmillan, 1950, pp. 127–62. Sickert exhibited a painted portrait of *Mrs. Leverson* at the N.E.A.C. spring 1895 (12). The portrait is untraced but it is just possible that it is the painting of a lady in a hammock, canvas, 13 × 13 (33 × 33), Private Collection, Salisbury, Rhodesia. This painting is believed by its owner to be a portrait of Sickert's wife Ellen, painted in Dieppe in 1885. However it neither looks like Ellen nor is it conceivable as a work of 1885. It does look like Mrs. Leverson and the painting technique and characterization are very closely related to the drawing.
A letter from Sickert to Mrs Leverson regarding her sitting for the portrait was sold at Sotheby's, 24–5 January 1955 (440).

59. G. J. HOLYOAKE c.1892

Canvas. 28½ × 22¾ (72·4 × 57·8)
'Sickert' t.r.
Coll. London, National Portrait Gallery (1918, presented by Sickert)
Exh. N.E.A.C. winter 1892 (63)
Chapter IV

George Jacob Holyoake (1817–1906) was, like Bradlaugh, an eminent secularist.

60. A LADY READING c.1891–4

Pen and ink. 16⅝ × 9⅛ (42·2 × 23·2)
'Sickert/Chelsea' b.l.
Coll. Adelaide, National Gallery of South Australia (1949)
Rep. The *Yellow Book*, I, April 1894, p. 221
Exh. Adelaide 68 (61)
Chapter IV, note 19

61. RICHARD LE GALLIENNE dated 1894

Chalk. Size and present whereabouts unknown
'Sickert. S. Pancras 1894' b.r.
Rep. The *Yellow Book*, IV, January 1895, p. 83
Chapter IV

A 'Bodley Head' portrait from a series by various artists of persons associated with the *Yellow Book* to which le Gallienne, a writer, was a contributor.

62. AGNES MARY BEERBOHM c.1894

Panel. 12¾ × 10¾ (32·4 × 27·3)
Miss Beerbohm (given to her by Sickert)/
Private Collection, England
Rep. B.43, Pl. 8; Bertram, Pl. 7
Exh. N.G.41 (15); Leeds 42 (118); Agnew 60 (17); Tate 60 (17)
Chapter IV

The sitter, sister of Max, later became Mrs. Vesey Knox. Sickert called her Aggie and was fond of her.

63. SKETCH FOR A PORTRAIT OF LADY EDEN
c.1894–8

Canvas. 9½ × 11¾ (24·1 × 29·9)
Last known owner John Fraser Esq.
Exh. Possibly N.E.A.C. spring 1898 (16)
Chapter IV

The sitter was the wife of Sir William Eden, Sickert's patron and formerly Whistler's patron before the famous quarrel of the Baronet versus the Butterfly. The flamboyant van Dyckian arrangement of the sitter with a dog is so unusual for Sickert that the portrait sketch is very difficult to date.

1890–5. LANDSCAPES

64. THE THEATRE OF THE YOUNG ARTISTS (Fig. 41)
dated 1890

Canvas. 21½ × 26 (54·6 × 66)
'Sickert—Dieppe—1890' b.l.
Coll. Southport, Atkinson Art Gallery (1923)
Rep. B.60, Pl. 9
Lit. W. H. Stephenson, *Sickert: the Man: and his Art: Random Reminiscences*, Southport, Johnson, 1940, p. 10
Exh. Sheffield 57 (7) as *The Little Theatre*; A.C.64 (3); Hull 68 (5)
Chapter IV

Stephenson recorded that Sickert signed and dated the picture after its purchase by the Atkinson Art Gallery. He mistakenly stated that the date inscribed was 1898.

65. CAFÉ DES TRIBUNAUX (Fig. 43) c.1890

Canvas. 23¾ × 28¾ (60·3 × 73)
Miss Sylvia Gosse/
Coll. London, Tate Gallery (1917)
Rep. *Pall Mall Gazette Extra*, 'Pictures of the Year 1891'; B.43, Pl. 12; Bertram, Pl. 8
Lit. Tate Gallery Catalogue, 1964, pp. 621–2
Exh. N.E.A.C. spring 1891 (42) as *Dieppe*; Sheffield 57 (14); Tate 60 (24)
Chapter IV

This picture was reproduced by the *Pall Mall Gazette Extra* as Sickert's N.E.A.C. contribution *Dieppe*. The Café des Tribunaux, in the Puits Salé (the name of the *place* in front of the café), was, and still is, the focal point of Dieppe where the two main streets converge. Sickert etched the subject in 1885. For another painting see C.69.

66. LE MONT DE NEUVILLE (Fig. 50) ?c.1892–4

Canvas. 12½ × 9½ (31·8 × 24·1)
'Sickert' b.r.
R.B.D./
Private Collection, South Africa
Exh. R.B.D.60 (15); R.B.D.63 (36)
Chapter IV

One of several versions of this subject, a climbing street in Le Pollet, the fishermen's quarter of Dieppe.
Versions:
1. Panel. 9½ × 5½ (24·1 × 14), last known owner C. N. Barlow Esq. Rep. B.60, Pl. 4. Exh. Edinburgh 53 (either 96 or 102); Tate 60 (7)

2. Panel. $9\frac{1}{2} \times 5\frac{1}{2}$ (24·1 × 14), last known owner C. N. Barlow Esq. Exh. Edinburgh 53 (either 96 or 102); Tate 60 (8)

3. Canvas. 15 × 12 (38·1 × 30·5), R. Middleton/Private Collection, Scotland

4. Canvas. $17\frac{1}{2} \times 14\frac{1}{2}$ (44·5 × 36·8), Jacques-Émile Blanche/ Coll. Musée de Rouen (1923) on loan to Musée de Dieppe. Exh. Bernheim 1904 (53) lent by Blanche; Brighton 62 (8)

5. Panel. $9\frac{1}{2} \times 7\frac{1}{2}$ (24·1 × 19·1), Agnew/Private Collection, London

Versions 1 and 2 were probably painted in the later 1880s. Version 5 could have been painted as late as about 1906. It is very difficult to date Sickert's small rough landscape sketches because he continued to make such studies in tone throughout his career. The most likely date for Fig. 50 and Versions 3 and 4 is in the first half of the 1890s.

Drawn studies include:

1. Crayon, pencil, chalk and wash, squared. 13 × 10 (33 × 25·4), Private Collection, England. Exh. N.G.41 (118); Leeds 42 (104). This study was probably used as a preparatory document for Fig. 50 and for the two paintings on canvas, Versions 3 and 4.

2. Charcoal. $12\frac{5}{8} \times 9\frac{1}{4}$ (32·1 × 23·5), Jacques-Émile Blanche/ Coll. Musée de Rouen (1923) on loan to Musée de Dieppe. Exh. Dieppe 54 (50); Brighton 62 (13)

3. Pencil. $11\frac{3}{4} \times 8\frac{1}{2}$ (29·9 × 21·6), Mrs. L. C. Wertheim/ Coll. Brisbane, Queensland Art Gallery (1953). Exh. Adelaide 68 (59)

4. Chalk and watercolour. $11\frac{1}{4} \times 8\frac{1}{2}$ (28·6 × 21·6), Sir William Eden/Coll. Major W. H. Stephenson. Rep. W. H. Stephenson, *Sickert: the Man: and his Art: Random Reminiscences*, Southport, Johnson, 1940, p. 66. Exh. N.G.41 (122) as *Dieppe*. This drawing is inscribed to 'W.E.' that is, Sir William Eden.

67. L'HÔTEL ROYAL, DIEPPE (Fig. 42) c.1893

Details and whereabouts unknown
Rep. The *Yellow Book*, IV, January 1895, p. 81
Exh. N.E.A.C. winter 1893 (64)
Chapter IV

Probably Sickert's first picture of this subject which he was to paint again many times. There is some confusion in the literature about the dating and exhibition history of Sickert's pictures of the *Hôtel Royal, Dieppe*. B.43, p. 40, stated that the picture belonging to the Musée de Dieppe (C.110, Version 1) was the version shown at the N.E.A.C. in 1893; B.60, p. 22 rectified this, stating that it was impossible to say which version was then exhibited. However, contemporary press reviews of the 1893 exhibition prove that the picture shown was Fig. 42, e.g.: the *Spectator*, 23 December 1893, 'The simple façade of the hotel makes a capital reflecting surface for the light. The bands of sky and lawn are well proportioned, and the crinolines, about which so much has been said, are a useful device for giving importance to the figures. Those pawn figures are well played in the general arrangement.'

This version of *L'Hôtel Royal* is a unique experiment in style and its probable debt to Beardsley is discussed in the text.

For other versions see Fig. 48 and Fig. 80, C.110 and versions.

68. L'HÔTEL ROYAL, DIEPPE (Fig. 48) c.1894

Canvas. $19\frac{3}{4} \times 24$ (50·2 × 61)
'Sickert' b.r.
Jacques-Émile Blanche/
Coll. M. Georges Mevil-Blanche, Offranville, France
Rep. B.43, Pl. 13 (mistakenly listed as in the de Pass collection)
Lit. Jacques-Émile Blanche, *Portraits of a Lifetime*, p. 48
Exh. Possibly N.E.A.C. winter 1894 (50); Bernheim 1909 (65); Dieppe 54 (2)
Chapter IV

Press reviews of the 1894 exhibition prove that in all but one detail the picture exhibited was very like Fig. 48. The exhibited picture presented a 'white house, and sun-reflecting windows' (*Pall Mall Gazette*, 17 November 1894); it showed a 'greenish light on the white building . . . relieved against a purple sky' (*Saturday Review*, 24 November 1894). These colour and light effects are striking features of Fig. 48. However, the *Saturday Review* also noted a red figure, and this figure is certainly missing from the picture here illustrated. This red figure is puzzling. Blanche, clearly describing Fig. 48 which he said he had before his eyes in his study, wrote: 'In it there is a rose and violet after-sunset sky, with the lawns of the marine parade; the houses of the Rue Aguado are a dull greenish-white and the Hôtel Royal has masts, from which hang flags with the French national colours; it is the evening of a national holiday. In the foreground there are a woman and a child clothed in white, and behind them walking forms— a soldier in red.'

Blanche was actually looking at the canvas when he described it so the mention of this soldier in red could not have been a lapse of memory. How the figure has disappeared from Fig. 48 is a dilemma. Moreover, if we accept Blanche's description as accurate, and accept that the picture did once have a red figure, there is no reason to reject it as the painting exhibited at the N.E.A.C. in 1894. Blanche bought Fig. 48 from the Bernheim 1909 exhibition.

Related picture or study:
Panel. $5\frac{1}{2} \times 9\frac{1}{4}$ (14 × 23·5), Leicester Galleries/Private Collection, London. The panel is inscribed 'To Bunny Stewart/Walter Sickert'.

69. CAFÉ DES TRIBUNAUX c.1890

Canvas. 26 × 20 (66 × 50·8)
Geoffrey Blackwell/
Coll. Ottawa, National Gallery of Canada (1946)
Rep. B.60, Pl. 8
Exh. Probably N.E.A.C. winter 1891 (41) as *Les Bonnes Sœurs*
Chapter IV

The *Star*, 30 November 1891, described *Les Bonnes Sœurs* as a Dieppe street in late afternoon light; this rather vague description supports the suggestion that C.69 is the exhibited picture because of the two nuns who figure so prominently in the landscape.

Study or related drawing:
?Pen and ink. Size and whereabouts unknown. Rep. the *Cambridge Observer*, 7 February 1893. This drawing is dated 1890. Its composition and incidental figures are the same as in the painting.

70. MARLBORO' SQUARE, CHELSEA dated 1892

?Pen and ink. Size and whereabouts unknown
'Marlboro' Square—Chelsea/Sickert Nov. 92' b.r.
Rep. The *Cambridge Observer*, 24 January 1893; B.60, p. 8
 (mistakenly entitled *Markham's Square*, p. 84)
Chapter IV, note 19

The correct title was published in the *Cambridge Observer*
and repeats Sickert's inscription, although there is no
Marlborough Square in Chelsea.

71. DIEPPE HARBOUR dated 1893

?Pen and ink. Size and whereabouts unknown
'Sickert 93' b.l.
Rep. The *Yellow Book*, V, April 1895, title page
Chapter IV, note 19

1890s. MUSIC HALLS AND THEATRICAL SUBJECTS

72. THE PIT AT THE OLD BEDFORD (Fig. 49) *c*.1890–5

Chalk heightened with white on toned paper
$16\frac{1}{2} \times 12$ (41·9 × 30·5)
'Sickert/The old Bedford—Camden Town' b.r. and colour
 and tone notes
Coll. London, The British Museum (1927)
Chapter IV

There are several drawings of the audience in the pit at the
Old Bedford closely related to Fig. 49, but I know of only
one painted version:
Panel. 16 × 14 (40·6 × 35·6), Alfred Jowett/Dr. Leonard S.
Simpson/Coll. Miss G. Simpson. Exh. Leeds 42 (119)

Related drawings include:
1. Chalk heightened with white. $18\frac{1}{4} \times 13\frac{1}{4}$ (46·4 × 33·7),
 Alfred Jowett/Christie's, 17 July 1959 (117)/Agnew/
 Private Collection, London. Rep. *Image*, No. 7, 1952,
 p. 16; B.60, Pl. 14a. Exh. N.G.41 (101); Leeds 42 (95).
 This drawing is very close to Fig. 49.
2. Pen and ink. Size unknown. Last known owner Miss
 Edith Sitwell (given to her by Sickert, see Sitwell,
 A Free House, p. xiv). Rep. Sitwell, p. xvi. In this drawing
 women wearing extravagant hats are more prominent
 than bowler-hatted men.
3. Pencil. $10\frac{5}{8} \times 9\frac{5}{8}$ (27 × 24·5), Coll. London, British
 Museum (1938). Rep. *Image*, No. 7, 1952, p. 22. A
 closer view of the two women in extravagant hats seen
 in Drawing 2.
4. Charcoal, pen and ink, heightened with white. 15 × $13\frac{1}{2}$
 (38·1 × 34·3), Dr. Robert Emmons/Coll. Derek Hill Esq.
 Similar in subject to Drawing 2.

73. THE GALLERY OF THE OLD BEDFORD (Fig. 45)
 c.1894

Canvas. 30 × $23\frac{3}{4}$ (76·2 × 60·4)
'Sickert' b.r.
Adolphe Tavernier/Contessa Soldedo de Rios/
Coll. Liverpool, Walker Art Gallery (1947)
Rep. B.60, Pl. 15; Rothenstein 1961, Pl. 1; Pickvance
 1967, Col. Pl. II; Lilly, Pl. 5
Exh. N.E.A.C. winter 1895 (73) as '*The Boy I Love is up
 in the Gallery*'; possibly Bernheim 1907 (22) as *Le Poulailler*

du Bedford, Camden Town and Bernheim 1909 (8) as
 Au Poulailler; Sheffield 57 (6); Tate 60 (23); A.C.1967,
 'Decade 1890–1900' (33)
Chapter IV

George Moore's description (the *Speaker*, 23 November
1895) of the picture exhibited in 1895 at the N.E.A.C.
proves that it was the version here illustrated as Fig. 45.
The description was quoted in the text and will not be
repeated here. See note to C. 74 for reasons why this
picture may be the one shown at Bernheim in 1907 and
1909. The original title of this picture suggests that it may
have been conceived as complementary to the earlier
painting of *Little Dot Hetherington* (Fig. 26) singing this
song; Fig. 45 shows the gallery and the boy to whom she
was pointing. The picture is sometimes known by the
alternative title *Cupid in the Gallery*. A dated etching of
1894 (slightly variant from Fig. 45 in that it shows more
roof and the disposition and number of figures are different)
was published in the *Idler*, March 1895, p. 169; its caption
was also 'The Boy I Love is up in the Gallery'.
The development of the composition, through the various
drawings and preliminary paintings, up until the next
stage reached in Fig. 45, is discussed in the text. Details
of the studies mentioned follow.

Drawings:
1. Black chalk heightened with white (with a separate
 study of a singer's head in blue pencil). 13 × 17 (33 ×
 43·2). Last known owner C. Marescoe Pearce Esq.
 This study is inscribed with the initials—an *aide-
 mémoire*—and the full words of the song 'O Bermondsey
 Flo'.
2. Pencil, pen and ink. 13 × 9 (33 × 22·9), Coll. London,
 Islington Public Libraries (1947). Exh. Sheffield 57
 (151). A study of heads, extensively inscribed with
 colour notes.
3. Pencil. 14 × $9\frac{3}{4}$ (35·6 × 24·8), Coll. London, British
 Museum (1938). A study of heads extensively inscribed
 with colour notes.
4. Pencil, chalk, pen and blue ink. $17\frac{1}{2} \times 12\frac{3}{4}$ (44·5 × 32·4),
 Sotheby's, 17 March 1965 (25)/Last known owner
 R. A. MacAlpine Esq. Exh. Agnew 60 (229). Archi-
 tecture with some figures placed within the gallery.
5. Pencil. $12\frac{1}{8} \times 7\frac{5}{8}$ (30·9 × 19·4), Mercury Gallery, Lon-
 don 1970. Exh. R.B.D.63 (40). Similar to Drawing 4.
6. Pencil. $6\frac{1}{8} \times 4$ (15·6 × 10·2), Coll. Liverpool, Walker
 Art Gallery (1948). Exh. A.C.49 (10b). The mirror
 and reflection.
7. Pencil. $12\frac{1}{2} \times 7\frac{3}{4}$ (31·7 × 19·6), Miss Ethel Sands/
 Private Collection, England. A study of the whole
 composition with colour notes.
8. Chalk, watercolour, gouache. $14\frac{1}{4} \times 10\frac{1}{2}$ (36·2 × 26·7),
 Private Collection, England. Exh. N.G.41 (126);
 Leeds 42 (96). A colour rehearsal for the whole
 composition.
9. Pencil, squared. 16 × 10 (40·6 × 25·4). Coll. London,
 British Museum (1914). A precise composition study.
10. Pen and ink, red chalk, heightened with white,
 squared. $19\frac{3}{4} \times 12\frac{1}{2}$ (50·2 × 31·8), Professor Tonks/Coll.
 Capetown, South African National Gallery (1936). A
 precise composition study.
Another drawing is reproduced as Fig. 44 (C.74).

Versions in oil probably executed as preliminary rehearsals for Fig. 45:
1. Panel. 9¾ × 6½ (24·8 × 16·5), Jacques-Émile Blanche/ From the collection of Edward le Bas. Exh. N.G.41 (42); Leeds 42 (120); R.A.1963, 'A Painter's Collection' (151). This panel is very close to the squared Drawing 9 in its figure disposition, although the roof (present in the drawing) is omitted from the painting and there is more space below the gallery in the painting than in the drawing. The architectural layout is close to Fig. 45.
2. Canvas. 21⅝ × 15 (54·9 × 38·1), E.M.B. Ingram/Coll. Cambridge, Fitzwilliam Museum (1941). Rep. B.43, Pl. 5; Bertram, Pl. 4. Exh. N.G.41 (18); Leeds 42 (121).

74. THE GALLERY OF THE OLD BEDFORD (Fig. 44)
c.1894

Charcoal on toned paper. 21½ × 15 (54·6 × 38·1)
'Sickert' b.r., 'Painted on a canvas given me by F. Forster in . . . at Neuville . . . sold to Cahen. Bt at Hotel Drouot by Bernheims' t.r., and colour notes.
Mrs. George Swinton/
Private Collection, England
Rep. *Image*, No. 7, 1952, p. 19; Rothenstein 1961 (mistakenly listed as belonging to the Arts Council, London)
Exh. N.G.41 (130); Leeds 42 (97); Edinburgh 53 (74); Tate 60 (35); A.C.64 (31)
Chapter IV

The inscription needs explanation. The drawing is closely related to the painting in the Fitzwilliam Museum (C.73, Painting Version 2) and it has been suggested that this is the painting referred to by Sickert in his historical note. However, the only two paintings with titles appropriate to this subject at the sale of Sickert's work, sponsored by Bernheim-Jeune, which took place at the Hôtel Drouot in 1909 were *Spectateurs* (47) and *Au Poulailler* (8). Sickert's annotated copy of the sale catalogue records that Émile Bernheim bought *Spectateurs* but its dimensions (50 × 61 cm.) do not approximate to any known version of *The Gallery of the Old Bedford*. Sickert did not record who bought *Au Poulailler*. However it measured 64 × 76 cm. The catalogue was totally inconsistent about the convention of stating height before width and inaccurate about exact dimensions. If the dimensions are read as 76 × 64 cm. the version of this subject which most nearly matches the picture on sale is that in Liverpool, Fig. 45. It is, moreover, probable that the 1909 *Au Poulailler* is the same picture as the 1907 *Le Poulailler du Bedford, Camden Town* (many of the pictures in the 1907 exhibition reappeared for exhibition and sale in 1909). Finally Fig. 45 has a French provenance.

75. THE GALLERY OF THE OLD BEDFORD (Fig. 46)
c.1898

Panel. 15 × 15 (38·1 × 38·1)
Sir Augustus Daniel/Harold Esselmont/
Coll. William Shand-Kydd Esq.
Exh. Edinburgh 53 (73); Tate 60 (22); R.B.D.63 (11)
Chapter IV

The composition is extended to the right as compared with Fig. 45 and related versions (C.73). The new figures who fill the extra space are, in their dress, out of character with the others.

76. THE GALLERY OF THE OLD BEDFORD (Fig. 47)
c.1898

Panel. 14¾ × 12 (37·5 × 30·5)
'Sickert' b.r.
Robert Emmons/
Private Collection, London
Exh. Sheffield 57 (4); Agnew 60 (5)
Chapter IV

Closely related in composition to Fig. 46; the different dimensions are explained by the omission of part of the mirror on the left. The tight handling of this panel, and its bright jewel colours (set off by the extravagant new figures, a pert soldier and a *femme du monde*) resemble Fig. 64.

77. THE PORK PIE HAT. HILDA SPONG IN 'TRELAWNY OF THE WELLS' (Fig. 64)
1898

Canvas. 84 × 84 (213·4 × 213·4)
Miss Sylvia Gosse/
Coll. Johannesburg Art Gallery (1913)
Lit. William Rothenstein, *Men and Memories*, Vol. 1, London, Faber, 1931, p. 335; Emmons, p. 140.
Exh. N.E.A.C. spring 1898 (7) as *Miss Hilda Spong as Imogen Parrot in Trelawny of the Wells*; Salon des Indépendants 1903 (2231) as *The Pork Pie Hat*; Bernheim 1904 (35) as *Portrait d'une actrice dans 'Trelawny of the Wells' Comédie de Pinero*
Chapter IV

Pinero was one of Sickert's favourite dramatists. The production of *Trelawny* represented in Fig. 64 took place at the Royal Court Theatre on 20 January 1898 so the time-bracket for the painting's execution is narrow, between January and April. Rothenstein related how he went with Sickert to see the play, that Sickert had Miss Spong photographed, and 'from a small print and with few sittings he achieved a life-size portrait'.

Contemporary press reviews prove that Fig. 64 was the picture exhibited at the N.E.A.C. in 1898, e.g.: the *Saturday Review*, 23 April 1898, 'Mr. Walter Sickert . . . occupies a self-defeating quantity of wall space. . . . Mr. Sickert has carried through what might be the design for a large poster or wall-painting with remarkable science; . . . the spacing and design, the simplified painting, the treatment in particular of the shot silk dress, of the golden net, of the daring wall-paper testify to a grasp of the principles of such flat decoration.' The reviewer added, 'Surely it would repay him to use the same material for a small colour engraving which would be more the size of his subject; for subjects have their sizes.'

References in several letters to different correspondents prove that it was this picture which was also exhibited in Paris in 1903 and 1904, e.g.: letter to Mrs. William Hulton, 'I have got . . . a woman in a life-sized crinoline and pork pie hat at the *Indépendants*'. The stylistic experiment exemplified in this large painting was not appreciated by Sickert's public; the Tate Gallery refused Miss Gosse's offer to give it to them (see Emmons, p. 140).

Version or study:
Panel. 13¼ × 9¾ (33·7 × 24·8), Mrs. Houston/Christie's, 12 November 1965 (90)/Coll. Dr. Dallas Pratt, New York. Exh. Fine Art Society 1969, 'The Channel Packet' (128).

78. THE GALLERY OF THE OLD BEDFORD c.1898

Canvas. 50 × 30½ (127 × 77·5)
'Sickert' b.r.
Mrs. Madeline Clifton/
Coll. Ottawa, National Gallery of Canada (1946)
Rep. Emmons, facing p. 136
Exh. Adelaide 68 (6)
Chapter IV

A harder, tighter, larger version of this subject than Fig. 45 and related pictures (C.73).
Like the 1894 etching and like the two squared drawings (C.73, Drawings 9 and 10), but unlike Fig. 45 and related pictures, it includes the gallery roof and the grille.

Version:
Canvas. 34 × 21½ (86·4 × 54·6), The Hon. Michael Astor/
Coll. Mr. and Mrs. Peter Hughes. This picture is very broadly treated as a mainly two-coloured (salmon pink and turquoise) map of the tonal fields of the subject. In composition it is identical to the Capetown squared drawing (C.73, Drawing 10) except that one figure in the drawing is omitted from the painting. Its treatment suggests it is a late reworking of the subject painted c.1915–20.

79. THE TOAST. 'TRELAWNY OF THE WELLS' c.1898

Canvas. 18¼ × 15 (46·3 × 38·1)
'Sickert' b.l.
André Gide/
Coll. Sir Noel Coward
Rep. B.60, Pl. 12
Chapter IV

This picture probably represents a scene from the same Royal Court 1898 production as Fig. 64 although it is very different in handling and style, being treated with almost expressionist roughness.

1895–6. VENICE, LANDSCAPES

80. THE DOGANA AND SANTA MARIA DELLA
SALUTE (Fig. 53) dated 1896

Canvas. 16¾ × 24 (42·5 × 61)
'Sickert 1896' b.r.
E. J. Power/Lt.-Col. Stanley Cohen/Harold Esselmont/
 Tooth/
Private Collection, London
Rep. B.43, Pl. 10
Exh. Agnew 60 (14)
Chapter V

The only known dated work of Sickert's first visit to Venice. The composition recalls Guardi's and Whistler's views of the same subject.

Versions (both Nocturnes of the subject):
1. Canvas. 19 × 24½ (48·2 × 62·2), Sir George Sutton/
 Christie's, 7 June 1946 (158)/the Hon. John Fremantle/
 Coll. Sir James McGregor, Sydney. Exh. Edinburgh
 53 (56); Adelaide 68 (9); Sydney 68 (2).
2. Panel 6¼ × 9¾ (15·9 × 23·8), Miss Lillian Richardson
 (bought from Sickert in 1895)/Mrs. J. MacNaughton/
 Sotheby's, 26 April 1972 (19). The original documentation relating to the sale of this panel (a postcard postmarked ?2.8.95 sent from Venice by an intermediary to

Miss Richardson) is preserved with the picture. Sickert apparently wanted 5 guineas for the panel but accepted 3 guineas.

Studies:
1. Pencil, pen and ink. 8¼ × 11½ (21 × 29·2), from the
 collection of Morton Sands.
2. Watercolour. 9 × 13½ (22·9 × 34·3), from the collection
 of Morton Sands. Exh. Brighton 62 (64).

81. THE FAÇADE OF ST. MARK'S (Fig. 51) c.1895

Oil on paper mounted on panel. 8¾ × 11¾ (22·3 × 29·9)
'Sickert' b.r.
Montague Shearman/
Coll. Oxford, Ashmolean Museum (1940)
Chapter V

On and after his first visit to Venice Sickert painted many versions of the full façade of St. Mark's. In Venice in 1900 and 1901 he returned to this subject but then painted only a portion of the main façade. Sickert probably used Fig. 51, and the study in oil and two drawings listed below as his main preliminary documents for the more finished paintings of this subject painted in Venice 1895–6 and in London c.1896–8.

Oil study (similar to but larger than Fig. 51):
Oil on paper mounted on panel. 18¾ × 23¾ (47·7 × 60·4),
Sir Walter Fletcher/Christie's, 1 November 1957 (60)/Coll.
Christopher Loyd Esq. Rep. Rothenstein 1961, Col. Pl. 2;
Pickvance 1967, Col. Pl. III. Exh. Agnew 60 (11).

Studies:
1. Black chalk and watercolour, squared. 17¾ × 23 (45·1 ×
 58·4), C. L. Rutherston/Coll. Manchester, City Art
 Gallery (1925). Exh. Hull 68 (30). Inscribed with colour
 notes.
2. Pen and ink, watercolour. 8½ × 11¾ (21·6 × 29·9), Miss
 Sylvia Gosse/Sotheby's, 23 April 1969 (44)/Private
 Collection, London. Rep. B.43, Pl. 11a. Exh. Leicester
 Galleries 1963, 'Artists as Collectors' (69).

82. THE FAÇADE OF ST. MARK'S. RED SKY AT NIGHT
(Fig. 52) c.1896

Canvas. 18 × 24 (45·7 × 61)
'Sickert' b.r.
Arthur Crossland/Lord Cottesloe/Arthur Tilden Jefress/
Coll. Southampton Art Gallery (1963)
Exh. N.G.41 (72); Leeds 42 (122); Wildenstein, London,
 1970, 'Pictures from Southampton' (30)
Chapter V

A label on the back states that this picture was painted in 1896.

Other versions of the subject probably painted in Venice 1895–6:
1. Canvas. 20 × 33½ (50·8 × 85·1), Cobden-Sanderson/
 Christie's, 2 August 1940 (75)/From the collection of
 Edward le Bas. Exh. Edinburgh 53 (59); Brighton 62
 (44); R.A.1963, 'A Painter's Collection' (165).
2. Canvas. Size and whereabouts unknown, formerly
 Coll. Montague Shearman Esq.

Sickert also made many studies of parts of the façade of St. Mark's on his first visit to Venice. They include:

1. Canvas. 15 × 18 (38·1 × 45·7), Private Collection, Paris. Exh. Dieppe 54 (26).
2. Panel. 6¼ × 9¼ (15·9 × 23·5), Paul Robert/Baron van der Heyden à Hauzeur/Private Collection, London. Dedicated to Paul Robert.
3. Panel. 9½ × 5¾ (24·1 × 14·7), from the collection of Morton Sands. Exh. N.G.41 (39); Brighton 62 (62).
4. Panel. 8¾ × 5 (22·2 × 12·7), Private Collection, London.

Of these No. 1 is a cool and delicate study in tone and colour with no drawn accents; the panels 2-4 are painted in blurred watery juxtapositions of low tones. Were it not for their Venetian subject matter they could be mistaken for Sickert's Whistlerian work of the 1880s.
Details of the four versions of *The Façade of St. Mark's* probably painted after Sickert's return from Venice are given under Fig. 68, C.100.

83. THE SCUOLA DI SAN MARCO. OSPEDALE CIVILE (Fig. 54) c.1895-6

Canvas. 27½ × 29 (69·9 × 73·7)
'Sickert' b.l.
Sir George Sutton/Mrs. William Miller/
Private Collection, England
Exh. Possibly N.E.A.C. spring 1896 (100) as *Sirocco*
Chapter V

The *Daily Telegraph*, 4 April 1896, described *Sirocco* as 'a view of the canal which goes from S. Giovanni e Paolo and the Scuola S. Marco out towards Murano'. There are many pictures of this subject but Fig. 54 is the only extant version to suit the title *Sirocco* (in its suggestion of an impending storm) and to accord with the description of the exhibited picture given in the *Daily Telegraph*: 'Gleams of silver catching here and there mouldings and surfaces of darker grey'. Other versions of the subject probably painted on Sickert's first visit to Venice include:

1. Canvas. 18 × 15 (45·7 × 38·1), from the collection of Morton Sands.
2. Canvas. 16½ × 11 (41·9 × 27·9), R. Middleton/Private Collection, Scotland.
3. Canvas. 16½ × 10½ (41·9 × 26·7), Private Collection, London. Exh. Leeds 42 (140); Sheffield 57 (16). Known as *Rio dei Mendicanti*.

Version 3 is a broadly executed sketch in two dull-toned colours, olive green and mulberry. Versions 1 and 2 are painted in more delicate feathery strokes and are full of pretty pastel-like colours, especially in the water and reflection around the bridge. It is possible that one of these two versions is *From the Hospital to the Grave*, shown at the N.E.A.C. winter 1896 (59). The *Daily Telegraph*, 19 November 1896, identified the subject of this curiously named picture as 'the waterway from the hospital in the Scuola S. Marco to the burial ground in mid-channel between the main island and Murano'. The reviewer noted that if Sickert 'displays no adequate sense of form, he at any rate gladdens the eye with a brilliancy and sparkle of colour, a frank play of light, for which we had not given him credit'. The *Star*, 17 November 1896, noted that Sickert had 'seen colour in the Venice which at first he seemed to find so grey and drear'. These press comments could well have been inspired by either picture listed as Versions 2 and 3 above.

Two more versions of this subject, one related to a dated drawing of 1901, are catalogued C.141.

84. THE RIALTO BRIDGE AND PALAZZO CAMERLENGHI (Fig. 55) c.1895-6

Canvas. 21¾ × 29¼ (55·3 × 74·3)
'Sickert' b.r.
Sir Michael Sadler/probably Christie's, 25 July 1930 (107) as *The Rialto Sunset*/Dr. Robert Emmons/Agnew/
Private Collection, England
Exh. Edinburgh 53 (61); Agnew 60 (15)
Chapter V

There are many versions of *The Rialto Bridge*. Each one is different from the others in composition and handling. They include:

1. Canvas. 20 × 24 (50·8 × 61), Judge Evans/The Rt. Hon. Sir Vincent Massey/Private Collection. Rep. Rothenstein 1961.
2. Canvas. 24 × 19½ (61 × 49·5), Adolphe Tavernier/Last known owner Hugo Pitman Esq. Exh. Bernheim 1904 (37) lent by Tavernier.
3. Canvas. 24 × 19½ (61 × 49·5), Coll. Dr. Walter Amstutz, Männedorf. Rep. B.60, Pl. 18. Exh. Tate 60 (72).
4. Panel. 5½ × 9 (14 × 22·9), Mrs. Mary Price/Jack Beddington/Christie's, 25 March 1960 (159)/Christie's, 19 July 1968 (89)/Christie's, 4 June 1971 (68)/Coll. D. F. L. Cook Esq.

Drawings include:

1. Pen and ink. Size and whereabouts of original unknown. Rep. the *Savoy*, II, April 1896, p. 145.
2. Pen and ink. Size and whereabouts unknown. Rep. B.43, Pl. 10a.
3. Pen and ink. Size and whereabouts unknown. Rep. Emmons, p. 108.
4. Pen and ink on paper mounted on panel. 5⅜ × 9⅜ (13·7 × 23·9), Sotheby's, 21 November 1962 (75)/Coll. the late Godfrey Winn Esq. Exh. R.B.D.63 (41).

Fig. 55 is the only painting on canvas exactly to repeat the composition and, more or less, the tonal pattern of the several drawings and the panel painting (Version 4).
See catalogue note to Fig. 68, C.100 for Sickert's habit of painting versions of earlier subjects at a much later date. If any of the extant *Rialto Bridge* subjects are such later reworkings the probability is that Versions 1 and possibly 3 were painted later.

85. SAILING BOATS ON THE GRAND CANAL (Fig. 57) c.1895-6

Canvas. 14½ × 18 (36·8 × 45·7)
'Sickert' b.r.
From the collection of Morton Sands
Rep. B.60, Pl. 19
Exh. Leeds 42 (128) as *The Mouth of the Grand Canal, Venice*; Brighton 62 (61) as *Dogana with Sailing Boat, Venice*; A.C.1967, 'Decade 1890–1900' (36)
Chapter V

86. THE LION OF ST. MARK (Fig. 56) c.1895-6

Canvas. 35½ × 35⅜ (90·2 × 89·8)
'Sickert' b.r.
André Gide/G. J. F. Knowles/

Coll. Cambridge, Fitzwilliam Museum (1959)
Rep. B.60, Pl. 29; Rothenstein 1961
Exh. Possibly Bernheim 1904 (1); Tate 60 (70)
Chapter V

The suggestion that Fig. 56 is the picture exhibited at Bernheim in 1904 is made partly because of its French provenance. Moreover, Gide lent his collection of Sickert paintings to the 1904 Bernheim exhibition but no *Lion of St. Mark* picture was among them. It is, therefore, probable that Gide bought his picture from this Bernheim exhibition.

Version:
Canvas. 23 × 23 (58·4 × 58·4), Dr. Robert Emmons/Capt. Sir Malcolm Bullock/Private Collection, England. Exh. Probably N.E.A.C.1896 (96). The owner says that a label on the back of the picture states that it was painted in 1895 and exhibited at the New Arts Club (which must mean the New English Art Club) in 1896. The *Daily Telegraph*, 4 April 1896, described *The Lion of St. Mark* at the N.E.A.C. as a study 'of fitful light and shade, now obscuring, now revealing in momentary brilliance, richly tinted architectural surfaces'. This paper's critic, and other press reviewers, seem to have forgotten *The Lion of St. Mark* when they were surprised by the colour and light in *From the Hospital to the Grave* (see note to C.83) a few months later.

Related painting:
Canvas. 25½ × 18 (64·7 × 45·7), Private Collection, England. A painting of *The Doge's Palace and The Lion of St. Mark* viewed from a different angle. It is very freely painted.

87. THE INTERIOR OF ST. MARK'S (Fig. 59) c.1895

Canvas. 26⅛ × 18⅝ (66·4 × 47·3)
'Sickert' b.l.
Howard Bliss/
Coll. London, Tate Gallery (1941)
Rep. Rothenstein 1961, Col. Pl. 3; Pickvance 1967, Col. Pl. IV
Lit. Tate Gallery Catalogue 1964, p. 636
Exh. Chicago: Pittsburgh 1938 (18); N.G.41 (54); Tate 60 (75)
Chapter V

Sickert's letter to Steer (quoted in the text) implies that he painted several interiors of St. Mark's but Fig. 59 and the painting listed below are the only such pictures known to me.

Related painting:
Canvas. 15½ × 11½ (39·4 × 29·2), Christie's, 13 November 1964 (90)/Miss Anne Joyce/Christie's, 13 May 1966 (93)/Coll. John A. Falk Esq. This picture almost certainly represents the interior of St. Mark's although it is known as *Interior of a Church with a Figure in a Niche*.

88. THE DOGE'S PALACE AND THE CAMPANILE (Fig. 58) c.1895-6

Panel. 6¼ × 9½ (15·9 × 24·2)
'Sickert' b.r.
Philip Wilson Steer/Sotheby's, 16 and 17 July 1942 (375) Steer Sale/Sotheby's, 22 July 1964 (174)/Agnew/
Private Collection, England
Chapter V

89. FONDAMENTA DEL MALCONTON (Fig. 66) c.1896

Canvas. 23 × 16 (58·4 × 40·6)
'Sickert' b.r.
Mme Jeanne Edwards de Gandarillas/Mrs. Errazuris/C. E. Eastman/Sotheby's, 1 May 1968 (20)/Agnew/
Private Collection, London
Rep. F. Wedmore, *Some of the Moderns*, London, Virtue, 1909
Chapter VI

This picture is one of a small group of night scenes painted in Venice, Dieppe, and London, c.1896-8. Another Venetian example is catalogued C.90.

Study:
Charcoal. 10¼ × 7¼ (26 × 18·5), Christie's, 19 July 1968 (84)/Agnew/Private Collection, London.

90. PONTE DELLA GUGLIE SUL CANNAREGIO c.1896

Canvas. 14½ × 17½ (36·8 × 44·5)
'Sickert' b.l.
Coll. Miss E. M. Hewitt, on loan to Manchester City Art Gallery.
Chapter VI

Study:
Pencil. 8 × 10½ (20·3 × 26·7), Piccadilly Gallery 1971. The inscription of the title on this drawing serves to identify the painting which has hitherto been called *Night Scene, Venice*.

91. GLI SCALZI. THE CHURCH OF THE BAREFOOT FRIARS c.1895-6

Canvas. 26½ × 22 (67·3 × 55·9)
'Sickert' b.l.
Paul Robert/Baron van der Heyden à Hauzeur/
Private Collection, London
Exh. Probably N.E.A.C. winter 1897 (10); Agnew 60 (44)
Chapter V

Study:
Watercolour, squared. 15½ × 13 (39·4 × 33), Sir Augustus Daniel/Coll. The Cottesloe Trustees. Exh. N.G.41 (119); Edinburgh 53 (89); Tate 60 (92).

Related drawing:
Chalk, heightened with white. 8¾ × 13¼ (22·2 × 33·6), Coll. H. K. B. Lund Esq. This shows a different view of the church, perhaps during Passion Week because the lamps are covered. It could have been drawn on a later visit to Venice.

1896-8. PORTRAITS AND FIGURES

92. MISS ELLEN HEATH (Fig. 60) c.1896

Canvas. 15½ × 13 (39·4 × 33)
'To Miss Heath/W.S.' t.r.
Miss Ellen Heath/
Coll. Leeds, City Art Gallery (1942)
Lit. J. Bradshaw, *Leeds Art Calendar*, No. 53, 1964, pp. 12-15, 'A Group of Paintings by Sickert and a Portrait by Ellen Heath'. Rep. p. 13
Exh. Sheffield 57 (95); A.C.1967, 'Decade 1890-1900' (37)
Chapter VI

Miss Heath was a friend and informal pupil of Sickert. Sickert also made a portrait drawing of *Miss Heath* which is not a study for Fig. 60 but a finished work in its own right:

Pen and sepia ink, black and red chalk. 12 × 9⅝ (30·5 × 24·5), Miss Ellen Heath/Coll. Leeds, City Art Gallery (1942). Exh. Tate 60 (34); A.C.64 (32). Sickert gave this drawing to Miss Heath in 1896, when he also gave her *The Harbour, Dieppe* (C.36). Possibly he gave her her painted portrait (Fig. 60) and his own *Self-Portrait* (Fig. 61) in the same year.

93. SELF-PORTRAIT (Fig. 61) *c.*1896

Canvas. 18 × 14 (45·7 × 35·6)
Miss Ellen Heath/
Coll. Leeds, City Art Gallery (1942)
Lit. J. Bradshaw, *Leeds Art Calendar*, No. 53, 1964, pp. 12–15, 'A Group of Paintings by Sickert and a Portrait by Ellen Heath'. Rep. p. 14
Exh. Sheffield 57 (94); Hull 68 (2)
Chapter VI

This bitter self-portrait seems to express Sickert's current disillusion and depression.

94. FRED WINTER (Fig. 62) *c.*1897–8

Canvas. 23½ × 14½ (59·7 × 36·8)
'Sickert' b.l.
Coll. Washington, D.C., The Phillips Art Gallery (1941)
Exh. New York 67 (39)
Chapter VI

Fred Winter was a sculptor and secretary of the New English Art Club. He was a near neighbour of Sickert in his Robert Street studio.

Another portrait of Winter by Sickert, painted *c.*1897–8; Canvas. 18 × 14 (45·7 × 35·6), W. K. Elmhirst/Sotheby's, 17 July 1968 (13)/Coll. Sheffield, Graves Art Gallery (1968). Exh. R.B.D.60 (28). This is a full-length of Winter, sitting on a chair, seen in profile against a plain background.

Study for the full-length portrait:
Red and black chalk. 19 × 15 (48·3 × 38·1), Coll. London, Islington Public Libraries (1947). Rep. *Image*, No. 7, 1952, p. 24. Exh. Sheffield 57 (110); A.C.64 (43). Sickert evidently favoured the use of red and black chalk for portrait drawings at this period (see C.92, *Miss Ellen Heath*).

95. SELF-PORTRAIT (Fig. 63) 1897

Pen and ink. 9⅜ × 7¼ (23·9 × 18·4)
'Sickert inv et del' b.l.c.
Coll. Sir John and Lady Witt
Rep. *The Year's Art*, London, Virtue, 1898, facing p. 132
Lit. R. Pickvance, the *Listener*, 24 August 1961, p. 281 (letter)
Chapter VI

The publication of this drawing in *The Year's Art*, 1898, implies it was executed in 1897 because each issue related events etc. which took place during the year prior to publication. If the drawing is a work of 1897 the Venetian background must have been drawn from imagination and

from landscape studies made in 1895–6. This drawing is one of the main arguments for suggesting a date of 1897–8 for the portrait of *Zangwill* (Fig. 65).

96. ISRAEL ZANGWILL (Fig. 65) *c.*1897–8

Canvas. 23½ × 20 (59·7 × 50·8)
'Sickert' b.r.
J. W. Freshfield/Robin Sanderson/
Coll. Edinburgh, Scottish National Gallery of Modern Art (1959)
Rep. B.60, Pl. 45
Lit. J. B. Manson, *Drawing and Design*, 3, No. 13, July 1927, pp. 3–9, 'Walter Richard Sickert A.R.A.', p. 4; Michael Ayrton, the *Listener*, 18 May 1961, 'Sickert's Portrait of Israel Zangwill' (Painting of the Month series), pp. 868–70, rep. p. 869, and ensuing correspondence June to August 1961 by Lillian Browse, Michael Ayrton, Ronald Pickvance, and Wendy Dimson
Exh. N.E.A.C. winter 1904 (65); Edinburgh 53 (60); Sheffield 57 (99a); R.B.D.60 (9); Tate 60 (85); Adelaide 68 (22)
Chapter VI

Israel Zangwill (1864–1926), the Zionist Jewish leader and novelist, was a friend of Sickert's first wife. This portrait presents an awkward problem of chronology. It was not exhibited until 1904. In some respects its conception —a dignified presentation against an open-air Venetian background—is closest to the 1905 portraits of *Mrs. Swinton* (Fig. 137, C.203). The case for dating the picture *c.*1904 rests on these two facts and is supported by the extraordinarily high quality of the painting and the subtlety of the characterization.

The first piece of evidence for an earlier dating is of doubtful value. Manson, in 1927, wrote that the picture was painted on Sickert's first visit to Venice in 1894. '1894' could be regarded as a minor slip but Manson's memory is demonstrably fallible in so many respects in this article that little heed can be attached to his evidence as a whole. Indeed, there is no reason to suppose the portrait was painted in Venice at all. The *Mrs. Swinton* portraits were painted in London as was the *Self-Portrait* drawing (Fig. 63). Zangwill is not recorded as having been in Venice at any of the times Sickert was there. The second piece of evidence in favour of an earlier dating is that the use of a profile pose and an architectural background is similar in the *Self-Portrait* drawing and *Zangwill*. Thirdly, Sickert studied Zangwill for his *Vanity Fair* cartoon, published 25 February 1897, called *A Child of the Ghetto* after the title of Zangwill's story set in the Venetian ghetto which had just been published. Since the painted portrait was evidently not done with the help of life sittings it is probable that Sickert's work for the caricature may have inspired him to paint Zangwill as well, perhaps making use of the same preliminary studies. The placing of the head and the characterization are similar in both painting and caricature. Finally, the handling of the portrait is closer to Sickert's portraits of *c.*1897–8 such as *Fred Winter* (Fig. 62) than to his later Venetian portraits of 1903–4. The black and purple colour scheme is especially close to that of the full-length portrait of *Fred Winter* (listed under C.94).

97. A PAIL OF SLOPS (Fig. 67) c.1896–8
Charcoal and pencil. 19¼ × 12⅜ (48·9 × 31·5)
'13 Robert Street Hampstead Rd./subject reprod. in
 Yellow Book' b.l. 'Rd. St. A.R.A.' b.r. (both in pen) and
 '13 Robert Street 1898–7–6–5' b.r. (in pencil)
Private Collection. England
Exh. Tate 60 (36)
Chapter XIV, note 10

A rare *genre* figure study done before the Camden Town
period. It may have been influenced by Millet. The
inscriptions were made years later (probably 1924) when
Sickert had not only forgotten the precise date of his draw-
ing but also where the subject had been reproduced. It was
not reproduced in the *Yellow Book* (which ceased publica-
tion in 1895) but in the *New Age*, 13 July 1911. Fig. 67
may not be the original of the reproduction (although it is
very similar) because the drawing in the *New Age* was
inscribed 'Sickert S. Pancras'.

98. GEORGE MOORE 'ESTHER WATERS' c.1897
Details and whereabouts of original unknown. Signed 'Sic'
Rep. *Vanity Fair*, 21 January 1897
Chapter IV, note 16

99. MAX BEERBOHM. 'MAX' c.1897
Details and whereabouts of original unknown. Signed 'Sic'
Rep. *Vanity Fair*, 9 December 1897
Chapter IV, note 16

Sickert made other studies and drawings of Beerbohm
(1872–1956), the brilliant caricaturist, critic, and writer
who in 1896, aged twenty-four, had just published his first
book *The Works of Max Beerbohm*. Beerbohm also caricatured
Sickert many times.
Study related to C.99:
Board. 12⅝ × 4½ (32·1 × 11·5), Sotheby's, 14 December
1960 (33g)/Agnew/Private Collection, London.
Other drawings by Sickert of Beerbohm include:
1. Pen and ink. 8½ × 7½ (21·4 × 18·9), Sotheby's, 17 March
 1965 (24)/Coll. Oxford, Ashmolean Museum (1965).
 This drawing is inscribed 'Drawn by Walter Sickert in
 the 'nineties' and signed 'Max'.
2. *Max as Jack in the Box*. Pen and ink. 4¼ × 4½ (10·8 × 11·5),
 Sotheby's, 17 March 1965 (24)/A. Mathews, Bourne-
 mouth/Private Collection, London.

1896–8. LANDSCAPES

100. THE FAÇADE OF ST. MARK'S. PAX TIBI MARCE
EVANGELISTA MEUS (Fig. 68) c.1896–7
Canvas. 35¾ × 47¼ (90·9 × 120)
'Sickert' b.r.
General Sir Ian Hamilton (bought by Lady Hamilton from
 Sickert)/
Coll. London, Tate Gallery (1949)
Rep. Bertram, Pl. 11
Lit. Tate Gallery Catalogue, 1964, p. 637, rep. Col. Pl.
 XIII
Exh. N.E.A.C. spring 1897 (9) under Latin title; probably
 Durand-Ruel 1900 (4) under Latin title; N.G.41 (10a);
 Leeds 42 (131); Tate 60 (69)
Chapter V

An old label on the back of the frame bears the inscription
of the Latin title and establishes that this is the version
exhibited at the N.E.A.C. in 1897. Fig. 68 is one of the large
versions of this subject probably painted in London after
Sickert's return from Venice. The squared drawing in
Manchester (listed under C.81) seems to have been an
important preliminary document for this painting which is
just over double the scale of the drawing. St. Mark's itself
is exactly double scale but it is surrounded by a little more
space than in the drawing. The pattern of light and shade
and details such as the flags are the same in painting and
drawing.
Versions:
1. Canvas. 39½ × 59½ (100·3 × 151·1), Miss B. D'Oyly
 Carte/Coll. London, British Council (1950). Exh.
 Adelaide 68 (17); Sydney 68 (4).
2. Canvas. 45 × 60 (114·3 × 152·4), Coll. J. E. Crawford
 Flitch Esq. on loan to Leeds City Art Gallery. Exh.
 Leeds 42 (132).
3. Canvas. 19 × 24 (48·3 × 61), Sotheby's, 14 December
 1932 (107)/R. Middleton/Private Collection, Scotland.
Stylistically all these versions fit a date of c.1896–8. How-
ever, it should be remembered that Sickert was liable to
paint versions of earlier subjects at almost any time in his
career. He wrote, for example, to Miss Ethel Sands during
the 1914–18 war, 'When I have done S. Mark's and the
Rialto I shall be through with this chewing of old cud
under which I chafe. But it is necessary to constitute bulk
and without bulk no commercial painter can be made.'
Which, if any, of the extant pictures is such a later rework-
ing I cannot tell.

101. CUMBERLAND MARKET (Fig. 71) c.1896–8
Canvas. 16 × 20 (40·6 × 50·8)
'Sickert' b.l.
Coll. Toronto, Art Gallery (1946)
Chapter VI

A London night scene near Sickert's Robert Street studio.
Version:
Canvas. 16 × 17 (40·6 × 43·1), Mrs. George Swinton/
Private Collection, Scotland. This picture is a little more
freely handled than Fig. 71; it is dedicated to Mrs. Swinton.
Another night landscape in the Cumberland Market area
of London is *Munster Square*, C.104.

102. QUAI DUQUESNE AND THE RUE NOTRE DAME
(Fig. 70) c.1896–8
Canvas. 21½ × 18 (54·6 × 45·7)
Mrs. W. L. Hosking/Sotheby's, 23 April 1969 (29)/
Coll. Perth, Art Gallery of Western Australia (1969)
Exh. Agnew 1969, 'British Painting 1900–1969' (19)
Chapter VI

A Dieppe landscape in the style of Fig. 71 and C.104.
Sickert showed a Nocturne at the N.E.A.C. in spring 1900
(60) under the title '*O ye Light and Darkness, bless ye the
Lord, praise him, and magnify him for ever*'. It represented 'A
street at night, lit up by the light in the surrounding win-
dows' (*Pall Mall Gazette*, 10 April 1900) and it was prob-
ably a Dieppe subject. The press was unanimous in finding
it harmonious.

103. THE SKITTLE ALLEY, SAN MORITZ

Watercolour. $6\frac{1}{8} \times 9\frac{3}{4}$ (15·6 × 24·8)

Coll. Whitworth Art Gallery, University of Manchester (1924)

Chapter VI

This watercolour could be a much later work. However, the only known visit by Sickert to Switzerland was in 1896.

104. MUNSTER SQUARE c.1896–8

Canvas. $17\frac{1}{2} \times 19\frac{1}{2}$ (44·5 × 49·5)

'Sickert' b.r.

John Cristopherson/Christie's, 19 July 1968 (108), bought Mrs. Wright

Exh. Hampstead 1965, 'Camden Town Group' (73)

Chapter VI

1898–1900. DIEPPE, LANDSCAPES

105. UNE RUE À DIEPPE (Fig. 69) 1898

Canvas. $21\frac{3}{4} \times 15$ (55·3 × 38·1)

André Gide/Major E. O. Kay/

Private Collection, London

Exh. Bernheim 1904 (32) lent by Gide; Sheffield 57 (11); Agnew 60 (40)

Chapter VII

This picture is inscribed on the reverse 'W. Sickert mio Dieppe 1898'.

106. THE FLOWER MARKET or LE MARCHÉ RUE DE LA BOUCHERIE (Fig. 74) c.1898

Canvas. $18 \times 21\frac{3}{4}$ (45·7 × 55·3)

'Sickert' b.r.

J. W. Freshfield/

Coll. Sydney, Art Gallery of New South Wales (1947)

Rep. B.60, Pl. 22

Lit. D. Thomas, *Art Gallery of New South Wales Quarterly*, 10, No. 1, October 1968, pp. 431–2, 'Some Problems of Dating and Identification', p. 432

Exh. Possibly N.E.A.C. winter 1898 (60) as *The Rag Fair*; Chicago: Pittsburgh 1938 (28) as *St. Jacques, Dieppe*; Tate 60 (38); Adelaide 68 (10); Sydney 68 (3)

Chapter VII

When this picture was acquired by the Sydney Art Gallery it was known as *Flower Sellers*; Thomas quotes the opinion of the curator of the Musée de Dieppe that the scene is the Marché aux Fleurs which stands in the Place Nationale, not in the Rue de la Boucherie. The Gallery therefore prefers the picture to be known henceforth as *The Flower Market*.

The identification of *The Flower Market* as *The Rag Fair* exhibited at the N.E.A.C. in 1898 is suggested by press descriptions of the exhibited picture: the *Daily Telegraph*, 17 November 1898: 'the view of a heavy Gothic apse and adjacent street somewhere in Flanders, named, in a very misleading fashion, "The Rag Fair". . . . The grey sky, too flat and curtainlike, is here the weak point; it has the tints, but not the atmospheric effects peculiar to Maris.' The improbable location by this reviewer of the scene as in Flanders can be disregarded, but the knowledge that the

title was misleading is helpful because this title is the only real argument against the identification of *The Rag Fair* as *The Flower Market*. Sickert's titles were frequently ambiguous and misleading; it is quite possible that the title *The Rag Fair* described the dress rather than the produce of the marketeers. The *Illustrated London News*, 3 December 1898, described the scene as 'held behind a deserted half-ruined church' and stated that it dealt with 'the picturesque poverty of French life'. The church in Fig. 74 is painted so broadly and bleakly that it might easily have been interpreted as a ruin.

St. James Gazette, 21 November 1898: 'an architectural scene, broadly treated and low in tone, and in a subtle grey colour-scheme'.

The *Saturday Review*, 19 November 1898: 'a well-drawn architectural study in a conventional blue-black tonality'. If the very early history of Fig. 74 could be discovered the problem of identification would be resolved. We know from Sickert's letters to William Rothenstein that *The Rag Fair* was bought on approval by Sir William Eden who, by 1899, exchanged it for another picture. It then went to the Carfax Gallery (for whom Rothenstein worked) and later Fred Brown offered to sell the picture. The only provenance we have for Fig. 74 is that it formerly belonged to J. W. Freshfield but when and from whom he acquired it is unknown.

Fig. 74 is generally believed to be a work of 1900 because in style and handling it is similar to dated paintings of that year such as *Le Grand Duquesne* (Fig. 77). However, the press comments on *The Rag Fair*, whether or not it is Fig. 74, suggest that by 1898 Sickert had already developed the handling typical of his work in 1900.

Drawing of a related subject:

Pen and ink. $12\frac{1}{2} \times 9$ (31·8 × 22·9), Coll. Hugh Beaumont Esq. Rep. the *New Age*, 10 August 1911; B.60, Pl. 22a. Exh. Tate 60 (28). Chapter XIV, note 10. Probably drawn earlier in the 1890s. Markets behind St. Jacques were a common occurrence and still take place today.

107. LES ARCADES ET LA DARSE (Fig. 75) c.1898

Canvas. $19\frac{3}{4} \times 24$ (50·2 × 61)

'Sickert' b.r.

Paul Robert/Baron van der Heyden à Hauzeur/

Private Collection, London

Rep. B.60, Col. Pl. II

Exh. Possibly N.E.A.C. winter 1898 (65) as *The Sea Front*; Tate 60 (40); Brighton 62 (38)

Chapter VII

Fig. 75 accords with the press descriptions of *The Sea Front* exhibited in 1898: 'a group of old French houses' (*Athenaeum*, 26 November 1898) which 'claims consideration for striking effects of tone and colour' (*Saturday Review*, 19 November 1898) and possessed 'audacious truthfulness of illumination' and 'boldness and severe simplicity of artistic arrangement' (the *Daily Telegraph*, 17 November 1898).

Fig. 75, for the same reasons as Fig. 74, is generally dated 1900. The same arguments against the exclusiveness of this dating apply to Fig. 75.

Sickert painted this subject many times from slightly different viewpoints and generally at a greater distance from the quay. Examples of such pictures include:

1. *The Harbour, Dieppe* of *c*.1885 (C.36).
2. *Le Bassin, Dieppe*. Canvas. 19½ × 24 (49·5 × 61), Paul Robert/Baron van der Heyden à Hauzeur/Private Collection, London.
3. *Le Port de Dieppe*. Canvas. 14½ × 17½ (36·8 × 44·5), Jacques-Émile Blanche/Georges Mevil-Blanche/Sotheby's, 19 July 1967 (44)/Leicester Galleries/Private Collection, England. Exh. Dieppe 54 (5); Leicester Galleries 1967–8, 'New Year Exhibition' (113).
4. *Le Bassin à Dieppe*. Canvas. 14½ × 17½ (36·8 × 44·5), Jacques-Émile Blanche/Georges Mevil-Blanche/Sotheby's, 19 July 1967 (45)/Leicester Galleries/Private Collection, England. Exh. Dieppe 54 (6); Leicester Galleries 1967–8, 'New Year Exhibition' (112).
5. *Une Dieppoise*. Canvas. 24 × 20 (61 × 50·8), Mrs. A. E. Anderson/Private Collection, England. Rep. B.60, Col. Pl. III. Exh. Edinburgh 53 (6); Tate 60 (43).

All these paintings include a deeper stretch of water in the foreground than Fig. 75. *Une Dieppoise* incorporates a strip of land on the near side with an old woman holding a pail boldly silhouetted against the background harbour. All except for the panel of *c*.1885 illustrate dramatic lighting effects, dawn or twilight. *Une Dieppoise* and *Le Bassin* (2) are very similar in style and handling to Fig. 75. Paintings 3 and 4 are more lightly and sketchily painted. Paintings 2–5 were probably all painted between 1898 and 1900.

Sickert's many drawings of this subject include:
1. C.71 (the drawing of 1893 published in the *Yellow Book*).
2. Pen and watercolour. 9 × 11 (22·9 × 27·9), Mrs. Lucy Carrington Wertheim/Christie's, 9 December 1960 (128)/R.B.D./Private Collection, London. Exh. Sheffield 57 (113); R.B.D. 1969, 'Sickert Drawings' (51).

There are also innumerable studies on panels and canvas of the cliffs around Dieppe harbour, and there are other drawings with a landscape background taken further out of town.

108. LA MAISON QUI FAIT LE COIN (Fig. 72)
 dated 1899
Canvas. 9¾ × 7¾ (24·8 × 19·7)
'Sickert—1899' b.l.
Mrs. L. A. Fenwick/Christie's, 10 March 1967 (133)/Tooth/
Private Collection, London
Exh. A. Tooth 1967, 'British Painting 1900–1950' (13) as *La Maison blanche à Dieppe*
Chapter VII

A corner in Le Pollet, the fishermen's quarter of Dieppe. Fig. 72 is the smallest of Sickert's paintings of this subject and the only one to be dated.

Versions:
1. Canvas. 21 × 17¾ (53·3 × 45·1), Christie's, 17 July 1959 (136)/Coll. Plymouth, Museum and Art Gallery (1959).
2. Canvas. 18 × 15 (45·7 × 38·1), Private Collection, Paris/Messrs. Roland, Browse, and Delbanco 1971. Exh. R.B.D.63 (1); New York 67 (1); Sydney 68 (20).

These versions may have been painted *c*.1898. They are painted less freely than Fig. 72, their paint is flat and glossy and their colours glowing.

Drawing:
Coloured chalks. 12½ × 9 (31·8 × 22·9), Jacques-Émile Blanche/Coll. Musée de Rouen (1923) on loan to Musée de Dieppe. Exh. Dieppe 54 (49) as *Vieilles Rues au Pollet*.

109. LE PETIT TRIANON (Fig. 73) *c*.1899
Canvas. 17½ × 14½ (44·5 × 36·8)
'Sickert Versailles' b.r.
H. M. Hepworth/
Coll. Leeds, City Art Gallery (1934)
Exh. Possibly Bernheim 1904 (54) as *Trianon. Jet d'Eau* lent by Jacques-Émile Blanche; Leeds 42 (126); Sheffield 57 (13)
Chapter VII

Probably painted in 1899 following Sickert's visit to Versailles in July of which he wrote to Rothenstein, 'We went to Versailles yesterday. Blanche said Aubrey adored the Grand Trianon which I can imagine' (for dating of letter see Chapter VII, note 17). Sickert showed *Le Grand Trianon* at the N.E.A.C. winter 1899 (53) described by *Truth*, 23 November 1899, as 'wilfully aggressive'. Fig. 73 could itself have merited this description.
The early history of *Le Petit Trianon* is unknown, so whether or not it is the picture lent by Blanche to the 1904 Bernheim exhibition is unproved.

110. L'HÔTEL ROYAL (Fig. 80) *c*.1899
Canvas. 18¼ × 21¾ (46·4 × 55·3)
'Sickert' b.r.
A. Clifton/F. R. Duckworth/G. Pilkington/
Coll. Hull, Ferens Art Gallery (1960)
Exh. A.C.64 (6); Hull 68 (9)
Chapter VII

Sickert had studied this subject *c*.1893–4 (Figs. 42, 48) and returned to it again *c*.1899–1900. At the end of the summer season in 1900 the old Hôtel Royal was demolished (to be replaced in 1901 by a more luxurious but less gracious new hotel). Sickert's *c*.1899–1900 versions of the old *Hôtel Royal* include:
1. Canvas. 18¼ × 21¾ (46·4 × 55·3), Coll. Musée de Dieppe (presented by Sickert in 1900). Exh. Dieppe 54 (3); Tate 60 (14); Brighton 62 (7).
2. Canvas. 12 × 15 (30·5 × 38·1), Messrs. Thos. Agnew & Sons, Ltd. 1971.
3. Board. 5 × 9 (12·7 × 22·9), A. de Pass/Coll. Capetown, South African National Gallery (1927).

Fig. 80 is a rougher, probably preliminary version of the Musée de Dieppe painting (1). The size and compositional layout of both pictures are identical. It is interesting that the square patch of light on the houses to the left in Fig. 80 is translated into two little light-touched figures in the more finished painting. Version 2 is much more lightly painted in pale-toned, thin, fluid washes of paint; it has a deeper foreground but shows less of the subject on each side. Version 3 is probably a study for Version 2 and perhaps for the central portion of the two bigger paintings.
The many drawings related to these paintings include:
1. Pen and ink, watercolour. 5½ × 8¼ (14 × 21), Sotheby's, 22 July 1964 (152)/Agnew/Private Collection, Scotland. Exh. Agnew 1965 'French and English Drawings 1900–1965' (88). Inscribed 'Many happy returns of the day 1899'. Closely related to Paintings Versions 2 and 3.

2. Pencil, pen and ink, wash, squared. 18 × 22 (45·7 × 55·8), Philip Jones/Sotheby's, 20 April 1966 (70)/R. A. McAlpine/Coll. Joan and Lester Avnet (on loan to Museum of Modern Art, New York). Exh. New York 67 (22). Inscribed 'Sickert the old Hotel Royal. Study for picture in Musée de Dieppe.'
3. Chalk on blue paper. 18 × 23¾ (45·7 × 60·3), Suzette Lemaire (to whom it is dedicated)/Christie's, 21 May 1965 (69)/Last known owner R. A. McAlpine Esq. Exh. R.B.D.63 (35).
4. Pen and ink, wash. Size and whereabouts unknown. Formerly Jacques-Émile Blanche. Rep. F. Wedmore, *Some of the Moderns*, London, Virtue, 1909.
5. Pencil, heightened with white. 22 × 17¼ (55·8 × 43·9). Jacques-Émile Blanche/Coll. M. Georges Mevil-Blanche. Exh. Dieppe 54 (34). Inscribed 'To Jacques Blanche 1902 Walter Sickert'. The date must refer to the dedication, not the execution, of the drawing because by 1902 the old Hôtel Royal was demolished.
6. Charcoal and wash. 18½ × 24 (47 × 61). Last known owner Austin Trevor Esq. Exh. Edinburgh 53 (69). Inscribed 'To Mrs. Price—Walter Sickert 1900'.

I have not seen Drawing 6 but Drawings 2–5 are all full composition studies for the painting in the Musée de Dieppe and Fig. 80.

For details of a related picture, the *Boulevard Aguado*, see C.125.

In all these paintings and drawings Sickert showed the Boulevard Aguado and the Hôtel Royal in diagonally receding perspective instead of parallel to the picture plane as in 1893–4 (Figs. 42, 48). A fenced flower bed seems to have been placed in front of the hotel between 1894 and 1899.

III. LE GRAND DUQUESNE (Fig. 78) c.1899

Canvas. 22 × 18 (55·9 × 45·7)
'Sickert' b.r.
Sir Walter Fletcher/Christie's, 1 November 1957 (59)/
Coll. Victor Montagu Esq.
Exh. Agnew 60 (67)
Chapter VII

The statue of Admiral Duquesne in the Place Nationale is by Dantan the Elder. Duquesne, a native of Dieppe, defeated the Dutch admiral de Ruyter in 1676. Sickert painted the statue many times. Another version is illustrated as Fig. 77. A large version of Fig. 78 was painted on commission in 1902 (C.156). Yet another version, seen from a different angle, formerly belonged to Jacques-Émile Blanche and is now in the collection of M. Georges Mevil-Blanche: canvas. 25½ × 21¼ (64·8 × 54). Exh. Bernheim 1904 (52) lent by Blanche; Dieppe 54 (9), rep. in catalogue. The dimensions and the placing of the signature suggest that Fig. 78 may be the painting entitled *La Statue de Tourville, à Dieppe* (there is no such statue in Dieppe) sold in the Cahen sale at Petit's Gallery, 24 May 1929 (79).

Painted study for Fig. 78:
Panel. 9¼ × 5¼ (23·5 × 13·4), Paul Robert/Baron van der Heyden à Hauzeur/Private Collection, London. Exh. Probably Bernheim 1904 (80) lent by Robert; Tate 60 (52).

Drawings of the subject include:
1. Chalk and wash on blue paper. 21 × 18¼ (53·3 × 46·4). Last known owner Sir George Barnes. Rep. B.60, Pl. 24a. Exh. Tate 60 (60). This drawing is dated 1899. It is very closely related to Fig. 78.
2. Pastel and watercolour. 12¾ × 9¼ (32·4 × 23·5), Lord Henry Cavendish-Bentinck/Coll. London, Tate Gallery (1940).
3. Coloured chalks. 11 × 8¾ (27·9 × 22·2), from the collection of Morton Sands.

Drawing 1 was probably a study for painting. Drawings 2 and 3 are coloured drawings of the type discussed Chapter VII, pp. 59–60, executed by Sickert to earn a little money easily and to give to friends. All the drawings of this type reflect compositions studied in paintings but they were not working drawings. The Musée de Rouen owns a large group of such drawings formerly in Jacques-Émile Blanche's collection; Lady Spencer-Churchill owned another large group (dedicated to her mother Lady Blanche Hosier, signified as 'B.H.' in the inscriptions). In the following catalogue entries only a few examples of such drawings of particular subjects will be listed.

112. LA RUE NOTRE DAME AND THE QUAI DUQUESNE (Fig. 79) c.1899

Canvas. 22 × 18¼ (55·9 × 46·4)
'Sickert' b.r.
Judge Evans/
From the collection of Morton Sands
Rep. B.60, Pl. 20; Rothenstein 1961, Col. Pl. IV; Pickvance, 1967, Col. Pl. V
Exh. Leeds 42 (124); Agnew 60 (54); Tate 60 (41); Brighton 62 (65)
Chapter VII

Sickert painted this subject (showing La Rue Notre Dame running at right angles from the arcaded Quai Duquesne towards St. Jacques in the background) many times in 1899, 1900, and again on commission in 1902 (Fig. 102).

Versions include:
1. Canvas. 22 × 18 (55·9 × 45·7), Jacques-Émile Blanche/ Private Collection, Paris. Exh. Probably Bernheim 1904 (69) or (79) lent by Blanche. Very close to Fig. 79 but it lacks the figure of an old woman.
2. Panel. 9 × 7 (22·9 × 17·7), R. Hippesley-Cox/Private Collection, England. Possibly a study for Fig. 79 and Version 1.
3. Canvas. 24 × 19½ (61 × 49·5), Gerald Kenrick/Coll. Birmingham, City Art Gallery (1953). Rather lighter in tone than Fig. 79 and Versions 1 and 2. Horse and cart cabs are prominent features.
4. Board. 9½ × 7½ (24·1 × 19), from the collection of Morton Sands. Exh. N.G.41 (21) as *Dieppe*; Leeds 42 (144); possibly Brighton 62 (69) as on canvas under title *Les Arcades*.
5. Panel. 9 × 5½ (22·9 × 14), Jacques-Émile Blanche/Coll. M. Georges Mevil-Blanche. Exh. Probably Bernheim 1904 (69) or (79); Dieppe 54 (8).
6. Board. 16 × 13 (40·6 × 33), Mrs. Marjorie Spencer/ Messrs. Roland, Browse, and Delbanco 1967. Exh. New York 67 (15), rep. in catalogue. Versions 4–6 all feature the horse cabs found in the Birmingham painting (3).

7. Canvas. $22\frac{1}{2} \times 18$ ($57 \cdot 1 \times 45 \cdot 7$), Geoffrey Blackwell/ Private Collection, London.

8. Canvas. 16×13 ($40 \cdot 6 \times 33$), Baroness Spencer-Churchill /Sotheby's, 15 December 1965 (35)/Coll. John Greenhill Esq. Sydney. Exh. Brighton 62 (51); New York 67 (12), rep. in catalogue; Adelaide 68 (11); Sydney 68 (19). Dated 1900. This painting is empty of all figures and incidents (as are Versions 9 and 10 listed below). This dated picture also omits the houses to the left of the Rue Notre Dame on the Quai Duquesne.

9. Canvas. $14\frac{1}{2} \times 11\frac{3}{4}$ ($36 \cdot 8 \times 29 \cdot 9$), Sir Frank Brangwyn/ Coll. London, Walthamstow, William Morris Gallery (1936). Exh. A.C.64 (4) and A.C.1967, 'Decade 1890–1900' (39) as *St. Jacques, Dieppe*.

10. Board. 9×6 ($22 \cdot 9 \times 15 \cdot 2$), Basil Burdett/Last known owner Sir Keith Murdoch (photograph with Messrs. A. Tooth & Sons Ltd.).

The many interrelationships between these various versions and studies of the subject suggest they were all painted *c*.1899–1900.

Drawings of the subject include:

1. Watercolour, charcoal, heightened with white. $22 \times 18\frac{1}{2}$ ($55 \cdot 9 \times 47$), Christie's, 21 December 1951 (90)/Private Collection, England. Rep. B.60, Pl. 21a; Rothenstein 1961. Exh. Tate 60 (61). Inscribed 'To John Strange Winter/W. Sickert 1899'. The 'Winter' of the dedication is sometimes misinterpreted as applying to the date. In fact 'John Strange Winter' was the pseudonym of Sickert's friend in Dieppe, the novelist and journalist Mrs. Stannard. This drawing includes the horse-drawn cabs of Paintings Versions 3–6; it also outlines the old woman seen in Fig. 79.

2. Charcoal and watercolour on blue paper. $11\frac{3}{4} \times 9\frac{1}{4}$ ($29 \cdot 9 \times 23 \cdot 5$). Coll. Sir Charles Madden, Bt. With the horse cabs of Paintings Versions 3–6.

3. Chalk. $10\frac{3}{4} \times 9$ ($27 \cdot 3 \times 22 \cdot 9$), R. Hippesley-Cox/Private Collection, England. Although this drawing is not coloured it appears to have been traced.

4. Charcoal and wash. $12\frac{1}{4} \times 9$ ($31 \cdot 1 \times 22 \cdot 9$), Lady Blanche Hosier/Private Collection. Rep. Rothenstein 1961. Exh. Tate 60 (63). One of the coloured drawings dedicated to 'B.H.' noted under C.111.

5. Charcoal and coloured chalks. $13 \times 9\frac{1}{2}$ ($33 \times 24 \cdot 1$), Jacques-Émile Blanche/Coll. Musée de Rouen (1923) on loan to Musée de Dieppe. Exh. Dieppe 54 (43). Close to Drawing 4.

6. Pen and ink, watercolour. $10\frac{3}{4} \times 9\frac{1}{4}$ ($27 \cdot 3 \times 23 \cdot 5$), Jacques-Émile Blanche/Coll. Musée de Rouen (1923) on loan to Musée de Dieppe. Exh. Dieppe 54 (42); Tate 60 (66); Brighton 62 (10).

7. Chalk, pen and ink, watercolour. $12 \times 9\frac{1}{4}$ ($30 \cdot 5 \times 23 \cdot 5$), Sotheby's, 12 May 1971 (17)/Messrs. Roland, Browse, and Delbanco, 1971.

113. ST. JACQUES FAÇADE (Fig. 76) 1899
Panel. $5\frac{3}{4} \times 6\frac{3}{4}$ ($14 \cdot 6 \times 17 \cdot 2$)
Miss Ethel Sands (given to her by Sickert *c*.1914)/
 Christie's, 12 June 1970 (28)/
Messrs. Roland, Browse and Delbanco 1971
Exh. R.B.D.1971, 'British Paintings and Drawings' (12)
Chapter VII

Sickert wrote to Miss Sands *c*. 1914, 'I am sending . . . you a little view of St. Jacques Dieppe with the white *hôtel du commerce* peeping over the barracks of the fair done in 1899—the *hôtel* from the window of which le Père Pissarro did a whole series'.

None of Sickert's many pictures of the St. Jacques façade is dated. Fig. 76 and the large commissioned picture of 1902 (C.157) are the only versions which can be dated on documentary evidence.

Sickert had painted this subject perhaps since the 1880s. *La Rosace*, Exh. N.E.A.C. winter 1894 (51) and *The Rose Window*, Exh. N.E.A.C. spring 1899 (54) were both paintings of St. Jacques but press comment was not detailed enough to discover which, if any, of the extant paintings were exhibited. Another *St. Jacques* was to be exhibited at the N.E.A.C. winter 1901 (125).

Nearly all the extant versions of this subject are works of 1899–1900. Exceptions are the commissioned picture of 1902 (C.157), a version painted in 1914 (Fig. 244), and two paintings on panel, each $9\frac{1}{2} \times 5\frac{1}{2}$ ($24 \cdot 1 \times 14$), R. Barr/ Coll. Mrs. H. D. Robertson. One of these panels is a delicate little tonal study in liquid paint; the other is slightly richer in handling with some dots of light scattered in the rose window and a few sharply drawn accents. Both were probably painted earlier in the 1890s.

The other versions of *St. Jacques Façade* painted 1899–1900 are catalogued under Fig. 85, C.118.

114. LE GRAND DUQUESNE (Fig. 77) dated 1900
Canvas. $15\frac{1}{8} \times 18\frac{1}{4}$ ($38 \cdot 4 \times 46 \cdot 4$)
'To Mrs. Price/W.S.1900' b.r.
Mrs. M. Price.
Coll. Melbourne, National Gallery of Victoria (1946)
Rep. B.60, Pl. 24
Exh. Durand-Ruel 1900 (28) lent by Mrs. Price; Tate 60
 (45); Adelaide 68 (12)
Chapter VII

Study for Fig. 77:
Chalk, pencil, pen and ink on grey paper. $9\frac{1}{4} \times 11\frac{7}{8}$ ($23 \cdot 5 \times 30 \cdot 2$), S. F. Hodgson/Coll. Melbourne, National Gallery of Victoria (1964). Exh. Brighton 62 (24); Adelaide 68 (62).

115. LA RUE PECQUET (Fig. 81) dated 1900
Canvas. $21\frac{1}{2} \times 18$ ($54 \cdot 6 \times 45 \cdot 7$)
'Le 5 Novembre/1900/Sickert' b.r.
Private Collection, France/
Coll. Birmingham, City Art Gallery (1948)
Rep. B.60, Col. Pl. VII; Pickvance 1967, Fig. 2, p. 5;
 Lilly, Pl. 28
Exh. Edinburgh 53 (1); Tate 60 (39); Adelaide 68 (15);
 Columbus Gallery of Fine Art, Ohio, 1971, 'British
 Art 1890–1928' (97)
Chapter VII

This view of the south door of St. Jacques seen down La Rue Pecquet was painted by Sickert many times, sometimes in 1899–1900 but more often in 1907–8 (Fig. 197, C.287). A very rough guide to the separation of the earlier from the later versions is a tree planted to the left of the door of St. Jacques and a fence across part of the portal found in the later pictures. The brushwork of the later versions is also much more broken, the paint is more thick and grainy in texture, and the colours are brighter.

Versions *c.* 1899–1900 include:

1. Canvas. 18 × 14¾ (45·7 × 37·5), Paul Robert/Baron van der Heyden à Hauzeur/Private Collection, London.
2. Canvas. 18¼ × 14½ (46·4 × 36·8), Mrs. M. Green/Coll. Leeds, City Art Gallery (1938). Exh. Adelaide 68 (8).
3. Panel. 7 × 5½ (17·8 × 14), Jacques-Émile Blanche/Coll. M. Georges Mevil-Blanche. Exh. Possibly Bernheim 1904 (55) lent by Blanche; Dieppe 54 (11).

The paint in Version 2 is more smudgily broken than in the other two pictures and Fig. 81 but Sickert did begin to experiment with this kind of handling in 1900 (see Fig. 90). The general low tonality and the dark colours of Version 2 suggest that it is an earlier rather than a later version of this subject.

Drawings *c.*1899–1900 of this subject include:

1. Pen and ink, black crayon, heightened with white. 22½ × 18 (57·1 × 45·7), Suzette Lemaire (to whom it is dedicated)/Coll. Birmingham, City Art Gallery (1953). Exh. Tate 60 (64); A.C.64 (36), rep. in catalogue.
2. Pen and ink, pencil, wash, squared. 10 × 6¼ (25·4 × 15·9), Mrs. George Swinton/Private Collection, England. Exh. Edinburgh 53 (75) as *Dieppe Street with Cart*. This drawing and Drawing 1 are the only drawings of the subject known to me which can be considered as studies for the paintings. The other drawings listed below are coloured, of the type discussed under Fig. 78, C.111.
3. Chalk and wash. 11¾ × 5¾ (29·9 × 14·6), Private Collection, London. Dated 1899.
4. Charcoal and wash. 9½ × 6 (24·1 × 15·2), Lady Blanche Hosier (to whom it is dedicated)/Private Collection. Exh. Tate 60 (63).
5. Charcoal and coloured chalks. 9⅞ × 6⅛ (25·1 × 15·5), Jacques-Émile Blanche/Coll. Musée de Rouen (1923) on loan to Musée de Dieppe. Exh. Dieppe 54 (48).
6. Charcoal and wash. 13¼ × 8¼ (33·7 × 21), Dr. Robert Emmons/A. W. Brickell/Christie's. 19 March 1971 (52)/Messrs. Thos. Agnew & Sons Ltd. 1971. Exh. Agnew 1971, 'A Century of Modern Drawings and Prints' (56).

116. SOUTH FAÇADE OF ST. JACQUES (Fig. 82) *c.*1900

Canvas. 21 × 18 (53·3 × 45·7)
'Sickert' b.l.
Stuart G. Bennett, Ontario/Sotheby's. 1 May 1968 (22)/The Leicester Galleries 1971
Exh. Leicester Galleries 1971, 'Paintings and Drawings and Sculpture by 19th and 20th century artists' (64)
Chapter VII

Sickert painted this subject again *c.*1907–8 (Fig. 198). Other versions of this view of the south façade of St. Jacques include:

1. Canvas. 21 × 17½ (53·3 × 44·5), Prof. Fred Brown/Geoffrey Blackwell/Private Collection, London. Probably painted *c.*1899.
2. *Le Marché aux Locques*. Canvas. 24 × 20 (61 × 50·8), J. W. Blyth/Coll. Kirkcaldy, Art Gallery (1964). Painted *c.*1903.

Study:
Chalk, squared in red. 11½ × 8½ (29·2 × 21·6), Coll. London, Islington Public Libraries (1947). Exh. Sheffield 57 (106). A working drawing for Fig. 82.

117. LE CHEVET DE L'ÉGLISE (Fig. 83) *c.*1900

Canvas. 21½ × 14½ (54·6 × 36·8)
'Sickert' b.r.
M. Moreau-Nélaton/M. Comiot/Tooth/
Private Collection, London
Exh. Agnew 60 (64)
Chapter VII

Sickert studied this subject on panel and canvas again in 1914 (Fig. 242, C.350) by which time the little tree in the background had grown to great height.
Study (a working drawing) for Fig. 83:
Pencil, squared. 10¼ × 7 (26 × 17·8), Coll. Liverpool, Walker Art Gallery (1948).
Related drawing of the subject:
Pen and ink, wash. 11½ × 9½ (29·2 × 24·1), Mrs. M. Clifton/Agnew/Private Collection, New York.

118. ST. JACQUES FAÇADE (Fig. 85) *c.*1899–1900

Canvas. 22 × 19 (55·9 × 48·2)
'Sickert' b.r.
Sir George Sutton/Mrs. William Miller/
Coll. Whitworth Art Gallery, University of Manchester (1970)
Rep. B.60, Pl. 23; Rothenstein 1961, p. 3
Exh. Tate 60 (44); Brighton 62 (52); New York 67 (11); Agnew 1969, 'British Paintings 1900–1969' (21)
Chapter VII

Fig. 85 is the most completely realized of all the versions of this subject. It was the basis of the 1902 commissioned picture (C.157). It shows St. Jacques towards dusk, caught dramatically in the last rays of the setting sun.
In his very many versions of this subject Sickert varied the points of cutting the composition, the incidental figures, the light effects, and the handling. Thus no one version is a replica of, or even very close to, another picture.

Versions on canvas painted *c.*1899–1900:

1. *St. Jacques by Moonlight.* 21¼ × 17¾ (54 × 45), A. Crossland/Christie's, 9 March 1956 (187)/Sotheby's, 22 July 1964 (158)/B. Organ/The Hamet Gallery 1971. Exh. Eldar Gallery 1919, rep. in illustrated catalogue; N.G.41 (90); Leeds 42 (141). A rough tonal study.
2. *St. Jacques. Sun Setting.* 15⅝ × 12¾ (39·7 × 32·4), Jacques-Émile Blanche/Coll. Musée de Rouen (1922) on loan to Musée de Dieppe. Exh. Dieppe 54 (12). Another informal version, and perhaps the most impressionistic in its communication of a particular light effect. It is little more than a study in tone, painted in greys and off-whites over a warm and vivid red-brown ground.
3. 24 × 19¾ (61 × 50·2), Paul Robert/Baron van der Heyden à Hauzeur/Private Collection, London. Exh. Probably Durand-Ruel 1903, 'Société Nouvelle de Peintres et de Sculpteurs' (133) lent by Robert. A crisply drawn and painted version of the scene by daylight.
4. 18 × 15 (45·7 × 38·1), A. Crossland/Christie's, 9 March 1956 (189)/J. R. Farquhar/Christie's, 21 January 1972 (50). Exh. Eldar Gallery 1919, rep. in illustrated catalogue; R.B.D.60 (4), rep. in catalogue. Quite sketchily defined but painted in thicker, broken stains and strokes. The handling of this version of *St. Jacques* is similar to that of the Leeds version of *La Rue Pecquet* (C.115, Version 2).

5. $21\frac{1}{2} \times 18$ ($54\cdot6 \times 45\cdot7$), Private Collection, Paris/Last known owner Herman Levy Esq., Montreal. Exh. R.B.D.1957 (5). The only painting besides the 1902 commissioned version to include the figures of two nuns, who are included in several of the drawings.

6. 18×15 ($45\cdot7 \times 38\cdot1$), Adolphe Tavernier/Vente Tavernier, Hôtel Drouot, 15 April 1907 (45)/M. Comiot/ Lord Cottesloe/Sotheby's, 14 July 1965 (66)/Coll. Mrs. Irina Moore. Exh. Bernheim 1904 (40) lent by Tavernier; New York 67 (10). The upper storey of St. Jacques is again lit up by the rays of the setting sun. This version includes a cart in the immediate foreground and a striped awning projects from the shop on the left (a feature of several of the drawings).

7. $14 \times 10\frac{3}{4}$ ($35\cdot5 \times 27\cdot3$), from the collection of Morton Sands. Exh. Brighton 62 (75). This picture shows a longer stretch of La Rue St. Jacques in the foreground than the other versions.

Versions on panel c.1899–1900:

1. Fig. 76, C.113.

2. $5\frac{3}{8} \times 4\frac{1}{2}$ ($13\cdot7 \times 11\cdot5$), Jacques-Émile Blanche/Coll. M. Georges Mevil-Blanche. Study for painting on canvas, Version 6.

3. $7\frac{5}{8} \times 5\frac{1}{2}$ ($19\cdot4 \times 14$), Miss Ethel Sands/R.B.D./Private Collection, England. Exh. Dieppe 54 (14); R.B.D.63 (45).

4. $6\frac{1}{2} \times 4\frac{3}{4}$ ($16\cdot5 \times 12$), the Very Rev. E. Milner-White/ Coll. Cambridge, Fitzwilliam Museum (1970).

5. $9\frac{1}{4} \times 7\frac{1}{2}$ ($23\cdot5 \times 19$), Warren Taylor (it is dedicated to Muriel and Warren Taylor)/Last known owner P. Oppenheimer Esq. Exh. Dieppe 54 (13).

6. $9\frac{1}{8} \times 7\frac{1}{8}$ ($23\cdot2 \times 18$), R. Hippesley-Cox/Private Collection, England.

7. $9 \times 6\frac{1}{2}$ ($22\cdot9 \times 16\cdot5$), Paul Robert/Baron van der Heyden à Hauzeur/Private Collection, England. A unique feature of this panel is that Sickert painted in tapering pinnacles above the actually truncated squared turrets flanking the rose window.

The drawings of this subject are catalogued under Fig. 84, C.119; Fig. 86, C.120.

119. ST. JACQUES FAÇADE (Fig. 84) c.1899

Pencil, pen and ink, squared. 18×15 ($45\cdot7 \times 38\cdot1$)
'Rd. Sickert fecit R.A.' b.l. deleted
Sir Edward Marsh/
Coll. University of Newcastle upon Tyne, Hatton Gallery (1954)
Exh. Tate 60 (65); A.C.64 (34)
Chapter VII

The largest and most complete of Sickert's drawings of this subject. None of the extant paintings exactly reflects all its detail; it is closest to the painting on canvas, Version 6, listed C.118.
Other working drawings for the *St. Jacques* paintings include:

1. Pencil, pen and ink, squared. $7 \times 4\frac{3}{4}$ ($17\cdot8 \times 12\cdot1$), Coll. London, Islington Public Libraries (1947). Exh. Sheffield 57 (109).

2. Pen and ink, squared. $6\frac{3}{4} \times 5\frac{3}{4}$ ($17\cdot2 \times 14\cdot6$), from the collection of Edward le Bas. Exh. R.A.1963, 'A Painter's Collection' (192).

3. Pencil, pen and ink. $8\frac{7}{8} \times 7\frac{3}{8}$ ($22\cdot5 \times 18\cdot7$), Mrs. Ala Story/Christie's 1972.

4. Pen and ink, watercolour, squared. $11 \times 9\frac{3}{4}$ ($27\cdot9 \times 24\cdot8$), Miss Sylvia Gosse/Coll. London, British Museum (1913).

5. Pen and ink, watercolour, squared. $9\frac{3}{8} \times 7\frac{3}{4}$ ($23\cdot8 \times 19\cdot7$), Sotheby's, 12 April 1967 (30) bought Dr. Mellanby.

Drawing 1 is very close in its detail to Fig. 84. Drawings 2–5 study the subject from a point further to the right and thus afford a view of the Hôtel du Commerce in the left background, an angle favoured in many of the paintings. The squaring on Drawings 1–3 is minute.
Two more squared drawings of this subject were probably made as fresh studies for a new version painted in 1914 (Fig. 244, C.349).
Two unsquared drawings may have been studies for the paintings listed C.118 on canvas Version 3 and on panel Version 7 (although they do not have the tapering pinnacles of the panel):

1. Pencil and watercolour. $10 \times 7\frac{1}{4}$ ($25\cdot4 \times 18\cdot4$), Mrs. M. Clifton/Coll. Lord Sherfield. Exh. Agnew 60 (249).

2. Pencil, pen and ink. $12 \times 8\frac{1}{2}$ ($30\cdot5 \times 21\cdot6$), Coll. Ottawa, National Gallery of Canada (1956). Colour notes suggest this is a working study.

120. ST. JACQUES FAÇADE (Fig. 86) c.1899–1900

Watercolour and chalk. $8\frac{1}{2} \times 7\frac{1}{4}$ ($21\cdot6 \times 18\cdot4$)
'Sickert Dieppe' b.r.
Coll. London, British Council (1939)
Chapter VII

One of the many coloured drawings of this subject. Fig. 86 exactly reflects the composition of Fig. 84 and C.119 Version 1. Other coloured drawings reflecting these same two squared working drawings include:

1. Charcoal and coloured chalks. $9 \times 7\frac{1}{2}$ ($22\cdot9 \times 19$), Jacques-Émile Blanche/Coll. Musée de Rouen (1923) on loan to Musée de Dieppe. Exh. Dieppe 54 (46); Brighton 62 (12).

2. Pencil and wash. $8\frac{1}{2} \times 7\frac{1}{4}$ ($21\cdot6 \times 18\cdot4$), Coll. Dr. S. Charles Lewsen.

3. Pen and ink, chalk, wash. $8\frac{1}{4} \times 7$ ($21 \times 17\cdot8$), from the collection of Edward le Bas. Exh. R.A.1963, 'A Painter's Collection' (195).

Fig. 86 and the drawings listed above are approximately the same size. Drawing 3 is the most spontaneously drawn and was perhaps copied from Fig. 84 but supported by direct observation of the subject. Fig. 86 and Drawings 1 and 2 were probably traced from Version 3 (the interrupted quality of the line drawings and the rubbed character of the shading in many of Sickert's coloured drawings suggest that this was his method).
Other coloured drawings of St. Jacques include:

4. Charcoal and coloured chalks. $8\frac{3}{4} \times 6\frac{3}{4}$ ($22\cdot2 \times 17\cdot1$), Jacques-Émile Blanche/Coll. Musée de Rouen (1923) on loan to Musée de Dieppe. Exh. Dieppe 54 (47). This drawing reflects the composition of squared drawings 2–4 listed C.119.

5. Pen and ink, watercolour. $11\frac{1}{4} \times 9$ ($28\cdot5 \times 22\cdot9$), J. W. Freshfield/Coll. Mrs. Rosemary Peto. Exh. N.E.A.C. 1945 (136). Very close to squared Drawing 3 listed C.119.

6. Chalk and wash. $12\frac{5}{8} \times 9\frac{1}{8}$ ($32\cdot1 \times 23\cdot2$), Lord Henry Cavendish Bentinck/Coll. London, Tate Gallery (1940).

This drawing does not reflect the composition of any of the squared drawings listed above although it is similar in arrangement to several paintings (e.g. C.118, painting on canvas Version 5, paintings on panel, Versions 3 and 7) as well as to the two unsquared drawings listed under C.119—particularly to the drawing in Ottawa.

The relationship of these coloured drawings to the squared studies has been stressed because the former were not preliminary working documents but finished works in their own right. They were derived from the same studies as were the paintings and thus represent a typical rationalization of Sickert's production effort.

121. LA HALLE AU LIN (Fig. 88) *c*.1900

Canvas. $14\frac{1}{2} \times 17\frac{1}{2}$ (36·8 × 44·5)
'Sickert Dieppe' b.r.
From the collection of Morton Sands
Exh. N.G.41 (34); Brighton 62 (66)
Chapter VII

Study for and drawings of *La Halle au Lin* include:
1. Pen and ink, pencil and wash, squared. $8\frac{5}{8} \times 9\frac{7}{8}$ (21·9 × 25·1), Jacques-Émile Blanche/Coll. Musée de Rouen (1923) on loan to Musée de Dieppe. Exh. Dieppe 54 (41). This may be a working study for Fig. 88 although, in common with all the drawings listed below, it omits the corner of St. Jacques glimpsed to the left in Fig. 88.
2. Pencil and wash. $8\frac{5}{8} \times 9\frac{7}{8}$ (21·9 × 25·1), Jacques-Émile Blanche/Coll. Musée de Rouen (1923) on loan to Musée de Dieppe. Exh. Dieppe 54 (40). Probably traced from Drawing 1. Like the drawings listed below this is a finished coloured drawing.
3. Coloured chalks. $8\frac{3}{4} \times 9\frac{1}{2}$ (22·3 × 24·1), Coll. Southport, Atkinson Art Gallery (1924). Rep. B.60. Pl. 16a. Exh. Sheffield 57 (108); A.C.64 (35). This drawing is dated 1900.
4. Black chalk. $8\frac{3}{4} \times 9\frac{1}{2}$ (22·3 × 24·1), from the collection of Morton Sands. This drawing is also dated 1900.

Related painting (an upright of the subject):
Canvas. $24 \times 19\frac{3}{4}$ (61 × 50·2), Jacques-Émile Blanche/Sotheby's, 22 July 1964 (157)/Coll. Derek Hill Esq. Exh. R.B.D. 60 (13).

122. LES ARCADES DE LA BOURSE (Fig. 90) dated 1900

Canvas. 12×16 (30·5 × 40·6)
'Sickert/1900' b.l.
Walter Howarth/Christie's. 14 July 1967 (194)/
Coll. Columbus Gallery of Fine Art, Ohio (1968)
Exh. Agnew 1968, 'British Painting 1900–1968' (11) as *Lobster Pots on the Quay, Dieppe*; Columbus Gallery of Fine Art 1971, 'British Art 1890–1928' (99) under the same title
Chapter VII

Sickert painted lobster pots on the quay again in 1910 (*The Elephant Poster*, Fig. 199).

123. LES ARCADES DE LA POISSONNERIE *c*.1900

Canvas. $24 \times 19\frac{3}{4}$ (61 × 50·2)
'Sickert' b.r.
Lord Howard de Walden/
Coll. London, Tate Gallery (1928)

Lit. Tate Gallery Catalogue, 1964, p. 627
Exh. Probably Durand-Ruel 1900 (40); Tate 60 (49); Adelaide 68 (14)
Chapter VII

Oil on panel study: $6\frac{3}{4} \times 5\frac{1}{4}$ (17·1 × 13·3), Mrs. Mary Price/Coll. Mrs. Rosemary Peto. Exh. N.E.A.C. 1945 (158). Dedicated to Mrs. Price.

124. LE COIN DE LA RUE STE. CATHERINE *c*.1900

Canvas. 15×18 (38·1 × 45·7)
'Sickert' b.r.
Private Collection, France/
Private Collection, England
Rep. B.60, Pl. 21
Exh. Edinburgh 53 (39); Tate 60 (42)
Chapter VII

Upright version:
Canvas. 18×15 (45·7 × 38·1), Mrs. George Swinton/Private Collection, England. This version and C.124 show the corner of St. Jacques on the left. Sickert also painted the subject omitting the church but extending the scene on the right. Such pictures include:
1. *Les Vieux Arcades*. Canvas. $15\frac{3}{4} \times 12\frac{1}{2}$ (40 × 31·7), Paul Robert/Baron van der Heyden à Hauzeur/Private Collection, London. Rep. B.60. Pl. 25. Exh. Tate 60 (56).
2. Panel. $6\frac{1}{4} \times 5\frac{1}{2}$ (15·9 × 14), Coll. Mrs. Rosemary Peto. A study for *Les Vieux Arcades*.
3. Panel. $9\frac{1}{2} \times 7\frac{1}{4}$ (24·1 × 18·5), Jacques-Émile Blanche/Coll. M. Georges Mevil-Blanche. Exh. Dieppe 54 (17). This panel includes oddly ill-proportioned figures in both lower corners.

A drawing, identical to *Les Vieux Arcades* in composition:
Pen and ink, coloured chalks. $9\frac{3}{4} \times 7\frac{7}{8}$ (24·8 × 19·7), Sir Michael Sadler/Coll. Leeds, City Art Gallery (1931). Sickert returned to this subject *c*.1903 (Fig. 108, C.155).

125. BOULEVARD AGUADO *c*.1899–1900

Canvas. $18\frac{1}{4} \times 21\frac{3}{4}$ (46·3 × 55·3)
'Sickert' b.l.
Edmund Davis/
Coll. Paris, Musée du Luxembourg (1912) formerly on loan to Musée National d'Art Moderne, now on loan to Musée de Dieppe
Rep. B.60, Pl. 17
Exh. Dieppe 54 (1); Tate 60 (15); Brighton 62 (14)
Chapter VII

126. PLACE DU MOULIN À VENT *c*.1900

Pen and ink, pencil, wash, squared. $9 \times 11\frac{1}{4}$ (22·9 × 28·5)
'Sickert' b.r. and b.l.
Jacques-Émile Blanche/
Coll. Musée de Rouen (1923) on loan to Musée de Dieppe
Exh. Dieppe 54 (37) as *Vieille Maison à Dieppe*
Chapter VII

I have identified this subject as the Place du Moulin à Vent, a little known square behind Dieppe harbour. Sickert exhibited a picture of this title at the N.E.A.C. winter 1900 (48) and at Durand-Ruel 1900 (14). C.126 could be a working drawing for the painting which I have not traced.

Coloured drawings of the subject include:
1. Charcoal and coloured chalks. $9 \times 11\frac{3}{8}$ ($22 \cdot 9 \times 28 \cdot 9$), Jacques-Émile Blanche/Coll, Musée de Rouen (1923) on loan to Musée de Dieppe. Exh. Dieppe 54 (36) as *Vieille Maison à Dieppe*.
2. Coloured chalks and watercolour. $8\frac{5}{8} \times 11\frac{1}{8}$ ($21 \cdot 9 \times 28 \cdot 3$), from the collection of Morton Sands.

127. LE VIEUX CHÂTEAU c.1900

Charcoal and coloured chalks. $8\frac{1}{2} \times 10\frac{5}{8}$ ($21 \cdot 6 \times 27$)
'Sickert' b.l. (in chalk), 'Dieppe' b.l. (in pen)
Jacques-Émile Blanche/
Coll. Musée de Rouen (1923) on loan to Musée de Dieppe
Exh. Dieppe 54 (45)
Chapter VII

I know of no painting of this subject but in view of the several coloured drawings I believe that Sickert probably did paint the subject.
Other drawings include:
1. Charcoal and pencil. $7\frac{3}{4} \times 10$ ($19 \cdot 7 \times 25 \cdot 4$), Mrs. Rowley Bristow/Private Collection, London. Dated 1900.
2. Pencil, pen and ink, wash. $7\frac{5}{8} \times 9\frac{1}{8}$ ($19 \cdot 3 \times 23 \cdot 2$), S. Eckman/Sotheby's, 19 October 1967 (68)/Coll. Perth, Western Australian Art Gallery (1967).

128. LE PUITS SALÉ. RUE DE LA BARRE AND THE CAFÉ DES TRIBUNAUX c.1900

Charcoal and coloured chalks. $6\frac{3}{4} \times 5\frac{1}{8}$ ($17 \cdot 2 \times 13$)
'Sickert—Dieppe' b.l.
Jacques-Émile Blanche/
Coll. Musée de Rouen (1923) on loan to Musée de Dieppe.
Exh. Dieppe 54 (44); Brighton 62 (11).
Chapter VII

There are many drawings of this subject. They differ from Sickert's earlier drawing and paintings of the scene (Fig. 43 and C.69) in that they show a much longer stretch of La Rue de la Barre. Nevertheless C.128 and the drawings listed below are generally dated c.1890. I believe them to be works of 1898–1900.
Other drawings include:
1. Pencil and watercolour. $7 \times 4\frac{3}{4}$ ($17 \cdot 8 \times 12 \cdot 1$), Coll. Martin Halperin Esq. Exh. R.B.D.60 (50); Tate 60 (31).
2. Charcoal and wash. $6\frac{3}{4} \times 5$ ($17 \cdot 2 \times 12 \cdot 7$), Lady Blanche Hosier (to whom it is dedicated)/Private Collection. Exh. Tate 60 (63).
3. Pencil and red chalk. 7×5 ($17 \cdot 8 \times 12 \cdot 7$), Mrs. Rowley Bristow/Private Collection, London.

Related painting:
Panel. 9×7 ($22 \cdot 9 \times 17 \cdot 8$), Christie's, 6 December 1963 (59)/Tooth/Private Collection, London. This picture is dated 1903. It is similar, but not identical, to the drawings listed above (the figures are different and more of the buildings on the left are included).

1900, 1901. VENICE, LANDSCAPES

129. THE DOGE'S PALACE AND THE CAMPANILE (Fig. 87) 1900

Canvas. 22×18 ($55 \cdot 9 \times 45 \cdot 7$)
'W. Sickert' b.r.

Paul Robert/Baron van der Heyden à Hauzeur/
Private Collection, London
Exh. Agnew 60 (43)
Chapter V; Chapter VIII

Dated 1900 on the reverse.
For other versions of this subject painted c.1901 see Fig. 99, C.138.

130. PIAZZA SAN MARCO (Fig. 89) dated 1900

Canvas. $16\frac{1}{2} \times 23\frac{1}{2}$ ($41 \cdot 9 \times 59 \cdot 7$)
'To Mrs. Price/W.S.1900' b.r.
Mrs. Mary Price/
From the collection of Morton Sands
Exh. Brighton 62 (57)
Chapter VIII

Fig. 89 is the earliest of several pictures of this subject. Later versions:
1. Canvas. $18 \times 25\frac{1}{2}$ ($45 \cdot 7 \times 64 \cdot 8$), Paul Robert/Baron van der Heyden à Hauzeur/Private Collection, London. Exh. Agnew 60 (41), rep. in catalogue. Probably painted in 1901, in Venice or shortly after Sickert's return to Dieppe. The squaring shows through very plainly. In composition and tonal pattern this version is very close to Fig. 89 but extra figures have been added and the handling is much heavier.
2. Canvas. 16×20 ($40 \cdot 7 \times 50 \cdot 8$), Coll. Newcastle, Laing Art Gallery (1932). Rep. B.60, Pl. 33. Exh. N.G.41 (45); Tate 60 (77); A.C.64 (11); Hull 68 (13). Probably painted c.1906 from a variety of earlier pictures and studies. The canvas, stamped Shea & Co., Fitzroy Street, is English. The landscape is similar to Fig. 89 and Version 1 in composition and tonal pattern, but the handling is more vehement. The harsh portrait of La Giuseppina inserted in the right foreground corner could have been derived from many similar portraits Sickert made of her in 1903–4 (in which she even wore the same turquoise blouse). However, the representation of the Campanile proves that this version was studied from pictures and drawings done in 1900 and 1901, and not from new studies of 1903–4, because the Campanile collapsed on 14 July 1902 and the copy which replaced it was not erected until 1912. The woman wrapped in a long shawl glimpsed behind La Giuseppina was derived from a study in chalk, $11\frac{1}{8} \times 8\frac{1}{2}$ ($28 \cdot 3 \times 21 \cdot 6$), Coll. Harrogate, Corporation Art Gallery (1947). This figure study gives no indication of the background landscape and was probably just part of Sickert's miscellaneous stock of drawings.
3. Canvas. $14\frac{1}{2} \times 17\frac{1}{2}$ ($36 \cdot 8 \times 44 \cdot 5$), Christie's, 6 December 1963 (60)/Norton Simon/Parke Bernet, New York, 5 May 1971 (49). This version, which was probably painted as late as 1910–14, must have been studied from drawings made in 1903–4 (or possibly from photographs) because it shows the Campanile collapsed with barriers around the site of the Loggia.

Studies for these paintings:
1. Chalk and watercolour. $10\frac{3}{4} \times 14$ ($27 \cdot 3 \times 35 \cdot 5$), Mrs. Grace Wheatley/Christie's, 11 November 1958 (14)/Barry Sainsbury/Sotheby's, 17 March 1965 (27)/Coll. Morgan Guarantee Trust. Rep. B.60, Pl. 33a. Exh. Agnew 60 (246). A complete drawing of the whole

subject which may have been used by Sickert when painting Fig. 89 and Versions 1 and 2.

2. Pencil, pen and ink. $7\frac{3}{4} \times 10\frac{1}{4}$ (19.7×27.3), Coll. Liverpool, Walker Art Gallery (1948). Shows less of the subject on both sides than the paintings.

131. SANTA MARIA FORMOSA (Fig. 91) c.1900

Canvas. 19×22 (48.2×55.9)
'Sickert' b.r.
André Gide/Harold Esselmont/Agnew/
Private Collection, England
Exh. Durand-Ruel 1903, 'Société Nouvelle de Peintres et de Sculpteurs' (135) lent by Gide; Agnew 60 (22); Agnew 1968, 'British Paintings 1900–1968' (12)
Chapter VIII

The Durand-Ruel exhibition was held from February to March 1903 so this picture cannot possibly be a work of Sickert's last visit to Venice 1903–4.

132. ST. MARK's (Fig. 92) dated 1901

Canvas. $23\frac{3}{4} \times 19\frac{1}{2}$ (60.3×49.5)
'Sickert—1901' b.r.
Sotheby's, 20 April 1966 (71)/Agnew/
Private Collection, London
Chapter VIII

Sickert painted this corner of the main façade of St. Mark's many times c.1901. Versions:

1. Canvas. $39\frac{3}{8} \times 33\frac{5}{8}$ (100×85.4), Jacques-Émile Blanche/ Coll. M. Bernard Mevil-Blanche. Exh. Possibly Bernheim 1904 (77) lent by Blanche; Dieppe 54 (25). The largest of all known versions. It is quite light in tone and painted in creamy colours, pale blues, pinky greys, and buffs, as is Fig. 92.
2. Canvas. $35\frac{1}{2} \times 27\frac{1}{2}$ (90.2×69.9), R.B.D./Private Collection, London. Exh. R.B.D.1957 (2), rep in catalogue.
3. Canvas. $24 \times 19\frac{1}{2}$ (61×49.5), Paul Robert/Baron van der Heyden à Hauzeur/Private Collection, London. Exh. Possibly Bernheim 1904 (82) lent by Robert; Agnew 60 (46).
4. Canvas. 18×15 (45.7×38.1), Adolphe Tavernier/Lord Cottesloe/T. W. Strachan/J. W. Blyth/Coll. Edinburgh, Scottish National Gallery of Modern Art (1965). Exh. N.G.41 (47); Leeds 42 (127); Edinburgh 53 (41). The handling of Versions 2, 3, and 4 is similar but Version 4 shows rather less of St. Mark's on the right than do Fig. 92 and the Versions listed above.
5. Canvas. Size unknown. Leicester Galleries/Private Collection, London. Like Version 4 this picture shows less of St. Mark's on the right than the other paintings, but it incorporates more space on the left.

Studies for these paintings:

1. Pencil, chalk, pen and ink. $18\frac{5}{8} \times 14\frac{1}{2}$ (47.3×36.8), Coll. Liverpool, Walker Art Gallery (1948). Exh. A.C.49 (20); Sheffield 57 (138); Hull 68 (33). This study is executed on three contiguous sheets of paper. Perhaps a fourth sheet (which would have completed the four quarters of the study) is missing, although the coincidence that Study 2 is also executed on three similar sheets argues against this hypothesis.
2. Chalk, pen and ink, watercolour, squared. $15\frac{1}{2} \times 13\frac{1}{2}$ (39.4×34.3), from the collection of Morton Sands. Exh.

Brighton 62 (63). Executed on three contiguous sheets of paper.

Sickert showed a *Nocturne St. Mark's* at the N.E.A.C. spring 1902 (53). None of the versions listed above, nor any of the pictures of the full façade of *St. Mark's* painted on and after Sickert's 1895–6 visit to Venice, suits the description of the exhibited work, *St. James Gazette*, 15 April 1902, as a 'mud-coloured St. Mark's against a coal black sky'. Besides *Red Sky at Night* (Fig. 52) the only true night representation of St. Mark's is a highly finished chalk and watercolour drawing. $16\frac{1}{2} \times 13\frac{1}{2}$ (41.9×34.3), Coll. Leicester, City Art Gallery (1939). Exh. Sheffield 57 (104); A.C.64 (33). The entire surface of this drawing is covered in close cross-hatching which conveys the dark-toned night effect; the sky is washed over in blue-black and touches of colour give emphasis to the chalk drawing of the façade. This drawing may reflect the appearance of the *Nocturne* painting exhibited in 1902 which, according to *Truth*, 10 April 1902, showed St. Mark's looking 'positively groggy on its underpins' as if 'it had really made a night of it'. The composition of the drawing is similar to Fig. 92 and versions, so that it is almost certainly a work of c.1901 rather than of the earlier visit to Venice.

133. THE HORSES OF ST. MARK's (Fig. 93) dated 1901

Canvas. $24\frac{1}{2} \times 19$ (62.2×48.3)
'Sickert 1901' b.r.
Private Collection, Scotland
Rep. B.43, Pl. 21; Bertram, Pl. 12
Exh. Edinburgh 53 (35); Agnew 60 (38)
Chapter VIII

Versions of this subject:

1. Panel. $20 \times 15\frac{3}{4}$ (50.8×40), George Moore/Lady Cunard /Howard Bliss/ M. V. B. Hill/R. C. Pritchard/Lord Evershed/Coll. The Cottesloe Trustees. Rep. B.60, Pl. 31. Exh. Chicago: Pittsburgh 1938 (7); N.G.41 (49); Tate 60 (74).
2. Canvas. $22\frac{1}{2} \times 18$ (57.1×45.7), Private Collection, England.
3. Canvas. $21\frac{1}{2} \times 18$ (54.6×45.7), Private Collection, Paris/Captain D. de Pass/Christie's, 14 July 1967 (145)/ Coll. Bristol, City Art Gallery (1967). Exh. Wildenstein, London 1969 'Pictures from Bristol' (38), rep. in catalogue.
4. Canvas. $19\frac{3}{4} \times 15\frac{1}{2}$ (50.2×39.4), Dr. Robert Emmons/ Coll. Hugh Beaumont Esq. Exh. Morley Gallery 1969, 'Artists at the Leicester Galleries from 1902–1969' (51).
5. Canvas. $8\frac{1}{2} \times 6\frac{3}{4}$ (21.6×17.1), last known owner Major Simmons.
6. Canvas. $19\frac{3}{4} \times 16\frac{5}{8}$ (50.2×42.3), E. Evershed/Coll. Birmingham, City Art Gallery (1945). Exh. A.C.64 (12), rep. in catalogue; Adelaide 68 (23). A label on the back reads 'Walter Sickert, *Venise St Marc, les Chevaux de Bronze, ou 1904 ou 1905*'.

Related painting, showing the upper parts of the lunettes but not without the bronze horses:
Golden Arches. Canvas. $13\frac{1}{2} \times 16$ (34.3×40.6), last known owner Major Simmons.
The compositions of Fig. 93 and Versions 1–6 are similar, only varying slightly with the points of cutting the subject. It is difficult to be definitive about dating the pictures. On

the whole Versions 1 and 2 seem to be close in date to Fig. 93. When, and by whom, the label was inscribed on Version 6 is unknown but if any authority can be attached to its information this would appear to be the latest version. The remaining three versions (3–5) were probably painted between 1901 and 1904.

Studies and drawings of the subject include:

1. Pen and ink, pencil, watercolour, squared. $9\frac{7}{8} \times 7\frac{3}{4}$ (25·1 × 19·7), Coll. Ottawa, The National Gallery of Canada (1955). This drawing, the larger coloured, dated drawing of 1901 (2), and the large coloured drawing (3) are the most important working studies extant for the paintings.

2. Chalk, watercolour. $19\frac{1}{8} \times 15\frac{3}{8}$ (48·6 × 39), Coll. Whitworth Art Gallery, University of Manchester (1930). Exh. Tate 60 (93); R.A.1968–9, 'Bicentenary Exhibition' (644). This drawing, coloured in strong blues and yellows, is dated 1901.

3. Charcoal and wash. $18\frac{1}{2} \times 14\frac{3}{4}$ (47 × 37·5). Coll. Mrs. Rosemary Peto.

4. Chalk, watercolour. 10 × 8 (25·4 × 20·3), Coll. Peter Pears Esq.

5. Charcoal and wash. $10\frac{1}{2} \times 8\frac{1}{4}$ (26·6 × 21), last known owner Mrs. G. Swinton (to whom it is dedicated). Exh. Edinburgh 53 (95).

6. Black and red chalk. $11 \times 9\frac{1}{4}$ (28 × 23·5), Private Collection, England. Rep. the *New Age*, 29 February 1912. Exh. N.G.41 (104). The original drawing and the reproduction, as well as the signature, are seen in reverse. Sickert must have traced it thus from another study, probably from Study 1 which it closely resembles.

134. SANTA MARIA DELLA SALUTE (Fig. 94) c.1901

Canvas. 22 × 18 (55·9 × 45·7)

'Sickert' b.l.

Coll. London, Royal Academy of Arts (1934, presented by Sickert as his Diploma Work)

Exh. R.A.1935 (532); A.C.64 (5); R.A.1968–9, 'Bicentenary Exhibition' (448)

Chapter VIII

Sickert painted many versions of this subject, each similar in composition but different in handling.

The versions include:

1. Canvas. $23\frac{1}{2} \times 19$ (59·7 × 48·3), Mrs. Leverton Harris/ Sir George Sutton/Mrs. William Miller/Private Collection, England. Rep. *Drawing and Design*, III, July 1927, p. 7. Exh. Agnew 60 (27), rep. in catalogue; Brighton 62 (56). This picture shows the scene in sunlight with a bright blue sky.

2. Canvas. 30 × 25 (76·2 × 63·5), Mrs. M. Clifton/Dr. Robert Emmons/Private Collection, England. Rep. Emmons, facing p. 116. Exh. Agnew 60 (49). Painted in soft-toned neutral greys and buffs.

3. Panel. $9\frac{1}{4} \times 7\frac{1}{2}$ (23·5 × 19), Dr. Robert Emmons/Edward le Bas/Private Collection, London. Rep. Bertram, Pl. 13. Exh. R.A.1963, 'A Painter's Collection' (142). Squared and very lightly painted.

4. Canvas. 24 × 20 (61 × 50·8), Judge Evans/Coll. Peter Pears Esq. Probably painted in London on commission for Judge Evans; the sharp drawing may have been traced onto the canvas. A warm pink colour pervades

the whole picture. Lillian Browse (B.60, p. 20) told how Mrs. Evans remembered going with her husband to Sickert's studio where he would show them 'a pile of small sketches and drawings and ask them to take their pick. He would then paint them an oil from whatever they chose, usually for £25.'

Drawing:

Pencil, chalk, watercolour. $23\frac{1}{2} \times 18$ (59·7 × 45·7), Private Collection. Exh. A.C.1961, 'Drawings of the Camden Town Group' (93). A very finished drawing of the subject.

135. THE STEPS OF SANTA MARIA DELLA SALUTE (Fig. 96) c.1901

Canvas. $17\frac{3}{4} \times 27\frac{1}{4}$ (45·1 × 69·2)

'Sickert' b.r.

Mme Blanche-Marchesi/Christie's, 10 March 1916 (136)/ Christie's, 9 July 1920 (69)/Christie's, 22 June 1923 (38)/Lord Henry Cavendish-Bentinck/

Coll. London, Tate Gallery (1940)

Lit. Tate Gallery Catalogue 1964, p. 631

Exh. Possibly Bernheim 1907 (4) as *Les Marches de la Salute*; Edinburgh 53 (3); Adelaide 68 (18)

Chapter VIII

Version:

Canvas. 15 × $18\frac{1}{2}$ (38·1 × 47), Lord Croft/W. E. Wallace/ R.B.D./Private Collection, California. Exh. Possibly Bernheim 1907 (4) if not Fig. 96; Sheffield 57 (96); Agnew 60 (18); R.B.D.63 (19), rep. in catalogue; New York 67 (42), rep. in catalogue. This version is similar in style and handling to Fig. 96 but it shows a deeper stretch of water in the foreground.

Drawing:

Charcoal and brown wash. $12\frac{1}{2} \times 15\frac{1}{4}$ (31·7 × 38·7), Christie's, 4 June 1971 (6). Exh. Carfax Gallery, May 1912 (25) as *Salute*.

136. THE BRIDGE OF SIGHS (Fig. 95) c.1901

Canvas. $14\frac{1}{4} \times 12\frac{1}{2}$ (36·2 × 31·8)

'Sickert' b.r.

From the collection of Morton Sands

Exh. Possibly Durand-Ruel 1903, 'Société Nouvelle de Peintres et de Sculpteurs' (131) as *Le Pont des Soupirs* lent by Léon Beclard; N.G.41 (61); Leeds 42 (129); Agnew 60 (19); Brighton 62 (59)

Chapter VIII

The early history of this picture is unknown; therefore whether or not it is the picture once owned by Beclard and exhibited in 1903 is uncertain.

Studies for Fig. 95:

1. Panel. $7\frac{1}{2} \times 6\frac{1}{8}$ (19 × 15·4), from the collection of Morton Sands.

2. Pencil and wash. 12 × $4\frac{1}{2}$ (30·5 × 11·5), from the collection of Morton Sands.

137. SAN GIORGIO MAGGIORE (Fig. 97) c.1901

Canvas. 17 × $24\frac{1}{2}$ (43·2 × 62·2)

'Sickert' b.l.

Adolphe Tavernier/Vente Tavernier, Hôtel Drouot, 15 April 1907 (44) as *Le Grand Canal—Venise, Effet de Nuit*/ Prince Bibesco/Sir Keith Murdoch/

Coll. Melbourne, National Gallery of Victoria (1953)
Exh. Bernheim 1904 (38) as *Le Grand Canal à Venise*, lent by Tavernier
Chapter VIII

It is possible that Fig. 97 is a work of Sickert's earlier visit to Venice, 1895–6. The description in the 1907 Hôtel Drouot catalogue confirms the identification of Fig. 97 as the picture which formerly belonged to Tavernier.
Studies:
1. Pencil, squared. $9\frac{3}{8} \times 14\frac{1}{2}$ (23·8 × 36·8), Coll. Liverpool, Walker Art Gallery (1948).
2. Pencil. $8\frac{1}{4} \times 12\frac{1}{4}$ (21 × 31·1), Coll. Liverpool, Walker Art Gallery (1948).
3. Watercolour. 11 × 15 (28 × 38·1), Coll. Liverpool, Walker Art Gallery (1948).
4. Watercolour. $9\frac{1}{4} \times 13\frac{3}{4}$ (23·5 × 34·9), Private Collection, England.

138. LE PALAIS DES DOGES AU CRÉPUSCULE (Fig. 99)
*c.*1901

Canvas. $23\frac{1}{2} \times 18$ (59·7 × 45·7)
Paul Robert/Baron van der Heyden à Hauzeur/
Private Collection, London
Exh. Agnew 60 (24)
Chapter VIII
Version:
Canvas. $20 \times 12\frac{1}{2}$ (50·8 × 31·7), Private Collection, France/ the Very Rev. E. Milner-White/Coll. York, City Art Gallery (1963). Exh. Edinburgh 53 (11).
Drawing:
Pastel and watercolour. $21\frac{3}{4} \times 14\frac{7}{8}$ (55·3 × 37·8), Mrs. Campbell/Christie's, 8 December 1922 (89)/Christie's, 27 April 1923 (11)/Coll. London, Tate Gallery (1923). Rep. V. & A. 'Twentieth Century British Watercolours', 1958, Pl. 10. Lit. Tate Gallery Catalogue, 1964, p. 623. Exh. Tate 60 (94).

139. SAN BARNABA

Canvas. $24 \times 17\frac{1}{2}$ (61 × 44·5)
'Sickert' b.r.
André Gide/Robert Smith/Sotheby's, 9 July 1969 (30)/ Coll. Count N. Labia, Capetown, South Africa
Rep. B.60, Pl. 30
Exh. Bernheim 1904 (29) lent by Gide
Chapter VIII

It is possible that this picture and the version listed below were painted in 1904 (see note to Drawing 3 below) rather than *c.*1901, but I incline to the earlier dating.
Version:
Canvas. 24 × 20 (61 × 50·8), Private Collection, Paris. This picture shows the church a little closer and bigger in relation to the picture surface than C.139.
Drawings:
1. Pencil, pen and ink, wash, squared. $12 \times 9\frac{3}{4}$ (30·5 × 24·8), Lady Ian Hamilton (to whom it is dedicated)/Mrs. Ursula Earle/Sotheby's, 20 April 1966 (60)/Agnew/ Private Collection, England. Exh. Agnew 1966, 'French and English Drawings 1780–1965' (68).
2. Watercolour, pen and ink, chalk, heightened with white. $11\frac{3}{4} \times 8\frac{3}{4}$ (29·8 × 22·2), Mrs. F. L. Evans/Christie's, 19 May 1972 (42). Inscribed 'San Barnaba 1–2 pm'.
3. Charcoal, pen and ink. $12\frac{1}{4} \times 8\frac{1}{2}$ (31·1 × 21·6), A. de Meyer/Major W. H. Stephenson/Christie's, 12 November 1965 (96)/Coll. E. M. Cockburn Esq. Exh. N.G.41 (129) as *Venezia*. This drawing is dedicated to Adolphe de Meyer and dated Venezia 1904. This dating poses a certain chronological problem. The drawing is closely related in composition to the two paintings and the drawings catalogued above. The date could refer to the dedication, not the execution, of the drawing. However, if (as I believe was the case) the drawing was executed in 1904, two alternative suggestions can be made.
Either all Sickert's pictures (paintings and drawings) of this subject were done in 1904; or this drawing is a later version of an earlier subject, undertaken like the Dieppe coloured drawings, as a finished 'presentation piece'. The fact that Gide already owned C.139 in 1904, to lend it to the Bernheim-Jeune exhibition in June, suggests that the painting was the work of an earlier visit to Venice.

140. PONTE DELLA PAGLIA
*c.*1901

Canvas. $22 \times 19\frac{1}{2}$ (55·9 × 49·5)
'Sickert' b.r.
Adolphe Tavernier/Sir George Sutton/Mrs. William Miller/
Private Collection, England
Rep. B.60, Pl. 28
Exh. Edinburgh 53 (8); Brighton 62 (55)
Chapter VIII

This bridge is the one over which the two figures are walking in Fig. 95.

141. SCUOLA DI SAN MARCO *or* OSPEDALE CIVILE
*c.*1901

Canvas. $26 \times 18\frac{1}{2}$ (66 × 47)
'Sickert' b.l.
Private Collection, England
Exh. N.G.41 (36); Agnew 60 (31); Tate 60 (91)
Chapter VIII

The composition of this picture recalls the earlier upright versions of this subject painted 1895–6 (C.83, Versions). However, its handling is incompatible with so early a dating and its composition and incidental detail are very close to a dated drawing of 1901:
Pencil. 11 × 7 (28 × 17·8), Lady Spencer-Churchill/Christie's, 18 March 1966 (30), bought Folio Society.

Related painting:
Canvas. $14\frac{3}{4} \times 18$ (37·5 × 45·7), last known owner Miss Ethel Sands. A landscape-shaped picture of this subject probably painted *c.*1901.

1900–2. PORTRAITS AND FIGURES INCLUDING THEATRE SCENES

142. SIGNOR DE ROSSI (Fig. 98)
dated 1901
Canvas. $21\frac{1}{4} \times 17\frac{3}{8}$ (54 × 44·1)
'al simpaticissimo e geniale Sig. de Rossi—/ l'amico Sickert—/Venezia 1901' t.r.
Signor de Rossi/Dr. Robert Emmons/
Coll. Hastings, Museum and Art Gallery (1949)

Rep. Emmons, facing p. 64
Lit. Emmons, p. 114
Exh. A.C.64 (7); Columbus Gallery of Fine Art 1971,
 'British Art 1890–1928' (98)
Chapter VIII

According to Emmons the sitter 'supplied vegetables, wholesale, to the city of Venice'. Emmons also said that Sickert considered it the best portrait he ever painted but 'guessed that it would not be greatly appreciated by the sitter or his family, and in 1927 wrote to his friend Mrs. Hulton in Venice to buy it back from them'. Emmons himself then acquired the picture.

Emmons' story is correct in substance but incorrect in detail. Sickert's letters to Mrs. Hulton about buying the portrait back for him, preserved in the Ashmolean Museum, were written during the winter of 1928–9. Sickert's main motive in desiring to buy the portrait back was to have it 'classified' as his work; he feared that if it remained hidden in Venice it would be lost to his *œuvre*. Signor de Rossi may have been a wholesale vegetable supplier but his connection with Sickert was because he was the *padrone* of Sickert's favourite eating place in Venice, the Trattoria Giorgione di San Silvestre (information given to the Ashmolean Museum by Lady Berwick, Mrs. Hulton's daughter).

143. VENETIAN STAGE SCENE (Fig. 104) c.1901

Panel. $9\frac{1}{4} \times 5\frac{3}{4}$ (23·5 × 14·6)
'Sickert' b.r.
J. L. Behrens/
Coll. Lord Ilford
Exh. Leicester Galleries 1962, 'J. L. Behrens Collection'
 (5) as *The Porch*
Chapter VIII

Studies:
1. *The Portico*. Panel. $5\frac{3}{4} \times 8\frac{1}{4}$ (14·6 × 21), Christie's, 21 November 1969 (117)/Christie's, 30 October 1970 (184), bought Pocock. A study for the upper architecture of Fig. 104.
2. *Pierrot and Woman Embracing*. Chalk and wash. $16\frac{1}{8} \times 12\frac{1}{4}$ (41 × 31·1), Lord Henry Cavendish-Bentinck/Coll. London, Tate Gallery (1940). A study for the figures. The Tate Gallery Catalogue, 1964, p. 632, suggests a date of 1903–4 for the drawing. However, not only is the handling of Fig. 104 and the panel study more compatible with a date of *c.*1901, but the drawing is probably that to which Sickert referred, in a letter to Mrs. Hulton written during the summer of 1901, as 'the Pierrot and popolana', 'on paper', sent from Venice to the Fine Arts Society.

144. NUDE ON A BED (Fig. 101) dated 1902

Pencil. $6 \times 10\frac{3}{4}$ (15·2 × 27·3)
'Sickert—Neuville 1902' b.r.
Coll. Professor A. Betts
Chapter VII; Chapter X

One of a small group of drawings of a nude model (probably Mme Villain) done in Neuville in 1902.

Related drawings include:
1. Pencil, pen and ink. $12\frac{5}{8} \times 8\frac{3}{8}$ (32·1 × 21·3), Coll. Salford, City Art Gallery (1947). Exh. A.C.64 (37).

This drawing is also inscribed 'Sickert Neuville 1902'. It shows a half-naked woman on a bed and studies of heads.
2. Charcoal. 7×10 (17·8 × 25·4), Coll. Manchester, City Art Gallery (1947). A nude on a bed, inscribed 'Sickert Neuville' but undated.

145. MRS. PRICE dated 1900

Sepia crayon. $8\frac{5}{8} \times 6\frac{3}{8}$ (21·9 × 16·2)
'To her mother/Sickert—1900' t.r., 'Portrait of Mrs. Price/née Mary Menzies Middleton' r. side, 'To Mrs. M.../Sickert/Palazzo .../1901' l. side
Private Collection, England

Sickert made several informal drawings of his friends during this period. C.146 and 147 are more examples of such portrait drawings. The drawing of Mrs. Price catalogued here is not strictly a portrait; it is a very charming and delicately drawn full-length seen from the back. Mrs. Middleton and two of her daughters, Mary—better known as Polly (Mrs. Price), and Eliza (soon Mrs. Fairbanks), were among Sickert's closest friends in Dieppe. The history of the Middleton family and their relations with Sickert is told by Miss Browse (B.60, pp. 36–7) and in greater detail by Simona Pakenham, *Sixty Miles from England*, London, Macmillan, 1967 (references too numerous to quote). Simona Pakenham, p. 161, relates how Mrs. Price disliked Sickert drawing her face and only permitted him to sketch or paint her back view. Another example of the back view drawings of Mrs. Price, this time seen with her sister Mrs. Fairbanks: Pencil $12\frac{1}{4} \times 8\frac{3}{4}$ (31·1 × 22·2), Mrs. Grace Wheatley/Christie's, 11 November 1958 (19)/Agnew/Private Collection, London. Rep. Simona Pakenham, op. cit. Exh. Agnew 60 (236) as *Study of Two Girls* (the title under which it was sold at Christie's).

146. MRS. WILLIAM HULTON dated 1901

Black and coloured chalks. $21\frac{7}{8} \times 14\frac{1}{8}$ (55·7 × 35·9)
'To Mrs. Hulton/Walter Sickert/Fiera di beneficenza 1901' b.r.
Mrs. William Hulton/Lady Berwick/
Coll. Oxford, Ashmolean Museum (1964)
Chapter VIII

Mrs. Hulton lived in Venice and was a close friend of Sickert. His letters to her have been frequently quoted in the text and it was Mrs. Hulton's help he enlisted so many years later to buy back his portrait of *de Rossi* (see note to C.142). In this full-length portrait Mrs. Hulton is wearing the dress she wore to go to a big fête.

147. AUGUSTINE EUGÉNIE VILLAIN

Chalk. $5\frac{1}{8} \times 4\frac{3}{8}$ (13 × 11·1)
'Augustine Eugénie Villain 1901' b.r.
Coll. Liverpool, Walker Art Gallery (1948)
Exh. A.C.49 (27b)

A small portrait head of the handsome fishwife of Dieppe who played so important a part in Sickert's life during this period. Madame Villain was nicknamed *La Belle Rousse* on account of her handsome figure and flaming red hair. Sickert lived in her house after his divorce in July 1899.

1902–5. DIEPPE, LANDSCAPES

148. LA RUE NOTRE DAME AND THE QUAI DUQUESNE (Fig. 102) 1902

Canvas. 52 × 41⅝ (132 × 105·7)
'Sickert' b.r.
Frederick Fairbanks/The Duke of Westminster/Christie's, 3 July 1942 (71)/
Coll. Ottawa, National Gallery of Canada (1946)
Rep. B.43, Pl. 18
Exh. *Salon des Indépendants* 1903 (2232) as *Dieppe* lent by Fairbanks; Adelaide 68 (16)
Chapter IX

One of four (or possibly more, see notes to C.150 and C.158) large pictures commissioned from Sickert by a Dieppe hotel-keeper in 1902 at 40 francs apiece as decorations for his café (for documentation see Chapter IX, note 3). The hotel-keeper did not like them whereupon Frederick Fairbanks, a young American expatriate musician living in Dieppe and recently married to Eliza Middleton (sister of Polly Price, see C.145), immediately bought the four pictures from him (the others are Fig. 100, C.156 and C.157). Fig. 102 is closely related to the earlier version illustrated as Fig. 79.

149. THE BATHERS, DIEPPE (Fig. 100) 1902

Canvas. 51¾ × 41⅛ (131·5 × 104·4)
'Sickert' b.l.
Frederick Fairbanks/
Coll. Liverpool, Walker Art Gallery (1935)
Rep. B.43, Pl. 17; Bertram, Pl. 9
Exh. *Salon des Indépendants* 1903 (2235) as *Bain de Mer* lent by Fairbanks; N.G.41 (5); Sheffield 57 (18); Tate 60 (53); Hull 68 (10)
Chapter IX

As far as I know *The Bathers* is not a large-scale repetition of an earlier composition. Nor have I discovered any studies, drawn or painted, for this commissioned picture.

150. LA DARSE (Fig. 103) c.1902

Canvas. 59½ × 21 (151·1 × 53·3)
'Sickert' b.r.
Christie's, 3 November 1928 (105)/Dr. Robert Emmons/
Coll. Glasgow, City Art Gallery (1949)
Exh. Edinburgh 53 (54); Sheffield 57 (88)
Chapter IX

When Fig. 103, together with another picture of the same size and subject, was shown in an exhibition of pictures from the Emmons Collection at Agnew's in 1947 (Nos. 52, 50 respectively) a note in the catalogue stated that they were two of a series of six pictures painted in 1904 for a café in Dieppe. The second picture (also sold at Christie's, 3 November 1928, lot 104) is now untraced. The café commission noted could only have been that of 1902 (not 1904) but whether Emmons had any proof that his two pictures originally belonged to the commissioned series is now unknown. They were not among the rejected pictures bought by Fairbanks and although their size is large and unusual (and thus possibly envisaged by Sickert for a specific function and setting) their scale is not the same as the other four pictures. They are narrower and taller. Nevertheless, Fig. 103 does seem to be a work of c.1902.

151. LA RUE DE LA BOUCHERIE WITH ST. JACQUES (Fig. 105) dated 1903

Panel. 7½ × 9½ (19·1 × 24·2)
'Sickert 1903' b.l.
Miss N. Horsfall/the Very Rev. E. Milner-White/
Coll. York, City Art Gallery (1963)
Rep. B.60, Pl. 27
Exh. Edinburgh 53 (103); Tate 60 (57); A.C.64 (8); Hull 68 (12)
Chapter IX

Sickert painted many versions of this subject. Some are catalogued here, and others under Fig. 110, C.154.

Versions:
1. Canvas. 18 × 21½ (45·7 × 54·6), Mrs. M. Clifton/Agnew/ Private Collection. Exh. Agnew 60 (37). Probably painted c.1902. The young trees dotted around the *place* in Fig. 105 and in Paintings Versions 2 and 3 below are absent from this picture which implies it was painted at an earlier date.
2. Canvas. 12¾ × 15¾ (32·4 × 40), Paul Robert/Baron van der Heyden à Hauzeur/Private Collection, London. Very similar in handling to the panel of 1903, Fig. 105.
3. Canvas. 13 × 16 (33 × 40·6), R. Shaw-Kennedy/Coll. Mrs. Harry Cohen, Westmount, Quebec. Exh. Agnew 1969, 'British Paintings 1900–1969' (3).

Studies and drawings include:
1. Pen and ink, wash, squared. 9 × 11½ (22·9 × 29·2), Jacques-Émile Blanche/Coll. Musée de Rouen (1923) on loan to Musée de Dieppe. Exh. Dieppe 54 (39). Probably used as the main preliminary study for Painting Version 1 of c.1902. This drawing and Drawings 2 and 3 below all show the scene empty of trees and could be works of any time between 1899 and 1902.
2. Charcoal and wash. 9½ × 11½ (24·1 × 29·2), Jacques-Émile Blanche/Coll. Musée de Rouen (1923) on loan to Musée de Dieppe. Exh. Dieppe 54 (38).
3. Charcoal. 8¾ × 11⅛ (22·3 × 28·2), Lady Blanche Hosier (to whom it is dedicated)/Private Collection. Exh. Tate 60 (63).
4. Pencil, pen and ink, watercolour. 9 × 11½ (22·9 × 29·2), Messrs. Thos Agnew & Sons Ltd. 1960.

152. DIEPPE (Fig. 106) dated 1903

Canvas. 12¾ × 15¾ (32·4 × 40)
'Sickert Dieppe—1903' b.l.
R. Middleton/
Private Collection, Scotland
Chapter IX

The exact subject of Fig. 106 is unknown and the painting itself may be unfinished.

153. THE CASINO. BOULEVARD DE VERDUN (Fig. 107) dated 1904

Panel. 12¾ × 15⅞ (32·4 × 40·4)
'Sickert—1904' b.r.
Private Collection, Paris/
Messrs. Roland, Browse and Delbanco 1971
Exh. R.B.D.63 (8); New York 67 (16); Sydney 68 (24)
Chapter XI

154. LA RUE DE LA BOUCHERIE (Fig. 110) c.1903-5

Canvas. $22\frac{1}{2} \times 27$ (57·2 × 68·6)
'Sickert' b.r.
Lord Howard de Walden/
Coll. Dr. Seymour Cochrane Shanks
Exh. Edinburgh 53 (21); Agnew 60 (47)
Chapter IX

Version:
Canvas. 20 × 24 (50·8 × 61), Judge Evans/Christie's, 12
July 1920 (68)/Lord Henry Cavendish-Bentinck/Christie's,
19 April 1940 (160)/E. J. Fattorini/Last known owner Mrs.
Lewis. Rep. *Drawing and Design*, III, No. 13, July 1927,
p. 8 (then in Lord Henry Bentinck's possession). Exh.
N.G.41 (93); Leeds 42 (158) on loan from Fattorini. This
picture may have been painted c.1906 on commission for
Judge Evans (see note to C.134, Version 4).

Study:
Panel. $9 \times 7\frac{1}{4}$ (22·9 × 18·4), R.B.D./Private Collection,
London. Exh. Tate 60 (46). A study for the left half of Fig.
110 and Version. This study and the Version on canvas
show market figures in the *place* who are omitted from Fig.
110. These market figures do, however, appear in Drawing 4
listed under C.151.

155. LA RUE STE. CATHERINE ET LES VIEUX
ARCADES (Fig. 108) c.1903-5

Canvas. $26\frac{1}{4} \times 20\frac{1}{4}$ (66·7 × 51·5)
'Sickert' b.r.
From the collection of Morton Sands
Exh. Sheffield 57 (15) as *Rue Notre Dame*; Agnew 60 (63)
Chapter IX

One of several upright versions of a subject Sickert had
studied c.1900 (C.124 and versions):

1. Canvas. 18 × 15 (45·7 × 38·1), Coll. Johannesburg Art
 Gallery (1930). This picture represents only the left
 side of the subject and omits the *Vieux Arcades*.
2. Board. $9\frac{3}{8} \times 7\frac{1}{2}$ (23·8 × 19), Sir Michael Sadler/R.
 Goldschmidt/Ronald Tree/R.B.D./Private Collection,
 London. Exh. R.B.D.1965, 'Christmas Presents' (36).
 A study for Fig. 108 and Version 3.
3. Canvas. $22\frac{1}{4} \times 19\frac{1}{2}$ (56·5 × 49·5), Coll. Johannesburg
 Art Gallery (1910). This version was commissioned from
 Sickert by Sir Hugh Lane in 1910 and presented to the
 Johannesburg Gallery in the same year by Sir Otto
 Beit (see Chapter IX, note 7 for documentation). It is
 closely related to the picture illustrated as Fig. 108 but
 it also includes a little cart in the foreground which
 appears in the study (2).

Drawings:
1. Chalk. 11 × 9 (28 × 22·9), Coll. Ralph Smith Esq.,
 Sydney. Exh. Adelaide 68 (63); Sydney 68 (33). This
 drawing is inscribed 'la Halle au Lin' (the name of this
 area around St. Jacques) and is dated 'April 15' and
 '1902'.
2. Charcoal and watercolour. $12 \times 9\frac{1}{2}$ (30·5 × 24·1), Coll.
 Ralph Smith Esq., Sydney. Exh. R.B.D. 1970, '25th.
 Anniversary Exhibition. Drawings of Importance of
 the 19th. and 20th. Century' (51). This drawing is
 especially closely related to Version 1 of the paintings
 listed above.

156. THE STATUE OF DUQUESNE 1902

Canvas. $51\frac{1}{2} \times 39\frac{3}{4}$ (130·8 × 101)
'Sickert' b.r.
Frederick Fairbanks/
Coll. Manchester, City Art Gallery (1935)
Rep. B.43, Pl. 16; Rothenstein 1961, Col. Pl. 5; Pickvance
 1967, Col. Pl. VI
Exh. *Salon des Indépendants* 1903 (2233) lent by Fairbanks;
 Sheffield 57 (17); Tate 60 (54)
Chapter IX

One of the café commission pictures, derived from earlier
pictures, primarily from Fig. 78.

157. ST. JACQUES 1902

Canvas. $51\frac{1}{2} \times 39\frac{3}{4}$ (130·8 × 101)
'Sickert' b.l.
Frederick Fairbanks/The Duke of Westminster/Christie's,
 3 July 1942 (72)/R. Middleton/
Private Collection, Scotland
Rep. B.43, Pl. 19
Exh. *Salon des Indépendants* 1903 (2234) lent by Fairbanks
Chapter IX

One of the café commission pictures, derived from earlier
versions of the subject, especially from Fig. 85 and several
squared drawings.

158. THE FAIR AT NIGHT c.1902

Canvas. 52 × 38 (132·1 × 96·5)
Mrs. Oswald Sickert/
Coll. Rochdale, Art Gallery and Museum (1942)
Rep. B.60, Pl. 26
Exh. N.G.41 (1a); Tate 60 (51); Hull 68 (8)
Chapter IX

Although this picture is approximately the same size as the
café commission paintings, as far as is known it had nothing
to do with the commission and it was not bought by Fair-
banks. Possibly Sickert began it with the commission in
mind but then substituted another subject.

Studies:
1. Board. $9\frac{1}{2} \times 7\frac{1}{2}$ (24·1 × 19), from the collection of Morton
 Sands. Exh. N.G.41 (17); Leeds 42 (143).
2. Charcoal and white chalk, squared. $10\frac{1}{2} \times 8\frac{5}{8}$ (26·7 ×
 21·9), Private Collection, England. Rep. B.60, Pl. 27a.
 Exh. Tate 60 (67).

159. CORNER IN DIEPPE c.1904-5

Canvas. 10 × 14 (25·4 × 35·5)
From the collection of Morton Sands
Exh. Brighton 62 (70)
Chapter XI

The dating of Sickert's rougher landscape sketches is
somewhat arbitrary; subjects such as this *Corner in Dieppe*
or *St. Jacques with a Florist Shop*, Canvas. $13 \times 16\frac{1}{8}$ (33 × 41),
R.B.D./Private Collection, London, Exh. R.B.D.63 (10),
rep. in catalogue, could belong to almost any date between
1898 and 1905. However the almost offhand fluency of
their brushwork suggests that they probably belong to the
later part of this date-bracket.

1903–4. VENICE, LANDSCAPES

160. IL TRAGHETTO (Fig. 109) 1903–4

Canvas. 18⅛ × 15 (46 × 38·1)
'Sickert' b.l.
Mme Lemoinne, Paris/
Coll. Dr. Henry M. Roland
Rep. B.60, Pl. 37
Exh. Bernheim 1907 (20); Dieppe 54 (30) as *Un Canal à Venise*; R.B.D.60 (2); Tate 60 (89)
Chapter X

On this, his last visit to Venice, Sickert painted many more figure than landscape pictures. Nevertheless, he told Blanche that he had sixteen landscapes in hand in spite of interruptions from the cold and wind and rain. *Il Traghetto* is one of the small group of extant landscapes which can confidently be accepted as works of this last visit.

161. SAN TROVASO 1903–4

Canvas. 15¾ × 17⅞ (39 × 45·4)
'Sickert' b.l.
Mme Lemoinne, Paris/R.B.D./
Private Collection, London
Rep. B.60, Pl. 44
Exh. Bernheim 1907 (11); Dieppe 54 (31); R.B.D.60 (10); Tate 60 (90)
Chapter X

162. RIO DI SAN PAOLO c.1903–4

Canvas. 24 × 19½ (61 × 49·5)
'Sickert' b.r.
Mme Bordeaux, Paris/
Coll. Toledo, Museum of Art, Ohio, U.S.A. (1954)
Rep. Bertram, Pl. 14; B.60, Col. Pl. IV
Exh. Tate 60 (76); New York 67 (40); Columbus Gallery of Fine Art 1971, 'British Art 1890–1928' (96)
Chapter X

163. SCUOLA DEL RIALTO dated 1904

Chalk. 11 × 7⅝ (28 × 19·4)
'Sickert S. del Rialto/oldest church in Venice' b.l.
'2.1.04' b.r.
Sotheby's, 14 December 1960 (47)/R.B.D./
Private Collection
Exh. R.B.D.60 (49); R.B.D.63 (21); New York 67 (30)
Chapter X

No painting related to this drawing is known to me.

1903–4. VENICE, PORTRAITS AND FIGURES

164. LA GIUSEPPINA AGAINST A MAP OF VENICE (Fig. 111) 1903–4

Canvas. 20 × 16 (50·8 × 40·6)
'Sickert' t.r.
Mark Oliver/
Coll. Mr. and Mrs. Peter Hughes
Rep. B.43, Frontispiece in colour; Bertram, Pl. 16; Rothenstein 1961, Col. Pl. 6; Pickvance 1967, Col. Pl. VII

Lit. B.43, pp. 21–2
Exh. R.A.1927 (87); Tate 60 (79)
Chapter X

Press reviews prove that this is the picture exhibited by Sickert at the Royal Academy, e.g.: the *Nottingham Guardian*, 30 April 1927, 'With her mop of black hair in a setting of living crimson and rose, a map, rose and green, of Venice on the wall'.

Fig. 111 belongs to a series of pictures of Venetian girl models seated on a floral couch.

Related pictures especially close to Fig. 111:
1. Canvas. 21¼ × 18 (54 × 45·7), Tooth/Private Collection, London. Exh. Sheffield 57 (19); Agnew 60 (32). La Giuseppina is seen almost full-length, the couch is seen more fully, but the map of Venice is omitted.
2. Canvas. 17¾ × 14¾ (45·1 × 37·5), from the collection of Morton Sands. The pose and placing of the figure, who is again La Giuseppina, are very close to Fig. 111, but as in Version 1 she wears different clothes and the map is omitted. In tone and colour this picture is more sombre than Fig. 111 and Version 1.

Drawings from the series related to Fig. 111 and Versions:
1. Pen and ink, chalk. 11⅜ × 8¼ (28·9 × 21), D. R. H. Williams/Coll. Manchester, City Art Gallery (1963). Dated 'Sickert, Venezia. 1903'. Very close to Painting Version 1.
2. Pencil. 9½ × 7½ (24·1 × 19), Coll. Professor Lawrence Gowing.

165. LE CHÂLE VÉNITIEN (Fig. 112) 1903–4

Canvas. 18 × 15 (45·7 × 38·1)
'Sickert' b.l.
Tooth/
Private Collection, England
Rep. B.60, Pl. 38
Exh. Bernheim 1907 (17)
Chapter X

In this picture and the related paintings listed below the model was La Carolina dell'Acqua. Fig. 112 has a Bernheim-Jeune label on the back and can be quite confidently accepted as the picture with this title exhibited in Paris in 1907.

Related paintings of *La Carolina*:
1. Canvas. 13⅛ × 10⅜ (33·3 × 26·4), Private Collection, England.
2. Canvas. 15 × 12 (38·1 × 30·5), Coll. Mrs. Jack N. Pritzker, Chicago, Illinois. Exh. Leicester Galleries 1968, 'Summer Exhibition' (93).

Both these paintings show the model with her head resting on the arm of the couch. In style and handling they are similar to Fig. 112, although they are not quite so vividly accented.

Drawings (all related more specifically to the two versions of *La Carolina* than to *Le Châle Vénitien*):
1. Pen and ink, charcoal. 12½ × 9 (31·7 × 22·8), Coll. Oxford, Ashmolean Museum (1943). Rep. *Image*, No. 7, 1952, p. 4. Exh. Tate 60 (95). Signed and dated 'Sickert —Venezia 1903' and inscribed with the name of the model 'La Carolina del'Aqua' [*sic*].

2. Charcoal. $9\frac{1}{2} \times 7\frac{3}{4}$ (24·1 × 19·7), L. C. G. Clarke/Coll. Oxford, Ashmolean Museum (1943). Very close to Painting Version 2 listed above.

3. Pen and ink, chalk. $10\frac{1}{2} \times 7\frac{3}{4}$ (26·7 × 19·7), Sotheby's, 6 April 1960 (27), bought Redfern Gallery.

4. Chalk, pen and ink. 11 ×9 (28 × 22·9), Coll. Hugh Beaumont Esq. Very close to Painting Version 2.

166. VENETIAN GIRL ON A COUCH (Fig. 116)

Pen and ink. Sketched in a letter to Jacques-Émile Blanche; letter written early 1904
Chapter VIII, note 17; Chapter X

Sickert sketched Fig. 116 to show Blanche what a picture he had sold to Gonse (a friend and patron) looked like. He described the picture as *'un vrai petit chef-d'œuvre légère-ment peint et bien indiqué avec peu. Une femme maigre dans un jupon écossais rouge et vert qui joue avec un médaillon'*. In its expressive, coy quality this sketch is more nearly related to Fig. 112 than to any other of the extant pictures of Venetian models on a couch.

167. LA GIUSEPPINA. LA BAGUE (Fig. 114) 1903-4

Canvas. 18 × 15 (45·7 × 38·1)
'Sickert' b.l.
M. Comiot/Tooth/
Private Collection, London
Exh. Sheffield 57 (20); Agnew 60 (23)
Chapter X

168. LA CAROLINA IN AN INTERIOR (Fig. 115) 1903-4

Canvas. 21 × 17 (53·3 × 43·2)
'Sickert' b.l.
Collection Bernheim-Jeune, Paris
Exh. Probably Bernheim 1907 (51) as *Stanza Veneziana* and Bernheim 1909 (60) as *Casa Veneziana*
Chapter X

The measurements of *Casa Veneziana* in the 1909 exhibition and sale approximate to those of Fig. 115, and the picture was bought by Bernheim themselves. There are many pictures of La Carolina either standing or seated in this room at 940 Calle dei Frati.

Versions related to Fig. 115, showing La Carolina standing:
1. Canvas. $21 \times 17\frac{1}{2}$ (53·3 ×44·5), H. G. Crawshaw/ Christie's, 28 March 1958 (36)/Private Collection, London. Exh. Agnew 60 (21).
2. Canvas. $21\frac{1}{2} \times 18\frac{1}{4}$ (54·6 ×46·4), H. Baum/Messrs. Roland, Browse and Delbanco 1971. Exh. R.B.D.60 (17), rep. in catalogue; Brighton 62 (20); R.B.D.63 (17); New York 67 (5), rep. in catalogue; Sydney 68 (23).

Version 1 is very close compositionally to Fig. 115; Version 2 shows La Carolina moved slightly to the left so that she stands in front of the mirror (as in Drawings 1 and 2 below).

Drawings related to Fig. 115 and Versions:
1. Pen and ink, chalk. 18 × 15 (45·7 × 38·1), Private Collection, England. Exh. N.G.41 (121); Leeds 42 (103). Dated 'Sickert-Venezia 1903'.
2. Pen and ink, charcoal. $11\frac{1}{2} \times 8\frac{1}{4}$ (29·2 × 21), Private Collection, England. Exh. Tate 60 (99).
These two drawings are very close to painting Version 2.

3. Charcoal. $11\frac{1}{2} \times 8\frac{1}{4}$ (29·2 × 21), Coll. Oxford, Asmolean Museum (1962).
4. Charcoal. $11\frac{1}{2} \times 8\frac{1}{4}$ (29·2 × 21), Coll. H. K. B. Lund Esq.
5. Chalk heightened with white. 11 × $8\frac{1}{2}$ (28 × 21·5), Private Collection, England.
Drawings 3-5 show the Calle dei Frati (sulle Zattere) interior without the figure.
6. *The Venetian Shawl*. Pencil, pen and ink. $11\frac{1}{2} \times 8\frac{1}{4}$ (29·2 × 21), Sotheby's, 8 July 1970 (37)/Coll. Leslie Kark Esq.
7. Pencil, pen and ink. 12 × $8\frac{1}{2}$ (30·5 × 21·5), Messrs. Thos. Agnew & Sons, Ltd. 1969.
Drawings 6 and 7 show the figure with only minimal indication of the background.

Related paintings showing La Carolina seated in this setting:
1. Canvas. $15\frac{3}{4} \times 11$ (40 × 28), James Wood/Mrs. Holden-White/J. H. Strachan/R.B.D./Private Collection, London. Rep. B.60, Pl. 41; Rothenstein 1961. Exh. Edinburgh 53 (4); R.B.D.60 (21); Tate 60 (82).
2. *Il Sciau di Glasgow*. Canvas. Details and whereabouts unknown. Formerly with the Leicester Galleries.

169. PUTANA A CASA (Fig. 113) 1903-4

Canvas. $18\frac{1}{2} \times 15$ (47 × 38·1)
'Sickert' t.r.
Hôtel Drouot, 26 February 1913 (54)/Mme Paulhan/ Hôtel Drouot, 26 February 1934 (177)/R. A. Harari/ Sotheby's, 4 July 1971 (30)/
Messrs. Roland, Browse and Delbanco, 1971
Exh. Probably *Salon d'Automne* 1906 (1551) as *Putana Veneziana* and Bernheim 1907 (78) and Bernheim 1909 (9) as *Putana a Casa*
Chapter X

A note in the 1934 Hôtel Drouot catalogue acknowledged that Fig. 113 was shown at the 1906 *Salon d'Automne* where it could only have been *Putana Veneziana*. This catalogue also acknowledged the earlier sale of the picture at the Hôtel Drouot and noted that an inscription by Sickert on the frame gave the title of the painting as *Putana a Casa* which suggests it is probably the picture of that name exhibited in Paris in 1907 and 1909 (the French provenance strongly supports this suggestion).

Related painting:
Putana Veneziana. Canvas. 18 × 15 (45·7 × 38·1), Coll. Mrs. Irina Moore. Exh. Possibly Bernheim 1907 (39) and Bernheim 1909 (27); Eldar Gallery 1919 (12), rep. in illustrated catalogue; Leicester Galleries 1967, 'Gallery Group II' (88) as *La Putana*. Like Fig. 113 this picture shows La Giuseppina seated on a chair in the foreground; the titles of both paintings acknowledge her real role.

170. LA CAROLINA IN A TARTAN SHAWL (Fig. 119)
 1903-4

Canvas. 15 × 18 (38·1 × 45·7)
'Sickert' t.l.
E. Carew-Shaw/Sotheby's, 15 December 1971 (17)
Exh. R.B.D.60 (5)
Chapter X

171. VÉNITIENNE ALLONGÉE À LA JUPE ROUGE
(Fig. 117) 1903-4
Canvas. 14¾ × 18⅛ (37·5 × 46)
'Sickert' b.r.
Jacques-Émile Blanche/
Coll. Musée de Rouen (1923)
Exh. Brighton 62 (2)
Chapter X

Related paintings:

1. *Girl Asleep* or *The Yellow Skirt*. Canvas. 10¾ × 14 (27·3 × 35·5), Dr. Robert Emmons/R. C. Pritchard/Christie's, 19 July 1968 (88)/Mayor Gallery 1971. The colour of the model's skirt has changed but otherwise this picture is very closely related to, and may be a study for, Fig. 117.
2. *Resting. La Giuseppina*. Canvas. 15 × 18 (38·1 ×45·7), J. L. Rayner/Howard Bliss/Lord Evershed/Coll. Melbourne, National Gallery of Victoria (1947). Rep. B.43, Pl. 23; Exh. Chicago: Pittsburgh 1938 (25); N.G.41 (44); Tate 60 (78).
3. *The Siesta*. Canvas. 15 × 18 (38·1 ×45·7), Dr. Robert Emmons/Private Collection, England. Rep. Emmons, facing p. 112. Exh. Agnew 60 (25).

The model in *Resting* and *The Siesta* is in much the same pose, on the same bed, as in Fig. 117; she is seen three-quarter length in *Resting* and half-length in *The Siesta*.
The sketch Sickert made in a letter to show Blanche what his '*femme couchée*' (the climax of a long series of experimental pictures) looked like was nothing like Fig. 117 and the related pictures which show a clothed model resting (between sittings). The sketch in the letter showed the girl semi-nude (her dress having ridden up over her thighs).

172. THE BERIBBONED WASHSTAND (Fig. 120) 1903-4
Canvas. 22¾ × 18½ (57·8 × 47)
'Sickert' t.r.
Mark Oliver/R. C. Pritchard/
Private Collection, Eire
Rep. B.43, Pl. 22; B.60, Pl. 39; Rothenstein 1961
Exh. Edinburgh 53 (45); Tate 60 (81)
Chapter X

The model for this rare Venetian painting of the nude was probably Carolina dell'Acqua and the setting is that used in the pictures of *La Carolina seated in an Interior*, listed under C.168.

173. FILLE VÉNITIENNE ALLONGÉE (Fig. 118) 1903-4
Canvas. 14¾ × 18⅛ (37·5 ×46)
'Sickert' b.l.
Jacques-Émile Blanche/
Coll. Musée de Rouen (1923)
Exh. Brighton 62 (1)
Chapter X

Related paintings include Fig. 122 and *La Giuseppina and the Model* (catalogued under C.174) as well as *Les Vénitiennes*, Canvas, 18 × 21¾ (45·7 × 55·3), Mrs. Montgomery Sears/ Coll. Boston, Museum of Fine Arts (1938). Exh. New York 67 (33). Both the models are clothed. La Giuseppina, seated in the background, is fully represented (her head is not cut off by the frame as in Fig. 118); the other girl (?La Carolina) is sitting up on the bed, dressed demurely, looking out of the picture.

174. CONVERSATION (Fig. 122) 1903-4
Canvas. 17½ × 14¼ (44·4 ×36·2)
'Sickert' b.l.
Howard Bliss/
Private Collection, England
Exh. Chicago: Pittsburgh 1938 (11) as *Conversations*; Leeds 42 (135) as *Conversation, No. 2*
Chapter X

Related painting:
La Giuseppina and the Model. Canvas. 18 × 21 (45·7 × 53·3), Mrs. M. M. Gill/Sotheby's, 15 December 1971 (23). There is a strong possibility that this picture is the one of the same size, similarly unsigned, exhibited under the title *Conversation, No. 1* at Leeds, 1942 (134). It was then owned by Miss Sylvia Gosse. The Leeds catalogue noted that *Conversation No. 1* and *No. 2* were of a very similar motif. *La Giuseppina and the Model* (?*Conversation, No. 1*) shows the nude model lying in a foreshortened pose on the bed talking to the clothed La Giuseppina who is this time sitting on the near side of the bed.

175. MARIA BIONDA (Fig. 126) 1903-4
Canvas. 18 × 15 (45·7 × 38·1)
'Sickert' b.l.
Lord Henry Cavendish-Bentinck/J. W. Freshfield/Dr. John Burton/Sotheby's, 6 April 1960 (146)/
Coll. Dr. and Mrs. Bernard Brandchaft, Los Angeles
Exh. Probably N.E.A.C. winter 1906 (71); possibly Bernheim 1909 (72); Brighton 62 (18); R.B.D.63 (6); New York 67 (2)
Chapter X

The picture at Bernheim-Jeune in 1909 was the same size as Fig. 126; it was bought by Bernheim at the sale.
Sickert showed a picture called *Maria Bionda* at the N.E.A.C. winter 1900 (11) and a drawing of this name at Durand-Ruel in Paris in December 1900 (43). Possibly they showed the same model but Fig. 126 could hardly have been the 1900 painting. Its setting is the same as that used for *Putana Veneziana* (listed C.169) and *Mamma mia Poveretta* (C.182, Version 2).

176. PUTANA VENEZIANA (Fig. 121) dated 1903
Charcoal. 12¼ × 8¾ (31·1 × 22·2)
'Sickert—Venezia 1903' b.r.
André Gide/
Coll. Hugh Beaumont Esq.
Exh. Tate 60 (96)
Chapter X

A considerable number of Sickert's Venetian figure drawings of 1903 are dated but, curiously, there are no dated figure drawings of 1904 and only one dated figure painting of this visit to Venice (*Conversation*, C.195).
Fig. 121 is one of a group of four informal Venetian bedroom studies, all drawn in charcoal, all dated 1903, all formerly in André Gide's possession, and all now in Hugh Beaumont's collection. The others are:

1. *Girl Dressing*. 12 × 8½ (30·5 ×21·6). Exh. Tate 60 (97).
2. *Venetian Nude*. 8½ × 12 (21·6 ×30·5). Rep. B.60, Pl. 44a.
3. *Venetian Girl*. 12¼ × 8¾ (31·1 × 22·2).

177. THE LARGE HAT (Fig. 124) *c.*1904

Canvas. 30 × 25 (76·2 × 63·5)
'Sickert' t.r.
J. Schlesinger, Vienna/R.B.D./
Private Collection, England
Rep. B.60, Pl. 47
Exh. Tate 60 (84)
Chapter X

The Large Hat is not definitely a Venetian work but there
are several reasons for presuming it to be so.
 (i) It formerly belonged to Sickert's friend and patron
 Schlesinger who bought several of his Venetian works
 of 1903-4.
 (ii) The sitter is probably the same model as the girl
 represented in a drawing inscribed 'Venezia': Chalk.
 12 × 8⅝ (30·5 × 21·9), H. Reitlinger/Sotheby's, 22 July
 1964 (151)/Private Collection, London. The model
 in the drawing appears to be fatter than in the painting
 but their semi-nudity, the flimsy ruffled edges of their
 dresses, and above all their profiles with spiky hair
 and cheeky *retroussé* noses, are similar.

178. DANSEUSE DE MEMPHIS, U.S.A. (Fig. 123) 1903-4

Canvas. 20 × 16 (50·8 × 40·6)
'Sickert' b.r.
Tooth/
Private Collection, London
Rep. B.60, Pl. 40
Exh. *Salon d'Automne* 1905 (1427); Bernheim 1907 (8);
 Bernheim 1909 (57); Sheffield 57 (22); Agnew 60 (33);
 Tate 60 (88)
Chapter X

Probably a Venetian portrait, although the sitter and the
meaning of the title are unknown. Perhaps the portrait
really does represent a dancer from Memphis.

179. GIORGIONE SAN SILVESTRE (Fig. 127) *c.*1903

As rep. the *New Age*, 14 March 1912
Original:
Chalk. 10½ × 6½ (26·8 × 16·5)
Mrs. M. Clifton/Agnew/
Private Collection, London
Exh. Agnew 1966, 'French and English Drawings 1780–
 1965' (72)
Chapter X

This scolding wife and hen-pecked husband were probably
observed at the Trattoria Giorgione San Silvestre where
Sickert used to eat, and where in 1903 he found his models.
Similar character studies are listed below, C.189, C.190.

180. SELF-PORTRAIT (Fig. 130) *c.*1903-4

Charcoal, pen and ink. 15⅝ × 11¼ (39·7 × 28·7)
Mrs. M. Clifton/
Coll. Oxford, Ashmolean Museum (1956)
Chapter X

The roughly sketched background appears to be the
beribboned washstand of Sickert's room at Calle dei
Frati, hence the presumption that this is a Venetian work.

181. SELF-PORTRAIT WITH LA GIUSEPPINA
(Fig. 128) 1903-4

Canvas. 18 × 15 (45·7 × 38·1)
'Sickert' b.r.
Last known owner Dr. Bevan-Pritchard
Chapter X

A separate portrait of La Giuseppina, which in its narrow
elongation of the figure recalls the distortion and stylization
of her portrait in the background of Fig. 128:
Canvas. 17½ × 14½ (44·5 × 36·8), J. W. Blyth/Sotheby's,
15 April 1964 (14)/Coll. Commander Sir Michael Culme-
Seymour, Bt.

182. MAMMA MIA POVERETTA (Fig. 125) 1903-4

Canvas. 18⅛ × 15 (46 × 38·1)
'Sickert' b.l.
Coll. Manchester, City Art Gallery (1911)
Exh. Stafford Gallery 1911 (11); A.C.64 (10); Hull 68 (11)
Chapter X

There are three known pictures of this sitter, La Giusep-
pina's aged mother. One version was exhibited N.E.A.C.
winter 1906 (85) as *Mamma mia, Poareta*; another N.E.A.C.
spring 1907 (73) as *La Vecchia*; another N.E.A.C. summer
1909 (178) as *La Vecchia*, but which version on which
occasion is unknown. Fig. 125 or Version 1 below may be
the picture of this size, called *Mamma mia, poareta*, exhibited
at Bernheim-Jeune in 1909 (71).

Related pictures:
 1. Canvas. 18 × 15 (45·7 × 38·1), A. Crossland/Leicester
 Galleries/Private Collection, London. Rep. B.43, Pl. 20;
 Bertram, Pl. 15. Exh. Eldar Gallery 1919; N.G.41 (71);
 Leeds 42 (136); Edinburgh 53 (19); Agnew 60 (20);
 Tate 60 (80); the setting is the same as in *The Beribboned
 Washstand* (Fig. 120).
 2. Canvas. 20¾ × 18 (52·7 × 45·7), Walter Taylor/Private
 Collection, Scotland. Exh. Agnew 60 (29). The setting
 is the same as in *Maria Bionda* (Fig. 126).

Drawings of *Mamma mia Poveretta* include:
 1. Pen and ink, chalk. 11¾ × 8¼ (29·9 × 21), Coll. Adrian
 Heath Esq. Exh. Leicester Galleries 1963, 'Artists as
 Collectors' (91). Dated 'Sickert Venezia 1903'.
 2. Pen and ink, blue chalk. 10½ × 6⅜ (26·7 × 16·4), Sothe-
 by's, 16 April 1962 (167)/Coll. N. Kessler Esq., Zurich.
 Rep. The *New Age*, 22 February 1912 as *La Vecchia*.
Both these drawings are profile portraits, unlike the paint-
ings which are full or three-quarter face. In his letter of
1 January 1904 to Mrs. Hulton Sickert wrote of his splen-
did model, 'A very old woman with a *fazzoletto*, black, with
peacocks' feathers on her head'.

183. LA JOLIE VÉNITIENNE (Fig. 129) 1903-4

Canvas. 19 × 15 (48·3 × 38·1)
'Sickert' b.l.
Adolphe Tavernier/Lord Cottesloe/Sotheby's, 14 July 1965
 (65)/R.B.D./
Private Collection, Scotland
Exh. Agnew 60 (35)
Chapter X

Version:
Canvas. 18 × 14¾ (45·7 × 37·5), Paul Robert/Baron van

der Heyden à Hauzeur/Private Collection, London. In the letter to Mrs. Hulton telling of his splendid models, among them the very old woman, Sickert also wrote of 'some very pretty young ones'.

184. CAQUETOÈRES (Fig. 131) 1903–4

Canvas. $15\frac{1}{2} \times 18\frac{1}{2}$ (39·4 × 47)
'Sickert' b.l.
Mrs. Ogilvie Grant/Dr. Robert Emmons/
Private Collection, London
Exh. *Salon d'Automne* 1906 (1544); Bernheim 1907 (12); Agnew 60 (30)
Chapter X

The title is probably Venetian dialect for *chiacatore(s)* meaning 'chatterboxes'.

185. VENETIAN GIRL SEATED ON A SOFA 1903–4

Canvas. $18\frac{1}{4} \times 15$ (46·4 × 38·1)
'Sickert' b.l.
Mrs. Montgomery Sears/
Coll. Boston, Museum of Fine Arts (1938)
Rep. B.60, Pl. 42
Exh. New York 67 (32)
Chapter X

This painting formerly belonged to Bernheim-Jeune and was almost certainly bought by Mrs. Sears in 1908 when, in a letter to Miss Hudson (dated from his sketch of *L'Américaine*, see note to Fig. 185, C.266), Sickert reported that his wife told him the lady had bought some of his pictures in Paris. Mrs. Sears probably bought *Les Vénitiennes* (catalogued C.173) on the same occasion.

Version (or preliminary study):
Panel. $18\frac{1}{2} \times 16\frac{1}{2}$ (47 × 41·9), Dr. Robert Emmons/Private Collection, England. A narrower picture of the subject, almost certainly painted before C.185 because it shows the picture on the background wall in the position which Sickert tried to erase in C.185. When Sickert extended the space to the right in C.185 the compositional balance required that the picture on the wall was also pulled over to the right.

Related drawings:
1. Pen and ink, charcoal. $11\frac{7}{8} \times 8\frac{5}{8}$ (30·2 × 22), C. Maydwell/Mrs. Pickford/Coll. Adelaide, National Gallery of South Australia (1958). Exh. Adelaide 68 (64).
2. Pen and ink, chalk. $12\frac{1}{4} \times 8\frac{1}{4}$ (31·1 × 21), Coll. London, Islington Public Libraries (1947). More distantly related to C.185 than is Drawing 1.

186. STUDY IN ROSE 1903–4

Canvas. $21\frac{1}{4} \times 15\frac{5}{8}$ (54 × 39·7)
'Sickert' b.l.
Coll. Mrs. Prince Littler
Exh. R.B.D.60 (32); R.B.D.63 (14)

An unfinished picture from the model on a couch series. It is a monochromatic study in tone and shows the model partly unclothed.

187. STUDIES OF THE HEAD OF A WOMAN dated 1903

Pencil, pen and ink. $11\frac{1}{2} \times 8\frac{1}{2}$ (29·2 × 21·6)
'Sickert/Venezia 1903' b.r.

Mrs. Dunne/
From the collection of Edward le Bas
Rep. B.60, Pl. 50a
Exh. Brighton 62 (45); R.A.1963, 'A Painter's Collection' (197)
Chapter X

188. TRIPLE STUDY OF A STANDING NUDE

Black and red chalk heightened with white. $17\frac{1}{2} \times 12$ (44·5 × 30·5)
'Sickert' b.r.
Christie's, 17 July 1959 (37), bought Craven
Chapter X

Assumed to be a Venetian work because the rather formal and academic format, of a figure studied from several aspects, was used by Sickert in Venice, e.g.:
1. *Triple Study of La Giuseppina.* Pencil. $12 \times 8\frac{3}{4}$ (30·5 × 22·2), Jack Beddington/Christie's, 25 March 1960 (97)/Coll. Hugh Beaumont Esq.
2. *Double Study of La Giuseppina.* Pencil. 11×9 (27·9 × 22·9), J. Stanley Clarke/Coll. Hugh Beaumont Esq. Exh. Agnew 60 (248).
Both these drawings, identified as La Giuseppina by Sickert's inscriptions, show the girl clothed.

189. SUPERB STUPIDITY dated 1903

Details and whereabouts of original unknown
'Sickert—Venezia—1903' b.l.
Rep. The *New Age*, 28 March 1912
Chapter X

190. THE GONDOLIER c.1903

Charcoal. $11\frac{5}{8} \times 7\frac{3}{4}$ (29·5 × 19·7)
R.B.D./
Private Collection, London
Exh. R.B.D.60 (38); Brighton 62 (27)
Chapter X

Like Fig. 127 and C.189 a character study.

191. WOMAN IN PROFILE WITH DOWNCAST EYES c.1903–4

Canvas. 20×16 (50·8 × 40·6)
'Sickert' b.r.
Dr. Robert Emmons
Coll. Ralph Smith Esq., Sydney
Rep. B.60, Pl. 36
Exh. Adelaide 68 (20); Sydney 68 (6)
Chapter X

The identity of the sitter is unknown and the portrait is not necessarily a Venetian work. The canvas size is English but so it is in other Venetian pictures, e.g. Figs. 111 and 124.

192. LA GIUSEPPINA 1903–4

Canvas. 18×15 (45·7 × 38·1)
'Sickert' b.l.
Sir Louis Fergusson/R. C. Pritchard/Leicester Galleries/
Private Collection, London
Exh. Eldar Gallery 1919, rep. in illustrated catalogue; R.B.D.60 (36)
Chapter X

193. LA GIUSEPPINA IN A LACE BLOUSE 1903–4

Canvas. 18¼ × 14½ (46·4 × 36·8)
'Sickert' t.r.
Dr. Robert Emmons/
Coll. Hugh Beaumont Esq.
Rep. B.60, Col. Pl. V
Exh. Tate 60 (87)
Chapter X

194. LA INEZ 1903–4

Canvas. 21½ × 18¼ (54·6 × 46·4)
'Sickert' b.l.
Dr. Robert Emmons/
Coll. Adelaide, National Gallery of South Australia (1954)
Rep. B.60, Pl. 35
Exh. Probably *Salon d'Automne* 1906 (1548); probably
 Bernheim 1907 (13 or 25); Adelaide 68 (19)
Chapter X

Study:
Pencil, pen and ink. 12½ × 9 (31·8 × 22·8), W. H. Spurr/
Coll. Whitworth Art Gallery, University of Manchester
(1960). Exh. A.C.64 (38). A study for the figure only (without
the candle). It is dated 'Sickert Venezia 1903' and inscribed
(as are several of Sickert's Venetian drawings) 'La
Chiozzota'. This almost certainly represents a misspelling of
'Ciosotta', the local dialect for a woman from the nearby
fishing village of Chioggia (called Ciosa in Venetian dialect).

195. CONVERSATION dated 1903

Canvas. 19 × 16 (48·3 × 40·7)
'Sickert—Venezia—1903' b.l.
Last known owners: Mr. and Mrs. S. Samuels, Liverpool
Chapter X

A two-figure painting related in theme and handling to
Caquetoères (Fig. 131).

Related painting:
Canvas. 18 × 14¾ (45·7 × 37·5), Miss La Primaudaye/L.
York Baker/Leicester Galleries/Private Collection, London.
Exh. N.G.41 (68) as *Venetian Study*; Edinburgh 53 (2) as
Venetian Woman standing in Profile. This painting is a single
figure study of the standing woman, in the same pose and
clothes as in *Conversation*.

196. LE TOSE 1903–4

Canvas. 17¾ × 20¾ (45 × 52·7)
'Sickert-Venezia' b.l.
Sir Hugh Walpole/
Coll. London, Tate Gallery (1941)
Rep. B.60, Pl. 43
Lit. Tate Gallery Catalogue 1964, p. 634
Exh. N.G.41 (55); Adelaide 68 (55)
Chapter X

A two-figure subject related to the paintings of women
gossiping (such as Fig. 131, C.195, and C.197 below) but
in *Le Tose* the women sit side by side on the couch and do
not talk to each other. *Le Tose* means 'The Girls'.

197. A MARENGO 1903–4

Canvas. 15 × 18 (38·1 × 45·7)
'Sickert' b.l.

R. E. A. Wilson/J. L. Rayner/
Coll. London, Tate Gallery (1922)
Rep. Bertram, Pl. 20
Lit. Tate Gallery Catalogue 1964, pp. 622–3
Exh. Probably N.E.A.C. winter 1906 (83); Bernheim 1909
 (73).
Chapter X

The Tate Gallery Catalogue discusses various possible
meanings of the title (a *marengo* being an old Italian coin, or
perhaps the reference is to the famous battle).

1904–5. DIEPPE, FIGURES

198. LA BELLE ROUSSE (Fig. 133) *c.*1904–5

Canvas. 17 × 21 (43·2 × 53·3)
Dr. Robert Emmons/Agnew/
Private Collection, London
Exh. Agnew 60 (48)
Chapter XI

The model was Mme Villain. The painting looks back to
the Neuville drawings from the nude of 1902 (Fig. 101,
C.144) but it was probably executed after Sickert's return
from Venice in the summer of 1904.

199. LE LIT DE FER (Fig. 132) *c.*1904–5

Pastel. 13 × 19 (33 × 48·3)
'Sickert' b.r.
C. B. Cochran/Sir George Sutton/
Present whereabouts unknown
Exh. Probably *Salon d'Automne* 1905 (1434)
Chapter XI

The medium (pastel) and the title of the work exhibited in
Paris in 1905 were the same as Fig. 132.

200. NUDE SPRAWLING ON A BED (Fig. 134) *c.*1904–5

Pastel. 27½ × 20½ (69·9 × 52)
Coll. Mr. and Mrs. Hamish Hamilton
Exh. R.B.D.60 (43)
Chapter XI

201. NUDE (Fig. 136) *c.*1904–5

Canvas. 15 × 18 (38·1 × 45·7)
'Sickert' b.r.
Mrs. A. E. Anderson/
Private Collection
Chapter XI

Study:
Pencil. 15¼ × 19¾ (38·7 × 50·2), F. Hindley-Smith/Coll.
Oxford, Ashmolean Museum (1939).

202. NUDE ON A BED *c.*1904–5

Canvas. 17½ × 21½ (44·5 × 54·6)
'Sickert' b.r.
M. Geoffrey, Paris/Howard Bliss/
Last known owner F. J. Lyons Esq.
Exh. Edinburgh 53 (23); Agnew 60 (45)
Chapter XI

1905–6. LONDON, PORTRAITS AND FIGURES

203. MRS. SWINTON. THE LADY IN A GONDOLA (Fig. 137)　dated 1905

Canvas. 12 × 13¾ (30·5 × 35)
'Walter Sickert 1905' b.r.
F. Hindley-Smith/
Coll. Oxford, Ashmolean Museum (1939)
Chapter XI

Fig. 137 is perhaps the portrait of Mrs. Swinton given to Lady Vala Machell as a wedding present (see B.60, p. 59). Mrs. George Swinton (1874–1966) was a singer. According to Emmons, p. 137, Sickert met Mrs. Swinton at a dinner party given by Mrs. Charles Hunter for Rodin to enable the Frenchman to meet the most beautiful women in London. Mrs. Swinton became a close friend of Sickert and he painted her often not only in formal portraits like Figs. 137 and 157 but also as his model for many informal studies, e.g. Fig. 139 and C.228.

Related portrait of Mrs. Swinton:
Canvas. 20¾ × 16¾ (52·7 × 42·5), Walter Howarth/Coll. M. Halperin Esq., Rep. F. Wedmore, *Some of the Moderns*, London, Virtue, 1909; B.43, Pl. 24; B.60, frontispiece in colour; Rothenstein 1961. Exh. Chicago: Pittsburgh 1938 (9); N.G.41 (7); Leeds 42 (142); Edinburgh 53 (33); Sheffield 57 (99c); Tate 60 (103).
Fig. 137 and this related portrait show Mrs. Swinton outlined against the background of the Venetian lagoon, as if she were gliding along in a gondola (hence the title). In fact Mrs. Swinton had never been to Venice and told me that Sickert painted these and other portraits of her in his Fitzroy Street studio, from life, drawings, and photographs. In Fig. 137 the background is painted in light, chalky-toned colours, rather like a true theatre backcloth. In the larger version catalogued above, the surface of the water is painted in broken strokes of colour which gives it a more deceptive naturalism.

204. LADY NOBLE (Fig. 138)　c.1905–6

Canvas. 20 × 16 (50·8 × 40·6)
'Sickert' t.r.
Lady Noble/
Coll. Bath, Victoria Art Gallery (1948)
Exh. Sheffield 57 (34); A.C.64 (13)
Chapter XI

Celia Saxton Noble (1871–1962), a friend of Jacques-Émile Blanche, commissioned this portrait which could be a work of either 1905 or 1906.

205. UNE TASSE DE THÉ (Fig. 140)　1905

Canvas. 20 × 16 (50·8 × 40·6)
'Sickert' b.r.
Coll. Auckland, City Art Gallery (1968)
Exh. One version (see below for second version), *Salon d'Automne* 1905 (1428); probably the same version Bernheim 1907 (79) and Bernheim 1909 (24) as *A Cup of Tea*; R.B.D.60 (12); R.B.D.63 (12); New York 67 (17); Sydney 68 (26)
Chapter XI

Version:
Canvas. 20½ × 16½ (52 × 42), from the collection of Morton Sands. Exh. N.G.41 (88); Leeds 42 (151); Agnew 60 (80); Brighton 62 (80)

206. THE VISITOR (Fig. 139)　c.1905

Canvas. 20 × 16 (50·8 × 40·6)
'Sickert' b.l.
Admiral Sir Charles Lambe/
Coll. Lady Lambe
Exh. N.G.41 (86); Leeds 42 (150); Sheffield 57 (29); Agnew 60 (83)
Chapter XI

The Visitor may represent Mrs. Swinton.

Related painting:
La Russe. Canvas. 19¾ × 15½ (50·2 × 39·4), Sotheby's, 12 April 1967 (63)/Agnew/Private Collection, London. The setting is identical to Fig. 139 but the figure is different. Like *The Visitor*, *La Russe* is handled with lightness and delicacy although there are passages of broken dabbed touches around the face and shoulder of the woman which are not found in Fig. 139.

207. COCOTTE DE SOHO (Fig. 135)　1905

Pastel. 24⅜ × 19⅝ (62 × 50)
'Sickert' b.l.
Hôtel Drouot, 5 June 1912 (114)/Mme Paulhan/Hôtel Drouot, 26 February 1934 (55)/
Present whereabouts unknown
Exh. *Salon d'Automne* 1905 (1433)
Chapter XI

208. NUDE (Fig. 141)　c.1905

Canvas. 16 × 20 (40·6 × 50·8)
'Sickert' b.r.
From the collection of Edward le Bas
Exh. R.A.1963, 'A Painter's Collection' (156)
Chapter XI

Close in conception and composition to *La Belle Rousse* (Fig. 133), but probably painted in London from studies made in France. One such study, entitled *La Belle Russe* [*sic*], is extant:
Black chalk on faded rose paper. 9¼ × 13 (23·5 × 33), Mrs. Grace Wheatley/Christie's, 11 November 1958 (11)/Agnew/Private Collection, London. The nude is posed exactly as in Fig. 141.

209. LE LIT DE CUIVRE (Fig. 142)　c.1906

Canvas. 16 × 20 (40·6 × 50·8)
'Sickert' b.l.
Michael Langworthy/
Coll. Nigel Haigh Esq.
Exh. Possibly Bernheim 1907 (55) and Bernheim 1909 (40); New York 67 (21); Adelaide 68 (34); Sydney 68 (27)
Chapter XI

Version:
Canvas. 15½ × 19½ (39·4 × 49·5), Private Collection, Copenhagen/Sotheby's, 12 April 1967 (62)/Coll. Exeter, Royal Albert Memorial Museum (1968). Exh. Agnew 1968, 'British Paintings 1900–1968' (13). Either Fig. 142 or this

version could be the picture exhibited in Paris in 1907 and 1909.

The pose of the model in Fig. 142 and Version is the same as in the pastel *Le Lit de Fer* (Fig. 132) but the bedstead, brass instead of iron, seems to be the one used in the *Nude* (C.202). Possibly Fig. 142 and Version were derived from studies made for the two earlier French nudes.

Related painting:

Canvas. 15¾ × 19¾ (40 × 50·2), Coll. Lincoln, Usher Art Gallery (1936). Exh. Sheffield 57 (35); A.C.64 (17). The pose of the nude is again the same as in *Le Lit de Fer*, *Le Lit de Cuivre* and Version but all surrounding space is excluded. The nude is seen large and close to the spectator. The picture is very dark in tone and colour; its handling suggests a date of 1906–7.

210. NUDE STRETCHING (Fig. 143) *c*.1906

Canvas. 20 × 16 (50·8 × 40·6)

'Sickert' b.r.

André Gide/Count Manassei/

Last known owner F. B. Hart Jackson Esq.

Exh. Agnew 60 (74)

Chapter XI

An iron bedstead has replaced the couch in the Fitzroy Street interior used as a setting for the clothed figure subjects of Easter 1906 (Figs. 149–151 and C.227).

211. LA HOLLANDAISE (Fig. 144) *c*.1906

Canvas. 20 × 15¾ (50·8 × 40)

'Sickert' b.r.

W. Marchant/Christie's, 28 January 1927 (148)/Mark Oliver/Hart Massey/R.B.D./

Private Collection, London

Rep. B.60, Pl. 46; Rothenstein 1961, Col. Pl. 7; Pickvance 1967, Col. Pl. VIII

Exh. Bernheim 1907 (33); Bernheim 1909 (54); Tate 60 (100)

Chapter XI

Study (Fig. 145):

Charcoal. 11 × 14 (28·1 × 35·5), Coll. Ottawa, National Gallery of Canada (1954). An exceptionally rich and finished drawing of the nude. The disposition of the hips and legs is just as in Fig. 144 but in reverse; the upper body is more closely related to *Nuit d'Été* (Fig. 147) but the arms are disposed differently. The setting and the bed are the same as in Fig. 144. This drawing is called *Sally* but it certainly shows the same model as in *La Hollandaise* and *Nuit d'Été*. The conception of the foreshortened nude anticipates *L'Affaire de Camden Town* (Fig. 190).

212. NUIT D'ÉTÉ (Fig. 147) *c*.1906

Canvas. 20 × 16 (50·8 × 40·6)

Paul Robert/Baron van der Heyden à Hauzeur/

Private Collection, London

Rep. B.60, Pl. 49

Exh. Bernheim 1907 (28); Agnew 60 (42); Tate 60 (101)

Chapter XI

Related painting:

Nude on a Bed. Canvas. 20 × 16 (50·8 × 40·6), Coll. N. L. Hamilton-Smith Esq. Related to Fig. 147 in handling and composition. The setting is the same but more of the room is shown. The body of the nude is disposed somewhat differently.

213. MORNINGTON CRESCENT NUDE. CONTRE-JOUR (Fig. 146) *c*.1906

Canvas. 20 × 18 (50·8 × 45·7)

'Sickert' b.r.

Judge Evans/

Coll. Lord Sainsbury

Rep. B.43, Pl. 33; Bertram, Pl. 22; Rothenstein 1961; Pickvance 1967, Col. Pl. X

Exh. N.G.41 (95) and Leeds 42 (164) as *Granby Street*; Agnew 60 (62); Tate 60 (113)

Chapter XI

This picture is usually dated *c*.1908 but I prefer a date of *c*.1906 for several reasons:

i. The extreme summariness of its execution is hard to accept in 1908 but can be regarded as a further extension of the economic handling of paintings like *La Hollandaise* (Fig. 144) and is closer still to certain music hall pictures of 1906, for example, *The Gallery of the Old Mogul* (C.240).

ii. One of the main reasons put forward for dating Fig. 146 to 1908 is the use of the Mornington Crescent as opposed to the Fitzroy Street interior. However, Sickert acquired this Mornington Crescent studio in 1906, even though he used it more frequently for paintings of the nude from 1907 onwards.

iii. The composition and setting of Fig. 146 is remarkably close to Gore's *Behind the Blind*, generally dated *c*.1906. Gore's association with Sickert was particularly close in 1906 when Sickert lent him his Neuville, Dieppe studio for the summer and let him paint in Mornington Crescent as well. It is possible that Gore's *Behind the Blind* and Sickert's *Nude. Contre Jour* were painted contemporaneously in Mornington Crescent.

214. NUDE BEHIND FLOWERS (Fig. 148) *c*.1906

Canvas. 17½ × 13¾ (44·5 × 35)

'Sickert' b.l.

Miss Joan Rayner/

Sotheby's, 7 April 1971 (17), bought Dyce

Chapter XI

Similar in conception and execution to Gore's *Self-Portrait in a Mirror with Still Life*.

215. FANCY DRESS. MISS BEERBOHM (Fig. 149) 1906

Canvas. 20 × 16 (50·8 × 40·6)

'Sickert' b.l.

Walter Taylor/Mark Oliver/Mrs. D. M. Fulford/

Coll. Liverpool, Walker Art Gallery (1945)

Exh. N.G.41 (67) as *Marie*

Chapter XI

At Easter 1906 Sickert sent Mrs. Swinton postcards containing cameo pen and ink sketches of the pictures on which he was currently working. His inscriptions often identify the models or sitters. Mrs. Swinton subsequently mounted the cards on three sheets. They are, perhaps, the most complete documentary evidence we have for Sickert's work at any single period although, curiously, in the case of several of the portraits they illustrated, little heed has been taken of them when dating the pictures. Besides portraits the sketches showed his current figure compositions, all done in Fitzroy Street. A sketch of *Fancy Dress. Miss Beerbohm* was included in the group.

Version:
Canvas. 19½ × 15½ (49·5 × 39·4), Walter Howarth/Coll. London, British Council (1949). Exh. N.G.41 (65); Leeds 42 (152). Probably painted later, c.1916. Much of the interior detail is omitted and the handling is very summary.

216. LES PETITES BELGES. JEANNE AND HÉLÈNE DAURMENT (Fig. 150) 1906

Canvas. 20 × 16 (50·8 × 40·6)
'Sickert' b.l.
Mrs. Montgomery Sears/
Coll. Boston, Museum of Fine Arts (1938)
Exh. Probably Bernheim 1907 (43)
Chapter XI

A sketch of Fig. 150 was sent to Mrs. Swinton (rep. Emmons, p. 192—Emmons reproduced several of these Easter 1906 cameo sketches).
The Daurment sisters modelled for Sickert for three months (see Chapter XI, note 13). They were Belgian by birth but had lived most of their lives in France. Sickert met them in Soho when he overheard them asking a policeman, in French, where they could buy coffee. Jeanne was a milliner and Hélène worked as a charwoman.

217. EASTER MONDAY. HÉLÈNE DAURMENT (Fig. 151) 1906

Canvas. 20 × 16 (50·8 × 40·6)
'Sickert' b.l.
Private Collection, Scotland
Rep. B.60, Pl. 48
Exh. Edinburgh 53 (42); Tate 60 (104)
Chapter XI

A sketch of Fig. 151 was sent to Mrs. Swinton at Easter 1906 (rep. Emmons, p. 243).

218. MRS. BARRETT (Fig. 152) 1906

Canvas. 20 × 16½ (50·8 × 41·9)
'Sickert' b.l.
Dr. Robert Emmons/Maurice Goldman/L. Y. Baker/Col. Robert Henriques/Sotheby's, 14 December 1960 (182)/ Coll. William E. Wallace Esq.
Rep. B.43, Pl. 31; B.60, Pl. 59; Rothenstein 1961, p. 4; Pickvance 1967, p. 6, Fig. 4
Exh. N.G.41 (9); Leeds 42 (155); Edinburgh 53 (58); Tate 60 (115); Brighton 62 (19); R.B.D.63 (15)
Chapter XI

Mrs. Barrett, whom Sickert painted many times, is said to have been his charwoman. Fig. 152 is persistently dated c.1908 in the literature, although Sickert sent a sketch of the portrait to Mrs. Swinton at Easter 1906 to show her a picture he was currently painting (rep. Emmons, p. 311; Image, No. 7, 1952, p. 33). The late dating has been influenced by the delicate handling of the portrait, in particular the use of stippled dots and dabs of quite thick paint to model the lights on the face. However, although Sickert developed these qualities in his work of 1907–8, he could and did sometimes paint in this manner in 1906. Fig. 152 is particularly close in its technique to The Old Model (Fig. 158) which has a terminus ante quem of January 1907 from its exhibition at Bernheim-Jeune.

219. MRS. BARRETT (Fig. 153) 1906

Canvas. 19¾ × 15¾ (50·2 × 40)
'Rd. St. A.R.A.' b.l. and 'Sickert' b.l.
Roger Fry/
Coll. London, Courtauld Institute of Art (1934)
Exh. Edinburgh 53 (14); Adelaide 68 (35)
Chapter XI

Two sketches of Fig. 153 were sent to Mrs. Swinton at Easter 1906 (rep. Image, No. 7, 1952, p. 34; one Emmons, p. 178), however, like Fig. 152, this profile portrait of Mrs. Barrett is often dated c.1908.

220. THE BELGIAN COCOTTE (Fig. 154) 1906

Canvas. 19½ × 15¾ (49·5 × 40)
'Sickert' b.l.
Private Collection, Paris/
Coll. London, The Arts Council of Great Britain (1953)
Chapter XI

A sketch of Fig. 154 was sent to Mrs. Swinton at Easter 1906 (rep. Emmons, p. 313; Image, No. 7, 1952, p. 33). The model is again one of the Daurment sisters—hence the title.

221. JEANNE. THE CIGARETTE (Fig. 155) 1906

Canvas. 20 × 16 (50·8 × 40·6)
'Sickert' b.r.
Vincent Astor/
Last known owners Mr. and Mrs. James Fosburgh, New York
Exh. Probably Bernheim 1907 (81) and Bernheim 1909 (62) as La Cigarette
Chapter XI

A sketch of Fig. 155 was sent to Mrs. Swinton at Easter 1906 (rep. Emmons, p. 227; Image, No. 7, 1952, p. 33). The model is Jeanne Daurment.

222. THE OLD MODEL (Fig. 158) c.1906

Canvas. 30½ × 25 (77·5 × 63·5)
'Sickert' b.l.
Mrs. M. Clifton/Agnew/
Private Collection, London
Rep. Sitwell, p. 203
Exh. Bernheim 1907 (47) and Bernheim 1909 (5) as Le Vieux Modèle; Agnew 60 (52)
Chapter XI

An unusual portrait of a male model who does not appear in any other paintings by Sickert known to me.

223. MRS. SWINTON (Fig. 157) c.1906

Canvas. 30 × 25 (76·2 × 63·5)
Christie's, 28 and 31 January 1927 (145) as Étude pour portrait: lady in a red dress/ the Hon. Mrs. Maurice Glyn/ J. W. Freshfield/
Coll. Cambridge, Fitzwilliam Museum (1955)
Lit. J. W. Goodison, the Burlington Magazine, 113, September 1971, pp. 551–2, rep. p. 550
Exh. Probably Bernheim 1907 (36) as Étude pour portrait
Chapter XI

The photograph on which Fig. 157 was based is reproduced, alongside the portrait, in the Burlington Magazine, 113, p. 550. Emmons, p. 137, stated that Sickert sent some of his

portraits of Mrs. Swinton to Paris. Fig. 157 has a *Douane* stamp on the back of the canvas; in view of the fact that it had been in France and was sold at Christie's under the French title it can almost certainly be accepted as the painting exhibited at Bernheim-Jeune in January 1907.

The background to Fig. 157 is not necessarily Venetian, and is probably entirely imaginary. The photograph on which the portrait was based shows Mrs. Swinton in formal day dress in an interior and gives no hint of so romantic a conception. For other portraits of Mrs. Swinton against a watery landscape see Fig. 137, C.203.

224. MRS. BARRETT *c.*1906

Pastel on millboard. 21¼ × 28 (54 × 71·1)
'Sickert' t.r.
J. B. Elliot/
Coll. London, Tate Gallery (1940)
Lit. Tate Gallery Catalogue 1964, p. 633
Chapter XI
Related work:
Mrs. Barrett. Blackmail. Pastel. 26 × 21¼ (66 × 54), Dr. Robert Emmons/Edward le Bas/Coll. Ottawa, National Gallery of Canada (1955). Rep. Emmons, facing p. 68.

The settings and compositions of these two pastel portraits of *Mrs. Barrett* are entirely different so that they cannot be called versions of each other. However, they do appear to be contemporary works. They are generally dated *c.*1908 (except by Emmons who dated *Blackmail* 'about 1904'), just as the painted portraits of *Mrs. Barrett* are often dated *c.*1908. I prefer a date of *c.*1906 for the pastel portraits because:
 (i) Sickert frequently used pastel at this period.
 (ii) His handling of the medium in the *Mrs. Barrett* portraits is similar to his handling of pastel in *Cocotte de Soho* (Fig. 135). The treatment of the backgrounds, the looking-glass reflections, the drapery etc. is the same in all these drawings.
 (iii) The shallow space and frontal presentation recall *Une Tasse de Thé* (Fig. 140, C.205); the incidental props of *Blackmail* (a hoop-backed chair and metal bedstead) are typical of 1905–6.
 (iv) Mrs. Barrett seems to have joined Sickert's *ménage* at Easter 1906 (when he sent Mrs. Swinton sketches of his current paintings of her, Figs. 152, 153, inscribed 'new model').

225. RECLINING NUDE. MORNINGTON CRESCENT
*c.*1906

Canvas. 16 × 20 (40·6 × 50·8)
'Sickert' t.r.
Private Collection, London
Rep. B.60, Pl. 50
Exh. Edinburgh 53 (36); R.B.D.60 (1)
Chapter XI

226. WOMAN IN RED AGAINST GREEN. MRS. NEVILLE
1906

Canvas. 16 × 20 (40·6 × 50·8)
'Sickert' b.l.
J. W. Blyth/R. Hart/R.B.D./
Private Collection
Exh. Leeds 42 (149); New York 67 (9); Adelaide 68 (26); R.B.D.1970, 'Sickert to Sutherland' (17)

Chapter XI

A sketch for, or related to, this painting was sent to Mrs. Swinton at Easter 1906 (rep. Emmons, p. 161). It included a second figure, a woman seated in profile on the right. *Woman in Red* shows only a single figure, Mrs. Neville, re-clining on the couch. Mrs. Neville, a dressmaker, was Max Beerbohm's sister.

227. BELGIAN COCOTTES. JEANNE AND HÉLÈNE DAURMENT 1906

Canvas. 20 × 16 (50·8 × 40·6)
'Sickert' b.r.
Sir Augustus Daniel/J. W. Blyth/
 Private Collection, London
Rep. B.60, Pl. 51
Exh. Probably Bernheim 1907 (67) as *The Map of London*; Edinburgh 53 (38); Tate 60 (105)
Chapter XI

Sickert sent two sketches of this painting to Mrs. Swinton at Easter 1906 (rep. Emmons, p. 293 and p. 320). One has the words 'Map of London' inscribed in capital letters across the framed picture sketched in the background and this suggests that C.227 is probably the picture exhibited under this title in Paris in 1907.

228. HEAD OF A WOMAN 1906

Canvas. Size unknown
Mrs. Leverton Harris/
Present whereabouts unknown
Rep. *Drawing and Design*, 3, July 1927, p. 5
Chapter XI

This picture is known to me only from its reproduction in 1927 (when it belonged to Mrs. Harris). A sketch very close to this profile portrait was sent to Mrs. Swinton at Easter 1906. The identity of the sitter is unknown.

229. LE JOURNAL *c.*1906

Canvas. 20 × 16 (50·8 × 40·6)
'Sickert' b.r.
Private Collection, France/R.B.D./
Private Collection, London
Rep. B.60, Col. Pl. VI
Exh. Edinburgh 53 (31); Tate 60 (86)
Chapter XI

Miss Browse (B.60, pp. 60, 73) believes this to be a Venetian work of *c.*1904 related to the studies of the foreshortened head of a woman done in Venice in 1903 (C.187). I believe that *Le Journal* is one of the Fitzroy Street portraits of 1906. The setting, with the green and white striped sofa (which is particularly close to *Head of a Woman*, C.228), confirms this suggestion. Mrs. Swinton told me that she believed *Le Journal* to be a portrait of herself (although she could not be absolutely certain of this after a lapse of some sixty years).

1906–9. MUSIC HALLS

230. NOCTES AMBROSIANAE (Fig. 159) 1906

Canvas. 25 × 30 (63·5 × 76·2)
'Sickert' b.r.

Walter Taylor/J. B. Priestley/
Coll. Nottingham, Castle Museum and City Art Gallery (1952)
Rep. B.60, Pl. 11
Lit. Wendy Dimson, the *Burlington Magazine*, 102, October 1960, pp. 438–43, 'Four Sickert Exhibitions', p. 441, rep. p. 440
Exh. N.E.A.C. summer 1906 (123); *Salon d'Automne* 1906 (1545); Tate 60 (18); A.C.64 (14)
Chapter XI

Sickert's London and Paris music hall pictures of 1906 and 1907 have often been misdated in Sickert literature and exhibition catalogues; his whole music hall production of these years has been attributed to various dates scattered over the period *c*.1887 to *c*.1901. The documentary and stylistic evidence for re-dating these music halls 1906 and 1907 is summarized in the *Burlington Magazine*, 102, October 1960 and again in the text here (Chapter XI for the London halls, Chapter XII for the Paris halls).
Noctes Ambrosianae is a view of the gallery of the Middlesex Music Hall, or Mogul Tavern as it was known to its familiars. Sickert wrote to Blanche in 1906 how he had 'started many beautiful music-hall pictures. I go to the Mogul Tavern every night' and how he was 'night and day absorbed in two magnificent Mogul Tavern pictures each measuring 30 inches by 25'. There are four Middlesex Music Hall pictures of this size (although today their measurements would be expressed as 25 × 30): two versions of *Noctes Ambrosianae*, *The Gallery of the Old Mogul* (C.240), and *The Old Middlesex* (Fig. 160).
It is not known which two of these four pictures were especially commended to Blanche by Sickert. However, it may be presumed that one was Fig. 159, the picture Sickert exhibited at the N.E.A.C. and the *Salon d'Automne* in 1906, and the picture of which he was to refer with such pride in letters to William Rothenstein (Chapter XI, note 19) and to Miss Hudson (Chapter XIII, p. 102).
The picture exhibited in 1906 can be identified as Fig. 159, rather than as the version in Birmingham catalogued below, because of its former possession by Walter Taylor. Sickert wrote to Rothenstein from Paris in 1906 (where *Noctes* had been on exhibition) that his 'situation has been simplified by the sale of Noctes Ambrosianae, for which Walter Taylor has paid me £40 bless him'. The *Sunday Times*, 7 October 1906, confirms that the *Salon d'Automne Noctes* was the same as that seen earlier at the N.E.A.C.

Version:
Canvas. 25 × 30 (63·5 × 76·2), Miss E. D. Trevelyan/Coll. Birmingham, City Art Gallery (1949). Exh. Edinburgh 53 (37). I have never come across a reference by Sickert to a second version of *Noctes Ambrosianae*. Stylistically this version and Fig. 159 are similar except that the picture illustrated is more carefully finished and incorporates more detail in both the architectural and figure definition. It is possible that the version was a full-scale rehearsal for Fig. 159 but more probable that it was painted later, after the sale of the original to Taylor.

Studies and drawings:
1. Pastel. 18¼ × 24 (46·4 × 60·9), from the collection of Morton Sands. Exh. Hull 68 (6). A full study in colour.
2. Pen and ink, heightened with white. 9 × 13½ (22·9 ×

34·3), Coll. Boston, Museum of Fine Arts (1962). A composition study, signed ('Rd. St. A.R.A.') and inscribed at a later date 'Study for engraving Noctes Ambrosianae'. It was, however, probably used as a study not only for the engraving but also for the paintings.
3. Pen and ink, chalk, heightened with white. 9⅛ × 13 (23·2 × 33), Coll. Liverpool, Walker Art Gallery (1948).
4. Pen and ink, heightened with white. 9½ × 9¼ (24·1 × 23·5), and another with identical details, both mounted on one sheet, Coll. Liverpool, Walker Art Gallery (1948). Exh. A.C.49 (13); A.C.64 (39).
Studies 3 and 4 are drawings of details of the composition, especially the figures; they are inscribed with colour notes.

231. THE OLD MIDDLESEX (Fig. 160) *c*.1906–7
Canvas. 25 × 30 (63·5 × 76·2)
'Sickert' b.r.
Leslie G. Wylde/Probably Christie's, 17 June 1932 (119)/ Sir Geoffrey Hutchinson/Christie's, 20 July 1951 (64)/
Coll. Fredericton, New Brunswick, Canada, The Beaverbrook Art Gallery (1954)
Rep. B.43, Pl. 2
Exh. Possibly Bernheim 1907 (38) as *The Middlesex Music Hall*
Chapter XI

I slightly prefer the dating 1906 to that of 1907, and certainly if this is the picture exhibited in Paris in January (the month of the Bernheim exhibition) it must have been painted in the earlier year.

Studies:
1. Fig. 161, C.232.
2. Pencil, pen and ink. 10¼ × 13⅞ (26 × 35·2), Dr. S. Leonard Simpson/Coll. Miss G. Simpson. Exh. Leicester Galleries 1964, 'New Year Exhibition' (39).
3. Pencil and chalk. 9 × 10 (22·9 × 25·4), Coll. Liverpool, Walker Art Gallery (1948). Exh. A.C.49 (3).
4. Pen and ink, chalk, heightened with white. 9½ × 8⅜ (24·1 × 21·4), Coll. Liverpool, Walker Art Gallery (1948). Exh. A.C.49 (4).
5. Pen and ink, chalk. 9½ × 9¼ (24·1 × 23·5), Coll. Liverpool, Walker Art Gallery (1948). Exh. A.C.49 (4).
6. Pen and ink, chalk. 9½ × 9¼ (24·1 × 23·5), Coll. Liverpool, Walker Art Gallery (1948). Exh. A.C.49 (4).
7. Pen and ink, chalk, heightened with white. 9¼ × 9⅛ (23·5 × 23·2), R.B.D./Private Collection, London. Exh. R.B.D.60 (48).
8. Pen and ink, chalk, heightened with white. 9½ × 8¼ (24·1 × 21), Mark Oliver/Agnew/Private Collection, U.S.A.
9. Chalk, heightened with white. 9 × 7 (22·9 × 17·8), Coll. Lord Methuen.
10. Pen and ink, chalk, heightened with white. 9 × 6¾ (22·9 × 17·1), Dr. S. Leonard Simpson/Coll. Miss G. Simpson.
Drawings 1–3 are full composition studies. Drawings 4–10 are studies of details: 4 is a programme cover; 5 and 6 are members of the audience; 7 is members of the orchestra and *artistes* not included in the painting: 8 is various orchestra figures: 9 is a 'cellist in the orchestra: 10 is the woman seated on the right side edge of the audience in the painting.

232. THE OLD MIDDLESEX (Fig. 161) c.1906

Pen and ink, charcoal, heightened with white
9⅜ × 11⅞ (23·8 × 30·2)
'Sickert' b.l.
Coll. Bedford, Cecil Higgins Art Gallery (1960)
Exh. R.B.D.60 (41); Tate 60 (29)
Chapter XI

The extraordinary technique of this drawing is sufficient
in itself to preclude an early dating (to the 1880s or 1890s)
of the painting Fig. 160 for which it is a study.

233. THÉÂTRE DE MONTMARTRE (Fig. 162) 1906

Canvas. 19¼ × 24 (48·9 × 61)
'Sickert' b.l.
Coll. Lady Keynes (on loan to King's College, Cambridge)
Rep. B.43, Pl. 15; B.60, Col. Pl. I
Exh. Probably Bernheim 1907 (35) and Bernheim 1909
 (63); N.G.41 (14); Leeds 42 (123); Edinburgh 53 (32);
 Agnew 60 (10); Tate 60 (48); Adelaide 68 (29)
Chapter XII

In the autumn of 1906 Sickert wrote in a letter to William
Rothenstein that he was doing 'a picture of the Montmartre
theatre' and in another letter that he was painting 'red and
blue places, instead of black ones. The Eldorado, the gaîté
Rochechouart, the théâtre de Montmartre' (for dating of
letters see Chapter XII, note 1). Fig. 162 is the only picture
of the Montmartre Theatre known to me, and the only Paris
music hall fully to justify the description 'red place'.

Study:
Chalk, heightened with white, squared. 9½ × 11½ (24·1 ×
29·2), Dr. Morland/Jack Beddington/Christie's, 25 March
1960 (99)/Agnew/Private Collection, London. Rep. B.60,
Pl. 15a. Exh. Agnew 1962, '89th Annual Exhibition of
Watercolours and Drawings' (173).
The dimensions of No. 63 at Bernheim-Jeune in 1909
correspond with those of Fig. 162 but in reverse. To avoid
repetition it is stated here that pictures shown at Bernheim
in 1909 (when dimensions were quoted) are assumed to be
the same as those shown under the same title in 1907 (when
dimensions were not quoted); and it is stated that Bernheim
were completely inconsistent about whether height or
width was cited first.

234. LA GAIETÉ ROCHECHOUART (Fig. 156) 1906

Canvas. 24 × 20 (61 × 50·8)
'Sickert' b.l.
Coll. Aberdeen, City Art Gallery (1950)
Exh. Possibly Bernheim 1907 (50) and Bernheim 1909 (64);
 A.C.64 (15)
Chapter XII

Sickert painted several different aspects of the Gaieté
Rochechouart in 1906. Either this picture or C.241 could
be the *Gaieté Rochechouart* shown at Bernheim-Jeune in 1907
and 1909.

Studies:
1. Pen and ink, pencil, chalk, heightened with white.
 12 × 9¾ (30·5 × 24·8), Coll. London, British Museum
 (1938). A study of the whole composition.

2. Pen and ink, chalk, heightened with white. 12¼ × 10
 (31·1 × 25·4), Coll. Liverpool, Walker Art Gallery
 (1948).
3. Pen and ink, chalk, heightened with white. 9½ × 11½
 (24·1 × 29·2), Coll. Aberdeen, City Art Gallery (1947).
 Exh. A.C.64 (42). Studies 2 and 3 are of the figures.

235. THE ELDORADO (Fig. 163) c.1906

Canvas. 19 × 23¼ (48·3 × 59)
Mme Jeanne Edwards de Gandarillas/Charles E. Eastman/
 Sotheby's, 1 May 1968 (19)/
Coll. Birmingham, Barber Institute of Fine Arts (1968)
Chapter XII

A painting of *The Eldorado* was shown at Bernheim in 1907
(42) but not in 1909. A different aspect of the Eldorado is
catalogued C.245.
Fig. 163 may be one of the 'blue places' mentioned to
Rothenstein. A smoky grey-blue runs throughout the
background architecture and pervades the total colour
harmony in which the figures are picked out in grey, black,
and violet, with touches of yellow ochres for the lights and
isolated notes of rust red glinting here and there.

Version:
Canvas. 19½ × 24½ (49·5 × 62·2), Mrs. M. Clifton/Coll.
J. C. King Esq. Rep. *Studio*, 100, November 1930, p. 324.
Exh. Agnew 60 (13) as *The Old Bedford*; New York 67 (13),
rep. in catalogue; Sydney 68 (21). Probably unfinished;
painted in blues, greys, with some green, over a very fine
canvas.

Studies include:
1. Chalk, pen and ink, heightened with white, squared in
 red. 9½ × 11¾ (24·1 × 29·9), Mark Oliver/Coll. Richard
 Attenborough Esq.
2. Chalk, heightened with white. 11½ × 9¼ (29·2 × 23·5),
 Coll. H. K. B. Lund Esq.

236. GAIETÉ MONTPARNASSE (Fig. 164) c.1907

Canvas. 24 × 20 (61 × 50·8)
'Sickert' b.r.
G.P. Dudley Wallis/the Hon. John Fremantle (Lord
 Cottesloe)/Mr. and Mrs. Emil Ford/
Coll. New York, Museum of Modern Art (1959)
Exh. Possibly N.E.A.C. summer 1909 (169); N.G.41 (69);
 Leeds 42 (156); New York 67 (36); Columbus Gallery
 of Fine Art 1971, 'British Art 1890–1928' (100)
Chapter XII

The Gaieté Montparnasse was not one of the music halls
which Sickert told Rothenstein he was painting in 1906.
There is, however, a chalk drawing, heightened with
white, 12¼ × 9¼ (31·1 × 23·5), Private Collection, England,
which is inscribed 'Gaité Montparnasse 1907'. It is probable
that Sickert's three known paintings of the *Gaieté Mont-
parnasse* (Fig. 164, Fig. 165 and Version) were all painted in
1907 even though the dated drawing is not specifically
related to any of them. (See Chapter XII, note 2 for the
suggestion that Sickert may have returned to London
briefly in December 1906 and then gone back again to
Paris in January 1907).

Studies:
1. Chalk, heightened with white, squared. 11⅝ × 9¼ (29·5 ×
 23·5), Coll. Manchester, City Art Gallery (1925).

2. Charcoal and chalk. 10¾ × 9¼ (27·3 × 23·5), Coll. Mrs. Stephen Raphael. Exh. Agnew 1966, 'French and English Drawings 1780–1965' (63), rep in catalogue.
Study 1 is a full composition drawing; study 2 examines the audience in the circle or gallery.

237. GAIETÉ MONTPARNASSE. DERNIÈRE GALERIE DE GAUCHE (Fig. 165) c.1907

Canvas. 23¼ × 19 (59 × 48·3)
'Sickert' b.r.
From the collection of Morton Sands
Exh. Bernheim 1909 (44); Agnew 60 (1); Brighton 62 (76)
Chapter XII

The suggestion that the *Gaieté Montparnasse* pictures were painted in 1907 rather than 1906 is supported by the fact that none of them were exhibited at Bernheim-Jeune in January 1907, but Fig. 165 and its complement, *Dernière Galerie de Droite* (details below) were shown in 1909:
Canvas. 23¼ × 19 (59 × 48·3), Dr. John Burton/Sotheby's, 6 April 1960 (145), bought Callinan. Exh. Bernheim 1909 (45).
Studies:
1. Pen and ink, chalk, heightened with white. 11½ × 8¼ (29·2 × 21), Coll. Liverpool, Walker Art Gallery (1948). Exh. A.C.49 (25). The curve of the gallery or circle.
2. Pen and ink, chalk, heightened with white. 12 × 9¾ (30·5 × 24·6), Coll. Liverpool, Walker Art Gallery (1948). Exh. A.C.49 (24). The wall festoon.
3. Pen and ink, pencil, chalk, heightened with white, squared. 12½ × 9½ (31·8 × 24·1), Last known owner C. Marescoe Pearce Esq. Rep. Emmons, facing p. 60. Exh. Sheffield 57 (101); Tate 60 (33). A composition study showing the subject as in Fig. 165, not in reverse as in *Dernière Galerie de Droite*.

238. THE NEW BEDFORD (Fig. 166) c.1908-9

Canvas. 36 × 14 (91·5 × 35·5)
'Sickert' b.l.
Hugh Hammersley/Dr. Robert Emmons/
Coll. A. D. Peters Esq.
Rep. B.43, Pl. 26
Exh. Probably A.A.A.1909 (240) and N.E.A.C. winter 1909 (9); N.G.41 (97); Leeds 42 (153); Agnew 60 (55)
Chapter XIII

The only music hall painting known to me executed between 1907 and 1914–15. In a letter to Miss Hudson written in 1908 (the letter can be dated because Sickert sketched *L'Américaine*, a dated work of 1908, to show Miss Hudson on what picture he was working) Sickert reported that he was 'doing the Bedford Music Hall'.
Fig. 166 is the basis of the later versions of *The New Bedford* (Fig. 255, C.365). The chronology of the many drawings of *The New Bedford* is complicated by the fact that Sickert studied the music hall again, intensively, in 1914–15 and yet the painting he then executed from these studies is substantially the same in composition and in much detail to Fig. 166. It is, therefore, difficult to separate the studies made in 1908 from those made in 1914–15. However, most of the extant studies, including almost all of the large collection in the Walker Art Gallery, Liverpool, seem to be works of the later rather than the earlier date.

Studies made c.1908 include:
1. Pencil and chalk. 12¾ × 5½ (32·4 × 14), H. H. Harrod/ Coll. London, Victoria and Albert Museum (1948). Possibly an early idea for the composition of Fig. 166; it shows the full height of the theatre with the heads of two figures (different from those in Fig. 166 and later versions) scribbled in the foreground.
2. Chalk, heightened with white, squared. 18 × 7¼ (45·7 × 18·4), C. Marescoe Pearce/Sotheby's, 12 April 1967 (31)/Mercury Gallery 1970. Exh. Tate 60 (128).
3. Pencil, chalk, heightened with white, squared. 17 × 13 (43·2 × 33), Coll. Lord Sherfield. Exh. Agnew 1970, 'From the Pre-Raphaelites to Picasso II' (67). Studies 2 and 3 are clearly related to Fig. 166; the main lines of the composition and several incidental figures found in the drawings are repeated in the painting.
4. Chalk. 11½ × 4¾ (29·2 × 12·1), Coll. Liverpool, Walker Art Gallery (1948). A study of the girl in the box wearing a wide-brimmed hat; it is copiously inscribed with colour notes.
5. ?Pen and ink, squared. Size and whereabouts of original unknown. Rep. the *New Age*, 29 June 1911. Virtually identical to Fig. 167 except that it is finished on the right where Fig. 167 is left blank.
6. Black and red chalk, squared. 18 × 8 (45·7 × 20·3), Private Collection, England. A full composition study similar in detail to Fig. 167.
7. Fig. 167, C.239.

239. THE NEW BEDFORD (Fig. 167) c.1908

Pen and ink, wash, squared. 18 × 7 (45·7 × 17·8)
'Sickert' b.r.
Private Collection, Scotland
Chapter XIII
The drawing reproduced in the *New Age* in 1911 (Fig. 166, C.238, Study 5) was clearly derived from this drawing, perhaps initially traced and then finished in pen and ink.

240. THE GALLERY OF THE OLD MOGUL 1906

Canvas. 25 × 30 (63·5 × 76·2)
'Sickert' b.l.
Jacques-Émile Blanche/Dr. Cobbledick/Sir Michael Redgrave/Anthony Lousada/
Coll. David Samuelson Esq.
Rep. B.60. Pl. 13
Exh. Bernheim 1907 (47); Bernheim 1909 (58); Edinburgh 53 (43); Sheffield 57 (9); R.B.D.60 (14); Tate 60 (76)
Chapter XI
Bought by Blanche from the 1909 exhibition (where it was catalogued as *The Mogul Gallery*). It is probable that the audience in C.240 are looking at a cinema screen, rather than at a live performance. Sickert showed a picture called *Cinematograph* at the N.E.A.C. winter 1912 (197) but the *Mogul Gallery* was then in France.
Studies:
1, 2, 3, 4. All chalk, heightened with white, all Coll. Liverpool, Walker Art Gallery (1948). 1. 9½ × 9 (24·1 × 22·9); 2. 9 × 11¾ (22·9 × 29·9), 1 and 2 exh. A.C.49 (5). 3. 9¼ × 9⅝ (23·5 × 24·5). Rep. B.60, Pl. 13a; 4. 9½ × 8½ (24·1 × 21·6), 3 and 4 exh. A.C.49 (6). 5. Pen and ink, chalk, heightened

with white. $9\frac{7}{8} \times 9\frac{1}{2}$ (25 × 24·1), Coll. Aberdeen, City Art Gallery (1947). All these drawings are studies of the audience.

241. GAIETÉ ROCHECHOUART c.1906
Canvas. $19\frac{3}{4} \times 24$ (50·2 × 61)
John McDonnell/
Coll. John Mills Esq.
Exh. Possibly Bernheim 1907 (50) and Bernheim 1909 (64) if not C.234; R.B.D.60 (34) rep. in catalogue; Tate 60 (19)
Chapter XII

A view looking from the stage at the darkened interior of the theatre.

Study:
Pen and ink, chalk, heightened with white. $9\frac{7}{8} \times 12$ (25 × 30·5), Coll. Aberdeen, City Art Gallery (1947). This study, inscribed with the title, is also inscribed 'Ju-jitsu' beneath a separate study of a woman's head, but the meaning of the inscription is unknown to me. The main feature of this drawing is the ornate light bracket.

242. LES LOGES c.1906
Canvas. 18×24 (45·7 × 61)
Christie's, 28 January 1927 (146)/Mark Oliver/
Private Collection, London
Rep. B.60, Pl. 14
Exh. Probably Bernheim 1909 (48); N.G.41 (85); Leeds 42 (146); Sheffield 57 (8); Agnew 60 (4); Tate 60 (50)
Chapter XII

Another view of the Gaieté Rochechouart.

Studies:
1. Pen and ink, chalk, heightened with white. $10 \times 12\frac{1}{4}$ (25·4 × 31·1), Coll. Liverpool, Walker Art Gallery (1948).
2. Pen and ink, chalk. $8\frac{3}{4} \times 12\frac{1}{2}$ (22.2 × 31·8), Coll. Aberdeen, City Art Gallery (1947), now lost, probably stolen during the 1960s. This study is inscribed with the name of the hall (and thus serves to identify the subject of *Les Loges*). Both studies show the figures in the *loges* but omit the foreground audience.

243. GAIETÉ ROCHECHOUART c.1906
Canvas. $12\frac{1}{2} \times 6\frac{1}{2}$ (31·8 × 16·5)
Coll. Derek Hill Esq.
Exh. Tate 60 (20)
Chapter XII

A rough impressionistic little sketch of a trapeze *artiste* glimpsed behind two members of the audience.

244. GAIETÉ ROCHECHOUART c.1906
Pen and ink, chalk, heightened with white, squared. $9\frac{5}{8} \times 11\frac{3}{4}$ (24·5 × 29·9)
'Gaité Rochechouard Sickert' b.r.
Miss Ursula Tyrwhitt/
Coll. Oxford, Ashmolean Museum (1965)
Chapter XII

No painting of this composition, a view of the theatre seen in a mirror, is known to me.

The misspelling of the name of the theatre is found on all Sickert's inscribed drawings of this music hall.

245. THE ELDORADO c.1907
Canvas. $20 \times 24\frac{1}{2}$ (50·8 × 62·2)
'Sickert' b.r.
J. B. Priestley/
Private Collection
Exh. Agnew 60 (71)
Chapter XII

A view of the sweeping curve of the dress circle taken from the opposite side to Fig. 163. Probably painted in 1907 rather than in 1906, partly because of the similarity of its colour harmony and handling to the Gaieté Montparnasse pictures, and partly because a dated drawing of 1907 is probably a study related to this painting.

Studies:
1. Pen and ink, chalk, heightened with white. 10×7 (25·4 × 17·8), Jack Beddington/Christie's, 25 March 1960 (100)/Private Collection, London. This drawing is inscribed 'Paris 1907'. It is a study of heads, drawn from the same angle as those seen in the painting and in the two studies listed below, but it cannot definitely be identified as a study for *The Eldorado*.
2. Pen and ink, chalk, heightened with white. $11 \times 9\frac{1}{4}$ (28 × 23·5), Agnew/Private Collection, London.
3. Chalk, heightened with white. $10\frac{7}{8} \times 9\frac{1}{2}$ (27·7 × 24·1), Agnew/Private Collection, London.

Studies 2 and 3 show the audience and indicate the architectural setting.

246. THE ELDORADO c.1906
Black chalk, heightened with white on brown paper, squared. $11\frac{5}{8} \times 9\frac{1}{4}$ (29·5 × 23·5)
Coll. London, British Museum (1913) presented by Sickert
Chapter XII

I know of no painting which reflects the composition of this squared drawing of the orchestra pit and part of the stage.

247. THE NEW BEDFORD c.1906–7
Canvas. 20×16 (50·8 × 40·6)
'Sickert' b.l.
From the collection of Edward le Bas
Exh. Sheffield 57 (91) as *The Old Bedford*; R.A.1963, 'A Painter's Collection' (148)
Chapter XIII

The first known painting by Sickert of *The New Bedford*; it shows the audience in a box. This box was to become an important feature of Sickert's later representations of the New Bedford, but in C.247 the dramatic vertical compositional structure of the later pictures was not yet conceived. The dark tonality and colours, and the general handling, suggest that C.247 was painted 1906–7. At the N.E.A.C. summer 1907 (27) Sickert showed a drawing of *The New Bedford*. A thumb-nail sketch in the catalogue belonging to the Tate Gallery archives shows it was similar in composition to C.247.

AUTUMN 1906. PARIS (HÔTEL DU QUAI VOLTAIRE), FIGURES

248. WOMAN WASHING HER HAIR (Fig. 170) 1906
Canvas. 18 × 15 (45·7 × 38·1)
'Sickert' b.l.
Lord Henry Cavendish-Bentinck/
Coll. London, Tate Gallery (1940)
Rep. Bertram, Pl. 19
Lit. Tate Gallery Catalogue, 1964, p. 630
Exh. Possibly Bernheim 1907 (21) as *La Toilette*
Chapter XII

One of the 'whole set of interiors in the hotel, mostly nudes' which Sickert told Rothenstein he was painting in Paris in the autumn of 1906. Later, when Miss Hudson stayed in the Hôtel du Quai Voltaire in Paris, Sickert was prompted to recall his own experiences in the hotel; he wrote to Miss Hudson, 'I had the most enchanting little model the thinnest of the thin like a little eel, and exquisitely shaped, with red hair'. Her name was Blanche and she 'called the part she sat upon "*ma figure de dimanche*" and had endless other endearing sayings'. Blanche was the model for Figs. 170, 171 and C.253.

249. SEATED NUDE (Fig. 171) 1906
Canvas. 17¾ × 14¾ (45 × 37·5)
'Sickert' b.l.
Angus Wilson/Odo Cross/Sotheby's, 17 March 1965 (28)/
Agnew Private Collection, England
Chapter XII

250. JEANNE (Fig. 168) 1906
Canvas. 15 × 18 (38·1 × 45·7)
'Sickert' b.r.
Christie's, 28 March 1930 (123)/Robert Haines/
Coll. Dr. and Mrs. Warwick Arrowsmith, Brisbane
Exh. Bernheim 1907 (10); Adelaide 68 (32)
Chapter XII

A study for this picture is reproduced as Fig. 172.

251. HÔTEL DU QUAI VOLTAIRE NUDE (Fig. 172) 1906
Pen and ink, chalk, heightened with white on brown paper.
12¾ × 11¼ (32·4 × 28·6)
'Hôtel du Quai Voltaire—Cézanne's model' b.l., 'Rd. St. A.R.A.' b.r. in pen; and 'Hl. du Quai Voltaire Old Model' b.r. in pencil
H. S. Reitlinger/Sotheby's, 26 May 1954 (569)/
Coll. Leicester, City Museum and Art Gallery (1954)
Exh. Sheffield 57 (105); A.C.64 (41)
Chapter XII, and note 7

The pen inscription, including the words 'Cézanne's model', was probably added later when Sickert signed the drawing. It is a study for *Jeanne*, Fig. 168.

252. RECLINING NUDE (Fig. 169) 1906
Canvas. 15 × 18 (38·1 × 45·7)
Howard Bliss/J. W. Blyth/Sotheby's, 15 April 1964 (17)/
Coll. Lady Turner, London
Exh. Tate 60 (102)
Chapter XII

Almost certainly another Hôtel du Quai Voltaire nude (compare the bed and its placing with Fig. 168). The style and handling of Fig. 169 were not unique to this one figure painting of 1906. *Regrets*, Canvas. 18 × 22 (45·7 × 55·9), John Caftanzoglou/Coll. Mme Mary Averoff, Paris. Exh. Bernheim 1907 (76); Bernheim 1909 (30) where it was bought by M. Caftanzoglou, is handled in the same manner. It shows a clothed figure, seated on a bed, looking down at a partially obscured reclining figure.

253. LE CABINET DE TOILETTE 1906
Canvas. 18 × 15 (45·7 × 38·1)
'Sickert' b.l.
Dr. Seymour Cochrane Shanks/
Coll. Count N. Labia, Capetown
Exh. Probably Bernheim 1907 (15); Agnew 60 (56)
Chapter XII

The model and setting are the same as in Figs. 170 and 171. The nude girl (Blanche) is seen full-length, standing in the doorway of the *cabinet de toilette* as represented in Fig. 170.

254. HÔTEL DU QUAI VOLTAIRE NUDE 1906
Black chalk, heightened with white. 9 × 13 (22·9 × 33)
'Hôtel du Quai Voltaire' b.l., 'Sickert' b.l.
Coll. Vernon A. Eagle Esq., New York City
Exh. R.B.D.60 (44); R.B.D.63 (37)
Chapter XII

The setting is the same as in Figs. 168, 169 and 172, but the model is differently posed.

1907–9. PORTRAITS AND FIGURES

255. WOMAN SEATED ON A BED (Fig. 176) dated 1907
Canvas. 26 × 32 (66 × 81·3)
'Sickert Dieppe 1907' b.l.
Coll. London, Arts Council of Great Britain (1955)
Chapter XIII

256. THE POET AND HIS MUSE *or* **COLLABORATION** (Fig. 173) c.1907
Canvas. 18 × 9 (45·7 × 22·9)
'Sickert' b.r.
Miss Sylvia Gosse/
Coll. Eastbourne, Towner Art Gallery (1955)
Exh. Probably Bernheim 1907 (72) as *Le Poète et sa Muse*;
 R.A.1925 (422) as *The Poet and his Muse*
Chapter XIII

Study for the female figure:
Charcoal, pen and ink, heightened with white. 8¼ × 4½ (21 × 11·5), Mrs. Grace Wheatley/Christie's, 11 November 1958 (21)/Coll. Alastair R. Goodlad Esq. Exh. Agnew 60 (233). Dated 'Paris 1907'.

Many press reviews prove that Fig. 173 is the work exhibited at the Royal Academy in 1925 as *The Poet and his Muse*. It is, therefore, probable that the painting is the work exhibited under the same title (in French translation) in Paris in January 1907. If it was painted in time for inclusion in this exhibition it is Sickert's first known picture of a nude woman and clothed man—although the subject of

Fig. 173 (artist and model) does not possess the illustrative associations typical of the later Camden Town domestic dramas.

The theme of painter and model seems to have interested Sickert at this period. Another example of about the same date is *The Painter and his Model*. Canvas. 23½ × 19¼ (59·7 × 49), Sotheby's, 17 July 1968 (11)/Coll. Mrs. E. Corob. Exh. Probably Bernheim 1909 (52). Its execution is even more summary than *Collaboration* and its lack of finish gives the subject an enigmatic, almost grotesque quality.

257. THE JUVENILE LEAD. SELF-PORTRAIT (Fig. 174)
1907

Canvas. 20 × 18 (50·8 × 45·7)
'Sickert' b.l.
Mrs. Wylde/David Niven/
Coll. Southampton, Art Gallery (1951)
Rep. B.43, Pl. 30; Bertram, facing p. 4; B.60, Pl. 55; Rothenstein 1961, Col. Pl. 8; Pickvance 1967, Col. Pl. IX
Exh. *Salon d'Automne* 1907 (1535) as *L'Homme au Chapeau Melon*; Edinburgh 53 (62); Tate 60 (114); Wildenstein London 1970, 'Pictures from Southampton' (31)
Chapter XIII, and note 2

A letter to Miss Hudson written in 1907, in which Sickert quoted this self-portrait as a 'punching-ball' when he had decided to paint more 'considered, elaborated works', was quoted in the text. Sickert described the picture as a 'life-sized head of myself in a cross-light which will I think become something in time'. Another letter to Miss Hudson (Chapter XIII, note 2) confirms that the *Salon d'Automne* picture was indeed this self-portrait.

258. THE PAINTER IN HIS STUDIO (Fig. 178) 1907

Canvas. 20 × 24 (50·8 × 61)
'Sickert' b.l.
Hugh Hammersley (bought from Sickert in 1907)/ Christie's, 25 April 1930 (125)/Dr. Robert Emmons/ Mrs. George Swinton/
Coll. Hamilton Art Gallery, Ontario (1970)
Rep. B.60, Pl. 58
Exh. N.E.A.C. summer 1907 (73) as *The Parlour Mantelpiece*; A.C.64 (16); R.B.D.1970, 'Sickert to Sutherland' (18)
Chapter XIII, and note 3

The evidence which proves that Fig. 178 is the picture exhibited in May-June 1907 as *The Parlour Mantelpiece* was quoted in Chapter XIII, note 3 but will be repeated here: (i) the annotation 'blue specs in face and casts' by No. 73 in the copy of the N.E.A.C. catalogue in the Tate Gallery archives; (ii) a letter to Miss Hudson reporting 'the New English is open, and to my amazement and joy my friend Hammersley bought my *autorittrato* at once'; (iii) confirmation that this '*autorittrato*' [self-portrait] was indeed the self-portrait with plaster-casts illustrated as Fig. 178 is obtained from a later letter to Miss Hudson telling of other purchases by Hammersley who already had 'my portrait with the casts in the last New English'.

259. MORNINGTON CRESCENT NUDE (Fig. 175) 1907

Canvas. 19½ × 16 (49·5 × 40·6)
'Sickert' b.l.
Hugh Hammersley (bought from Sickert in 1907)/ Lord Cottesloe/T. W. Strachan/
Coll. William E. Wallace Esq.
Rep. B.43, Pl. 32; B. 60, Pl. 56
Exh. Leeds 42 (163); Edinburgh 53 (27); R.B.D.60 (20); Tate 60 (110); Brighton 62 (32)
Chapter XIII, and note 4

See Chapter XIII, note 4 for a summary of the evidence which serves to date Fig. 175 and other Mornington Crescent paintings of the nude (e.g. Fig. 179), as well as the paintings of *Little Rachel* (Fig. 182, C.263 and Fig. 184), 1907.

Drawings related to Fig. 175 (discussed in the text):
1. Chalk. 15¼ × 10 (38·8 × 25·4), Professor Henry Tonks/ Coll. Capetown, South African National Gallery (1936).
2. Chalk. 13⅜ × 7⅝ (33·9 × 19·4), Coll. Oxford, Ashmolean Museum (1966). Inscribed 'Maud', presumably the name of the model.
3. Chalk, heightened with white. 14¾ × 10 (37·5 × 25·4), Coll. Liverpool, Walker Art Gallery (1948). Exh. A.C.49 (21).

All three drawings are studies of the nude seen from the back; in 2 and 3 her hair hangs loosely. Later, in Fig. 188, she is joined by a man.

260. MORNINGTON CRESCENT NUDE. CONTRE-JOUR (Fig. 179) 1907

Canvas. 20 × 24 (50·8 × 61)
'Sickert' b.l.
Hugh Hammersley (bought from Sickert in 1907)/
Coll. Adelaide, Art Gallery of South Australia (1963)
Rep. F. Wedmore, *Some of the Moderns*, London, Virtue 1909 as *Camden Town Interior*; B.43, Pl. 29
Exh. Agnew 60 (75); Adelaide 68 (30); Sydney 68 (9)
Chapter XIII, and note 4

In 1907 (for dating see Chapter XIII, note 4) Sickert wrote to Miss Hudson that Hammersley came to his studio and bought three new pictures, two nudes (which must be Figs. 175, 179) and a child by a window (which is almost certainly Fig. 182).

261. MORNINGTON CRESCENT NUDE (Fig. 177) c.1907

Canvas. 18 × 20 (45·7 × 50·8)
'Sickert' b.l.
O. Sainsière/Norton Simon/Parke-Bernet, New York, 5 May 1971 (50)/Agnew
Private Collection, England
Chapter XIII

Related in theme, composition, and handling to Fig. 179 and C.276.

262. NUDE STUDY: WOMAN RECLINING No. 21 (Fig. 180) c.1907

Chalk, heightened with white, on brown paper
14⅜ × 9¼ (36·5 × 23·2)
'Sickert' b.l., '21' t.r.
Dr. E. J. Sidebotham/

Coll. Whitworth Art Gallery, University of Manchester (1924)
Chapter XIII

A study of the model for some of the Mornington Crescent Nudes (e.g. Fig. 179, C.276, C.277) and the *Camden Town Murder* (Fig. 192).

263. GIRL AT A WINDOW. LITTLE RACHEL (Fig. 182) 1907

Canvas. 20 × 16 (50·8 × 40·6)
'Sickert' b.r.
Probably Hugh Hammersley (bought from Sickert in 1907)/ Dr. Robert Emmons/T. W. Strachan/
Coll. William E. Wallace Esq.
Exh. Edinburgh 53 (13); R.B.D.60 (24); Brighton 62 (31)
Chapter XIII, and note 4

See Chapter XIII, note 4 for suggestion that this is the 'child at a window' bought by Hammersley in 1907. In any case it is one of a series of paintings and drawings of Little Rachel done in Mornington Crescent in 1907. Sickert described Little Rachel to Miss Hudson as 'a little Jewish girl of 13 or so with red-hair'. Some paintings of her have been known as *The Frame-Maker's Daughter* which perhaps explains how she came to model for Sickert. Information in the archives of Thos. Agnew & Sons, Ltd. identifies the model as Miss Siderman who died, aged 70, in 1963.
Other paintings of Little Rachel include:
1. Canvas. 21 × 16 (53·3 × 40·6), Coll. Keith Baynes Esq. Exh. Agnew 60 (59) as *Chez Verney*; Columbus Gallery of Fine Art 1971, 'British Art 1890–1928' (101), rep. in catalogue. The title *Chez Verney* has nothing to do with *Chez Vernet*, a Dieppe café which Sickert drew and painted *c.*1920. In fact the title *Chez Verney* was probably given to the painting of Little Rachel by mistake. Mr. Baynes also owns a painting of the Dieppe subject, *Chez Vernet*, and it is probable that at some time the title of the later picture, misspelt or anglicized, was applied to the Mornington Crescent subject. How and when the confusion occurred is unknown.
Studies for Painting 1 include:
a. Pen and ink, chalk, heightened with white. 13¼ × 9½ (33·7 × 24·1), Mrs. Grace Wheatley/Christie's, 11 November 1958 (7)/Agnew/Private Collection, London. Exh. Agnew 60 (247). A complete composition study.
b. Chalk, heightened with white. 12½ × 8½ (31·7 × 21·6), Coll. University of Reading (1957). Inscribed (after its execution, at the same time as it was signed 'Rd. St. A.R.A.') 'Rachel—study for painting in possn. of Keith Baynes Esq.'.
Sickert's habit of painting Little Rachel and a nude on alternate days (as described to Miss Hudson) is strikingly illustrated by a painting of the nude, seen from the back, within a setting and composition identical to Painting 1. The nude is looking at herself in the oval mirror on the chest of drawers, just as Little Rachel does in Mr. Baynes's painting. The *Nude* is: Canvas. Size unknown. J. B. Priestley/Last known owner F. J. Lyons Esq.
2. Canvas. 24 × 20 (61 × 50·8), Mrs. Rayner/Dr. Robert

Emmons/Coll. Brisbane, National Art Gallery of Queensland (1956), Rep. B.43, Pl. 34. Exh. Eldar Gallery 1919 (1); Edinburgh 53 (55); Adelaide 68 (38); Sydney 68 (11).
3. *The Frame-Maker's Daughter.* I have seen a photograph of this painting but its details and whereabouts are unknown to me. It is a three-quarter length portrait of Rachel seated; its format suggests it may be the picture 24 × 12, mentioned B.43, p. 50, then owned by Samuel Carr.
4. Canvas. 16 × 12 (40·6 × 30·5), Dr. Cobbledick/Present whereabouts unknown. Exh. Chicago; Pittsburgh 1938 (23); N.G.41 (66). Rep. *Britain Today*, No. 63, 3 October 1941.
5. Fig. 184.
Drawings of Little Rachel, excluding those listed as studies for Painting 1 above, include:
1. Pastel. 25 × 19 (63·5 × 48·3), Christie's, 19 July 1968 (246)/Messrs. Roland, Browse and Delbanco 1971. Rep. Rothenstein 1961. Exh. R.B.D.1971 'British Paintings and Drawings' (44) as *The Frame-Maker's Daughter*. A profile portrait.
2. Pen and ink, chalk, heightened with white. 14½ × 9¾ (36·8 × 24·8), Christie's, 12 June 1970 (48)/Abbott and Holder, Barnes. This sheet of studies is perhaps related to Painting 3 listed above.
3. Charcoal, heightened with white. 12¼ × 8½ (31·1 × 21·8), Coll. Manchester, City Art Gallery (1947).
4. Charcoal, heightened with white. 10 × 14½ (25·4 × 36·8), Coll. London, British Council (1943). Inscribed 'le petit Jesus' (usually misread 'le petit Jewess', see Chapter XIII, note 7).
Drawings 3 and 4 show Rachel seated on a leather couch.

264. LITTLE RACHEL (Fig. 184) 1907

Canvas. 16⅝ × 13¾ (42·2 × 35)
'Sickert' t.l. and b.l.
Sotheby's, 12 July 1961 (165)/
Coll. Plymouth, City Museum and Art Gallery (1961)
Exh. R.B.D.60 (27)
Chapter XIII

265. LE COLLIER DE PERLES (Fig. 183) *c.*1907–8

Canvas. 20½ × 16 (52 × 40·6)
Coll. Commander Sir Michael Culme-Seymour, Bt.
Lit. R. Pickvance, *Apollo*, 76, April 1962, pp. 404–5, 'Sickert at Brighton'
Exh. Brighton 62 (48)
Chapter XIII

Assumed by Pickvance to be a Venetian work of *c.*1904, but more likely to be a portrait of Mrs. Barrett (wearing imitation beads) painted *c.*1907–8. Other portraits of Mrs. Barrett of about this period include:
1. *The Red Blouse*. Canvas. 19¾ × 15¾ (50·2 × 40), Coll. Lady Hayward, Adelaide. Exh. Adelaide 68 (36). The sitter appears to be wearing the same clothes, and perhaps the same necklace, as in Fig. 183.
2. *Contemplation*. Panel. 15½ × 13⅜ (39·4 × 34), A. C. J. Wall/Christie's, 30 October 1970 (206)/Messrs. Roland, Browse and Delbanco 1971. This picture probably

represents Mrs. Barrett. It may have been painted *c.*1909 because the colours used are bright (royal blue, yellow, scarlet, emerald green) and the paint is very thickly impasted.

266. L'AMÉRICAINE (Fig. 185) dated 1908

Canvas. 20 × 16 (50·8 × 40·6)
'Sickert-1908' b.r.
Lord Henry Cavendish-Bentinck/
Coll. London, Tate Gallery (1940)
Rep. Bertram, Pl. 21; B.60, Pl. 54
Lit. Tate Gallery Catalogue 1964, p. 630
Exh. N.E.A.C. summer 1909 (188) as *The American Sailor Hat*; Bernheim 1909 (4) under the same title
Chapter XIII

In a letter to Miss Hudson Sickert sketched this picture (to show his correspondent what he was currently painting) and explained, 'I am deep in two divine costergirls—one with sunlight on her indoors. You know the *trompe l'œil* hat all the coster girls wear here with a crown fitting the head inside and expanded outside to immense proportions. It is called an "American sailor" (hat).'

There are drawings of this model including:
1. Pen and ink, chalk. 12⅛ × 9⅝ (30·8 × 24·5), Private Collection, Scotland. Inscribed 'The "American Sailor" Hat'.
2. Chalk, heightened with white. 9½ × 7½ (24·1 × 19), Sotheby's, 9 December 1970 (48)/Messrs. Thos. Agnew & Sons, Ltd. 1971. Exh. Agnew 1971, 'A Century of Modern Drawings and Prints' (55). This drawing is inscribed 'Camden Town' and dated 'Sickert 1908'.

Neither drawing shows the model in the same pose as Fig. 185.

267. THE NEW HOME (Fig. 181) 1908

Canvas. 20 × 16 (50·8 × 40·6)
'Sickert' b.l.
Leeds, City Art Gallery, exchanged 1938/A. J. L. McDonnell/ Last known owner F. A. Girling Esq.
Rep. B.43, Pl. 39; Rothenstein 1961. Col. Pl. 16; Pickvance 1967, Col. Pl. XI
Exh. N.E.A.C. summer 1908 (59); Sheffield 57 (97); Tate 60 (123)
Chapter XIII

Possibly the other 'divine costergirl' mentioned in Sickert's letter to Miss Hudson of 1908 (see note to C.266).
The identification of Fig. 181 with the picture exhibited in 1908 is proved by (i) the review in the *Pall Mall Gazette*, 3 June 1908: 'Here is a young woman ill at ease, apparently her hat not yet removed—her head and bust seen large against the mantelshelf—and she taking very unkindly to the second-rate, sordid lodging, to which she is condemned by an unkindly Fate'; and (ii) a thumb-nail sketch of *The New Home* in the annotated catalogue of the N.E.A.C. exhibition in the Tate Gallery archives; it clearly represents Fig. 181. It should be noted that this identification disproves the undocumented tradition that Fig. 181 represents either Christine Sickert (née Angus) or her sister, painted in 1911 or 1912.

Another painting of this model of about this date: *Girl in a Sailor Hat*. Canvas. 20 × 16 (50·8 × 40·6), Oliver Brown/ R.B.D./Private Collection. Exh. Leicester Galleries 1967, 'Gallery Group II' (87).

268. THE CAMDEN TOWN MURDER (Fig. 188) 1908

Chalk, heightened with white. 10 × 9¾ (25·4 × 24·8)
'Sickert' b.r.
Coll. Dr. S. Charles Lewsen
Exh. Edinburgh 53 (86) as *The Discussion—Man and Woman seated on a Bed*; Sheffield 57 (136) as *Figures in an Interior*
Chapter XIII

The etching of this composition is dated 1908 and called *The Camden Town Murder*, although in common with nearly all Sickert's pictures with this title it bears no identifiable relationship to an episode in the history of Emily Dimmock's murder in September 1907 (beyond depicting the intimacy of lovers).

269. THE CAMDEN TOWN MURDER *or* **WHAT SHALL WE DO FOR THE RENT?** (Fig. 192) *c.*1908

Canvas. 10 × 14 (25·4 × 35·5)
'Sickert' b.r.
Private Collection
Rep. B.43, Pl. 28; B.60, Pl. 62
Chapter XIII

Fig. 192 is now known as *The Camden Town Murder* but the drawn studies for it are usually called by the alternative title.

Studies include:
1. Chalk, heightened with white. 9¼ × 14¾ (23·5 × 37·5), Dr. Robert Emmons/Christie's, 1 June 1956 (120)/Mrs. Cyril Kleinwort/Sotheby's, 15 April 1964 (13)/Agnew/ Private Collection, U.S.A. Rep. Emmons, p. 130; Bertram, Pl. 23.
2. Chalk, heightened with white. 9¾ × 14¼ (24·8 × 36·2), Mark Oliver/Coll. the Hon. Robert Coe, Cannes. Inscribed 'Sketch for "What shall we do about the rent?"'.
3. Chalk, heightened with white. 9¾ × 13 (24·8 × 33), Miss Sylvia Gosse/Coll. London, British Museum (1913). Rep. *Image*, No. 7, 1952, p. 39.

Studies 1 and 2 are preparatory to Fig. 192. Study 3 is related to Fig. 192 in that the bed (with vertical bars) is the same, the curtain behind it is the same, and the green paper on which it is drawn was also used for Study 2. However, this study of a nude is without the second (male) figure and is also closely related to the Mornington Crescent Nudes of 1907, to C.276 in particular.

270. THE CAMDEN TOWN MURDER. LA BELLE GÂTÉE (Fig. 187) 1908

Black chalk, heightened with white. 10½ × 8 (26·7 × 20·3)
'Sickert' b.r.
Montague Shearman/
Coll. H. K. B. Lund Esq.
Exh. Eldar Gallery 1919 (26); N.G.41 (100)
Chapter XIII

An etching of this composition is dated 1908 and is called by the French title—which indeed seems more appropriate to the action of the figures.

271. L'AFFAIRE DE CAMDEN TOWN (Fig. 190) 1909
Canvas. 24 × 16 (61 × 40·6)
'Sickert' b.r.
Paul Signac/
Coll. Fred Uhlman Esq. (on loan to the Hatton Gallery,
University of Newcastle upon Tyne)
Rep. B.60, Pl. 60
Exh. Bernheim 1909 (15) bought by Signac from Hôtel
Drouot sale; Tate 60 (117); Adelaide 68 (37)
Chapter XIII

The most dramatic and convincing of all Sickert's pictures
with the murder title, although the facts of the case indicate
that Fig. 190 cannot be interpreted as a literal transcription
of any part of the murder story. Nevertheless, a real link
with the actual murder is that Sickert's male model for
this and other two-figure subjects of this period was the man
accused, but ultimately acquitted, of the murder (see
Chapter XIII, note 26).
There are many drawings preparatory to this painting.
The metamorphosis of its conception from a study of two
women talking (*Conversation*, Fig. 189) to this brutal picture
is discussed in the text.

Studies include:
1. Pen and ink, chalk. 13½ × 9¾ (34·3 × 24·8), Sotheby's,
 21 November 1962 (171)/Coll. Hatton Gallery, Univer-
 sity of Newcastle (1962). Inscribed 'Nude with foot'.
2. *Conversation*, Fig. 189, C.272.
3. *Dettaglio*. Charcoal, heightened with white. 14½ × 9½
 (36·8 × 24·1), L. C. G. Clarke/Coll. Oxford, Ashmolean
 Museum (1943). The title is taken from the inscription
 'Dettaglio/Cn.Tn.Murder'.
4. *The Crisis*. Chalk. 14⅞ × 10⅛ (37·8 × 25·7), R. E. Abbott/
 Coll. Whitworth Art Gallery, University of Manchester
 (1960). Rep. B.60, Pl. 58a.
5. Chalk. 10½ × 8⅜ (26·8 × 21·3), Coll. Fred Uhlman Esq.
 (on loan to the Hatton Gallery, University of Newcastle
 upon Tyne). A study of the nude which corresponds
 exactly to the painting; it includes the chamber pot
 under the bed.
6. Chalk, heightened with white. 14½ × 9½ (36·8 × 24·1),
 H. S. Reitlinger/Sotheby's, 21 November 1962 (78)/
 Coll. Nigel Haigh Esq. Later inscribed 'Study for the
 Camden Town Murder in the possession of Signac'.
7. Pencil, chalk, heightened with white. 11¾ × 9½ (29·9 ×
 24·1), Sotheby's, 8 July 1970 (38), bought Dr. Forsyth.
 Later inscribed 'Study for murder of Emily Dimmock
 in St. Paul's Road Camden Town'.
8. Chalk, heightened with white, squared. 14 × 9 (35·5 ×
 22.9), P. Signac/Mouradian et Valotton, Paris, 1970.
 Inscribed 'A Signac/Sickert 1909'.
Sickert often drew his black chalk drawings on highly
coloured paper at this period; the green paper used for
two studies for Fig. 192 was noted above. Sickert used
magenta paper for Studies 3 and 4 for *L'Affaire de Camden
Town*; Study 8 is drawn on hot pink paper; Study 6 is on
green paper and Study 5 on paler pink paper.

272. CONVERSATION (Fig. 189) c.1908-9
Chalk, pen and ink, heightened with white on buff paper.
 13¼ × 9¼ (33·7 × 23·5)
'Sickert' b.r.

Howard Bliss/
Coll. London, Royal College of Art (1950 or 1951)
Exh. A.C.1961, 'Drawings of the Camden Town Group'
 (97)
Chapter XIII

273. DAWN, CAMDEN TOWN (Fig. 191) c.1909
Canvas. 19¾ × 16 (50·2 × 40·6)
'Sickert' b.r.
Mrs. M. Clifton/
Coll. The Earl and Countess of Harewood
Exh. Carfax Gallery, December 1912, 3rd. Camden Town
 Group Exhibition as *Summer in Naples*; Chicago: Pitts-
 burgh 1938 (30); Agnew 60 (70)
Chapter XIII

The identification of *Dawn, Camden Town* with *Summer in
Naples* (a particularly capricious title) is proved by the
Yorkshire Observer's description of the exhibited work (1
December 1912): 'a British navvy fully dressed and a dirty
complexioned woman with nothing to cover her at all
sitting back to back upon a small bed in an East London
attic'.
I have not found a catalogue of the third exhibition of the
Camden Town Group and must rely on press reviews to
discover which pictures Sickert exhibited there.

Study:
Despair. Pencil. 10⅝ × 10⅞ (27 × 27·7), Coll. London, Tate
Gallery (1917). Exh. Carfax Gallery, May 1912 (1). The
inscription 'Fat Girl' under the mount must refer to the fe-
male figure in the painting, but the drawing studies the
man alone.

274. SALLY. THE HAT (Fig. 186) c.1909
Canvas. 19½ × 15½ (49·5 × 39·4)
'Sickert' b.l.
Robin Sanderson/Sotheby's, 23 April 1969 (32)/Agnew/
Private Collection, London
Exh. R.B.D.60 (6)
Chapter XIII

Studies include:
1. Chalk, heightened with white. 14⅜ × 9⅜ (36·5 × 23·8),
 Coll. Dr. S. Charles Lewsen, Exh. N.G.41 (114) and
 Sheffield 57 (114) as *Granby Street*.
2. Pencil. 14½ × 9 (36·8 × 22·9), Paul Guillaume/Coll. The
 University of Reading (1957).
This setting is used again in *Home Life* (C.278).

275. SUMMER AFTERNOON (Fig. 193) c.1909
Canvas. 19 × 15 (48·3 × 38·1)
Dr. Alastair Hunter/J. W. Blyth/
Coll. Kirkcaldy, Museum and Art Gallery (1964)
Exh. Possibly *Salon d'Automne* 1909 (1582 or 1583) as
 L'Affaire de Camden Town; probably Carfax Gallery
 June 1911, 1st. Camden Town Group Exhibition (10)
 as *Camden Town Murder Series No. 1* or (11) as *Camden
 Town Murder Series No. 2*; Edinburgh 53 (12) as *The
 Camden Town Murder*.
Chapter XIII
Fig. 193 is also known as *What shall we do for the Rent?*

Version:

Canvas. 20 × 17½ (50·8 × 44·5), Dr. Robert Emmons/L. Y. Baker/Private Collection, England. Rep. B.60, Pl. 61; Lilly, Pl. 16. Lit. Andrew Forge, the *Listener*, 16 June 1960, pp. 1051–3, rep. p. 1051. Exh. possibly *Salon d'Automne* 1909 and probably Carfax Gallery June 1911 as one of a pair with Fig. 193 (for exact details see exhibition list for Fig. 193); Tate 60 (118); Hampstead 1965, 'Camden Town Group' (64). This is a more contracted version of Fig. 193; it omits the legs of the man and cuts off the space on the right more abruptly. There is no evidence to substantiate the possibility that Fig. 193 and Version are the pictures shown at the *Salon d'Automne* in 1909; the suggestion is made because the pictures exhibited in Paris seem, from their like titles, to have been a complementary pair. The probability that these are the pictures shown in London in 1911 (the first paintings on the murder theme to have been exhibited in England, as opposed to France) is indicated by press reviews, e.g.:

The *Sunday Times*, 18 June 1911, 'the unclothed figure on the bed and the clothed figure of the man seated at the side afford a contrast which has interested painters for centuries, though Mr. Sickert has given a novel note to a favourite theme by viewing it in dim twilight through a quivering veil of atmosphere'.

The *Daily Telegraph*, 22 June 1911, noted that in both pictures 'a sinister being sits quietly watching in the dim, struggling light of morning the nude figure of a woman stretched out on a miserable couch'.

When, and on what grounds, the perverse title *Summer Afternoon* was given to the paintings is unknown.

If, as I believe probable, the pictures are *The Camden Town Murder Series Nos. 1* and *2* the numbers must refer to their respective relationship to each other rather than to the Camden Town Murder pictures as a whole group. In this case it is probable that Fig. 193 is *No. 1*, and the more contracted version *No. 2*.

Related drawing:

Stemmo Insieme. Charcoal, heightened with white. 9½ × 14½ (24·1 × 36·8), From the collection of Edward le Bas. Exh. R.B.D.63 (32); R.A.1963, 'A Painter's Collection' (198). The setting is the same as in Fig. 193 but now both figures lie on the bed.

276. MORNINGTON CRESCENT NUDE 1907

Canvas. 18 × 20 (45·7 × 50·8)

'Sickert' b.l.

Coll. Lady Mosley, Paris

Chapter XIII

Studies:

1. Charcoal, pen and ink, heightened with white. 9⅛ × 13⅞ (23·2 × 35·2), Coll. H. K. B. Lund Esq.
2. Charcoal, pen and ink, heightened with white. 9 × 13 (22·9 × 33), Coll. Auckland, City Art Gallery (1955).
3. Chalk. Size and whereabouts unknown. Rep. B.43, Pl. 29a.

277. PETIT MATIN 1907

Canvas. 20 × 15¾ (50·8 × 40)

'Sickert' b.l.

Present whereabouts unknown

Rep. *Drawing and Design*, 3, July 1927, p. 139

Exh. Probably *Salon d'Automne* 1907 (1536) as *Nu*; Bernheim 1909 (12)

Chapter XIII, and note 19

Petit Matin can probably be identified with *Nu* from Sickert's description to Miss Hudson of the painting which he had sent to Paris (together with his self-portrait *L'Homme au Chapeau Melon*, Fig. 174) as 'the heavy woman sitting on the edge of the bed'. The model and the setting of *Petit Matin* are the same as in Fig. 179 and C.276. The picture was bought by Bernheim-Jeune from the sale of Sickert's work in 1909. Its ownership was not acknowledged in *Drawing and Design*.

278. HOME LIFE, CAMDEN TOWN c.1909

Canvas. 19½ × 15½ (49·5 × 39·4)

'Sickert' b.l.

Sir Hugh Walpole/

Coll. A. D. Peters Esq.

Rep. The *Burlington Magazine*, 102, October 1960, p. 440

Exh. Agnew 60 (79)

Chapter XIII

The setting is the same as in Fig. 186 and the female model is again Sally; the handling of the picture is very close to that of Fig. 191 (*Dawn, Camden Town*).

Studies:

1. Black and white chalk on pink paper. 14 × 9½ (35·6 × 24·1), Sotheby's, 6 April 1960 (28) bought Leicester Galleries.
2. Pencil. 14 × 9½ (35·6 × 24·1), Private Collection, Sussex/ Lady Epstein/Beth Lipkin Galleries 1971.
3. Pencil. 11¾ × 8¾ (29·8 × 22·2). Coll. M. V. B. Hill Esq. Studies 1 and 2 are for the female nude seen from the back. Study 3 is of the seated man with the hips of the nude lightly indicated.

279. REFLECTED ORNAMENTS c.1909

Canvas. 11 × 15½ (28 × 39·4)

'Sickert' b.l.

Coll. Salford, Art Gallery and Museum (1964)

Chapter XIII

An extraordinarily brightly coloured and thickly impasted rendering of ornaments reflected in a mirror on a mantel-shelf.

280. CHICKEN. WOMAN AT A MANTELPIECE c.1907–8

Panel. 14¾ × 12 (37·5 × 30·5)

Mrs. A. E. Anderson/

Private Collection, England

Exh. Carfax Gallery June 1911, 1st. Camden Town Group Exhibition (9) as *Chicken*, lent by Miss Jean McIntyre

Note to C.316

Mrs. Anderson's maiden name was Miss Jean McIntyre. She was a Rowlandson House pupil who Sickert believed had exceptional talent.

A pencil inscription on the back of this panel reads 'Chicken lent by Miss Jean McIntyre'. More evidence that this picture is indeed *Chicken* is the annotation in the Camden Town Group Exhibition catalogue in the Courtauld Institute of Art Library 'girl at mantel glass'.

Sickert called a great number of his paintings *Chicken* from about 1909 until 1915. Perhaps his model nicknamed Chicken posed for them all.

281. WELLINGTON HOUSE ACADEMY. STANDING NUDE c.1909

Chalk on magenta paper. 15 × 10¼ (38·1 × 26)
'Rd.St. A.R.A.' b.r., 'Wellington House Academy' b.l.
H. S. Reitlinger/
Coll. Leicester, City Art Gallery (1954)
Exh. Sheffield 57 (112); A.C.64 (44)
Chapter XIII

The model seems to be Sally and her pose is close to that in Fig. 186. The use of magenta paper and the placing of the bed recalls Sickert's work on *L'Affaire de Camden Town* (Fig. 190, C.271). The rectangular washstand and the chamber pot were incidental features of C.278. Sickert post-inscribed a great number of his drawings 'Wellington House Academy'. The inscription had reference to a school which flourished in the nineteenth century and was attended for two years by Charles Dickens. Sickert had a studio in the house where the school had been (in Hampstead Road).

282. MAN WASHING HIS HANDS c.1909

Chalk, heightened with white, on magenta paper. 12⅞ × 8½ (32·7 × 21·6)
Coll. London, British Museum (1912)
Rep. *Image*, No. 7, 1952, p. 21
Exh. Carfax Gallery, May 1912 (4) as *Wash and Brush Up*
Chapter XIII

1906–12. LANDSCAPES

283. THE ANTIQUE SHOP (Fig. 194) c.1906

Panel. 9½ × 7½ (24·1 × 19)
'Sickert' b.r.
Agnew/
Private Collection, England
Exh. Agnew 60 (85)
Chapter XII

The subject is the antique, junk, or print shop on the corner of the Rue Ste. Catherine near the Vieux Arcades in Dieppe. In the painting on canvas and the two studies listed below the opening to the Vieux Arcades is represented, so that the composition is similar to that used in the paintings listed under C.124 (without church).
Fig. 194 is a study for a painting on canvas:
23½ × 19½ (59·7 × 49·5), Ian Greenlees/Sotheby's, 26 April 1961 (194)/Private Collection, London.
Other studies of this subject include:
1. Panel. 10 × 6 (25·4 × 15·2), R.B.D./Private Collection, London. Exh. Tate 60 (47).
2. Board. 9⅜ × 7½ (23·8 × 19), A. M. Clifton/Sir Humphrey Rolleston/Mrs. William Gibson/Coll. Martin Halperin Esq.
These two studies are more lightly painted than Fig. 194 and the painting on canvas. Study 2 is drawn in pencil and hardly more than touched in colour. On its verso is *La Rue Pecquet*, Fig. 197.

284. LA RUE DU MORTIER D'OR, DIEPPE (Fig. 201)
c.1906

Canvas. 13 × 16 (33 × 40·6)
'Sickert' b.l.
Jacques-Émile Blanche/R.B.D./
Private Collection, London
Exh. R.B.D.60 (8)
Chapters XII and XIII

Probably painted in 1906 when Gore was working in Sickert's Neuville studio and may have influenced Sickert towards using brighter colours (a clear blue sky and very green trees) and a more broken execution.

285. LA SEINE DU BALCON (Fig. 196) 1906

Canvas. 20 × 24 (50·8 × 61)
Private Collection, London
Exh. Bernheim 1909 (49); Brighton 62 (39)
Chapter XII

A view from the Hôtel du Quai Voltaire almost certainly painted when Sickert was staying there during the autumn to winter of 1906.
According to Sickert's annotated catalogue Fig. 196 was bought by someone called Griffith (perhaps Frank Griffith —later to be Sickert's pupil—then studying at *L'École de la Palette* in Paris) from the 1909 sale of Sickert's work.

286. LA RUE NOTRE DAME DES CHAMPS, PARIS. ENTRANCE TO SARGENT'S STUDIO (Fig. 195) c.1906

Canvas. 23¾ × 18¾ (60·3 × 47·7)
From the collection of Morton Sands
Exh. Probably Bernheim 1907 (52) and N.E.A.C. winter 1907 (19); N.G.41 (63); Leeds 42 (147); Agnew 60 (58); Brighton 62 (78)
Chapter XII

B.60, p. 65 groups Fig. 195 together, stylistically, with *Les Loges* (C.242) but dates both landscape and music hall c.1901. I agree with the grouping (the turquoise and purple colour scheme is a striking feature of both pictures) but prefer a date of 1906 for the two Paris subjects. The landscape is almost certainly the one shown at Bernheim-Jeune in January 1907.

287. LA RUE PECQUET (Fig. 197) c.1907

Board. 9⅜ × 7½ (23·8 × 19)
'Sickert' b.r.
A. M. Clifton/Sir Humphrey Rolleston/Mrs. William Gibson/
Coll. Martin Halperin Esq.
Exh. R.B.D.60 (25); Tate 60 (58)
Chapter XIII

An unfinished study for *The Antique Shop* (Fig. 194, C.283) is on the verso.
Sickert painted this subject, the south door of St. Jacques as seen down La Rue Pecquet, many times between 1906 and 1908. For earlier versions, painted c.1900, see Fig. 81, C.115.
The versions listed below can be distinguished from earlier versions not only by their handling but also by the tree to the left of the top of La Rue Pecquet (when the composition permits this part to be seen) and by a builder's fence across

part of the doorway of St. Jacques (in a few pictures this passage is glossed over so that although the shape of the fence is suggested the palings are not defined).

Versions painted c.1906–8 include:

1. Canvas. 25¼ × 19¼ (64·1 × 48·9) From the collection of Morton Sands. Rep. B.60, Pl. 52. Exh. Sheffield 57 (28) as *Dieppe Church (St. Jacques)*; Agnew 60 (63); Tate 60 (59); Brighton 62 (68). A longer stretch of La Rue Pecquet is shown in this version than in any of the others.
2. Canvas. 25 × 20 (63·5 × 50·8), Mrs. William Miller/ Private Collection, England. Exh. probably Brighton 62 (84) as *Église St. Jacques. Dieppe*.
3. Canvas. 24¾ × 20 (62·9 × 50·8), Mrs. Rosemary Peto/ Tooth/Private Collection, London.
4. Canvas. 25½ × 15½ (64·8 × 39·3), Mrs. Charles Hunter/ R.B.D./Private Collection, Scotland. Exh. R.B.D.63 (16), rep. in catalogue.
5. Canvas. 19¾ × 11 (50·2 × 28), Sotheby's, 12 April 1967 (61)/Private Collection, London.
6. Canvas. 16 × 13 (40·6 × 33), Coll. Lord Croft.
7. Canvas. 12¾ × 9⅝ (32·4 × 24·5), Sir Hugh Walpole/Coll. Edinburgh, Scottish National Gallery of Modern Art (1965).
8. Board. 9 × 7 (22·9 × 17·8), from the collection of Morton Sands. Exh. N.G.41 (20) as *Dieppe Church*; Leeds 42 (145) as *St. Jacques, Dieppe*.
9. ?Board. 9 × 7 (22·9 × 17·8), J. W. Bravington (bought from Sickert in 1910)/Messrs. Arthur Tooth & Sons, Ltd. 1940/Present whereabouts unknown.

In most of these versions Sickert used quite thick, often impasted paint applied in small broken touches. In a few (Nos. 4, 5, 7) his paint was thinner and smoother but the colours used (with much violet and green in No. 5 for example) and the relatively broken *facture* suggest that these versions cannot date before 1906–7.

Study:

Pen and ink. 9⅝ × 6 (24·5 × 15·2), Miss Sylvia Gosse/ Coll. Martin Lack Esq. Exh. Leicester Galleries 1963, 'Artists as Collectors' (68).

Sickert probably made use of his earlier studies when painting *La Rue Pecquet* later in the decade. However, the broken pen and ink stroke employed in the study listed above suggests that it was executed c.1907–8.

288. SOUTH FAÇADE OF ST. JACQUES (Fig. 198)

c.1907–8

Canvas. 29¼ × 24¼ (74·3 × 61·6)
'Sickert' b.l.
Jacques-Émile Blanche/
Coll. Musée de Rouen (1923) on loan to Musée de Dieppe
Exh. Dieppe 54 (10); Brighton 62 (5)
Chapter XIII

Compare with the earlier version of this subject, Fig. 82.

Study:

Chalk, watercolour, squared. 12¾ × 8⅞ (31·5 × 22·5), Hugh Hammersley/R. Hart/Christie's, 19 March 1971 (54)/ Messrs. Roland, Browse & Delbanco 1971. Exh. Edinburgh 53 (94); R.B.D.1971, 'British Paintings and Drawings' (38). Inscribed 'Walter Sickert Dieppe 1907'. This is a working study for the painting which may, however, have been painted a little later than the drawing.

289. THE ELEPHANT POSTER (Fig. 199) 1910

Canvas. 25 × 20 (63·5 × 50·8)
'Sickert' b.r.
Christie's, 11 March 1927 (135)/
Private Collection, England
Exh. N.G.41 (83); Agnew 60 (73)
Chapter XIV

The owner of this picture told me that Sickert informed him that it was painted in 1910.

Studies and versions include:

1. Panel. 8½ × 6¼ (21·6 × 15·9), R. H. S. Waley/Tooth/ Private Collection, London. Exh. Tate 60 (37) as *La Halle au Lin*; Tooth 1961, 'British Painting. Today and Yesterday' (19).
2. Board. 9 × 7 (22·9 × 17·8), Lady Gosse (dedicated to her by Sickert)/Miss Sylvia Gosse/Coll. Miss Jennifer Gosse. Exh. Leicester Galleries 1963, 'Artists as Collectors' (75) as *Les Arcades, Dieppe*.
3. Pen and ink, pencil, chalk, squared. 8⅝ × 6¼ (21·9 × 15·9), J. E. Bullard/Coll. Oxford, Ashmolean Museum (1961).

The drawing and the two oil studies were probably all executed c.1910.

290. THE GARDEN OF ROWLANDSON HOUSE, SUNSET (Fig. 200) c.1910

Canvas. 24 × 20 (61 × 50·8)
'Sickert' b.l.
Lord Henry Cavendish-Bentinck/
Coll. London, Tate Gallery (1940)
Lit. Tate Gallery Catalogue 1964, p. 629
Exh. Whitechapel Art Gallery 1914, 'Twentieth Century Art' (434)
Chapter XIV

Rowlandson House was the name of the school Sickert ran from 1910–14, at 140 Hampstead Road.

Sickert did not often paint London landscapes but the period 1910–12 was one of the exceptions. He left several records of Rowlandson House (now demolished) e.g.:

1. Pencil and watercolour. 5⅞ × 3½ (15 × 8·9), Mr. and Mrs. Redwood-White/Messrs. Roland, Browse & Delbanco 1971. Exh. R.B.D.1969, 'Sickert Drawings' (48). This shows the house with the flags hanging out to celebrate the coronation of George V in June 1911. Dedicated (as are many drawings of this time, summer 1911) to his future wife, 'Miss Christine Angus'. A painting related to this drawing, called *Celebrations*, was once with the Redfern Gallery but its present whereabouts are unknown to me.
2. *The Little Master*. Details of original unknown. Rep. the *New Age*, 17 August 1911. This shows a little female figure painting in the garden.
3. *Londra Benedetta*. Details of original unknown. Rep. the *New Age*, 27 July 1911. The garden.

291. ST. REMY (Fig. 202) c.1911

Canvas. 20 × 24 (50·8 × 61)
'Sickert' b.r.
Coll. Bernheim-Jeune, Paris.

St. Remy is the second most important church in Dieppe but Sickert painted it less frequently than St. Jacques.

The Bernheim family date this picture *c*.1911, and it is certainly close in handling and similar in format and composition to a dated painting of the church done in 1912 (details and present whereabouts unknown, formerly in the Sassoon Collection, possibly exh. Carfax Gallery April 1914 No. 41).

Earlier pictures of *St. Remy* include:

1. Canvas. $13\frac{3}{4} \times 10\frac{5}{8}$ (35 × 27), Jacques-Émile Blanche/ Coll. Musée de Rouen (1923) on loan to Musée de Dieppe. Exh. Bernheim 1904 (72) lent by Blanche; Dieppe 54 (15).
2. Panel. $9 \times 5\frac{1}{2}$ (22·9 × 14), Jacques-Émile Blanche/Coll. M. Georges Mevil-Blanche. Exh. Dieppe 54 (16).

Both probably painted *c*.1900.

292. THE ROAD TO THE CASINO — dated 1907

Canvas. $17\frac{3}{4} \times 21\frac{1}{4}$ (45 × 54)
'Sickert 1907' b.l.
E. F. Benson/G. P. Dudley Wallis/E. Duveen/Sotheby's, 17 July 1968 (47)/R.B.D./
Private Collection
Rep. B.60, Pl. 53
Exh. R.B.D.1970, 'Sickert to Sutherland' (21)
Chapter XIII

The only dated landscape painting known to me executed between 1904 and 1912.

Study:
Panel. $7\frac{1}{2} \times 9\frac{1}{2}$ (19 × 24·1), Lord Howard de Walden/ A. J. L. McDonell/W. J. Bilson/Last known owner J. S. Embiricos Esq.

293. THE HANDCART, or THE BASKET SHOP. RUE ST. JEAN, DIEPPE — *c*.1911–12

Canvas. $19\frac{3}{4} \times 24\frac{1}{4}$ (50·2 × 61·6)
'Sickert' b.l.
Private Collection, Scotland
Chapter XIV, note 7

Upright version:
Canvas. $24 \times 19\frac{3}{4}$ (61 × 50·2), Mrs. M. Clifton/Lord Cottesloe/Private Collection, London. Rep. B.60, Pl. 67. Exh. Probably Carfax Gallery May 1912 (55) as *The Basket Shop*; N.G.41 (57); Leeds 42 (168); Agnew 60 (57).

Oil studies include:

1. Panel. $9\frac{3}{4} \times 7\frac{3}{4}$ (24·8 × 19·7), Frank Rinder (bought from Sickert 1914)/Sotheby's, 21 November 1962 (164)/ Private Collection, Northern Ireland.
2. Board. $9\frac{1}{2} \times 7\frac{1}{2}$ (24·1 × 19) Mrs. Frances Evans/Christie's, 19 May 1972 (39).

Drawings (both studies for C.293):

1. Pencil and watercolour. $8\frac{1}{4} \times 10\frac{5}{8}$ (21 × 27), Coll. Manchester, City Art Gallery (1938). Rep. B.60, Pl. 53a.
2. Pencil, chalk, wash, heightened with white, squared. $9\frac{3}{4} \times 11\frac{1}{2}$ (24·8 × 29·2), Sotheby's, 1 May 1968 (10), bought Mrs. Parr.

1910–AUTUMN 1914. PORTRAIT AND FIGURE PAINTINGS

294. JACQUES-ÉMILE BLANCHE (Fig. 204) — *c*.1910

Canvas. 24 × 20 (61 × 50·8)
Miss Hilda Trevelyan/

Coll. London, Tate Gallery (1938)
Rep. Blanche, *Portraits of a Lifetime*, facing p. 117; B.43, Pl. 36
Lit. Tate Gallery Catalogue 1964, p. 627
Exh. N.E.A.C. summer 1912 (163); Edinburgh 53 (53)
Chapter XIV

Sickert and Blanche (1861–1942), the French painter, writer, and critic, were lifelong friends (see Chapter II). Blanche painted Sickert several times, but Fig. 204 is the only portrait by Sickert of Blanche known to me. Emmons, p. 139, wrote that the portrait was painted at Rowlandson House where Sickert began to work and teach in 1910; however, Blanche himself reproduced the portrait as a work of 1906. Blanche had little memory for exact dates and stylistically 1910 is the more likely date. The lights on the face and scarf have an almost *pointilliste* character and the touches of pure colour also argue in favour of the later dating.

Miss Trevelyan, the first owner of the portrait, was a mutual friend of Sickert and Blanche.

295. TWO WOMEN (Fig. 203) — *c*.1911

Canvas. 20 × 16 (50·8 × 40·6)
'Sickert' b.l.
Coll. Preston, Harris Museum and Art Gallery (1938)
Exh. Sheffield 57 (38); A.C.64 (18); Hull 68 (14)
Chapter XIV

Many of Sickert's paintings and drawings of 1911 feature coster women wearing boater hats. The painting and drawing of *Lou! Lou! I Love You* (C.315) and the drawing *Alice* (Fig. 228) are other examples.

296. OFF TO THE PUB (Fig. 205) — *c*.1911

Canvas. 20 × 16 (50·8 × 40·6)
'Sickert' b.r.
Howard Bliss/
Coll. London, Tate Gallery (1943)
Rep. Bertram, Pl. 29
Lit. Tate Gallery Catalogue 1964, p. 636
Exh. Probably Dunmow Artists' Picture Show, November 1911; Chicago: Pittsburgh 38 (15)
Chapter XIV

There are two pictures called *Off to the Pub*, each different in composition but similar in theme, showing a man at the door about to leave his wife for the purpose explained in the title. The style, composition, and handling of the other version (Fig. 212) suggest it was painted in 1912. *A Few Words* (Fig. 213) was also originally called *Off to the Pub* but it too must be a work of about 1912. The handling of Fig. 205, on the other hand, and the appearance of the coster woman in the background, suggest it was painted in 1911. It is, therefore, probable that this is the version of *Off to the Pub* exhibited in November 1911 at Dunmow. Sickert contributed to this show because his brother Bernhard—who lived at Little Easton near Dunmow—helped to organize it. The show was open for three days only and I can trace no catalogue. However, the *Essex Herald*, 21 November 1911, reported that Walter Sickert 'struck a new line by his contribution of modern Impressionist art, very strongly executed, "Off to the Pub" and "A Tiff"'. It is not possible to identify *A Tiff* because the

title is suited to so many of Sickert's two-figure composi-
tions of this date; a drawing *The Tiff* is catalogued under
C.331, and similar compositions are called by other titles
denoting domestic strife.

If Fig. 205 is a work of 1911 it is the first painting known to
me to feature Hubby as the male model.

297. THE STUDIO. THE PAINTING OF A NUDE
(Fig. 206) *c.*1911–12

Canvas. 29½ × 19½ (75 × 49·5)
'Sickert' b.l.
From the collection of Morton Sands
Rep. B.60, Pl. 74
Exh. Eldar Gallery 1919 (41) as *The Studio*; Agnew 60
 (61) as *The Model*; Tate 60 (126); Brighton 62 (82) as
 The Model
Chapter XIV

I do not agree with the date of *c.*1917 given by Miss
Browse (B.60, p. 78) for this painting. However, there is an
outside possibility that the picture is a much earlier work,
of 1906, and thus a brilliant premature experiment in
style and handling. Stylistically the date of 1906 seems
unlikely but Sickert did show a picture called *Le Grand
Miroir* at Bernheim-Jeune in January 1907 (48), re-exhibited
in 1909 (3) when its dimensions were quoted as 76 × 50
cms. The title and size fit *The Studio*, although I am still
inclined to reject these facts as coincidences and maintain
the date of 1911–12 for Fig. 206.

298. THE MANTELPIECE (Fig. 210) *c.*1911–12

Canvas. 30 × 20 (76·2 × 50·8)
Coll. Southampton Art Gallery (1932)
Rep. B.43, Pl. 27
Exh. Chicago: Pittsburgh 1938 (10); N.G.41 (6); Leeds 42
 (154); Edinburgh 53 (9); Tate 60 (107); Adelaide 68
 (31)

The Mantelpiece is another contender for identification as
Le Grand Miroir shown at Bernheim-Jeune in 1907 and
1909 (see note to C.297). Moreover, this picture is usually
dated *c.* 1907. However, I believe that the date of *The
Mantelpiece* is linked with that of *The Studio*. The pictures
are the same size. The compositional organization of *The
Mantelpiece* (a far-off echo of Whistler's pictures of similar
theme) has the same sort of complexity and subtlety as that
of *The Studio*. The real subject and its reflection, which
includes a cross-reflection of another mirror within the
main reflected image, create an extraordinarily close-knit
structure of contrasting diagonal and parallel lines and
afford an extensive knowledge of different aspects of the
interior. Its handling is similar to that of *The Studio*; the
smooth juicy paint is similarly enlivened with scattered
impasted dots of light. Finally both pictures appear to
represent the same interior, showing the same glass-
fronted arched cupboard and the same jacket hanging from
a hook (glimpsed in reflection in *The Mantelpiece*).

299. PORTRAIT OF HAROLD GILMAN (Fig. 207) *c.*1912

Canvas. 24 × 18 (61 × 45·7)
Mrs. Harold Gilman/
Coll. London, Tate Gallery (1957)
Rep. Lilly, Pl. 12

Lit. Tate Gallery Catalogue 1964, p. 639; Lilly, p. 54
Exh. Edinburgh 53 (24); Tate 60 (122)
Chapter XIV

The Tate Gallery Catalogue quotes Mrs. Gilman's con-
firmation of a date of *c.*1912 for this portrait of her husband.
Gilman (1876–1919) was a frequenter of Sickert's Fitzroy
Street circle, a member of the Camden Town Group, and
at this time a close friend of Sickert (in 1915 they quarrelled
—see Appendix, note 12). He acted as Sickert's model for
many drawings in 1912 (e.g. Figs. 231 and 232 and C.339).

300. GIRL DOING EMBROIDERY (Fig. 208) *c.*1912

Canvas. 20 × 16 (50·8 × 40·6)
'Sickert' b.r.
Arthur Crossland/Christie's, 9 March 1956 (188)/
Private Collection, London
Rep. B.60, Col. Pl. VIII as *Girl Reading*
Exh. N.G.41 (62) and Edinburgh 53 (20) as *Girl Reading*;
 Sheffield 57 (30) as *Girl doing Embroidery*; Tate 60 (108)
 as *Girl Reading*
Chapter XIV

Study:
Pencil. 10 × 7¼ (25·4 × 18·4), Malcolm Young/Messrs. Thos.
Agnew & Sons Ltd. 1971. Exh. Tate 60 (127); R.B.D.1969,
'Sickert Drawings' (43); Agnew 1971, 'A Century of Modern
Drawings and Prints' (37). The study, which defines the
action of the subject more clearly than the painting, tends
to support the title used here rather than the more common
description *Girl Reading*. This study is drawn in a hard,
almost deliberately gauche manner favoured by Sickert
in 1911–12 for many drawings, particularly for those done
in Rowlandson House (e.g. Fig. 227).

301. SHUTTERED SUNLIGHT (Fig. 209) *c.*1912

Canvas. 24 × 20 (61 × 50·8)
Sir Hugh Walpole/Malcolm Young/
Coll. Mrs. Irina Moore
Exh. R.B.D.60 (3); R.B.D.1966, 'La Vie Intime' (29)
Chapter XIV

Shuttered Sunlight is related to a long series of drawings
illustrating bedroom arguments which Sickert executed
*c.*1912. For example when *Amantium Irae* (Fig. 234) was
exhibited at the Carfax Gallery in 1912 several of the
critics remarked that other drawings in the show were
similar to it in subject and composition except that in
Amantium Irae the man faced the spectator, whereas in the
other drawings he was seen from the back. Examples
quoted in the press included *Curtain Lecture* (40) and *Home
Truths* (6). It is impossible to say which, if any, of the
extant drawings were *Curtain Lecture* and *Home Truths* but
their description suits several of the studies listed below.

Related drawings include:
1. *An Argument*. Dated 1912. Details and whereabouts of
 original unknown. Rep. the *New Age*, 25 April 1912.
 The setting and compositional format are similar to
 Fig. 209 but the scene is cut on both sides and the
 positions of man and woman are reversed.
2. *Back-Chat*. Chalk and watercolour. 9¼ × 14½ (23·5 ×
 36·8), Coll. Mrs. Frank Shaw. Exh. R.B.D.1969, 'Sickert
 Drawings' (49), rep. in catalogue. The setting is again
 the same but two women sit on the far side of the bed.

3. *Hubby and Marie.* Pen and ink, chalk. $11\frac{3}{4} \times 9\frac{1}{2}$ (29·9 × 24·1), From the collection of Edward le Bas. Rep. *Image*, No. 7, 1952, p. 26. Exh. R.A.1963, 'A Painter's Collection' (193). The woman is placed much as in Fig. 209 and she is dressed similarly, but the man stands with his back to the spectator and looks into a mirror on the far wall. However, the area behind the woman in the painting suggests that it may once have contained just such a standing man behind her who was then painted out. This drawing could have been either *Curtain Lecture* or *Home Truths* exhibited at the Carfax Gallery in 1912.

4. *The City Dinner.* Chalk. $18\frac{1}{2} \times 10\frac{3}{4}$ (47 × 27·3), Mrs. Rowley Bristow/Private Collection, London. Related to *Hubby and Marie*, with the woman on a bed in the foreground and a man tying his tie in the background.

There are many other similar drawings, as well as studies for these four drawings, extant.

302. THE OLD SOLDIER (Fig. 211) dated 1912
Canvas. $15\frac{5}{8} \times 12\frac{5}{8}$ (39·7 × 32)
'Sickert' b.r., 'Le Pollet 1912' b.l.
A. D. Peters/
Coll. J. B. Priestley Esq.
Chapter XIV

The subject and composition of *The Old Soldier* are unusual for Sickert. It is probably the painting of which Sickert wrote to Miss Sands in a letter dated Easter Monday 1913: 'I have happily decided to hold over the finishing of the blind sailor. It won't do for me to come out just now with an important sentimental work unfinished or *à peu près*.' The old man in Fig. 211 holds a stick and is led by his wife, which suggests that he is blind; and the picture seems to be unfinished: no background is indicated and the figures are little more than roughed in with colour. Presumably Sickert's reputation at this period was as a painter of realistic subjects and it is interesting that he considered the effect that an out-of-character 'sentimental' picture would have on his public. Whether the picture represents an old soldier (as suggested by the current title) or a sailor (as quoted in Sickert's letter) is immaterial because the man is not shown in uniform. Support for the hypothesis that Fig. 211 is *The Blind Sailor* is obtained from a study: Chalk. $10 \times 5\frac{1}{2}$ (25.4 × 14), Mrs. F. L. Evans/Christie's, 19 May 1972 (43)—quoted in the catalogue as a study for 'The Blind Son'.

303. OFF TO THE PUB (Fig. 212) c.1912
Canvas. $19\frac{1}{4} \times 11\frac{1}{2}$ (48·9 × 29·2)
'Sickert' t.r.
Christie's, 29 January 1943 (155) as *The Weekend*/
 Captain A. K. Charlesworth/Lady George Cholmondeley/
Coll. Leeds, City Art Gallery (1966)
Rep. B.60, Pl. 63
Chapter XIV
Related painting Fig. 213, C.304
Studies include:
1. Chalk, heightened with white. 20 × 14 (50·8 × 35·6), Alfred Jowett/Present whereabouts unknown. Rep. *Image*, No. 7, 1952, p. 30. Exh. Edinburgh 53 (64). A very full drawing incorporating all the information used in the painting.

2. Pencil, pen and ink. $10\frac{1}{2} \times 8\frac{1}{2}$ (26·8 × 21·6), Coll. London, Arts Council of Great Britain (1950). Rep. B.60, Pl. 62a; Rothenstein 1961. Exh. Adelaide 68 (70). This drawing also shows both figures, and defines Hubby in considerable detail.

3. Chalk, pen and ink. $9\frac{1}{2} \times 7\frac{1}{2}$ (24·1 × 19), Miss M. Bullard/Coll. Oxford, Ashmolean Museum (1962). Exh. A.C.1961, 'Drawings of the Camden Town Group' (100). A lighter study showing the upper body of the woman.

4. Chalk, pen and ink, wash. $12\frac{3}{8} \times 7\frac{3}{4}$ (31·5 × 19·7), Mrs Grace Wheatley/Christie's, 11 November 1958 (25)/ Agnew/Private Collection, London. Exh. Agnew 60 (228). A study for the woman.

304. A FEW WORDS (Fig. 213) c.1912
Canvas. 20 × 12 (50·8 × 30·5)
'Sickert' b.r.
Mrs. M. Clifton/Lord Jessel/
Private Collection, London
Exh. Carfax Gallery 1916 (12) as *Off to the Pub*; Agnew 60 (69)
Chapter XIV

The identification of *A Few Words* with the *Off to the Pub* exhibited in 1916 is suggested (i) by a note in the Tate Gallery archives copy of the catalogue which noted the painting as showing three figures (the other two pictures with this title are two-figure groups, Figs. 205, 212), and (ii) by the description of the picture in an exhibition review in the *Athenaeum*, December 1916, which noted the china dog on the mantelpiece (on the shelf in front of the mirror in which the whole scene is reflected).

Sickert evidently favoured small upright canvases at this period (*A Few Words*, *Off to the Pub* Fig. 212, and *Sunday Afternoon* Fig. 214 are all painted on canvases measuring 20 × 12).

In *A Few Words* Sickert used the composition of *Off to the Pub* in the background combined with a figure in the foreground derived from a drawing called *Charwoman in a Plumed Hat*. Charcoal and blue wash. $12\frac{1}{4} \times 9\frac{3}{4}$ (31·1 × 24·9), Mrs. Grace Wheatley/Christie's, 11 November 1958 (12)/Coll. Bedford, Cecil Higgins Art Gallery (1960). Exh. R.B.D.60 (42); Tate 60 (133); Agnew 1962, 'Watercolours from the Cecil Higgins Art Gallery' (64). This charwoman in plumed hat and buttoned coat often modelled for Sickert at this period. Other examples of drawings for which she modelled include:
1. *That Boy of Mine will ruin Me.* Charcoal, pen and ink. Size unknown. Last known owner Dr. Robert Emmons. Rep. Emmons, facing p. 200.
2. *Patient Merit.* Pencil, blue wash. 6 × 4 (15·2 × 10·2), Coll. Liverpool, Walker Art Gallery (1948). Emmons reproduced a very similar but not identical drawing, p. 91; its details and whereabouts unknown.

A Few Words is more colourful and less summarily executed than *Off to the Pub*.

305. SUNDAY AFTERNOON (Fig. 214) c.1912–13
Canvas. 20 × 12 (50·8 × 30·5)
'Sickert' b.l.
Bernard Falk/Christie's, 18 November 1955 (61)/
Coll. Fredericton, New Brunswick, Canada, Beaverbrook Art Gallery (1955)

Rep. B.43, Pl. 40; Bertram, Pl. 27
Exh. N.G.41 (58); Leeds 42 (170); Edinburgh 53 (49)
Chapter XIV

The interrelationships of *Sunday Afternoon* and a series of drawings and paintings, in which Sickert experimented with the basic conception of each figure separately and combined them with different figures to make new two-figure groups, is summarized in the text. Marie reappears in *Granby Street* (Fig. 216) and *Vacerra* (C.341); Hubby looms in the foreground of *Hubby and Emily* (Fig. 217) and the drawing *Second Officer* (listed C.308). He reappears seated in the foreground on the bed in *Camden Town Interior*. Canvas. 16 × 12 (40·6 × 30·5), Coll. Robert Haines Esq., Sydney, but in this picture more of his figure is seen and a nude is included in the background.

Drawings specifically related to Fig. 214 include:
1. Three sheets of drawings each mounted with several small sketches, most done in pencil, some with chalk, Coll. Liverpool, Walker Art Gallery (1948). Two sheets Exh. A.C.49 (30) and two of the sketches rep. in catalogue and in *Image*, No. 7, 1952, pp. 23, 31; Sheffield 57 (117).
2. Chalk, heightened with white. 12⅜ × 9⅜ (31·5 × 23·8), Coll. T. Osborne Robinson Esq., on permanent loan to Northampton, Museum and Art Gallery. Exh. A.C.64 (48). Inscribed 'Wellington House Academy, Study for engraving' but also related to the painting.
3. Pen and ink, chalk, heightened with white. 8¾ × 14¼ (22·3 × 36·2), N. Kessler/d'Offay Couper Gallery/Private Collection, England. Exh. d'Offay Couper Gallery 1970, 'English Drawings' (29).

These studies are all for the figures separately. Studies 2 and 3 are for Hubby; the Liverpool sheets include sketches of both Hubby and Marie.

Version:
Canvas. 14½ × 12¾ (36·8 × 32·4), Earl and Countess Jowett/Private Collection, London. Painted thinly in greys, greens, and browns, this may be a later reworking of *c.* 1915.

306. GRANBY STREET (Fig. 216) *c.*1912–14
Canvas. 20 × 16 (50·8 × 40·6)
'Sickert' b.l.
Roger Senhouse/Christie's, 19 March 1971 (35)/
d'Offay Couper Gallery 1971
Exh. Eldar Gallery 1919
Chapter XIV

Related to *Sunday Afternoon* (Fig. 214) and to the drawing *Vacerra* (C.341).

307. LADY OF THE CHORUS (Fig. 215) *c.*1912–13
Canvas. 16 × 13¾ (40·6 × 34·9)
V. Hiller/Sotheby's, 26 April 1961 (188)/R.B.D./
Private Collection, London
Exh. Brighton 62 (17); R.B.D.63 (4)
Chapter XIV
Study:
Pencil, pen and ink, squared. 14¾ × 10¼ (37·5 × 26), Coll. Southampton Art Gallery (1951). Exh. Eldar Gallery 1919 (16), rep. in illustrated catalogue; Sheffield 57 (148); A.C.1961, 'Drawings of the Camden Town Group' (96). The dating of the painting relies, to a

certain extent, on the dating of the drawing. The drawing is busily hatched and could belong to any time between 1911 and 1913. However the setting and its spatial organization are the same as that used in *Ticking him Off*, 11 × 8¾ (28 × 22·2), last known owner E. L. Franklin Esq. *Ticking him Off* is undated but it has the flamboyant, *mouvementé* quality typical of Sickert's drawings *c.*1913 (e.g. *Miss Enid Bagnold*, details and whereabouts of original unknown. Dated 1913. Rep. the *New Age*, 1 January 1914.)

Related painting:
Wellington House Academy. Canvas. 17¾ × 13¾ (45 × 35), J. W. Freshfield/Last known owners Mr. and Mrs. R. Dennis. Exh. Agnew 60 (81). The setting is the same as that seen in *Lady of the Chorus*; the theme (a nude, seated on a bed which is placed almost at right angles to the surface) is the same. However, the placing of the furnishings is altered and the handling is more fluent and summary. A date of *c.*1913 is suggested.

308. HUBBY AND EMILY (Fig. 217) *c.*1913
Canvas. 15¾ × 13 (40 × 33)
'Sickert' b.l.
R. Middleton/
Private Collection, Scotland
Chapter XIV and note 20, and Chapter XV

This picture may be the life-size head of Hubby which Sickert, in a letter probably written late in 1913, told Miss Sands he was repainting, as an experiment, to see how an increased scale helped to avoid congestion in the painting.

Study:
Second Officer. Chalk, pen and ink. 11⅜ × 9½ (28·9 × 24·1), Coll. Oxford, Ashmolean Museum (1960). Exh. Carfax Gallery April 1914 (9); Agnew 60 (256). The figure of Hubby is very similar in drawing and painting but the female figure is quite different. In the drawing she is seen over Hubby's left shoulder in exaggeratedly diminished perspective. Her presence in the painting may have been an afterthought. The model in the painting is Emily, not Sickert's usual model Marie.

309. HUBBY AND MARIE (Fig. 218) early 1914
Canvas. 18½ × 15 (47 × 38·1)
'Sickert' b.r.
J. Stanley-Clarke/
Coll. Hamilton Art Gallery, Ontario, Canada (1960)
Chapter XIV, and note 21

In a letter to Miss Hudson written in February 1914 (the envelope is postmarked 22 February) Sickert sketched some of the 'direct little pictures' he was currently painting, including Fig. 218.

Study:
Wellington House Academy (it is so inscribed). Pen and ink, chalk, pencil. 12¾ × 18¾ (32·4 × 47·6), Coll. Preston, Harris Museum and Art Gallery (1958). Exh. A.C.64 (49).

Related picture:
Canvas. 20 × 16 (50·8 × 40·6), C. L. Rutherston/Coll. Manchester, City Art Gallery (1925). Exh. Hull 68 (15). This painting is a variation of the drawing and painting catalogued above. Marie is turned further to profile, a little more setting is included, and Hubby's pose is slightly

altered to recall his attitude in the drawing *Second Officer* (listed under C.308). The Manchester picture is more loosely and thinly painted than the version illustrated here (in which the paint is thicker and more creamy). The handling of the Manchester picture is very close to that of *Nude seated on a Couch* (Fig. 220).

310. NUDE SEATED ON A COUCH (Fig. 220)
early 1914

Canvas. 20 × 16 (50·8 × 40·6)
'Sickert' b.r.
Coll. Manchester, City Art Gallery (1925)
Exh. Sheffield 57 (32)
Chapter XIV, and note 21

Another of the 'direct little pictures 20 × 16' sketched for Miss Hudson in February 1914 (see note to C.309). The same interior is seen in *Army and Navy* (Fig. 219).

311. ARMY AND NAVY (Fig. 219)
early 1914

Canvas. 20 × 16 (50·8 × 40·6)
'Sickert' b.r.
Coll. Bristol, City Art Gallery (1935)
Exh. Carfax Gallery April 1914 (21); Sheffield 57 (39); A.C.64 (19)
Chapter XIV

The exhibition of this picture in April 1914 provides it with a *terminus ante quem* (it was bought from the exhibition by the Contemporary Art Society). In fact *Army and Navy* must have been painted at the same time as *Nude seated on a Couch* (Fig. 220). The interior is identical and the second figure is again seen in reflection only. In the recipe given to Miss Sands in a letter of *c*.1913, quoted in full in the text, Sickert wrote how his method of painting in free loose coat upon free loose coat, each coat made up of different size touches and each allowed to dry completely before the next was laid on, meant keeping two pictures 'at least going for time to dry'. *Army and Navy* and *Nude seated on a Couch* could be just such a pair of absolutely contemporary pictures, painted in rotation.

Study:
Pencil. 13 × 8 (33 × 20·3), Coll. Keith Baynes Esq. Inscribed not only with the title 'Army and Navy' but also 'Bully Forbes sail like a witch light breeze' which may be an *aide-mémoire* for naval jargon. The title of the painting and drawing may be taken to imply that the two men (one seen only as a reflection) are reminiscing about their experiences in the different services.

312. PORTRAIT OF ETHEL SANDS (Fig. 221) *c*.1913–14

Canvas. 22 × 18 (55·7 × 45·7)
'Sickert' b.r.
Christie's, 30 June 1933 (130)/Miss Ethel Sands/ Christie's, 12 June 1970 (30)/
Private Collection, England
Exh. Sheffield 57 (85)
Chapter XVIII

Miss Sands, a lady amateur painter of American birth but English upbringing, was a close friend of Sickert for many years. Sickert's letters to Miss Sands and to her friend Miss Hudson are an integral part of this book.

Sickert evidently painted Miss Sands several times. In a letter written in 1913 to Miss Sands he referred to 'your head by me' with the implication that it was currently on view at the A.A.A.; however, although Sickert was listed as an exhibitor no work by him is cited in the A.A.A. catalogue. It is nevertheless possible to suggest that the work exhibited at the A.A.A. in 1913 was not the picture illustrated here because in his letter Sickert went on to say, 'I will end by doing a head of you that shall live as long as paint. Do help me by getting realistically and *confidentially* photographed, laughing if possible. . . . I want "perceptual" information.' It is probable that Fig. 221 is the result of Miss Sands's compliance with Sickert's request for a realistic laughing photograph. It is thinly painted in sharp colours (light brown, acid yellow, red, blue, and green).

In another letter of 1913 Sickert mentioned his use of photographs in connection with a portrait of Miss Sands. He wrote of a photograph which he called '*la bonne sans place*' which 'shortened my work in the big head I began at Newington, having already drawn the lines and proportions'. This photograph apparently showed Miss Sands wearing a hat. The big head painted from it could be the portrait exhibited at the A.A.A. in 1913.

313. ENNUI (Fig. 223)
c.1914

Canvas. 60 × 44¼ (152·4 × 112·4)
'Sickert' b.r.
Coll. London, Tate Gallery (1924)
Rep. Bertram, Pl. 28; Rothenstein 1961, Col. Pl. 11; Pickvance 1967, front cover
Lit. Virginia Woolf, *Walter Sickert: a Conversation*, London, Hogarth Press, 1934; Tate Gallery Catalogue 1964, pp. 623–4
Exh. N.E.A.C. summer 1914 (164); Tate 60 (124)
Chapter XV

Fig. 223 is the largest and most highly finished of all versions of this, Sickert's most famous subject. Versions (including what may be considered preliminary rehearsals):

1. Canvas. 16 × 13 (40·6 × 33), Dr. A. S. Cobbledick/Coll. Commander Sir Michael Culme-Seymour, Bt. Exh. Chicago: Pittsburgh 1938 (1); N.G.41 (91); Agnew 60 (96).
2. Canvas. 20 × 16 (50·8 × 40·6), Howard Bliss/Walter Howarth/Coll. H.M. Queen Elizabeth, The Queen Mother. Rep. B.43, Pl. 42; Emmons, facing p. 124. Exh. Chicago: Pittsburgh 1938 (13); N.G.41 (64); Edinburgh 53 (10); Sheffield 57 (44); Agnew 60 (86); Adelaide 68 (41).
3. Canvas. 18¼ × 15 (46·4 × 38·1), Coll. Edward G. Robinson Esq. U.S.A. Exh. New York 67 (43). Dated 1916 and dedicated to Asselin (that is Maurice Asselin, see C.362).
4. Canvas. 30 × 22 (76·2 × 55·9), F. Hindley-Smith/Coll. Oxford, Ashmolean Museum (1939). Rep. B.60, Pl. 71; Lilly, Pl. 6.

The theme and composition of *Ennui* developed naturally from the long series of two-figure domestic subject pictures of 1911–13. Versions 1 and 2 were probably preliminary ideas painted *c*.1913 for the picture exhibited in 1914. Neither includes the table in the foreground of the Tate Gallery *Ennui*. The dated version of 1916 (3) is a telescoped view of the main part of the subject; it shows Hubby and

the glass but less of the table and excludes much of the peripheral space (including the woman's head). The composition of Version 4 is identical to that of Fig. 223 but it is painted half-scale and many of the areas of plain, flat colour are transformed into busily patterned passages (the table, walls, and even the woman's blouse). Miss Browse (B.60, p. 77) dates this version 1917 or 1918; like Miss Browse I believe the picture is a later reworking of Fig. 223 but am unable to establish an exact date for its execution.

Although Fig. 223 is the best-known version of *Ennui* it is not the picture which inspired Virginia Woolf's brilliant literary interpretation. Her pamphlet on Sickert was occasioned by the loan exhibition of Sickert's work at Agnew's in 1933; the version of *Ennui* there exhibited was that now in Oxford (Version 4) but then in the possession of Mr. Hindley-Smith. There are a large number of drawn studies for *Ennui*.

They include:

1. Five studies of details of the composition, various sizes and media, Mrs. L. Powell/Coll. Leeds, City Art Gallery (1951). Exh. Hull 68 (39–43 inclusive).
2. Three studies of details of the composition, various sizes and media, Coll. Oxford, Ashmolean Museum (1949). Exh. Tate 60 (136, 137, 140).
3. Pen and ink, chalk. 15 × 11 (38·1 × 28), Coll. Leeds, City Art Gallery (1947). Exh. Sheffield 57 (118); Hull 68 (38). This is a full composition study, related in the points at which it is cut (to omit the table and mantelpiece) to Versions 1 and 2.
4. Pen and ink. 16 × 13 (40·6 × 33), Alfred Jowett/Christie's, 19 July 1959 (119)/Coll. London, Tate Gallery (1960). Exh. N.G.41 (106); Leeds 42 (108); Edinburgh 53 (84). A composition study similar to Fig. 223 except that it shows a little more space to right and left and the matchbox is placed differently.
5. Pen and ink, pencil, blue chalk. 14¾ × 11 (37·5 × 28), Coll. Whitworth Art Gallery, University of Manchester (1927). Exh. Tate 60 (141). Dated below the mount 1914. A composition study very close to Fig. 223.
6. Pen and ink, pencil. 15¼ × 11¼ (38·7 × 28·5), Coll. Oxford, Ashmolean Museum (1949). Exh. Tate 60 (138). A composition study in which the framed picture is elaborated but the rest of the subject only roughly indicated and the mantelshelf omitted.
7. Chalk, pen and ink, squared. 14¾ × 10½ (37·5 × 26·7), H. C. Laurence/Coll. Oxford, Ashmolean Museum (1943). Rep. *Image*, No. 7, 1952, p. 46; Rothenstein 1961; Lilly, Pl. 7. Exh. Tate 60 (139); R.A.1968–9, 'Bicentenary Exhibition' (643). The most elaborate of all the composition studies; it includes all the details except the glass on the mantelshelf.

Another study for *Ennui* is privately owned but its details are unknown to me.

Sickert etched *Ennui* in 1915.

314. GIRL IN A WHITE DRESS c.1910–13

Canvas. 18 × 15 (45·7 × 38·1)
'Sickert' b.r.
Last known owners Mr. and Mrs. S. Samuels, Liverpool
Lit. B.60, p. 43
Chapter XIV

Miss Browse quotes the inscription on the back of the picture, 'This was painted by me before the students at the Westminster Technical Institute, Vincent Square'. The heavy impasto of this demonstration picture was presumably built up in one sitting. Its bold, fresh if clumsy handling is similar to that seen in *Lady of the Chorus* (Fig. 215) and *Jack Ashore* (C.319) but they were not demonstration pictures. Sickert began to teach at the Westminster Technical Institute in about 1908 and continued on its staff, with interruptions, until 1918. C.314 is traditionally dated 1910 but I believe it may have been executed rather later, c.1912–13.

315. LOU! LOU! I LOVE YOU c.1911

Canvas. 11¼ × 7¼ (28·6 × 18·5)
'Sickert' b.r.
Christie's, 28 July 1955 (282) as *Two Women seated on Bed*/
Private Collection, England
Rep. B.60, Pl. 64
Exh. Probably Carfax Gallery, December 1911, '2nd. Exhibition of the Camden Town Group' (12), Brighton 1913–14, 'The Work of English Post-Impressionist and Cubist Painters arranged by the Camden Town Group' (59), and Carfax Gallery 1916 (3), all as *Mother and Daughter*; Tate 60 (120)
Chapter XIV

The etching of this subject is called *Mother and Daughter* and the *Evening Standard*, 6 December 1911, described the picture exhibited at the Camden Town Group as showing women 'of the coster type'—hence the identification of the painting catalogued here as *Mother and Daughter* exhibited in 1911, 1913–14, and 1916. The present title of the picture is taken from the caption given to a drawing of the subject, original of unknown whereabouts, published in the *New Age* 6 July 1911. The drawing is dated 1911 and is identical in composition to the painting. It was even probably the same size as the painting because most of the original drawings published in the *New Age* measured approximately 11 × 7 inches.

316. OEUILLADE c.1911

Canvas. 15⅛ × 12 (38·4 × 30·5)
'Sickert' b.l.
Howard Bliss/
Coll. Cambridge, Fitzwilliam Museum (1945)
Exh. Possibly Carfax Gallery May 1912 (18) and/or Brighton 1913–14, 'The Work of English Post-Impressionist and Cubist Painters arranged by the Camden Town Group' (58)
Chapter XIV

There is another picture called *Oeuillade*, canvas. 19¼ × 15½ (49 × 39·4), Miss J. Rayner/Sotheby's, 15 December 1971 (26), Exh. *Biennale* XVII, Venice 1930, British Section (21) lent by Mrs. G. E. Rayner. This picture could also be the one shown in London or Brighton or both, although stylistically it suggests a slightly later dating. It is curious how Sickert tended, at this period, to show the same few works, or certainly works with the same title, at different exhibitions; *Oeuillade*, *Mother and Daughter* (C.315) and *Chicken* are examples. Sickert showed a *Chicken* with the Camden Town Group in 1911 (C.280); he showed *Chicken*

with the same group in December 1912 and again at Brighton 1913–14 (56). It is impossible to say whether the same picture was shown on all these different occasions. The 1912 picture was described by the *Yorkshire Observer*, 1 December 1912, as 'a pretty portrait of a girl'; since C.280 shows the girl from the back it is unlikely to have been the pretty portrait of 1912. Many of the pictures of Chicken (playing the piano for example) were done in the winter of 1914–15 (C.352)—too late to be considered as the picture exhibited before the war. Edward le Bas owned a *Chicken* portrait, Canvas. 20 × 16 (50·8 × 40·6), Rep. Lilly, Pl. 11, Exh. N.G.41 (52); Leeds 42 (174); Sheffield 57 (92); Agnew 60 (77) and Tate 60 (125) as '*Poule*'; R.A.1963, 'A Painter's Collection' (144), but this painting is so close stylistically to the series of 'direct little pictures 20 × 16' which Sickert told Miss Hudson he was painting in February 1914 (particularly to *The Blue Hat*, C.320) that it could not be the work exhibited in 1912 or even 1913–14. A pencil, pen and ink squared study for this painting, 7¾ × 6½ (19·6 × 16·5) is in the Carlisle City Art Gallery, Exh. A.C.64 (53). Another *Chicken* formerly belonged to Percy Moore-Turner, Canvas. 15 × 12 (38·1 × 30·5), Rep. B.60, Pl. 66. Exh. Eldar Gallery 1919 (35); N.G.41 (22). This picture does look like a work of *c.*1911–12 but it is difficult to imagine it being described as a 'pretty portrait'. Another work shown at Brighton 1913–14 (86) which had recently been exhibited elsewhere—at the Carfax Gallery March 1913 (40)—was the drawing *The Tattooed Sailor*, Pen and charcoal, 14¾ × 10¼ (37·5 × 26), Sir Hugh Walpole/Fleming Williams/Coll. Mark Glazebrook Esq. Rep. B.60, Pl. 89a (misdated *c.*1917). Exh. R.B.D.60 (40); Tate 60 (144).

317. WOMAN WITH RINGLETS *c.*1911

Canvas. 13½ × 11½ (34·3 × 29·2)
'Sickert' b.r.
F. Hindley-Smith/
Coll. Cambridge, Fitzwilliam Museum (1939)
Chapter XIV

Closely related to *Oeuillade* in handling and subject, a near view of a woman's head.

318. MISS HUDSON AT ROWLANDSON HOUSE *c.*1912

Canvas. 36 × 20 (91·5 × 50·8)
'Sickert' b.r.
Miss A. H. Hudson/
Last known owner Miss Ethel Sands
Rep. B.43, Pl. 37
Exh. Chicago: Pittsburgh 1938 (29)
Chapter XIV

Miss Anna Hope Hudson (usually called Nan), like her friend Miss Sands, was a painter, a disciple of Sickert and a member of the Fitzroy Street Group. Sickert took great interest in their welfare and artistic education and greatly valued their friendship, as they did his. Like Miss Sands, Nan Hudson was American by birth; she maintained more contact with America than did her friend.

Sickert evidently painted more than one portrait of Miss Hudson. C.318 is traditionally dated 1912 but in letters of 1910 he implied that he had already painted Miss Hudson. For example, when he asked her to give him

sittings he told her he wanted to paint a picture which would be 'more *portrait*, and less effect' than an existing portrait of the lady. C.318 is more effect than portrait and therefore it could be the picture already painted by 1910 but its handling argues against this dating. Moreover, it is probable that the later portrait, painted when Miss Hudson eventually complied with Sickert's repeated requests for morning sittings (in letters of 1910–11), was also 'effective'; Sickert suggested that Miss Hudson should 'come in some "creation" you fancy yourself in because I fancy you in anything'.

319. JACK ASHORE *c.*1912–13

Canvas. 14½ × 11¾ (36·8 × 29·8)
Howard Bliss/
Last known owners Mr. and Mrs. S. Samuels, Liverpool
Rep. B.60, Pl. 65; Rothenstein 1961, Col. Pl. 9; Pickvance 1967, Col. Pl. XII; Lilly, Pl. 10
Exh. Tate 60 (119)
Chapter XIV

The fact that Hubby was the model for the painting and several drawings of *Jack Ashore* proves that the subject could not have been executed before the autumn of 1911 when Hubby appears to have joined Sickert's *ménage*. The handling of the painting and of the drawings, however, suggests a later date, *c.*1912–13. The title of the subject may have reference to Hubby's past at sea (Emmons, p. 139).

There are many drawings related to *Jack Ashore*. In all of them more of the peripheral space is shown than in the painting (which cuts off part of Hubby's head). Two drawings called *Jack Ashore* were exhibited at the Carfax Gallery in April 1914 (6, 10) but which two is unknown.

Drawings include:
1. Charcoal, pen and ink. Size unknown. Last known owner Dr. Robert Emmons. Rep. Emmons, facing p. 146; Bertram, Pl. 24.
2. Charcoal, pen and ink. 13⅛ × 10¾ (33·3 × 27·3), Mrs. Marci Thomas/M. Langworthy/Coll. New York, Museum of Modern Art (1967). Exh. New York 67 (28).
3. Chalk, pen and ink. 13⅜ × 10½ (34 × 26·7), Mrs. Grace Wheatley/Christie's, 11 November 1958 (16) as *A Man conversing with a Woman*/Coll. Bedford, Cecil Higgins Art Gallery (1960). Exh. Agnew 60 (243).
4. Chalk. 12½ × 9½ (31·7 × 24·1), Coll. Robert Haines Esq., Sydney (mistakenly listed B.60, p. 84 as belonging to the Queensland Art Gallery, Brisbane, of which Mr. Haines was then director).

Study 4 was later signed and inscribed 'Study for engraving "Jack Ashore"' but it was probably drawn much earlier than the engravings (a small and a large plate) done in the 1920s (although it may have been re-used for the engravings). There is, however, one drawing of *Jack Ashore* which probably was done specifically as a study for the dated engraving of 1923. It is pencil, red chalk, 13½ × 10 (34·3 × 25·4), Coll. London, Arts Council of Great Britain (1950), Exh. Tate 60 (132); Adelaide 68 (65). Like the engraving it is very neatly defined and shows the composition in reverse (perhaps because this drawing was traced directly from earlier studies, as is suggested by its rubbed dirty surface).

320. THE BLUE HAT early 1914

Canvas. 18¼ × 15 (46·3 × 38·1)
'Sickert' b.r.
Coll. Wellington, National Art Gallery of New Zealand
(1951).
Exh. Adelaide 68 (40)
Chapter XIV, note 21

This painting, a close-up bust of a young woman wearing a
blue hat, was one of the 'direct little pictures' which Sickert
wrote to Miss Hudson that he was painting early in 1914.
The sketch Sickert made of the painting in his letter of
February 1914 identifies the model as 'Lil'. Sickert quoted
the size of all this series of pictures as 20 × 16; possibly
part of the canvas of *The Blue Hat* is obscured by the
frame.

1910–AUTUMN 1914. PORTRAIT AND FIGURE DRAWINGS

321. MRS. STYAN (Fig. 222) dated 1910

Pen and ink, chalk, heightened with white, on grey paper
17¾ × 11¾ (45·1 × 29·9)
'Sickert 1910' b.l.
Alfred Jowett/Christie's, 17 July 1959 (118)/
Coll. Lord Reigate
Exh. N.G.41 (111); Leeds 42 (106); R.A.1968–9, 'Bicen-
tenary Exhibition' (638)
Chapter XIV

The sitter was painted by Wilson Steer in 1906 (see D. S.
MacColl, *Life Work and Setting of Philip Wilson Steer*, London,
Faber, 1945, p. 207). She was probably the Mrs. E. M.
Styan who bequeathed several Sickert etchings to the
British Museum.

322. MORNING (Fig. 225) dated 1911

Chalk. 10½ × 6¼ (26·8 × 15·9)
'Sickert 1911' b.l.
Mrs. M. Clifton/Christie's, 9 October 1942 (99)/S. Samuels/
 Sotheby's, 19 July 1967 (85)/R.B.D./
Private Collection, London
Rep. The *New Age*, 21 March 1912
Exh. R.B.D.1969, 'Sickert Drawings' (58)
Chapter XIV

One of several half-length studies of a woman, sometimes
clothed, sometimes unclothed, seen with her head in
profile against a window background drawn by Sickert
in 1911 and 1912. Other examples include:
1. *Who did you say?* Chalk. 12½ × 9 (31·8 × 22·9), from
 the collection of Edward le Bas. Rep. the *New Age*,
 4 January 1912. Exh. R.A.1963, 'A Painter's Collection'
 (188) as *Seated Girl*.
2. *Rowlandson House* (it is so inscribed). Pencil. 14 × 9⅛
 (35·6 × 23·3), J. A. McCullum/Coll. McCullum Collec-
 tion, University of Glasgow (1939).
3. *How old do I look?* Charcoal, pen and ink, on linen.
 11 × 7 (28 × 17·8), Private Collection, England. Dated
 1912.

323. TO MISS ANGUS (Fig. 227) dated 1911

Pencil. 11 × 8 (28 × 20·3)
'To Miss Angus/Walter Sickert 1911' b.r.
Coll. The University of Reading (1911)
Chapter XIV

The somewhat disjointed, schematic quality of this drawing
is typical of many drawings of this period. Another example
is *Nude, Rowlandson House*, pencil, 13½ × 8¼ (34·3 × 21), Coll.
University of Reading (1957), in which the setting is
identical to that of Fig. 227. These drawings and others
like them may have been demonstration pieces done by
Sickert to show his pupils at Rowlandson House how to
relate figures to their backgrounds.
Fig. 227 is one of a group of drawings inscribed to Christine
Angus during the months in 1911 when Sickert wooed her.
A landscape thus inscribed was listed under C.290. The
aloof young lady regarding the rather humble middle-
aged man in Fig. 227 may be a humorous reference to
Sickert's own relationship with Christine at this time.

324. A WEAK DEFENCE (Fig. 224) 1911

Chalk, pen and ink. 14½ × 9¾ (36·8 × 24·7)
Coll. London, Arts Council of Great Britain (1948)
Exh. A.C.64 (47); Adelaide 68 (69)
Chapter XIV

The composition of Fig. 224 recalls *La Belle Gâtée* of 1908
(Fig. 187) but the bed and figures are now drawn much
larger.

Study:
Pen and ink. 13½ × 8⅞ (34·3 × 22·5), Coll. Leeds, City
Art Gallery (1951). Exh. Sheffield 57 (116); A.C.64 (45).
Dated 1911. A study for the woman's figure (without her
head).

325. ROGER FRY. VISION, VOLUME, AND RECESSION
(Fig. 226) c.1911

Pen and ink. 6¾ × 3¾ (17·2 × 9·5)
Coll. London, Islington Public Libraries (1947)
Rep. *Image*, No. 7, 1952, p. 32.
Exh. Sheffield 57 (120); A.C.1961, 'Drawings of the
 Camden Town Group' (103)

A portrait or caricature of Roger Fry lecturing. Fry
(1866–1934), the artist, critic, and writer on aesthetics,
was a friend of Sickert (although Sickert disagreed with
Fry's enthusiasm for the work of Cézanne and the French
Post-Impressionists). Fry owned two Sickert paintings
(Figs. 153, 260). Sickert had painted Fry in 1893 because
in a letter to Lowes Dickinson written that year Fry reported
that Sickert 'is doing a wondrous thing of me which will
be splendid colour'. This portrait is not traced.
Sickert also etched Fig. 226.

326. ALICE (Fig. 228) dated 1911

Pen and ink. Size unknown
'Sickert' t.r., 'Alice' b.l., 'June 1911' b.r.
Whereabouts of original unknown
Rep. The *New Age*, 22 June 1911
Chapter XIV

327. SALLY (Fig. 229) c.1911

Pen and ink. 12¼ × 7½ (31·1 × 19)
'Rd. St.' b.r., 'Harrington Square Camden Town' b.l.
Coll. Bedford, Cecil Higgins Art Gallery (1958)
Exh. Tate 60 (130); Agnew 1962, 'Watercolours from the Cecil Higgins Art Gallery Bedford' (75)
Chapter XIV

Fig. 229 is generally dated 1909. Indeed the Bedford Art Gallery has discerned the date inscription '0.9' from some random squiggles between the words 'Harrington' and 'Square'. I totally disagree with this dating.

The drawing was evidently post-inscribed but if Sickert's memory of where it was drawn was correct it cannot date before 1911 when Sickert moved, after his marriage, to Harrington Square. In 1912 he and his wife moved again to 68 Gloucester Crescent.

It is true that other drawings and paintings of Sally nude at a washstand are works of 1909 (e.g. Fig. 186 and C.278). However, the style of Fig. 229, with its organized variety of pen and ink hatching techniques, is typical of 1911 but inconceivable in 1909. Furthermore, in the 1909 Sally subjects the washstand is a two-tiered rectangular trolley-like object, not a semi-circular table as in Fig. 229. This semi-circular table does, however, appear in other works of 1911–12, e.g. *Nude*. Chalk. 14½ × 8¼ (36·8 × 21), Coll. Ralph Fastnedge Esq. Dated 1912.

Related drawing:
Sally. Pen and ink. 14¼ × 10½ (36·2 × 26·8), Private Collection, London. Exh. Edinburgh 53 (104).
Sickert etched *Sally*.

328. THE ARGUMENT (Fig. 230) dated 1911

Pen and ink. 12½ × 8 (31·8 × 20·3)
'Sickert 1911' b.l.
Coll. Auckland, City Art Gallery (1961)
Rep. The *New Age*, 13 June 1912
Chapter XIV

Compare this published drawing with a preliminary study for the composition, *The Visitor* (Fig. 231). In *The Argument* the space is constricted to telescope attention on the standing figure and thus project a more commanding image on the page. The second figure in *The Visitor* is excised from *The Argument*. Similar comparisons can be made between the preliminary drawings for *The Comb* and the version finally published (C.337) and *Amantium Irae* (Fig. 234) and its preliminary version *The Tiff*, C.331.

Painted version of *The Argument*:
The Objection. Canvas. 32½ × 19½ (82·5 × 49·5), Dr. Robert Emmons/Christie's, 1 June 1956 (123)/J. O. Stanley-Clarke/Sotheby's, 13 December 1961 (126)/Coll. Perth, Western Australian Art Gallery (1968). Rep. B.60, Pl. 70; Lilly, Pl. 32. Exh. Brighton 62 (22); R.B.D.63 (9); New York 67 (3); Sydney 68 (29). Dated 1917.

329. THE VISITOR (Fig. 231) 1911

Pen and ink, chalk, on buff paper. 17¾ × 12¼ (45·1 × 31·1)
Coll. Huddersfield, Art Gallery (1953)
Exh. Edinburgh 53 (98); Sheffield 57 (142); A.C.64 (51); Hull 68 (37)
Chapter XIV

The preliminary version of *The Argument*, Fig. 230. The visitor of the title, wearing a top hat, is Gilman.

330. MR. GILMAN SPEAKS (Fig. 232) dated 1912

Pen and ink. 12 × 7¾ (30·5 × 19·7)
'Sickert 1912' b.r., 'Mr. Gilman speaks' b.l.c.
Miss Sylvia Gosse/
Coll. London, Victoria and Albert Museum (1926)
Rep. Pickvance 1967, Fig. I, p. 4
Exh. Obachs Gallery, January–February 1912, 'Society of Twelve' (106); A.C.64 (52)
Chapter XIV

The broken touch of this drawing, especially in the face of Gilman who stands to look at the spectator, may have influenced the painted portrait of *Gilman* (Fig. 207) or vice versa.

331. AMANTIUM IRAE (Fig. 234) dated 1912

Pen and ink. 10⅝ × 6½ (27 × 16·5)
'Sickert 1912' b.r.
Rex NanKivell/Agnew/
Private Collection, London
Rep. The *New Age*, 7 March 1912
Exh. Carfax Gallery May 1912 (14)
Chapter XIV

The title of Fig. 234 is taken from Terence, *Andria*: '*Amantium irae amoris integratio est*'.

This published drawing, like *The Argument* (Fig. 230), was worked out in a preliminary version incorporating more space and detail:
The Tiff. Pen and ink. 11¼ × 9 (28·5 × 22·9), Miss Lowe/R.B.D./Private Collection, London. Rep. *Image*, No. 7, 1952, p. 40. Exh. R.B.D.60 (39); Brighton 62 (25).

332. MY AWFUL DAD (Fig. 235) c.1912

Chalk. 14⅞ × 10¾ (37·8 × 27·4)
Coll. Oxford, Ashmolean Museum (1961)
Chapter XIV

Version:
Chalk. 13¾ × 9¾ (35 × 24·8), Samuel Courtauld/Coll. London, Courtauld Institute of Art (1935). Exh. N.G.41 (128); Leeds 42 (110); Edinburgh 53 (72); Sheffield 57 (111). This drawing is inscribed with the title 'My awful dad'.
My Awful Dad is a variation upon *Vacerra* (C.341); the mature figure of Marie is replaced by a young girl. This girl probably modelled for Sickert in *Past and Present*, an untraced figure picture shown at the Third Camden Town Group Exhibition in December 1912, described by the *Daily Telegraph*, 17 December 1912, as 'a mature wench and another younger—both equally objectionable'; according to the *Outlook*, 14 December 1912, the girl possessed 'a bright impertinent eye' and 'plaited hair'.
Sickert painted this subject many years later, probably in the 1930s (Fig. 291, C.411).

333. RECONCILIATION (Fig. 233) c.1913–14

Pen and ink. 9⅛ × 7⅛ (23·2 × 18)
'Sickert' b.l.
Coll. Liverpool, Walker Art Gallery (1948)
Rep. The *New Age*, 5 March 1914
Exh. Carfax Gallery April 1914 (15); A.C.49 (31)
Chapter XIV

Reconciliation shows figures in explicit, interrelated movement which is rare in Sickert's work but less so at this period, *c.*1913–14. Another such drawing of about this time:

Hubby and Marie. Pencil, pen and ink, wash. 15½ × 10 (39·4 × 25·4), Coll. Professor A. Betts. Two figures about to embrace on a couch.

334. MR. JOHNSON dated 1911

Pen and ink. 12¾ × 8 (32·4 × 20·3)
'Sickert 1911' b.r., 'Fare tutti mestieri svergognati per compar onoratamente' t.l.c.
Last known owner C. Marescoe Pearce Esq.
Rep. Emmons, p. 55
Exh. Obachs Gallery, January–February 1912, 'Society of Twelve' (107); Edinburgh 53 (66); Tate 60 (134)
Chapter XIV

The phrase inscribed on the drawing was written down for Sickert by Degas who took 'delighted relish' in it (Sickert, the *Burlington Magazine*, 31, November 1917, pp. 183–91, 'Degas', p. 191).
In 1911 Sickert did many drawings of women combing their hair by a mirror—as the woman in the background of *Mr. Johnson* is doing. Possibly this subject, so beloved by Degas, inspired the inscription. Mr. Johnson is presumably the figure seated on the couch.
Sickert etched the subject.

335. WHERE CAN IT BE? dated 1911

Pen and ink. Size unknown
'Sickert 1911' b.r.
Whereabouts of original unknown
Rep. The *New Age*, 4 April 1912; B.60, title page
Chapter XIV

The male model may be Hubby who first appears in Sickert's work in 1911.

336. PREOCCUPATION dated 1911

Pen and ink. 13¼ × 8 (33·7 × 20·3)
'Sickert 1911' b.r.
Sir Sigismund Neumann/
Coll. Johannesburg, Art Gallery (1912)
Rep. The *New Age*, 1 February 1912; Emmons, p. 163; B.60, p. 52
Chapter XIV

The compositional organization of this drawing, with a couch seen in head-on foreshortening, is the same as in *Mr. Johnson* but now the woman is seated on the far arm of the couch and looks at herself in a mirror; the man reads a newspaper.

337. THE COMB dated 1911

Pen and ink. 11½ × 7½ (29·2 × 19)
'Sickert 1911' b.c.
Lord Cottesloe/Sotheby's, 14 July 1965 (68)/
Coll. Mr. and Mrs. Deane F. Johnson, Los Angeles
Rep. The *New Age*, 18 January 1912
Exh. Carfax Gallery May 1912 (33); Agnew 1966, 'French and English Drawings' (65)

Chapter XIV
There are two preliminary drawings for *The Comb*; both show more peripheral space with the figures smaller in relation to the page:
1. *The Toilet at the Window.* Pen and ink, pencil, wash. 15 × 10⅛ (38·1 × 25·7), Dr. Robert Emmons/Coll. Birmingham, City Art Gallery (1948). Exh. A.C.1961, 'Drawings of the Camden Town Group' (98).
2. *In the Dressing Room.* Pencil. 15⅜ × 9⅞ (39 × 25·1), Coll. Whitworth Art Gallery, University of Manchester (1960).

338. A CONVERSATION PIECE dated 1911

Pen and ink. 12⅝ × 7¾ (32 × 19·7)
'Sickert 1911' b.l.
Coll. Auckland, City Art Gallery (1952)
Rep. The *New Age*, 25 January 1912; *Image*, No. 7, 1952, p. 25
Exh. Carfax Gallery May 1912 (46); Adelaide 68 (68)

339. THE PROPOSAL *c.*1911

Pen and ink. Size unknown
Whereabouts of original unknown
Rep. The *New Age*, 11 January 1912
Chapter XIV

The male model in a top hat may be Gilman.

340. TWO WOMEN IN A BEDROOM *c.*1912

Pen and ink. 12½ × 8½ (31·8 × 21·6)
'Rd.St.A.R.A.' b.l.
Coll. London, British Council (1948)
Chapter XIV

This drawing has been dated 1910 (B.60, p. 97). However, its setting is identical to that used for the drawing of a *Nude*, dated 1912, listed under *Sally* (C.327). Moreover, the style of the drawing, with its neatly hatched cast shadows, and its outline drawing and modelling dissolved into delicately broken flecked touches, is very close to that of *Mr. Gilman Speaks* (Fig. 232). Thus a date of 1912 is strongly indicated for C.340.
The same two women, similarly posed and in the same interior but seen from a different angle, are studied in another drawing, pen and ink. 10 × 7 (25·4 × 17·8), Sotheby's, 17 March 1965 (97), bought Chalmers.

341. VACERRA *c.*1912

Charcoal, pen and ink. Size unknown
'Vacerra' b.l., 'Sickert' b.r.
Last known owner Dr. Robert Emmons
Rep. Emmons, facing p. 178
Chapter XIV

The title is taken from Martial, *Epigrams*, XI, 66: '*Et delator es, et calumniator/Et frandator es, et negotiator/Et bellator es, et lanista: miror/Quare non habes, Vacerra, nemmos*'. Sickert inscribed this epigram in full on the etching of the subject which he named *Et delator es*. The character Vacerra is described in several of Martial's epigrams. He seems to have been a mean and petty swindler.
The woman's figure in *Vacerra* is related to Marie in *Sunday Afternoon* (Fig. 214).

Study:
Chalk. $13\frac{1}{4} \times 10\frac{1}{4}$ (33·7 × 26), Coll. H. K. B. Lund Esq. This shows the woman only and is inscribed 'Study for engraving illn. Martial "Et delator es"', but the study is also related to the drawing from Emmons's collection.

1913-14. DIEPPE, LANDSCAPES

342. LA SCIERIE DE TORQUEVILLE *or* LE VIEUX COLOMBIER (Fig. 236) 1913
Canvas. $26 \times 41\frac{1}{2}$ (66 × 105·4)
'Sickert' b.r.
W. Rees Jeffreys/Christie's, 26 November 1954 (67)/
Coll. Dundee, Art Gallery (1955)
Rep. B.43, Pl. 38
Lit. Lilly, pp. 37–9
Exh. Carfax Gallery April 1914 (22)
Chapter XV (letters quoted below dated notes 5, 14, 16)
In July 1913 Sickert wrote to Miss Sands, 'I have started studies of an old farmyard with a dovecot raised up on one beam of timber, innumerable mossy timber beams, writhing like snakes on the ground, a *"fond"* of fat rich dark chestnut trees going out of the picture and posts and gates and barrels in shadow showing mysterious *clairière* effect of leafage in the distance. A Corot-Millet subject Germanised a little— Schubert and Klaus Groth *in Stimmung*.' On 27 July he reported, 'I am painting the dovecot in the saw-mills subject 108 × 66. I have worked into the drawing and water-colour study with a great deal of fine pen-work and also on two sectional studies in oils, *toiles de six*, each, half the picture.' In August he told Miss Sands, 'Yesterday I gave the first coat to a large canvas of the "Scierie de Torqueville" which is the name of the *colombier* picture. . . . P. Foriet sent me a *lovely* coarse canvas with a coat of white tempera. Yesterday I squared up the drawing and laid in, without medium, the large tones which now lie *flat* and thick like a bed of porphyry or granite and then onto that I expect I shall easily paint the delicate finish.'
By the end of September the picture was 'had safely'. These letters provide accurate documentation for the extant studies related to Fig. 236.
The 'drawing and watercolour study' which was worked into 'with a great deal of fine pen-work' and finally squared in August is:
Pencil, pen and ink, watercolour, squared. $8\frac{1}{2} \times 14$ (21·6 × 35·6), Messrs. Roland, Browse & Delbanco 1971. Exh. New York 67 (23); Adelaide 68 (71); R.B.D.1969, 'Sickert Drawings' (56). This shows rather more of the subject laterally than does the painting.
The large painting itself is the size quoted by Sickert to Miss Sands (although Sickert quoted the measurements in reverse, width before height, just as he did for the Middlesex Music Hall pictures of 1906). There are extant more than two sectional studies, each half the picture, painted on 'toiles de six' but Miss Lilly (p. 37) noted that he did several small versions and in a later letter to Miss Sands he wrote of 'the big dovecot picture and the 4 or 5 or 6 oil studies for it':
1. Canvas. $15\frac{3}{4} \times 12\frac{3}{4}$ (40 × 32·4), F. M. S. Winand/ Sotheby's, 12 April 1967 (70) as *In the Forest of Fontainebleau*/Coll. Captain A. H. Parker-Bowles. This shows the right half of the scene.

2. Canvas. $15 \times 12\frac{3}{4}$ (38·1 × 32·4), Mrs. Wilde/Martin Oliphant/Sotheby's, 24 November 1969 (348) bought Manor Gallery. This shows *le vieux colombier*, the left side of the subject.
3. *Le Vieux Colombier*, canvas, $15\frac{3}{4} \times 12\frac{1}{2}$ (40 × 31·7), Dr. David Guthrie/Sotheby's, 22 November 1972. Very close to Painting 2.
4. Canvas. $16 \times 12\frac{1}{2}$ (40·6 × 31·7), Dr. David Guthrie/ Sotheby's, 22 November 1972. Similar to painting 1.
When Sickert quoted French canvas sizes he always referred to 'Figure' rather than 'Paysage' or 'Marine' sizes. A *Toile de 6F*, as it is called, measures 41 × 33 cms., which is near enough to the measurements of these studies for *La Scierie de Torqueville* allowing for the inaccuracies of measuring framed pictures. The subject, the timber yard at Torqueville, still exists (but without the dovecot). Torqueville is a hamlet just outside Envermeu where Sickert and his wife had a house. The name of the hamlet has been misquoted as 'Tocqueville' presumably because Mr. Jeffreys (the first owner) misread Sickert's writing in the letter quoted by Miss Browse (B.43, p. 51) explaining the location of the picture.

343. CHÂTEAU DE HIBOUVILLE (Fig. 238) dated 1913
Pencil, pen and ink, watercolour. $10\frac{3}{4} \times 14\frac{3}{4}$ (27·3 × 37·5)
'Château de Hibouville Envermeu 1913' b.r.
Miss Ethel Sands/Christie's, 12 June 1970 (22)/
Christie's, 30 October 1970 (185)/K. T. Powell/Sotheby's, 15 December 1971 (117b)
Exh. Leicester Galleries 1971, 'Paintings and Drawings and Sculpture by 19th. and 20th. century artists' (37)
Chapter XV (letters quoted below dated notes 12, 13)
Early in August 1913 Sickert promised to send Miss Sands sketches of 'the Château of Hibouville peeping from its woods with an avenue and a cornfield in front'. Later in the month he wrote to Miss Sands, 'I expect I shall paint a large picture of the Château de Hibouville . . . They have cut the cornfield *comme de piste*. So I shall perhaps lay in a large canvas to finish next summer. I did the drawing from the best of all motives. *Solely* to show *you* clearly what a place I thought interesting was like.'
Fig. 238 is the sketch Sickert sent to Miss Sands.
Sickert also made another study of the subject (which presumably he preserved for his own use). It is identical in composition and very similar in detail. Chalk, pen and ink, watercolour, squared. $9\frac{3}{4} \times 14\frac{1}{4}$ (24·8 × 36·2), Sotheby's, 28 March 1962 (10)/Coll. Cambridge, Fitzwilliam Museum (1964). Exh. Agnew 1964, 'Drawings and Watercolours 1860–1960' (12). The squaring on this drawing suggests Sickert did in fact paint the subject, but it is probable that he made only a rough oil sketch of it. A painting of the *Château de Hibouville* was exhibited at the Carfax Gallery in April 1914 (2)—and must therefore have been painted the previous summer—but the price Sickert asked for it, 30 guineas as opposed to 250 guineas for *La Scierie de Torqueville*, indicates that it could not have been a very finished work. In his letters to Miss Sands written in 1914 Sickert did not refer to painting this subject and it is possible he never returned to it. A painting called the *Château de Hibouville* exhibited in late retrospectives (e.g. Leicester Galleries 1929) may be the picture shown at the Carfax Gallery in 1914.

344. LA VALLÉE DE L'EAULNE (Fig. 237) c.1913

Canvas. 16 × 12 (40·6 × 30·5)

'La vallee de l'Eaulne' b.l., 'Rd. St.A.R.A.' b.r.

Private Collection, England

Chapter XV

This picture was inscribed at the owner's request when he bought the picture from Sickert.

Fig. 237 is probably one of the *sous-bois* subjects of which Sickert wrote to Miss Sands in 1913. Envermeu and the surrounding countryside where Sickert painted in 1913–14 is in the Eaulne valley. Fig. 237 is not the 'gap in the trees' which Sickert sketched in a letter to Miss Sands and described to her so feelingly (see Chapter XV, p. 134). It must be one of the other 'woods pictures' which prompted Sickert to write, '*le lyrisme dans la peinture il n'y a que cela*'. It is painted entirely in different shades of green.

345. PETIT BOIS DE HIBOUVILLE (Fig. 239) 1913

Pen and ink, watercolour. 6¾ × 5 (17·2 × 12·7)

'Petit bois de Hibouville' b.l.c., 'Die Schöne stille Waldein-
 samkeit' t.l.c.

Miss Ethel Sands/Christie's, 12 June 1970 (24)/
Messrs. Roland, Browse & Delbanco 1971

Exh. R.B.D.1970, 'Christmas Presents' (161)

Chapter XV

Sickert sent this sketch to Miss Sands in 1913 to show her one of his 'woods' subjects. The German inscription, from 'the Schumann-Heine I think it is "*Und über mir schwebt die schöne stille Waldeinsamkeit*" ', underlines how conscious Sickert was of his heritage when he studied subjects of which his 'grandfather and . . . father did endless drawings and paintings' and in which he himself felt 'so at home'.

Sickert showed two oils of woodland subjects at the Carfax Gallery in April 1914, *Petit Bois* (3) and *Waldeinsamkeit* (13). Fig. 239 could be related to either of these pictures which, however, have not been traced. Their prices suggest they were small sketches. I have seen a photograph of a picture, with M. Mouradian of Paris in 1926, which showed a forest glade with the light catching the trees. M. Mouradian remembered its colours were greens and greys.

346. THE OBELISK (Fig. 240) 1914

Canvas. 23¼ × 18¼ (59 × 46·4)

'Sickert' b.r.

Private Collection, England (on loan to the Whitworth Art
 Gallery, University of Manchester)

Chapter XV (letters quoted below dated notes 13, 16, 17,
 25–9)

In August 1913 Sickert wrote to Miss Sands of 'a motive that interests me very much. An obelisk on rising ground. I am looking down on it and the plain below rises above the whole length of the obelisk with a river and willows. So the obelisk serves as a measure of the receding plain.' By the end of the summer Sickert thought he 'had' the subject safely and commented that he had his 'usual sitting from the forest at the obelisk picture'.

In 1914 Sickert returned to the subject. In July, 'My pilgrimage . . . to Martin Église put the obelisk subject back again into my mind and I have had a good day's work at it'.

In other letters he reported: 'I have just had a sitting on my obelisk picture begun it on a small canvas'; 'Yesterday I had my sunshine and the afternoon in the forest at the obelisk subject'; 'I have been up in the forest again. I was reading a letter you wrote to me last year about a sketch I sent you of the obelisk design . . . I think I shall make the valley in shadow so as to make the silver river tell more'; and lastly 'I shall be glad to be on the hill again above the Arques obelisk. I will make a fine canvas of that *toile de 12F*. And finish it here, while I can refer to nature. One war at a time'. Fig. 240 is, without doubt, the picture painted in 1914 on a '*Toile de 12F*' (that is a French '*figure*' canvas size measuring approximately 61 × 50 cms) in which Sickert put the valley in shadow to make the 'silver river tell more'. There are other versions:

1. Canvas. 15¾ × 12¾ (40 × 32·3), Leicester Galleries/
 Private Collection, U.S.A.
2. Canvas. 14½ × 15 (36·8 × 38·1), P. C. Bull/Christie's,
 10 March 1961 (95)/Sotheby's, 12 April 1967 (35)
 and Sotheby's, 26 November 1969 (210) as *An Obelisk
 near Bath*, bought Norton.

It is probable that the first version listed was painted in 1913; the accents are more muted than in Fig. 240 or Version 2. Version 2, like Fig. 240, is painted in a flat patchwork of high-toned chalky colours although its definition is more fuzzy than in Fig. 240. It is probably the picture begun 'on a small canvas' in 1914.

Study:

Pencil, pen and ink, watercolour, squared. 9¾ × 9½ (24·8 × 24·1), Miss Sylvia Gosse/Coll. London, Victoria and Albert Museum (1947). Exh. Carfax Gallery 1916 (25).

347. CAFÉ DES ARCADES or CAFÉ SUISSE (Fig. 241)
 c.1914

Canvas. 25 × 25 (63·5 × 63·5)

'Sickert' b.l.

Mrs. Rowley Bristow/
Private Collection, London

Rep. Emmons, facing p. 158

Exh. Leeds 42 (167); Agnew 60 (53)

Chapter XV (letters quoted below dated note 24)

In two letters to Miss Sands written shortly after his arrival in Dieppe in 1914 Sickert referred to painting this subject: 'I have bought a note-book and done some studies already for the café-arcade picture. I think I will do some small oil panels'; and 'I shall probably come into Dieppe every Saturday. To study my arcade café picture'.

There are three more versions of this subject of which two are oil on canvas studies (I know of no oil on panel studies in spite of Sickert's intention to paint some):

1. 16 × 13 (40·6 × 33), Coll. N. L. Hamilton-Smith Esq.
 Rep. B.60, Pl. 82.
2. 15¾ × 12½ (40 × 31·8), Coll. G. V. Miskin Esq.

Another version is carried to the same degree of finish as Fig. 241:

Canvas. 21½ × 15 (54·6 × 38·1), Mrs. M. Clifton/Coll. Leeds, City Art Gallery (1942). Exh. Leeds 42 (166); Adelaide 68 (50).

Both this picture and Fig. 241 are painted in dry, flat, but thick paint applied in patches of bright, sharp and

sweet, and very varied colours (violet, greens, pink, pale blue, with notes of orange, scarlet, and navy blue). The rougher studies are also painted in a fairly wide range of lively colours but their general tonality is darker and the paint much thinner. All these pictures are generally considered to be post-war works but the documentary evidence for dating them 1914, taken together with the similarity of their handling to other Dieppe landscapes of 1914 (e.g. Fig. 243), strongly suggests that they were painted before the war. Moreover, the fact that the Leeds version formerly belonged to Arthur Clifton (of the Carfax Gallery) supports this suggestion. Sickert broke with Clifton before the end of the war and it is highly improbable that Clifton would have continued to buy Sickert works after then because his existing stock was already very large.

There are a great number of studies for this subject. They include:

1. Pencil, pen and ink, wash. $14\frac{1}{2} \times 10\frac{1}{2}$ (36·8 × 26·7), L. G. Duke/Sotheby's, 10 December 1970 (132). A study, inscribed with colour notes, for the whole composition.
2. Pencil. $4\frac{1}{2} \times 2\frac{3}{4}$ (11·3 × 7), Coll. Liverpool, Walker Art Gallery (1948). Exh. A.C.49 (27a). A study for the waiter as is Study 3.
3. Charcoal. $9\frac{5}{8} \times 5\frac{7}{8}$ (24·5 × 15), Lady Spencer-Churchill/ Messrs. Thos. Agnew & Sons, Ltd. 1968. Exh. Agnew 1968, 'French and English Drawings. 19th. and 20th. Centuries' (38). Inscribed '*Le garçon du Café Suisse*'.

348. RUE AGUADO (Fig. 243) 1914

Canvas. 20 × 24 (50·8 × 61)
'Sickert' b.l.
Montague Shearman/Dr. Robert Emmons/
Private Collection, England
Exh. Agnew 60 (109) as *La Rue Aguado Envermeu* (in fact the street is in Dieppe)
Chapter XV

In 1914 Sickert wrote to Miss Sands of this subject: 'At Dieppe the other day . . . I sat down on the *plage* my eye having been caught by the stars and stripes flying with the Union Jack and the tricolor in front of the (new) Hôtel Royal. On the left in such sparkling sunlight that it was grey and black a back row of cut bushes then forward sprays of tamarisk, then a border of grey-blue flowers and then in front geraniums. I literally as Whistler used to say "rattled it off". Something has given me back my youth and my talent. And the flower beds were bounded by a wire . . . and at intervals benches without backs painted hedge-sparrow-egg-green, on the right the row of houses the Hôtel Royal the flags and the tobacco factory with its two chimneys.'

In several other letters of this summer Sickert wrote of drawing the subject and in one of painting it: 'I have squared up a *toile de 12F* of a scene on the front at Dieppe. . . . With the stars and stripes. I am very keen to see how I get on with this painting indoors under the immediate influence of the recollection'.

Fig. 243 is a *Toile de 12F* (but aligned to be landscape instead of upright in format).

Sickert, in his letters, referred to this subject as *The Flags on the Front* but it is now known as the *Rue Aguado*.

Painted studies:

1. Canvas. $12 \times 15\frac{1}{2}$ (30·5 × 39·4), Christie's, 12 June 1970 (53) wrongly listed as *Street in Envermeu Near Dieppe*/ Private Collection, England. A roughly scrubbed sketch in thin paint.
2. Panel. $7\frac{1}{4} \times 9\frac{1}{2}$ (18·5 × 24·1), Coll. Hugh Beaumont Esq. Dated 'August 1914'.

Drawings:

1. Pen and ink, pencil, squared. $9\frac{3}{4} \times 11\frac{3}{4}$ (24·8 × 29·9), Coll. Leeds, City Art Gallery (1942). Rep. B.60, Pl. 17a. Exh. N.G.41 (120); Sheffield 57 (143). A very precisely drawn and detailed study inscribed with colour notes.
2. Pencil, pen and ink. $5\frac{1}{4} \times 7\frac{3}{4}$ (13·4 × 19·7), Sotheby's, 17 July 1968 (12) bought J. Lyons. Rep. Sitwell, *Orion* II, 1945.

When war broke out in August 1914 Sickert and his wife left Envermeu to go and live in Dieppe. Sickert then wrote to Miss Sands, 'I am enjoying immensely the enforced study again of countless subjects here I have always loved. I do very elaborate pen drawings and then small *pochade* panels'. *La Rue Aguado* is just such a subject—an old favourite from the 1890s—and the painted and drawn studies for it illustrate the precise procedure outlined to Miss Sands. Figs. 244 and 242 are more examples of Dieppe architectural subjects to which Sickert returned with pleasure after war broke out. The quality of the paint (flat, dry, and thick), the light tonality, the bright and varied colours, of *La Rue Aguado* are very similar to the *Café des Arcades* (Fig. 241) as well as to *St. Jacques* (Fig. 244) and the *Chevet de l'Église* (Fig. 242).

349. ST. JACQUES (Fig. 244) c.1914

Canvas. $26\frac{1}{2} \times 19\frac{3}{4}$ (67·3 × 50·2)
'Sickert' b.r.
E. M. B. Ingram/
Coll. Toronto, Art Gallery of Ontario (1946)
Chapter XV

Another example of one of Sickert's former Dieppe subjects to which he returned after war broke out in August 1914 (see note to C.348). For earlier versions see Fig. 76, C.113 and Fig. 85, C.118.

Studies probably executed in 1914:

1. Pen and ink, squared. $7\frac{1}{4} \times 6\frac{1}{2}$ (18·5 × 16·5), Coll. London, Islington Public Libraries (1947). Exh. Sheffield 57 (107).
2. Blue chalk, pen and ink, squared. $8 \times 7\frac{7}{8}$ (20·3 × 20), J. N. Bryson/Messrs. P. & D. Colnaghi 1971. Exh. Colnaghi 1971, 'English Paintings Drawings and Prints' (112).

Fig. 244 and the Islington squared drawing are generally dated *c.*1900. However, although their compositions are similar the difference between the style and handling of Fig. 244 and the 1899–1900 versions is remarkable (and beautifully illustrates how far Sickert's style and technique had developed during fourteen years). In Fig. 244, as in Figs. 241 and 243, Sickert translated sunlit effects into a clear patchwork of clean, chalky-toned, bright colours. The style of the two pen drawings, very neat and precise in their definition, is exactly the same as that of the *Rue Aguado* drawn studies (listed C.348).

350. CHEVET DE L'ÉGLISE (Fig. 242) c.1914

Canvas. 22¾ × 16¼ (57·8 × 41·3)

Asa Lingard/Sotheby's, 8 March 1944 (62)/Sotheby's, 24 November 1969 (259)/

Coll. Vane Ivanovic Esq., Monaco

Exh. N.G.41 (35)

Chapter XV

Another subject which Sickert painted c.1900 (Fig. 83, C.117) and returned to again in 1914.

Studies:

1. Panel. 10 × 6 (25·4 × 15·3), Private Collection, England. A study for the upper part of the subject.

2. Pencil, pen and ink, squared. 15¼ × 10¾ (38·7 × 27·4), Coll. Dr. S. Charles Lewsen. A precise and accurate study for a painting typical of 1914.

3. Charcoal and wash, pen and ink, squared. 14¾ × 10¼ (37·5 × 27·4), Coll. Hugh Beaumont Esq. Identical in composition and detail to the drawing listed above but with colour added. Both drawings are very close to the painting illustrated.

The painting on canvas, the panel study and the precise squared drawings provide a text-book illustration of Sickert's method in Dieppe in 1914. The paintings are sunlit, full of high-toned chalkily bright colours applied in flat, dry patches.

Circumstantial proof of the different dates of Fig. 83 and Fig. 242 is that the tiny sapling of the earlier picture is a tall broad tree in the version illustrated here.

AUTUMN 1914–1918. PORTRAITS AND FIGURES

351. THE SOLDIERS OF KING ALBERT THE READY (Fig. 245) dated 1914

Canvas. 77¼ × 60 (196·2 × 152·4)

'Sickert—1914' t.l.

S. G. Wylde/Christie's, 14 December 1932 (111)/G. P. Dudley Wallis/Christie's, 21 May 1943 (71)/Christie's, 17 July 1959 (64)/Christie's, 5 July 1963 (22)/Sotheby's 9 July 1969 (22)/

Coll. Sheffield, Graves Art Gallery (1969)

Rep. B.43, Pl. 43

Lit. Emmons, pp. 179–80

Exh. N.E.A.C. winter 1914 (151); N.G.41 (13); Sheffield 57 (43)

Chapter XV

Inspired by an incident of Belgian heroism in the defence of Liège in August 1914, Sickert began this picture on his return to London in October and it was ready for exhibition in November. His haste to get it finished in time for the New English was explained to Miss Sands: 'it is topical and I shall run a better chance of selling it before the new enthusiasm for the Belgians has cooled' (the picture was offered for sale for the benefit of the Belgian Relief Fund). Emmons relates that Sickert used a photograph for the basic design. I have traced similar press photographs but none very close to the painted composition. In any case Sickert could only have used such a photograph as an initial inspiration because he told Miss Sands: 'A great waggon wheel and a bit of a sack-full of corn or cement

have done wonders for what Ricketts and Shannon call the "compo"'. Indeed, none of Sickert's letters to Miss Sands mentions a photograph but they do frequently relate his use of Belgian soldiers as models and his delighted acquisition of incidental paraphernalia such as 'the artilleryman's forage cap with a little gold tassel' which is 'the sauciest thing in the world'.

The chief importance of this picture is that it is the first certain example of Sickert preparing a painting in camaieu. His method, as related to Miss Sands, is quoted in full in the text in Chapter XV. 'The best way on earth to do a picture', he proclaimed. The tonal camaieu preparation, being nearly all white, dried quickly and explains how Sickert was able to complete so thickly built up a picture with such speed. Each passage has been built up in several superimpositions of differently coloured patches although the underlying pale blue and pale pink camaieu is allowed to tell here and there. The picture is very colourful: violet and turquoise are dominant but notes of countless other colours are used, lemon yellow, orange, warm browns, pinks, scarlet, greens, and prussian blue among them.

Many drawn studies for the painting exist, including:

1. Pen and ink, charcoal. 12 × 11 (30·5 × 28), Coll. Bristol, City Art Gallery (1958). Exh. Tate 60 (142).

2. Pen and ink, chalk, wash. 10¾ × 8¾ (27·3 × 22·2). From the collection of Edward le Bas. Exh. R.A.1963, 'A Painter's Collection' (204).

3. Pen and ink, chalk. 11¾ × 10 (30 × 25·4), Coll. Lord Reigate. Exh. Leicester Galleries 1958, 'New Year Exhibition' (4). Inscribed and dated 'Belgium 1914'.

4. Pen and ink, chalk. 11 × 10½ (28 × 26·8), Christie's, 24 April 1964 (31), bought Hart.

Related painting.

The Integrity of Belgium. Details and whereabouts unknown. Exh. R.A. January 1915, 'War Relief Exhibition' (210). This picture is sometimes published as Fig. 245 but they were in fact two separate pictures. Press reviews give some idea of what *The Integrity of Belgium* looked like and I quote the fullest description here in the hope that the painting may be discovered and identified: the *Sunday Times*, 17 January 1915: 'Here again the resistance of Belgium is his theme. He shows the land far stretched to the horizon, the mists rising from the ground; in the foreground is a soldier leading the attack; to the left are faintly discerned the ranks of the resolute Belgians.'

Sickert seems to have started painting this picture soon after the completion of Fig. 245. In December 1914 he wrote to Miss Sands and Miss Hudson, 'I have laid in my R.A. picture in camaieu. I have got a magnificent platform 7 foot by 7 to get Veronese-like foreshortenings.'

352. TIPPERARY (Fig. 248) dated 1914

Canvas. 19½ × 15½ (49·5 × 39·4)

'Sickert-1914' b.r.

Sotheby's, 24 November 1969 (346)/Rutland Gallery/ Private Collection, London

Exh. Rutland Gallery 1970, 'This England' (55)

Chapter XV

Sickert painted several piano pictures during the first winter of the war. Fig. 248 may be the one of which Sickert wrote to Miss Sands: 'Chicken has been playing

the *Contes d'Hoffmann* while I have been painting her reflection at the piano'. This letter must have been written shortly after Sickert's return to London because he remarked upon his state of mind since mobilization.

Related paintings (that is, other piano pictures painted during the winter of 1914–15) include:

1. *Tipperary.* Canvas. 20 × 16 (50·8 × 40·6), Lord Henry Cavendish-Bentinck (bought from Sickert in 1914)/ Coll. London, Tate Gallery (1940). Rep. Bertram, Pl. 25; B.60, Pl. 68; Rothenstein 1961. Lit. Tate Gallery Catalogue 1964, pp. 630–31.
 Studies for this picture include:
 (i) *The Baby Grand.* Pen and ink, pencil, chalk. 13 × 11 (33 × 28). From the collection of Morton Sands. Rep. *Image*, No. 7, 1952, p. 38; Sir John Rothenstein, *British Art since 1900*, Phaidon, London, 1962, Pl. 4. Exh. Obach's Gallery 1915, 'Society of Twelve' (11); N.G.41 (124); Leeds 42 (111); Sheffield 57 (119).
 (ii) Pen and ink, chalk. Size unknown. Leicester Galleries/Private Collection. Dated 'Sickert 1914'. The Tate Gallery catalogue enters into the question of who was the model or sitter for this picture; Miss Sands herself is one of the suggestions. However, it is clear from Sickert's letters to Miss Sands that the model was the girl nicknamed Chicken who often sat for Sickert and sat for nearly all the piano pictures. *Tipperary* and *Chopin* show Chicken alone, without the soldier of Fig. 248.
2. *Chopin.* Canvas. 20 × 16 (50·8 × 40·6), Earl and Countess Jowett/Private Collection, London. Exh. Eldar Gallery 1919 (21), rep. in illustrated catalogue.

Study for this picture:
Chalk, pencil, heightened with white. 11¼ × 8½ (28·6 × 21·6), Mrs. Rawnsley/Coll. Wakefield, City Art Gallery (1945). Exh. Sheffield 57 (141); A.C.64 (54).
These piano pictures are quite small in scale, they are executed in diluted paint ('thin free hard rubs of paint mixed with turpentine', as Sickert told Miss Sands in the letter quoted above referring to his picture of Chicken at the piano playing the *Tales of Hoffmann*), and their colours are fairly low-toned and muddy with much use of a warm reddish-brown and yellowy greens. Sickert continued to paint his smaller, informal pictures in this manner for some years to come.
Another piano picture, canvas, 30 × 22 (76·4 × 55·9) is in a Private Collection, England. It is dated 1914 on the back.

Sickert's interest in piano subjects during the winter of 1914–15 had been anticipated before the war.

1. He published *The Music Lesson*, a drawing dated 1914, in the *New Age*, 29 January 1914; original untraced. It shows Chicken seated at the piano and Hubby listening.
2. Sitwell, p. xvii, reproduced a pen and ink drawing (details and whereabouts unknown) of a similar subject.
3. *Wellington House Academy.* Canvas. 16 × 20 (40·6 × 50·8), J. W. Blyth/Coll. Kirkcaldy Art Gallery (1964). Lit. Lilly, p. 36. Dedicated to W. H. Davies. The title comes from the inscription. The painting shows a hatless girl (probably not Chicken) at a grand piano, facing the spectator; Hubby is in the background. Sickert sketched this subject in his letter of February 1914 to Miss Hudson

as one of the series of 'direct little pictures 20 × 16 on the way' (see note to Fig. 218, C.309, and Chapter XIV, note 21).
4. Sickert told Miss Sands in a letter sent from Dieppe in August 1914 that he had begun 'a study of Tavernier's daughter at the piano, which I am going to paint life-sized for him. . . . It is pleasant to draw and listen to Beethoven'. The Leicester Galleries owned a pen and ink drawing exh. 'Gallery Group Exhibition' (32) in 1963, rep. *Illustrated London News*, 7 September 1963 called *Girl Leaning on a Piano, Dieppe*, 11¾ × 9 (29·8 × 22·9), which could be related to this project. The painting was probably abandoned when Sickert returned to England.

353. WOUNDED (Fig. 247) *c.*1914–15
Canvas. 25 × 30 (63·5 × 76·2)
'Sickert' b.r.
Probably Christie's, 30 June 1933 (135) as *Le Blessé*/ Christie's, 9 October 1942 (55)/R. Middleton/
Private Collection, Scotland
Exh. Probably Carfax Gallery 1916 (23) as *The Nurse*
Chapter XVI

Studies include:
1. Pencil, chalk, on thick woven paper, faint squaring. 11½ × 16 (29·2 × 40·6), Coll. Dr. S. Charles Lewsen. Some colour notes.
2. Pen and ink, pencil, squared. 10¾ × 13¾ (27·3 × 35), Messrs. Thos. Agnew & Sons, Ltd. 1971. Exh. Agnew 1969, 'From the Pre-Raphaelites to Picasso' (170). Dated 1914.
Both are full composition studies.
Sickert etched this subject, and the studies may also be related to the etching.

354. THE BUST OF TOM SAYERS. SELF-PORTRAIT (Fig. 250) *c.*1913–15
Canvas. 23¼ × 19½ (59 × 49·5)
'Sickert' b.l.
From the collection of Morton Sands
Rep. B.60, Pl. 75
Exh. Eldar Gallery 1919 (17); N.G.41 (60); Agnew 60 (76); Brighton 62 (81)
Chapter XVI

The marble bust of the boxer Tom Sayers appears in several of Sickert's works of about this date, particularly in his drawings, including:
1. *Interior with Figures.* Pencil, pen and ink, wash. 11½ × 8 (29·2 × 20·3), C. Marescoe Pearce/Sotheby's, 8 July 1970 (42), bought New Grafton Gallery. Rep. Bertram, Pl. 32. Study related to this drawing, showing the woman more fully, with the standing man only lightly indicated: pencil, pen and ink. 16½ × 13¼ (41·9 × 33·6), Coll. Liverpool, Walker Art Gallery (1948). Exh. A.C.49 (29). The male figure in these drawings may be Hubby, in which case they must have been done before the summer of 1914 (see Chapter XIV, note 18), but he could be Mr. Minnie, a man of the same physical type who modelled for Sickert from 1914 onwards.
2. *Degas at New Orleans.* Chalk, pen and ink, heightened with white. 15¼ × 12¾ (38·7 × 32·4), Lord Cottesloe/ Sotheby's, 14 July 1965 (69)/Sotheby's, 15 December

1971 (21). Exh. Probably Carfax Gallery April 1914 (8) as *The artist's home in New Orleans*. This drawing shows the same two models as in *Interior with Figures* (1) with the addition of a negro butler (hence the title, presumably a reference to Degas's visit to New Orleans where negro servants must have waited on him) This negro also modelled for Sickert in a painting called *Negro Spirituals*, canvas, 19½ × 15½ (49·5 × 39·4), Sotheby's, 26 April 1972 (6). Exh. Redfern Gallery 1964, 'Summer Exhibition' (672), rep. in catalogue. This is not a portrait of Paul Robeson, as is sometimes suggested.
Study for *Negro Spirituals*: pen and ink, chalk. 15 × 11 (38·1 × 28), Coll. Liverpool, Walker Art Gallery (1948). Exh. A.C.49 (57).

3. Drawing inscribed 'Bust of Tom Sayers'. Charcoal, pen and ink. 11 × 12½ (28 × 31·7), H. S. Reitlinger/Sotheby's, 26 May 1954 (581)/John Christopherson/Sotheby's, 14 December 1966 (204)/Messrs. Roland, Browse & Delbanco 1971. Exh. Adelaide 68 (44); R.B.D. 1969, 'Sickert Drawings' (59). A seated woman is looking at the ornament.

355. THE IRON BEDSTEAD (Fig. 246)　　c.1915–16
Board. 8½ × 10½ (21·6 × 26·7)
Coll. London, Islington Public Libraries (1947)
Exh. Sheffield 57 (59)
Chapter XVI

An unfinished sketch for a subject which Sickert both painted on a larger scale (I have seen a photograph of such a painting, exh. Redfern Gallery 1939, 'Camden Town Group' (22) but cannot trace its details or whereabouts) and etched.
Study:
Pencil, pen and ink, squared. 6 × 9½ (15·2 × 24·1), Coll. Wakefield, City Art Gallery (1947). Exh. Sheffield 57 (139) as *The Afternoon Nap*; A.C.64 (46).

356. SUSPENSE (Fig. 249)　　c.1916
Canvas. 30 × 23 (76·2 × 58·4)
'Sickert' b.l.
Coll. Belfast, Ulster Museum (1929)
Rep. B.43, Pl. 44; Bertram, Pl. 30
Exh. Heal's Mansard Gallery 1917, 'London Group' (11); Eldar Gallery 1919 (3); Sheffield 57 (48); Tate Gallery 1964, 'London Group Jubilee Exhibition' (40)
Chapter XVI
Version:
Canvas. 17½ × 27½ (44·4 × 69·8), Sotheby's, 14 July 1965 (12), bought de Jongh.
Studies include:
1. Pen and ink, squared. 16¼ × 11½ (41·2 × 29·2), Coll. Lord Methuen.
2. Pen and ink, squared. 16¾ × 11½ (42·5 × 29·2), Coll. London, British Council (1947).
3. Pen and ink, pencil, squared. 14½ × 9½ (36·8 × 24·1), Miss Evie Hone/Coll. Dublin, National Gallery of Ireland (1955). Exh. Wildenstein, London, 1967 'Drawings from the National Gallery of Ireland' (99).

4. Pen and ink. Size and whereabouts unknown. Last known owner Dr. Robert Emmons. Rep. Emmons, p. 155.
5. Pen and ink. 13½ × 11¼ (34·3 × 28·5), Sotheby's, 16 December 1964 (55)/Coll. Belfast, Ulster Museum (1965). Exh. Agnew 1965, 'French and English Drawings' (80).
6. Watercolour. 13¾ × 9¾ (34·9 × 24·7), Private Collection, London.
The Ulster Museum once owned a full squared composition study for *Suspense* but it is now mislaid.

357. RESTING. THE NAPOLEON III TOBACCO JAR (Fig. 253)　　c.1916
Canvas. 10½ × 14 (26·6 × 35·5)
Miss Sylvia Gosse/J. W. Blyth/
Coll. Kirkcaldy, Art Gallery (1964)
Exh. Edinburgh 53 (91)
Chapter XVI
Version:
Canvas. 17¼ × 23 (43·8 × 58·4), Last known owner C. Marescoe Pearce Esq.
Studies include:
1. Chalk, pen and ink, heightened with white. 9¼ × 12 (23·5 × 30·5), Coll. Leeds, City Art Gallery (1947). Rep. B.43, Pl. 45a.
2. Pencil, pen and ink, squared. 9½ × 12¼ (24·1 × 31·1), R.B.D./Private Collection. Exh. Brighton 62 (26); R.B.D.63 (33).
A drawing of the same interior, inscribed 'Warren Street', showing a girl seated on the couch: chalk, watercolour. 13½ × 10½ (34·3 × 26·7), Sotheby's, 6 July 1960 (13)/with Messrs. Thos. Agnew & Sons Ltd, 1960. Sickert had a studio in Warren Street during the war. The title of Fig. 253 and Version is taken from the little tobacco jar placed on the table.

358. THE FUR BOA (Fig. 252)　　c.1916
Canvas. 19¾ × 15¾ (50·2 × 40)
'Sickert' b.r.
R. Middleton/
Private Collection, Scotland
Rep. B.60, Pl. 73
Chapter XVI

A portrait of Marie Hayes, Sickert's model.

359. OLD HEFFEL OF ROWTON HOUSE (Fig. 251)　　c.1916
Canvas. 21¼ × 15¼ (54 × 38·7)
'Rd.St.A.R.A.' b.l.
Mrs. D. M. Fulford/
Coll. York, City Art Gallery (1945)
Exh. Hull 68 (17)
Chapter XVI
Versions:
1. Canvas. 30 × 25 (76·2 × 63·5), Bernard Falk/Christie's, 18 November 1955 (57)/Coll. Dunedin, Public Art Gallery Society Inc., New Zealand (1955). Exh. Eldar Gallery 1919 (20), rep. in catalogue; N.G.41 (2).

2. Canvas. 10½ × 7½ (26·6 × 19), Bernard Falk/Christie's, 18 November 1955 (66)/Coll. Lord Ilford. Exh. Agnew 60 (84).
3. Canvas. 24 × 20 (61 × 50·8). Whereabouts unknown; inscribed 'Paganini of Soho'. Old Heffel is here seated on a sofa, not on a chair as in the other paintings listed. He is on a sofa in the drawing listed below.
4. Panel. 10¾ × 8 (27·3 × 20·3), Coll. Dr. S. Charles Lewsen. Exh. Edinburgh 53 (85) with measurements reversed; Sheffield 57 (41).
Study:
Chalk, pen and ink, squared. 9 × 7½ (22·8 × 19), Mrs. Rowley Bristow/Private Collection, London.
Sickert also etched this subject.

360. REVERIE c.1915–16
Canvas. 20 × 16 (50·8 × 40·6)
'Sickert' b.l.
Lord Ivor Spencer-Churchill/
Coll. The Cottesloe Trustees
Rep. B.60, Pl. 72
Exh. Eldar Gallery 1919 (19); N.G.41 (56); Leeds 42 (176); Hampstead Festival 1965, 'Camden Town Group' (67)
Chapter XVI

361. CAMDEN TOWN PORTRAIT c.1915–16
Canvas. 20 × 16 (50·8 × 40·6)
'Sickert' b.l.
Arthur Crossland/Christie's, 3 February 1956 (189)/
Coll. Cardiff, National Museum of Wales (1956)
Rep. B.43, Pl. 46
Exh. Eldar Gallery 1919 (18); N.G.41 (48); Leeds 42 (175); Edinburgh 53 (25); Adelaide 68 (42)
Chapter XVI

362. PORTRAIT OF MAURICE ASSELIN c.1915–16
Canvas. 20 × 16 (50·8 × 40·6)
'Sickert' b.l., 'ASSELIN' b.r. (inscribed later because the name is missing from the reproduction of the portrait in the 1919 Eldar Gallery catalogue)
Hugh Blaker/A. D. Peters/Sotheby's, 20 April 1966 (62)/
Coll. E. V. Thaw & Co. Inc., New York
Exh. Eldar Gallery 1919 (43) as Sketch for portrait of Asselin; Sheffield 57 (36)
Chapter XVI
Version:
Canvas. 20 × 16 (50·8 × 40·6), Coll. Stoke-on-Trent, City Museum and Art Gallery (1941). Exh. A.C.64 (20). Maurice Asselin (1882–1947), the French painter, was Sickert's closest friend during the first two years of the war. For a time he shared Sickert's Red Lion Square studio and acted as joint host at the Fitzroy Street 'At Homes'. Sickert wrote about his painting in the Burlington Magazine, 28, December 1915, 'A Monthly Chronicle' (Sickert compared the paintings of Asselin and of Roger Fry, to the detriment of the latter).

363. THE LITTLE TEA PARTY. NINA HAMNETT AND ROALD KRISTIAN c.1916
Canvas. 10 × 14 (25·4 × 35·5)
'Sickert' b.l.

Miss Sylvia Gosse (bought from the Carfax Gallery in 1916)/Christie's, 11 December 1931 (45) as A Tea Party/ Howard Bliss/
Coll. London, Tate Gallery (1941)
Rep. B.43, Pl. 45; Lilly, Pl. 13
Lit. Nina Hamnett, Laughing Torso: Reminiscences of Nina Hamnett, London, Constable, 1932, pp. 81–2; Tate Gallery Catalogue 1964, pp. 633–4
Exh. Carfax Gallery 1916 (4); Chicago: Pittsburgh 1938 (27); N.G.41 (38)
Chapter XVI
Nina Hamnett (1890–1956) was a painter and friend of Sickert during the war period. Some of Sickert's letters to her written from Bath in 1918 are quoted in the text. Sickert wrote an appreciation of her work in the Cambridge Magazine, 8 June 1918; in a letter to Miss Sands written in 1918 he commented that she had 'grown up but still has a little XIVe. Arr. +Roger provincialism to get rid of'. Roald Kristian, a painter, was Nina Hamnett's husband for a short time (they married in 1914). In Laughing Torso Nina Hamnett recalled their sitting for Sickert looking 'the picture of gloom'.
Studies:
1. Pencil, pen and ink. 10 × 12¼ (25·4 × 31·1), Coll. Huddersfield, Art Gallery (1951). Exh. Sheffield 57 (123); Hull 68 (47).
2. Charcoal, heightened with white. 9⅛ × 14 (23 × 35·5), Coll. London, Tate Gallery (1945). Less detailed than Study 1, the head of Nina Hamnett being omitted.
3. Watercolour. 9 × 8¼ (22·9 × 21), Coll. Richard Attenborough Esq.
Sickert also drew Nina Hamnett nude (she was very proud of her body): Pencil, pen and ink on orange paper. 11½ × 7¾ (29·2 × 19·7), Mercury Gallery 1971.

1914–18. THEATRES AND MUSIC HALLS

364. THE BRIGHTON PIERROTS (Fig. 254) 1915
Canvas. 24½ × 29½ (62·2 × 75)
'Sickert' b.r.
From the collection of Morton Sands
Rep. Emmons, facing p. 174
Exh. Agnew 60 (50); Tate 60 (146); Brighton 62 (83)
Chapter XVI
Sickert stayed with his friend Walter Taylor in Brighton in September 1915. He reported to Miss Sands that he went every night for five weeks to the Pierrot theatre, but he painted the subject immediately after his return to London. Sir William and Lady Jowett so much liked the picture which had already been bought by Morton Sands that they at once commissioned a second version: Canvas. 23 × 29 (58·4 × 73·6), Earl and Countess Jowett/Private Collection, London. Rep. Bertram, Pl. 33; B.60, Pl. 69. Exh. N.G.41 (50); Leeds 42 (172); Sheffield 57 (45). This version is signed and dated 'St. 1915'. It is a little fresher and brighter in colour and lighter in tonality than Fig. 254.
Studies include:
1. Pen and ink on blue paper. 6¾ × 8¾ (17·1 × 22·2). Whereabouts unknown. Rep. B.60, Pl. 69a as in the collection of Morton Sands but it was not in Mr. Sands's

collection when I visited it in 1960 and it is not now in the collection which has remained intact following Mr. Sands's death. This is a study for the whole composition.

2. Pencil. $6\frac{3}{4} \times 9$ ($17\cdot3 \times 22\cdot8$), Coll. Liverpool, Walker Art Gallery (1947). Exh. A.C.49 (61). A study for the whole composition.

3. Pencil. 9×7 ($22\cdot8 \times 17\cdot8$), Coll. Liverpool, Walker Art Gallery (1947). Exh. A.C.49 (61). A study of the pierrette at the piano.

Related painting (probably done in Brighton in 1915): *The Rehearsal*. Canvas. $19\frac{1}{2} \times 21$ ($49\cdot5 \times 53\cdot3$). From the collection of Morton Sands. Exh. N.G.41 (53); Leeds 42 (177); Agnew 60 (78); Tate 60 (147); Brighton 62 (77). An indoor scene on stage, painted in the hot colours (with much use of strong sweet pinks) found in *Brighton Pierrots*.

365. THE NEW BEDFORD (Fig. 255) *c.*1915–16

Tempera and oil on canvas. $72 \times 28\frac{1}{2}$ ($182\cdot9 \times 72\cdot4$)
'Sickert. P.R.B.A.' t.r.
W. Marchant/Christie's, 28 January 1927 (144)/Charles Jackson/Christie's, 19 May 1933 (110)/
Coll. Leeds, City Art Gallery (1937)
Rep. Emmons, facing p. 184; Bertram, Pl. 34; B.60, Pl. 76
Exh. N.G.41 (8); Leeds 42 (173); Edinburgh 53 (34)
Chapter XVI

The only picture completed from the series of music hall scenes commissioned in 1914 by Miss Ethel Sands to decorate her dining-room. The history of the commission, and the relationship to it of the different pictures of *The New Bedford* catalogued below, are discussed in the text.
The signature is a later addition (Sickert became President of the Royal Society of British Artists in 1927).

Related painting (probably a smaller scale rehearsal for Fig. 255):
Canvas. 30×15 ($76\cdot2 \times 38\cdot1$), Sir Edward Marsh (bought from Carfax Gallery in 1916)/Coll. London, Tate Gallery (1953). Rep. Rothenstein 1961, Col. Pl. 12; Pickvance 1967, Col. Pl. XIII. Lit. Tate Gallery Catalogue 1964, p. 638. Exh. Carfax Gallery 1916 (14); Chicago: Pittsburgh 1938 (26); Tate 60 (109).
This painting shows a fractionally broader slice of the interior than Fig. 255. Both are heavily dependent on the 1908–9 version (Fig. 166).

Studies related to Fig. 255 and Version, all in the Walker Art Gallery, Liverpool:

1. *Figures in a Box*. Pencil, pen and ink on account book paper. $5\frac{3}{4} \times 3\frac{3}{4}$ ($14\cdot6 \times 9\cdot5$). Exh. A.C.49 (39b).

2. *Woman in a Box*. Pen and ink on account book paper. $6 \times 3\frac{3}{4}$ ($15\cdot2 \times 9\cdot5$). Exh. A.C.49 (40d).

3. *Entrance beneath a Box*. Charcoal, pen and ink on account book paper. $6 \times 3\frac{3}{4}$ ($15\cdot2 \times 9\cdot5$). Exh. A.C.49 (40f).

4. *Top of a Box*. Pencil, pen and ink on account book paper. $12\frac{3}{4} \times 5$ ($32\cdot4 \times 12\cdot7$). Rep. *Image*, No. 7, 1952, p. 18. Exh. A.C.49 (40b).

5. *Curtain below a Box*. Pencil, pen and ink on account book paper. $12\frac{3}{4} \times 5\frac{1}{4}$ ($32\cdot4 \times 13\cdot3$). Exh. A.C.49 (40a).

6. *Top of a Box*. Chalk, pen and ink on graph paper. $4\frac{1}{4} \times 8$ ($10\cdot8 \times 20\cdot3$). Exh. A.C.49 (40e).

7. *Top of a Box*. Chalk on graph paper. $4\frac{1}{4} \times 8$ ($10\cdot8 \times 20\cdot3$).

It is impossible to be completely certain that these drawings were done in 1914–15 rather than in 1908–9 because the pictures Sickert painted at the earlier and the later dates were so similar compositionally. However, the style of the drawings listed above accords better with the later dating and the use of pen and ink and an account book for so many of the drawings accords with Sickert's report in a letter to Miss Sands that he went to the Bedford in 1914–15 with an account book and an 'unupsetable ink bottle'.

366. THE NEW BEDFORD (Fig. 256) *c.*1915–16

Canvas. $39 \times 12\frac{1}{4}$ ($99 \times 31\cdot1$)
'Sickert' b.l.
A. J. Abrahams/E. S. Cooper-Willis/Christie's, 30 October 1970 (162)/
Coll. Count N. Labia, Capetown, South Africa
Exh. Tate 60 (110)
Chapter XVI

This painting shows the view of the subject which Sickert etched in 1915. It represents the box beneath the gallery adjoining the lower set box seen in Fig. 255. It is not derived from the earlier 1908–9 picture but is a new composition. The studies listed below all show this box or parts of the architecture of the interior only found in this painting. They can, therefore, be ascribed with greater certainty to 1914–1915.

1. *Box, Caryatid and Gallery*. Pencil, pen and ink, heightened with white on brown paper. $12\frac{5}{8} \times 5\frac{3}{4}$ ($32 \times 14\cdot6$), Mrs. L. Powell/Coll. Leeds, City Art Gallery (1947). Rep. B.60, Pl. 76a; Rothenstein 1961. Exh. Sheffield 57 (144); Hull 68 (36).

2. *Audience below Box and lower part of Box*. Pencil, pen and ink on account book paper. $12\frac{1}{2} \times 5\frac{1}{4}$ ($31\cdot7 \times 13\cdot3$), Coll. Liverpool, Walker Art Gallery (1948). Exh. A.C.49 (41).

3. *Audience below Box and balustrade of Box*. Pencil, pen and ink, heightened with white on brown paper. $9\frac{1}{2} \times 5\frac{1}{4}$ ($24\cdot1 \times 13\cdot3$), Coll. Manchester, City Art Gallery (1947) —mistakenly catalogued B.60, p. 105 as *The Old Bedford*.

4. *Caryatid and part of a Box*. Pencil on account book paper. $12\frac{3}{4} \times 5\frac{1}{4}$ ($32\cdot4 \times 13\cdot3$), Coll. Liverpool, Walker Art Gallery. Rep. *Image*, No. 7, 1952, p. 17. Exh. A.C.49 (40c).

5. *Figures in a Box*. Pencil on account book paper. $10\frac{1}{2} \times 5$ ($26\cdot6 \times 12\cdot7$), Christie's, 12 June 1970 (40) and Christie's, 11 December 1970 (39) mistakenly catalogued as *The Old Bedford*/Clarges Gallery, London 1971.

6. *Figures in half a Box*. Chalk, heightened with white, on grey paper. $9\frac{1}{4} \times 8\frac{3}{4}$ ($23\cdot5 \times 22\cdot2$), Coll. Dr. S. Charles Lewsen. Exh. N.G.41 (103).

7. *Caryatid*. Chalk, heightened with white, on grey paper. $11 \times 4\frac{1}{4}$ ($28 \times 10\cdot8$), Coll. Lord Methuen.

367. THE NEW BEDFORD (Fig. 257) *c.*1915–16

Canvas. $23\frac{1}{2} \times 32$ ($59\cdot7 \times 81\cdot3$)
'Sickert' b.l., 'The New Bedford' b.r.
Coll. Harrogate, Corporation Art Gallery (1933, bought from Sickert's studio)
Exh. Sheffield 57 (55); A.C.64 (22); Hull 68 (4)
Chapter XVI, and notes 21, 32, 33

Almost certainly a sketch connected with the Sands dining-room project. It probably gives a rough idea of the design for a complete wall, the mantelpiece wall being the most likely. I believe that, as executed, this wall would have been decorated by three adjoining canvases. The three unfinished pictures listed below together re-create the view of the New Bedford sketched in Fig. 257. They show consecutive segments of the subject but omit a band right across the lower edge of the scene as represented in Fig. 257. Two of the paintings (2 and 3) are less tall than the third (1) which represents the box on the left of Fig. 257. I suggest that their different height may be explained by the fact that they could have been designed to go over the mantelshelf, and the upper frame of the hearth may have been intended to function as the balustrade to the boxes which are omitted from the paintings.

1. Tempera on canvas. 66 × 45 (167·6 × 114·3), Christie's, 22 February 1957 (14)/Beaux Arts Gallery/Private Collection, Los Angeles but precise location unknown. The medium of this picture was listed as tempera in the Christie's catalogue. The other two paintings are known to me from photographs only but the dry appearance of their paint supports the suggestion that they too were painted in tempera. Sir Philip Hendy (see Chapter XVI, note 21) believed the unfinished *New Bedford* subjects for Miss Sands were laid in, in a broad *chiaroscuro*, in tempera. He also believed (see note 33) that this painting and the two listed below were indeed connected with the Sands dining-room scheme.

2. ?Tempera on canvas. 54 × 47 (137·1 × 119·4), Christie's, 30 June 1933 (163)/Beaux Arts Gallery, present whereabouts unknown.

3. ?Tempera on canvas. Size and whereabouts unknown (known to me from a photograph belonging to Sir Philip Hendy). From the photograph it looks as if it is carried out on the same scale as Paintings 1 and 2.

Study for Fig. 257:
Pen and ink, cross and diagonally squared. 5¼ × 10¾ (13·3 × 27·3), Mouradian et Valotton, Paris 1969. A detailed composition study of the whole subject except that it omits a band across the lower part of the scene as represented in Fig. 257.

Study for Painting 2 listed above:
Pen and ink, black chalk heightened with white. 14⅛ × 9⅝ (35·9 × 24·4). From the collection of Morton Sands.

1914–18. LANDSCAPES

368. THE MILL POOL *or* RUSHFORD MILL, DEVON
(Fig. 258) 1915

Canvas. 25 × 30 (63·5 × 76·2)
'Sickert' b.r.
Geoffrey Blackwell/Horace Noble/
Coll. Cambridge, Fitzwilliam Museum (1953)
Exh. Probably Carfax Gallery 1916 (5) as *Rushford Mill*
Chapter XVI

The subject of Fig. 258 has been identified by Mr. Jack Goodison as Rushford Mill which lies a few miles from Chagford in Devon where Sickert spent some time in 1915 (apparently to convalesce after a bad bout of influenza). The foliage in his Chagford subjects confirms the tradition that his visit took place in summer. Fig. 258 was originally acquired by the Fitzwilliam Museum as a Chagford subject but subsequently, and with some misgivings, it was identified as an Auberville landscape (and therefore dated to the post-war period *c*.1919–20). This mistaken identification arose because one of two drawn studies for the painting (Study 1 below) is inscribed 'Auberville'. The inscription, however, is not in Sickert's hand; by whom, and on what authority it was inscribed is unknown. The two drawings are:

1. Pencil, pen and ink, squared. 8¼ × 10⅝ (21 × 27), Coll. Liverpool, Walker Art Gallery (1948). Exh. A.C.49 (53). Inscribed 'Auberville' (see above).
2. Pencil, pen and ink. 8¼ × 10⅝ (21 × 27), Coll. Liverpool, Walker Art Gallery (1948). Study 1 seems to have been traced from this drawing.

Painted study for *Rushford Mill*:
Panel. 6 × 9⅛ (15·2 × 23·2), Nina Hamnett/Coll. Dr. S. Charles Lewsen. This painting is called *The House at Chagford* (which confirms the identification of *The Mill Pool* as a Chagford subject) and is dedicated 'to N.H.', that is, Nina Hamnett. Any remaining doubt that the title of this panel may not be a correct identification of its location must be dispelled by comparing it with another panel, inscribed 'Chagford' in Sickert's hand, from Dr. Lewsen's collection. The two pictures are identical in handling, size, and the type of red wood panel used.

369. CHAGFORD CHURCHYARD (Fig. 259) *c*.1915–16

Canvas. 24 × 32 (61 × 81·3)
Sotheby's, 9 July 1958 (120) as *A Cemetery*/Christie's, 16 November 1962 (166)/Christie's, 21 May 1965 (76)/
Coll. Commander Sir Michael Culme-Seymour, Bt.
Exh. Possibly Carfax Gallery 1916 (8) as *The Churchyard*
Chapter XVI

The churchyard was one of Sickert's favourite motifs in Chagford. Paintings include:

1. Canvas. 28 × 23 (71·1 × 58·4), Harcourt Johnstone/ Christie's, 2 December 1932 (118)/Sotheby's, 20 December 1967 (149), bought McIntyre. Squared and neatly drawn, but barely touched with thin colour.
2. Panel. 9½ × 6¼ (24·1 × 15·9), Messrs. Roland, Browse & Delbanco. Exh. R.B.D.63 (47); R.B.D.1963, 'Christmas Presents' (66).

Drawings include:
Pencil and watercolour. 9 × 7⅛ (22·8 × 18), Coll. London, British Council (1949).
With reference to Sickert's Chagford subjects it should be noted that many of his drawings of various motifs (few of which he ever painted) are squared and inscribed with a note suggesting the size of canvas to which they could be transferred. This note is sometimes misread as a date, e.g. *Chagford*, a squared pen and ink drawing sold at Sotheby's, 15 April 1964 (12) was catalogued as dated '22.X.16'— implying that Sickert was in Chagford in October 1916 —whereas in fact it should read as a transfer note '22 × 16'.

370. QUEEN'S ROAD, BAYSWATER STATION (Fig. 260)
 c.1916

Canvas. 25 × 30 (63·5 × 76·2)
'Sickert' b.r.
Roger Fry/
Coll. London, Courtauld Institute of Art (1934)
Exh. Carfax Gallery 1916 (19)
Chapter XVI

371. PULTENEY BRIDGE, BATH (Fig. 261) c.1916–17

Canvas. 27½ × 45 (69·8 × 114·3)
'Sickert' b.r.
Miss Sylvia Gosse (1917)/Dr. Robert Emmons/R. C. M.
 Cotts/Sotheby's, 26 April 1961 (189)/Hugh Beaumont/
Coll. Mr. and Mrs. Paul Mellon
Rep. Emmons, facing p. 188
Exh. Tate 60 (149); New York 67 (45)
Chapter XVI

There are a great number of paintings of this, Sickert's
favourite Bath subject. In each version he varied the
points of cutting the scene. Some versions were painted
many years later than the original studies and paintings.
Versions painted c.1916–19 include:
1. Canvas. 25 × 36 (63·5 × 91·5), Sir Alexander Park Lyle/
 Private Collection, England. Rep. B.60, Pl. 78. Exh.
 Agnew 60 (93).
2. Canvas. 20 × 25 (50·8 × 63·5), Sir George Sutton/Mrs.
 William Miller/Private Collection, England. Exh.
 Edinburgh 53 (30); Agnew 60 (98), rep. in catalogue.
3. Canvas. 20 × 27½ (50·8 × 69·7), Private Collection,
 England. Rep. B.43, Pl. 47. Exh. N.G.41 (3); Leeds 42
 (178).
4. Canvas. 14½ × 18¼ (36·8 × 46·3), Harcourt Johnstone/
 Coll. The Trustees of Sir Colin and Lady Anderson.
 Exh. Burgh House Hampstead 1959, 'Treasures from
 Hampstead Houses' (12).
5. Canvas. 9 × 11¼ (22·9 × 28·5), Sir Michael Sadler/
 Sir Austen Harris/Coll. Mrs. Beatrice Moresby. Exh.
 Agnew 60 (94). Inscribed 'Sickert-Bath-1918'.
Versions 4 and 5 may be the 'couple of small sparkling
canvases like one sees in the windows of Boussod & Valadon
et cie' noted in a letter to Miss Hamnett, but unfortunately
Sickert did not specify the subject to which he referred
when he told her about these pictures.
I have seen a photograph of yet another version of the
subject, details and whereabouts unknown, with the
Leicester Galleries in 1940.
Oil studies include:
1. Plywood. 9 × 5¾ (22·9 × 14·6), Coll. London, Islington
 Public Libraries (1947). Exh. Sheffield 57 (50). A
 sketch for a small part of the subject.
2. Board. 13¾ × 10 (34·9 × 25·4), Messrs. Roland, Browse &
 Delbanco 1970. Exh. New York 67 (7); Sydney 68 (30).
 A sketch for the bridle path part of the subject.
Drawn studies for the subject include:
1. Pen and ink, wash, squared. 9 × 11½ (22·9 × 29·2),
 Alfred Jowett/Christie's, 17 July 1959 (120)/Coll. The
 Cottesloe Trustees. Rep. B.43, Pl. 47a. Exh. N.G.41
 (99); Leeds 42 (113). Inscribed with colour notes.
2. Pencil, pen and ink, squared. 10½ × 8½ (26·6 × 21·5),
 Coll. Maidenhead, Reitlinger Bequest.

3. Pencil, wash. 8⅛ × 7¼ (20·5 × 18·5), Coll. Lord Reigate.
4. Pen and ink, watercolour. 9 × 12 (22·9 × 30·5), Christie's,
 28 November 1930 (12)/Coll. Leeds, City Art Gallery
 (1931). Exh. Sheffield 57 (127); Tate 60 (152). Dated
 'Sickert 1919'.
Versions probably painted much later (during the 1930s)
include:
1. Canvas. 25 × 26 (63·5 × 66), Max Koetser/Nicholas von
 Slochem/Sotheby's, 20 June 1962 (128)/Coll. Sir
 Alfred Beit, Blessington, Co. Wicklow. Exh. Beaux Arts
 Gallery 1933 (13) as Christine at Bath (because it shows
 the figure of Christine, remembered posthumously, on
 the bridal path), rep. in catalogue and date given as
 1932.
2. Canvas. 32 × 36 (81·3 × 91·5), Mrs. Mattei and Mrs.
 Ricardo/Sotheby's, 22 July 1964 (160)/Coll. London,
 Department of Environment (1964) location Foreign
 and Commonwealth Office. Exh. Leeds 42 (199).

372. THE BELVEDERE or BEECHEN CLIFF, BATH
 c.1916–18

Canvas. 25 × 25 (63·5 × 63·5)
'Sickert' b.l.
Sir George Sutton/Mrs. William Miller/
Private Collection, England
Rep. B.60, Pl. 80
Versions:
1. Canvas. 28 × 28 (71·1 × 71·1), Lord Henry Cavendish-
 Bentinck/Coll. London, Tate Gallery (1940). Rep. B.43,
 Pl. 48. Lit. Tate Gallery Catalogue 1964, pp. 628–9.
 Exh. Tate 60 (150).
2. Canvas board. 8 × 8 (20·3 × 20·3), Coll. Hugh Beaumont
 Esq. Exh. R.B.D.1963, 'Christmas Presents' (22). A
 small, sparkling version of the subject which incorporates
 all the information found in the larger pictures.
Oil study:
Board. 14 × 10 (35·5 × 25·4), Coll. Bath, Victoria Art
Gallery (1942). Exh. Sheffield 57 (52).
Drawings include:
1. Pencil, pen and ink, watercolour, squared. 8 × 8 (20·3 ×
 20·3), Coll. London, British Museum (1931). Exh. Tate
 60 (151).
2. Pencil, pen and ink, wash, squared. 8⅞ × 8 (22·5 ×
 20·3), Coll. London, British Museum (1933).
3. Pen and ink, squared. 12 × 10 (30·5 × 25·4), Last known
 owner Mrs. Sickert. Rep. B.43, Pl. 48a.
4. Pen and ink, watercolour, heightened with white,
 squared. 8⅝ × 8⅜ (22 × 21·4), J. N. Bryson/P. & D.
 Colnaghi & Co. Ltd 1971. Exh. Colnaghi 1971, 'English
 Paintings, Drawings and Prints' (103).
5. Pen and ink. 8 × 7 (20·3 × 17·8), Coll. London, Islington
 Public Libraries (1947). Exh. Sheffield 57 (125).
6. Pen and ink. 10¾ × 9¾ (27·3 × 24·8), Coll. Brinsley Ford
 Esq.

373. LANSDOWNE CRESCENT, BATH c.1916–18
Canvas. 23⅛ × 25 (58·7 × 63·5)
'Sickert' b.l. (signed later because signature not present in
reproduction in the Eldar Gallery catalogue)
Coll. Sydney, Art Gallery of New South Wales (1945)
Exh. Eldar Gallery 1919 (4); Adelaide 68 (45); Sydney
 68 (12)

Versions and oil sketches include:
1. Canvas. 14 × 10 (35·5 × 25·4), Private Collection, England.
2. Panel. 10 × 8 (25·4 × 20·3), Bernard Falk/Christie's, 18 November 1955 (68)/Coll. Fredericton, New Brunswick, Canada, Beaverbrook Art Gallery (1955). Rep. B.60, Pl. 79.
3. Panel. 8 × 10 (20·3 × 25·4). Private Collection, England.

Drawn study:
Pencil, pen and ink. 9¼ × 10 (23·5 × 25·4), Private Collection, England. Rep. B.60, Pl. 78a; Rothenstein 1961; Lilly, Pl. 36.

374. MR. SHEEPSHANKS' HOUSE, CAMDEN CRESCENT, BATH c.1916–18

Canvas. 24½ × 30¼ (62·2 × 76·8)
'Sickert' b.r., 'Mr. Sheepshank's House—Camden Crescent —Bath' b.l.
Coll. Durban, Museum and Art Gallery (1939)
Rep. B.43, Pl. 49

Versions and oil sketches include:
1. Canvas. 30 × 20 (76·2 × 50·8), Sir Michael Sadler/Coll. Marcus Wickham-Boynton Esq., Burton Agnes Hall, E. Yorks. Exh. Sheffield 57 (54); Agnew 60 (90); Hull 68 (16).
2. Canvas. 24 × 20 (61 × 50·8), Earl Jowett/Private Collection, London. Exh. Sheffield 57 (51); Agnew 60 (106).
3. Panel. 13 × 9½ (33 × 24·1), Private Collection, England. Exh. N.G.41 (37); Edinburgh 53 (93); Agnew 60 (88); Tate 60 (148).
4. Panel. 10 × 8 (25·4 × 20·3), Bernard Falk/Christie's, 18 November 1955 (67)/Coll. Fredericton, New Brunswick, Canada, Beaverbrook Art Gallery (1955).
5. Board. 13¾ × 10 (34·9 × 25·4), John Lehmann/Messrs. Roland, Browse & Delbanco 1971. Exh. New York 67 (18) as House at Bath; Sydney 68 (31); R.B.D.1970, 'From Sickert to Sutherland' (10). A study of the corner of the house.
6. Board. 13½ × 9½ (34·3 × 24·1), Harcourt Johnstone/Mrs. H. A. C. Gregory/Christie's, 16 November 1962 (137)/ Coll. Count N. Labia, Capetown, South Africa.

Drawn study:
Pencil, pen and ink, squared. 9½ × 10½ (24·1 × 26·7). From the collection of Edward le Bas. Rep. Image, No. 7, 1952, p. 43. Exh. R.A.1963, 'A Painter's Collection' (187). Mr. Sheepshanks was the brother of the distinguished astronomer Richard Sheepshanks who was (see B.60, pp. 10–11) Sickert's maternal grandfather.

1919–20. STILL LIFE

375. LOBSTER ON A TRAY (Fig. 262) c.1919

Canvas. 20 × 24 (50·8 × 61)
'Sickert' t.l.
Howard Bliss/J. W. Blyth/
Coll. Kirkcaldy Art Gallery (1964)
Exh. N.G.41 (12); Edinburgh 53 (15); Sheffield 57 (78)
Chapter XVII

One of a group of culinary still lifes painted in Envermeu. Other examples are catalogued below. Sickert also made

several still-life drawings at this time of which I do not know painted versions, e.g.:
1. A Loaf of Bread. Black chalk, heightened with white. 10¼ × 14 (26 × 35·5), Sotheby's, 8 July 1970 (40)/Coll. Commander Sir Michael Culme-Seymour, Bt.
2. Fish on a Plate. Black chalk, sepia wash. 9¾ × 11¾ (24·8 × 29·8), Sotheby's, 26 November 1969 (209), bought Lemmerton. This drawing is inscribed 'Envermeu'.

376. THE MAKINGS OF AN OMELETTE dated 1919

Canvas. 16 × 13 (40·6 × 33)
'Sickert. Envermeu. 1919' b.l.
Coll. Washington D.C., Phillips Art Gallery (1930)
Exh. Agnew, New York, 1929 'Contemporary British Artists' (12) as A Quoi faire une Omelette; New York 67 (38).

A trolley with a plate of eggs on the lower tray, and a plate of mushrooms, a glass of wine, and a knife on the upper tray.

Related paintings:
Take Five Eggs. Canvas. 13 × 16½ (33 × 41·9). Last known owner Dr. Robert Emmons. Exh. Savile Gallery 1930 (27); Agnew 60 (100). This picture was signed ('Rd.St. A.R.A.') at a later date. It shows a plate of five eggs (whereas in the similar plate in The Makings of an Omelette there are six eggs).
Mushrooms. Canvas. 13 × 16 (33 × 40·6), Private Collection, London. A separate painting of the upper part of C.376. Sickert also etched Mushrooms.

A study for Mushrooms:
Pencil, pen and ink, squared. 12¾ × 15½ (32·4 × 39·4), Coll. Rugby, Art Gallery (1947).

377. ROQUEFORT 1919

Canvas. 16 × 13 (40·6 × 33)
'Sickert' b.l.
Coll. London, Tate Gallery (1924)
Rep. Bertram, Pl. 28
Lit. Tate Gallery Catalogue 1964, pp. 624–5
Exh. Goupil Gallery March 1920 'Paintings and Drawings by British and Foreign Artists' (19); Sheffield 57 (56)

Cheese on a glass covered plate, a bottle and glass of wine, and a knife on a wooden table.

Study:
Black chalk, pen and ink, heightened with white. 12¾ × 10½ (32·3 × 26·7), Philip James Esq. Rep. Image, No. 7, 1952, p. 42 as Still Life—Cheese and Wine. Exh. Tate 60 (158). This drawing is inscribed 'Envermeu'.

378. RED CURRANTS c.1919

Board. 9 × 12 (22·9 × 30·5)
'Sickert' b.r.
Private Collection, England
Exh. N.G.41 (40); Leeds 42 (165); Sheffield 57 (40)

Probably red currants in a colander although the painting is related to a drawing of Cherries in a Colander. Chalk, heightened with white. 12¼ × 11 (31·1 × 28). From the collection of Edward le Bas. Exh. R.A.1963, 'A Painter's Collection' (191).

1919–26. DIEPPE AND LONDON, LANDSCAPES

379. DIEPPE SANDS (Fig. 263) *c.*1919
Canvas. 10 × 20 (25·4 × 50·8)
'Sickert' b.r.
Christie's, 13 April 1928 (98) as *The Beach at Dieppe*/Mrs.
 Cyril Kleinwort/Major E. O. Kay/
Coll. Nicholas Hicks Esq.
Exh. Sheffield 57 (47)
Chapter XVII

Study for *Dieppe Sands*:
Pencil, pen and ink, squared. 5¼ × 10 (13·3 × 25·4). Christie's, 20 March 1970 (267)/Private Collection, London.
Dated 1919.

Related picture or study:
Canvas. 18 × 24 (45·7 × 61), Christie's, 20 March 1970 (97)/Martin & Sewell 1971. Exh. Martin & Sewell 1971, 'Some English Pictures and Drawings' (59), rep. in catalogue. Only a broad band across the canvas has been used for the subject, a study of the main beach tent with the figures along the beach lightly indicated.

380. DIEPPE RACES (Fig. 264) *c.*1920–6
Canvas. 20 × 24 (50·8 × 61)
'Sickert' b.r.
Mrs. D. M. Fulford/
Coll. Birmingham, City Art Gallery (1945)
Exh. Savile Gallery 1926; London Group Retrospective
 1928 (162) lent by Mrs. Fulford
Chapter XVII

I have traced no catalogue of the Savile Gallery exhibition in 1926; it was held from May to June and contained thirty-seven paintings and thirteen drawings representing retrospective and recent work (this exhibition is not to be confused with the retrospective drawings exhibition held at the Savile Gallery in February). Press reviews prove that *Dieppe Races* was exhibited. Mrs. Fulford probably bought the picture from the Savile Gallery exhibition, because she already owned it when it was shown with the London Group two years later. Its date, quoted in the London Group catalogue, was given as 1926. It is possible that the picture was painted from a photograph in that year but more likely that it was at least begun in Dieppe *c.*1920 (also with the help of photographic documents) and perhaps finished several years later in London. It is also possible that the date 1926 was a mistake, perhaps caused by its previous exhibition in that year.

381. THE SERPENTINE, LONDON (Fig. 265) *c.*1920
Chalk, pen and ink, squared. 4⅞ × 8 (12·4 × 20·3)
'Sickert P.R.B.A.' b.l., 'The Serpentine' b.r. and inscribed with colour notes
John Cristopherson/Sotheby's, 17 March 1965 (98)/
Coll. William B. O'Neal, Charlottesville, Virginia
Exh. Agnew 1965, 'French and English Drawings' (83)
Chapter XVII

Signed and inscribed 1927–9 when Sickert was President of the R.B.A., but possibly drawn in 1920 when Sickert was in London for a few months.
Sickert made several drawings and paintings of different

aspects of the Serpentine in Hyde Park at this period, e.g.:
1. Canvas. 16 × 20 (40·6 × 50·8), Mrs. Rowley Bristow/
 Private Collection, London. Rep. B.43, Pl. 60. Exh.
 Leeds 42 (183); Agnew 60 (107).
A pencil and watercolour drawing for this picture, 8¾ × 11½ (22·2 × 29·2), last known owner Miss Sylvia Gosse. Rep. B.43, Pl. 60a.
2. Canvas. 16 × 20 (40·6 × 50·8), J. W. Blyth/Sotheby's,
 20 April 1966 (54)/ Private Collection, London. Exh.
 Edinburgh 53 (50), measurements misquoted as 20 × 24
 inches.
Fig. 265 is not a study for either painting although it is similar in subject (trees, grass, little chairs etc.).

382. IN THE WONDERFUL MONTH OF MAY (Fig. 266)
 *c.*1920–4
Canvas. 22½ × 25 (57·1 × 63·5)
'Sickert' b.r.
Coll. Boston, Museum of Fine Arts (1931)
Exh. Goupil Gallery 1924, 'Modern British Art' (4) as
 Regent's Park; Agnew, New York 1929, 'Contemporary
 British Artists' (15) as *Im Wunderschönen Monat Mai*; New
 York 1967 (34)
Chapter XVII

Sickert had used this title (a line from Heine) for a much earlier, untraced or unidentified painting (*Im Wunderschönen Monat Mai* exhibited N.E.A.C. spring 1891 No. 61).

Study for Fig. 266:
Pen and ink, squared. 7⅛ × 8½ (18·1 × 21·5), Coll. Keith Baynes Esq.
This study was almost certainly also used for Sickert's engraving of this subject, called *Sussex Place, Regent's Park* and dated 1920. Sickert must have drawn and engraved the subject when he was in London for a few months early in 1920. I believe it is likely that he painted the subject at the same time, but the possibility that he painted Fig. 266 later from his squared drawing cannot be dismissed. Its exhibition in 1924 provides the picture with a *terminus ante quem*.

383. THE GARDEN OF LOVE *or* **LAINEY'S GARDEN**
(Fig. 267) *c.*1924–7
Canvas. 32¼ × 24¼ (81·9 × 61·6)
'Sickert' b.r.
Christie's, 4 March 1932 (67)/Howard Bliss/
Coll. Cambridge, Fitzwilliam Museum (1945)
Exh. Leicester Galleries 1932 (34); Chicago: Pittsburgh
 1938 (22); Leeds 42 (186)
Chapter XVII

Sickert had a studio on Noel Street (later Road), Islington, from 1924 onwards and other studios in Islington from 1927 onwards when he and his wife also lived in the borough. They left London and Islington for good in 1934. Fig. 267 is one of a group of Islington landscapes painted towards the beginning of this 'Islington Period'. Another Islington landscape is reproduced in Fig. 268.

Drawing (or study) related to Fig. 267:
Pen and indian ink on mauve paper. 16 × 12⅛ (40·6 × 30·7), Howard Bliss/Coll. Cambridge, Fitzwilliam Museum (1945). Inscribed 'Londra benedetta—II' and 'Lainey's garden'.
Drawing and painting are identical in subject, composition,

and incidental detail. The drawing is just half the scale of the painting, but it is not squared. Whether Sickert painted from the drawing, or transcribed both from a separate document (possibly a photograph) is uncertain. By the middle 1920s Sickert usually worked from photographs and made hardly any drawings. There are a few drawings of houses and gardens in Islington but these were probably not executed as studies for painting; they are casual records made by Sickert before the habit of a lifetime's sketching virtually died. Examples of such drawings are *Canonbury Tower* and *Row of Houses*, both pencil, $11\frac{1}{2} \times 8\frac{3}{4}$ (29·2 × 22·2), Coll. London, Islington Public Libraries (1947). *Row of Houses*, Rep. *Image*, No. 7, 1952, p. 36. Exh. Sheffield 57 (152 and 140 respectively).

384. THE HANGING GARDENS OF ISLINGTON (Fig. 268) *c.*1924–6

Canvas. $23\frac{1}{2} \times 19\frac{1}{4}$ (59·7 × 48·9)
'Sickert' b.l.
Christie's, 30 June 1933 (165)/Christie's, 3 April 1936 (95)/ Tooth/
Private Collection, London
Exh. Savile Gallery 1926
Chapter XVII

See note to Fig. 264, C.380 for information about the Savile Gallery exhibition.
The Hanging Gardens of Islington is a view of the gardens of Noel Street as seen from the Regent's Canal. Sickert engraved the subject.

Related painting:
Fading Memories of Sir Walter Scott. Canvas. 20 × 24 (50·8 × 61), Private Collection, France/Coll. Adelaide, Art Gallery of South Australia (1957). Rep. B.43, Pl. 61. Exh. Adelaide 68 (54). Another view of the back gardens of Noel Street as seen from the Regent's Canal. The title must have been suggested by the Neo-Gothic architecture of the house on the left of the picture.
Another Noel Street landscape with a curious title is *Laylock and Thunderplump.* Canvas. 30 × 25 (76·2 × 63·5), the Hon. Mrs. Clyss/Coll. London, Department of Environment (1958). Exh. London Group 1927 (25). A view of a house in Noel Street with two figures at a window working at their sewing machines; the figures are said to represent Sickert's landlady and her daughter (nicknamed as in the title of the picture). According to Cicely Hey's recollection the painting was done during the summer of 1924.

385. GATE TO THE CHÂTEAU D'AUBERVILLE
 dated 1919
Canvas. $20 \times 24\frac{1}{4}$ (50·8 × 61·6)
'A Madame Forget/Walter Sickert 1919' b.l.
Madame Forget/
Last known owner Mrs. Stephanie Kennedy
Rep. B.60, Pl. 81
Chapter XVII
Version:
Canvas. 20 × 24 (50·8 × 61), Evan Charteris/Coll. Norwich, Castle Museum (1961). Inscribed 'Auberville/residence of Madame Forget'.
Auberville is near Envermeu. Sickert was friendly with M. and Mme Forget who were related to Berthe Morisot.

386. THE HAPPY VALLEY *c.*1920

Canvas. $14\frac{1}{2} \times 21\frac{3}{4}$ (36·8 × 55·2)
'Sickert' b.l.
Sotheby's, 15 December 1971 (19)
Chapter XVII

'One of my last Envermeu pictures was called The Happy Valley', Sickert wrote to Mrs. Schweder in 1922 (quoted Emmons, p. 191). He went on, 'But I can't bear the sight of those scenes now' (his wife having died at Envermeu).

1919–26. DIEPPE AND LONDON, PORTRAITS AND FIGURES

387. THE PREVARICATOR (Fig. 270) *c.*1920–2
Canvas. 24 × 16 (61 × 40·6)
'Sickert' b.l.
W. H. Stephenson/Lt.-Col. A. E. Anderson/Christie's, 9 October 1942 (85)—Sale in aid of the Red Cross/
Last known owners Mr. and Mrs. S. Samuels, Liverpool
Rep. B.43, Pl. 57; B.60, Pl. 84 (incorrect measurements quoted); Rothenstein 1961
Exh. Savile Gallery 1928 (21); Tate 60 (156)
Chapter XVII
Studies:
1. Pen and ink, squared. $10\frac{3}{4} \times 8\frac{1}{4}$ (27·3 × 21), Coll. London, British Council (1940). Rep. *Image*, No. 7, 1952, p. 41. Exh. Tate 60 (188). Inscribed with title and 'picture in the possession of Stephenson, Southport'.
2. Pencil, pen and ink. $8\frac{3}{4} \times 7$ (22·2 × 17·8), John Baskett/ Private Collection, England.
One of a small group of Dieppe bedroom subjects studied from 1920 to 1922 but sometimes finished in London after Sickert's return. Another example is reproduced as Fig. 271; yet another is *La Parisienne* or *Lola in a Grey Cloak*: Canvas. 22 × 18 (55·8 × 45·7), G. F. Sandiford/Last known owner Sir Alexander Park Lyle, Bt. Rep. B.43, Pl. 56. *La Parisienne* is dated 1923 and must therefore have been completed in London.
Studies for *La Parisienne* include:
1. Pen and ink, squared. $10\frac{1}{4} \times 7\frac{7}{8}$ (26 × 20), Coll. Sheffield, Graves Art Gallery (1947). Exh. Sheffield 57 (135).
2. Pen and ink, wash. $10\frac{1}{2} \times 8\frac{1}{2}$ (26·6 × 21·6) with the Savile Gallery 1927, present whereabouts unknown. Rep. *Drawing and Design*, III, No. 13, July 1927, p. 9. Exh. Savile Gallery 1926 (1).

388. L'ARMOIRE À GLACE (Fig. 271) dated 1924
Canvas. 24 × 15 (61 × 38·1)
'Sickert—1924' b.l.
W. H. Stephenson (bought from Sickert in 1924)/
Coll. London, Tate Gallery (1941)
Rep. Bertram, Pl. 43
Lit. W. H. Stephenson, *Sickert: the Man; and his Art: Random Reminiscences*, Southport, Johnson, 1940, pp. 15–17; Emmons, pp. 306–7; B.60, p. 37; Tate Gallery Catalogue 1964, p. 635
Exh. London Group 1925 (73); N.G.41 (94); Sheffield 57 (60)
Chapter XVII

Sickert studied this subject in Dieppe in 1922. The etching of the subject is dated 1922. A proof exhibited at Agnew 1971, 'A Century of Modern Drawings and Prints' (176) is inscribed below the mount, '*Moi, mon rêve ça a toujours été d'avoir une armoire à glace*'. One of the studies for the painting listed below is also dated 1922. The painting, however, was done in London—or at least completed there—in 1924. Sickert's letter to Stephenson explaining the subject of *L'Armoire à Glace* as a 'sort of study à la Balzac' is quoted in full in the text. Miss Browse identifies the model as Marie Pepin, Walter and Christine Sickert's *bonne*, not to be confused with Marie Hayes, the model for many of the Camden Town pictures.

Studies:

1. Crayon, pen and ink, watercolour, squared. $10\frac{1}{4} \times 7\frac{3}{8}$ (26·1 × 18·8), Walter Howarth/Coll. London, Tate Gallery (1941). Exh. Savile Gallery 1926 (44); N.G.41 (108); Sheffield 57 (149); Tate 60 (189). Inscribed 'L'Armoire à Glace' and 'Picture Stevenson [*sic*] collection Southport', and signed and dated 'Sickert 1922'.
2. Crayon, pen and ink. $11 \times 5\frac{1}{8}$ (28 × 13), Charles Jackson/Coll. London, Tate Gallery (1952).
3. Pencil, pen and ink. $10\frac{1}{2} \times 7\frac{3}{4}$ (26·6 × 19·7), Coll. Liverpool, Walker Art Gallery (1948). Exh. A.C.49 (47).
4. Pen and ink (with watercolour dabbed all round the drawing, presumably as trials for colour). $8\frac{1}{2} \times 5\frac{1}{2}$ (21·6 × 14), from the collection of Edward le Bas. Exh. R.A.1963, 'A Painter's Collection' (200).
5. Pen and ink, chinese white. $10\frac{1}{4} \times 6\frac{1}{4}$ (26 × 15·9), Coll. Cambridge, Fitzwilliam Museum (1943).
6. Pen and ink, watercolour. $10 \times 6\frac{1}{2}$ (25·4 × 16·5), Coll. Major W. H. Stephenson (given to him by Sickert and dedicated 'To W. H. Stephenson in grateful sympathy, Sickert'. Rep. Stephenson, *Random Reminiscences*, loc. cit., frontispiece; Lilly, Pl. 18.
7. Pen and dark green ink, chalk. $11\frac{1}{2} \times 9$ (29·3 × 22·9), Coll. Whitworth Art Gallery, University of Manchester (1960). Inscribed 'La Sourire d'Almaviva'.
8. Pencil, pen and ink, watercolour. $10\frac{3}{4} \times 8\frac{1}{4}$ (27·3 × 21), Coll. Boston, Museum of Fine Arts (1960). Inscribed 'Moi, depuis que j'ai mon armoire à glace je suis contente'.

Related drawing:

The New Tie. Pen and ink, watercolour. $10 \times 6\frac{1}{2}$ (25·4 × 16·5), Coll. Glasgow, City Art Gallery (1922). Signed and dated 'Sickert 1922', and inscribed with title. This drawing includes a man adjusting his tie in front of the mirror. Sickert etched the subject.

389. PORTRAIT OF VICTOR LECOUR (Fig. 269)
 dated 1924 (1922-4)

Canvas. $32 \times 23\frac{3}{4}$ (81·3 × 60·3)
'Sickert—1924' b.l.
G. Beatson Blair/
Coll. Manchester, City Art Gallery (1941)
Rep. B.43, Pl. 58; Bertram, Pl. 41; B.60, Col. Pl. X; Rothenstein 1961, Col. Pl. 14; Pickvance 1967, Col. Pl. XIV; Lilly, Pl. 33
Lit. Emmons, pp. 188-9

Exh. R.A.1925 (17); Edinburgh 53 (28); Tate 60 (157); Hull 68 (19); R.A.1968-9, 'Bicentenary Exhibition' (450)

Chapter XVII

In January 1922 Sickert wrote from Dieppe to Adrina Schweder, his late wife Christine's sister, that he had 'got on well with a portrait of the Sous-Prefet, who is a beautiful gracious young creature, like a "lion" of the time of Gavarni, and of Victor Lecour, a superb great creature like a bear'. Victor Lecour, as Sickert explained in another letter to Mrs. Schweder, used to run the restaurant 'Clos Normand' at Martin Église a few miles outside Dieppe. The portrait of the Sous-Prefet is catalogued below. The portrait of Victor Lecour is dated 1924 so it must have been completed in London.

Two portraits of *Victor Lecourt* [*sic*] *of Martin Église* were sold at Christie's, 30 November 1928 (101, 103) but both were much smaller pictures than Fig. 269.

Portrait of the Sous-Prefet, sometimes called *Rue Aguado* (Sickert's studio, where he painted Fig. 269 and this portrait was at 44 Rue Aguado): Canvas. $32 \times 25\frac{1}{2}$ (81·3 × 64·8), Asa Lingard/Private Collection, London. Exh. N.G.41 (82); Agnew 60 (108).

Studies for the *Sous-Prefet*:

1. Chalk, pen and ink, squared. $11\frac{1}{4} \times 9$ (28·6 × 22·9), Coll. Liverpool, Walker Art Gallery (1948). Exh. A.C.49 (49); Hull 68 (54).
2. Pen and ink. $10\frac{1}{2} \times 8\frac{1}{4}$ (26·7 × 21), Coll. Liverpool, Walker Art Gallery (1948). Exh. A.C.49 (49); Hull 68 (54).

390. CICELY HEY (Fig. 273) 1922-3

Canvas. $24\frac{1}{2} \times 29\frac{1}{2}$ (62·2 × 74·9)
'Sickert' b.r.
Percy Moore Turner/Sir Michael Sadler/Christie's, 30 November 1928 (152)/Mark Oliver/
Coll. London, British Council (1948)
Rep. B.60, Pl. 89; Rothenstein 1961, Col. Pl. 13
Exh. Savile Gallery 1930 (11) as *Cicely*; Adelaide 68 (53); Sydney 68 (15).

Chapter XVII

Cicely Hey, daughter of Dr. Darwin Hey, was a painter. She met Sickert when she was taking the door money for a Roger Fry lecture in 1922. She remained friendly with him until he left London in 1934. In 1924 she married the *Daily Telegraph* art critic (later editor of the *Burlington Magazine*) R. R. Tatlock. In her plate note Miss Browse (B.60, p. 82) says this picture was painted in a room at the Bachelor's Hotel, Covent Garden, where Sickert lived for a time after his return from Dieppe in 1922. However, Miss Hey (Mrs. Tatlock) herself remembered that this and other portraits of her done at about the same time, 1922-3, were painted in Sickert's studio at 15 Fitzroy Street.

Miss Hey's recollection that Sickert made drawings of her which he squared, transferred to cartoons, and then traced onto his canvases, is discussed in the text. No such drawings are known today. There are, however, several oil studies related to Fig. 273:

Reveille Camden Town. Canvas. 24×20 (61 × 50·8), probably Christie's, 2 December 1932 (116)/G. P. Dudley Wallis/Christie's, 17 July 1959 (68)/Christie's, 5 July 1963 (20)

bought Helborn. Exh. Sheffield 57 (42). This picture is a summarily executed sketch, different in its proportions from Fig. 273, but still showing Cicely Hey peering out over the bed-rail and cut off short by the edge of the canvas.

Related painting:

Canvas. 24 × 20 (61 × 50·8), Messrs. Roland, Browse and Delbanco 1971. Exh. R.B.D.1971, 'British Paintings and Drawings' (1), rep. in catalogue. A close-up bust of Cicely Hey in the same pose, dress, and setting as in Fig. 273 and *Reveille*. The head is fully modelled in broad strokes and dashes of full paint so that this picture cannot be considered as a study for Fig. 273. It is a complete painting in its own right.

Study related to this picture and to Fig. 273:

Canvas. 24 × 20 (61 × 50·8), Reitlinger Bequest, Maidenhead/Sotheby's, 9 December 1970 (53)/Brook Street Gallery 1971.

Cicely Hey also remembered Sickert painting her picture as reflected in a mirror with himself in the background. She said he called the picture *Death and the Maiden* because she once let him realize that she considered him to be old. I do not know the present whereabouts or the details of the picture but it was exhibited at the R.A.1926 (349) and a photograph is in the Leicester Galleries archives. It is a curiously distorted two-figure group, showing an elongated Miss Hey seated on a bed with a grotesquely haggard Sickert seated behind her.

391. CICELY HEY (Fig. 272) c.1922–4

Canvas. 29¾ × 13⅞ (75·5 × 35·2)
'Sickert' b.r.
R. R. Tatlock/Sotheby's, 9 July 1958 (119) as *Before the Footlights*, a study of a girl singing/Sotheby's, 26 April 1961 (186) as *The Actress*, head and shoulders of Cicely May [*sic*]/
Messrs. Roland, Browse & Delbanco 1971
Exh. Brighton 62 (21); R.B.D.63 (18); New York 67 (6); Sydney 68 (32)
Chapter XVII

392. CHRISTINE DRUMMOND SICKERT, NÉE ANGUS, BUYS A GENDARMERIE 1920

Canvas. 20 × 16 (50·8 × 40·6)
'Sickert' b.l.
Alfred Jowett/Christie's, 17 July 1959 (122)/
Last known owner Angus Wilson Esq.
Rep. B.43, Pl. 51; Bertram, Pl. 36; Lilly, Pl. 19
Exh. Chicago: Pittsburgh 1938 (19) as *Christina*; N.G.41 (78); Leeds 42 (181); Agnew 60 (92)
Chapter XVII, note 3

This picture records Christine signing the papers connected with her purchase of the Maison Mouton in Envermeu in 1920, shortly before she died. The house was in fact next door to the gendarmerie.

393. THE BAR PARLOUR 1922

Canvas. 41 × 62 (104·1 × 157·5)
'Sickert A.R.A.' b.l.
Coll. Lady Keynes
Rep. *Drawing and Design*, IV, June 1928, p. 170

Exh. London Group Retrospective 1928 (159) on loan from J. Maynard Keynes; Chicago: Pittsburgh 1938 (14) as *The Bar*; Leeds 42 (179)
Chapter XVII

When this picture was exhibited in 1928 with the London Group its date was given as 1922. It shows two women seated back to back in front of a bar parlour background (shelves with glasses etc., a chest of drawers). The subject was probably the bar of the Bachelor's Hotel (see note to Fig. 273, C.390) where Sickert stayed for some time in 1922.

Studies:

1. Pen and ink, squared. 8 × 13 (20·3 × 33), Whereabouts unknown. Rep. Sitwell, facing p. 266; Lilly, Pl. 14 (incorrectly described as in the Aberdeen collection).
2. Pen and ink, red wash, squared. 7¾ × 12¾ (19·7 × 32·4), Coll. Aberdeen, Art Gallery (1947).

Study 2 shows a man on the left writing as he leans on the chest of drawers.

394. AMPHITRYON c.1923–5

Canvas. 20¾ × 15 (52·7 × 38·1)
'Sickert' b.r.
W. H. Stephenson/
Coll. J. Neville Clegg Esq.
Rep. B.60, Pl. 88
Lit. W. H. Stephenson, *Random Reminiscences*, op. cit., p. 11, rep. p. 12
Exh. N.G.41 (92); Agnew 60 (101)
Chapter XVII

This picture was probably the last of Sickert's personally conceived figure subjects. Stephenson relates the meaning of the title. The reference is to the story of how Jupiter disguised himself as Amphitryon in order to become the lover of Alcmene, Amphitryon's wife; the son they thus conceived was Hercules. The mythological reference, however, was only loosely associated with the subject, a tale of marital infidelity. Stephenson tells how Sickert also had an alternative contemporary title for the picture, *X's Affiliation Order* (X disguising the name of a fellow artist).

1919–26. DIEPPE AND LONDON, MUSIC HALL, CASINO AND THEATRE SUBJECTS

395. SHOREDITCH EMPIRE *or* THE LONDON, SHOREDITCH (Fig. 274) dated 1920

Canvas. 28½ × 19½ (72·4 × 49·5)
'Sickert—Shoreditch 1920' b.l.
R. C. Pritchard/Angus Wilson/Odo Cross/
Coll. Christchurch, New Zealand, Robert McDougall Art Gallery (1965)
Exh. Crane Kalman 1958, 'A Miscellanea of Paintings of the Theatre Circus and Music Hall' (6)
Chapter XVII

When Sickert was in London for a few months at the beginning of 1920 he made many drawings and some paintings in the Shoreditch music halls, the London (sometimes known as the Empire) and the Olympia.

Study for Fig. 274:
Chalk, pen and ink, squared. $9\frac{3}{4} \times 6\frac{1}{2}$ (24·7 × 16·5), Sir Michael Sadler/Crane Kalman 1958, present whereabouts unknown. Rep. Sitwell, p. xxxii. Exh. Crane Kalman 1958, 'A Miscellanea of Paintings of the Theatre Circus and Music Hall' (47).

Another view of this music hall was studied in detailed drawings:
1. Pencil. Size and whereabouts unknown. Rep. *Aspects of British Art*, ed. W. J. Turner, London, Collins, 1947, p. 56.
2. Chalk, squared. 15×7 (38·1 × 17·8). Last known owner C. Marescoe Pearce Esq. Inscribed with colour notes and identical in composition to Drawing 1. However, I do not know a painting of this composition. Its vertical format resembles Fig. 274 but spatially it is more complicated; the florid curves of the architecture and the indication of some audience figures in the immediate foreground recall the *New Bedford* pictures.

396. THE TRAPEZE (Fig. 276) dated 1920
Canvas. $25 \times 31\frac{3}{4}$ (63·5 × 80·6)
'Sickert' b.r., 'Sickert 1920' b.l.
Frank Hindley Smith/
Coll. Cambridge, Fitzwilliam Museum (1939)
Rep. B.43, Pl. 53
Exh. Tate 60 (153)
Chapter XVII

Version:
Canvas. $24\frac{1}{2} \times 32$ (62·2 × 81·3), Oswald Falk/Coll. Mr. and Mrs. Paul Mellon. Exh. London Group winter 1923 (57) as *Mlle Leagh*; Brighton 62 (23); R.B.D.63 (7), rep. in catalogue; New York 67 (44). A rather sketchier version. The subject was studied in Dieppe.

397. VERNET'S (Fig. 275) dated 1920
Canvas. 29×20 (73·7 × 50·8)
'Sickert—1920' b.r.
Probably Christie's, 21 June 1929 (138) as *Au Café Concert*/
 Geoffrey Blackwell/
Private Collection, England
Rep. B.43, Pl. 52; Bertram, Pl. 38
Chapter XVII

Sickert made many paintings and drawings of *Vernet's*, each showing a different aspect of the scene.
Drawings related to Fig. 275 include:
1. Pencil, pen and ink, watercolour, squared. $13\frac{3}{4} \times 8\frac{7}{8}$ (34·9 × 22·6), Coll. Liverpool, Walker Art Gallery (1948). Exh. A.C.49 (50); Hull 68 (50).
2. Pen and ink. $12 \times 5\frac{7}{8}$ (30·5 × 15), Colnaghi/Private Collection, London. Exh. Colnaghi 1971, 'English Paintings Drawings and Prints' (101).
Drawing 2 is a fairly complete representation of the scene as painted and is inscribed with colour notes, the title, and the information 'Study for W. H. Bnk's picture'; the first owner of Fig. 275 is unknown.
Other paintings of *Vernet's* include:
1. Canvas. $24 \times 19\frac{1}{2}$ (61 × 49·5), Private Collection, London. Exh. Savile Gallery 1930 (21). This picture shows a group of figures (cut off at the left edge of the canvas) seated at a rectangular table. The top of a bentwood

chair is in the foreground. An arched opening in the background frames a view through doors and passageways. There are many drawings related to this painting, several of them in the Walker Art Gallery, Liverpool:
 (i) A sheet with three drawings, pencil, pen and ink, various sizes. Exh. A.C.49 (23); Hull 68 (49). Two of these drawings study individual figures from the painting, and the third studies the whole interior.
 (ii) Pen and ink. $10\frac{3}{4} \times 8\frac{1}{8}$ (27·3 × 20·6). Studies of the man smoking sketched on one of the three drawings listed above.
2. Later version of the painting of *Vernet's* listed above (1). Canvas. 24×20 (61 × 50·8), Coll. Keith Baynes Esq. (bought from Sickert in 1925). Signed and dated 'Sickert 25'.
3. *Au Caboulet au bout du Quai*. Canvas. $24\frac{1}{8} \times 20$ (61·3 × 50·8), Dr. John Parkinson/Coll. Montreal Museum of Fine Arts (1946). Exh. Agnew 1931, 'Recent Pictures by British Artists' (25). A study of the stage and the café beyond seen from the wings. Drawings related to this painting include:
 (i) *An Actress*. Pencil. $10\frac{3}{8} \times 7\frac{3}{4}$ (26·4 × 19·7), Coll. Wakefield, City Art Gallery (1939).
 (ii) Pencil, pen and ink. $11\frac{5}{8} \times 7\frac{1}{2}$ (29·5 × 19), Coll. Boston, Museum of Fine Arts (1963).
Both drawings are inscribed 'Vernet's' which confirms the identification of the painting as a Vernet's subject.
4. *O Nuit d'Amour*. Canvas. $35\frac{1}{2} \times 27\frac{1}{2}$ (90·2 × 69·8), Coll. Miss E. M. Hewit (on loan to Manchester, City Art Gallery). Exh. London Group summer 1925 (71). Probably a Vernet's subject. It shows a brightly illuminated restaurant or *café concert* seen at night from the street; painted in glowing colours, emerald green, ochre, violet, turquoise and what *The Times*, 6 June 1925, described as 'maudlin blue'.
This list of Vernet's paintings is by no means complete. A glance at old sale and exhibition catalogues proves the existence of several more pictures. There are also very many drawings of Vernet's, most of them inscribed with the title. An idea of the number of such drawings may be obtained from the fact that Sickert's exhibition of drawings at the Savile Gallery in 1926 included eleven Vernet's subjects.

398. BACCARAT (Fig. 278) dated 1920
Canvas. 24×18 (61 × 45·7)
'Sickert—1920' b.r.
Mrs. Frances Evans (bought from Sickert in 1920)/
 Sir Evan Charteris/
Coll. The Cottesloe Trustees
Rep. B.60, Pl. 83
Exh. Edinburgh 53 (57); Agnew 60 (91); Tate 60 (154)
Chapter XVII

Version of Fig. 278:
Canvas. $21\frac{1}{2} \times 17\frac{1}{2}$ (54·6 × 44·5), Christie's, 2 December 1932 (115). Last known owner R. S. Humphrey Esq. Rep. Emmons, facing p. 170. Inscribed 'à Mademoiselle Levache/Souvenir de Walter et Christine Sickert—Envermeu 1920'.

Study:
Pencil. $10\frac{7}{8} \times 8\frac{1}{4}$ (27·7 × 21), R. A. Harari/Private Collection, London. A full drawing of the subject, with colour notes and a now illegible dedicatory inscription from 'Siccy'.

Sickert made drawings, in pencil, often on small cards, in the Casino and he painted from these sketches and from memory. The Walker Art Gallery, Liverpool, has five of these Baccarat sketches, various sizes, acquired through the Sickert Trust 1948; the Ashmolean Museum, Oxford, has nine pencil on card sketches, each 5½ × 3½ (14 × 9) bound together into a book (presented by the Sickert Trust 1946). One of the Ashmolean sketches is a study of the woman in the middle on the far side of the table as seen in Fig. 278 and others are more distantly related to the painting and the version listed above.

Other Casino gambling paintings, all oil on canvas:

1. 20¼ × 16½ (52 × 42), Mark Oliver/Z. Lewinter-Frankl/ Odo Cross/Coll. Auckland, City Art Gallery (1965). Rep. B.60, Pl. 85. Exh. Agnew 60 (95); Tate 60 (155); Adelaide 68 (52); Sydney 68 (14). One of the Walker Art Gallery sketches, Rep. *Image*, No. 7, 1952, p. 47, Exh. A.C.49 (52a) is related to this picture and one of the Ashmolean sheets includes a study of the back-view man.

2. *The Fur Cape*. 22¾ × 16⅝ (57·8 × 42·2), Lord Henry Cavendish-Bentinck/Coll. London, Tate Gallery (1940). Rep. B.43, Pl. 54; Bertram, Pl. 39. Lit. Tate Gallery Catalogue 1964, pp. 629–30. Exh. Goupil Gallery 1921 (77) as *Baccarat No. 1*; Adelaide 68 (51). Three of the Walker Art Gallery sketches, Exh. A.C.49 (51) are related to this picture.

3. 20¼ × 14¼ (51·4 × 36·2), Walter Howarth/R.B.D./Private Collection, London. Rep. B.43, Pl. 55; B.60, Col. Pl. IX. One of the Ashmolean Museum sketches was the basis of this painting. Another rather clumsier version of this picture was with the Leicester Galleries in 1929 and was included in their Sickert retrospective exhibition in that year as *Banco* (75), rep. in catalogue. Its present whereabouts is unknown.

4. *The Old Fool*. 30 × 20 (76·2 × 50·8), last known owner Sir John Elliott. Rep. B.60, Pl. 91. Exh. The London Group spring 1924 (29); N.G.41 (76). Dated 1924, and therefore painted in London, possibly from *The System* (5).

5. *The System*. 28½ × 14¾ (72·4 × 37·5), Samuel Courtauld/ Mrs. R. A. Butler/Coll. R. A. Bevan Esq. Exh. Savile Gallery 1928 (32).

Paintings 4 and 5 are closely related to each other and unlike the other Casino pictures they do not show Baccarat being played. The game appears to be Boule.

399. SIGNOR BATTISTINI SINGING (Fig. 280) 1925

Canvas. 29 × 20 (73·6 × 50·8)
Leslie G. Wylde/Christie's, 17 June 1932 (120)/R. A. Harari/Sotheby's, 4 July 1971 (31)/
Coll. The Earl and Countess of Harewood
Rep. Emmons, facing p. 216; B.43, Pl. 49; Bertram, Pl. 42; B.60, Pl. 90
Lit. Emmons, p. 200
Exh. London Group January 1926 (82); London Group Retrospective 1928 (161) lent by Mr. Wylde; Edinburgh 53 (18); Tate 60 (162); Tate Gallery 1964, 'London Group Jubilee Exhibition' (41)
Chapter XVII

When this picture was exhibited at the retrospective London Group exhibition in 1928 its date was given as 1925. Indeed, it could not have been painted any later than 1925 because the 1926 London Group exhibition was held in January.

Emmons states the picture was painted from a scribble Sickert made on a programme of the concert where Signor Battistini was singing.

400. THAT OLD FASHIONED MOTHER OF MINE *c.*1920

Canvas. 23½ × 18¾ (59·7 × 47·6)
Sir George Sutton/
Coll. The Cottesloe Trustees
Rep. B.60, Pl. 87
Exh. Savile Gallery 1930 (19)
Chapter XVII

Perhaps a painting done in the Shoreditch Olympia. In conception it is very close to a drawing, inscribed 'Shoreditch Olympia' and dated 1920, pen and ink, watercolour. 10½ × 7½ (26·6 × 19), Mrs. Price/Coll. Glasgow, City Art Gallery (1922). Rep. B.60, Pl. 86a. Exh. Tate 60 (187).

The painting, a close-up view of a male *artiste* on stage, seen at an angle, is handled very broadly; the drawing is loose-wristed, the paint (a range of bright electric blues) is slashed onto the canvas.

There are several other music hall paintings handled in exactly this way, also showing close-up views of *artistes* on stage seen at an angle, e.g.: *Miss Hilda Glyder*. Canvas. 23½ × 19¾ (59·7 × 50·2), Sotheby's, 17 March 1965 (26)/ Coll. the Earl and Countess of Harewood. Exh. Biennale, Venice 1932 (77). A smaller picture of *Miss Hilda Glyder*, called *You'd be Surprised*, canvas, 17¾ × 14⅝ (45·1 × 37·2) was sold Sotheby's, 6 July 1960 (14), bought Churcher.

1927 ONWARDS. PORTRAITS AND FIGURES

401. LAZARUS BREAKS HIS FAST. SELF-PORTRAIT
(Fig. 279) *c.*1927

Canvas. 30 × 25 (76·2 × 63·5)
'Lazarus breaks his fast' t.r.
Mark Oliver/Dr. Robert Emmons/
Coll. Mr. and Mrs. Eric Estorick
Rep. Emmons, facing p. 222; Bertram, Pl. 44; B.60, Col. Pl. XI; Rothenstein 1961, Col. Pl. 15; Pickvance 1967, Col. Pl. XV
Exh. Savile Gallery 1930 (7); Edinburgh 53 (48); Agnew 60 (110); Tate 60 (164)
Chapter XVIII

The painting was dated 1927 by Emmons who knew Sickert at this period.

This self-portrait, the first in which Sickert cast himself in patriarchal, biblical mould, was painted from a squared and numbered photograph formerly in the collection of Miss Powell.

Study:
Pen and ink, charcoal. 10 × 9 (25·4 × 22·9), Sir Michael Sadler/Maurice Goldman/ A. K. Snowman/Coll. Mr. and Mrs. Eric Estorick. Exh. Edinburgh 53 (92); Tate 60 (190). Probably itself drawn from the photograph as a sort of intermediate stage in visualizing the photograph as a personally executed work. When Sickert grew more used to working from photographs he omitted this stage.

402. REAR ADMIRAL LUMSDEN, C.I.E., C.V.O.
(Fig. 277) 1927-8
Canvas. $95\frac{1}{2} \times 35\frac{1}{4}$ (242·5 × 89·5)
Mark Oliver/
Coll. The Minneapolis Institute of Arts (1964)
Lit. Emmons, pp. 210, 212; B.60, p. 41
Exh. R.A.1928 (652); Agnew 60 (51); Tate 60 (163)
Chapter XVIII

Begun in Brighton in 1927, submitted unfinished to the R.A. in 1927 but rejected, and finished in London in 1928. The portrait was the picture of the year at the Royal Academy in 1928. It was the first of Sickert's late, life-size, grand full-length portraits of persons of distinction. This example was not commissioned but it set the formula for later commissioned portraits.

403. THE RT. HON. WINSTON CHURCHILL (Fig. 281)
 c.1927
Canvas. 18 × 12 (45·7 × 30·5)
The Hon. Baillie Hamilton/The Hon. Michael Berry/
 Sotheby's, 12 July 1950 (138)/
Coll. London, National Portrait Gallery (1950)
Exh. Savile Gallery 1928 (10); N.G.41 (98); Tate 60 (169)
Chapter XVIII

Winston Churchill (1874–1965), statesman, prime minister 1940–5 and 1951–5, Knight of the Garter 1953, was a keen amateur painter. He took some lessons in painting from Sickert at the period when this portrait was painted. He was, at the time, Chancellor of the Exchequer. His wife's mother, Lady Blanche Hosier, had been a friend of Sickert in Dieppe.
The portrait was painted partly from a photograph and partly from life. Two studies exist:

1. Pen and ink, squared. 7 × 4 (17·8 × 10·2), Coll. Liverpool, Walker Art Gallery (1948). Exh. A.C.49 (62b); Hull 68 (56).
2. Pen and ink, squared, washed over the verso with indian red to aid tracing the drawing onto canvas. $17 \times 11\frac{3}{4}$ (43·2 × 29·9), Private Collection, London (bought from Sickert shortly after its execution).

The drawings may themselves have been done from a photograph.
The portrait is painted in two colours only, a deep green-blue and a hot pink.

404. THE RAISING OF LAZARUS (Fig. 284) c.1929-32
Canvas. 96 × 36 (243·9 × 91·5)
Christie's, 2 December 1932 (114) presented by Sickert to be sold for the benefit of Sadler's Wells; it was bought by the Beaux Arts Gallery/
Coll. Melbourne, National Gallery of Victoria (1947)
Rep. Emmons, facing p. 262; B.43, Pl. 62; Bertram, Pl. 44; B.60, Pl. 92
Exh. R.A.1932 (629); Beaux Arts Gallery 1933 (18); Tate 60 (172); Adelaide 68 (55)
Chapter XVIII

Painted from photographs (one is in the possession of the Islington Public Libraries) showing a lay figure being transported up the gloomy stairs to Sickert's studio. Cicely Hey is the woman in the foreground (acting the part of Lazarus's sister), Sickert is Christ, the macabre lay figure is

Lazarus. Cicely Hey remembered Sickert drawing on the photographs 'just to emphasize certain points'. The painting has extraordinary visionary power; the definition is handled with elliptical freedom; the colours are striking (wine red, sharp emerald green, and silvery white).
Sickert made preliminary studies for the picture, one on his wallpaper in Highbury Place where the work was painted.

1. Oil on red wallpaper now laid on canvas. 96 × 36 (243·9 × 91·5), last known owner Sir Osbert Sitwell. Exh. London Group November 1935 (179); Agnew 60 (111). This green monochrome study was removed from the wall when Sickert decided to leave London.
2. Canvas. 28 × 11 (71·1 × 28), Private Collection. Exh. Beaux Arts Gallery 1933 (19); Edinburgh 53 (7). Sizes were given in the 1933 Beaux Arts Gallery Sickert exhibition which facilitates identification of the works there shown.

405. THE SERVANT OF ABRAHAM (Fig. 283) c.1929
Canvas. 24 × 20 (61 × 50·8)
'Sickert' t.r., 'The Servant of Abraham' across lower edge
Coll. London, Tate Gallery (1959)
Rep. Sitwell, in colour as frontispiece; B.60, Pl. 96; Rothenstein 1961, p. 1
Lit. Tate Gallery Catalogue 1964, p. 640
Exh. Savile Gallery 1930 (28); Tate 60 (173)
Chapter XVIII

Painted from a squared-up photograph, formerly belonging to Miss Catherine Powell and also lent to the Tate Gallery Sickert exhibition in 1960.
The Tate Gallery catalogue 1964 quotes information from Mrs. Helen Lessore that the portrait was conceived as if it were part of a large mural decoration and Sickert deliberately used a broad technique to show how he would have treated such a grand-scale commission. Miss Browse in her plate note (B.60, p. 83) herself perceived this and quoted Sickert's words, 'We cannot well have pictures on a large scale nowadays, but we can have small fragments of pictures on a colossal scale'.
Traditionally dated 1929, this is the last of Sickert's patriarchal self-portraits of the later 1920s. He continued to paint himself, as an incident in landscapes and as straight self-portraits, but his conception became calmer and more domestic. Examples of later self-portraits include:

1. *Self-Portrait with the Blind Fiddler.* Canvas. 26 × 16 (66 × 40·6), Christie's, 26 July 1957 (109)/R.B.D./ Private Collection, London. Rep. B.60, Pl. 93. Exh. R.B.D.60 (35); Tate 60 (175). Also painted c.1929 from a photograph now in the Islington Public Libraries collection.
2. Canvas. 27 × 10 (68·5 × 25·4), Sir Alec Martin/Coll. London, Tate Gallery (1943). A *grisaille* full-length showing Sickert wearing a loud check suit, painted in the 1930s. Many press photographs show Sickert wearing this suit; it was obviously the suit he wore for most public occasions. The portrait is perhaps closest to a photograph in the *Daily Mirror*, 8 March 1934.
Sickert painted himself wearing the same suit in the company of Miss Gwen Ffrangcon-Davies:
3. Canvas. $26\frac{1}{4} \times 15\frac{3}{4}$ (66·8 × 40), Reitlinger Bequest, Maidenhead/Sotheby's, 9 December 1970 (52). The picture is inscribed 'Sickert pinxt' and, in capital letters,

'GWEN FFRANGCON-DAVIES AND ANR'. It is painted in green monochrome and has a very narrow date-bracket, between May and June 1932. It was painted from a photograph published in the *Daily Sketch*, 30 April 1932, showing Miss Ffrangcon-Davies and Sickert arriving together at the Private View of the Royal Academy in 1932 (where *The Raising of Lazarus* was to be seen). The painting done from this photograph was exhibited at 24 Ryder Street, 'Twelve Paintings by Modern Artists', in July 1932. The *Sunday Graphic*, 24 July 1932, reproduced the painting and the original photograph.

4. *Home Life*. Canvas. 29½ × 22 (75 × 55·9), Evan Charteris/ Last known owner Stanhope Joel Esq. Rep. *Apollo*, 27, March 1938, p. 159. Exh. Leicester Galleries 1938 (5); Agnew 60 (105). Dated 1937. A portrait study of Sickert slipping off to his wine cellar, done in St. Peter's-in-Thanet.

406. PORTRAIT OF HUGH WALPOLE (Fig. 282)
dated 1929

Canvas. 30 × 25 (76·2 × 63·5)
'Sickert 1929' b.r.
Coll. Glasgow, City Art Gallery (1947)
Lit. Andrew Forge, the *Listener*, 7 October 1965, pp. 531-2, 'Sickert's portrait of Hugh Walpole' (Painting of the Month series)
Exh. Savile Gallery 1930 (4); Tate 60 (174); Tate Gallery 1964, 'London Group Jubilee Exhibition' (42)
Chapter XVIII

One of two portraits by Sickert of Hugh Seymour Walpole (1884-1941), novelist, knighted 1937. Walpole collected Sickert's work himself and wrote the catalogue preface to several Sickert exhibitions. Fig. 282 was painted from photographs and probably done for Sickert's own pleasure. A drawing, probably taken from the same photographs, exists: pen and ink, charcoal, heightened with white. 11 × 9 (28 × 22·9), Private Collection, England. Dedicated to 'Vera' (?Cuningham). It is not a working study but a finished portrait in its own right. The other portrait, Canvas. 16⅞ × 16½ (42·9 × 41·9), Sir Hugh Walpole/Coll. Cambridge, Fitzwilliam Museum (1943) is dated 1928 and was commissioned. The 1928 portrait was exhibited with the London Group, January 1929 (19). It was begun at the end of October 1928 with the help of some sittings from life and was painted directly without preliminary drawings or studies (information given to the Fitzwilliam Museum by Sir Hugh Walpole).

407. VISCOUNT CASTLEROSSE (Fig. 285)
1935

Canvas. 82 × 27½ (208·3 × 69·8)
'Sickert/St. Peter's in Thanet' b.r.
Sir James Dunn (commissioned)/
Coll. Fredericton, New Brunswick, Canada, Beaverbrook Art Gallery (1959)
Exh. R.A.1935 (477)
Chapter XVIII

Sickert was in financial difficulties in the early 1930s. A fund was raised to help him, and undoubtedly with the same motive Sir James Dunn commissioned twelve portraits including three of himself (two were executed), his wife, Lord Beaverbrook, as well as Lord Castlerosse (details below). Information about the commission is given in Lord Beaverbrook's book, *Courage. The Story of Sir James Dunn*, Canada, Brunswick Press, 1961.

The portrait of Lord Castlerosse was the talking point of the Royal Academy exhibition. It is painted in bright, arbitrary colours, strong blue, pink, and chocolate brown. Every newspaper and periodical had something to say about it, even the *Tailor and Cutter* who complained of the cut of the suit and the colour of its cloth. Lord Castlerosse himself recalled in the *Sunday Express*, 12 May 1935, that he never saw the portrait before its exhibition: 'All I did was to have luncheon with Sir James Dunn, and there I met Mr. and Mrs. Sickert.

'Mrs. Sickert took a snapshot or two, and that was all that was asked of me.' Sickert apparently told Castlerosse that his method was a return to the spirit of traditional eighteenth-century practice when portrait artists did not expect their sitters to pose formally but instead observed them as they talked together. The St. Peter's inscription establishes the date of Fig. 285 as 1935 (Sickert moved to St. Peter's at Christmas 1934).

The Beaverbrook Art Gallery also owns two portraits by Sickert of *Sir James Dunn, Bt.*, commissioned by the sitter, one full-length, 72 × 24 (182·9 × 61), Exh. R.A.1934 (325), the other seated, 53½ × 35½ (135·9 × 90·1); they have a portrait of Lady Dunn (entitled *In Phoenix Park*) on loan to them from Lady Beaverbrook, 65½ × 24 (166·3 × 61), also commissioned by Sir James Dunn.

The three-quarter-length portrait of Lord Beaverbrook, commissioned by Sir James Dunn, 69 × 42 (175·3 × 106·8), dated 1935, is in the Collection of the Beaverbrook Library, London. The photograph from which it was painted, and the correspondence between Sickert and Beaverbrook relating to the portrait, are also in the Beaverbrook Library archives. Sickert painted Beaverbrook against an artificial St. Peter's seascape. The portrait was rejected by the Royal Academy because of its colossal scale.

408. KING GEORGE V AND QUEEN MARY (Fig. 286)
1935

Canvas. 25 × 29¾ (63·5 × 75·5)
'Sickert' b.r.
Coll. The Trustees of Sir Colin and Lady Anderson
Rep. Rothenstein 1961, Col. Pl. 16; Pickvance 1967, Col. Pl. XVI
Exh. Leicester Galleries 1935, 'Summer Exhibition' (108) as *His Majesty*; Tate 60 (183)
Chapter XVIII

Painted in 1935 from a press photograph of the King, dressed in the uniform of Admiral of the Fleet, during one of the Jubilee Drives. The King and Queen Mary are seen framed by the window of their car. The painting was much written of in the press and reproduced in the *Daily Telegraph*, 18 July 1935, as *His Majesty* on show at the Leicester Galleries. It may be stated here that the publicity Sickert's work attracted in the 1930s was great; the pictures he exhibited were discussed at length and often illustrated in the press—which greatly facilitates their identification today. The several cuttings books in Islington Public Library contain an almost exhaustive collection of Sickert's

press notices and these cuttings have been used to identify the exhibition details of pictures catalogued in this book. Hereafter specific references to press notices proving the exhibition history of individual works will not be given unless they are of particular interest.

The conception of Fig. 286 is similar to that of an earlier portrait of King George V, called *A Conversation Piece at Aintree*. It shows the King at Aintree, seen framed in the window of his car together with his trainer, Major Featherstonhaugh. It was painted from a Press photograph, published in the *News Chronicle* in 1927 (its inscription acknowledges 'By courtesy of Topical Press, 11 and 12, Red Lion Court, E.C.4. Aintree—25.3.27'). The frank acknowledgement of the photographic document caused a stir in the press.

Details of *A Conversation Piece at Aintree*:
Canvas. 18½ × 18½ (47 × 47), Miss Sylvia Gosse/ Christie's, 20 July 1951 (63)/Coll. H. M. Queen Elizabeth, the Queen Mother. Exh. London Group October 1931 (142); Beaux Arts Gallery 1932 (31); Chicago: Pittsburgh 1938 (21); Agnew 60 (104); Tate Gallery 1963, 'Private Views' (8).
This painting is generally dated 1927 but I believe that it was probably painted later, towards the end of the date-bracket 1927–30 (the original photograph being taken in 1927, and the painting first being exhibited at Christmas 1930, according to a press cutting, at the Lefevre Gallery in an exhibition of which I can find no catalogue). In 1931 the painting was offered by the Beaux Arts Gallery as a gift to the Glasgow Art Gallery but the city council turned it down as not majestic enough.

409. KING EDWARD VIII (Fig. 287) 1936

Canvas. 72 × 36 (182·9 × 91·5)
'Sickert' b.r.
Sir James Dunn/
Coll. Fredericton, New Brunswick, Canada, Beaverbrook Art Gallery (1959)
Exh. Leicester Galleries 1936, 'Summer Exhibition' (129) as *HIS MAJESTY THE KING*
Chapter XVIII

Version:
Canvas. 72 × 36 (182·9 × 91·5), Mrs. N. G. McLean (given to her by Sickert)/Christie's, 5 July 1963 (18)/Coll. London, Headquarters Welsh Guards, Wellington Barracks (1963). This version is almost identical to Fig. 287, the most obvious difference being that the signature 'Sickert' is placed b.r. in front of the foot instead of behind it.
The Christie's catalogue entry for this version states that it represents Edward VIII on 27 January 1936 leaving the vigil in Westminster Hall in honour of his father George V who had just died. This information is not correct, in so far as the version represents the same event as Fig. 287, and Fig. 287 was the subject of widespread publicity when it was shown to the public in July 1936. The picture shows the King, in the uniform of an officer of the Welsh Guards, arriving at a Church Parade Service of the Welsh Guards on St. David's Day (1 March 1936).
Fig. 287 was painted, in a fortnight, from a photograph taken by a freelance photographer, Harold J. Clements, which was published in the press. It was the first portrait

of the new King (who was to reign for a few months only). The painting was greatly admired as an outstanding likeness; Sickert's artistry was so loudly praised that Mr. Clements was offended at having been forgotten as the author of the original document.

410. THE MINER (Fig. 290) c.1935–6

Canvas. 50¼ × 30¼ (127·6 × 76·8)
Coll. Birmingham, City Art Gallery (1944)
Exh. Leicester Galleries 1936 (54) as *Black-and-White*; Carnegie Institute, Pittsburgh, 1936, 'International Exhibition' (109) as *The Miner*; Sheffield 57 (68); Tate 60 (185); A.C.64 (25)
Chapter XVIII

A rare contemporary figure group (as opposed to portrait or Victorian Echo) of this period. It was painted from a press photograph and according to contemporary press reviews of the 1936 exhibition it represented the reunion of a miner and his wife following his return to the pit-head after a stay-down strike.

411. MY AWFUL DAD *or* HUBBY (Fig. 291) c.1936–8

Canvas. 27⅜ × 20½ (69·5 × 52)
'Sickert' t.r.
Alfred Jowett/Dr. Leonard S. Simpson/
Coll. Miss G. Simpson
Exh. Leicester Galleries 1938 (11) as *Hubby*; N.G.41 (10); Leeds 42 (195); Tate 60 (165)
Chapter XIV, and Chapter XVIII

Version:
Canvas. 27 × 20 (68·6 × 50·8), Private Collection, England. Exh. Tate 60 (166).
Both painted from drawings of c.1912 (Fig. 235, C.332). The Leicester Galleries 1938 exhibition was of 'Recent Paintings', and all the works included were supposed to have been executed between 1936 and 1938.

412. SIR THOMAS BEECHAM CONDUCTING (Fig. 289) 1938

Canvas. 38¾ × 41⅛ (98·5 × 104·5)
'Sickert' b.r.
J. M. Cargher/Christie's, 3 December 1948 (33)/
Coll. New York, Museum of Modern Art (1955)
Rep. B.60, Pl. 95
Exh. Carnegie Institute, Pittsburgh 1939, 'International Exhibition' (153); Edinburgh 53 (44); Tate 60 (184); New York 67 (37)
Chapter XVIII

In a letter to Irene Scharrer (collection d'Offay Couper Gallery 1971) postmarked 15 March 1938 and sent from Broadstairs, Sickert wrote, 'I am at work on dear Beecham conducting' which almost certainly referred to this painting. Although Sickert enjoyed classical music, music was not one of his chief joys. In the 1920s he had painted another portrait of a conductor, *Eugene Goossens Conducting*, canvas, 16 × 26 (40·6 × 66), Morton Sands/Coll. J. B. Priestley Esq. Rep. B.60, Pl. 86. Exh. Agnew 60 (82). This picture is close in composition and conception to Sickert's music hall paintings showing the audience and orchestra.

413. PEGGY ASHCROFT IN HER BATHING COSTUME
ON A DIVING PLANK c.1934
Canvas. Size unknown
'Sickert' b.l.
Last known owner E. L. Franklin Esq.
Exh. Leicester Galleries 1934 (15)
Chapter XVIII

A photograph of this picture is in the Leicester Gallery
archives.

414. THE HON. LADY FRY c.1934-8
Canvas. 44¾ × 50 (113·7 × 127)
'Sickert' t.r.
Sir Geoffrey Fry (commissioned from Sickert)/ Mrs. Alan
 Ross (daughter of Sir Geoffrey and Lady Fry)/
Coll. Brighton, Art Gallery and Museum (1969)
Chapter XVIII

A portrait of Alathea, Lady Fry in bed, seen behind a large
newspaper. The sitter was a daughter of Lord Burghclere.

415. SIR ALEC MARTIN, K.B.E. 1935
Canvas. 55 × 42½ (139·7 × 108)
'Sickert' b.l.
Sir Alec Martin (commissioned in 1935)/
Coll. London, Tate Gallery (1958)
Lit. Tate Gallery Catalogue 1964, pp. 639-40
Chapter XVIII

Sir Alec Martin, K.B.E., was Sickert's executor and chair-
man of Christie, Manson & Woods. He commissioned this
portrait of himself and those of his wife (née Ada Mary
Fell, married Sir Alec in 1909) and youngest son (Claude
Phillip Martin) from Sickert in 1935. The portraits of Sir
Alec and of Lady Martin were done in Sickert's house at
St. Peter's-in-Thanet; the portrait of the boy was begun
in the garden of the Martins' house at nearby Kingsgate
and finished in Sickert's house. Thérèse Lessore took
snapshots of all three sitters from which Sickert painted,
although he also had sittings from life. The details of the
portrait of Lady Martin are the same as those of Sir Alec.
The portrait of Claude Phillip measures 50 × 40 (127 ×
101·6).

1927 ONWARDS. THEATRE SUBJECTS

416. MISS GWEN FFRANGCON-DAVIES AS ISABELLA
OF FRANCE IN MARLOWE'S EDWARD II: LA LOUVE
(Fig. 288) 1932
Canvas. 96 × 36 (243·9 × 91·5)
'LA LOUVE' across lower edge, 'BERTRAM PARK phot.' b.r.,
 'Sickert P.' b.l.
Coll. London, Tate Gallery (1932)
Rep. Bertram, Pl. 47
Lit. Tate Gallery Catalogue 1964, p. 626
Exh. Wilson Galleries 1932 (no catalogue); Tate 60 (180)
Chapter XVIII

Miss Ffrangcon-Davies told the compiler of the Tate
Gallery catalogue that Sickert painted this portrait from
a photograph he particularly liked when he was looking
through her photograph albums. It had been taken by

Bertram Park at a dress-rehearsal of the Phoenix Society's
production of *Edward II*. The play itself was privately
performed on 28 November 1923: Sickert was not present.
Sickert saw the photograph and painted the portrait in
1932. An account of the way the picture was done, in the
form of a reporter's interview with sitter and painter,
appeared in the *Manchester Evening News*, 6 September 1932.
The title '*La Louve*' (she-wolf) was given to Isabella of
France because of her fierce character. Together with young
Mortimer she secured the downfall of the king who, in
one passage of the play, exclaimed of the crown

> ''tis for Mortimer, not Edward's head,
> For he's a lamb, encompassed by wolves'.

Sickert painted Miss Ffrangcon-Davies many times. *Gwen
Again* is catalogued separately (C.425). His *Self-Portrait*
with the actress is catalogued under C.405, Painting 3.
Other pictures of Miss Ffrangcon-Davies include:
1. *Gwen Ffrangcon-Davies in The Lady with a Lamp*. Canvas.
 48 × 27 (121·9 × 68·5), Coll. H. M. Tennant Ltd., at
 present in the foyer of the Globe Theatre, London.
 Exh. Leicester Galleries 1934 (16) as *Gwen Ffrangcon-
 Davies*; Tate 60 (181). Miss Ffrangcon-Davies played the
 part of Florence Nightingale in *The Lady with a Lamp* in
 the autumn of 1929 on tour (she had previously acted
 as Elizabeth Herbert in the same play in January 1929
 at the Arts and Garrick Theatres). In this picture she
 is seen as Florence Nightingale (under which title the
 work was exhibited at the Carnegie Institute, Pittsburgh,
 1938 International Exhibition No. 122). The painting
 was done from a photograph, probably towards the end
 of the date-bracket 1929-34.
2. *The Victor*. Canvas. 19 × 16¾ (48·2 × 42·5), Coll. London,
 Islington Public Libraries (1947). Exh. Sheffield 57
 (79). Not a portrait of Miss Ffrangcon-Davies. It shows a
 wolf at bay fiercely facing a group of hunters who cower
 in the woods behind. It is, however, inscribed 'To Miss
 Ffrangcon-Davies—Gwen and her audience', and a
 label on the back reads 'Gwen Ffrangcon-Davies gets
 busy with her audience'. Evidently Sickert recognized
 something of the ferocity of a wolf in Miss Ffrangcon-
 Davies's character which may explain why he twice
 chose to paint her as *La Louve*, Isabella of France (see
 Gwen Again, C.425).

417. PEGGY ASHCROFT AND PAUL ROBESON IN
OTHELLO (Fig. 293) c.1930-6
Canvas. 38 × 19½ (96·5 × 49·5)
Harcourt Johnstone/Christie's, 30 October 1942 (65)/ R.
 Middleton/
Private Collection, Scotland
Exh. Leicester Galleries 1936 (55)
Chapter XVIII

The production of *Othello* starring Peggy Ashcroft as
Desdemona and Paul Robeson as Othello opened at the
Savoy Theatre, London in May 1930.
Sickert used vivid colour to heighten the drama of this
picture; the background curtain is scarlet (with wine red
shadows), Othello's sleeves are scarlet, his suit emerald
green, and Desdemona's gown is gold.
Sickert painted Peggy Ashcroft in different roles, perhaps
more often than any other actor or actress. Her portrait

in a bathing suit is catalogued C.413. Her portrait in silhouette before a Venetian landscape background is catalogued under C.449. Various other Peggy Ashcroft paintings and drawings are catalogued below (Fig. 292, C.423 and 424). However, the full list of Peggy Ashcroft paintings is so extensive that it cannot be given here. Only one further example will be quoted because it has recently come into circulation: *Peggy Ashcroft as Nina in The Seagull*. Canvas. 39 × 17½ (99 × 44·5), the Hon. Mrs. D. Hazlerigg/ Sotheby's, 14 July 1971 (99) as *Study in Blue, a Portrait of Dame Peggy Ashcroft*. Exh. Beaux Arts Gallery 1937 (6). A full-length standing portrait. Miss Ashcroft played Nina in *The Seagull* at the New Theatre in May 1936; the picture was exhibited at the Beaux Arts Gallery April–May 1937. Its identification is confirmed by the *Daily Telegraph*'s description of the exhibited work, 27 April 1937, as 'a symphony in blue'.

418. JULIET AND HER NURSE (Fig. 292) 1935–6

Canvas. 30 × 24 (76·2 × 61)
'Sickert' b.l.
Coll. Leeds, City Art Gallery (1937)
Exh. Leicester Galleries 1936 (53); N.G.41 (43); Leeds 42 (193); Edinburgh 53 (40); Sheffield 57 (69); Tate 60 (182); Hull 68 (23)
Chapter XVIII

Edith Evans as the nurse and Peggy Ashcroft as Juliet in *Romeo and Juliet*, performed at the New Theatre from October 1935 until March 1936.

419. THE TAMING OF THE SHREW (Fig. 294) c.1937

Canvas. 39 × 24 (99 × 61)
'Sickert' t.r.
Alfred Jowett/
Coll. Bradford, City Art Gallery (1944)
Exh. Leicester Galleries 1938 (7); Leeds 42 (194); A.C.64 (26); Hull 68 (25)
Chapter XVIII

Leslie Banks as Petruccio and Edith Evans as Katherine in a production of the play at the New Theatre, March 1937.

420. THE PLAZA TILLER GIRLS dated 1928

Canvas. 30 × 25 (76·2 × 63·5)
'Sickert 1928' b.r.
Coll. M. V. B. Hill Esq.
Rep. B.60, Pl. 94
Exh. Savile Gallery 1930 (17); N.G.41 (46); Sheffield 57 (61); Agnew 60 (97); Tate 60 (167)
Chapter XVIII

The Plaza Tiller Girls were a fashionable cabaret troupe. The date on this painting is sometimes misread as 1927 (e.g. catalogues of Agnew and Sheffield exhibitions). The picture was painted from a photograph.

Version:
Canvas. 24 × 18¼ (61 × 46·3) was with Messrs. Arthur Tooth & Sons, Ltd. in 1929 but is now of unknown whereabouts. This smaller version was also signed and dated 'Sickert 1928' but b.l. instead of b.r.

Study (possibly used for etching):
Pen and ink, squared, 6 × 5 (15·2 × 12·7), Sotheby's, 22 November 1972.

Related subject:
High Steppers. Canvas. 51 × 47½ (129·5 × 120·7), Sotheby's, 3 April 1963 (48)/Private Collection, London. Exh. Leicester Galleries 1940 (8). The chorus line faces in the opposite direction from *The Plaza Tiller Girls* and the girls are kicking their legs up, not just stepping out. The painting was probably painted much later than *The Plaza Tiller Girls*, perhaps in the late 1930s (the 1940 exhibition at the Leicester Galleries was of 'Recent Paintings'). The canvas is even coarser and the paint scraped on more drily.

421. SIR NIGEL PLAYFAIR AS TONY LUMPKIN IN SHE STOOPS TO CONQUER 1928

Canvas. 70 × 49 (177·8 × 124·5)
'Sickert' t.r.
Sir Nigel Playfair/
Coll. Giles Playfair Esq. (on loan to the Garrick Club)
Rep. B.43, Pl. 63
Lit. Emmons, pp. 212–3
Exh. R.A.1929 (388); Tate 60 (168)
Chapter XVIII

Presented to the sitter by fellow artists and workers in January 1929 to celebrate the tenth anniversary of Sir Nigel Playfair's management of the Lyric Theatre, Hammersmith. Sickert gave the money subscribed to the Sadlers Wells rebuilding fund.
The help Munnings gave Sickert (by providing a chart to show the proper distribution of mud splashes on the boots of Tony Lumpkin) was documented in the text. The picture caused a furore at the Royal Academy in 1929.
Study (squared for transfer):
Pen and ink, wash, heightened with white chalk, 10 × 7 (25·4 × 17·8), Sotheby's, 22 November 1972. Inscribed '70 × 49', that is, the size of the painting.

422. JOHNSTONE FORBES-ROBERTSON AS HAMLET c.1931–2

Canvas. 28 × 23¾ (71·1 × 60·3)
'In grateful and precious memory of a friendship of half a century—Sickert' across lower edge
Johnstone Forbes-Robertson/
Coll. Mr. and Mrs. David Tomlinson
Exh. Beaux Arts Gallery 1932 (17) as *Sweet Prince*; Crane Kalman 1958, 'A Miscellanea of Paintings of the Theatre, Circus and Music Hall' (7)
Chapter XVIII

Hamlet was Johnstone Forbes-Robertson's most famous role. As actor-manager his production of the play at the Lyceum Theatre in 1897 was widely acclaimed. His farewell performances at Drury Lane in 1913 included Hamlet and his final appearance was in this part. Sickert must have painted C.422 from an old photograph.

423. AS YOU LIKE IT. PEGGY ASHCROFT, VALERIE TUDOR AND WILLIAM FOX dated 1933

Pen and ink, watercolour. 7½ × 10½ (19 × 26·8)
'Sickert 1933/The Wells' b.r., 'Rosalind, Celia and Orlando' b.c.

Alfred Jowett/Christie's, 17 July 1959 (121)/R.B.D./
Private Collection, London
Exh. N.G.41 (102); Leeds 42 (114); R.B.D.60 (51); Tate
 60 (191)
Chapter XVIII

A very rare example of a drawing of this later period.
Sickert seems to have made a small group of drawings of
As You Like It in 1933 and it is possible that he sketched in the
theatre as well as working from photographs. Another
drawing of the same title, subject and players as C.423 is:
Pencil, pen and ink, squared. 8½ × 11⅝ (21·6 × 29·5), Coll.
Liverpool, Walker Art Gallery (1948). Exh. A.C.49 (62a);
Hull 68 (58).

There are several other drawings, an oil study, and a
painting, of this production of *As You Like It*; they show
only two figures, Rosalind and Orlando (Peggy Ashcroft
and William Fox) at the moment when Rosalind gives
Orlando a chain from her neck and says 'Wear this for
me':
Canvas. 30 × 13 (76·2 × 33), Coll. London, Department of
Environment (1960), location 1 Carlton Gardens, London.
Panel. 8¾ × 7¾ (22·2 × 19·6), Sir Hugh Walpole/Leicester
Galleries/Private Collection, London.
Pen and ink, black chalk, heightened with white. 8¼ × 11½
(21 × 29·2), Private Collection, London. Dedicated to
Peggy Ashcroft.
Pen and ink, watercolour. 8¼ × 11¼ (21 × 28·5), Sotheby's,
12 July 1961 (31)/Coll. Boston, Museum of Fine Arts
(1962). Inscribed and dated 'the Wells 1933'.
A painting of another production of *As You Like It* (New
Theatre, February 1937) is *A Theatrical Incident*, canvas,
39¼ × 35½ (99·7 × 90·1), Sotheby's, 8 July 1970 (41); it
shows Edith Evans as Rosalind and Marie Ney as Celia.

424. PEGGY ASHCROFT AS MISS HARDCASTLE IN
SHE STOOPS TO CONQUER after 1932

Canvas. 50 × 28 (127 × 71·1)
'PEGGY ASHCROFT AS/MISS HARDCASTLE' across lower edge
Coll. H. M. Tennant Ltd. (in the foyer of the Globe
 Theatre, London)
Exh. Sheffield 57 (81)
Chapter XVIII

Sickert painted this Old Vic production of *She Stoops to
Conquer*, which ran from December 1932 until May 1933,
several times. Other paintings include:
1. *Peggy Ashcroft and Valerie Tudor in She Stoops to Conquer.*
 Canvas. 50 × 40½ (127 × 102·8), Christie's, 30 June 1933
 (109)/Arthur Crossland/Christie's, 3 February 1956
 (187)/Coll. Dunedin, Public Art Gallery Society Inc.,
 New Zealand (1956). Exh. Adelaide 68 (56). Painted
 between December 1932 and June 1933.
2. *Peggy Ashcroft as Miss Hardcastle.* Canvas. 29½ × 39½
 (75 × 100·3), Christie's, 11 March 1960 (173), bought
 Voltere. Exh. Beaux Arts Gallery 1935 (2); Beaux Arts
 Gallery 1949, 'Paintings and Drawings by W. R.
 Sickert' (16), rep. in catalogue. Inscribed 'St. Peter's'
 where Sickert went to live at Christmas 1934 so that it
 must have been painted early in 1935, before its exhibi-
 tion in July.
3. *Peggy Ashcroft as Miss Hardcastle and Valerie Tudor as Miss
 Neville.* Canvas. Size unknown. Last known owner Mrs.

Hickling. Exh. Leicester Galleries 1934 (4). Signed
'Sickert R.A.' A photograph is in the Leicester Galleries'
archives.

425. GWEN AGAIN *c.*1935–6

Canvas. 55 × 39½ (139·7 × 100·3)
'Sickert—St. Peter's-in-Thanet' b.l. and inscribed across
 top edge 'L'Oltraggio che scende sul capo d'un re/
 imobil mi rende, tremolo mi fe'
Private Collection, Scotland
Exh. Leicester Galleries 1936 (49)
Chapter XVIII

A rough translation of the inscription is 'The insult offered
to a king makes me speechless, makes me tremble'. I have
been unable to discover its origin but it clearly refers to the
character and deeds of Isabella of France, the part which
Gwen Ffrangcon-Davies is again playing (see Fig. 288).
The St. Peter's inscription on this picture and its exhibition
in April 1936 fix the limits of its date-bracket. Like *Othello*
(Fig. 293) it is very vividly coloured; the background is
again scarlet (with wine red shadows) and the actress's
dress is emerald green.

1927 ONWARDS. 'ECHOES'

426. THE SEDUCER (Fig. 296) *c.*1929–30

Canvas. 16½ × 23½ (41·9 × 59·7)
'After/John Gilbert' b.l., 'The Seducer' b.c., 'Sickert
 transcripsit' b.r.
J. W. Blyth/Sotheby's, 15 April 1964 (19), bought Ellis
Exh. Savile Gallery 1930 (26)
Chapter XVIII, note 27

More of Sickert's Echoes are after John Gilbert (1818–97)
than after any other Victorian artist. Sickert had admired
Gilbert greatly since his youth and had known him person-
ally. He drew Gilbert's portrait for the *Pall Mall Gazette* in
1893 (catalogued under C.52).

427. SIRENS ABROAD (Fig. 295) 1930s

Canvas. 31 × 19½ (78·7 × 49·5)
'Sickert' b.r., 'J. S. Secombe' b.l.
Last known owner Mrs. E. P. Dorian Reed
Rep. B.43, facing p. 33 (in colour)
Exh. Leicester Galleries 1938 (20)

After J. S. Secombe. Painted in a wide variety of sharp,
sweet colours, sky blue, lilac, pink, green, lemon, and
orange.

428. EVENING (Fig. 302) late 1930s

Canvas. 19 × 29 (48·2 × 73·7)
'Sickert' b.r.
J. W. Blyth/
Coll. Kirkcaldy, Art Gallery (1964)
Exh. Leicester Galleries 1940 (14)

The original author of this design is unknown to me.
The picture is done in very cool, pale colours.

429. SUISQUE PRAESIDIUM *c.*1927

Canvas. Circular, diameter 35 inches (88·9)
'Anon del' b.l., and inscribed 'SUISQUE PRAESIDIUM' around
 lower perimeter
Private Collection, Scotland (bought from Sickert)
Exh. Savile Gallery 1928 (14)
Chapter XVIII

Probably Sickert's first Echo. Emmons, p. 211, noted
that an Echo done from a pot lid was the first of the series;
Suisque Praesidium was copied from the lid of a pomade pot.
It shows a Highlander's farewell to his family as he goes
off to battle. The owner of the picture told me that it was
once gaily coloured but that Sickert then decided to turn
it into a virtual monochrome by painting it all over in
grey-blue; traces of the original colours are still visible.
Suisque Praesidium is one of the first two Echoes Sickert ever
exhibited (at the Savile Gallery in February 1928).

430. A NATIVITY *c.*1929–30

Canvas. 15¼ × 22 (38·7 × 55·8)
'After John Gilbert' b.l., 'A Nativity' b.c., 'Sickert transcrip-
 sit' b.r.
Private Collection, Scotland (bought from Sickert)
Rep. *Studio*, 99, May 1930, p. 368 (together with Gilbert's
 original)
Exh. Savile Gallery 1930 (3)
Chapter XVIII, note 27

431. THE TICHBORNE CLAIMANT *c.*1930

Canvas. 20½ × 35 (52 × 88·9)
'Sickert' b.l.
Coll. Southampton, Corporation Art Gallery (1939)
Exh. London Group October 1930 (121) as *The Claimant*;
 Leicester Galleries 1931 (21); Sheffield 57 (77)
Chapter XVIII

Many of Sickert's Echoes were portraits of Victorian
personages rather than subject pictures. This picture of
Arthur Orton, the Tichborne Claimant, was painted from a
photograph (taken in Paris in the 1860s by Mayer Frères)
which belonged to Sickert.
Sickert held strong views, expressed in letters to the press
(e.g. the *Daily Telegraph*, 15 March 1935, the *Sunday Times*,
22 March 1936), on the Victorian *cause célèbre* of the 1870s
whereby Arthur Orton claimed to be Sir Roger Tichborne
and heir to a considerable fortune.

432. THE BEAUTIFUL MRS. SWEARS dated 1930

Canvas. 14¾ × 23½ (37·5 × 59·7)
'Sickert 1930' b.r.
Private Collection, England
Rep. *Apollo*, 13, June 1931, p. 346
Exh. Leicester Galleries 1931 (16), rep. in catalogue;
 N.G.41 (74); Leeds 42 (189); Tate 60 (176)
Chapter XVIII

The original of this Echo is unknown to me. Mrs. Swears
was the beauty of the season in Lowestoft whom Sickert
had admired when he went there with his family on holiday
as a boy (see Emmons, p. 21).

433. DUBLIN FROM PHOENIX PARK dated 1930

Canvas. 17 × 28½ (43·2 × 72·4)
'Sickert/30' b.r.
Asa Lingard/Arthur Crossland/
Present whereabouts unknown
Rep. *Apollo*, 13, June 1931, p. 347
Exh. Leicester Galleries 1931 (27); N.G.41 (81)
Chapter XVIII, note 24

After Francesco Sargent, many of whose landscape engrav-
ings Sickert painted as Echoes.

434. SHE WAS THE BELLE OF THE BALL *c.*1930–1

Canvas. 23¼ × 19¼ (59 × 48·8)
'Sickert' t.r., monogrammed 'AC' t.l.
Sir Michael Sadler/Lady Olivier/Godfrey Winn/
 Sotheby's, 15 December 1971 (207)
Rep. *Studio*, 101, 1931, p. 453 (in colour)
Exh. Leicester Galleries 1931 (6)
Chapter XVIII, note 26

A particularly gay Echo similar to *Sirens Abroad* (Fig. 295)
in its colours. Painted after Adelaide Claxton (hence the
monogram inscription).

435. VICINIQUE PECUS *c.*1930

Canvas. 24 × 19 (61 × 48·2)
'Sickert' b.r.
Samuel Courtauld/Mrs. R. A. Butler/
Coll. F. H. Mayor Esq.
Exh. Leicester Galleries 1931 (1), rep. in catalogue; Tate
 60 (171)
Chapter XVIII, note 25

After Kenny Meadows, whose opulent tales of romance and
flirtation Sickert particularly enjoyed transcribing.

436. THE PRIVATE VIEW *c.*1930

Canvas. 19 × 29¼ (48·2 × 74·3)
'After G. Bowers' b.l.
Sotheby's, 5 October 1954 (22)/Sotheby's, 14 December
 1960 (141a)/
Coll. London, Department of Environment (1962) at
 present in the British Embassy, Cairo
Exh. Leicester Galleries 1931 (9)
Chapter XVIII, note 28

After Georgie Bowers. Sickert inscribed another Echo after
Georgie Bowers of similar subject—*The Royal Academy*—'to
the dear and perpetual memory of Georgie Bowers. The
R.A.' Canvas. 13 × 20 (33 × 50·8), Mark Oliver/Present
whereabouts unknown. Exh. Savile Gallery 1930 (22);
Leeds 42 (190).

437. HAMLET *c.*1930

Canvas. 16⅛ × 26 (41 × 66)
'Sickert' b.l. 'J.G.' b.r.
Coll. Paris, Musée National d'Art Moderne (bought by the
 Louvre in 1932)
Exh. Leicester Galleries 1931 (13)
Chapter XVII

After John Gilbert, the graveyard scene from *Hamlet*. One
of the uglier of Sickert's Echoes.

438. DOVER c.1931

Canvas. 21 × 22½ (53·3 × 57·1)
'Sickert' b.l.
Sir Hugh Walpole/
Coll. Leicester, City Art Gallery (1945)
Rep. *Illustrated London News*, 7 September 1957
Exh. Beaux Arts Gallery 1932 (5); Sheffield 57 (72); Tate
 60 (179); A.C.64 (24)
Chapter XVIII, note 24

After Francesco Sargent.

439. HER SERENE HIGHNESS c.1931

Canvas. Size unknown
'Sickert pinxt' b.l.
Whereabouts unknown
Rep. *Studio*, 103, May 1932, p. 271
Exh. Beaux Arts Gallery 1932 (2), rep. in catalogue
Chapter XVIII, note 25

After Kenny Meadows.

440. SUMMER LIGHTNING c.1931

Canvas. 24¾ × 28¼ (62·9 × 71·7)
'Sickert' b.r.
Coll. Liverpool, Walker Art Gallery (1932)
Rep. *Illustrated London News*, 9 April 1932; *Studio*, 103,
 May 1932, p. 272; Bertram, Pl. 46
Exh. Beaux Arts Gallery 1932 (8); N.G.41 (75)
Chapter XVIII, note 27

After John Gilbert's engraving *The Unexpected Rencontre*.
Sickert's Echo and Gilbert's engraving were reproduced
together in the *Illustrated London News*, 9 April 1932.

441. THE IDYLL c.1931

Canvas. 27 × 28½ (68·6 × 72·4)
'Sickert' b.c.
Coll. Kingston upon Hull, Ferens Art Gallery (1932)
Rep. *Illustrated London News*, 9 April 1932; *Studio*, 103,
 May 1932, p. 267 (in colour)
Exh. Beaux Arts Gallery 1932 (3); Chicago: Pittsburgh
 1938 (24); Sheffield 57 (73); Hull 68 (22)
Chapter XVIII, note 27

Reproduced in the *Illustrated London News*, 9 April 1932,
together with Gilbert's original engraving of the subject
called *An Embarrassing Moment*. For some reason *The Idyll*
was published by Miss Browse (B.60, p. 93) as after T.
Robinson and this misinformation was repeated in the 1968
Hull exhibition catalogue.

1927 ONWARDS. LANDSCAPES

442. BARNSBURY (Fig. 297) c.1928–30

Canvas. 20 × 24 (50·8 × 61)
'Sickert' t.l.
Coll. Glasgow, City Art Gallery (1931)
Exh. Probably Beaux Arts Gallery 1931, 'The Art of
 Yesterday' (58); Royal Glasgow Institute 1931, '70th.
 Annual Exhibition' (424)—bought by the Glasgow Art
 Gallery from this exhibition; Sheffield 57 (83)
Chapter XVIII

The painting exhibited at the Beaux Arts Gallery under the
title *Barnsbury* was dated in the catalogue 1928. However,
it is possible that this picture was not Fig. 297 which
belonged to Barbizon House, not the Beaux Arts Gallery,
before its acquisition by Glasgow.
Fig. 297 must have been painted from an old photograph
because the premises of R. Thorne & Co. in what is now
365 Caledonian Road were occupied by the firm from
1890 to 1913 (information received by the Glasgow Art
Gallery from Mr. Geoffrey Fletcher, letter 12 January 1965).

443. BAIRD'S HILL HOUSE, ST. PETER'S-IN-THANET
(Fig. 298) c.1935–8

Canvas. 20 × 24 (50·8 × 61)
'Sickert' b.l.
The Leicester Galleries/
Present whereabouts unknown
Exh. Leeds 42 (196)
Chapter XVIII

Sickert lived in Hauteville, St. Peter's-in-Thanet, between
December 1934 and December 1938. Baird's Hill House
belonged to a neighbour.

444. THE GARDEN. ST. GEORGE'S HILL HOUSE,
BATHAMPTON (Fig. 300) c.1939–40

Canvas. 34 × 27 (86·3 × 68·6)
'Sickert' b.r.
R. Middleton/
Private Collection, Scotland
Chapter XVIII

Sickert lived in this house from December 1938 until his
death in January 1942. Many of his latest paintings are of
the house and its gardens. Other examples catalogued
below are *The Open Window* (C.451), *A Scrubbing of the
Doorstep* (Fig. 299), and *The Invalid* (C.450).

445. THE VINEYARDS, BATH (Fig. 301) c.1939–41

Canvas. 21 × 31½ (53·3 × 80)
'Sickert' b.r.
R. Middleton/
Private Collection, Scotland
Chapter XVIII

One of several Bath townscapes painted from photographs
probably taken by Thérèse Lessore while Sickert was
living in Bathampton. They are all painted in flat, gritty
paint on very coarse canvases, mainly in a grey monochrome
with only a few relieving touches of pale blue in the skies
and green in the trees. Another example is *Bladup Buildings*,
canvas, 19 × 27½ (48·2 × 69·8), R. Middleton/Private Collec-
tion, Scotland.
A slightly more coloured example is *Lansdowne Road*,
canvas, 22½ × 34½ (57·1 × 87·6), Major E. O. Kay/Coll.
Nicholas Hicks Esq. Exh. Sheffield 57 (53).

446. A SCRUBBING OF THE DOORSTEP (Fig. 299) 1941

Canvas. 24 × 29 (61 × 73·6)
'Sickert' b.r.
Dr. A. W. Laing/Sotheby's, 8 July 1970 (70)/New Grafton
 Gallery/

Private Collection, England
Exh. Leeds 42 (200)
Chapter XVIII

Catalogued at Leeds in 1942 as having been completed in November 1941. Like the late Bath townscapes it is painted very thinly in pale, washed-out colours and is almost monochromatic in effect.

Version:
Canvas. 19½ × 23½ (49·5 × 59·7), J. W. Blyth/Sotheby's, 15 April 1964 (18)/Private Collection, London.

447. THE FRONT AT HOVE. 'TURPE SENEX MILES TURPE SENILIS AMOR' dated 1930

Canvas. 25 × 30 (63·5 × 76·2)
'Sickert—30' b.l.
R. E. A. Wilson/Lady Dawson of Penn/
Coll. London, Tate Gallery (1932)
Rep. B.43, Pl. 64; Bertram, Pl. 45
Lit. Tate Gallery Catalogue 1964, p. 625
Exh. French Gallery 1931, 'Anthology of English Painting' (38) lent by R. E. A. Wilson; Tate 60 (177)
Chapter XVIII

The scene is a view of Adelaide Crescent with Brunswick Terrace and The Lawns in the foreground.
The Latin quotation is from Ovid, *Amores*, I, ix, line 4 and means 'An old soldier is a wretched thing, so also is senile love'. This is presumably a wry comment on the overtures made by the old man seated on a bench (a self-portrait) towards the lady alongside.

448. HOME SWEET HOME c.1935–8

Canvas. 34½ × 28½ (87·6 × 72·4)
'Sickert' b.r.
Coll. Worthing, Museum and Art Gallery (1946)
Chapter XVIII

Sickert included himself in this study of the front of his house at St. Peter's-in-Thanet. He is seated in the porch.

449. IL CANNAREGIO probably mid-1930s

Canvas. 30¾ × 35¾ (78·1 × 90·8)
'Sickert' b.l., 'Canaregio' [*sic*] b.l.
Coll. Aberdeen, City Art Gallery (1938) now on loan to Marischal College, University of Aberdeen
Exh. Leicester Galleries 1938 (9); Sheffield 57 (74)
Chapter XVIII

Version:
Canvas. 25 × 30 (63·5 × 76·2), A. Margulies/Private Collection, London. Exh. Leicester Galleries 1940 (11). Very similar in handling to C.449 but not inscribed with the title.

Related painting:
Viscere Mei. Canvas. 23 × 17 (58·3 × 43·2), Private Collection, Scotland (bought from Sickert). Exh. Savile Gallery 1928 (8). The background of this picture is Il Cannaregio but a mother and child group, painted from a photograph (which the owner of the picture remembers having seen), is in the foreground. The figures are painted in a crusted, glowing, green monochrome. The exhibition date of this picture places it as a work of the 1920s; it is possible that Sickert had a photograph or a drawing of Il Cannaregio which he particularly liked and which he used several times during his later career.
The very effective stylization of *Viscere Mei* was repeated in another, later, painting: *Variation on Peggy*. Canvas. 22 × 27¾ (55·9 × 70·5), Private Collection, London. Exh. Beaux Arts Gallery 1935 (8), rep. in catalogue. This picture shows Peggy Ashcroft, painted as a green monochrome silhouette, standing on a bridge in front of a pink, blue, and white Venetian landscape background with Santa Maria della Salute in the distance. Dame Peggy Ashcroft told me that it was painted from a holiday snapshot taken in Venice which was published in the *Radio Times* (where Sickert saw it).

450. THE INVALID c.1939–40

Canvas. 25 × 30 (63·5 × 76·2)
'Sickert' b.r.
Coll. Mrs. R. P. Schweder
Exh. Leicester Galleries 1940 (2); Commonwealth Institute, London 1969, 'British Painting since 1900' (7)
Chapter XVIII

This picture shows Sickert, in back view, stomping up his garden at Bathampton, stick in hand, to survey the view.

451. THE OPEN WINDOW *or* THE GARDEN WINDOW c.1939

Canvas. 35 × 27 (88·9 × 68·6)
'Sickert' b.r.
Coll. Leeds, City Art Gallery (1940)
Exh. Leicester Galleries 1940 (12), rep. in catalogue; N.G.41 (79); Leeds 42 (198); Sheffield 57 (71)
Chapter XVIII

The house is St. George's Hill House, Bathampton, and the figure at the window is Thérèse Lessore.

General Index

Index of Works